THE POWER OF FEMINIST ART

THE POWER OF FEMINIST ART

THE AMERICAN MOVEMENT OF THE 1970s, HISTORY AND IMPACT

**EDITED BY NORMA BROUDE
AND MARY D. GARRARD**

CONTRIBUTORS JUDITH K. BRODSKY
NORMA BROUDE
JUDY CHICAGO
LAURA COTTINGHAM
JOANNA FRUEH
MARY D. GARRARD
SUZANNE LACY
YOLANDA M. LÓPEZ
LINDA NOCHLIN
GLORIA FEMAN ORENSTEIN
ARLENE RAVEN
CARRIE RICKEY
MOIRA ROTH
MIRIAM SCHAPIRO
MIRA SCHOR
JUDITH E. STEIN
FAITH WILDING
JOSEPHINE WITHERS

HARRY N. ABRAMS, INC., PUBLISHERS

Project Manager: Ruth A. Peltason
Designer: Dana Sloan
Photo Editor: catherine Ruello

Front cover (clockwise from top):
Ester hernández. *La Ofrenda II* (detail). 1988
WAC demonstrators at the opening of the Downtown Guggenheim,
 July 25, 1992. Photo by Lisa Kahane (detail)
May Stevens. *Mysteries and Politics* (detail). 1978
Judith Baca (collective work). *Uprising of the Mujeres* (detail). 1979
Miriam Schapiro. Me and Mary cassatt (detail). 1976

Back cover:
Cheryl Donegan. *MakeDream.* 1993

Pages 2-3:
Miriam Schapiro. *Big OX No. 2.* 1968

Library of Congress cataloging-in-Publication Data

The Power of feminist art: the American movement of the 1970's, history
and impact / edited by Norma Broude and Mary D. Garrard; contributers,
Judith K. Brodsky....[et al.]
 p. cm.
Includes bibliographical references and index.
ISBN 0-8109-3732-8 (cloth) ISBN 0-8109-2659-8 (pbk.)
1. Feminism and art—United States. I. Broude, Norma. II. Garrard,
Mary D. III. Brodsky, Judith K.
N72 .F45P68 1994
701' .03—dc20 94—1543

Paperback edition published in 1996 by Harry N. Abrams,
Incorporated,New York

Clothbound edition published in 1994 by Harry N. Abrams, Inc.

Printed and bound in China
10 9 8 7 6 5 4 3 2

CONTENTS

CONTRIBUTORS

Judith K. Brodsky
Printmaker and professor at the Mason Gross School of the Arts, Rutgers, the State University of New Jersey. She has also served as provost of Rutgers University. The third national president of Women's Caucus for Art (1976–78), she gave the organization a national political voice, and was a founder of the Coalition of Women's Arts Organizations. Currently, she is president of the College Art Association of America (1994–96).

Norma Broude
Professor of art history at The American University, she is the author of two groundbreaking feminist articles on Edgar Degas (1977 and 1988), and *Impressionism, A Feminist Reading* (1991). She is the editor of *World Impressionism: The International Movement* (1990) and general editor of The Rizzoli Art Series. With Mary D. Garrard, she co-edited *Feminism and Art History: Questioning the Litany* (1982) and *The Expanding Discourse: Feminism and Art History* (1992).

Judy Chicago
Internationally renowned feminist artist and educator. She created the feminist art programs at Fresno (1969–70) and, with Miriam Schapiro, at CalArts, where they directed and contributed to the Womanhouse project (1971–72). With Arlene Raven and Sheila de Bretteville, she founded the Feminist Studio Workshop in the Woman's Building, Los Angeles (1973). In 1979, she created *The Dinner Party*, a monumental collaborative installation that has become a feminist icon. Her other projects include *The Birth Project* (1980–85) and *The Holocaust Project* (1985–93).

Laura Cottingham
Art critic in New York, who has been writing extensively over the past ten years on contemporary women artists and feminist issues in vanguard American and European publications. She is presently an adjunct professor at Cooper Union.

Joanna Frueh
Art critic, art historian, and performance artist, who teaches at the University of Nevada, Reno. She has written extensively on contemporary women artists, including an exhibition catalogue on Hannah Wilke (1989). With Cassandra Langer and Arlene Raven, she co-edited *Feminist Art Criticism: An Anthology* (1988) and *New Feminist Criticism: Art, Identity, Action* (1994).

Mary D. Garrard
Professor of art history at The American University, and pioneering feminist scholar, she is the author of *Artemisia Gentileschi: The Image of the Female Hero in Italian Baroque Art* (1989) and articles on Sofonisba Anguissola and feminist art history. In 1974–76, she was second national president of Women's Caucus for Art. With Norma Broude, she co-edited *Feminism*

and Art History: Questioning the Litany (1982) and *The Expanding Discourse: Feminism and Art History* (1992).

Suzanne Lacy

One of the original students in the feminist art programs at Fresno and CalArts. A nationally and internationally renowned performance artist who has created large-scale public performances focused on social issues, Lacy is presently dean of fine arts at the California College of Arts and Crafts, Los Angeles. She also writes art criticism.

Yolanda M. López

An educator and artist, she teaches drawing and painting at the University of California, Berkeley, where she is also director of the Worth-Ryder Student Gallery. Teaches in the ethnic studies program at the California College of Arts and Crafts, Oakland.

Linda Nochlin

In the 1970s, while teaching art history at Vassar College, she pioneered feminist art history. Today, she is the Lila Acheson Wallace Professor of Modern Art at the Institute of Fine Arts, New York University. A respected lecturer and art historian, her publications include "Why Have There Been No Great Women Artists?" (1971), *Women Artists: 1550–1950* (1976), *Women, Art, and Power and Other Essays* (1988), and *The Politics of Vision: Essays on Nineteenth-Century Art and Society* (1989).

Gloria Feman Orenstein

A professor at the University of Southern California, Los Angeles, with a joint appointment in Comparative Literature and the Study of Women and Men in Society. Author of *The Theatre of the Marvelous: Surrealism and the Contemporary Stage* (1975), *The Reflowering of the Goddess* (1990), and the co-editor of *Reweaving the World: The Emergence of Ecofeminism* (1990).

Arlene Raven

An early feminist activist in Los Angeles, she was a founder of Womanspace (the first feminist art gallery), the Feminist Studio Workshop, the Woman's Building, and *Chrysalis* magazine. Today, she is an art critic in New York, writing for such publications as *Arts*, the *Village Voice*, and *New Art Examiner*. She is the author of *Crossing Over: Feminism and Art of Social Concern* (1988), and co-editor of *Feminist Art Criticism: An Anthology* (1988) and *New Feminist Criticism: Art, Identity, Action* (1994).

Carrie Rickey

Formerly an art critic and film critic for the *Village Voice* and erstwhile contributor to *Art in America* and *Artforum*. Her writings have been published in numerous anthologies, including *Rolling Stone's History of Rock 'n' Roll*. At present she is film critic for *The Philadelphia Inquirer*.

Moira Roth

Noted art historian and art critic, and professor of art history at Mills College. Since the 1970s, she has written many important articles and organized exhibitions on feminist women artists such as Suzanne Lacy, Faith Ringgold, Miriam Schapiro, and May Stevens. Author of *The Amazing Decade: Women and Performance Art in America* (1983).

Miriam Schapiro

Internationally renowned feminist artist and educator. With Judy Chicago, she created the Feminist Art Program at CalArts (1971) and directed the Womanhouse project. She was a founding member of the Heresies collective (1976), and co-founder of the New York Feminist Art Institute (1979). Originator of the "femmage" concept and technique, she helped to launch the Pattern and Decoration movement, in which she was a leading figure. Her works include the hearts and fan series of the 1970s, *Anatomy of a Kimono* (1976), and the monumental public sculpture *Anna and David* (1987).

Mira Schor

A participant in the feminist art program at CalArts, where she was one of the twenty-one students who created Womanhouse. She is a painter and also teaches at the Parsons School of Design. Co-editor of the journal *M/E/A/N/I/N/G*, she has also contributed articles to *Art Journal, Artforum,* and *Heresies*.

Judith Stein

Art historian who has also served as a curator at the Pennsylvania Academy of the Fine Arts, where she organized exhibitions on Red Grooms and Horace Pippin. Author of the central essay in the catalogue, *Making Their Mark: Women Artists Move Into the Mainstream, 1970–85* (1989). Presently the Chair of the College Art Association Committee on Women in the Arts.

Faith Wilding

A participant in the feminist art programs at Fresno and CalArts, she was one of the twenty-one students who created Womanhouse. She is a painter and adjunct professor of art at Cooper Union and also teaches at Vermont College, Montpelier. Author of *By Our Own Hands: A History of the Women Artists' Movement in Southern California, 1970–1976* (1976).

Josephine Withers

Professor of art history and women's studies at the University of Maryland. Author of *Julio Gonzales: Sculpture in Iron* (1978), *Women Artists in Washington Collections* (exh. cat., 1979), and *Pablo Picasso* (1993). She has written on such topics as blockbuster exhibitions, Meret Oppenheim, Jody Pinto, Eleanor Antin, May Stevens, and the Guerrilla Girls.

PREFACE AND ACKNOWLEDGMENTS

Our personal catalyst for creating this book was an event in April 1992. To celebrate the twentieth anniversary of the ground-breaking Corcoran Conference on Women in the Visual Arts (the first national conference of women in visual arts professions), we joined Ellouise Schoettler, Claudia Vess, Josephine Withers, and other Washingtonians to organize an anniversary reunion at the Corcoran Gallery in Washington, D.C. Women came from many parts of the United States, to share their memories and to relive the passionate commitments and proud achievements of those revolutionary years. The impact of that experience made the two of us acutely aware of the historical need for a book that would document and define the critically important originating phase of the Feminist Art movement.

Beginning in the early 1970s, the Feminist Art movement presented a challenge to mainstream modernism that radically transformed the art world in the United States over the next two decades. Seen today by some critics as the cutting edge of postmodernism and by others as a movement that was more anti- than postmodern, early feminist art precipitated sweeping and fundamental changes—most of all, the conscious designation of female values and experiences as a legitimate basis for the creation of "high" art; but also, an early challenge to the hegemony of modernist abstraction, which ushered in the postmodern appreciation for diversity, as well as the return of serious content— both political and personal—to mainstream art. By the early 1990s, in fact, feminist art's revolutionary lessons had been so successfully assimilated into contemporary artistic practice that its own history, as well as the history of the many feminist arts organizations and publications that had helped to generate and support it, seemed in imminent danger of being forgotten and lost.

The Power of Feminist Art consists of essays written specially for this volume by many of the artists, critics, and art historians who participated in the events of the 1970s. Part I, which includes interviews with Judy Chicago and Miriam Schapiro, documents the first feminist art education programs at Fresno and CalArts and the now legendary Womanhouse project created by students from the CalArts program. Part II tells the story of the developing movement, traced through the influential publications, organizations, and alternative exhibition spaces that it generated. Part III chronicles the multiple forms of feminist art: the movement's newly emergent focus on political activism, social protest, and public art; its exploration of such formerly taboo aesthetic areas as "pattern and decoration"; subjects such as divinity or the body viewed from female perspectives; and the new strategies of collaboration and interactive performance. Part IV analyzes the backlash against 1970s

feminism in the art world of the 1980s and examines the continuing impact of 1970s feminism on subsequent generations of feminist artists who now work in a gender-conscious and multicultural world.

The Power of Feminst Art is itself a prime example of feminist collaboration, built upon the knowledge, memories, and experiences of its eighteen contributors. The first book on its subject, it reproduces and discusses hundreds of works of feminist art from the 1970s and beyond. Yet despite its broad scope, the book does not pretend to be—nor could it have been—totally inclusive. We see it, rather, as an overture to future scholarship that will expand upon its selective focus, complementing the advantages of memory with those of hindsight.

There is not space here to thank the many people who contributed to the realization of this book. We want to express our gratitude in particular, however, to Lucy R. Lippard, who was an invaluable source of information and inspiration for many of the eighteen authors. Gratitude at a primary level is also due to Paul Gottlieb, president of Abrams, for recognizing the value of this project and putting the enthusiastic support of the house behind it. We extend our warm appreciation to Ruth Peltason, our editor, with whom we have enjoyed a dynamic and creative interaction, and whose personal commitment to the book supported us all through the many editorial challenges posed by a project of this scope. Special thanks are also due to our picture researcher Catherine Ruello, for her initiative, tenacity, and good humor; and to our designer Dana Sloan, for an excellent design that is both sensitive and powerful. Finally, we thank our sixteen collaborators for their deep dedication to the project, for their individual creative contributions to the book, and for the support and encouragement they have consistently given us along the way.

Norma Broude and Mary D. Garrard

INTRODUCTION: FEMINISM AND ART IN THE TWENTIETH CENTURY

BY NORMA BROUDE AND MARY D. GARRARD

What is feminist art? In the early 1970s, artists, critics, and historians who were part of the feminist movement believed that, like the women's movement itself, art made by feminist women represented a radical new beginning, a Part Two in the history of Western culture to complement the largely masculine history that would now become Part One. The goal of feminism, said early spokeswomen, was to change the nature of art itself, to transform culture in sweeping and permanent ways by introducing into it the heretofore suppressed perspective of women.[1] In the new world order that would follow—Part Three—there would be gender balance in art and culture, and "universality" would represent the experiences and dreams of both females and males.

Twenty years later, we may smile at so utopian a vision, having learned that there is no such thing as a singular female perspective; that not all art by women is feminist, not even all art made by women who are feminists; having lived to see the Feminist Art movement of the 1970s contextualized by critics and historians as just another avant-garde movement followed by other movements; and finding ourselves in a period that is chillingly (to feminists) called "postfeminist," in which self-defined feminist art continues to be made, but in forms that differ radically from their 1970s predecessors.

How then do we situate the Feminist Art movement on the broader stage, conceptually and historically? Is it merely another phase of avant-garde? Or is it not, rather, to borrow a phrase that has been used to describe the cultural climate of the 1960s, "one of those deep-seated shifts of sensibility that alter the whole terrain"?[2] The feminist critic Lucy R. Lippard argued persuasively in 1980 that feminist art was "neither a style nor a movement," but instead "a value system, a revolutionary strategy, a way of life," like Dada and Surrealism and other nonstyles that have "continued to pervade all movements and styles ever since."[3] What was revolutionary in feminist art, Lippard explained, was not its forms but its content. Feminist artists' insistence on prioritizing experience and meaning over form and style was itself a challenge to the modernist valorization of "progress" and style development: "in endlessly different ways," wrote Lippard, "the best women artists have resisted the treadmill to progress by simply disregarding a history that was not theirs." Thus the agenda of feminist art could not be subsumed into that of modernism, and the very appearance of feminist art as early as 1970 was a distant early warning that modernism, and its theoretical commitment to formal values alone, was destined to become a finite historical stage, in this case to be replaced by postmodernism.

Feminist art and art history helped to initiate postmodernism in America. We owe to the feminist breakthrough some of the most basic tenets of postmodernism: the understanding that gender is socially and not naturally constructed; the widespread validation of non-"high art" forms such as craft, video, and performance art; the questioning of the cult of "genius" and "greatness" in Western art history; the awareness that behind the claim of "universality" lies an aggregate of particular standpoints and biases, leading in turn to an emphasis upon pluralist variety rather than totalizing unity.[4]

These conclusions could be reached because feminism had

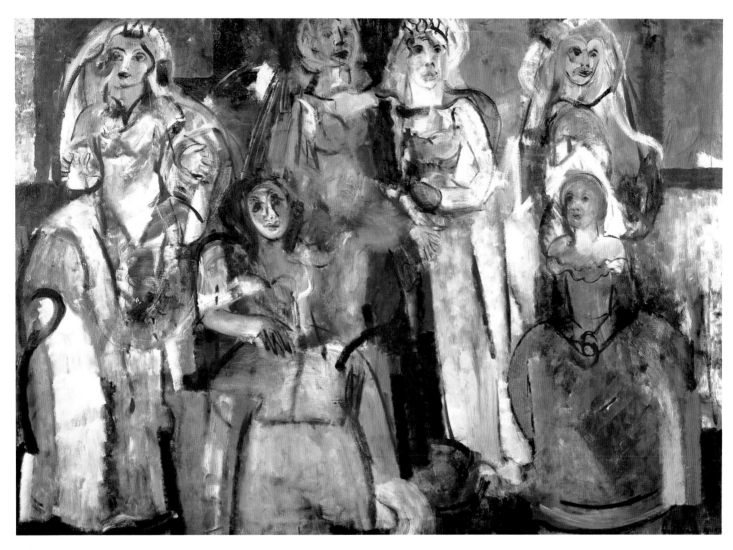

Grace Hartigan. *Grand Street Brides*. 1954. Oil on canvas,
72 × 102½″. The Whitney Museum of American Art, New York.
Gift of an anonymous donor

created a new theoretical position and a new aesthetic category—the position of female experience. In so doing, it reduced what had previously been considered universal in art to its actual essence: the position of male experience. Quick to follow were the modifiers—not just male experience, but white male experience, and then heterosexual white male experience. And once any given work of art was understood to proceed out of and be shaped by specific conditions of gender, race, sexuality, or class, it became equally clear that audiences also responded to art out of their own conditioning, i.e., the art we find most compelling is art with whose maker we share a basis of common beliefs or experience. If it is commonplace in our postmodern era to speak of pluralism and diversity, and if more attention is paid in art publications today to art that arises from a rainbow of races and ethnicities and that addresses social concerns rather than formalist progressions, that is something feminism helped to bring about.

It was the Feminist Art movement, with its politically forceful reinstatement of figurative imagery, portraiture, and the decorative, that forced an expanded definition of modernism and opened up new avenues of expression to male as well as to female artists. Yet, ironically, postmodernism's definition and critique of modernism as a sterile and reductive formal language lacking in rich content was based uncritically upon modernism's self-definition as pure and transcendent of all lesser values, a self-definition that was, in turn, based upon the systematic denial of the contributions of women to the history of twentieth-century art. Feminist art history, through its rediscovery of the oeuvres and "different voices"[5] of neglected women artists such as Paula Modersohn-Becker, Frida Kahlo, Alice Neel, Louise Bourgeois, and many others, has revealed that diversity and pluralism were in reality a far greater part of the modernist movement than either modernism or postmodernism (intent on defining itself in opposition to the modernist "other") has permitted us to see.[6]

The deep-seated shift brought about by the Feminist Art movement of the 1970s concerns more than just the perspective of modernism vs. postmodernism. The movement was also a major watershed in women's history and the history of art. Until c. 1970, there had not yet existed a self-conscious and universalizing female voice in art—self-conscious in articulating female experience from an informed social and political position, and universalizing in defining one's experience as applicable to the experience of other women: "the personal is political," in the 1970s slogan. From the sixteenth through the eighteenth centuries, women artists had worked in relative cultural isolation, grouped together by men's classification rather than by choice. Even in the nineteenth century, though some women artists participated in social movements, feminism and art had not yet joined forces. Käthe Kollwitz's fellow socialists were not feminists; Paula Modersohn-Becker's band at Worpswede was not a feminist group. In nineteenth-century France, many women artists joined in promoting a "l'art feminin" that defined the feminine in art according to the principle of "separate spheres," yet these women were frequently at odds with political feminists, and the "feminine" art that they championed was defined by societally- and self-imposed gender stereotypes that turned out to be limiting, conservative rather than progressive.[7] In the wake of the Arts and Crafts movement in England, women worked to advance the status of woman-identified arts such as needlework, but advancing the social status of women was not an overt part of the movement's agenda.[8]

In America, women's support of other women was manifested at the Philadelphia Centennial of 1876, which boasted the first all-female exhibition space in its Women's Pavilion and, more dramatically, in the Woman's Building in the Chicago World's Columbian Exposition of 1893, which was created totally by women, from its architect, sculptors, and muralists to the women from all nations who submitted arts and crafts. Yet suffragists objected to the Women's Pavilion on grounds of class (Elizabeth Cady Stanton complained that working class women were not represented, and the exhibits did not expose woman's "political slavery").[9] The Chicago Woman's Building, with its murals of *Primitive Woman* by Mary F. MacMonnies and *Modern Woman* by Mary Cassatt, embraced to some degree the agendas of both suffragists and conservative women, thanks to chief organizer Bertha Palmer's insistence on their common cause, but the factions remained separate and opposed.[10] Perhaps the nearest model for the union of art and feminist politics was the banner imagery produced in England at the turn of the twentieth century to support the suffragist movement. Yet its practitioners did not form an art movement nor did they challenge or seek to reform existing categories and hierarchies of art.[11]

As the twentieth century wore on, many women artists found circumstantial opportunities to exhibit and develop their work—for example, the circle of Alfred Stieglitz (in which women photographers were active), the WPA projects of the 1930s, the Surrealist movement—but the women in these groups did not especially identify with each other, and the groups in no way provided them with feminist structures for their art. Indeed, the Surrealist group did the very opposite. There, the concept of the *Femme-Enfant*, the "Woman-Child," was extolled as ideal and muse by the men of Surrealism, who regarded woman as the incarnation of spontaneity and innocence, untrammeled by reason or logic, and therefore naturally in touch with intuitive knowledge and the world of dreams and the imagination. Surrealism thus exalted the female, but the female imprisoned within a world of childhood and immaturity. And it perpetuated Western culture's dichotomous equation of woman with nature and the intuitive, and man with culture and the cerebral, thereby celebrating—according to the values of patriarchal society—a relationship of inequality.[12]

Although women had increasingly swelled the enrollments of art schools in the United States during the first half of the twentieth century, very few had been able to make the crucial

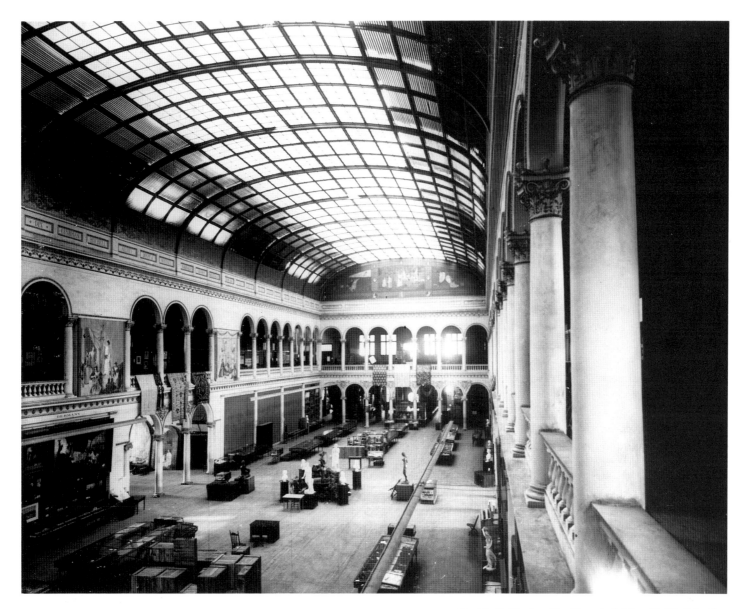

Sophia G. Hayden. The Woman's Building, World's Columbian Exposition, Chicago, 1893. Main gallery, with Mary Cassatt's mural, *Modern Woman*. Courtesy the Chicago Historical Society

transition from amateur to professional status. The best-known exception was, of course, Georgia O'Keeffe, whose public image, to her own dismay and distaste, had been managed by her husband and dealer, the photographer Alfred Stieglitz, to conform to a male observer's sexualized notion of what a "real" woman and her art would be like.[13] In the 1930s, New Deal art programs such as the WPA afforded women artists an unprecedented opportunity for professional employment and identity under conditions that were theoretically egalitarian, but that were still limited by societal assumptions about the cultural superiority of male experience and the male point of view as the appropriate foundations for the making of art.[14]

The narrow window of opportunity for women artists that had briefly opened during the economic hard times of the 1930s quickly snapped shut again in the forties, with the emergence of the critical apparatus that supported the Abstract Expressionist movement and its macho mystique—to which

women artists were automatically denied access. Such an artist was Lee Krasner (a.k.a. Mrs. Jackson Pollock), whose teacher Hans Hofmann, in the late 1930s, paid her work what was then considered a compliment: "This is so good that you would not know it was done by a woman."[15] Like many women artists in the circles of the Surrealists in the 1930s and the Abstract Expressionists in the 1940s, Krasner took on the time-honored role of "wife of" and support of a male artist who was soon to become better known than she, and in whose shadow she lived until the Feminist Art movement of the early 1970s forced her "rediscovery."[16] Nina Leen's famous documentary photo of "The Irascibles" says it all (page 16). Among these fourteen men, whose names are all today a familiar part of the saga of Abstract Expressionism, there is only one woman, the painter Hedda Sterne, about whose work we know only that it had been characterized disparagingly by Clement Greenberg in a review of 1944 as "a piece of femininity."[17] Her unfamiliar name, given

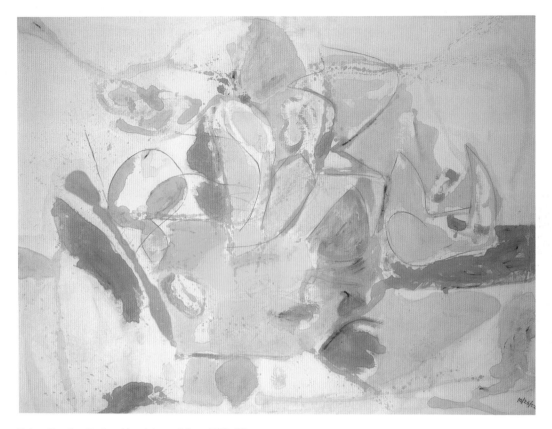

Helen Frankenthaler. *Mountains and Sea.* 1952. Oil on
canvas, 86¾ × 117¼″. Collection the artist, on extended loan to
the National Gallery of Art, Washington, D.C.

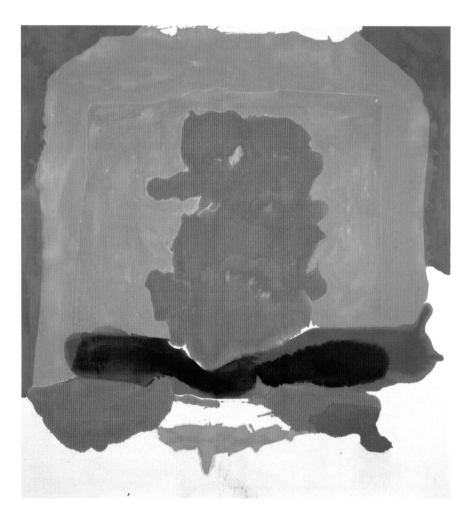

Helen Frankenthaler. *Small's
Paradise.* 1964. Acrylic on canvas,
100 × 93⅝″. National Museum of
American Art, Smithsonian Institution,
Washington, D.C. Gift of George
L. Erion

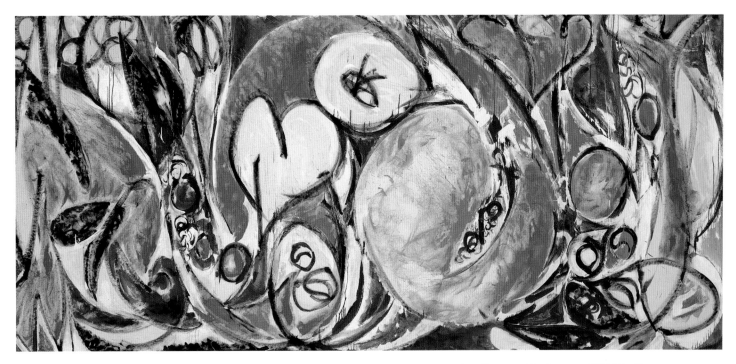

Lee Krasner. *The Seasons*. 1957–58. Oil on canvas, 92⅞ × 203¾″. The Whitney Museum of American Art. © The Estate of Lee Krasner

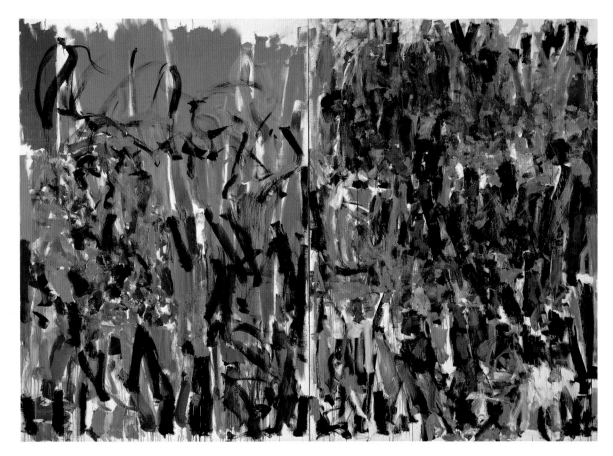

Joan Mitchell. *No Rain* (diptych). 1976. Oil on canvas, 110 × 158″. © The Estate of Joan Mitchell. Courtesy Robert Miller Gallery, New York

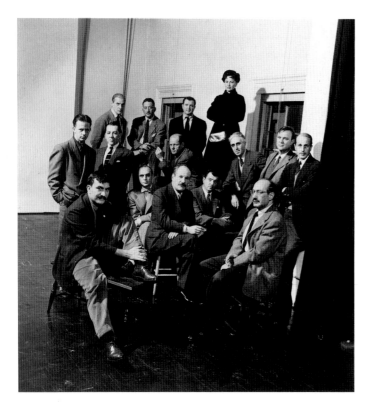

The Irascibles. 1951. Photograph by Nina Leen. From top left, clockwise: Willem de Kooning, Adolph Gottlieb, Ad Reinhardt, Hedda Sterne, Richard Pousette-Dart, William Baziotes, Jackson Pollock, Clyfford Still, Robert Motherwell, Bradley Walker Tomlin, Theodoros Stamos, Jimmy Ernst, Barnett Newman, James Brooks, Mark Rothko. Life Magazine, © Time Inc.

no gloss in subsequent annals of the movement, would no doubt be lost to us today were it not for this amazing photograph, in which she is positioned, like the traditional female muse or allegorical personification of the art of painting, to hover above and behind the men, from whom she is thus emphatically distinguished and to whose group she is clearly not meant to belong.

But despite limited opportunities in general for women artists to make a name for themselves during this period, by the late 1950s, a few, such as Grace Hartigan, Joan Mitchell, and Helen Frankenthaler, had been able to achieve unusual visibility and recognition in the art world as "second-generation Abstract Expressionists," in part because they had cast themselves—and were being cast by critics—as disciples and followers of the innovative male founders of the radical but by then established Abstract Expressionist movement. Stereotyped in the critical press as imitators of the styles of men and as jealous rivals for the favors of male mentors, these women had to pay a price for membership even on the peripheries of this all-boys' club, and that price was isolation, especially from one another. In response to the question, "What was it like to be a woman in the macho 50s?", Joan Mitchell told an interviewer in 1985: "Do you mean, am I a feminist? I am. But I really like painting, whoever does it. The men helped me more than the women. It's still a small world for women and they're cutthroat with each other. At that time, the galleries wouldn't carry more than, say, two women. It

was a quota system."[18] And in a 1975 interview, Miriam Schapiro commented on her relationships with other women artists in the 1950s:

Joan Mitchell, Grace Hartigan, Jane Freilicher, Jane Wilson and Helen Frankenthaler were all friends and still are. We never discussed problems of ambition and ruthlessness. The spirit of the times did not permit such frankness—woman artist to woman artist. We identified and had camaraderie more on the basis of being women than on the basis of being artists. . . . When Helen and I were together . . . we never discussed our paintings. We were in the same gallery and didn't discuss our work."[19]

Women artists in the 1950s and 1960s suffered professional isolation not only from one another, but also from their own history, in an era when women artists of the past had been virtually written out of the history of art. H. W. Janson's influential textbook, *History of Art,* first published in 1962, contained neither the name nor the work of a single woman artist. In thus excluding women from the history of art, Janson followed an approach that had already been established in such earlier twentieth-century art history textbooks as David Robb and J. J. Garrison's *Art in the Western World* and E. H. Gombrich's *The Story of Art.* But over the next two decades, it was Janson's book that became the focus of indignation for a generation of college-educated Americans who had been startled by feminism into questioning the assumption, implicit in Janson's omissions, that women never had made nor ever could make art that was aesthetically or historically significant. Janson himself later justified his actions in qualitative terms. "I have not been able to find," he said in 1979, "a woman artist who clearly belongs in a one-volume history of art."[20] It was in the context of such programmatic cultural and historical exclusion that feminist artists such as Mary Beth Edelson, in her memorable poster of 1971, *Some Living American Women Artists/Last Supper,* and Judy Chicago, in *The Dinner Party* of 1979 (page 227), were motivated to create imagery that would literally bring women artists, for the first time, to the table of history.

In the pre-feminist 1950s and 1960s, it was rare indeed for a woman artist to find any place at all in the narrative of modernism. And when she did, her position was not defined as that of an innovator (although she may have been one), but as a facilitator of the work of the male artists who followed her. This pattern in the criticism was established early on for Helen Frankenthaler, whose stained canvas, *Mountains and Sea* of 1952, was given canonical status by Clement Greenberg, when he told of how the experience of seeing it had caused Morris Louis to "change his direction abruptly."[21] Greenberg positioned Frankenthaler not as the innovative leader of a new school of painting, but as a precursor, a link between the first generation of male Abstract Expressionists and the male painters of the Washington Color School, thereby providing her with the only credentials that would at that time have allowed her inscription, albeit marginally, into the annals of art "his-story."

Abstract Expressionism glorified a "virile" art, whose very potency and purity depended on its practitioners' rejection of

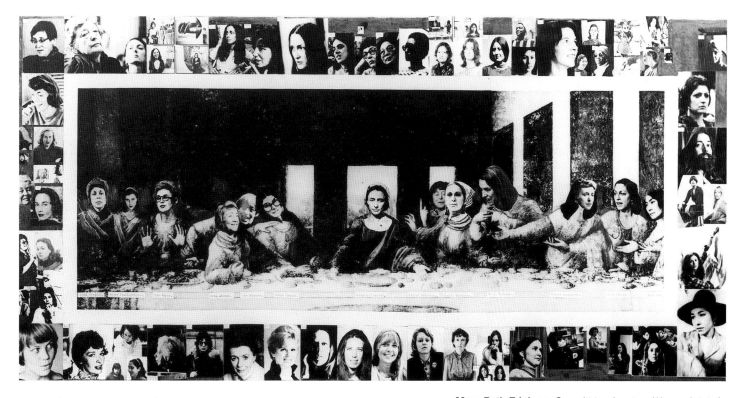

Mary Beth Edelson. *Some Living American Women Artists/ Last Supper.* 1971. Offset poster. Left to right: Lynda Benglis, Helen Frankenthaler, June Wayne, Alma Thomas, Lee Krasner, Nancy Graves, Georgia O'Keeffe, Elaine de Kooning, Louise Nevelson, M. C. Richards, Louise Bourgeois, Lila Katzen, Yoko Ono. Border: 67 other women artists. Courtesy the artist

and struggle to achieve transcendence over the female-gendered world of nature. The women artists associated with the first and second generations of that school professed allegiance to its principles. However, consciously or unconsciously, they developed for themselves a range of personal imagery that—as later feminist artists and critics, in search of foremothers, were quick to point out—appears to have challenged the established paradigm: the taste, for example, for landscape metaphors in the work of Frankenthaler and Mitchell; the egg, breast, and plant forms, and the procreative metaphors that became central to the iconography of Lee Krasner's work from the late 1950s on; or the predilection for figuration and for an iconography that often draws upon the life experiences and roles of women in the art of Grace Hartigan.

The question of how—or whether—the fact of being female had in any way affected the style or the content of these women's art was a question that was increasingly foregrounded by feminist criticism in the 1970s. And for those women artists of an older generation, who had long struggled to negotiate their female identities and to find acceptance as "artists" pure and simple, within and despite what Lee Krasner would later describe as "the misogyny of the New York School,"[22] it was an explosive and uncomfortable issue that bred both confusion and

anxiety. Reactions ranged from Frankenthaler's adamant refusal to be associated or categorized in any way with "women artists" and their issues[23] to Krasner's touching openness and willingness to enter into a dialogue with a much younger generation of radical feminists. When students working with Miriam Schapiro in the Feminist Art Program at CalArts in 1975 asked Krasner to send them a "letter stating the intentions of your art" for inclusion in their book, *Art: A Woman's Sensibility*, she replied, with an implicit awareness of *their* concerns: "I try to merge the organic with the abstract—whether that means male and female, spirit and matter, or the need for a totality rather than a separation are questions I have not defined as yet."[24]

Among the women of the New York School, Grace Hartigan, who exhibited her works under the name George Hartigan until 1954, has been the most vociferously resistant to feminist readings. Understandably fearful, as many women of her generation were, of being ghettoized and stereotyped as a woman artist—i.e., as something lesser—Hartigan has consistently maintained that she faced no discrimination and that she was, in effect, simply one of the boys. Of her reasons for adopting a pseudonym, she has said: "It had absolutely nothing to do with the feeling that I was going to be discriminated against as a woman. It had to do with a romantic identification with

Grace Hartigan. *Bread Sculpture*. 1977. Oil on canvas,
76×92″. Courtesy C. Grimaldis Gallery, Baltimore

George Sand and George Eliot."[25] Although Hartigan formed her style in the late 1940s on the model of the painterly abstractions of Pollock, de Kooning, and Kline, by 1952 she started to turn away from "pure" abstraction and began a lifelong quest for a meaningful iconography. At first inspired by the street life of New York's Lower East Side—the "vulgar and vital in American modern life" as she then put it[26]— and attracted, perhaps unconsciously, by the rituals of women's lives, their dignity as well as their emptiness, she painted *Grand Street Brides* in 1954, inspired by the dressed-up mannequins in a bridal shop window (page 11). The increasing independence and fertility of invention in her work over the next decades is exemplified by *Bread Sculpture* of 1977, whose seemingly whimsical imagery, derived from a book that describes what can be made out of dough, stresses maternal icons and fertility goddesses and plays on the idea of creating art out of the materials of basic human sustenance.

When faced in the 1970s by inevitable feminist comparisons between her own interpretations of women and those of her mentor de Kooning, Hartigan resisted readings of female identification in her own work and of misogyny in de Kooning's, adamantly defending the universality of his art (and by extension, her own). To Cindy Nemser's suggestion that "the way you portrayed women is very different from de Kooning's violent interpretations of women," she replied, vehemently but evasively:

> *I disagree with you. The violence is in the paint. De Kooning's women are very loving. . . . When those first women—those fifties women—were shown, I had a big argument with Jim Fitzsimmons, who is now the editor of* Art International. *He said that they were destructive, that it was hatred, Kali the blood goddess. He pointed to one painting that had big palette knife strokes slithering across the chest and said, "Look, de Kooning is wounding her with blood." So I went to Bill and I said, "Jim Fitzsimmons said that you stabbed that woman and that is blood." Bill said, "Blood? I thought that it was rubies."*[27]

And to Nemser's comment on *Grand Street Brides* that "it's interesting that you picked up on that particular ritual. It is one that women are trying to come to terms with today," Hartigan abandoned her previously professed fascination with the "vulgar and vital in American modern life" and countered: "I really hadn't thought of it. I was really thinking of Goya and Velásquez, of that empty ritual of the court, all of the trappings . . ."[28]

Even a younger artist like Eva Hesse—who came to prominence in the late 1960s in a proto-feminist critical context, singled out by Lucy Lippard who emphasized her predilection for circles, soft materials, veils, layering, and repetition—even Hesse struggled uncomfortably with feminist as opposed to mainstream formalist readings of her work.[29] When asked by Nemser in a 1970 interview if some of her forms had male and female sexual connotations, she quickly retorted: "No! I don't see that at all. I'm not conscious of that at all or not even unconscious. I'm aware they can be thought of as that even in the process of making them, but I am not saying that."[30] And about the meaning of the circle in her art, she said: "I think the circle

Eva Hesse. *Ringaround Arosie*. 1965. Pencil, acetone varnish, enamel, ink, glued cloth-covered electrical wire on papier-mâché on Masonite, 26⅜ × 16½ × 4½". © The Estate of Eva Hesse. Courtesy Robert Miller Gallery, New York

is very abstract. I could make up stories about what the circle means to men, but I don't know if it is that conscious. I think it was a form, a vehicle. I don't think I had a sexual, anthropomorphic, or geometric meaning. It wasn't a breast and it wasn't a circle representing life and eternity."[31]

Today, in the 1990s, women artists of the pre-feminist and post-feminist generations are being, in the first instance, critically resurrected and in the second, given critical priority over the feminist generation of the 1970s. The result is to bolster and restore the very art-historical and critical metanarrative that the feminist generation had threatened to disrupt. The art of such pre-feminist women as Louise Bourgeois, for example, is assimil-

Louise Bourgeois. *Femme-Maison.* c. 1947. Ink on paper,
9⅛ × 3⅝". Private collection. Courtesy Robert Miller Gallery,
New York

able today by the mainstream only to the extent that it can be understood to have internalized the man-centered focus of the traditional woman. Bourgeois's work, writes *New York Times* critic Michael Kimmelman, "deals with sexual identity" and "is about polarities—male and female, aggressive and passive."[32] Resurrected now after decades of neglect (she was the only woman to be included in the Guggenheim Museum's inaugural show for its Soho branch in 1992, selected at the last minute to counter and forestall further objections to that show's traditionalist all-male lineup), Bourgeois's intuitive and perversely metamorphic imagery is being used and positioned critically to prop up the old stereotypes rather than to challenge them, and she herself is being used as a role model to support the relegation and confinement of women artists to work that "deals with sexual identity" in its most limited and limiting dualistic sense.

This strategy and these readings are not new ones. As Whitney Chadwick has observed of Bourgeois's *Femme-Maison* paintings of 1946–47: "Although Bourgeois pointed to the home as a place of conflict for the woman artist, critics [at the time] read the paintings as affirming a 'natural' identification between women and home."[33] Today, what is genuinely radical and rebellious about Bourgeois's woman-centered art is being further submerged by a mainstream criticism that wants to bend her into being a "link" between masculinist movements. There is certainly great irony in the fact that Bourgeois is now being described, in Kimmelman's words, as "a link to the European roots from which postwar American art sprang," since, having been marginalized and ignored all these years, she could hardly have played an influential role for America's mainstream male artists, even though her related work and strategies do in many instances predate theirs.

In recent years, in fact, following the pattern that Greenberg established for Frankenthaler, and as part of the ongoing backlash against feminism that was begun in the 1980s, we have seen a continuation and escalation of critical attempts to reposition some of the most prominent of the pre-feminist women artists, so that they may now be seen as "links" between male-dominated movements. For example, Hartigan's art, with its predilection for figuration and aversion to the false posturing of gestural abstraction, has come to be seen—and rightly so—as a threat to the historical integrity of Abstract Expressionism, whose self-definition and position in the normative canon have been closely dependent upon the exaltation of the macho gesture. At first relegated to the deviant category of the movement's "second generation," Hartigan has twice been repositioned by critics in the eighties and nineties in ways that seem designed to distance her from the sacrosanct movement that her "different voice" might threaten to taint. In the 1980s, there was a brief effort to make her into a forerunner of the so-called New Expressionism in the art of Julian Schnabel, David Salle, and others—a connection that she vigorously rejected.[34] And in 1993, her work, long ignored by the New York art world, was featured prominently in an exhibition at the Whitney Museum entitled "Hand-Painted Pop: American Art in Transition, 1955–62," where it was offered up as a "link" between Hartigan's beloved Abstract Expressionism and Pop Art, a movement that she had always scorned and despised.[35]

And when Lee Bontecou's canvas and wire wall reliefs of the sixties are shown again today, after long banishment from mainstream galleries and museums, we read, predictably, that "Bontecou's reliefs fall between and link major art movements— Abstract Expressionism of the 1950s and Pop Art and Minimal Art of the 1960s."[36] We hear nothing of the multiple meanings that these works held in the 1970s, either for the women artists who identified "the large, velvet lined cores of Bontecou's work" with "the central cavity of the female and thus the female herself,"[37] or for the male critics who, from their own point of view, imposed on them a related but very different kind of sexualized meaning, as emblematic of the threatening *vagina dentata*. Miriam Schapiro has recently said of Bontecou's works: "They were not sexual in the ways the men were then saying. Many of these works were about living in the world and being menaced by war. It was unusual at the time she produced them for women to express anger and rage in art. Women's rage is frightening to men, and so they metamorphosed it into the conventional idea of the *vagina dentata,* creating a myth that could contain the power of women's anger. Bontecou's work was hot for a time, but then she was driven out of the art world."[38]

This persistent and escalating relegation of pre-feminist women artists to the no-man's land of "linkage" is in part an inevitable result of the continuing refusal (on the part both of the critical establishment and many of the women themselves) to acknowledge gender as a relevant factor and category of analysis in the framing of the history of mainstream modernism. Nevertheless, the fact remains that these women and their art can never be comfortably accommodated within the structures of the male-dominated and male-defined movements in which they originally worked—unless or until we are willing to acknowledge the historical existence *within* these movements of the different voices of women, and to modify our characterization of modernism accordingly.

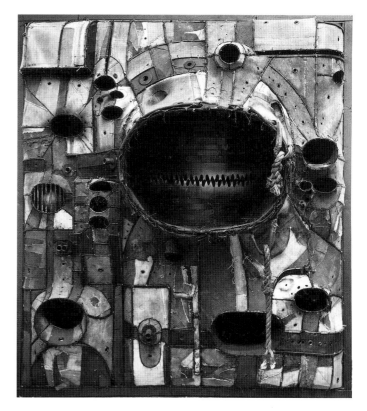

Lee Bontecou. *Untitled.* 1961. Welded steel and canvas, 72 × 66 × 25″. The Whitney Museum of American Art, New York

SEVENTIES FEMINIST ART

Women artists of the feminist generation differed from the women artists of the fifties and sixties most of all in the deliberate grounding of their art in their socialized experience as women and—the corollary of that position—in their acceptance of women's experience as different from men's but equally valid. In exposing for open consideration what had previously been hidden or ignored, they connected—for the first time, in a conscious way—the agendas of social politics and art. The key principle was consciousness-raising, defined by women's movement theorists as a "method of using one's own experience as the most valid way of formulating political analysis."[39]

Accordingly, early feminist artists advocated reliance upon the self as the sole source of knowledge, and while Hartigan or Krasner would not have disagreed with that principle, the difference was in the level of sociopolitical awareness about what a female self was. Feminist artists asserted a new position for "woman" in art, as subject rather than object, active speaker and not passive theme. And although many earlier women artists might have supported that goal (even the conservative advocates

of *l'art feminin*), the difference was that 1970s feminists were no longer so clear about the nature of female identity, realizing that it was up to them to redefine it. Thus, while the seventies feminist artist was acutely aware of the artificiality and repressive power of what would later be called "the social construction of gender," her problem was to find, within a self already badly warped and damaged by social roleplaying, an authentic voice that might serve as a basis for a new and "liberated" construction of female identity.

Women of the 1970s discovered that, in today's parlance, the inner self was a realm already socially inscribed, when they found that there was no way for a woman whose consciousness was being raised to answer the question, "Who am I?" outside the frame of reference of her gender. The invention of personas and the exploration of roles so prevalent in early feminist art were, on one level, a way of examining the relation between female roles and the inner self, and of clarifying their differences. Their construction of fantasy roles (Eleanor Antin, Lynn Hershman; see pages 168 and 167) and their sometimes deliberately childlike play (*The Dollhouse* at Womanhouse; see Raven, page 65) may be instructively compared with something like Claes Oldenburg's Ray Gun series of 1960–62, whose imaginary hero, based on comic book heroes like Buck Rogers, is a magic "ray gun." Both forms of art concern fantasy life, but with the critical distinction that feminists were self-conscious about the gender dimensions of their roleplaying, whereas Oldenburg could not imagine a frame of reference outside masculinity (even when, in retrospect, his subject begs for it). Oldenburg's magically empowered alter-ego holds New York at bay—a comic hero with real bravado, whose dream is phenomenal personal power.[40] Yet for feminist women, the romantic construct of the self vs. society did not hold up. Through feminism, women were among the first to arrive at the realization that the self may only exist within social framing, and so the cliché of the individual vs. society, which had been a male myth all along, was brought into question by feminist women, who now saw the categories as not only interdependent but also problematic.

It was the achievement of feminists to articulate that very problem in art. In the words of Judy Chicago, the agenda for women artists was "to transform our circumstances into our subject matter . . . to use them to reveal the whole nature of the human condition."[41] Instead of asking, "Who am I?," they posed a new question, "Who are we?," as if only by exploring the shared, collective "circumstances" of women could individual women come to understand themselves as human beings. One of the first areas of circumstantial identity to be explored was the female body. Artists such as Faith Ringgold, Adrian Piper, and Eleanor Antin sought to reclaim women's bodies from the societal straitjacket of sex-objecthood through semiplayful exploration of dieting and fasting, ways in which social expectations literally shaped the female body. From the early 1970s, feminist artists understood their task to be, in the words of Lisa Tickner, "the de-colonizing of the female body," reclaiming it from masculine objectification.[42] Carolee Schneemann, in her memorable *Interior Scroll* performance, attempted the metaphoric transformation of the female body from passive object to speaking agent. Other artists created body images for the female viewer—

Sylvia Sleigh, in her witty inversions of male/female roles; Hollis Sigler, Janet Cooling, Harmony Hammond, Terry Wolverton, and others, in images and performances directed to the lesbian gaze. Joan Semmel sought gender balance through images of men and women in bed together, "sensuality with the power factor eliminated," as Semmel described them.[43] And other feminist artists redrew the male body as negative cultural signifier: Nancy Spero, May Stevens, Judith Bernstein, whose phallicized images of helmets, bombs, and screws defined the phallus as sign of power long before Jacques Lacan's similar (but not similarly critical) theory was known in the United States.

Other feminist artists reclaimed the ancient Great Goddess through images, rituals, and performance art in an effort to reestablish a female dimension that has long been largely missing in world religions. Their enterprise, which paralleled that of feminist theologians, aimed to replace the "masculine archetype, characterized by the mind-body duality,"[44] with mind and matter reintegrated. For feminist artists, as in ancient times, the earth is identified as the body of the Great Mother, and through the use of their own bodies in nature-sited rituals, artists like Ana Mendieta, Mary Beth Edelson, Donna Henes, Betye Saar, and Betsy Damon forged a new way to affirm the connection between microcosm and macrocosm. In asserting their own sense of connection with matrifocal ancient cultures, these artists were less interested in reinstating female procreativity as a cosmic principle than with changing the gender-distorted relationship between humans and nature that has been a hallmark of patriarchy, to emphasize the wholeness of a nonhierarchized continuum between nature and culture. In these respects, the legacy of the work of Goddess artists lies in the growing contemporary concern for the environment, the ecology movement, and in the quest for the renewal of spiritual meaning in modern society. In this spiritual current of feminist art, as in others, the focus is upon "we" and not "I."

As feminist artists explored female experience and identity through their art, they created and addressed a new audience. Lucy Lippard has argued that feminist art replaced the modernist "egotistical monologue" with a dialogue—between art and society, between artist and audience, between women artists of the present and those of the past—and with collaboration as a creative mode.[45] The feminist position is that (in Lippard's words) "art can be aesthetically *and* socially effective at the same time," by contrast to the masculinist avant-garde model, in which the creative isolation of the artist, out of touch with society, is highly valued. Feminist art is instead deliberately pitched to a public and social context, and as Lippard says, is "characterized by an element of outreach, a need for connections beyond process or product, an element of *inclusiveness*."

Hence, collaborative art, performance art, environmental art—not exclusively but predominantly feminist forms in the 1970s and 1980s—had in common structures that transcended the individual, whether through rituals that connect modern feminism with ancient myth, or through social protest aimed at affecting public policy. Within the feminist movement, women of color led the way in creating effective forms of social protest art—from Faith Ringgold's tireless activism in the late sixties, fighting racism and sexism simultaneously, to the *Wall of Respect*

for Women, a product of multicultural collaboration by Tomie Arai and other artists in New York City, itself a monument to feminist collaboration. In the mural projects of Las Mujeres Muralistas in San Francisco, as in the citywide performance art projects of Suzanne Lacy and others in Los Angeles, a broader connection between art, community, and social policy was forged.

Also, in the late 1970s and 1980s, women artists became increasingly prominent in the field of public art in the United States—an involvement that may seem paradoxical, given the traditional association of women with the private sphere and men with the public. But in an era when Richard Serra's *Tilted Arc* had become a symbol for an old-fashioned attitude that saw artistic freedom as superior to and irreconcilable with the needs of the public, an era when the public's acceptance of the art that invaded its spaces could no longer be taken for granted, the involvement of women artists in a multitude of publicly funded, large-scale, urban projects led in crucial ways to the reshaping of this entire field. Women introduced new attitudes and iconographies to public art projects, in which they sought to express the self not simply as the personal "I," but worked instead to blend the personal with the public, pointing the way toward a reconciliation of the traditional conerns of the artist with those of the community. Artists such as Alice Adams, Alice Aycock, Agnes Denes, Lauren Ewing, Jackie Ferrara, Nancy Holt, Valerie Jaudon, Joyce Kozloff, Mary Miss, Patsy Norvell, Beverly Pepper, Jody Pinto, Alexis Smith, Mierle Ukeles, and many, many others turned landfills into public parks, designed and decorated plazas, convention centers, schools, bridges, airports, and railroad stations. Sensitive to the social and cultural history of the sites where they had been invited to intervene, they interacted closely with members of the community, worked in teams with engineers and architects, and negotiated with local governments and art agencies. "I have thought a lot about why women have such a powerful voice and presence in this field," Joyce Kozloff has recently written. "Partly I believe [it is] because women are acculturated to the interpersonal, relating skills that public art requires. And partly because the women in the field (most of whom were in their forties in the 1980s) came to maturity during the social and political movements of the sixties and seventies, and really have a passionate commitment to extending art into the real world."[46]

THE PROBLEM OF ESSENTIALISM

As Kozloff's comment suggests, feminist artists of the 1970s were highly conscious of a common thread of "women's sensibility" that seemed to run through the great diversity of their art forms. And at its best, feminist art did shape a tentative female universal out of multiple particulars, whose very differences made emergent patterns resonate. However, this high-wire fusion of the private and universalizing agendas backfired when, in the 1980s, critics singled out feminist art's most literalist experiments and proclaimed them to be "essentialist"—false universals that did not represent all women (something their creators had never claimed in the first place). French feminist critiques of Freud's theories of femininity and his familiar dictum that "biology is destiny" ("There is no such thing," wrote Hélène Cixous in 1975, "as 'destiny,' 'nature,' or 'essence,' but living structures . . ."[47]) were applied to visual representation by British feminist film theorists such as Laura Mulvey, Pam Cook, and Claire Johnston, who saw as anethema to feminism the idea of a historically unchanging feminine essence.[48] By 1980, feminist art criticism had begun to identify feminist art that focused on the female body with a wrongheaded belief in a "female essence residing somewhere in the body of woman."[49]

But even from the beginning, first-generation feminists had been criticized for what would later be called "essentialism." Writing in 1972 in response to an idea that was already in the air at the time, Patricia Mainardi disclaimed the notion of a "feminine sensibility" in art, resisting the implicit restriction of women's art to the realm of female anatomy, when men had a wider range of expressive possibility, with "the freedom to be sensitive and delicate or strong and bold . . . to make art out of their loves and hates, their politics and religion."[50] For women, said Mainardi, "the only aesthetic freedom worth fighting for is the freedom to do the same." Without naming names, Mainardi spoke of a "right wing of the women artists' movement" that was "codifying a so-called 'female aesthetic,'" an implied indictment of Judy Chicago's centralized-core imagery, which became explicit in a critique written by Cindy Nemser a year later. Nemser reported that in 1971, Chicago, fresh from her Fresno teaching, was answering the frequently asked question—was there a women's art distinct from men's art?—with her theory of "Cunt Art," a case for (in Nemser's description) "an intrinsic female imagery created out of round, pulsating, 'womb-like' forms."[51] Nemser denounced this theory, and in later writings she adduced the diversity and range of contemporary women's art to argue against any too narrowly defined aesthetic for women's art in general.[52]

The ur-text for the aesthetic credo that had been formulated by Chicago and Schapiro was an article co-authored by the two artists in March 1972, and published in *Womanspace Journal* the following year. "What does it feel like to be a woman?," they asked. "To be formed around a central core and have a secret place which can be entered and which is also a passageway from which life emerges? What kind of imagery does this state of feeling engender?"[53] The artists went on to point to some of the "many women artists [who] have defined a central orifice whose formal organization is often a metaphor for a woman's body": Georgia O'Keeffe, whose "haunting mysterious passage through the black portal of an iris" was "the first recognized step into the darkness of female identity" (page 26); Lee Bontecou, whose images of vaginal central cavities present female identity as both active and passive (page 26); Louise Nevelson and her boxes, Deborah Remington's eggs, Schapiro's "centralized hollows," and Chicago's "central core images."[54]

What the critics saw as potentially confining women to their biological identity, Schapiro and Chicago saw as a means of liberating women from negativizing attitudes about female anatomy and their own bodies. They cautioned, in fact, that the "visual symbology" they described should not be seen simplistically as "vaginal or womb art," but rather as the framework for an imagery that would reverse the loathing and devaluation

of female anatomy in patriarchal culture. The woman artist could take "that very mark of her otherness and by asserting it as the hallmark of her iconography, [establish] a vehicle by which to state the truth and beauty of her identity."[55] It was in this spirit that they had embraced the derogatory sexual term "cunt," traditionally used by men to alienate women from their own sexuality, with the goal of reclaiming a female descriptor and transforming it into a celebratory term.

In seeking to reinstate a positive view of femaleness through frank celebration of the female body and its biological powers, Chicago and Schapiro anticipated the approaches of certain feminist writers of the period who also later came to be denounced as essentialist, especially Mary Daly and Adrienne Rich. Daly claimed that "female energy is essentially biophilic," while Rich described the female body—its diffuse sensuality, lunar-timed menstruation, its power to give birth—as having "far more radical implications than we have yet come to appreciate."[56] Rich noted what Chicago and Schapiro had earlier observed: "Patriarchal thought has limited female biology to its own narrow specifications. The feminist vision has recoiled from female biology for these reasons; it will, I believe, come to view our physicality as a resource, rather than a destiny."[57]

In part, the emphasis on the biological and sexual in early feminist art must be understood against the historical background of the severe repression of women's sexuality in the 1950s and 1960s. Heterosexual women were not encouraged to experience their bodies directly, but only as they were perceived and used by men and children. Young women were taught to value their bodies as a trophy to give or withhold (officially, only the latter) in response to male desire, and, after marriage, as the vehicle for wifely duty. Female sexual pleasure was framed and mediated by constructs of "good girl vs. bad girl," chastity vs. shame. Given the centuries of indoctrination of women in the determinism of their biological identity, it is not surprising that in the early seventies feminist artists should have taken their first rebellious step by challenging the most repressive category—the sexual. Indeed, they may have made the most radical move possible when they asserted the power to define their sexuality in art on their own terms, not men's. Thus they openly celebrated the female body from an experiential viewpoint, exploring their and society's attitudes about the body, and proclaiming female organs—through "cunt" imagery—as metaphoric emblems of women's *independent* power and freedom from male dominance.

First-generation feminists reexamined what "female" meant, not in an effort to limit it to a biological essence, but rather, to test the culturally constructed definitions of the "feminine" that they knew. In Chicago's *Cock and Cunt* play performed at Womanhouse in 1972, "HE" and "SHE" sport giant cloth penis and vagina appendages, conspicuously attached to their natural bodies as foreign materials. When HE tells SHE that "A cunt means you wash the dishes," she looks at her appendage and says, "I don't see where it says that on my cunt." From a position of commonsensical self-knowledge, and with the subversive power of humor, Chicago and her students ridiculed gender roles in human anatomy (thereby challenging the Freudian construct that "biology is destiny"), and mocked the social definitions of what belongs "naturally" to the sphere of the female.

The CalArts students who created Womanhouse were guided by the theory-in-formation of their teachers Chicago and Schapiro, but because as a matter of process, consciousness-raising and self-examination preceded artmaking, individual solutions were grounded in experience rather than theory. For this reason, the art produced by the students could not be essentialist because it did not claim that level of generalization. Yet Schapiro and Chicago themselves theorized a "central core imagery" that did aim to establish a certain universalizing formal iconography for women, and whose potential scope could be demonstrated in the recurrence of centralized forms in women's art. When this thesis was taken up for consideration by Lucy Lippard in her introduction to the "Women Choose Women" exhibition of 1973, critical reaction escalated, and charges of what would later be called essentialism began to be heard in every quarter, especially from women artists.[58] In fact, in her very brief remarks, Lippard herself had entertained the thesis of women's special predilection for centrally focused images only in a tentative and exploratory way, noting that she had observed in women's art made in 1970–71 certain recurrent preoccupations, such as "a uniform density, or overall texture, often sensuously tactile and repetitive to the point of obsession; the preponderance of circular forms and central focus (sometimes contradicting the first aspect) . . . a new fondness for the pinks and pastels and the ephemeral cloud-colors that used to be taboo unless a woman wanted to be 'accused' of making 'feminine' art."[59]

By 1973, however, what Lippard had observed in women's studios, a large sample of which was included in the "Women Choose Women" exhibition, could no longer be regarded as a pure product of the female unconscious unmediated by feminist theory. The choice of pinks and pastels, fruit and vaginal imagery, eggs and breasts, on the part of women artists connected to each other through their common awareness of the broader women's movement was a political act, a defiance of the conventions that had made it death for earlier women artists to associate themselves with forms and iconography that had been stereotypically and pejoratively deemed "feminine." Traditionally feminine iconography was now reclaimed by politicized women artists to serve the cause of feminist art. And thus, paradoxically, while the raging debate within feminism in the period between 1970-75 was about whether or not women's art could be defined in absolute terms, emerging feminist consciousness in an ever-broadening spectrum of artists was making it impossible to identify a "pure" woman artist who could be said to have a female essence untouched by feminist ideas. Increasingly, women's art was distinguished both by the use of female-identified forms in a self-conscious way and by resistance to the idea that women should use such forms.

The 1970s debate about women's art was consistently misdirected to the question of "whether" rather than "how" women used certain forms. For example, critics of essentialist theory correctly pointed out that both men and women have used biomorphic or centralized imagery—Hepworth but also Moore and Arp, O'Keeffe but also Dove and Baziotes, Chicago but also Johns and Noland. Indeed the centralized-core form has assumed an archetypal status in art, Jungian or otherwise,

recurring in Neolithic stone circles, medieval manuscripts, Gothic rose windows, and Renaissance central-plan churches, to name but a few. This recurrent archetypal structure, which may or may not be gender-specific, seems to be deeply embedded in the human psyche. However, each age provides a different theoretical justification for its use—theology for Gothic and Renaissance art (in different ways), Freudian psychology for Surrealism, and feminism for Chicago and Schapiro. Similarly, both male and female artists in the 1960s and 70s used central form imagery, yet the question to be posed is not whether the form language is essentially female or male, but, rather, what is *signified* when that form language is used by women or men.

In this case, the categoric female is appropriate. In 1974, Judy Chicago observed, "I'd say the difference between *Pasadena Lifesavers* and a [Kenneth] Noland target is the fact that there is a body identification between me and those forms, and not between Noland and the target. I really think that differentiates women's art from men's."[60] Theorist that she is, Chicago believes that women's art, like her own, proceeds from body identification. That many pre-feminist women artists have used centralized imagery, as Chicago and Schapiro pointed out, does not prove that all women mystically share this viewpoint. But we can say that under the influence of feminist theory in the 1970s, many women were drawn to use centralized imagery with the understanding that it is about the body, a theoretical position not taken by men as a group. (It was, in fact, not in men's interest, as the dominant group, to define themselves as a group at all, though it *was* advantageous for women, like other socially oppressed groups, such as blacks and Chicanos, to identify themselves as a group in order to solidify their opposition to oppression.)

Today, the founders of feminist art do not renounce or deny their characterization as essentialist, and it is perhaps more useful to further articulate the term than to resist it. We would do well to replace the term *biological essentialism* (which no known feminist has ever championed) with two others—*cultural essentialism* and *political essentialism*—which can be historically distinguished. Cultural essentialism, roughly equivalent to what is today called socially constructed femininity, is society's gender-stereotyped conditioning of women's self-image and experience. It is very difficult for women to escape this conditioning, even when we want to, for we are all contaminated by past meaning. Moreover, if femininity is a social construction, then we must acknowledge that women have had a role in constructing it, simply by their gradual, ever-self-implicating acceptance and perpetuation of its terms.

How can women ever escape from cultural essentialism? The first step, according to early seventies feminists, was to identify its manifestations. When Judy Chicago observed about her *Menstruation Bathroom* at Womanhouse, "However we feel about our own menstruation is how we feel about seeing its image in front of us,"[61] she introduced the pragmatic view that to deal with the social construction of woman that has been imposed on us we have to begin by acknowledging its effects upon our psyches. And for artists, imaging is a means of discovering how one feels about such things. The young artists at Womanhouse began by representing what could be called the icons of

their own oppression—lingerie, dollhouses, women's clothing, makeup—since these familiar objects had helped to shape their identities, which were composed of gender-socialized attitudes as well as rebellious ones. Mimicking the societally ordained forms of femininity proved to be the first step of separation, of gaining critical distance from that which is being mimicked. As Luce Irigaray would later observe, when women lack a language of their own outside that of the patriarchy, mimicry is the only available form of critiquing its values, of exposing "by an effect of playful repetition what should have remained hidden."[62]

Although it was not then so named, cultural essentialism was recognized in the early 1970s as the problem to which *political* essentialism—the deliberate celebration of culturally essentialist forms—offered a solution. The claim of Schapiro and Chicago that women's art might have common and enduring characteristics must be understood as, above all, a deeply political claim. Its purpose was not to establish a Procrustean identity for women's art but, rather, to help balance gender values in society, by asserting the inherent validity of all things in women's sphere—from vaginas to lipsticks—as fit subject matter for art. Through art made by women (which would necessarily present such things differently from men), those feminist artists believed they could, in Schapiro's words, "redress the trivialization of women's experience."[63] As a necessary first stage of value-building, comparable to the "Black is beautiful" phase of the civil rights movement, it perhaps necessarily left the sorting out of what is biological and what is cultural to a later stage.

Equally political in intent—but misread as culturally essentialist—was the impulse on the part of many early feminist artists to connect with a historical female ancestry—Mary Beth Edelson with the ancient Great Goddess, Miriam Schapiro with Mary Cassatt and Frida Kahlo, May Stevens with Artemisia Gentileschi, Judy Chicago with all the historical guests at *The Dinner Party*. When Schapiro led the way in singling out for admiration the anonymous women whose art was needlework—most of all, the quilt makers—anti-essentialist critics argued that to glorify the "female" categories of art production was to "ghettoize" women's art, by reifying modern women's association with female-stereotyped art forms.[64] However, Schapiro was not saying that "female traditionalist" categories should be perpetuated, merely that they have existed historically, and that within severe social constraints, women have made a culture that deserves attention, admiration, and commemoration. From this perspective, to pay homage to women's traditional arts is not to identify with a cultural dead end; it is to honor those whose creativity took particular channels because it was prevented from taking others. And in a different but related instance, when Schapiro and Joyce Kozloff chose to use a variety of non-Western decorative patterns (such as Islamic or Japanese) in their work of the 1970s and 80s, they did so not because women had originally invented or produced those patterns (in fact, they had not)—it was not, in other words, an embrace of biological essentialism but a culturally specific challenge to it, for it was their intention to liberate an area of visual expression that had long been gendered as feminine by male Euroculture and hence devalued, policed, and controlled in Western art.

Thus to incorporate references to women's traditional arts in

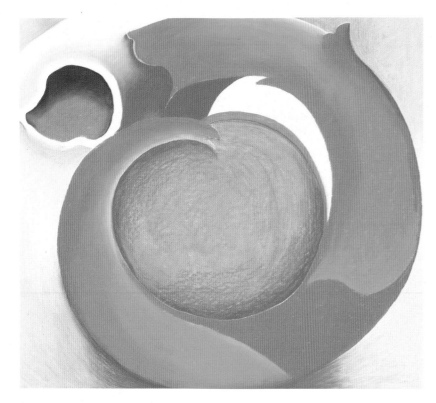

Georgia O'Keeffe. *Goat's Head with Red.* 1945. Pastel on paperboard, mounted on paperboard, 27⅞ × 31¹¹⁄₁₆″. Hirshhorn Museum and Sculpture Garden, Smithsonian Institution, Washington, D.C. Gift of Joseph H. Hirshhorn, 1972

Lee Bontecou. *Untitled.* 1963. Soot and analine dye on muslin, 39 × 36″. Private collection

Rose window, north transept. 13th century. Stained glass. Chartres Cathedral, France

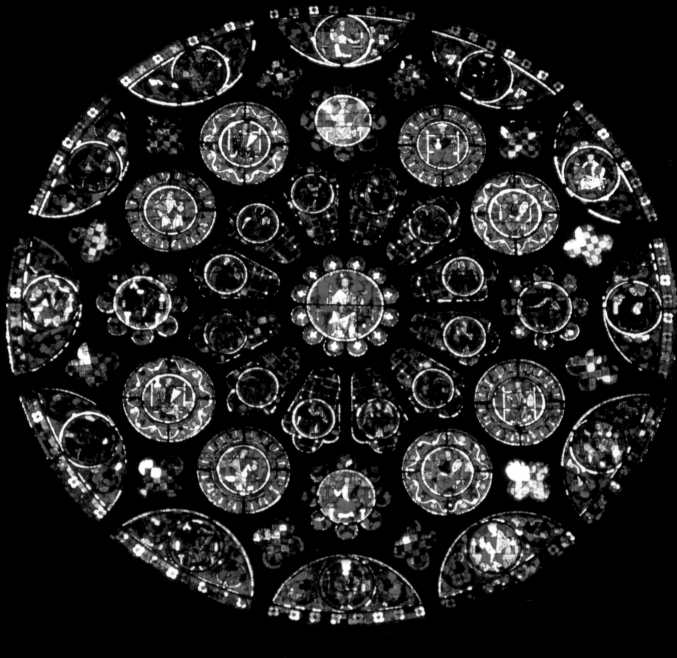

one's own contemporary art was not only to make creative use of devalued but still aesthetically viable forms and ideas, but also to make political use of them in order to engage the dominant male culture dialectically. In reviving the art and rituals of their foremothers, feminists gave those forms new life and status in the cultural order by challenging the value system that had subordinated them. But feminists of the early 1970s were not colonial quilters or Neolithic earth mothers, they were largely urban, educated, middle-class women. Their desire to pay homage to their female forebears was already a *historicization* of their identification with female tradition, and if they then brought those genres, tastes, and values into "high art" in modern culture, it was in the spirit of a revival that aided the creation of something distinctly different. As Walter Pater said about classical revivals, "we can't be Greeks now."[65] The classical analogy is apt on another level, because just as the forms and values of classical antiquity were revived in the Renaissance and again in the eighteenth century for social and political reasons—serving as moral justification for the cultural empowerment of a particular viewpoint[66]—so the 1970s feminist articulation of a body-based female aesthetic gained political credibility and power when coupled with a self-conscious definition and revival of a female tradition in art.

Thus while the idea of a categoric women's art may be philosophically dubious, it was a valuable creative principle for the historical Feminist Art movement, which drew in its early stages upon a form of female essentialism—a belief in the unitary reality of the category *female*—as its source of artistic inspiration. The significance of the category female for early feminists was not biological (that was merely its sign) but political, for feminism's power, it was then believed, was the power of women as a group. In this sense, the accuracy of the essentialist belief is beside the point, since right or wrong, it was an enabling myth. Like other empowering essentialist ideas in history (e.g., that Jesus Christ was the Son of God, that there is a Great Chain of Being, that utopian political states will bring peace and justice to Earth, or that the human male but not the female may possess artistic genius), it opened the way to political change in society, and a door to creativity and discovery in art.

BEYOND THE SEVENTIES

Feminist artists who emerged in the eighties and early nineties have maintained an ambivalent dialogue with seventies feminist art: they developed directly from it, yet are at pains to distance themselves both from it and from the "essentialist heresy" by which contemporary critical theory has increasingly characterized seventies feminism.[67] And, indeed, the first generation's approach contrasts strikingly with postmodernist theory's curious insistence that although an essentialist 'feminine' does not exist, "femininity," as a social construction, is not a stable reality either. This, of course, has left wide open the ontological question of what *is* real, while depriving women of their history by dismissing as beneath consideration practically everything that flesh-and-blood women have historically accomplished in the real world. Postmodernism's anti-essentialist position thus attacks the theoretical foundation of first-generation feminism on seemingly logical grounds, but ignores the diverse artistic superstructure that was built upon it. As many women have complained, this perpetually deconstructive, negative, and hostile stance is an unproductive approach for feminists. Moreover, as a postmodern position, it is also theoretically inconsistent, for why should "essentialist feminism" be the only exception to the postmodern tenet that culture produces multiple meanings, all of them equal in value?

In a sense, the very figment of an essentialism that never was has served as a creative prod to women artists working in the eighties and nineties—artists such as Janine Antoni, Ida Applebroog, Barbara Kruger, and Lorna Simpson—to demonstrate the many ways that women's art can expand and articulate female identity beyond the given of female anatomy (see Schor and Cottingham chapters). More problematic, however, has been the emergence in the 1980s of a "feminist" art that revives old masculinist constructs of the female body, theoretically in a critical spirit (though this is not always visually clear), while putting down as naive and reductively biological the far more radical female imagery of the early years. Disturbed and bewildered by the popularity of Cindy Sherman's work, the critic Jeff Perrone, writing in 1983, cut to the heart of the issue:

> *Sherman poses herself in Playboy-like centerfolds, albeit clothed in little schoolgirl outfits that make her appear both withdrawn and New Wave, seductive and scared—a punk virgin waiting to get laid. I think some people (men) like it so much because some critics and collectors (men) like a little blonde served up in juicy color. That her photographs are ostensibly about female representation in popular culture seems beside the point, not to mention evasive. Her work is, from the consumer's point of view, having your cheesecake and eating it too.*[68]

Perhaps as a result of postmodernism's denunciation of essentialism, the only acceptable way remaining for post-70s women to represent themselves appears to be in slightly ironized versions of the old familiar images of femininity—i.e., as sex objects and victims—that have traditionally been devised by and for men. Such images can be read as a critique of the social construction of femininity and of the power and complicity of representation in creating the illusion of fixed identity—but, as Perrone pointed out, they don't have to be. And the question remains open whether the male viewer, whose voyeuristic position is still privileged by such images, is being made by the artist to feel comfortable, or uncomfortable, with that position.

The answer to that question constitutes a major difference between Sherman's postmodern images (see page 257) and the staged "costume images" produced in the early 1970s by students in the Feminist Art Program. Dori Atlantis's 1970 photograph of Cheryl Zurilgen as Kewpie Doll, for example (Wilding, page 37), breaks through the confinement of that stereotype to become an act of defiance and self-empowerment by virtue of a parody so relentless and so clearly exaggerated that this image can no longer function in the normal way—to gratify

and empower a male spectator while disempowering and defining the female objects of his gaze—but rather, it unequivocally ridicules and exposes that mechanism.

The very ambiguity of Sherman's brand of feminist art, on the other hand, may have unintentionally opened the door to some of the 1990s' most blatant reassertions of the social manipulation of female identity, such as the "Living Doll" fashion photographs recently featured by *The New York Times Magazine* in the hope of inducing "women past the age of puberty," as the caption put it, to "want to dress up like little girls."[69] Distressingly close in appearance to the self-affirming feminist statements of the early seventies, these photographs, which advocate acquiescence to oppression all over again in the name of fashion, are in reality total inversions of those early images and are anything but feminist. The dialectical relationship between them is in all likelihood not the result of influence, but of the reemergence of an atavistic instinct—and an all too familiar strategy—to repress women by infantalizing them and hoping that they will go along with it. But by now, thanks in part to the power of feminist art, we know the difference.

Certainly the best evidence that within women lies something other than determinist social constructions is the fact that feminists could rebel against and question patriarchy at all. In feminism's rebellious challenge to masculinist art, the mind and body worked together to produce a coherent female self—and, as well, a blanket denial of the passive feminine being that had been the patriarchy's creation. So coherent a self is both terrifying to our culture and a terrifying responsibility to live up to. It

is no wonder that today, as in earlier feminist movements, men and often women have worked to submerge, deny, or distort women's effort to do so. And yet, the case can be made that feminism, in its very recurrences, has demonstrated an enduring power to survive its challengers.

In the 1970s, feminism's exploration of "who *we* are" was powered by a complex dynamic interchange between the political goal of fulfilling a shared agenda for all women and the necessary path to that goal through the diversity of individual experience. Feminist art kept those potentially contradictory goals in a state of tension, holding in balance a pull in opposite directions by public-political and private-aesthetic values.

Of course, it had been the goal of feminism to dissolve what it saw as the artificial boundary between those categories, to insist that on every level, "the personal is the political." In the 1970s, this phrase was understood to imply that the reality of women's lives was larger than their traditional circumscription in the realm of the private and the personal and that, indeed, the very categories of private and public were in themselves political fictions. In the 1990s, the phrase could be understood in almost an opposite sense, to describe the rather cynical contemporary doctrine that there is no self outside socially inscribed roles and meanings: the personal is only the political. But for feminists of the 1970s, the slogan contained in its implicit rejection of the traditional doctrine of "separate spheres" an empowering idea: the personal was liberated to become the political, which it had never before been for women. And thus a path was opened to creative action upon and within society.

EDUCATION IN THE EARLY SEVENTIES

THE FEMINIST ART PROGRAMS AT FRESNO AND CALARTS, 1970-75

BY FAITH WILDING

What does a woman need in order to become an artist? In 1970, Los Angeles sculptor Judy Chicago began an educational experiment in Fresno, California, which would explore this question, and which, together with work then being done by women artists, chiefly in Los Angeles and New York City,[1] launched what became a national Feminist Art movement.[2] The Feminist Art movement of the 1970s contested the canons of modernism and Greenbergian formalism as taught then in art schools; it introduced instead feminist content and gender issues; non-hierarchical uses of materials and techniques; a multiple-voiced, fluid subject; and a rupture of the Euro-American male litany of artistic criteria, aesthetic values, and art-historical practices. The following is a description and analysis of two of the experimental educational programs which were an important part of the 1970s Feminist Art movement, and which served as models for art production based on feminist theory, art history, and pedagogy.

THE FEMINIST ART PROGRAM AT FRESNO STATE COLLEGE, 1970-71

A charismatic, ambitious, fiercely independent woman, Judy Chicago was strongly influenced by the radical feminist movement, which had risen out of the New Left movements of the 60s. Inspired by feminists who had begun to see women's issues as distinct from those of other liberatory political movements, such as the antiwar movement, from which they had emerged, Chicago decided to address feminist issues in her art, and to develop a feminist pedagogy for women art students. In 1970 she accepted a teaching position at Fresno State College (now California State University, Fresno) with the proviso that she be allowed to develop a women's program in the art department. It came to be called the Feminist Art Program, and later served as the model for a subsequent program at California Institute of the Arts in 1971, as well as for similar programs in other parts of the country.

In the late 1960s Chicago was using abstract, formal images to express her feelings as a woman. She had found very little sympathy for such experiments in the male-dominated art world. Painting as a woman, writing as a woman—these were concepts which had not previously been explored as a conscious art practice or a teaching methodology. Chicago envisioned an art community of women who would implement feminist theories and practices to create work based on their common experiences in society.

Chicago chose Fresno State College because of its isolation from the art world. It served as an experimental ground where she could try to answer the question of what women students needed in order to become artists.[3] Fresno students and faculty had founded an Experimental College which offered courses in Marxist politics, anarchist theory, and Black, Chicano, Armenian, and Women's Studies. Suzanne Lacy, a psychology student, and I had organized an off-campus consciousness-raising group, and in 1970 we were teaching an Experimental College class in feminist readings called "The Second Sex."

Knowing of my feminist activities, Art Department Chair

Miss Chicago and the California Girls. 1971. Poster produced by the Feminist Art Program, Fresno State College, Calif., 1970–71

Faith Wilding. *Flesh Petals.* 1970. Graphite on paper, 30 × 24″. Collection the artist. One of many "cunt" images generated by the Fresno Feminist Art Program.

Heinz Kusell brought Chicago to meet me. Chicago asked me to help her recruit students for a new "Women's Class" in the Art Department. In Governor Ronald Reagan's California, the campus was in more than the usual turmoil when we began our interviews: bomb scares caused building evacuations, antiwar marches and demonstrations took place weekly, five professors had been fired for their political activism. Most of the women we interviewed were art students, some of whom were already taking Chicago's outdoor site sculpture class. She challenged them with questions such as: "Do you want to be an artist?" "Do you want to achieve something in your life?" She told them forthrightly that she was looking for women strong enough to become leaders—to give up makeup, "girl stuff," and traditional sex roles; and to challenge the male hierarchy of the Art Department. It was clear from the beginning that joining the women's art class was a risk—Chicago wanted us to change our lives, just as she was changing hers. Eventually, fifteen students joined the class.[4]

Chicago insisted that the women's art class be held off-campus in an autonomous space so that a radical break could be made with the curriculum and structures of the patriarchal institution. Looking for a studio space was itself instructive, as we learned to deal with condescending realtors who couldn't believe a bunch of girls wanted a place in which to *work.* During the first six weeks we met in each other's houses for consciousness-raising, reading, discussion, and sharing our first art pieces. Once, after an emotional consciousness-raising session about street harassment, Chicago suggested we make a piece in response. She asked, "How does it feel to be walking down the street and have guys start coming on. Try to contact the thoughts and feelings so that the rest of us can identify immediately." Never in our previous art education had we been asked to make work out of a real life experience, much less one so emotionally loaded. With license to use any media or form we wanted, we came back the next week with poems, scripts, drawings, photos and performance ideas. I remember the almost unbearable mixture of excitement, fear, and pain in the room as this raw work burst forth, and as we identified with the feelings portrayed. By fortuitous accident, it seemed, we had stumbled on a way of working: using consciousness-raising to elicit content, we then worked in any medium or mixture of media—including performance, roleplaying, conceptual- and text-based art, and other nontraditional tools—to reveal our hidden histories.

Eventually we found studio space in a 5,000-square-foot former barracks. With each woman contributing $25 a month, we rented this space for a seven-month period. To learn how to build and use tools was our first project: we erected an exhibition wall forty feet in length, using woodframing and sheetrock construction. Wielding these new skills, we then built and refurbished different spaces in the building, including a kitchen for our Wednesday night dinners, a "rap" room, offices, a darkroom, open studio space, and smaller spaces which were used for Environments.[5] Working off-campus in a building we controlled dissolved the normal academic time and space boundaries. We became part of the larger urban community: the tract homes, streets, flea markets, antique stores, malls, and swap-

meets were our resource and research spaces, rather than the sculpture shop or the drawing studio.

Once we moved into the studio, we began to formulate a curriculum based on Chicago's ideas and on group discussions about what we needed to learn. Instead of holding structured classes, we worked in groups, rotating responsibility for leadership. The groups included: consciousness-raising; reading/ discussion; autobiography writing; photo/film techniques; art-history research; performance and play-acting; studio work with individual instruction from Chicago; group critiques; and Wednesday night dinners for social time. Each woman planned her weekly work schedule and formulated her semester's goals according to the credits (between 6 to 15) she was receiving from the college. We soon developed strong emotional and psychological bonds. Most of us ended up working (and practically living) at the studio every day.

Chicago was an extremely demanding and exacting teacher. Believing that women students had traditionally lacked the mentorship male professors gave their men students, she became our role model. She felt that women students were either ignored or coddled by most male teachers and that we needed to learn to be assertive, to express our anger, to make demands on ourselves and others, and to identify and ask for what we needed. The group process made fundamental demands on us to analyze and change our traditional gender roles, which often caused psychological turmoil, and emotional explosions. The class was forcing us to confront the damage done to women as a gendered group in an intensely personal way, which exposed our fears, desires, ambitions, and repressions. Seeing authority and power vested in a woman was a central part of our education. The unspoken curriculum was learning to contend with manifestations of power: female, male, political, and social.

The Feminist Art Program was a radical departure from traditional art education in many ways. Most important, it was based on an analysis of the content of what we would today call socially constructed female experience as revealed through consciousness-raising, a tool used in the feminist political movement nationally. Consciousness-raising helped us to discover the commonality of our experiences as women, and to analyze how we had been conditioned and formed on the basis of our gender. The procedure was to "go around the room" and hear each woman speak from her personal experience about a key topic such as work, money, ambition, sexuality, parents, power, clothing, body image, or violence. As each woman spoke it became apparent that what had seemed to be purely "personal" experiences were actually shared by all the other women; we were discovering a common oppression based on our gender, which was defining our roles and identities as women. In subsequent group discussions, we analyzed the social and political mechanisms of this oppression, thus placing our personal histories into a larger cultural perspective. This was a direct application of *the* slogan of 1970s feminism: "The personal is the political."[6]

How did the application of consciousness-raising to art-making actually work?

To put ourselves in touch with our basic feelings and needs, we began discussing our sex lives very openly in C-R. This was scary . . . we had never talked about "our" sexual needs before and weren't really sure whether we had any. . . . We read The Myth of the Vaginal Orgasm *by Ann Koedt, discussed masturbation, and began up-fronting many of the sexual frustrations with guys, when we objected to 'the invasion of the Cock'. . . . We learned that as long as we could not demand that our sexual needs be met, we could also not make demands that other needs in our lives be met. . . .*[7]

After these discussions we brainstormed about how we could represent our sexuality in different, more assertive ways. In her efforts to explore female sexual imagery Chicago was now working with us in the studio, making a cut paper "cunt alphabet." This inspired the idea of doing images of "cunts"—defiantly recuperating a term that traditionally had been used derogatorily and thereby opposing the phallic imagery developed by men. We vied with each other to come up with images of female sexual organs by making paintings, drawings, and constructions of bleeding slits, holes, and gashes, boxes, caves, or exquisite vulval jewel pillows. Making "cunt art" was exciting, subversive, and fun, because "cunt" signified to us an awakened consciousness about our bodies and our sexual selves. Often raw, crude and obvious, the cunt images were *new*: they became ubiquitous in women's art of the 70s, and they served as precursors for a new vocabulary for representing female sexuality and the body in art.

"Cunt art" therefore originated from an attempt to analyze, confront, and articulate our common social experiences; it was not a set of predetermined images based on essentialist notions about women's sexuality. Soon, however, it became codified and theorized (largely by Chicago and Miriam Schapiro, who lectured nationally on this topic in 1971–72) as "central core imagery"—the supposed tendency of women artists to structure images around a central (sexual) core. But because there was no understanding of how and why this imagery emerged, and of the historic place it occupied in the interrogation of the representations of female sexuality and identity, many 1970s feminist artists were falsely categorized as "essentialists" by 1980s feminist theorists.

Since we were committed to building a new context and making new standards for our art, we felt no compunctions about appropriating and inventing ways of working that subverted traditional art production. Avant-garde practices such as Dada, Happenings, and Situationist tactics inspired us, and we began to combine these with production methods and materials traditionally used by women. This was part of a determined strategy to explode the hierarchies of materials and high/low art practices, and to recover positive values for denigrated or marginalized practices. Tampons, Kotex pads, artificial flowers, sewing materials, underwear, household appliances, glitter, lipstick, jewelry, old letters and journals, eggs, animal entrails, blood, and sex toys were used to recombine the organic, artificial, sentimental, and anti-aesthetic in our art.

Much of our work was collaborative and collective—we freely intermingled our styles and expertise. The modernist legacy of the individual genius working on his [sic] piece was effectively negated by the collision of disciplines and activities in the studio, as well as by the content of the work.

Victorian Whore. 1970. Karen LeCoq, model. Costume by Nancy Youdelman, photograph by Dori Atlantis. Feminist Art Program, Fresno State College

Victorian Lady. 1970. Miriam Schapiro, model. Costume by Nancy Youdelman, photograph by Dori Atlantis. Feminist Art Program, Fresno State College. These costumes were used to examine female identity and imposed behavioral and sexual roles.

Kewpie Doll. 1970. Cheryl Zurilgen, model. Costume by Nancy Youdelman, photograph by Dori Atlantis. Feminist Art Program, Fresno State College

If art grows from other art, then finding precursors engaged in a similar project is vitally important—students and feminist artists still suffer from the invisibility of art made by women both in the past and contemporaneously. In the program, vital inspiration for our visual work came from research projects, and from reading women's literature, psychology and psychoanalysis, sociology, feminist theory, poetry, and philosophy. This intellectual, interdisciplinary approach to studio work required that our study of gender reach into all aspects of culture and knowledge. Just as consciousness-raising exposed a common pool of experiences, so our reading revealed the way women's social and cultural conditioning have often formed their world views, lives, and aspirations. Searching for female precursors in art, we discovered that few study materials existed—none of the commonly used art history textbooks mentioned women artists (much less commented on their absence), nor were slides of women's work available. Thus we began a project to recover the histories of women in art—writing articles, putting together a slide library, and collecting biographies and visual materials from women artists nationally.

Performance and performative modes (still largely untheorized at that time) often provided the starting point of our investigations. For example, after a day of staging a mock beauty pageant in the studio, we photographed ourselves for a group poster as "Miss Chicago and the California Girls," (page 33) combining combat boots, bikinis and sleazy makeup. We tried to invert the oppressive images of women we had all grown up with by restaging them in an exaggerated or parodic manner, which called attention to women's stereotypical representation as being obsessed with fashion, makeup, adornment, body shaping, seduction, posturing, rivalry, and competition. These elaborately staged and photographed "costume images," with deliberately generic titles such as *Whore, Bride, Kewpie Doll,* and *Victorian Lady,* anticipated the work of artists such as Cindy Sherman. We also explored sexual identity and codes of femininity in our lives as well as in our art by constantly experimenting with our "look."

Right from the start, the issue of violence—particularly sexual violence—as experienced by women, emerged in our art work. At that time the feminist movement had barely begun a socio/political analysis of violence against women, and the need to create feminist support services for abused women was just beginning to be recognized. *Rape* was still a shameful, whispered word; it was incredibly shocking to discover, in a consciousness-raising session, that several women in the group had been raped, including one by her doctor while she was on the examining table after he'd given her an abortion. We reacted by beginning to research the history and literature of sexual violence, and by trying to make images of our paradoxical experiences of violence, pleasure, danger, death, and desire. A journal entry describes some of this work:

We make daily visits to a nearby slaughterhouse, watching mesmerized as the cow is stunned, her throat slit, the blood we have come for collected in buckets. This is violent territory, a place of daily death and pain as hidden from public life as are our own lives as women. We carry the buckets of steaming blood back to the Women's Studio. We make blood paintings;

blood performances; we bathe in the blood. Later we take tape-recorders and film cameras to the slaughterhouse. In a performance imitating ritual sacrifice and domination we superimpose sounds and images of the slaughterhouse on a young woman who is hanging from a meathook by her bound hands. As she "milks" blood out of herself at the behest of a booted "cowhand", buckets of blood are thrown over her. (Faith Wilding, 1970)

While these performances and ritualistic works often had a cathartic effect on our group, our larger purpose was to find new metaphors and a new visual language for the hidden experiences of women. Chicago's *Cock and Cunt* play, Nancy Youdelman's *Death* sculpture, and Faith Wilding's *Sacrifice Environment,* are examples of this effort. Many of our images were aesthetically crude, but they provided a powerful impetus for us as developing artists, as well as opening up subject matter which is still being mined by many women artists in the 1990s.

Disoriented by some of her powerful teaching experiences in the Feminist Art Program, Chicago had been discussing them with Miriam Schapiro, a New York artist then teaching at the California Institute of the Arts (CalArts). Schapiro was a successful painter who had also been exploring symbols of femininity in her work. An experienced and generous teacher, Schapiro was the first woman artist from the outside to come and give us critiques of our work. Excited and inspired by what she saw, Schapiro initiated a liaison between the Fresno Program and CalArts, and she facilitated our art history research trips to Los Angeles.

In the spring of 1971 we invited the public into our studio for a series of open houses. One weekend close to a hundred women artists came from San Francisco, Los Angeles, and points between. We served food, and then presented a program of performances, films, Environments, art history slide lectures, and discussions. In return, the artists showed their slides, talked about their experiences, shared their histories and discussed ideas and plans for future women's art shows and building an alternative community. The weekend provided such a rich sharing of experiences that it can be said that from this moment the Feminist Art movement was launched on the West Coast.

Also that spring we were invited to write a special issue of *Everywoman* magazine.[8] This publication first brought news of our work to women nationally. Our next move was to take us away from our utopian privacy and anonymity, back into an academic institution, there to begin intersecting with the art world and with questions of public culture.

Being in a separatist program allowed us to do work we could not otherwise have done and gave us a chance to gather strength for the struggles ahead. But it deprived us of a social context for the work, and somewhat limited our critical perspective. This changed when the Feminist Art Program moved to CalArts. At CalArts, and in the subsequent years of its development, feminist art generally took on a much larger social and political agenda—it became more closely intertwined with feminist activism, and it began to focus increasingly on a critique of the representation of women in language, the media, art history, and popular culture.

Cay Lang, Vanalyne Green, Dori Atlantis, and Sue Boud. *Cunt Cheerleaders.* 1970. Feminist Art Program, Fresno State College. Wearing garish pink and red satin outfits, the cheerleaders performed audacious routines for visitors to the art program.

THE FEMINIST ART PROGRAM AT THE CALIFORNIA INSTITUTE OF THE ARTS

In 1971 Judy Chicago was hired by Paul Brach, then Dean of the Art School at CalArts, with the intent that she and Miriam Schapiro (who was already teaching there) would initiate a Feminist Art Program. Schapiro and Chicago had planned and prepared for this throughout the spring and summer of 1971, and the program started in the fall with twenty-two women enrolled.[9] The faculty included codirectors Miriam Schapiro and Judy Chicago; art historian Paula Harper; and me, as graduate teaching assistant.

CalArts had just relocated to its new campus in Valencia, twenty miles north of downtown Los Angeles. The Feminist Art Program moved to CalArts at a fortuitous moment when CalArts had temporarily been turned into an avant-garde institution—though still very much a male-dominated one. Many of the faculty were also involved in iconoclastic art practices.[10] Because of the hiring of faculty couples there was a relatively large number of women faculty.[11] The many strands of research, performance, and art production at CalArts influenced the Feminist Art Program, and were in turn influenced by it, though the latter influence was rarely acknowledged.

Brach generously allocated the Feminist Art Program a large studio space, tools, and other equipment, as well as a budget for research and materials. We were also given autonomy in determining program content and structure. Whereas several of the original Fresno students (including Suzanne Lacy and me) came from nonart backgrounds, the women at CalArts (many of whom came from New York City and other large urban centers) were art students with a strong investment in being in an art school. By joining the Feminist Art Program, which posed a di-

rect challenge to the male institutional hierarchy, they took the risk of making explicit that which had always been implicit—namely that women art students had always received a different education than their male counterparts.[12] The main points of difference were the mentorship traditionally offered to male students by their male teachers; the myths of (male) genius and mastery deemed as necessary to the making of art; the lack of social expectation of achievement and ambition for women; and the traditional hierarchies of materials and methods taught in art schools which devalued many of the skills and experiences women have been trained in.

Chicago and Schapiro decided to address some of these issues directly by beginning the Feminist Art Program with an intense collaborative project involving all the students, and applying the methodology developed in Fresno: consciousness-raising, reading, research, and role-playing—and then making art from the content arrived at through this process. The project was Womanhouse, a collaborative art-environment addressing the gendered experiences of women in the context of a real house located in an urban neighborhood in Los Angeles. Womanhouse was highly successful in securing broad public visibility nationally for the idea of a feminist art. In contrast to Fresno, where our work had been seen by very few people, we were now exposed to a national audience, and we could see how our work related to a social and art-world context.

For the Feminist Art Program, Womanhouse became the watershed which pointed up real differences among the students, and between students and faculty. Mira Schor remembers:

I was a participant in the Feminist Art Program at CalArts in 1971–72, under the direction of Judy Chicago and Miriam Schapiro. The Program undertook the dual project of cri-

Judy Chicago. *Cock and Cunt* Play. 1970. Performed by Faith Wilding (left) and Janice Lester (right) at Womanhouse, Los Angeles, 1972. Photograph by Lloyd Hamrol. This parodic sexual comedy ends with a self-castration image in which the "Cock" rips off his penis and beats the "Cunt" to death for demanding sexual pleasure.

Faith Wilding. *Sacrifice.* 1970. Installation with mannequin, Kotex, mixed media. Feminist Art Program, Fresno State College. An early use of menstruation imagery (the walls were lined with blood-soaked Kotex) combined with religious imagery, in this case the sacrificial female whose belly is filled with rotting cow guts.

tiquing male authority, specifically how art education had to that point dealt with its female students (who usually form the majority of the undergraduate art student body), and of trying to formulate presumably different and fairer authority structures which would not dispirit and destroy female creativity. Like many feminist activist groups at the time, there were immediately contradictory forces apparent, between any group's need for leaders, certain individuals' desire to lead, and a movement which ideally sought to undermine leadership as presently constituted.[13]

Working on this project also raised issues of leadership and power versus feminist principles and tenets, art versus politics, individual versus group work, and separatism versus interaction with the school community.

Throughout the construction and exhibition of Womanhouse, Chicago and Schapiro had employed different approaches to teaching, leadership, and power. In general, Schapiro seemed more committed to mediating between the Program and CalArts, while Chicago wanted a more radical separation. There had been many conflicts, rebellions, and strong disagreements between students and faculty about structure, and about the conduct of group processes and working methods. In particular, many of the students resisted what they saw as an increasingly ideological formulation and application of a "feminist line" to their art and their lives by Chicago and Schapiro. They also resented the full-time commitment to Womanhouse, which left little time for other activities. Chicago and Schapiro had often been on the road, to raise funds and to spread the word about the program, leaving the students to struggle along by ourselves—effectively bonding us into a close-knit group, making collective decisions, and running our own show. Conflicts often arose, however, when the teachers returned and began to reassert their authority and control. In their different ways both faculty members were forceful, sometimes abrasive, women with strong egos, whose professional and personal lives were also being transformed in this new venture. They increasingly clashed with each other over personal differences and power. In the end, all these conflicts were valuable in teaching us about the complex mechanisms of power, that women are not exempt from the need to fight for power, and that we must learn how to do so constructively.

THE CALARTS FEMINIST ART PROGRAM AFTER WOMANHOUSE

After Womanhouse, the Feminist Art Program continued through the spring of 1973 as a series of workshops offered by Chicago and Schapiro; I led a reading, journal writing, and consciousness-raising group, and Paula Harper lectured on women's art history. The original cohesive group, however, had dispersed, though many of the students continued to participate in one or more of the workshops.

Chicago's workshop began with *Route 126*, a project in site-specific performance and sculpture, in which we made spontaneous, playful, and humorous pieces along Highway 126. We

Karen LeCoq. *Dress Piece: 9 pink lipstick domes in white eyelet dresses, wondering when they're going to be old enough to wear lipstick and when they're going to be asked to dance.* 1972. Feminist Art Program, California Institute of the Arts, Valencia

investigated the idea of inserting symbols of private female experience into the public space of the highway. Our work in the landscape also initiated an investigation into the topic of women and nature.[14]

The Performance Workshop (begun by Chicago at Womanhouse) continued to be an important vehicle for research and for presenting and reformulating materials concerning women's experiences.[15] As documented by Moira Roth,[16] Suzanne Lacy, and others, early feminist performance was often used as a didactic tool based upon immediate skills derived from women's social conditioning and life experiences, such as dress-up, mimicry, masquerade, confession, autobiography, exhibitionism, story-telling, and play-acting. *Ablutions* (by Judy Chicago, Suzanne Lacy, Sandy Orgell, and Aviva Rahmani) was one of the earliest public pieces to treat the subject of rape. Presented in a Venice, California, studio in June 1972, *Ablutions* unfolded as a sequence of images of female bondage, abuse, rape, fertility, cleansing, and healing. As in many of the photo images and

Dori Atlantis, Suzanne Lacy, Jan Lester, Nancy Youdelman. *I Tried Everything.* 1972. Photo-documentation of breast enlargement devices. Feminist Art Program, California Institute of the Arts, Valencia. An installation of photographs and objects which documented the (non)effects of breast enlargement devices and parodied women's obsession with "improving" their bodies to meet societal conventions.

environments produced in Fresno, *Ablutions* not only depicted the violent victimization of women, but it carried an empowering, cathartic effect. Finally a long silence was being broken—"victims" were speaking, the hidden was being revealed and charted. Suzanne Lacy's artist book, *Rape Is . . .* , also provided a new way to talk about rape.

Much of our performative and documentary work also dealt with questions of identity. Identity politics were vigorously practiced by all the marginalized and disenfranchised groups that churned up the cultural and political revolutions in the late 60s and early 70s. In the Feminist Art Program we discussed the issues of race, class, and sexual preference, and read the new feminist literature. While working on Womanhouse we locked ourselves up in a house one day and held a "gay/straight dialogue" led by the lesbian women in the program who felt that the issues of sexual choice and discrimination against lesbians were not being addressed.

We grappled with the question already articulated by Virginia Woolf—"I mean, what is a woman?"[17]—by trying to show how the representation of women reinforced traditional gender roles, and by critiquing these roles. *I tried everything*, a collaboration between Nancy Youdelman, Suzanne Lacy, Dori Atlantis, and Jan Lester, was a paradigmatic piece which drew on the work of performance artist Eleanor Antin, then teaching in California, and is a precursor of much subsequent feminist work on media, advertising, and the male gaze.

Meanwhile Schapiro led a feminist workshop in painting, drawing, and collage, in which students explored the expression of "femaleness" in art—which in this context meant visual pleasure, pattern, decoration, color, texture, evocations of bodily pleasures and sensuality. Already in Womanhouse we had begun to look specifically at women's traditional arts as a source for imagery—and Schapiro was working with appliquéd fabrics,

pattern, and clothing images in her art. Our critiques considered ways in which women's traditional arts had often incorporated private subject matter, disguising it in patterns, decorative motifs, and obsessive marks. Clothing—especially dresses and panties—became an iconic image: the mythical pink lace dresses which could turn us into princesses; the delicate panties stained by our menstrual blood; the housedresses which signified our roles. We incorporated "female" materials such as fabrics, lipstick, sequins, pins, lace, and paper dolls into our paintings and constructions. We attempted to depict women's sexual pleasure by painting orgasms and showing the multiple pleasure centers of the female body. The results were often squishy, stained, dripped, or boldly colored rhythmical compositions such as Ann Mills's *Squee*. Other sources tapped were autobiographical, often psychological, narratives and journals. The collaborative *Journal of Consciousness*, an original artist book, treated subject matter such as panties, shoes, breasts, and body fluids. We discussed the specific meanings of our images, and how to make these more manifest. A pair of bloody panties, for example, could be seen as a sign of sexual pleasure, sexual violation, menstruation, or erotic obsessions.[18] Our methodology of arriving at imagery defied the High Modernist (Greenbergian) banishment of nonformal content—be it literary, political, or personal.

While working to expand, enrich, or re-invent the visual languages of painting and drawing as viable mediums for our new emphasis on the body as content, we began to speculate about a "female touch" or "female sensibility." The terms *feminist art* and *female sensibility* need to be distinguished from each other. We began to use *feminist art* in the early 70s to refer to art that consciously focused on the political, social, and/or personal experiences of women, and that attempted to deconstruct the myths of femininity and the traditional representations of

RAPE

RAPE IS

when a stranger in the street
uses you for his fantasy
and leaves you feeling naked.

Suzanne Lacy. *Rape Is* (two views). 1972. Limited edition book,
printed at CalArts. Feminist Art Program, California Institute of the
Arts. Collection the artist. After literally breaking open the book by
"violating" its red seal, the reader is confronted with various
definitions of rape. Significantly, there are no illustrations in
the book.

Sherry Brody

Sherry Brody. Panties, from *The Journal of Consciousness* (collaborative portfolio). 1972. Ink on paper, 18 × 20″. Feminist Art Program, California Institute of the Arts, Valencia. Collection Miriam Schapiro

Mira Schor. *Shoe.* 1972. Gouache on paper, 9½ × 6¾″. Feminist Art Program, California Institute of the Arts, Valencia. Courtesy the artist. This fancifully painted shoe is a humorous commentary on shoe fetishism and women's alleged obsession with shoes.

Opposite:
Sherry Brody and Chris Rush. Dresses, from *The Journal of Consciousness* (collaborative portfolio). 1972. Watercolor and pen and ink on paper, 18 × 20″. Feminist Art Program, California Institute of the Arts, Valencia. Collection Miriam Schapiro. Early 1970s feminist art prefigured the proliferation of clothing imagery in the 80s and 90s.

Sheila Levrant de Bretteville/Women's Design Program, CalArts. Still from *Menstruation*, "A Discussion Among 12–14 Year-Old Girls." 1971. A series of videotapes and literature created by Sheila de Bretteville to evaluate the way in which menstruation was introduced in the schools. Courtesy Sheila Levrant de Bretteville

women. *Female sensibility*, also a term from the early 70s, was far more nebulous and problematic. Lucy Lippard explained:

> *"female imagery" was first used . . . to mean* female sexual *imagery. That wasn't understood and it got all confused. I prefer "female sensibility" because it is vaguer. There is a lot of sexual imagery in women's art—circles, domes, eggs, spheres, boxes, biomorphic shapes, maybe a certain striation or layering. But that's too specific . . . I like fragments, networks, everything about everything.*[19]

And Linda Nochlin speculated:

> *I'm interested in exploring the quality and the style and seeing what possibilities there are for inventing or adapting languages or forms in women's work. I don't want to pin it down because women aren't any more alike in an easily definable way than men. Perhaps we should talk of female styles, always in the plural.*[20]

It is not surprising that the early 70s brought a profusion of women's sexual and erotic art, since perhaps for the first time in history large numbers of women artists were meeting together regularly, showing each other their work, discussing its content, consciousness-raising about personal issues, reading feminist theory and history, and being profoundly changed and influenced by each other's work. Women were subverting precisely those images and materials that had become the marks of their

oppression, and engaging in a liberatory program that emphasized positive aspects of the female experience, as well as exposing personal pain in such a way that its political basis could be understood by others.

Toward the end of the 1972 spring semester several of the women in Schapiro's workshop built a phantasmagoric tableau called *The Bus*.[21] A depiction of a range of women from different walks of life, and in aggravated states of emotional distress, *The Bus* became the nucleus of a show of visual work by the Feminist Art Program in the CalArts Gallery. Our art, which had been encouraged and validated internally by the program and was meant to contest formalist standards, was subjected to scathing criticism by many in the school. It became increasingly evident that the program could not continue successfully in an institutional framework without taking on the project of integrating a feminist discourse into every aspect of its structure and curriculum. Chicago was not interested in expending her energy in this way and resigned her position at CalArts in 1973 to become a cofounder with Sheila de Bretteville and Arlene Raven of the Feminist Studio Workshop, an alternative art school for women housed in the Woman's Building. Thereafter Schapiro, who was still deeply commited to feminist educational principles, carried on the Feminist Art Program at CalArts (with graduate assistant Sherry Brody) on a one day-per-week basis until 1975, when she moved back to New York. At CalArts, Schapiro continued to teach the process of directed image-making derived from an examination of female experience and history. In 1974 her class organized a celebration of women in

the arts at CalArts for which they published an artist book *Anonymous was a Woman.*[22] This culminated the four-year experiment in an alternative arts education for women within a traditional art school.

Concurrently with the Feminist Art Program, the Feminist Art movement in Los Angeles and elsewhere grew rapidly: Womanspace, a Los Angeles feminist gallery, and *Womanspace Journal* were launched in 1973; the West Coast Conference of Women Artists was hosted by the Feminist Art Program and West-East Bag (WEB)[23] at CalArts in January 1973; and, in the fall of 1973, the Woman's Building opened its doors to the public. Viable alternative communities for women artists now existed, which perhaps lessened the pressure to maintain separate programs for women in traditional institutions.

HOW DOES YOUR GARDEN GROW?

One of the strongest effects the Feminist Art Program had at CalArts was the connections it fostered among women faculty and students throughout the Institute, with the result that special courses for women were taught in design, writing, theater, film, dance and music.

An example is Sheila de Bretteville's Women's Design Program started in the fall of 1971. De Bretteville was interested in the social implications of design and in exploring the particular qualities which women might contribute to it. With Suzanne Lacy as graduate assistant, de Bretteville organized a two-day-a-week program, adapting techniques developed in the Feminist Art Program, and applying feminist values to design problems. Student projects explored the dynamics of public/private, similarities/differences, hierarchy/authority, and power issues between women. De Bretteville created a supportive environment for her students, for she opposed the idea of growth through confrontation. The women explored issues of collaboration while learning the techniques of mass production, democratic distribution, and how to control the way their images were used publicly, by producing works such as the *Broadsheet* and the *Menstruation Tapes*. In 1973, de Bretteville joined Judy Chicago and Arlene Raven in founding The Feminist Studio Workshop; and in 1974 she made the difficult decision to leave CalArts because: "I came to realize the ability of the dominant culture to annihilate a positive act, and to change and misuse the original meanings and intents of forms."[24]

The Feminist Art Program introduced feminist theory, feminist art, art history, and criticism at CalArts. We found that even within a progressive school, sexism, gender roles, hierarchies, and established critical frameworks (of modernist practice) were still entrenched. Then, as now, categories of "universal value" were invoked: the "standards" and "quality" of our art productions were often derided and ridiculed by both students and faculty. When tested by our resistant practices, the boundaries between high art and a more multivocal production proved to be stubbornly rigid. Still, the presence of a feminist art practice and critique simultaneous with other avant-garde practices did provide a unique moment when "perhaps for a brief period only, (CalArts) was distinguished by the inability of any one group or aesthetic to dominate over any other."[25] However, CalArts' institutional memory proved to be a short one. The 1981 10th-Anniversary Show of Alumni included only two women (neither of them members of the program) out of sixteen artists exhibited, and there was no sign of any of the groundbreaking feminist activity of its early history.[26]

CONCLUSION

Participation in the Feminist Art Program made a lasting impression on the women students involved in it. Many of them have gone on to become strong artists and teachers who have continued to explore feminist issues in their work, and to continue a feminist critique of representation.

The impact of the Feminist Art movement—and the Feminist Art Program—on postmodern art, though still largely unacknowledged, has been far-reaching. Critic Laura Cottingham writes:

> It is within the feminist art movement of the 70s that the suggestion of what has come to be termed "post-modernity" first surfaced most defiantly, that is, without serious regard for the most fundamental and previously unquestioned prerequisites of what comprises art and artistic "quality" within the Euro-American High Modernist tradition. From the beginning until the end of the 70s, the women's art movement challenged the entire valuative system of American Modernism: the feminist art movement reclaimed craft, insisted on the importance of content, contested the mythology of history, favored collective over individual production, asserted a place for the autobiographical, and, perhaps most radically, refuted the idea that art is ever neutral or universal because the Movement discovered that the voice previously called universal was actually nothing more than the voice of a Euro-American man.[27]

In 1992–93, there has been a resurgence of interest in the early Feminist Art movement on the part of students, critics, and new generations of feminist women and men artists, who know very little of the 70s history. This ignorance is largely due to the lack of education about contemporary art issues and critical movements—including feminism—in art departments and art schools nationally. But there are hopeful signs: students are increasingly demanding the inclusion of feminist art history and theory in their classes, and the task of a historical evaluation of feminist art in the 70s is being initiated.

The early 90s have been marked by a resurgence of feminist political and art activism—the membership of groups like the Women's Health Action Mobilization (WHAM) and the Women's Action Coalitions (WAC) include many women artists. Simultaneously, there's been a flurry of women's shows in the New York City galleries, and a reappearance and reworking of many of the feminist images of the 70s. I hope this groundswell of activity offers women artists a chance to reconnect to our history in a way that will empower artists to continue to recontextualize, reimagine, revise, and renew the still vital issues which gave birth to the Feminist Art movement.

WOMANHOUSE

BY ARLENE RAVEN

Womanhouse, a daring, avant-garde site installation in an actual house and an unexpected happening during one month in 1972 in residential Hollywood, directly addressed the everyday life of an ordinary housewife. The collaborative art environment was created by twenty-one students in the Feminist Art Program at the California Institute of the Arts under the direction of artists Judy Chicago and Miriam Schapiro. For a brief, fanciful moment, a condemned mansion at 553 Mariposa Avenue was transformed into an artistic revelation about women in their homes.

Womanhouse was created in only six weeks in 1971 and then open to the public between January 30 and February 28, 1972. The abandoned house, which had been lent to the group by the city of Los Angeles, was eventually destroyed by the city as planned, but not before Womanhouse made a widespread difference in feminist art making and in all subsequent American art. Entirely new aesthetic subjects that had until then remained in the distant shadows in suburban American homes burst into the public sphere through the installation and performance art of Womanhouse. The suburban home, where the contents of a woman's concerns such as nurturance, sex, self-consciousness, rape, and murder had been imprisoned since the 1950s, was well known to the young artists who created Womanhouse. They had lived their childhood and adolescence right there.

Judy Chicago, a pioneer in feminist education, had demanded an all-female space for her art class at Fresno State College in 1970. She was convinced that no critical frame of reference yet existed that would allow for an understanding of a woman's struggle and suggest an appropriate way to respond to it.[1] "Womanhouse became both an environment that housed the work of women artists working out of their own experiences and the 'house' of female reality into which one entered to experience the real facts of women's lives, feelings, and concerns," Chicago summarized.[2] Miriam Schapiro was already a well-known painter who had shown her hard-edged works at the prestigious Andre Emmerich Gallery in New York and a feminist leader in the incipient women's movement in the arts in Los Angeles.

The initial idea to create Womanhouse was Paula Harper's, then staff art historian for the Feminist Art Program at the California Institute of the Arts in Valencia. Although Harper helped to conceptualize the project at the beginning of the 1971 academic year, the collaborative art environment was substantially developed and executed by the twenty-one female students of the program under the direction of Chicago and Schapiro. Los Angeles artists Wanda Westcoast, Sherry Brody, and Carol Edson Mitchell also collaborated in the environments and exhibited their work in Womanhouse. Largely responsible for the successful completion of what proved to be a vast creative undertaking, students thus were granted the professional status of artists working among artists, not as trainees in an academic hothouse.

Faith Wilding, a weaver turned painter in Chicago's all-female class at California State University, Fresno, organized in 1970, had followed Chicago to CalArts in 1971 to be a graduate student/MFA candidate in the Feminist Art Program. In her essay for this book, Wilding describes in detail the hoped-for accomplishments laid out by the faculty, in which students were

Camille Grey. *Lipstick Bathroom.* Mixed media site installation at Womanhouse, 1972

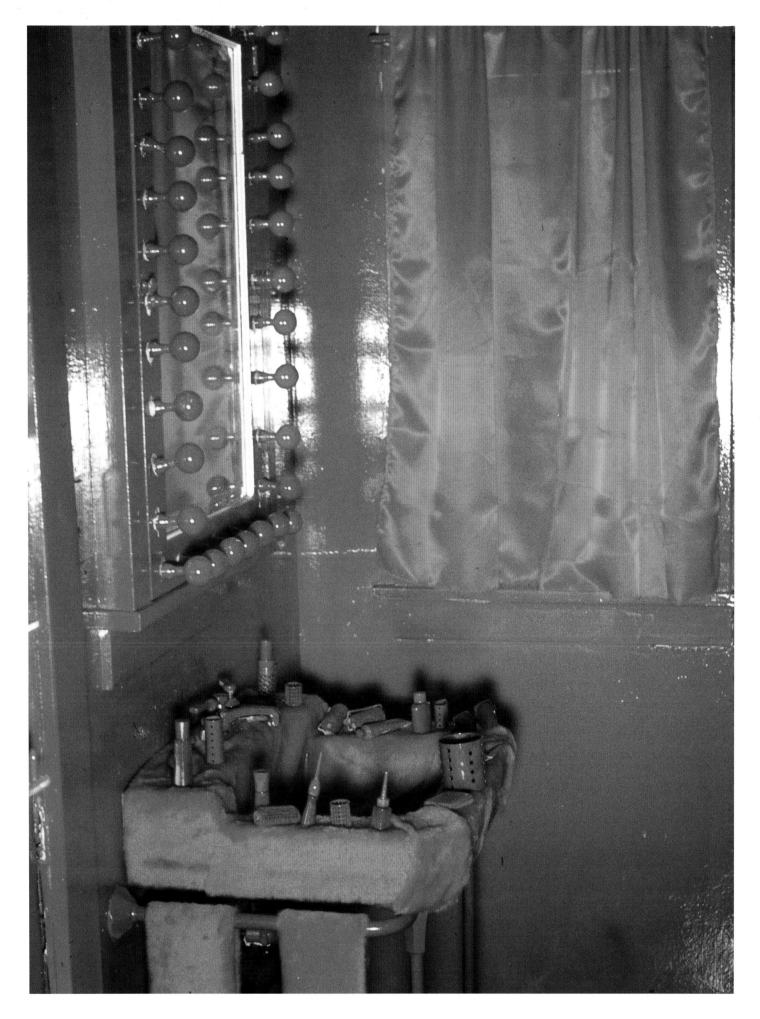

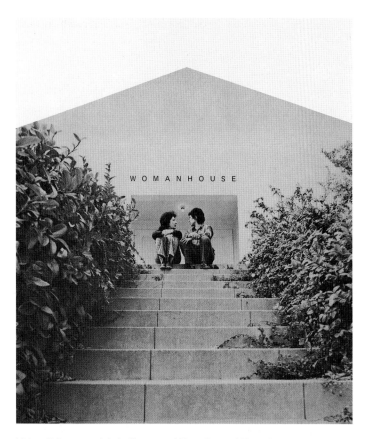

Miriam Schapiro and Judy Chicago at Womanhouse. Womanhouse
catalogue designed by Sheila Levrant de Bretteville. 1971

encouraged to grapple with the emotional and conceptual issues
of the project. A "learning by doing" educational method at
Womanhouse put into practice the psychological self-discoveries
offered by the consciousness-raising format of the women's
movement. Designed to be a structured conversation,
consciousness-raising allowed each contributor to speak about
her experiences uninterrupted and to hear the testimonies of
other women; in this way, women shared life experiences, in-
stead of remaining isloated by their concerns and fears. The
insights of the consciousness-raising circle were immediately put
to use in the task at hand—building Womanhouse. Concrete and
worldly applications meant goals and deadlines, expectations
and measurable achievements.

Repairing and structuring the house as an independent ex-
hibition space as well as a work of art in itself was a vital
element in a course of study and work designed to build stu-
dents' skills and to teach them to work cooperatively. This focus
on collaboration cannot be over-emphasized, for collaboration as
form or subject has characterized much of the feminist art cre-
ated after Womanhouse in Southern California. Because the
West Coast became a model and leader for feminist production
nationally and internationally, the influence of the transitory col-
laboration at Womanhouse has been pervasive and lasting.

Moreover, every contributor to Womanhouse was forever
changed by the experience. Each felt taken apart and put back
together, but altogether differently. The profound alterations in
self-image, self-esteem, and artistic identity affected the individ-
uals in the group to such an extent that the majority were
launched on challenging personal and professional paths.

Abandoned and condemned, the house on Mariposa Ave-
nue was still architecturally imposing but also in need of
extensive reconstruction. Vandals had broken windows. Fixtures
and furnishings required replacement. The house had no hot
water, heat, or plumbing. In November, when the twenty-one
CalArts Program students began work on the house, they had a
rude awakening. One surprise was the amount of work required
to create the collaborative environment. Another astonishing re-
alization was that the nature of the work ranged from cleaning
to construction, labor that crossed not only class and gender
lines, but that was outside of the scope of "art" experienced by
the rest of the art school. Students enrolled in the conceptually
oriented CalArts learned graphics and text display, electronic
music and "idea art," in which an art object may not even be
made. But for the Feminist Art Program workers, skills such as
carpentry and window glazing became part of the creative
process. Before picking up a paint brush, etching plate, sculpt-
ing tool, or video camera, each young artist had already used
electric saws, drills, and sanders.

The seventeen rooms of the house increasingly inspired the
group. One by one, the rooms became clean white cubes and
rectangles for the presentation of a radical and complex contem-
porary art. As each young artist unclogged toilets or re-hinged
doors, she imagined the transformed environment and even-
tually chose one of the spaces in the house for "her" room,
wherein she created her own installation environment. Even the
initial plans for the environmental artworks demanded a range
of competence never remotely necessary in more conventional

art making or art-educational settings. But involving the art world, the local community, and the American feminist network of individuals and institutions was part of Chicago's and Schapiro's pedagogic plan.

Although all women working the stipulated eight-hour day had freely chosen to do so, most found the labor unbearably taxing. In other American art schools of the 1960s, these same students might never have learned the real and absolute necessity of consistent, hard work in the field of fine arts. And they might very well have been among the many women discouraged by art teachers from becoming artists at all.

Various meetings were necessary to air feelings, discuss plans for the art environments, or to prepare Womanhouse's eventual exhibition to the public. Group meetings were initiated to air the students' tangled feelings of anger at one another and themselves, anxiety about the successful completion of the project, and resentment of the authority of their female role models, which arose as their own emotional growth and physical dexterity increased. In these meetings, the frequent disputes over territory in the house and the articulation of ideas were often resolved, which in turn pushed forward the progress of the work. Smaller collaboration groups explored the possible forms and meanings they wanted to infuse into the environment. And because the group as a whole had decided to add special events and present performances during the exhibition, additional work groups were formed.

The relationship between biology and social roles underlay the content of Womanhouse, its rooms and activities. Moreover, Womanhouse presented a special kind of direct—even, some felt, obvious—representation of women in their homes. Most of the rooms replicated the conventional areas of a house—bathroom, dining room, kitchen—while at the same time they challenged the activity of that room and the meaning of that activity to women's self-image, through creative exaggeration of the ordinary physical and emotional elements of each space. Three different conceptual bathrooms, for example, were designed: Robbin Schiff's *Nightmare Bathroom*, Camille Grey's *Lipstick Bathroom*, and Judy Chicago's *Menstruation Bathroom*. Shawnee Wollenman's *Nursery*, with its giant-sized components, made the viewer feel like a child. Faith Wilding's *Crocheted Environment* had a second wall or skin of a cavelike protective yet open fabric tent, much like a modern weaver's version of African tribal menstruation huts. Vicki Hodgett's kitchen, called *Eggs to Breasts*, featured a ceiling and walls covered with fried-egg "breasts" and innumerable plates of prepared food. Mannequins were also employed: one mannequin, in full bridal attire, paused on the staircase, her bridal train (which turned from white to dingy gray) trailing to the kitchen. Another mannequin represented a woman segmented and confined by the shelves of her linen closet. Beth Bachenheimer's many-shoed shoe closet conveyed ways a woman could change her identity. And there was much more. In every theme room, feelings raged in the striking colors chosen to represent household roles and arenas, in the many media colliding together, and in the surprising juxtapositions of abstract forms and representational images.

Womanhouse literally brought to life the ideas and viewpoints first articulated in Betty Friedan's 1963 *The Feminine Mystique* and soon to be developed in *Ms.* magazine, which was founded in 1972. The emphasis in these first feminist ideas and viewpoints concerning menstruation, sexuality, marriage, and promiscuity, pregnancy and post-partum depression, psychic breakdown and suicide in middle-class suburban homes was one of frustration and despair.[3] This kind of bold looking at issues created an apprehensive tension in the audience for Womanhouse, provoking argument as well as revealing terrible pain.

The only two human figures one sees in Womanhouse are the bride and a mannequin literally closeted with her sheets (*Linen Closet* by Sandy Orgel, page 55)—the one sumptuously dressed in every convention of bridalwear and the other naked among her clean, pressed linens. They are, in fact, two cinematic aspects of the same woman, who squeezed herself into a cultural identity which finally dictated that, in the words of Betty Friedan, "fulfillment as a woman had only one definition for American women after 1949—the housewife-mother."[4] Many white middle-class women were alone, confined in their homes, and didn't know who they were except in relationship to family members. How, then, was the American housewife to answer the cardinal existential question about twentieth-century identity established in the first years of the modern era—"Who am I?" She could only respond with "'Tom's wife, . . . Mary's mother.'"[5]

Friedan saw in the feminine mystique the echo of Nazi Germany's imperative that women's realm consist only of "*Kinder, Kuche, Kirche.*" It was with trepidation that Friedan described in the early 1960s a condition so hidden and censored that even the women affected could not name it. It became the problem that had no name.

In contrast to the linear nature of writing, the visual information of Womanhouse could be taken in all at once. Insight into the illogic of the prevailing division of work by gender was first introduced in 1971 by Jane O'Reilly in her article, "The Housewife's Moment of Truth:" "We are . . . clicking-things-into-place-angry, because we have suddenly and shockingly perceived the basic disorder in what has been believed to be the natural order of things."[6] The instantaneousness of feminist insight could be felt as a completely pure personal moment of truth.

A year before Womanhouse was completed, *Ms.* author Judy Syfers pointed with irony to the advantage of being a person *with* a wife rather than a wife: "I want a wife who will keep my house clean. A wife who will pick up after me. I want a wife who will keep my clothes clean, ironed, mended, replaced . . . My God, who wouldn't want a wife?"[7] No husband appears in Womanhouse, but "husband" symbolically is the whole wider world of social relations and territory beyond the hearth.

Artist and historian Pat Mainardi specified housework as a political issue about which women had been coerced and brainwashed. "Probably too many years of seeing television women in ecstasy over their shiny waxed floors or breaking down over their dirty shirt collars. Men have no such conditioning. They recognize the essential fact of housework right from the beginning. Which is that it stinks."[8] Even more so, housework is presented in Womanhouse as the stinking fact that is also a mantle of identity.

The bride's train in Kathy Huberland's *Bridal Staircase*

makes no material connection to a bedroom—to consummation of the marriage vows or celebration of the marital union on a honeymoon directly following the wedding ceremony. Rather, we follow the filmy path down the staircase to the pantry, where we pass a row of plates on a sideboard, each illuminated by a bare hanging light bulb. On the plates are breakfast, lunch, and dinner, immediately followed by more of the same—breakfast, lunch, and dinner. The linear, repetitive path of plates which represents the continuity of "women's work" finally leads to the entrance of Robin Weltsch's sensuous, pink *Kitchen*.

Through Wanda Westcoast's vacu-formed plastic kitchen curtains, the warm light in which the room is bathed falls on Vicki Hodgetts' plastic fried eggs mounted on the ceiling, which are transformed into equal numbers of breasts on the walls. Visually "traveling" to the frying pan on the stove, the small round images reassume the appearance of eggs. When Hodgetts, Weltsch, and Susan Frazier began work on the kitchen, they were stuck for images. Schapiro suggested a consciousness-raising session about feelings raised by the kitchens of their childhood memories. The flesh-pink kitchen, the institutional source of all mothers' milk, had also been the war zone of the home. Struggles between mothers and daughters for psychological power were embedded in the gestures of giving and receiving food. Part of growing up and slipping back into childhood often revolved around who selected food— mother or self. The process of probing one's own autobiography threw light on the personal origins of the social meanings of food. At the stove, the hearth of the kitchen, the egg is the image of nourishment that means food and that also signifies the hunger in many women's hearts and lives. The food, made of plastic, is not edible. But because women have breasts, they are to be nourishers and must also cook the family meals. The dilemma between nature and culture, organic food and its plastic representation— the giving mother and the consuming daughter—is succinctly contained in that frying pan.

The Womanhouse *Dining Room*, a collaboration among Beth Bachenheimer, Sherry Brody, Karen LeCoq, Robin Mitchell, Miriam Schapiro, and Faith Wilding, is a formal family room, but unoccupied (page 56). The table is elaborately laid, but with entirely inedible artificial food (such as treated bread dough) on sewn fabric plates. A mural interpretation of a still-life by Anna Peale on the wall features food more believable (although two- dimensional) than the chilly dinner on the table. The *Dining Room* is linked to other spaces by the passage of the viewer from room to room.

When moving from the kitchen, through the pantry, to the dining room, questions arise: How did the nurturing breast that becomes the emblem of the *Kitchen*, the plates of food prepared and placed in line in the pantry, conceptually move from the private rooms of food preparation to the social act of eating and breaking bread together? And how did this evolution become empty and perverted?

Faith Wilding's *Crocheted Environment*, consciously based on the ancient female art of architecture, was adapted by Wilding as a formal mode in her sculptural environment (page 62). Wilding made forms inspired by and derived from those of the female body. *Crocheted Environment* has numerous meanings,

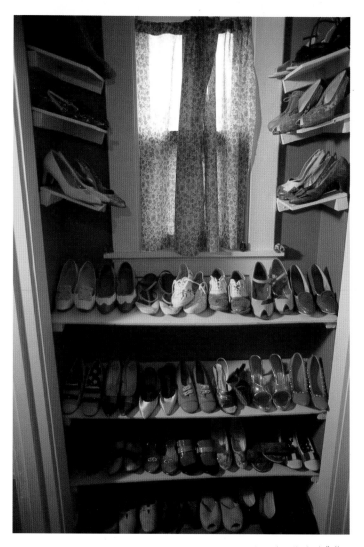

Beth Bachenheimer. *Shoe Closet*. Mixed media site installation at Womanhouse, 1972

Kathy Huberland. *Bridal Staircase*. Mixed media site installation at Womanhouse, 1972. The bride is portrayed as an offering— encased in lace, flowers, and dreamy sky blue. As she descends the stairs the blue slowly changes to gray. "The bride's failure to look clearly where she is going leaves her up against the wall." (Huberland)

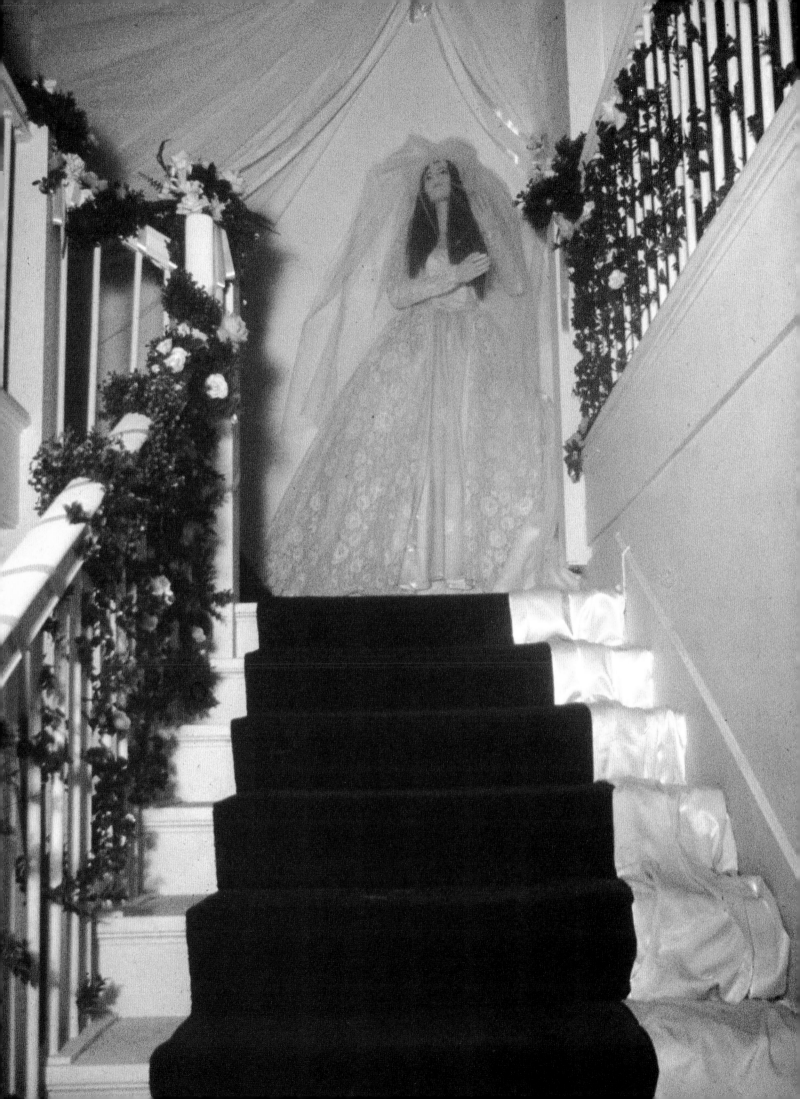

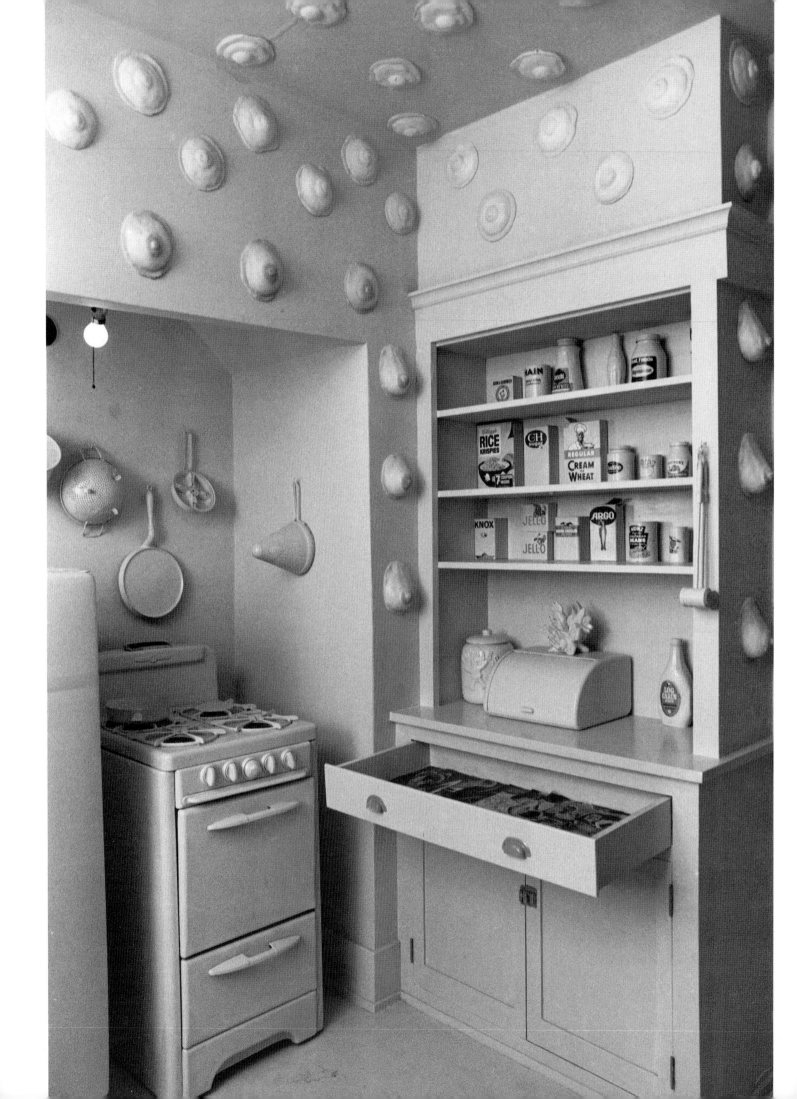

for it represents a mother's woven nest of blood and everyone's "first" room, the sacred heart of the Virgin Mary, and the hearth of the home. The traditional housewife may have wanted to create this nest of her physical home most of all for herself. Often deprived of having been herself mothered, marrying young and having children before she could complete her own childhood or education, housewives of all ages needed to be nourished again—this time in the metaphorical womb of the home, to develop into fully adult humans. Feminism provided a second look at the all-encompassing needs of people for mothering. The birthing and nurturing nest that Wilding created was a representation of not only a site but a biological passage. And because intercourse, pregnancy, and birth can be accompanied by blood, actual menstrual blood and bloodlike color as well as images of body organs concerned with feminine biological events and roles appear with frequency in women's art.

Menstruation Bathroom is a blood relative of Wilding's *Crocheted Environment*, this time presenting women's blood as taboo and, by implication, puberty as the moment of shame when signs of womanhood appear and must be hidden behind a locked bathroom door. Pristine white, with feminine hygiene products double-wrapped, the bathroom was shrouded in silence and became a metaphor for the unspeakable (page 57). Judy Chicago recalls, "Under a shelf full of all the paraphernalia with which this culture 'cleans up' menstruation was a garbage can filled with the unmistakable marks of our animality. One could not walk into the room, but rather, one peered in through a thin veil of gauze, which made the room a sanctum."[9]

The black, green, and rust-colored *Nightmare Bathroom* depicted a woman in the bathtub (page 57). Made entirely of sand, she was literally erased by an audience that couldn't keep its hands off her during the six weeks of the exhibition. The vulnerability of the naked body in the unguarded setting of the bath cannot exist without the bather's awareness of a potential intruder. Sand-filled bottles that originally held toiletries serve as a residue and symbol of past losses to both the underside of vulnerability and the limiting nature of fear. A snake, reminiscent of the slimy creature who was the biblical corrupter of the once innocent Eve, crawls toward her on the ground. Who might come in through the window? Or open the door? Or thrust up from the toilet?

In addition to *The Nursery*, whose large scale, and in particular gigantic working rocking horse, makes adults feel child-sized, there are three other bedrooms—*Personal Space* by Janice Lester, *Painted Room* by Robin Mitchell, and *Leah's Room* by Karen LeCoq and Nancy Youdelman. Lester's and Mitchell's spaces look, appropriately, like college dormitory rooms, with small single beds and references to self and vocation. These two singular post-adolescent bedrooms avoid the decorative quality we associate with homemaking and the sexual and procreational functions of the marriage bed.

In contrast, the watermelon-pink *Leah's Room*, a tableau of the aging courtesan of Colette's novel, *Cheri*, is elaborate and fantastic (page 60). During the public viewing of Womanhouse, a young woman sat at the dressing table applying the makeup that transformed her from biological female to culturally-created woman. Fantasy far exceeds fact, we may conclude, in the night-

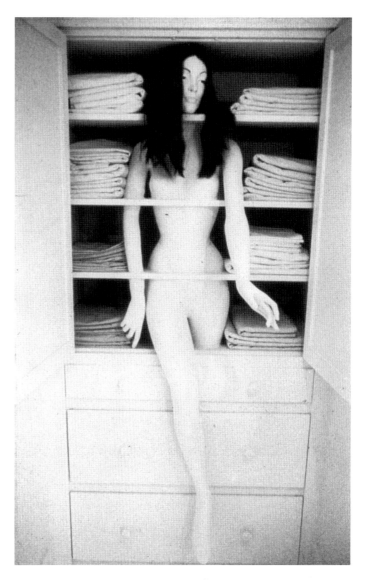

Sandy Orgel. *Linen Closet.* Mixed media site installation at Womanhouse, 1972. Orgel wrote: "As one woman visitor to my room commented, 'This is exactly where women have always been—in between the sheets and on the shelf.' It is time now to come out of the closet."

Susan Frazier, Vicki Hodgetts, Robin Weltsch. *Nurturant Kitchen* (detail). Mixed media site installation at Womanhouse, 1972

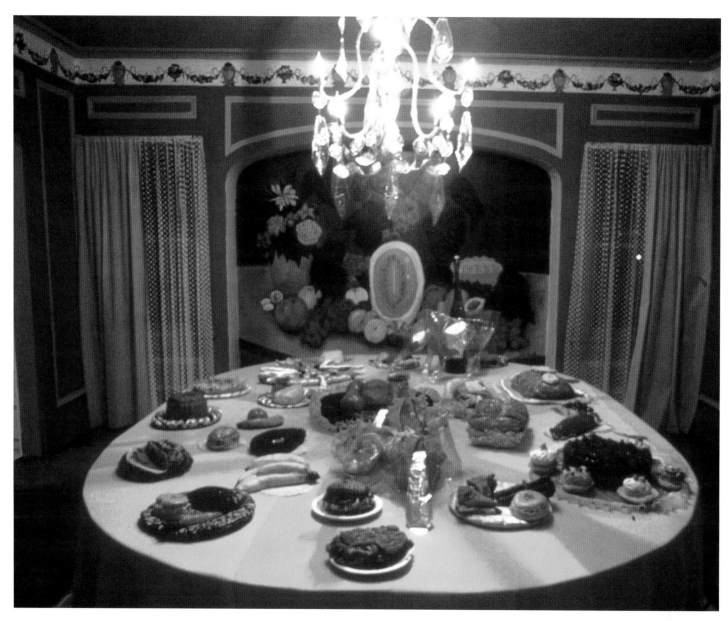

Beth Bachenheimer, Sherry Brody, Karen LeCoq, Robin Mitchell, Miriam Schapiro, Faith Wilding. *Dining Room.* Mixed media site installation at Womanhouse, 1972. This room was the most extensive collaborative effort of the Womanhouse students. Seven women painted walls, ceiling, mural (after a 19th-century still life by Anna Peale), molding; created the chandelier; sewed curtains, tablecloth, and plates; sculpted bread dough for the "food."

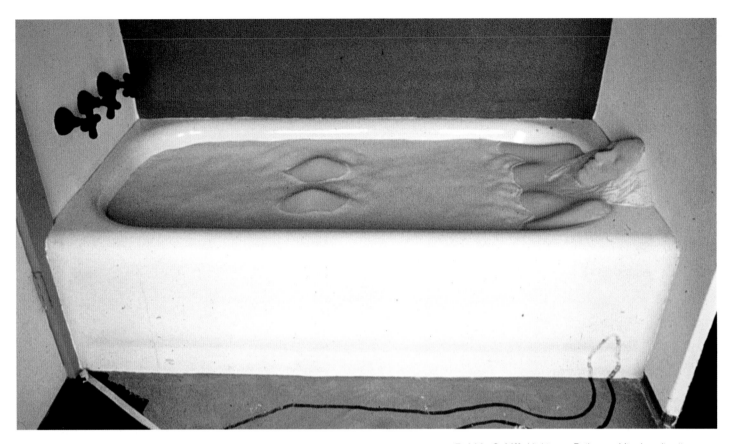

Robbin Schiff. *Nightmare Bathroom.* Mixed media site installation at Womanhouse, 1972

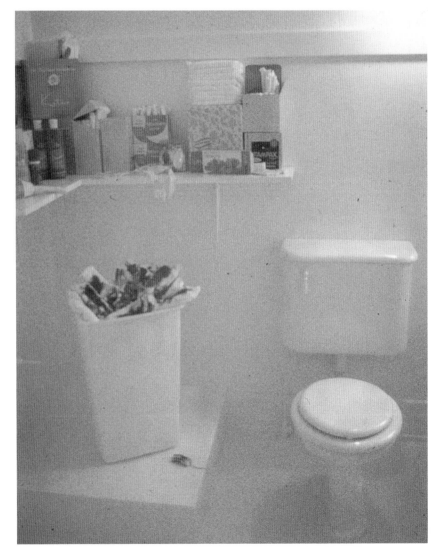

Judy Chicago. *Menstruation Bathroom.* Mixed media site installation at Womanhouse, 1972. Chicago described her room as "very, very white and clean and deodorized—deodorized except for the blood, the only thing that cannot be covered up. However we feel about our own menstruation is how we feel about seeing its image in front of us."

life of Leah and also of the average housewife. But there is no realistic, pedestrian portrayal of the bedroom. Fact meets fantasy only when one contemplates the two female character types embodied in the courtesan and the modern-day Mrs. Are both characters—kept women and working girls at the same time—not poles apart but two sides of the same coin?

Miriam Schapiro and Sherry Brody created *Dollhouse Room*, a house within a house, and a world within a world of its own (pages 64, 65). *Dollhouse* consisted of six rooms under a triangular roof. In each elaborately constructed and decorated room, safety and comfort associated with the home vied with the yet unnamed terrors of the domestic arena. Schapiro, who used fabrics in her paintings, and Brody, who made soft sculptures of sewn garments, employed the same materials, skills, and impulses in the *Dollhouse* that they did in their individual work. Conversely, the experience of creating art for Womanhouse also affected their subsequent art.

To arrive at the visual and verbal forms of the *Cock and Cunt* play, Judy Chicago followed the format of simple exercises developed during the previous year in her female art class at Fresno State College. The play was performed in the Womanhouse living room by two women wearing black leotards. The SHE character wore a gigantic pink vagina; HE wore a satiny outsized penis. At first this exaggeration of genitals seems comic. But as the dialogue between the two actors progresses, the truly grisly tone of the piece emerges. SHE is doing the dishes and asks for help. HE is shocked: "Help you do the dishes?" "Well," SHE replies, "They're your dishes as much as mine!" His retort emphasizes the traditional biology/culture dynamic: "But you don't have a cock! A cock means you don't wash dishes. You have a cunt. A cunt means you wash dishes." SHE questions him: "I don't see where it says that on my cunt." The scene then shifts from kitchen to bedroom, where sexual intercourse leads to a wistful statement by SHE—"You know, sometimes I wish I could come too"—and ultimately to the murder of SHE by HE.[10]

In this schematic dialogue between husband (played by Faith Wilding) and wife (Janice Lester), the deadly portrayal of the battle between the sexes demonstrates the culturally assumed connection between biological differences and sex roles. The *Cock and Cunt* play addresses the traditional relationship between white, middle-class men and women in their physical particulars and also in broad social terms—as an aspect of the balance of power within the political patriarchal institution. The play leaves no doubt in the minds of its audience that the personal and cultural uses to which biological differences have been put have had dire, indeed mortal consequences for women.

Also during this time, a number of prominent spokeswomen for female autonomy and women's rights pondered the dangerous dimensions of the social synergy between women and men. Ti-Grace Atkinson explained the interrelationship of the sexes as a political and economic structure.

The class of women is one-half of a dichotomized class definition of society by sex. The class of women is formed by positioning another class in opposition: the class of men, or the male role. Women exist as the corollaries of men, and exist as human beings only insofar as they are those corollaries . . . over thousands of years, men have created and maintained an enclosure of institutionalized oppression to fortify their domination of women by using many institutions and values as vehicles of oppression, e.g. marriage, family, sexual intercourse, love, religion, prostitution. Women are the victims of this oppression.[11]

"The rationale which accompanies that imposition of male authority euphemistically referred to as 'the battle of the sexes'" Kate Millett wrote, "bears a certain resemblance to the formulas of nations at war, where any heinousness is justified on the grounds that the enemy is either an inferior species or really not human at all. The patriarchal mentality has concocted a whole series of rationales about women which accomplish this purpose tolerably well. And these traditional beliefs still invade our consciousness and affect our thinking to an extent few of us would be willing to admit."[12] Shulamith Firestone asked, "How does the sex class system based on the unequal power distribution of the biological family affect love between the sexes?"[13]

Chicago dramatized what Atkinson, Millett, Firestone, and other feminist theorists illuminated: women's most intimate relationships, including love and motherhood, are an intrinsic part of a "sex class system" in this country.

But Womanhouse is addressed to women's relationships with others primarily as internal dialogues in their/our own minds and as aspects of self. The housewife, whose role is evoked in Womanhouse, has but one clear relationship, and that is to her environment as a whole. In this relationship, she is unbearably lonely. The tasks and implications of the home surround her in a complex, unified yoke.

The environment packed with images and objects in every inch and corner of the spaces of the house on Mariposa Street suggests, ultimately, an overwhelming despair. The hundreds of lipsticks and shoes, sheets, plates of food, yards of material, rooms of color and stories and messages do not really offer much of a life. Even though we are told that our life is what we make of it, in fact for mid-century women, the same human existence seems excessively predetermined and prescribed. The Womanhouse protagonist is tortured from birth to death with these diametrically opposed states of being thrust in her face.

In the performance *Waiting*, Faith Wilding becomes the woman who maintains and seethes in her home. She exemplifies the consciousness-raising effort of the women's movement of the time—breaking silence by speaking, and thus revealing women's bitterness as a chorus of single voices. Wilding's *Waiting* is a litany that rhythmically described women's lives as reactive to the actions of others and as characterized by waiting—"Waiting for my breasts to develop/Waiting to get married/Waiting to hold my baby/Waiting for the first grey hair/Waiting for my body to break down, to get ugly/Waiting for my breasts to shrivel up/Waiting for a visit from my children, for letters/ Waiting to get sick/Waiting for sleep. . . ."[14]

Wilding's waiting woman rocks slowly in her chair and speaks in a low monotone from beginning to end. She is as immobile and expectant as the players of Samuel Beckett's *Waiting for Godot*. She presents herself—when all is said, done, seen, and

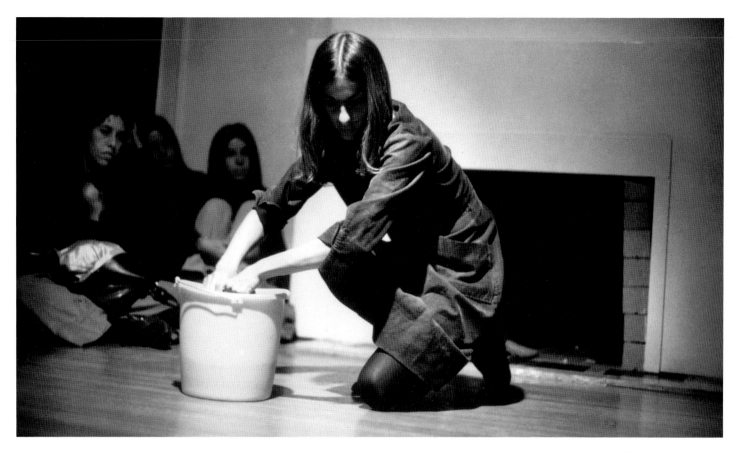

Feminist Art Program Performance Group. *Scrubbing.*
Performed by Chris Rush at Womanhouse, 1972. Photograph
by Lloyd Hamrol

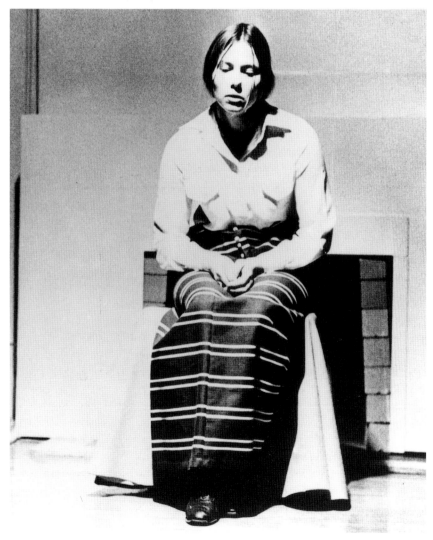

Faith Wilding. *Waiting.* 1971. First performed by Faith
Wilding at Womanhouse, Los Angeles, 1972. Photograph by
Lloyd Hamrol

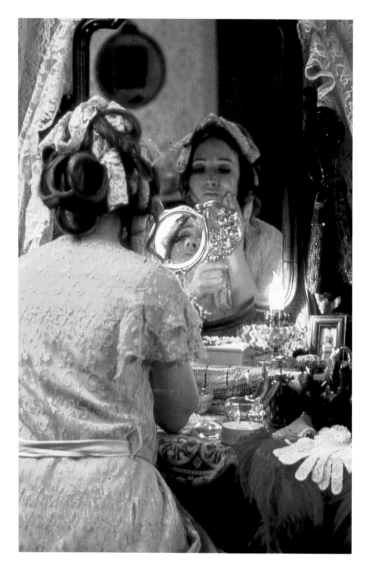

Karen LeCoq and Nancy Youdelman. *Leah's Room*, based on Colette's *Cherie*. Mixed media site installation at Womanhouse, 1972. In this performance, a woman continually applied layers of makeup, expressing, the artists said, "the pain of aging, of losing beauty, pain of competition with other women. We wanted to deal with the way women are intimidated by the culture to constantly maintain their beauty and the feeling of desperation and helplessness once this beauty is lost."

heard—as a sign of Nothingness, which is a keystone of modern art and a part of the existential gestalt of our time. But her existential emptiness is overcrowded with mundane incident. In the act of waiting in the empty space which she attempts to fill with the litany of all she has waited for in her life, Wilding is the American female vernacular of existential modern "man," a lone figure whom we know in the spare sculptures of Alberto Giacometti or in the narrow space of the stripe of a Barnett Newman painting.

Beckett's singular figures waiting for God, an interpretation of human hope and futility based on Heidegger's philosophy and Sartre's fictional characters, somehow find courage and the

will to be in a world devoid of ultimate external meaning. But the housewife has not freely and fully committed herself to her own life, nor has she been invited by the structure of her existence to do so.

The housewife is a full-time solitary worker who has not, in her own mind, stood alone. Sitting and waiting, she still feels "stood up." And for the young women working on the Womanhouse project, even as they evoked her they bade her good-bye as an image of the women they would become. Their work had already led them into far different realms than the woefully stricken traditional female model they portrayed.

But what was the relationship between the woman addressed in Womanhouse and the young women students who created environments? Mostly in their late teens and early twenties, only a very few of the women had married. They had not experienced what they depicted in Womanhouse as wives and mothers, but rather as daughters.

Three Women, written by the Feminist Art Program Performance Group and performed by Nancy Youdelman, Shawnee Wollenman, and Jan Oxenberg, differed from most of the Womanhouse performances because it grew indirectly out of the experiences of those developing the piece. In their performance group, they asked themselves a hypothetical question: "What if our lives had taken a different turn?" In roleplaying sessions, they explored the psyche of three female stereotypes: a hippie, a prostitute (with a golden heart), and a mother (naive and still looking for a Mr. Right). Judy Chicago remembers:

> *One evening, in the performance workshop we* [Chicago, Kathy Huberland, Judy Huddleston, Sandy Orgel, Christine Rush, Nancy Youdelman, Faith Wilding, and Shawnee Wollenman], *all dressed up, making up our faces, putting on wigs and outlandish costumes. Immediately, the room was transformed into a brothel, as if the act of self-decoration was seen as it really is, a kind of prostitution of the self to gain male approval. We related to each other "through" our roles, and out of that evening grew a piece called* Three Women, *based on the autobiographies of three women in the group. Each of them had reached crossroads in their lives when they had to make decisions about being "women" in the sense that society demanded, or defying society and being themselves. They had all made healthy choices, but it was easy for them to imagine what would have happened to them if they had accepted society's commands.*[15]

In fact, these students—each someone's daughter—had determined to make original choices in their lives. They wanted to break out of all previously defined roles and live in the world as artists. They were influenced not only by the content of feminist thought current in 1971, but by experiences in their own families. Their child's and adolescent's points of view formed the strong center of their oeuvre. Their visions, however, were still to some extent covert. Seldom did a real memory become a direct autobiographical subject, and in their communal work, the Feminist Art Program artists were less clear in articulating personal realities than they were in their individual efforts. Thus, in *Three Women*, the focus on fantasy, and the elaborate costuming

that concealed authentic individual identity in favor of cultural exaggeration, drew the text away from imagining the more probable futures of the players.

Since beginning to work together, the participants in Womanhouse shared in a new experience. They had interacted and created in an all-female community of artists, led by Schapiro and Chicago, female teachers who had become powerful role models. They were strong and resourceful—and still women!—synthesizing two qualities that had been nearly contradictions in terms. Relationships with their female peers and elders were given a name by feminist theorists: "woman-identification." These new relationships were expressed in only one performance at Womanhouse.

Birth Trilogy was a ritual of rebirth and new identity symbolizing the community of women who attend their own and one another's birth. "It was a three-part piece," Judy Chicago remarks:

In the first part, six women stood in a line, legs spread, bodies close together, arms around each other's waists. Slowly, they began to push down with their legs, making them into a birth passage, through which the last woman in line was pushed, propelled by the thrusting legs of the other women. After three "babies" had been born, the three women playing "babies" lay down on the floor while the three other women sat down back to back. Then, the "babies" slowly crawled to the "mother" figures, who embraced them, rocked them, comforted them, and nurtured them. The third part was called "Wailing." All six women knelt on the floor, heads together and arms around each other, forming a kind of dome shape with their bodies. One of the women began to hum, a slow, haunting melody. The other women joined in, and the humming became louder and louder, more and more rhythmic. The sound was like the danger cry made by Algerian and Tunisian women, and as it reached a higher and higher intensity, became the sound of orgasm, of labor, of joy, of ecstasy.[16]

The ritual diagram of *Birth Trilogy* was almost identical to ancient wiccan initiation ceremonies. The consciousness-raising circle among feminist art performers was historically significant not only as "speaking bitterness," a practice of modern Chinese culture, but also because it derived from an ancient Western tradition—dramatic ceremonies performed by witches' covens at sacred sites. In the wiccan initiation ceremony, coven members stand one behind the other with legs spread apart, forming a birth canal. The initiates line up to pass through the canal, but each is first challenged by a coven member who places a knife at her breast, saying, "It is better for you to rush upon my blade than to enter with fear in your heart." The initiate responds, "I enter the circle in perfect love and trust." In *Birth Trilogy*, the circle was recast before an audience, from the private to the public realm and from a secret ceremony to an art performance.

"On the first night that Womanhouse was open," Judy Chicago writes,

we performed only for women. The response was overwhelming. The actresses could hardly get through the lines of the

Cock and Cunt play (a comedy), the laughter and applause was so loud. During the Three Women *piece, women cried, laughed, and empathized, and the* Waiting *play caused a profound silence—everyone was deeply moved. After the performances, the acting group was ecstatic, and our ecstasy lasted until our next performance the following week, which was for a mixed audience. Through the evening, there was inappropriate silence, embarrassed laughter or muffled applause.*[17]

Womanhouse turned the house inside out, thereby making the private public. The anger that many women had felt in isolation in the single nuclear-family suburban American dwelling was flung out at the 10,000 people who came to see the environment and performances. The audience for Womanhouse became, after the fact, much larger than the sum of its eye witnesses. Johanna Demetrakas, who made a 40-minute color feature film about Womanhouse, provided those who were not at the site a dramatic view of the rooms and many of the performances, including the strong, spontaneous reactions of the audiences present. The hundreds of thousands of readers of *Time* magazine in 1972 got a sense of Womanhouse's startling effects in the magazine's lively report on the project.[18]

It would be impossible to overstate the impact of Womanhouse on its artists and audience. Those who did not see the installations or witness the performances (including this author) experienced Womanhouse through its visual and verbal documentation, and through its kinship with the work of female artists working in the early 1970s.

Looking back on Womanhouse more than two decades later, we can see this extraordinary student project as more than a mirror of the tone and concerns of the women's movement of that time. Womanhouse held the raw, explicit expression of an incipient feminist sensibility that has, to this day, provided a source and reference for a tradition of innovative and socially concerned contemporary art made by women.

The heritage and legacy of Womanhouse is a work-in-progress of its own. As the lives and works of female artists of the past are retrieved and incorporated into the canons of feminist art and so-called high art, the installations and performances produced for Womanhouse will be seen to rest on a broader, much richer base. And as Womanhouse is written into current history and criticism, its influence will be more fully acknowledged.

The kinship web among woman-made art over time embraces Louise Bourgeois, for instance, whose series of works in the mid-1940s called *Femme-Maison* (Woman House) merged the female form and the house form (page 20), to Miriam Schapiro, who extended the subject of home and the personal experience of community in Womanhouse when she created a group of paintings in the 1980s using collage elements and shaped canvases. A vintage embroidery that says "Welcome to Our House" is glued to the center of Schapiro's monumental canvas, *Wonderland* (page 84). Schapiro, always respectful of the so-called traditional female arts of sewing, quilt making, and embroidery, symbolically linked her contemporary collage-paintings with the handiwork of other women by incorporating the design, color, or even, as in *Wonderland*, the piecework itself, in her art.

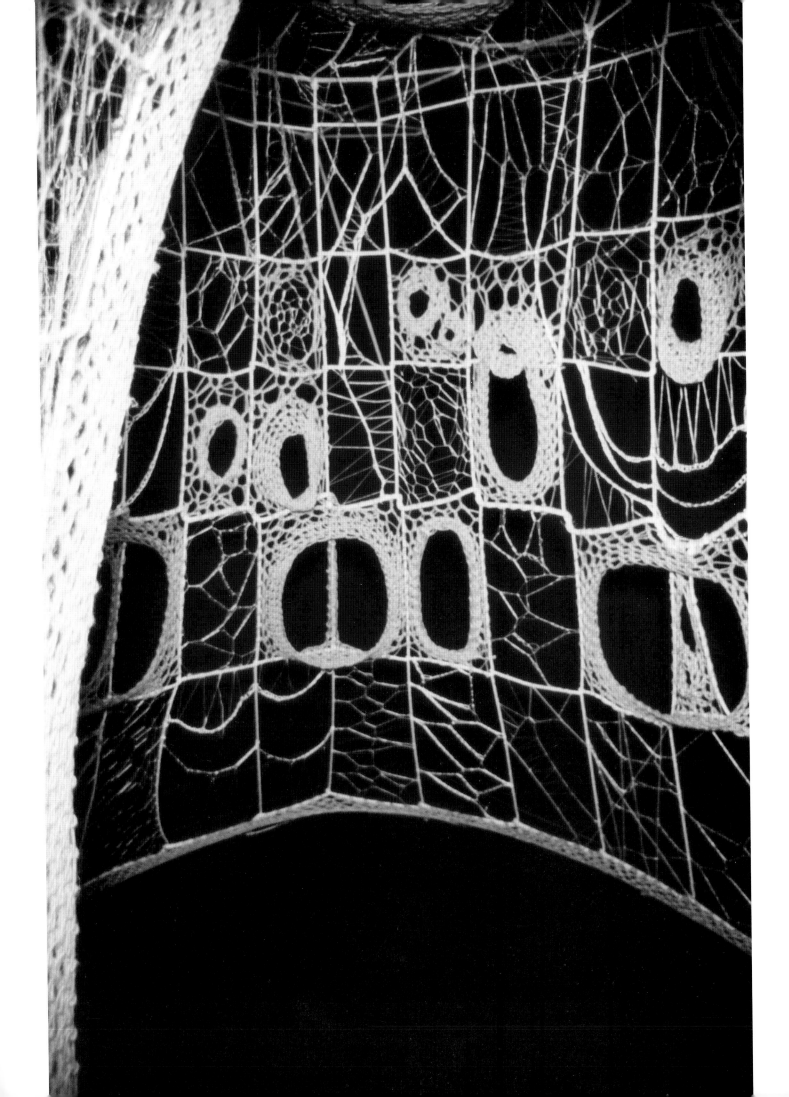

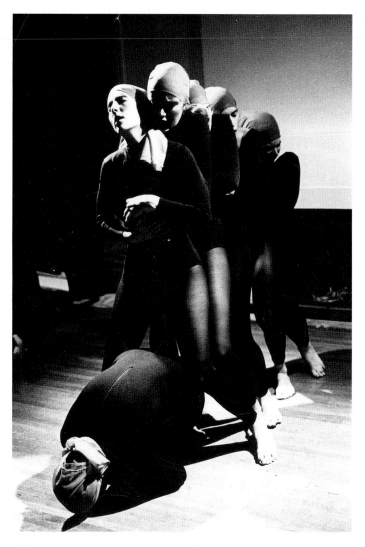

Birth Trilogy, a group performance conceived and written by the Feminist Art Program Performance Group, and presented at Womanhouse, 1972. Photograph by Lloyd Hamrol

Faith Wilding. *Crocheted Environment*. Mixed media site installation at Womanhouse, 1972. According to Wilding, this environment was a contemporary response to the round-shaped shelters built by female ancestors for themselves and families.

Sheila de Bretteville, director of the Women's Design Program at CalArts and, in 1973, a cofounder with Chicago and this author of the Los Angeles Woman's Building, made the 1972 catalogue for Womanhouse in the simple shape of a house. Schapiro's *The House That Miriam Built*, 1982 (part of my exhibition "At Home" held at the Long Beach Museum of Art in 1983—two months of installations, performances, artists' books, poetry readings, and videotapes celebrating feminist art in Southern California), was also shaped like a schematic house. Schapiro recalled:

> *Inspired by the theme of this ["At Home"] show, I have made several new paintings whose materiality is literally the fabric of the home. Augmenting my paintings is an installation worked on by a number of California artists close to me (friends, ex-students, mentors). Their contribution is a way of enlarging the scope of my room, making it symbolic of the larger framework of feminist connections.* [19]

Poet Adrienne Rich warned that "Whatever is unnamed, undepicted in images, whatever is omitted from biography, censored in collections of letters, whatever is misnamed as something else, made difficult-to-come-by, whatever is buried in the memory by the collapse of meaning under an inadequate or lying language—this will become, not merely unspoken, but unspeakable." [20] Although the bedroom was represented in five incarnations in Womanhouse it was never actually occupied. The bedroom of sex and intimate secrets is probably the most tightly closed closet of all, yet has also been a persistent model for formulating feminist and humanistic artistic statements specifically from the female point of view about sex, sexuality, marriage, domesticity, and violence. Lesbians in the Feminist Art Program did not find rooms of their own in which to express their sexuality, much less their sexual practice. But a decade after Womanhouse, Nancy Fried, a participant in the community of the Woman's Building, created the lesbian bedroom—a double taboo—as the subject of her art. Made on plaques of bread dough, Fried's work depicts homey scenes of lesbian life, including sexual relationships, which serve to break the conspiracy of silence and calm the hysteria about lesbianism and lesbians, common to the Womanhouse project and subsequent educational feminist art programs.

The fertile shoes of the Womanhouse *Shoe Closet* are but one of literally hundreds of objects and images that found their way into women's art after Womanhouse. Artists such as Cheri Gaulke, Eleanor Antin, Anna Homler, Nancy Kay Turner, and Carole Caroompas are but a few of the feminist artists who were inspired by Womanhouse's shoe closet environment. Cheri Gaulke, who arrived in Los Angeles a few years after the Womanhouse project and had gone to study at the Feminist Studio Workshop, where she made this project a major part of her education, used shoes as a major metaphor in her work. Her shoe stories include *Golden Lotus*, 1977, a tiny artist-made book of printed images glued to gauze and wrapped in a rectangle on a wooden platform. *Golden Lotus* makes a connection between two kinds of distortion—Chinese footbinding and the bonsai tree, culture-directed nature cut back and twisted for

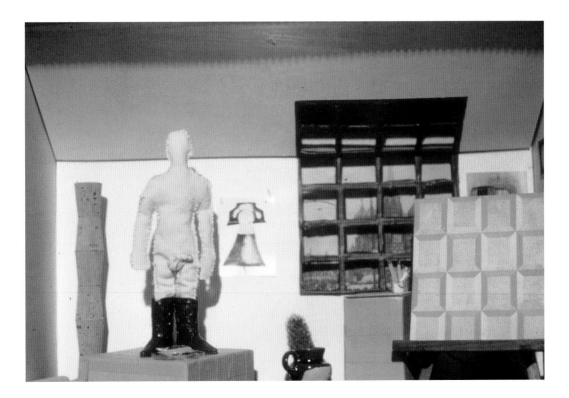

Sherry Brody and Miriam Schapiro. "Artist's Studio," from *The Dollhouse*. Three-dimensional construction and mixed media for Womanhouse, 1972. Collection Miriam Schapiro

Opposite:
Sherry Brody and Miriam Schapiro. *The Dollhouse*. Three-dimensional construction and mixed media, 48 × 41 × 8". Created for Womanhouse, 1972. Collection Miriam Schapiro. The *Dollhouse* juxtaposes the beauty, charm, and relative safety of the traditional home with the unspeakable terrors that actually exist there.

"beauty." Eleanor Antin's one hundred black boots "stood in" for the artist in 1971 as they became a character in a hybrid performance work of hers. Anna Homler's *Birthing Shoe* is an actual woman's high-heeled shoe containing numerous tiny plastic babies. Homler made a womb house of the shoe, with the proverbial old woman in the shoe or the modern working girl her implied but absent subject. Nancy Kay Turner's *Rubbing Her The Wrong Way*, a handmade one-of-a-kind artist's book, uses pictures of spike-heeled shoes culled from Japanese comic books, newspapers, magazines, 1930s-60s "how to" self-help books, and dream fragments, to retrace her steps and thus reflect on herself as an artist and woman. Los Angeles artist Carole Caroompas "shoe-walks" through time in a work titled *Remembrance of Things Past*.

From Womanhouse's repetitive washing and ironing, Mierle Laderman Ukeles took scrubbing into the Wadsworth Atheneum in Hartford, Connecticut, in July 1973, when she performed *Washing, Tracks, Maintenance: Maintenance Art Activity III*. Ukeles would wash several areas of the museum where visitors were sure to walk. She would then wait for spectators to soil the floor with their shoes. Then she would rewash the space, doing so in this fashion until the museum closed. The rags that she used were piled on the site, and the area was stamped with a Maintenance Art stamp as an artistic self-documentation.

Ukeles's *Maintenance*, broadly interpreted and applied to municipal, national, and global sites and issues, became the central concern of her art from that time.

In 1993, as I write this essay about Womanhouse, Rhonda Roland Shearer has placed eight colored nine-foot bronze statues of women vacuuming, caring for children, and cleaning the toilet at the foot of an imposing equestrian statue of George Washington in New York City's Union Square Park. "I want George to get off his high horse," Shearer told me, echoing the sentiments of the Womanhouse performer SHE, "and help with the dishes."

"If men had babies, there would be thousands of images of the crowning," Judy Chicago insisted on the logo of her *The Birth Project*. The Womanhouse dining room and kitchen had been expressed and expanded in a 1979 multimedia installation, *The Dinner Party*. *The Birth Project*, which merged fine arts and the traditionally female craft of needlework, was inspired most by *The Birth Trilogy* and and executed in the early 1980s by women in their homes across the United States.

The outermost historical and conceptual perimeters of the great and complex tapestry of women's art, thought, and heart that draw from the threads first spun by Womanhouse are still spinning off. And the axial lineage of Womanhouse, back and forward in time, is not yet whole cloth.

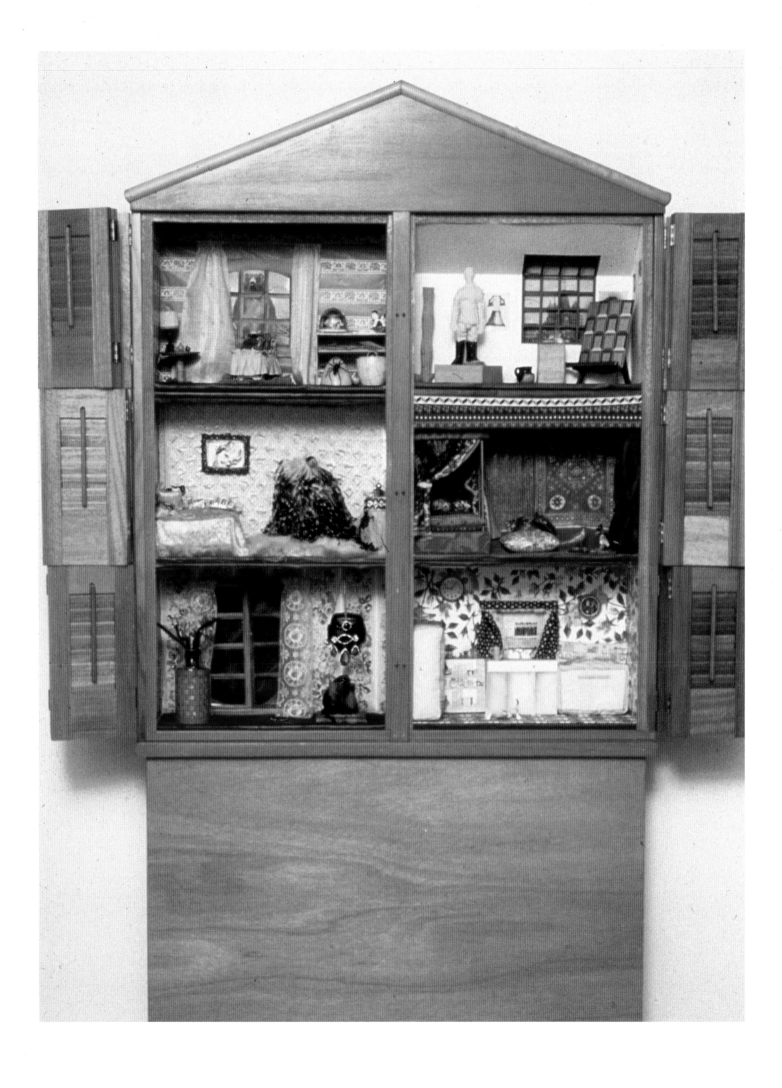

CONVERSATIONS WITH JUDY CHICAGO AND MIRIAM SCHAPIRO

BY NORMA BROUDE AND MARY D. GARRARD

Judy Chicago and Miriam Schapiro, 1971

Judy Chicago and Miriam Schapiro were the first people to theorize and develop a form of education in the visual arts based on feminism. Since their work together in the Feminist Art Program at CalArts and at Womanhouse, they have each written and given many interviews in which aspects of that experience are described [see Bibliography].

We have asked them, now at a remove of more than two decades, to reflect in a more pointed way on their pioneering feminist work of the early 1970s, and to relate those early experiences to the present and the future. Although they have different perceptions and memories of those days and each has gone her own way in the intervening decades, the following conversations, recorded separately with each artist in the spring of 1993, reveal that Schapiro and Chicago have continued to share the feminist values that motivated their groundbreaking venture.

CONVERSATION WITH JUDY CHICAGO

Broude and Garrard: *Judy, how did you come to start the Fresno Feminist Art Program?*

Chicago: I went to Fresno in 1969. In 1968, I had begun reading the first information that was coming out of the New York radical feminists and I couldn't believe it. I had felt so completely isolated and alienated for years. During the sixties, when I would try and discuss the fact that I was encountering discrimination in the art world, people would say to me, "What, are you a suffragette?" When I read that material, I thought "Oh, my God! I can actually start to tell the truth about what I have been going through and be believed because other women are experiencing this too." I began doing lectures and then I got a teaching job at Fresno State University [an environmental sculpture course, spring 1970]. I said to the chairman: "I'm very concerned about the fact that so many young women go into the college art system and so few come out the other end into professional life. I would like to address this." He was an open guy, and he said, "OK, you can do anything you want here." So I went to Fresno to set up a woman's program.

I put out a call to women students and out of the group that applied, I selected fifteen. I took them off campus into a space of our own where, in addition to making art, we began to do work on women's art history. There wasn't any information, there weren't any slides, there wasn't anything. We were copying slides from books, making our own slide archives. I felt that it was important to establish an historical context for the art the students were making, art with female subject matter, i.e., feminist art, a term I used then. Sometime around the middle of that year [academic year 1970–71], I think, I met Mimi [Miriam Schapiro]. I invited her to come up and speak at Fresno, and to see the program.

NB/MG: *What made you think that Mimi would be sympathetic?*

JC: Well, I knew who she was—a woman artist who had achieved. I had seen some of her work, and I recognized an affinity between her Ox paintings and Egg paintings and my

Pasadena Lifesavers. She came up and we talked, and I brought her to the studio and showed her what I was doing with the women, and what their work was like, and what we were doing with art history. Faith Wilding, a weaver who was just beginning to paint, was my teaching assistant. I almost didn't even let Suzanne Lacy into the class. When I interviewed her, she was a psychology student, twenty-five years old, and she had never made art. She said, "I want to be creative." I replied, "Forget it!" It just goes to show that you never know who is going to turn out to have real talent . . .

At the end of the year, Mimi and Paul Brach invited me to bring my program to CalArts. Because the Valencia building wasn't finished yet, we met away from the school. I now know how important it is for women to have their own spaces away from the patriarchal paradigm. And that's how Womanhouse happened. Paula Harper, the art historian who was working with us, suggested that we deal with women's feelings about the home, which was, of course, a way of dealing with issues of female roles. Womanhouse grew directly from the consciousness-raising methods I had developed earlier, and that Mimi and I then used.

NB/MG: *The teaching methods and applications of consciousness-raising you devised for the Fresno program seem to have been unprecedented, innovative, and powerful. How did you arrive at them? Where did they come from?*

JC: They came from within myself. I had read many of the texts of the early women's movement, but I had never been in a consciousness-raising group myself. I "came to consciousness" in my studio and through my struggle for empowerment which had been going on for ten years. I wondered whether the process I had gone through could have relevance for my students. I used my own experiences to fashion the program, which worked better than I could have ever imagined.

My concept of the teacher is as a facilitator of growth. This is particularly essential when working with students whose self-image is impaired. To commit yourself to female empowerment is to face the extent to which women's self-esteem has been damaged by patriarchal culture. I think it's inappropriate for women teachers who care about women to concentrate primarily on the transmission of traditionally agreed-upon information and neglect issues of self-esteem. Moreover, most of that information relates to men's history and achievements. Dealing with young women means doing remedial education, and, also, providing them with information about their history as women. It also means helping them repair their self-esteem along with developing skills.

NB/MG: *How did the students at Fresno respond to your giving them permission to make women's art?*

JC: I don't like to say women's art because feminist art education is about making art which is authentic to one's lived experience. The same process could be applied to anybody who wishes to make art that comes from the reality of their own concerns. Making women's art sounds like there is a style. That's not

the issue. It's about helping people find personal content, getting at that content, and then determining the most appropriate forms to express that content. That's how I teach now and that's how I taught then.

How did they react? Let me give you an example. There's a photograph of four young women from the Fresno program in the "cunt" cheerleader outfits that they made, entirely on their own. They would do "pussy" cheers and "cunt" cheers at the airport when we went there to pick up arriving visitors like Ti-Grace Atkinson. I was quite embarrassed. I was, after all, a middle-class girl, on the one hand trying to free them, and on the other trying to hold back from constraining them, because once I lifted the lid, there was an explosion, and it was almost beyond belief.

NB/MG: *Let's talk about CalArts and Womanhouse.*

JC: CalArts, for me, was not a success. Because I brought my program into a male-dominated institution, my young students were exposed to one set of values when they were working with me, but as soon as they left the room, they got a whole other set of messages. I realize now that I sabotaged my own program by bringing it into CalArts, and even though the school intended to be supportive, the program was dangerous because authenticity is dangerous in the art world. It was impossible for my young students to stand up to the pressure of the institution. While we worked on Womanhouse, everything was fine, because we weren't on the campus, but as soon as we got onto the campus, I was very unhappy and my students were unhappy. I submitted my resignation quite rapidly.

NB/MG: *What kind of reception did Womanhouse have in Los Angeles?*

JC: Well, first let's back up to my program at Fresno. At the end of that school year [spring 1971], I invited people from the art community of Los Angeles up to see the program. Several hundred people came. We did performances and had a show of the work. That was the first time the Los Angeles community had been exposed to feminist art. And then, when Womanhouse opened to the public the following January, nine thousand people came in one month to see it [January 30–February 28, 1972]. The impact was just enormous because it was the first time, really, that there was public art with openly expressed female subject matter.

I had laid the groundwork in Fresno, but still, this was on a much bigger scale, in part because of Mimi's and my collaboration. The performances were extremely powerful. Womanhouse opened up whole new areas of subject matter and technique, as well as performance work. That is what's so upsetting about the effort to write out all of this history. In early feminist art, there were many issues—personal content, personal subject matter, the body—that have since moved into the mainstream, but whose origins have not been credited.

NB/MG: *Tell us how you developed what has come to be called your "central-core imagery."*

Judy Chicago. *Rearrangeable Game Board.* 1967. Sandblasted
aluminum, 18×18″. Collection of Elyse and Stanley Grinstein,
Los Angeles

Judy Chicago. *Pasadena Lifesavers, Yellow No. 4.* 1969–70.
Sprayed acrylic on Plexiglas (series of fifteen), 59 × 59″.
Whereabouts unknown. Courtesy of artist

Judy Chicago. *Peeling Back* (The Rejection Quintet). 1974. Prismacolor pencil on rag, 30 × 24". San Francisco Museum of Modern Art

JC: In my early work, I had naturally created forms with a center, but then I learned to disguise my content. During the sixties, it was simply impossible in the L.A. art scene to make art that revealed your gender and still be taken seriously. The formal language of art had become its subject matter, and personal content had to be submerged or coded in a visual language intended had a small audience.

I was determined to be part of the art world and so I developed methods of hiding or coding my subject matter in the forms of contemporary art. This was not altogether negative because I learned a great deal about the formal language of art, which has stood me in very great stead as I have taken on subjects that are outside the realm of historical iconography. One needs visual tools, and needs to understand the language of contemporary art in order to violate it if you want to, or to expand it, or extend it, or challenge it.

Much of my struggle as an artist in the seventies grew out of my effort to put together the sophisticated formal language of contemporary art with the rather raw and unexpressed subject matter I wanted to begin to deal with. I was still locked into a formal structure, as in *Pasadena Lifesavers.* I had internalized the idea that, if I let go to my real forms, they would be considered ugly. The message I had gotten loud and clear in graduate school and in the art world was that my natural forms—which of course expressed my natural content—were repugnant. And so I became frightened by my own forms. I remember that when I started working on the first plate images for *The Dinner Party,* I felt terrified by the images that were coming out. I went

to Anais [Nin], who was my mentor, and I said, "Anais, I feel like something terrible is happening inside me," and she explained to me that I was beginning to allow my power as an artist to express itself but that I had internalized the idea that this power, for women, was negative. This is really the place where many women artists have been stopped. It's not about talent, it's about the degree to which we can fully realize our creative power, because it's tied to self-power, and we've been taught that female power is destructive.

NB/MG: *How did you overcome that conditioning?*

JC: It wasn't really until I had the support of the community I built in the *Dinner Party* studio that I broke through this. I would make a drawing that, had I been by myself, I would have censored. But everybody said, "Oh, my God, that's fabulous!" It was my natural drawing and so I began to accept my natural impulses which had been in all my early work. I had distanced myself from them and been locked up, unable to reach them. And, of course, the Fresno program helped me as much as it helped my students. Finally, Lucy Lippard asked me why my images were still locked in such a formal structure. And that's when I did the drawing from the *Rejection Quintet,* where I peeled back the formal structure I'd been using to cover my real content.

Lucy and I knew each other from the early sixties. We used to have these meetings all over the country, through the early years of the women's movement; we would strategize and make plans. We had many disagreements, but that's part of the strength of our relationship. At a certain point, she felt comfortable enough to directly challenge me about the gap between my form and my content. This is something women don't do enough for each other. We somehow feel we're supposed to always be supportive and nurturing. We're frequently dishonest with each other and don't give real feedback, and therefore, we don't grow. Lucy gave me important feedback, and it was a very important step for me. I peeled back my coded imagery and finally broke through to the beginning of new imagery and the reappearance of the butterfly, which had appeared in my early work. This became pivotal in the imagery of *The Dinner Party.*

By the way, coding is not unique to women. Many African-American artists also created coded art to disguise subject matter that was not considered important subject matter in art. For a long time, if you revealed yourself in your art as a person of color, a woman, or a homosexual, it disqualified you from the art dialogue.

NB/MG: *Is that as true about postmodern art as it was about modern art? Postmodernism supposedly calls for language that will allow each individual to speak for his or her individuality.*

JC: But there is still a visual code that separates art from the larger community. The artist's submission to this code allows art to be bought and sold like pork bellies in the market and manipulated as commodities. The whole notion of feminist art, as I was trying to articulate it, is that the form-code of contemporary art has to be broken in order to broaden the audience base and

in order to reconnect art to the fabric of the human community. What I have been after from the beginning is a redefinition of the role of the artist, a reexamination of the relation of art and community, and a broadening of the definitions of who controls art and, in fact, an enlarged dialogue about art, with new and more diverse participants.

NB/MG: *A lot of people would say that's not the opposite of postmodernism.*

JC: But what has happened with postmodernism is that there was a theoretical broadening and then a renarrowing.

NB/MG: *Yes, because that theoretical broadening actually prevented women from drawing on the strengths of their own history, now labeled* essentialist. *What do you think about the postmodern bugaboo of essentialism?*

JC: The thing about essentialism is that it's being used by women to attack women. It's also being used by women to attack and discredit their foremothers, which is horrendous, actually. When the *Birth Project* first entered the public sphere, I read an early review that said in a headline, "Judy Chicago's art degrades women." Why does Judy Chicago's art degrade women? Well, because I presented women on their backs giving birth. This is really fascinating—it's not the history of ob-gyn that has done this, it is moi with my paintbrush.

Talk about missing the point. The point of the vaginal reference in *The Dinner Party* was to say that these women are not known because they have vaginas; that is all they had in common, actually. They were from different periods, classes, ethnicities, geographies, experiences, but what kept them within the same confined historical space was the fact that they had vaginas. Now, how does this get turned into, "Judy Chicago reduced women to vaginas?"

NB/MG: *So, what you were really doing was turning around what vaginal imagery can mean?*

JC: Of course. It took me years to be able to create an active vaginal form. There's almost no iconographic tradition for this, nothing comparable to the flying phallus from Greek art. To envision oneself as passive at one's core is very different from envisioning oneself as active. Power begins with claiming your own sexuality, your own womanhood.

NB/MG: *That is precisely what distinguishes you from the people, many of them women, who are skeptical of essentialism because they accept the Lacanian mystification of the phallus, and the privileging of the phallus but not the vagina as a positive cultural sign.*

JC: Absolutely. We women participate in our own ongoing repression. We buy the package, nobody makes us do it. This is about psychological imprisonment. No one holds a gun to our heads, we can now go to college, we can now make our own money. But what this ridiculous dialogue reveals is women's lack of courage to challenge phallic theory. Why should phallic forms

be any more potentially universal than vaginal ones? It's about power, not reason—the power to enforce the male perspective, which some women have subscribed to.

NB/MG: *The insidious thing is that postmodernism has even deconstructed courage. Along with all the other things that used to get men into positions of power, courage is no longer a virtue.*

JC: Isn't that interesting? As soon as women lay claim to the terrain, they are aided and rewarded for pulling the terrain out from under themselves.

NB/MG: *Changing the subject, what do you think about traditional distinctions between art and craft? Do you think they should be fused as categories?*

JC: No, I'm not sure that they should be. I think intent is the issue here. And issues of quality. I do not think that all weaving is art. And some painting isn't art. I think that the categories are all right as descriptive categories, but we're talking about categories that contain within them inherent evaluations.

NB/MG: *How do we decide what's quality?*

JC: That's the question, isn't it? Who gets to decide, and what standards do we use? I would say the person who has done the most work in this area is Lucy. In her book *Mixed Blessings* she is the first person to try and come up with another standard of how you measure quality, how you can look across diversity, and arrive at new standards of quality. I would say the issue of quality needs to be connected to the question of authenticity. For example, how can a white man functioning within a Euro-American curatorial and art-historical structure evaluate the authenticity of a black woman's painting? And, because his standard of measurement does not apply, it throws him off balance, and he falls back on, "It's not quality." Whereas, in actual fact, his standard of measurement may be inappropriate.

NB/MG: *However, the rule of authenticity would only work if everybody's experience is given equal validity. Yet how can standards of quality emerge when what is art for person X is not necessarily art for person Y?*

JC: Of course, one would have to accept the diversity of all human experience as potentially valid. But we have all been raised to believe, implicitly or explicitly, that some human experiences are more important than others. Challenging that assumption is at the root of feminism. I believe that standards can and do emerge from dialogue, but the dialogue has to be much bigger than it is now.

NB/MG: *But the larger the dialogue, the more fragmented we get.*

JC: Well, maybe we have to. But the solution to fragmentation is not to reestablish a narrow set of standards. It's to allow people to define and represent themselves in the way they feel is true and express that in the art they want to make. Then, hope-

Judy Chicago. *The Great Ladies Transforming Themselves into Butterflies.* 1973. Acrylic and ink on canvas, 40 × 40". Collection Deborah Marrow and Mike McQuire, Santa Monica, California.

fully, through that process, we will come to realize that there is some common human experience around which we can organize and reach consensus. I'm afraid there is no alternative to that, uncomfortable as it might be.

We cast the dialogue incorrectly in the seventies. We cast it around gender, and we were also simplistic about the nature of identity. Identity is multiple. That's why, when I started looking at Jewish experience, people would say, "Oh, you've stopped being a feminist?" It's because they had a very narrow concept of identity, which we women helped to create. But I've learned a lot in these years, that one is both a woman and a person of color; an American and of African descent, as well as a person of a particular class. One's identity is larger than singular. So, if we can't cohere around identity, perhaps we can cohere around shared values.

NB/MG: *Yet for many feminists, it's patriarchal oppression that's at the root of the problem for all these multiple identities.*

JC: Patriarchal oppression is not connected entirely to gender. It is basically connected to a system of values that a few may benefit from, many men subscribe to, and some women buy into. But there are some men who do not buy into patriarchal values, and by casting the dialogue entirely around gender and not values we set the stage to alienate men who could have been our friends, and prepared the way for women who are our enemies to get into positions of power. We had no idea this was going to happen. But that is why I am very, very careful today. I try to make clear that feminism, even though it starts with f-e-m, does not mean female only. Feminism is a set of principles, and a way of looking at the world that, for me, is rooted in a redefinition of power—from power over others to empowerment. There are women as well as men who are addicted to gaining power over others. And then there are some men who are uncomfortable with traditional gender roles and the prevailing definitions of power, who have never been offered new options that would allow them to be bigger human beings. The spirit of my work grows out of a redefinition of power. That's why people have come to work with me, to become empowered. But, that has gotten filtered through the perception that to have power necessarily means to have power over others. People think that I operate out of this structure of power and dominance, whereas nothing could be further from the truth.

NB/MG: *Are you referring to criticisms that have been made of your methods of collaboration?*

JC: A lot of people today are working exactly the way we worked in the *Dinner Party* studio. There was a fascinating article in *Art in America,* a story on artists' assistants, about, among others, Vito Acconci and how he works collaboratively. It seems that Vito Acconci works totally in collaboration with two other people, but when he goes to the opening, his collaborators sit in the audience and he sits with the dealers and curators.

So what do they do? They say I, who put everybody's picture up who worked on the *Dinner Party,* I who include everybody who worked with me in the *Birth Project,* I exploit women.

Talk about turning reality on its head. I who have always championed everybody I've worked with—they come with me, they stand with me, their names are on the wall, they're credited in the book—yet I called am an exploiter, while all these other people sit on the dais with the curators, while their collaborators, who aren't even named, sit in the audience. And that's acceptable.

In my collaborative projects, people worked within the framework of my images. But the framework was large enough for them to be able to bring in their own ideas and identities. For example, Audrey Cowan, the woman I've woven with since *The Dinner Party*, says the traditional role of the weaver in an artist-weaver relationship has been that of a robot. But with me, she is a participant in the translation of my cartoon into weaving.

NB/MG: *Has the weaver ever had a significant input into the development of one of your images, or has an image been transformed along the way because of a dialogue between you two?*

JC: No. Except in the following way: Audrey will look at my cartoon and say, "That won't work," or "I can't do that on the warp." Audrey depends on me for my pictorial capacity and I depend on her for her weaving capacity, that is our collaboration. And it's the same for needleworkers. Needlework, historically, is an interpretative art. Many needleworkers don't know how to draw. Most of them work from kits, which are degrading to women and their skills. So I gave them the opportunity to bring their skills into the service of imagery they cared about, like the subject of birth or women's history. But most of the needleworkers don't want to design the images, they want to stitch. And that has to be OK. Now, the other type of collaboration is OK, too—it's just not the way I work. If people don't want to work the way I work, fine. This is what I have to offer, it's just one way, it's not the only way.

NB/MG: *Judy, what do you see as the future of feminist art?*

JC: Our next task is to preserve the art we've created and to find a way to make clear what that art stands for. We must stop the cycle of repetition *The Dinner Party* describes, but this can only be achieved if we join together to create feminist institutions, that is, institutions based on a new set of values. Here I need to reiterate what I said before: the issue is not merely one of gender but of values. True feminist art embodies a value system based on the opportunity for empowerment for everyone, rather than the notion of striving for power over others, which is the patriarchal paradigm.

One of the things I've learned from my work on the *Holocaust Project* [1993] is the way that Jews have been able to translate memory into mortar. And this is what we women must do. We must translate our memory and our values into lasting monuments, lasting institutions. We're just at the beginning of doing this—of being able to imagine ourselves as the creators of institutions, the shapers of culture, the deciders of artistic values. We must make feminist values understandable, translate them into images, then preserve these for future generations.

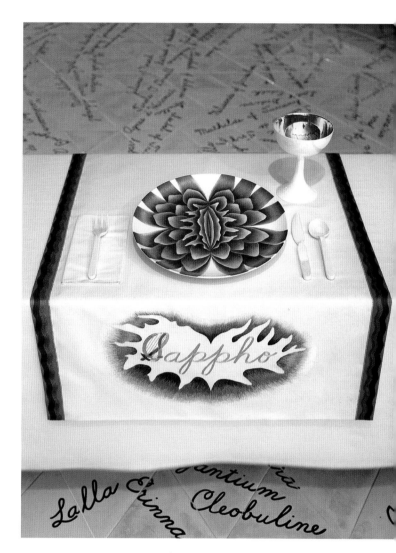

Judy Chicago. "Sappho" place setting from *The Dinner Party*. 1979. China paint on porcelain and multimedia; plate 14″ diameter. Collection the artist

CONVERSATION WITH MIRIAM SCHAPIRO

NB/MG: *Mimi, what was your first experience with women's traditional arts and how did they affect your development as an artist?*

SCHAPIRO: The knitting, sewing, tatting, and embroidery my grandmother worked at were the first traditional arts I saw. When I was young, my parents were part of a bohemian world that valued ethnic crafts. Later in my life it became clear that many of the crafts I grew up with were attributable to women, and ultimately my understanding of women's culture led me to a more comprehensive art of my own.

NB/MG: *How did you come to have a positive view of women?*

MS: All aesthetic and social ideas essential to me as a woman have come from my connections to other women.

Having been schooled in a man's world, the female education I received from my mother, her sister, and their mother lay dormant until 1965 when I read Simone de Beauvoir's *The Second Sex* and Doris Lessing's *The Golden Notebook.* Reading de Beauvoir was explosive. I discovered a new language, which finally showed me the social circumstances of my female condition. Later her ideas would release me from my hidden rage. Confronting anger was a very slow process for me since, at the age of forty-two, I was already normalized as a bourgeois woman and a professional painter.

In 1967, my husband, Paul Brach, our son, Peter, and I moved to California. It was then that the American rumblings of feminist social protest reached my undeveloped consciousness. In Los Angeles, June Wayne was having her Joan of Art groups, we had large meetings of women artists, we planned actions against the Los Angeles County Museum. I became convinced that we women could effect changes and become leaders of a cultural revolution in the 1970's and I was willing to commit my life to this.

NB/MG: *How did you meet Judy Chicago?*

MS: I was teaching at the University of [California at] San Diego in La Jolla. I invited her to give a talk about her Fresno program for women artists.

Her talk was stirring. Afterward Judy and I began to talk about our lives and our art. Idea after idea emerged from these sessions. Finally, at her invitation I went to Fresno to see what her group was doing. I remember that they had constructed a large wall in their studio, and had done all the carpentry themselves. They were *building* their studio, which gave them, as women, a completely new awareness of empowerment.

NB/MG: *Judy had seen your work. When did she see* Ox, *for example?*

MS: She saw my work when she came to U.C.S.D. to lecture. *Ox,* my first "cunt " painting, was made in 1968. We realized when I showed her this painting that we were both working with similar content. Her Pasadena Lifesaver series also imaged the hole in the center of an iconic form.

Later, when we began working together, we organized a national conference for women artists at California Institute of the Arts [1972]. That conference was one of the most exciting events of my life. The artists came from all over the United States. Judy and I anticipated surprises, but we had no idea what was in store for us. Their slides showed sculpture and painting collaged with twigs, cloth, clay, jewels, fibers, ribbon. So many of the works had a common center. Oh, my God, we were so excited! After the event, Judy and I wrote our theory of central core imagery.

NB/MG: *Was* Ox *an unconscious arrival at central core imagery, as opposed to your more conscious use of it later? What inspired that painting?*

MS: Yes, I believe it was unconscious for all of us. The painting is a very strong image with a seemingly neutral subject—the letter O superimposed on the letter X. The O was actually a hexagon with a pink labial interior, whose geometry masked its sexual meaning. In painting this image I behaved unconsciously, like all women artists mentored by men. The piece was so powerful to me that when it was finished I turned it to the wall for six months before I dared approach it again. After all I was well tutored in where the power lay. It was not supposed to be in a painting I would paint.

The meaning of the image is the meaning of a woman's being, a woman's body, no longer hidden but finding its way spontaneously into a morphological framework of art—something new in the twentieth century.

NB/MG: *You could encode meanings quite safely in the hard-edged structure because it could be looked at in another way by others who did not understand. Yet it was also blowing open the hard-edged form, because the hard-edged forms of male Minimalists didn't have glowing pink cores.*

MS: That's right.

NB/MG: *Tell us how you started the Feminist Art Program at CalArts.*

MS: Judy and I thought up the program and presented it to Paul Brach, dean of the art school. As my husband, he was enthusiastic about my becoming a feminist. He watched as I moved from being private to becoming a public person and understood that I was stretching myself. But his response to this proposal was simply: "Look, I don't want to be the deciding factor in bringing in this program, it's very radical. You have to take it before the department yourself. You have to convince them that this is a worthwhile experience for the art school."

At that time I was the only woman on the art school staff. Besides Paul, there was John Baldessari, Alan Hacklin, Allan Kaprow, John Mandel, and Stephan von Heune. The way I presented my case was to invite each one to dinner to discuss the program. You both remember the story of Adelaide Labille-

Guiard, who also wanted something from an institution? She wanted to be a member of the French Academy in the eighteenth century. It was said that the strong portraits with her signature were painted by her husband. To thwart this gossip, she invited each of the academicians to her studio and painted his portrait. Needless to say she prevailed.

After the dinners, we had a formal meeting of the faculty to decide whether they would accept the idea of having Judy and me teach a feminist art program, *separating* the women from the men in that coeducational institution and teaching them differently.

NB/MG: *And you prevailed?*

MS: Yes, they voted it in. My method in dealing with my colleagues was to take it slowly. It was a time when we women were finding our own voice, and the prospect of our incipient power was frightening to the men. They found it hard to see us in a new light. When Judy insisted on locking the door to the large studio where we worked, rumor flew about the school that we were in that room inciting revolution.

NB/MG: *What kind of experience was CalArts for the women who had come out of the Fresno experience with Judy?*

MS: The women expanded in the new school. It was a more sophisticated environment where they came in contact with many artists with different points of view. For example, the music department brought dancers and drummers from Africa to teach native dances. A daily sight was Oriental and Caucasian teachers and students doing Tai-Chi in our halls. Yet the Fresno students were unsteady in the face of those hip students they encountered at the most avant-garde art school in the country. The irony is that they were the true avant-gardists. They created Womanhouse, a historical phenomenon for students in an art school.

NB/MG: *What was it like for the students who worked on Womanhouse?*

MS: Womanhouse was fraught with exhilaration, tension, and fear all the time we worked on it. It was not placed on campus but in downtown Hollywood, on Mariposa Street. There were no men looking over our shoulders, no institutional authorities. Judy and I were the authorities. We had no model for making feminist art on this scale. Most of our women students were inexperienced in making art, period, and they were not always able or willing to work hard toward a goal. They were riotous feminists and they walked around CalArts wearing hiking boots

Miriam Schapiro. *Shrine: Homage to M. L.* 1963. Magna and graphite on canvas, 72 × 80″. Collection the artist

Miriam Schapiro. *Big OX No. 2.* 1968. Acrylic on canvas, 90 × 108″. Museum of Contemporary Art, San Diego. Gift of Harry Kahn

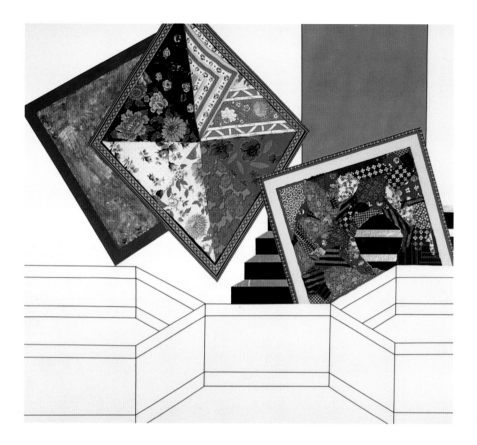

Miriam Schapiro. *Lady Gengi's Maze.* 1972. Acrylic and fabric collage on canvas, 72 × 80″. Collection the artist

Miriam Schapiro. *Explode.* 1972. Acrylic and fabric collage on canvas, 80 × 72″. Everson Museum of Art, Syracuse, N.Y.

Group photograph of some of the women who worked collaboratively on Womanhouse, 1971. Top row, left to right: Ann Mills, Mira Schor, Kathy Huberland, Christine Rush, Judy Chicago, Robbin Schiff, Miriam Schapiro, Sherry Brody. Bottom row, left to right: Faith Wilding, Robin Mitchell, Sandra Orgel, Judy Huddleston.

with blue jeans or long dresses. They cut off their hair, they let it grow. They were young and wanted to party or be alone; instead they had to come to work on the project every day after working at their waitress jobs, driving their battered cars over miles of freeway from CalArts in Valencia to Mariposa Street and back to their homes in Los Angeles.

Yet they were brilliant in thinking up solutions to problems and working out new ideas. They came to Womanhouse and did consciousness-raising in each room, defining each room from their experience. Judy and I pushed them to finish a huge job on time. We treated them always as though they could accomplish anything. Still, there was much fear in the group: tension between Judy and me, between the students and Judy, between the students and me.

NB/MG: *Was that fear a displacement of the fear you felt in confronting the larger world with what you were doing?*

MS: Definitely. By making Womanhouse we women took on power, metaphorically confronting the symbolic penis with the symbolic vagina, creating a mandate for change.

On the other hand, there was a residual negativity about the house for the students as well. Dysfunctional family experiences, whether mild or extreme, do not go down without leaving everlasting pain. Yet with it all, they managed to make women's culture real—alive. They were only half realized women themselves and yet they made a truly original work of art.

As an aside let me say that it took them years longer than the men in their class at CalArts to receive recognition for their own personal art. Whereas David Salle, Eric Fischl, and Ross Bleckner received early attention in the New York art world, it took Mira Schor, Faith Wilding, and Karen LeCoq more than a decade to be noticed.

NB/MG: *What impact did Womanhouse have in Los Angeles at the time it opened?*

MS: Incredible! The students acted as docents, and people came all day long and at night for the performances. We were on television and radio, *Life* magazine, and the Encyclopedia Brittanica interviewed us. We were given an hour on public television with Gloria Steinem. But for me the stunning impact was on women artists throughout America and Europe. Stories came back to us about pirated Womanhouse slides that were being shown in Europe.

NB/MG: *How did you personally react to the images produced by students in the Feminist Art Program? How did they relate to your notions of quality in art?*

MS: As a formalist, I was used to the rigor of modernism, Hans Hofmann's "push and pull" theory of plastic painting. I incorporated these ideas in my work and still do when it suits me. I was shocked by some of the students' new images. Among them were sculptures made of soft material—huge bulbous female figures without regard to classical notions of form. Those self representations were really raw. I saw one artist draw a body by taking the graphite in her hands, and instead of holding it as you would hold a pencil, she grabbed it in her fist, drawing

black lines over black lines. Much of this art lacked the aesthetic harmony we were used to but it was *authentic*.

NB/MG: *But, Mimi, as someone steeped in modernism, you must have been conscious that that kind of breakthrough is part of modernism.*

MS: I was caught up *in* the maelstrom, unconscious of theory, trying to understand what was taking place, trying to internalize the epic proportions of feminist art and feminist teaching.

NB/MG: *Was the use of women's traditional arts a conscious strategy for women in the program?*

MS: Needlework arts were used by some artists in a spontaneous way, but there was no emphasis in our program on any specific aspect of female culture. The only rule we used was to let consciousness-raising spur our feelings so that we could make authentic art. For example, I would advise the women: "As you listen to your colleagues tell their stories, let a slide drop in your mind, so that you're actually imaging what they are saying. They are using language—you make a pictorial translation for yourself."

NB/MG: *Where did the students get the idea of going back and looking at older women's culture?*

MS: If you mean art history, that came with the Fresno group. At CalArts we continued exploring libraries for literature on the history of women in art but most of the time it was fruitless. In 1971, books on women artists weren't yet being published.

One day Nancy Youdelman found a catalogue of the Woman's Building in the World's Columbian Exposition in Chicago in 1893. As teachers, we were thrilled to see this book, and all the art and crafts by women listed in the catalogue, because it validated our emphasis on women's culture—our own rich heritage. Gradually, we found other books—in flea markets or antique shops—about women in ceramics, architecture, music. Each time we made a discovery, we had endless discussions on the subject of *us* and where we came from.

NB/MG: *How did the Womanhouse experience affect your own artistic development?*

MS: We learned from our students. In particular, I was influenced by Sherry Brody, who was a graduate assistant in the program. She was one of the women Judy and I met when we traveled all over California in 1971 to have consciousness-raising sessions with women and see their slides.

When we went to Sherry's studio I saw a sculptural piece called *Lady in Pink and Mr. Tux.* It was a life-sized soft sculpture, made of sewn canvases painted and glazed, and it affected me deeply. Neither figure was built on an armature, so the bodies hung on hangers, limp and propped against a wall. They were portraits of a couple, totally dependent on their appearance for self definition, yet empty inside. This was feminist art, in content and form. Sherry loved to work with decoration and

Patsy Norvell. *Hair Quilt.* 1972–73. Hair with Magic tape and vinyl, 79 × 62". Collection the artist

clothing; this echoed in me and gave me permission to develop my ideas, which ultimately led to *The Anatomy of A Kimono.*

NB/MG: *How did you and Sherry collaborate on the* Dollhouse *room at Womanhouse?*

MS: Sherry made the *Pregnant Woman,* a sort of bas-relief in fabric whose stomach kept drooping; we laughed as we bolstered it up.

The *Dollhouse* was my idea—I wanted many things from it. I wanted the paradox of being adult and playing house within Womanhouse—a box within a box, a child within the woman. Yet the decisions were sophisticated. I made a Duchampian parlor, where I had his *Fresh Widow*—I satirized it, I feminized it. I had a snake in the parlor, and in the nursery the baby was in an alabaster egg and a monster was in the crib, while a large bear menaced at the window.

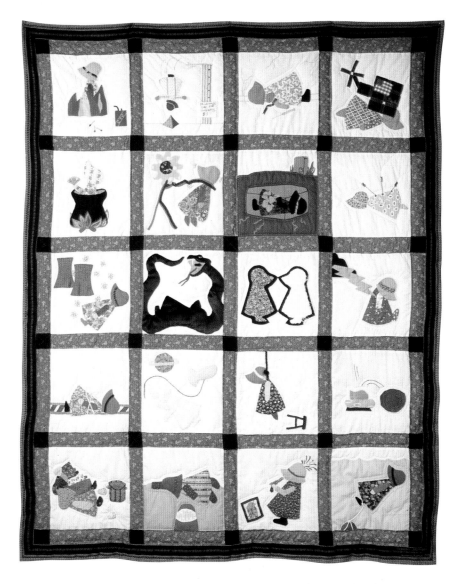

Members of Seamsters Local No. 500, Lawrence, Kansas. *The Sun Sets on Sunbonnet Sue.* 1982. Quilt, Size unknown. Courtesy Miriam Schapiro

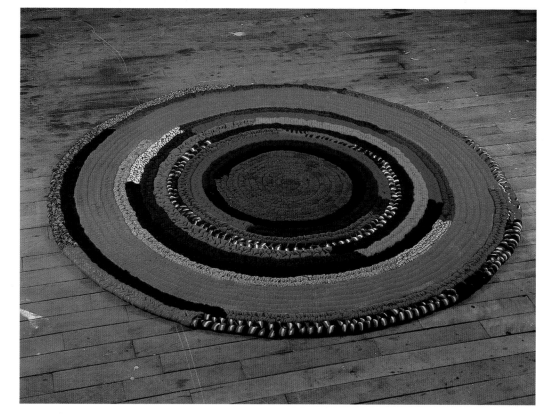

Opposite:
Mimi Smith. *Steel Wool Peignoir.* 1966. Steel wool, nylon, and lace, 59 × 29 × 8″. Collection the artist

Harmony Hammond. *Floor Piece VI (Sculpture).* 1973. Cloth and acrylic paint, diameter approx. 5′. Collection the artist

NB/MG: *Why?*

MS: Babies and children are often fearful, and I wanted to re-create that fear, but also have it appear as antipatriarchal satire. For example, in the artist's studio, outside the window is the Cathedral of St. Basil on Red Square, Moscow, built by Ivan the Terrible. I wanted ours to represent another revolution. And in the kitchen, thirteen men from an etching by Magritte stare through the window.

NB/MG: *So, the* Dollhouse *represented the domestic world of women and the contradiction embedded there, that it's supposed to be the private sphere where women withdraw for safety, but there's no place where you're safe. Is it physical safety or one's identity that's at stake?*

MS: Well, it's everything, really. They talk about date rape now, or a husband raping his wife. Sexuality has been deromanti-cized to a great extent since the women deconstructed romance. One of my favorite early works was by Mimi Smith, which shows the peignoir as a soft sculpture. At first sight it looks very ele-gant, made of sheer materials, and lined with what seems to be a very lovely gray fabric. But it's actually Brillo.

She's saying here that the peignoir, which is usually consid-ered part of boudoir intimacy, is now suddenly a protective garment, an armor for the bedroom. This is a form of de-construction, even though the piece was done in 1966. I have always claimed that feminists were the early deconstructionists.

Another early act of deconstruction in art was Harmony Hammond's floor piece, which she called sculpture. She made an exact simulation of a hooked rug; she glued it, painted it, and called it a floor piece. And she had the effrontery to submit it to a sculpture show. This was unheard of. It raised fundamen-tal questions about what could and couldn't be sculpture.

NB/MG: *Do you think women are different from men?*

MS: Could we say, are men different from women?

NB/MG: *Yes, it could have been the other way around.*

MS: But it never is. The way the question is framed, men are the norm. We are experienced in providing background music. We let our fathers dominate; Sylvia Plath's poem, "Daddy," tells us about this. And since we women are well schooled in the way men think, the task before us is to educate men to see the fe-male within themselves so they can finally identify with us too.

Women are conservators, we collect, we save, we curate our lives, keep our diaries, journals, scrapbooks, so that we can prove we lived. Quilts show us this. Our history of quilts is a rec-ord of friendship quilts and commemorative quilts; we've commemorated someone's twenty-first birthday, a woman's giving birth, a wedding, mourning quilts when someone dies. And now the Names Quilt, made by men as well as women. Here is our symbol of partnership.

NB/MG: *The quilt keeps coming up for you, and for feminist theorists such as Elaine Showalter, as a kind of central metaphor for the whole feminist enterprise.*

MS: Quilting, one of America's great arts, was almost entirely produced by women. Women have a great pride in that. The friendship quilts tell us how women valued their relationships; writers like Carol Gilligan have shown that women define their identities in the context of relationships. Even women who are not feminists make quilts today. Yet it's still a subversive activity in certain circles. When I exhibited at the National Gallery in Washington, that bastion of high art, many of the women staff members—secretaries, curators—sidled up to me and confided that they made quilts and did needlework. They wanted to tell me about it, but secretly.

NB/MG: *Do you see continuations of nineteenth-century women's traditions in quilts made in our own time?*

MS: I am thinking of several modern quilts that are interesting. Patsy Norvel in the early seventies sewed a gridded vinyl quilt with twenty pockets and filled them with cuttings of hair do-nated by her sisters in her consciousness-raising group. In Mary Beth Edelson's contemporary quilt, *Woman Rising*, the Goddess stands on an energized ground flanked by text naming all of Mary Beth's friends—women who are part of our community and who support her.

Then there is one of the funniest quilts of modern times. It's called *The Sun Sets on Sunbonnet Sue*. It was made in 1982 in Lawrence, Kansas, by a group of women who call themselves "The Seamster's Local #500." Sunbonnet Sue, a legend in the iconography of quiltmaking, is everything the contemporary lib-erated woman wants to escape, so this group kills her off square by square. She is boiled, hanged, demolished by a nuclear blast. She is drowned, murdered, electrocuted, and finally, she com-mits suicide.

NB/MG: *Women's traditional arts and the idea of community have continued to play an important part in your own work.*

MS: Yes. *Wonderland* is a painting I made after returning from Australia in 1983. While I was there I found needlework to incorporate into my femmage works: crocheted aprons, table linen detailing maps of Australia, a potholder with the words Elizabeth Rex. When I returned to New York I made a painting, assembling my fabrics around the central image of an apolo-getic housewife. This is an enormous painting, whose very small center shows a woman embroidered in cloth in a twenties kitchen. She makes a slight curtsy in our direction as if to say, "I'm sorry, excuse me for living." I felt that by making a large canvas magnificent in color, design, and proportion, filling it with fabrics and quilt blocks, I could raise a housewife's lowered consciousness.

The painting is me, torn in two. I present myself as the painter who can organize and master a huge canvas and then there's the other side of me which belongs to all the women who were not liberated—all my ancestors who were trapped in a world where they were punished for being women, where noth-

ing they did was good enough. That's what the painting is about.

NB/MG: *You gave the housewife space, but she doesn't use it. She's afraid to use it, but you are not afraid to give her that space.*

MS: I made the painting for her. Part of my essential philosophy is that I make all these works for women, my primary audience, some of whom are gone. My affiliation is to the past as well as to the present.

NB/MG: *Maybe you're doing it for them because they're giving you something back.*

MS: Absolutely.

NB/MG: *And that's collaboration.*
You've said that collaboration was a big factor at Womanhouse. How did the concept carry over for you, after the Feminist Art Program experience?

MS: I moved around the country teaching women artists how to empower themselves by emerging from isolation and joining with others to build working groups, reading and consciousness-raising groups and exhibition networks. Since 1971, I have kept up with many of these women and have an extensive collection of slides of their work. They are part of a great human collaboration of mine. Once when I was on the road in the early stages of lecturing—it was all so new to me, this business of being a public person—I couldn't think where I was, so I upfronted this to my audience and asked them to help me. I said, "If you send me a handkerchief and tell me what town it's from and add your name, I'll save it, I'll do something with it."

When I returned to my studio, all the handkerchiefs they had given me went into a quiltlike grid painting called *Connection.* I used the handkerchiefs from the nun, the teacher, the high school student—from all of them. It's one of my favorite paintings.

When it was exhibited at the Andre Emmerich Gallery in 1976, I wrote a text explaining the history of the work and put it on the bench in the gallery for the public to see. Emmerich looked at the text and said to me, "This has nothing to do with art."

NB/MG: *Many of your philosophical ideas would today be described as* essentialist. *What do you think about that?*

MS: *Essentialism* is a word that women who aspire to being "grown up" (identifying with their male professors and male role models) use to label feminist artists. Every ten years, feminism is redefined. I'm now used to being called a "first-generation feminist," but before I realized the powers this gave

me, it was disturbing. The women I call "grown up" are trying to show that they're very good at the dialectic process, good at abstract thinking. Women, of course, are not supposed to be able to do abstract thinking, nor higher mathematics or physics. So, obviously, they have to distinguish themselves as thinkers, as the culture part of nature/culture within feminism. Now, someone's got to be left over to be nature. Who's it going to be?

NB/MG: *First-generation feminists, of course.*
What do you think the long-range influence of feminism on modern art has been and will be?

MS: I think that postmodernism came into being in part as a result of the feminist art explosion. Clearly the pioneering sensibilities of feminist artists of the early seventies helped change the direction of art. We challenged modernism. We "told our story," and that process became the hallmark of multiculturalism. The Pattern and Decoration movement, made up of women and men, influenced artists in America and overseas. Our visual questioning of gender uniqueness led to the cutting edge of Mapplethorpe and Madonna. We tried to erase the harsh line between high art and craft, and now craft has found its way into ideational art and political art in a highly energized manner.

As seen by feminists, craft is the bridge into the newly democratized art of the future. As capitalism invades Europe, Asia, and Africa, technology will play the largest role in changing the look of art. Animation, computer graphics, etc., will move into areas never before called art. Music, film, and computers will fuse. But because painting itself is a craft, I foresee that it will always continue.

I often wonder about the young American women artists of today who until now have known nothing about their history, have not even seen our images. Yet for two decades they have repeated the images and icons we created in the seventies. Why am I seeing the art of my generation being created anew each decade? One answer may be that much of the early art never reached cultural visibility beyond a small audience. In the absence of representations, of icons, of memory, contemporary women artists are condemned endlessly to repeat the ills of survival in the patriarchy, reinventing images of the penis, the cunt, doll dresses, patent leather pumps, quilts, narratives of the struggle between woman and man, mother and daughter. Each generation opens the wounds, which close in the night behind them.

But if women commit themselves to the feminist education of men, if they strike out for social justice, if they continue to protect the environment, if they *name* and affirm their own creativity, if they refuse to see themselves as the second sex, if they sustain the progress toward gender equality, then it is a certainty that feminism will continue to affect art as well as life. Feminism is the philosophy that will facilitate the changes that are needed—in relationships between men and women, and in the struggle between the powerful and the powerless.

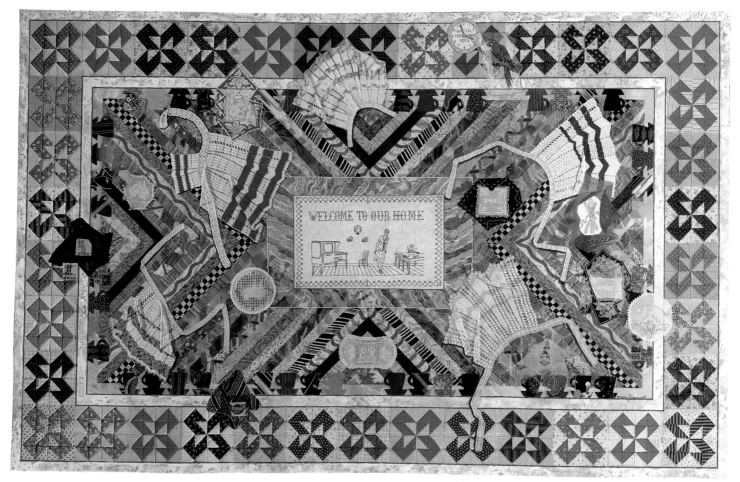

Miriam Schapiro. *Wonderland.* 1983. Acrylic and fabric
femmage, 90 × 144″. Collection the artist

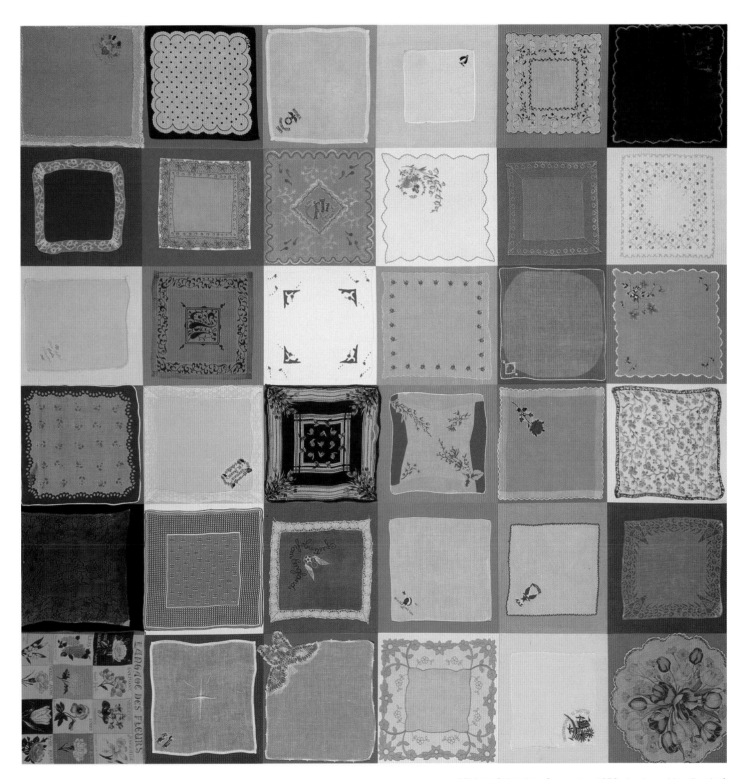

Miriam Schapiro. *Connection.* 1976. Acrylic and handkerchiefs,
72 × 72″. Collection the artist

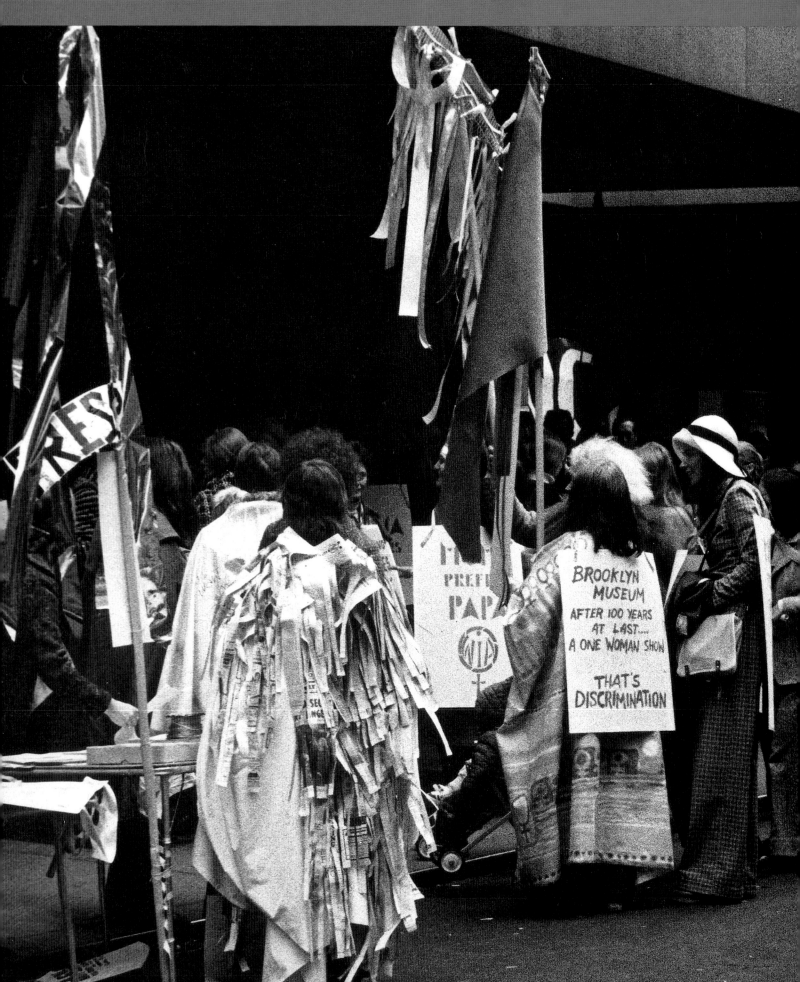

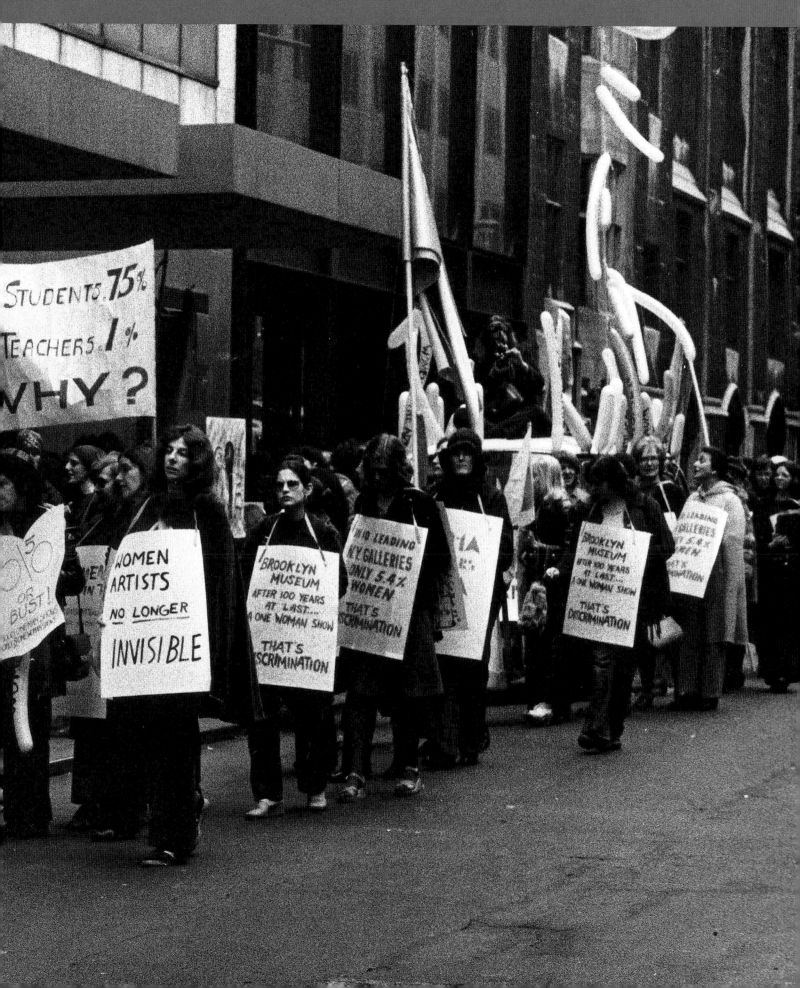

FEMINIST POLITICS: NETWORKS AND ORGANIZATIONS

BY MARY D. GARRARD

The feminist 1970s. It was the best of times and the worst of times, perhaps the best *because* the worst. In the wake of an earlier feminist movement that had gained American women the vote, and the war years that had given many women a brief taste of heading households and doing "men's jobs," progress was stalled. Women slept through the Eisenhower years. Their lack of self-esteem had made discrimination invisible to them. In the Kennedy and Johnson years, they fought for civil rights, but not women's rights. Then, in the late 1960s, as she had done so many times before, Sleeping Beauty woke up. No kiss, no prince—just the click of consciousness that precedes self-possession.

The story of feminist networks and organizations in the visual arts is but a chapter in the larger women's movement that, for many of us who participated, filled the 1970s to overflowing. Like the larger national narrative, ours is a story both of long-term gains and Pyrrhic victories. The activist triumphs of the early seventies—such as forcing museums to show more art by women—seem hollow when we read, twenty years later, that museum exhibitions can still be mounted with few or no women in them;[1] and they seem hollow when we observe young feminists today protesting masculinist museum policies in ritual performances that reenact (eerily, the point goes unacknowledged) the street rituals that initiated the movement twenty years ago. On the other hand, the birth and growth of feminist organizations in the arts *can* be read as a success story—the exponential growth of women's presence in art and art politics; the rise of feminist artists and art historians, in a short generation, from abject political poverty to an awards ceremony in the White House; the preeminence of feminists in the leadership of the College Art Association.

The complexity of the story is partly suggested by the contradictions of these external indicators. A deeper history of the 1970s would require explaining how, under the powerful idea of feminism, some women took charge of their own lives and motivated other women to do the same, which led to their individual and collective empowerment. It would require a case study of the complicated dynamic of political movements and social progress: the building of solidarity around an issue, which led to protest actions, which led to wider networking and deeper solidarity, which led to the construction of a broader agenda and the founding of organizations. And with the institutionalization of feminism came, in rapid succession, the four entropic stages of regression: self-satisfaction, complacency, internal balkanization, amnesia. This essay will briefly trace that dynamic as it played out in feminist arts organizations in the 1970s, emphasizing to some extent those with which I was personally involved.

I will also underline the special nexus of the visual arts, political activism, and feminism in that era. For the very forms of social protest are at base aesthetic structures, whose success depends heavily on their artistic effectiveness. The protest demonstration is a visual display of an ideological position through dress or costume, signs bearing messages, and chants or songs performed by the participants. As a highly structured public ritual that embodies a symbolic confrontation between two ideologies, one dominant and the other insurgent, the protest

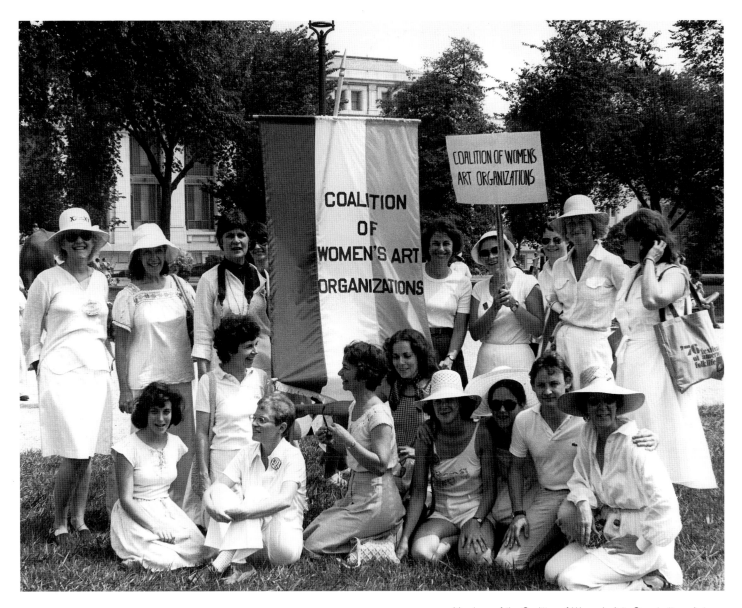

Members of the Coalition of Women's Arts Organizations during the Equal Rights Amendment march in Washington, D.C., 1976. Back row, left to right: Lila Snow, Cynthia Navaretta, Ellouise Schoettler, Laura Huff, Dee Levy; (four women unidentified). Front row, left to right: unidentified, Joan Mister (kneeling), Mary Garrard, Charlotte Robinson, unidentified, Zita Dresner, Barbara Berman, unidentified, Josephine Withers.

demonstration is more than "merely" aesthetic, however, for it aims to influence a third entity, public opinion, and through it public policy. As specialists in aesthetic display, artists and musical performers were prominent in the peace demonstrations and protests of 1968-72, though their own art was not always political. Feminist artists of the early seventies broke new ground by directly putting their art in the service of their politics, and it was feminism, ultimately, that shaped street and civic protest into a type of performance art that was both self-conscious and socially conscious, and that deliberately smudged the boundary between art and politics. The intertwined histories of feminist protest and feminist art are thus inseparable at their point of origin. It is not surprising that the most prominent feminist social action group of the 1990s, Women's Action Coalition (WAC), has been spearheaded by artists.

1968–1972

The modern feminist movement in America can be traced to the publication of Betty Friedan's *The Feminine Mystique* in 1963, the addition of the category of sex to Title VII of the Civil Rights Act of 1964, and the founding of the National Organization for Women (NOW) in 1966. Simultaneously, radical feminist consciousness emerged within New Left and civil rights organizations such as the Student Non-violent Coordinating Committee (SNCC) and Students for a Democratic Society (SDS), prodded by the realization of women working in these "freedom" movements that they themselves were not so free, and by the suddenly conspicuous misogyny of movement men (symbolized by Stokely Carmichael's infamous remark of 1964 that "the only position for women in SNCC is prone").[2] By 1968, "women's lib" groups had sprung up across the nation and had begun to publish their views—notably, in the movement's first journal, *voices of the women's liberation movement*. Out of New York Radical Women, the earliest political discussion group, founded in 1967, came WITCH in 1968, and Redstockings, whose manifesto was published in 1969.

Redstockings and WITCH took theory to the streets. Their "zap actions" and "witch hexes" were disruptive public demonstrations of the kind that had been practiced by the New Left. Now focused on women's issues, they drew zany inspiration from the inversion of misogynist stereotypes. WITCH, for example, was "officially" an acronym standing for Women's International Terrorist Conspiracy from Hell, but was variously explained, depending on the occasion, as Women Incensed at Telephone Company Harassment, Women Infuriated at Taking Care of Hoodlums, or Women Inspired to Commit Herstory. The first WITCH action in New York—on Halloween, 1968—was against banks and brokerage firms ("Up Against Wall Street"), a "hexing" that resulted in a five-point stock market decline. In Atlantic City, August 1968, the Miss America beauty pageant was the target of the first major demonstration of the new Women's Liberation Movement: in that "action," bras and girdles were symbolically trashed (*not* burned) as instruments of women's oppression, and a live sheep was crowned Miss America.[3]

Early feminist political actions, regarded as outrageous by a shocked public, were fueled by women's own growing outrage as they discovered the dimensions of sex discrimination in their personal lives and in the larger world. Consciousness-raising, the facilitating practice of feminism, which emphasized the political importance of personal experience, was pioneered in 1969 by the Redstockings. "Consciousness-raising is not 'therapy,'" they proclaimed, "which implies the existence of individual solutions and falsely assumes that the male-female relationship is purely personal."[4] Redstockings concentrated on dissolving "the divisions between women that keep us apart," shaping a theory of sisterhood that had earlier been articulated by New York Radical Women in their statement of Principles:

> We take the woman's side in everything. . . . We define the best interests of women as the best interests of the poorest, most insulted, most despised, most abused woman on earth. Her lot, her suffering and abuse is the threat that men use against all of us to keep us in line. . . . Until Everywoman is free, no woman will be free.[5]

Sisterhood produced a form of growth for which the best analogy is cell division. No sooner had an organization formed than it would split into other groups, impelled by policy differences among members. This created more groups, more issues, more action, and wider involvement. NOW experienced its first major organizational split as early as 1968, when New York chapter president Ti-Grace Atkinson challenged Betty Friedan's hierarchical, male-model structure, proposed instead a more egalitarian rotating-leadership model, and walked out to form a new group, The Feminists. Out of Redstockings came Redstocking Artists, founded in 1970 by Pat Mainardi, Irene Peslikis, Marjorie Kramer, and Lucia Vernarelli. This group started the "first women artists' feminist-oriented journal," *Women and Art*, first published December 1971.[6] A split in the ranks of Redstocking Artists between Marxist and non-Marxist factions led to the creation of the (non-Marxist) *Feminist Art Journal* in April 1972, by Mainardi, Irene Moss, and Cindy Nemser.

In 1969, Women Artists in Revolution (WAR) was formed within the male-dominated Art Workers Coalition, the largest of several new radical artist groups. WAR's secession was sparked by the Whitney Museum's 1969 Annual, which included only 8 women among the 143 artists shown. WAR feminists—among them Sara Saporta, Dolores Holmes, Jacqueline Skiles, Juliette Gordon, Silvia Goldsmith, Jan McDevitt—demanded that the museum change its policies to include more women artists. Meanwhile, artists became prominent in the steadily intensifying national antiwar movement. In May 1970, the Art Workers Coalition organized the New York Art Strike, to protest the U.S. invasion of Cambodia, the Kent State killings, and racial violence in Mississippi. The strike produced a one-day shutdown on May 23, 1970, of many New York museums and galleries, and the withdrawal of a large part of the U.S. representation at the Venice Biennale that year. In June, a "Biennale-in-Exile" exhibition was organized at the School of Visual Arts to sustain the protest that officially opposed "war, racism, fascism, sexism and repression." Before the exhibition could open, however, a new

organization emerged to protest that show's exclusion of women and blacks. The new group, WSABAL (Women, Students and Artists for Black Art Liberation) was led by artist Faith Ringgold, whose demands for compensatory quotas—50 percent black, 50 percent women, 25 percent students—significantly helped to launch both the feminist and black art movements.[7]

In the fall of 1970, a new group called the Ad Hoc Women Artists' Group sustained the pressure on New York museums. The Ad Hoc Group, organized by Brenda Miller, Lucy Lippard, Faith Ringgold, and Poppy Johnson, concentrated on discrimination against women in Whitney annuals, demanding 50 percent representation in current shows and resisting the museum's effort to placate women with upcoming O'Keeffe and Nevelson shows. The Ad Hoc Group's focussed approach proved effective: the percentage of women in the Whitney Sculpture Annual of 1970 rose to 22 percent (from 5 to 10 percent averaged in previous years). The Ad Hoc Group met weekly to plan short-term political actions, rotating their site from studio to studio. They had no rules, no officers, no members list. Due to strong leadership and media visibility, however, Ad Hoc Group founders began to be charged with "superstarism," a criticism to which emergent feminists committed to the cause of Everywoman have from the beginning been perennially sensitive. As new feminist groups formed in New York, they adopted ever more egalitarian structures.[8]

April 1971 saw the emergence of Women in the Arts (WIA). Rotating their leadership at meetings, and resisting media demands for "stars" (though the organization was led by highly visible women such as Sylvia Sleigh), WIA set out to pressure the male museum establishment at a new level. In an open letter to MoMA, the Brooklyn Museum, the Metropolitan, Guggenheim, and Whitney museums, and the New York Cultural Center, they demanded an exhibition of 500 works by women artists. Following the group's negotiations with the museums, the "Women Choose Women" exhibition opened in January 1973, at the New York Cultural Center, the first and largest event of its kind, and one of critical importance for the women's movement in art.[9]

By 1970, the women's movement had grown to include radicals and conservatives; whites, blacks and Chicanas; housewives, students, and women professionals, serving as a "huge umbrella under which all stood together."[10] The movement had reached a peak of media visibility. On August 26, 1970, the anniversary of women's suffrage, the first national demonstration for women's equality was held in Washington, D.C. That same month, Kate Millett's explosive *Sexual Politics* was published, a blistering indictment of the masculinist bias of Western literature that would serve to spark feminist scholarship in literature and art history. On the August 31, 1970, cover of *Time* magazine was Alice Neel's portrait of Kate Millett, a sculptor as well as a writer. One of the movement's first anthologies, *Sisterhood is Powerful*, was published in 1970. Editor Robin Morgan's introduction to the book reads like a report from the trenches:

> *It is now the spring of 1970. During the past few months, wildcat strikes by women workers at General Electric, Bendix, and the New York Bell Telephone Company surprised both management and labor. . . . The first serious woman jockey was pelted by rocks before a major race. Housewives in Stockton, California, went on strike for wages and for a clear definition of their "job"—in writing. Women's caucuses have been formed or are forming in the American Political Science Association, the Anthropological Association, the Modern Language Assocation. . . . Welfare mothers have been disrupting welfare centers all over the country. . . . Roman Catholic women are in revolt over the Pill. . . . the outgoing Miss USA exposes the commercial way in which she has been used, and denounces her exploiters. . . . Women's Liberation Centers are being set up by local groups all around the country, to try to deal with the women who are pouring into the movement every day. Nurses are organizing. Women in the Armed Forces are organizing. . . .[11]*

The word *sisterhood* was spoken freely, earnestly, and unselfconsciously at that time. The unity of women and the cause of feminism were assigned the highest priority, because sexism was seen as the original "alienizing" act from which other human oppressions sprang. Asked to consider "the comparatively insignificant oppression of women" with racism and imperialism, Morgan wrote: "This is a male-supremacist question . . . it dares to weigh and compute human suffering, and it places oppressed groups in competition with each other (an old, and very capitalistic, trick: divide and conquer)."[12]

In the fall of 1970, simultaneous with the Whitney protests, political actions erupted in California. Women in Los Angeles organized to protest the "Art and Technology" show at the Los Angeles County Museum of Art, which opened without a single woman artist in it. Out of this action came the formation in 1970 of the Los Angeles Council of Women Artists (LACWA), which also included art historians, critics, curators, and collectors, led initially by Joyce Kozloff, who had recently moved to California from New York.[13] LACWA pressured the museum to show women's work, and served as a networking agency: its members came out of isolation to share stories of discrimination. Their testimonies were collected by the council, turned into statistics, and made the basis for political demands.

In the early seventies, especially in California, there were many spontaneous individual efforts to help women artists rise from societally imposed amateurism and isolation into professionalism. In fall 1971, Los Angeles printmaker June Wayne, founder of the pioneering Tamarind Lithography Workshop, organized a series of seminars at her studio called Joan of Art, in which, through role playing, women artists were taught how to function effectively in the art world, from documenting and pricing their work to negotiating with dealers and galleries. The highly practical education afforded by Joan of Art was spread through Wayne's insistence that "graduates" conduct similar seminars for other women.[14] In early 1972, Wayne's Tamarind Workshop issued a groundbreaking survey exposing gender-bias in art publication reviews covering shows by men and women.[15] Meanwhile, the educational work of Judy Chicago and Miriam Schapiro at CalArts gained high visibility in the Los Angeles area when Womanhouse went on view early in 1972. The West Coast Women Artists' Conference opened at Womanhouse on

FIFTY CENTS AUGUST 31, 1970

The Politics of Sex

TIME

Kate Millett
of Women's Lib

Alice Neel, portrait of Kate Millett on the cover of *Time*
magazine, August 31, 1970

January 21, 1972, bringing California women artists together in large numbers. Miriam Schapiro convened the conference calling for women to "come out of our dining room workshops, our bedroom and kitchen table studios," and join the larger, heretofore male, art world.[16]

The momentum gained from Womanhouse and the West Coast Conference led to the creation in 1972–73 of the Woman's Building in Los Angeles, in the words of its founders, "a new art community built from the lives, feelings and needs of women."[17] By early 1972, the energy generated in California and on the East Coast had joined to shape the framework of a national movement. West-East Bag (WEB) had been created in 1971 to serve as "an international information liaison network of women artists." By 1973, WEB boasted representatives—among them Ellen Lanyon, Rosemary Wright, Alison McMaugh, Suzanne Bloom, Athena Tacha, Karen Eubel—in twenty states and eight foreign countries.[18] The first slide registry of women's art, the Ad Hoc Committee's Women's Art Registry, developed in 1970–71 by Lucy Lippard and supported by WEB, was followed by numerous registries in other cities. The registries served as instant banks of women's work, useful for exhibition organizers, but also for women artists themselves, to learn of each other's work beyond the local level. The near-simultaneous explosions across the country of feminist activism in the arts (as in the movement in general) can only be explained by the special phenomenon of women's networks.[19] By contrast to men's networks, which were typically structured along vertical professional lines, women's networks were friendship networks, laterally spread, and geographically unbounded. Information circulated quickly when there was no reason to hold it back, no status or position to protect, and when there was among women an intense personal need to know. Networking of this kind continued throughout the seventies and beyond, through personal exchanges and through the prominent women in the movement—Judy Chicago, Harmony Hammond, Joyce Kozloff, Joan Snyder, and especially Miriam Schapiro (nicknamed "Mimi Appleseed")—who crisscrossed the country to speak on college campuses and to women's groups, bringing news and spreading ideas.

1972–1978

Around 1972, the Feminist Art Movement shifted from an activist first phase to a consolidating second phase. That year saw a turn from guerrilla actions, usually aimed at museums to produce immediate results, to the creation of organizations whose sights were set on long-term changes within existing institutions. From 1972 onward, the key structures that had supported networking and lifted it to a professional level—women's organizations, centers, galleries, conferences and panels, and publications—were themselves increasingly institutionalized. In New York, the radical groups changed rapidly. By 1972, WAR had abandoned its attacks on museums to concentrate on consciousness-raising, while the Ad Hoc Group turned to research discrimination against women artists teaching in universities and to support a slide registry at Barnard College.

By 1972, WSABAL had also become relatively less activist, though the "Where We At" exhibition led to other exhibitions of black women artists and to an intensified effort on the part of leaders Kay Brown and Faith Ringgold to bring black women together within the feminist movement.[20]

In 1972, feminism's new "permanent" status in the arts was manifested in three important developments. First, the Women's Caucus for Art (WCA) was created on January 28, 1972, at the San Francisco convention of the College Art Association (CAA). The women from CalArts—Judy Chicago, Miriam Schapiro, and art historian Paula Harper—helped to wrest a meeting space from a bemused College Art Association. Thanks to groundwork laid by art historian Ann Sutherland Harris, the meeting drew an overflow crowd. Women artists met art historians and museum women; the traditional subdisciplinary boundaries between these groups dissolved in the heat of their new common energy. Now at a national forum, women who had experienced professional discrimination in the arts told their stories, and found they were not alone. Still thriving today, the caucus has served as the largest and most continuous feminist political structure in art professions.

Second, early 1972 saw the founding of *The Feminist Art Journal (FAJ)*, the first stable and long-lasting feminist art journal with a national readership. From its first issue of April 1972, to its last in 1978, *FAJ* rallied women and focused the issues. Its combative spirit was announced at the outset when, in her first editorial statement, editor Cindy Nemser quoted the English suffragist Christabel Pankhurst: "Do not appeal, do not beg, do not grovel. Take courage, join hands, stand beside us, fight with us." "In our own words," Nemser added, "we say 'Women artists, we now have our own place to be our own selves in print. The battle has begun.'"[21]

At the very moment that clarion was sounded, a third major forum for feminist art opened. The Conference of Women in the Visual Arts, held at the Corcoran School of Art in Washington, D.C., on April 20–22, 1972, was organized by seven Washington artists and art historians—Mary Beth Edelson, Barbara Frank, Cynthia Bickley, Enid Sanford, Susan Sollins, Josephine Withers, and Yvonne Wulff—who were outraged that no women had been included in the 1971 Corcoran Biennial (pages 96–97).[22] Other conferences were held around the country in 1972—in Ithaca, Buffalo, New Haven, Wisconsin, and New York City, for example. Yet the Corcoran conference stands out in many people's memories for its consciousness-raising impact.[23] Attending were representatives of all the New York and California feminist groups; among the speakers were artists Helen Frankenthaler, Miriam Schapiro, Judy Chicago, June Wayne, art historian Linda Nochlin, museum scholar Adelyn Breeskin. Equally memorable was the audience's participation. No one present has forgotten the (then) virtually unknown septuagenarian Alice Neel, who seized the stage uninvited and presented a marathon slide show of her own work, which had received practically no notice before that moment. Many of the women who came together in Washington were radicalized on the spot. Among the many lives that were changed that weekend, Arlene Raven decided to leave the East Coast for California and join the movement. And a community of feminists in the arts was formed—symbolized by Mary Beth Edelson's poster of

June Wayne, printmaker and founder of Tamarind Lithography Workshop, speaking at "Women/Artmakers," a lecture series organized by Double X at the Los Angeles Institute of Contemporary Art, March 31, 1975. Photograph by Nancy Youdelman

the preceding year—that has endured to this day and promises to outlast the twentieth century.

The early conferences established an effective new format for the discussion of issues, and for networking. Their structures—especially the panel discussion—would become a vital part of WCA conferences (and, in turn, of CAA conferences). Throughout the seventies and eighties, the WCA/CAA conferences, along with panels sponsored by women's galleries,[24] were important sites where, through debate and argument, feminist art tried to clarify its own identity on such issues as the value of separatist art training for women or whether there were significant differences between the art of men and women.

The organizational development of the Women's Caucus for Art is exemplary of a group's evolution from radical structurelessness to institutional permanence. Out of the original meeting at the 1972 CAA convention came a loose leadership structure: Ann Sutherland Harris, who had been a feminist activist at Columbia University and had collected valuable statistics on discrimination against women art historians, emerged as chair of the Women's Caucus of the College Art Association.[25] Harris played a critical leadership role in getting the organization rolling—her outrage at gender injustice and her exhortations to action were inspiring. At that volatile early moment, however, many "actions" were undertaken and many strategies and tactics invented by individuals rather than by the organization. An example is the famous Rip-Off File, created by Nancy Spero and Joyce Kozloff in 1973, an effectively inflammatory desk-top publication of art world horror stories told by feminists.[26]

In 1973, Norma Broude and Meredith Johnson created and maintained the WCA Job Roster, a separate placement service for women candidates; Broude then became the caucus's first Affirmative Action Office. In 1974, Janice Ross conducted a survey on MFA programs for the Women's Caucus that was eventually published by the CAA; and in 1976, H. Diane Russell carried out the first survey of women in museums. Simply by asking pesky questions at meetings, Eleanor Dodge Barton pioneered the reform of discriminatory insurance and pension benefits in CAA-sponsored policies. Other caucus members came forward to foster and document the rapid growth of the new "disciplinary" field of women's studies in art, which flourished in course syllabi before it had produced any books. In 1974, I compiled a sourcebook for slides of works by women; in 1975 and 1978, Athena Tacha, Lola Gellman, Elsa Fine, and Judy Loeb gathered into two publications the syllabi of courses on women and art being taught across the country.[27]

In 1974, the Women's Caucus was going strong, much of its energy coming from the widely diverse activities of loosely affiliated women's groups in several cities. One of those groups was Front Range in Colorado, another was the Washington Women Art Professionals, based in a city with several active feminist groups in the arts.[28] Seeking to extend the life of the caucus, Ann Sutherland Harris asked me to become its second president. I did so with the support of the WWAP group. Aiming to give the organization a structure that would insure its survival, stabilize its national leadership, and build its membership, I named a national advisory board of thirty prominent and active women in the arts. Together we approached the College Art Association for more visible representation at the forthcoming annual CAA meeting. At the 1975 CAA meeting in Washington, the caucus had a "hospitality center" and two time slots—one for a business meeting, the other for three concurrent workshops.

Meanwhile, the CAA Board of Directors was asking the Women's Caucus of the College Art Association to drop the affiliation with CAA that its name implied, so that the CAA would not have legal responsibility for our activities. Obliged to incorporate legally, we renamed ourselves "Women's Caucus for Art," a move that proved serendipitous, since the organization could now expand its activities beyond the CAA world. But the WCA preserved a familial and adversarial relationship with its parent organization. Serving as a gadfly on gender matters, the WCA pressured the CAA Board of Directors to change the CAA from "an old boy's club" into a more open, balanced, and democratic organization. An immediate target was the CAA Board itself. In 1970, only one of the twenty-four board members was female; by 1975, there were eleven women.[29] After caucusing with WCA leaders, women board members and/or the Chair of the Committee on the Status of Women introduced numerous resolutions that brought significant change to the CAA. For example, since women had tended to complete their graduate degrees later than men, eligibility for the Arthur Kingsley Porter Prize, awarded annually to the best *Art Bulletin* article by a young scholar, was changed in 1976 from being "under the age of 35" to "not more than 10 years beyond the Ph.D." In the same year, after having gained full benefits for pregnancy in the CAA group insurance plan, the WCA got CAA to challenge the sex-discriminatory pension plans of TIAA-CREF—the first large professional organization to do so.[30]

These changes did not come easily; they were bitterly contested by many members of the CAA Board. The women on the board, joined and spurred by an official WCA representative, horrified the board's elegant and refined Brahmins. We broke all rules of decorum, shamelessly passing notes around the table before important votes, winking and applauding each other. We caucused before each board meeting to plan our strategies, and invariably celebrated afterward. No victory went unpunished. In 1977, for example, the CAA Board set a limit on the number of sessions "affiliated societies" could sponsor at CAA meetings—a move covertly aimed at the WCA, the largest and most active of the affiliated groups. And, unquestionably, political activism cost some women jobs, exhibitions, promotions, or status. In marked contrast to "normal" professional behavior both before the feminist seventies and in the decade that followed, many feminists put their reputations on the line, taking professionally risky stands. In the end, their collective gamble paid off. To date, the CAA has chosen three female presidents who were open feminists in the 1970s, and early WCA activism has given the CAA its most politically seasoned board members and officers.[31]

The political activism and membership expansion of the first two WCA presidencies accelerated under its third (and first artist) president, Judith K. Brodsky. Two regional chapters were organized during my term (in Kansas City and San Francisco); there were seventeen by the end of Brodsky's term. In 1976, the status of both women and the arts caught the interest of the first Democrats to occupy the White House since the women's move-

Artist Muriel Magenta and art historians Linda Nochlin and Ann Sutherland Harris, left to right, during the Women's Caucus for Art conference, San Francisco, January 28, 1972.

Women's Caucus for Art business meeting, Washington, D.C., at the 1975 conference. Officers, from right: Norma Broude, Diane Russell, Claire Sherman, Mary Garrard, Hylarie McMahon, Francie Woltz, Ellouise Schoettler.

Lois Mailou Jones taking the floor at the Conference of Women in the Visual Arts held at the Corcoran School of Art, Washington, D.C., April 20–22, 1972. Photograph by Susie Fitzhugh

In 1979, the Women's Caucus for Art inaugurated the first Honor Awards for lifetime achievement by women artists, in a ceremony at The White House, Washington, D.C. The awards were given to (from left to right) Selma Burke, Louise Nevelson, Alice Neel, Isabel Bishop, and (in absentia) Georgia O'Keeffe.

Woman's Year conference in Houston in 1977, thanks to the work of WCA and CWAO, women in the arts represented one distinct category that had gained strong government support.

Under Brodsky's leadership, the WCA instituted what has become for many its central annual event—the Honor Awards Ceremony honoring the lifetime achievements of senior women artists. In 1979, on the occasion of the CAA-WCA conference in Washington, the first awards were given to Louise Nevelson, Alice Neel, Selma Burke, Isabel Bishop, and (in absentia) to Georgia O'Keeffe, in a ceremony in the Oval Office. Contrary to what one might expect, the awards were not bestowed by President Carter. They were awards given *by* women *to* women, by strong and self-confident women to their living artistic foremothers, in whose footsteps they now proudly walked.

1978–1982

When the Carter administration ended in 1980, the women's movement was already waning as a national political force. The drive for the Equal Rights Amendment had stalled. Husbands of working women had begun to suffer documented depression,[33] and as a gender voting gap opened between women (60 percent declaring themselves liberal or radical) and men (60 percent moderate to conservative), Ronald Reagan was voted into office. The New Right led the Republican party to oppose both legal abortion and the ERA; Reagan was the first president to oppose the ERA since Congress passed it in 1972.[34] In 1982, for the third time in the twentieth century, the drive for the ERA ended, killed by stubborn state legislatures and a new, antifeminist national mood.[35] In the late 1970s, however, women's organizations had made an all-out effort to ratify the ERA through an economic strategy that almost worked: for over three years, they had sustained a national boycott of unratified states.

In 1977, the Women's Caucus for Art petitioned the CAA to move its 1980 conference from New Orleans in nonratified Louisiana to a city in a ratified state. Over the objections of many female board members, the CAA Board voted to honor its prior arrangements in New Orleans (though it did vote to refrain from holding future conventions in nonratified states). The WCA, not under contractual obligation, had a choice. The WCA Advisory Board voted to go to New Orleans with CAA, but to sustain a modified boycott while in the city, not spending money for housing or food, and conducting protest activities on behalf of ERA. Many WCA members protested this decision, arguing that the caucus should fully support the national boycott. The WCA experienced its deepest division as an organization over this issue, and President Lee Anne Miller faced a more severe test of leadership than had any of her three predecessors.

A team was sent to New Orleans to assess the situation. Gradually, as ties with the community were developed, arrangements for housing, food, and transportation began to emerge. Many New Orleans women in the arts urged the WCA to come, to help strengthen their local position by providing national support, a plea amplified by Elsa Fine, who explained that Southern women "still have a more difficult time than elsewhere."[36] The Florida WCA chapter and Southeast Women's

ment had begun. With the encouragement of President Jimmy Carter, Joan Mondale, wife of the Vice President, carved out a role for herself as spokesperson for the arts: working closely with WCA leaders, Mondale spoke out in particular for women in the arts. The time was right to organize for legislative action. In 1977, Brodsky conceived and formed the Coalition of Women's Arts Organizations (CWAO), headed by Joyce Aiken and Ellouise Schoettler. The CWAO—embracing the great diversity of women's arts organizations that existed by that time— helped to lobby Congress on behalf of women in the arts, and joined the WCA in pressing the National Endowment for the Arts to include more women on its panels.[32] The CWAO was highly visible in the first major march on Washington in 1976 to urge passage of the Equal Rights Amendment. At the International

Caucus for Art (SEWCA) joined the drive to go to New Orleans, in the conviction that, as NOW Florida legislative coordinator Tina Slaney put it, "The need for professionals to meet with one another far outweighs boycotting a convention."[37]

The dissenting WCA group proposed holding an alternative conference in a ratified state; this was supported by the Arizona chapter and the Marxist Caucus, while the CWAO volunteered to cosponsor it. Advocates argued that the WCA, then the largest and strongest women's caucus of any professional association in America, and the CWAO, which represented some seventy-five organizations, could best help the ERA drive by mounting a protest conference. They agreed with other national ERA leaders that "the boycott is crucial" to gaining legislative support for the Amendment. When the boycott forced the New Orleans City Council to pass a pro-ERA resolution, Cynthia Ware, ERA chair of the League of Women Voters for New Orleans, advised: "Pass the word. Tighten the screws!"

Two conferences were held in January 1980, the modified boycott in New Orleans and an alternative WCA-CWAO conference in Washington, D.C. I wish I could say that the spirit of complementarity and sisterhood prevailed; in reality, there was a great deal of anger, suspicion, and mistrust on both sides. Reading now (for the first time since 1979) my collection of memos, letters, and broadsides on this subject, I am especially struck by the wise voice of Sandy Langer, who observed in a letter written to Lee Anne Miller that summer that the WCA's internal conflict "must delight the patriarchs of the CAA; after all, as long as we're fighting with each other we can't draw a bead on them."

But I cannot entirely condemn the controversy as wasteful, because it generated on each side a determination to prove itself right to the other, a desire to gain the other's respect. And out of that strange competitive tango came two feminist art performances that had value in themselves. Framed in self-consciously differing terms, each was addressed not only to its immediate audience, but also to the other, each speaking a different theme of feminism to those who would best understand. The entire New Orleans conference was conceived as a performance, the brainchild of performance artist Suzanne Lacy, featuring red-beans-and-rice community strategy sessions, art events designed to foster political consciousness and action, an "Arts for ERA" raffle, and a jazz procession from the hotel to the Awards Ceremony. The CAA convocation address that year was delivered by Alessandra Comini, who with characteristic style and iconoclastic humor, sharply challenged the "holy cows and pure bull" of the traditionally phallocentric profession of art history."[39]

The Washington alternative conference presented awards to seven women whose courageous political acts had helped bring significant social change—civil rights leader Rosa Parks, former congresswoman Bella Abzug, antipornography leader Lynn Campbell, *Ms.* founding editor Gloria Steinem, ERA organizer Sonia Johnson, Catholic advocate for women's ordination Sister Theresa Kane, and writer Grace Paley. The moods of the two conferences were quite different: one, held in museum auditoriums, a solemn and dignified tribute to national leaders who had inspired the feminist revolution and the ERA drive; the other, strutting flamboyantly through a lazy and colorful city, consciousness-raising for ERA in the local patois. Yet the link

between political action and art was emphasized in each conference, whether through the radicalizing potential of street performance, or by defining in aesthetic terms influential social acts performed by women who were not artists at all.

1982 AND BEYOND

The 1980s were lean years for feminism, and the WCA found itself increasingly concerned with consolidating gains and simply holding its place. The principal growth was in the regional chapters and in the ever-expanding artist membership, with the result that the WCA's dominant constituency gradually changed from university-based art historians and artists to artists, primarily, based in cities and communities across the country. Serving important new needs, the WCA was still healthy and vital, yet structural problems had emerged with these changes. So large and diverse a membership no longer agreed on goals for the national organization. Many members identified more closely with their local chapter, seeing "national" as a distant, alien, and even suspect entity. Veterans of the early activist years grew impatient with newer members' loss of focus on the social feminist agenda. When Muriel Magenta became president in 1982, she set two goals: to strengthen links between the national office and the chapters, and to "raise the feminist consciousness." She effectively met the first of these goals; but the second may not have been possible—for anyone—in those years.

WCA presidents in the eighties found ways to strengthen the permanent base of the organization. Under Magenta, a national headquarters at Moore College in Philadelphia was established, and developed by Ofelia Garcia (1984–86). Annie Shaver-Crandell (1986–88) supervised the formation of the WCA Archives at Rutgers University. Christine Havice (1988–90) worked to build the chapters and oversaw the first regional conferences, activities sustained by Iona Deering (1990–92) and Jean Towgood (1992–94).[40] Over time the WCA has followed a model that sociologists have described as characteristic for large organizations: a progression from grass-roots activism toward conservatism, goal transformation, and accommodation to society.[41] When one adds to this pattern of organizational development America's growing conservatism in the 1980s, it is noteworthy that the WCA managed to sustain even a degree of focus on feminist goals.

In the 1980s, the mantle of feminist activism in the arts was taken up by new groups. First came the Guerrilla Girls. Reacting to MoMA's 1984 International Survey of Painting and Sculpture (less than 10 percent female), the Guerrilla Girls took aim on the streets of SoHo, plastering walls with crisp and ironic statistical indictments of the art world establishment. Their anonymity, insured by wearing gorilla masks in public appearances, was the key to the Guerrilla Girls' success, for it permitted them to minimize personal risk while maximizing collective power.[42] The year 1989 saw the appearance of SisterSerpents, a collective of artists in Chicago who use art as a weapon for broader social change. With their distinctive winged serpent as a symbol, SisterSerpents have produced hard-hitting satirical posters lampooning fetus worship and raging at vio-

The Women's Caucus for Art and the College Art Association annual conference in New Orleans, Louisiana, January 1980.

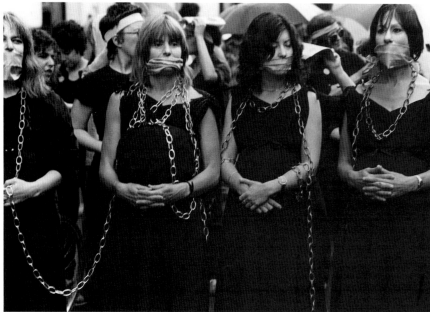

"No More Nice Girls," agitating for pro-choice rights, New York City, 1982. Photograph by Terry Kearns

The Women's Caucus for Art and the Coalition of Women's Arts Organizations alternative conference, held in Washington, D.C., January 1980. The conference was held in protest of the WCA/CAA conference held in non–ERA-ratified Louisiana. Pictured, left to right: Alice Neel, Adelyn Breeskin, Mary Garrard, and Miriam Schapiro.

lence against women.[43] In the later 1980s, as artists began to explore racial or ethnic identity in the increasingly multicultural United States, feminist organizations for women of color emerged, such as Coast to Coast (African-American women), Vistas Latinas (a group of Latina artists), and Godzilla (Asian-American artists with a strong feminist element).[44] In recent years, women of color have worked to define the unique positions of their individual groups, often sharply challenging white women's authority—and tendency—to speak for women in general.

The 1990s were ushered in by Women's Action Coalition (WAC), founded in New York shortly after the controversies in 1991 over Clarence Thomas's appointment to the Supreme Court and William Kennedy Smith's rape trial acquittal. WAC's skyrocketing membership growth was phenomenal (early New York meetings drew crowds of 800 to 1000; there are now chapters in over 20 American cities).[45] In its focus on action rather than theory and its fluid, nonhierarchic structure, WAC resembled feminist groups of the early 1970s, just as its often witty and outrageous "WAC attacks" replicated the "zap actions" of the first phase of feminism. In one respect this is not surprising, since many WAC activists were also first-generation feminists, survivors into America's third decade of feminism. However, the older women in WAC frequently complain that the younger activists do not want to hear of their seventies antecedents. As (first-generation) writer Barbara Ehrenreich explains, "I think they have to redefine the movement in order to make it their own."[46] It seems that for the newest generation of feminist activists—in a curious inversion of a patriarchal platitude—it is necessary to forget their past in order to be able to repeat its successes.

And yet it also remains true, as George Santayana said, that those who forget history are doomed to repeat its mistakes. The women's movement can be said to have gone on for one hundred and fifty years or nearly six hundred years, depending on whether you start with Seneca Falls or Christine de Pizan, but, as author Ursula Le Guin has observed, it has yet to last continuously beyond one generation.[47] Historian Gerda Lerner similarly cautions that the "absence of collective memory" has seriously retarded the growth of feminist consciousness since the fourteenth century, condemning women to repeat their arguments "as if no woman before her had ever thought or written."[48] Can we afford to keep on forgetting? Will we ever progress?

I speak from memory of the feminist 1970s: It was a wonderful time to be alive. Many of us felt newly born at the age of twenty or thirty or forty. Among the women who made common cause for feminist action, differences of age, race, class, sexual or geographical identity were for a brief moment totally insignificant. We found ourselves part of a new kinship network, something like family or friendship, but beyond these in that we were connected for a purpose. We shared a vision—of the marvelous, the earth-shaking, the sublime. The entire past was not what we had thought: reality could be totally reconfigured, the world could be changed.

Such deep rents in the social fabric are not permitted for long, however. Gradually, feminism's vast contradictions of the so-called natural order have themselves become naturalized—like fabulous dragons locked into tapestries, stitch by pedestrian stitch. But I cannot end on a metaphor so disparaging to the needle arts. Fabulous dragons must be kept alive in some way, to inspire us again in the future. So it's only right that they should live, when memory is gone, in the histories that women weave and the golden-age myths that we spin.

HOW MANY WOMEN HAD ONE-PERSON EXHIBITIONS AT NYC MUSEUMS LAST YEAR?

Guggenheim	**0**
Metropolitan	**0**
Modern	**1**
Whitney	**0**

The Guerrilla Girls. *How Many Women Had One-Person Exhibitions at NYC Museums Last Year?* Poster. Franklin Furnace Archives, Inc., New York

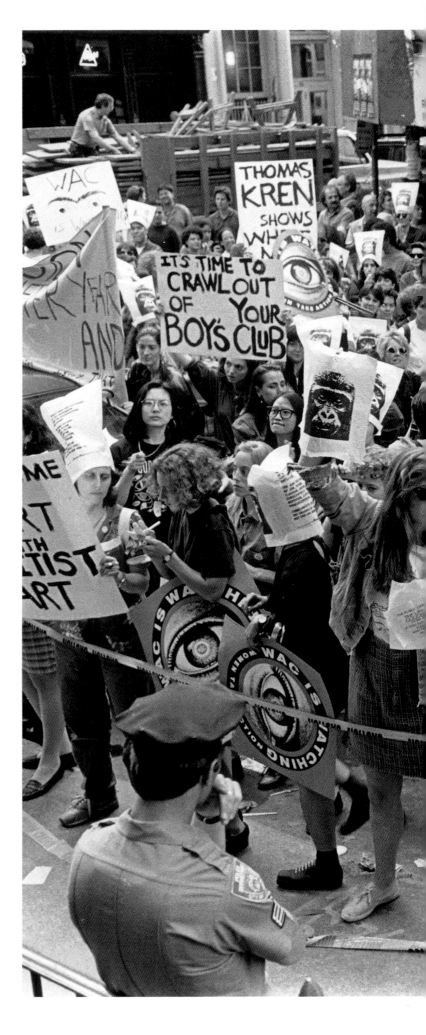

Members of the Women's Action Coalition (WAC) demonstrating against sex discrimination and racism at the inaugural opening of the Soho Guggenheim Museum, New York, July 25, 1992. Photograph by Lisa Kahane

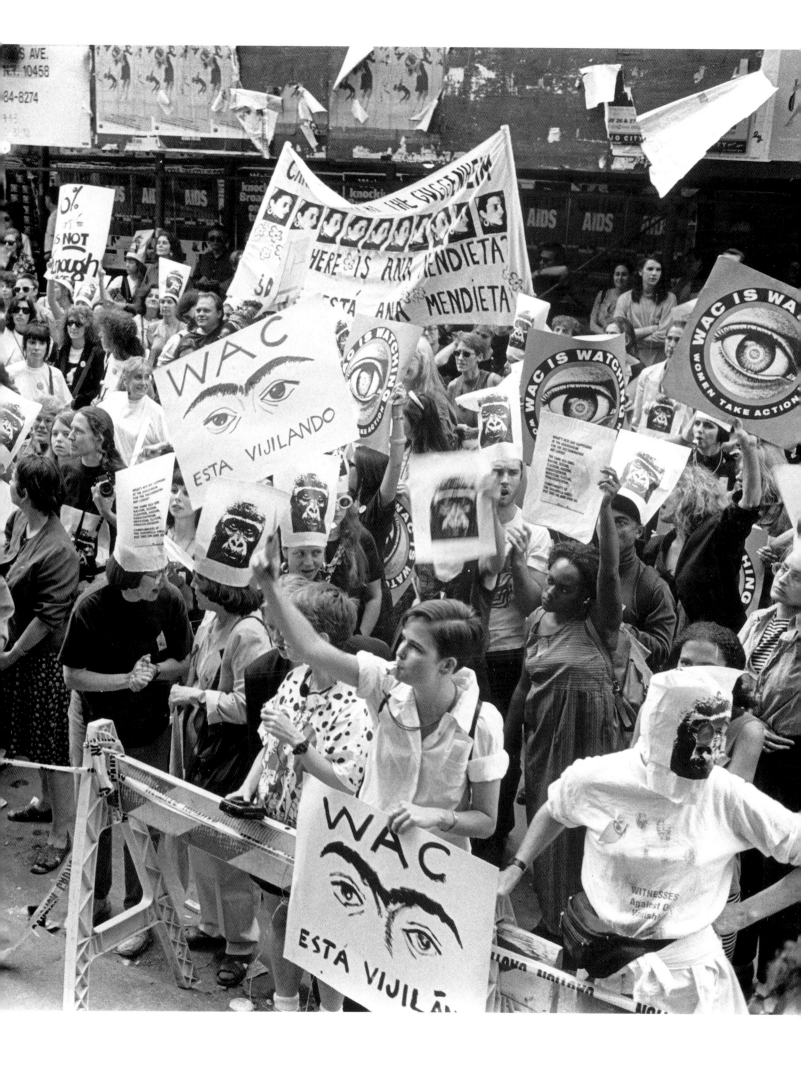

EXHIBITIONS, GALLERIES, AND ALTERNATIVE SPACES

BY JUDITH K. BRODSKY

During the years 1970 to 1980, women artists protested their exclusion from mainstream exhibitions and museums in New York and Los Angeles. Rather than merely demonstrating, however, they created their own exhibition opportunities. One goal of the many alternative exhibitions and women's galleries established during the 1970s was to show that women artists were actively producing good work, thereby putting pressure on mainstream institutions to include more exhibitions of work by women artists. Another goal was to provide women artists with an emotional and intellectual support system to help overcome their feelings of isolation. A third, more radical goal was to provide venues for showing feminist art that could not be seen elsewhere.

What did the alternative exhibition and gallery strategy accomplish? It provided the opportunity for many women artists across the United States to be documented. Although the reputations of many of the artists who participated in these exhibitions and galleries have not survived the succeeding years, these artists would be lost to history without the exhibition opportunities of the 1970s. Today, the greater acceptance and inclusion of women artists among mainstream institutions, while still far from parity, would not exist without the visibility afforded them through alternative exhibitions. Before the 1970s, women artists were almost invisible. By 1980, *Artnews* could run a cover photo of a group of twenty well-known women artists with the headline, "Where are all the men artists?"

The alternative gallery system of the 1970s provided women artists with a support structure that helped many to develop the confidence and long-term commitment necessary for producing a lifetime body of work. The pragmatic experience of raising funds, developing press coverage, and running the business side of galleries provided education and training that often resulted in jobs during the 1980s at the very institutions that previously had been the targets of political action.

Another accomplishment of the alternative exhibition movement was the establishment of a common body of ideas among a substantial number of women across the United States through the panels, discussions, classes, and even schools that were set up in conjunction with exhibition spaces. From the very beginning, education programs accompanied exhibitions and provided venues for critics like Lucy Lippard or artists like Miriam Schapiro, leaders in developing feminist approaches, to talk about their ideas with women artists.

And finally, the alternative galleries and exhibitions allowed women to show work addressing their bodies, their sexuality, and their lives in images that were considered unacceptable to mainstream galleries and museums which had been threatened by the content that women were introducing. On this basis, these institutions had dismissed their work as not being aesthetically sound.

While the artists who originated alternative exhibitions and galleries agreed on the goals, sharp theoretical and strategic differences surfaced from the start. Some women artists worried that alternative exhibitions and galleries dedicated solely to the work of women artists might be self-defeating, giving institutions and galleries an excuse to continue with their traditional policies of showing work by blue-chip white male artists.

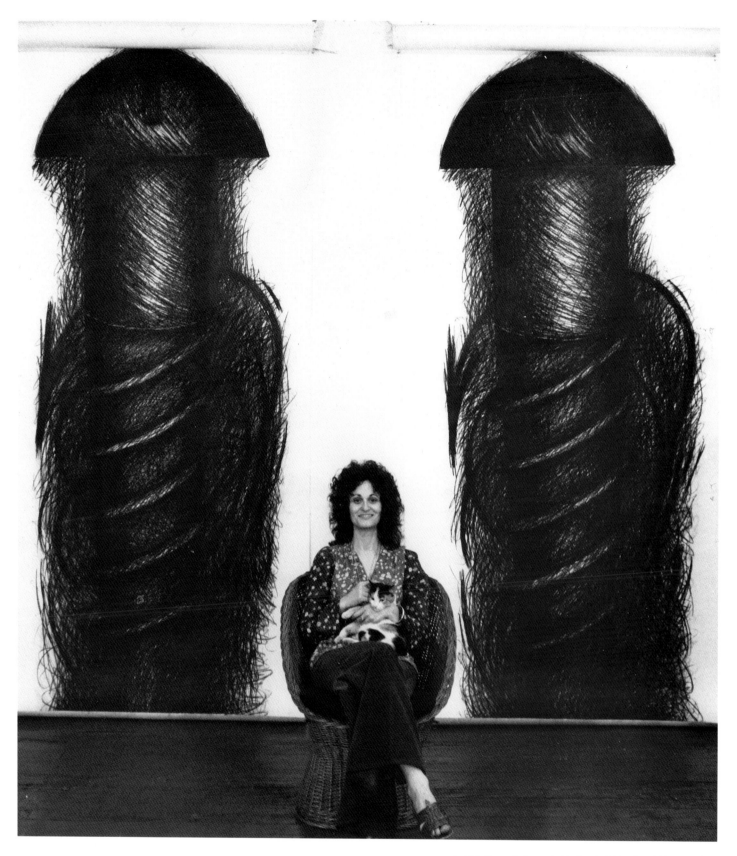

Judith Bernstein seated in front of *Two Panel Vertical*. 1973.
Charcoal on paper, 12½ × 12½′. Courtesy Cindy Nemser

In spite of the controversies, the burst of energy that produced alternative exhibitions and galleries swept everything along in front of it and resulted in a series of national, regional, and local exhibitions and the establishment of alternative galleries across the country.

The earliest exhibitions took place in Los Angeles and New York. Even before 1970, women artists and curators on the West Coast began to take responsibility for their own exhibition opportunities. Josine Ianco-Starrels became conscious of the fact that "women were 'being left out'" and organized a show in 1968 at the Lytton Galleries of Contemporary Art in Los Angeles called "25 California Women of Art."[1] Then, in 1970, another pioneering curator, Dextra Frankel, director of the gallery at California State University at Fullerton, furthered the development of feminist ideas on the West Coast by giving Judy Chicago her first one-woman show. San Diego State University Women's Center was also showing women artists in 1970, and racial as well as gender issues resulted in an all-women's show at Galeria de la Raza in San Francisco the same year.

In the early days of feminist activity among women artists in New York, the issue of race was also a catalyst. Black artist Faith Ringgold, and her daughter, Michele Wallace, a writer, founded Women, Students and Artists for Black Art Liberation (WSABAL) in response to '' group Artists' Strike Against Racism, Sexism, Repression and War, which was organized in 1970 by Carl Andre and Robert Morris in reaction to the United States invasion of Cambodia. Andre and Morris succeeded in persuading American artists to withdraw from the Venice Biennale by arguing that the proposed American exhibition did not reflect the social and political unrest of the times. Their plan was to show the withdrawn work at the School of Visual Arts in New York. Ringgold and Wallace publicly objected because, despite the group's name, the only artists in the proposed show were white males. Andre and Morris countered that was because no blacks or Puerto Ricans were in the proposed Venice Biennale selection. Ringgold and Wallace continued their protest with the result that the show was changed to include women, and black and Puerto Rican artists.

Ringgold introduced the concept of the open show. She argued that black artists and particularly black women artists had been excluded from consideration as serious artists on the basis of "standards"; therefore, the process of selection based on standards of excellence was suspect, nothing but a device to promote the interests of white men. If black artists in general and black women in particular were going to be included in the mainstream art world, the social and artistic constructions that had caused their exclusion would have to be eliminated. Open shows became a necessary means of overruling prevailing standards. As women artists began to plan alternative exhibitions and create new galleries, discussion heated up over the issue of standards of excellence versus open shows. A compromise strategy developed. It consisted of using a large number of curators, who, the theory went, would choose a more diverse and innovative group of artists.

Museum, the alternative space which had been the location for the show organized by Andre and Morris, was the site of the first all-women's exhibition in New York. In February 1970,

"X to the 12th Power," sponsored by Women Artists in Revolution (WAR), opened at Museum. Twelve women artists, including organizers Carolyn Mazello and Vernita Nemec, and Dolores Holmes, all members of WAR, were represented. The show participants issued a statement objecting to the sexist oppression of the art world.

Another early exhibition was organized by Patricia Mainardi, who had formed a women's caucus within the predominantly male Figurative Artists' Alliance. The exhibition was an open one and was held at the International House in Manhattan in December 1970. The women's caucus also presented one of the very first panels of women artists discussing feminist art.

The Women's Interart Center, established in 1970 as the first alternative feminist space, provided a succession of exhibitions of work by women artists throughout the 1970s. It originated when members of WAR wanted to have a space of their own. Along with a group called Feminists in the Arts, WAR established a graphics and silk-screen workshop under the direction of artist Jacqueline Skiles. In the spring of 1970, the Women's Interart Center approached the New York State Council on the Arts for a grant. At first, their request was rejected, but they picketed the office and eventually were awarded five thousand dollars. This small grant was typical of the size of the awards made to feminist art groups by government agencies and private foundations.[2]

In the summer of 1971, six black women artists—Faith Ringgold, Kay Brown, Jerrolyn Crooks, Pat Davis, Mai Mai Leabua, and Dindga McCannon—began planning an exhibition called "Where We At Black Women Artists," which they thought was probably "the first black women's art exhibition in known history."[3] The show was held at Acts of Art Gallery, 15 Charles Street, New York, and included twelve black women artists. They also decided to establish an ongoing organization with the same name. Where We At quickly grew to seventeen members and had other exhibitions at Weusinyumba Ya Sanaa Gallery in Harlem and other venues around the city.[4]

In the meantime, the alternative exhibition and gallery movement was growing on the West Coast. Dextra Frankel continued to have an impact. In 1972, she curated a show at the Long Beach Museum of Art called "21 Artists: Invisible/Visible." Along with Frankel, Judy Chicago and Miriam Schapiro visited studios throughout the state to choose the artists. The attitude they brought to the selection process is described in the introduction to the catalogue:

Perhaps since we saw only the work of women during these months, we began to perceive the work in a new way. We did not realize at the time, but a new sensibility was being revealed to us, a sensibility that delineated emotional exposure, softness, and delicacy. We saw very little work which had to do with the nature of physical material or focused exclusively on ideas about art. Physical materials were used for the expression of emotion and sensuousness in color, shape, and form. Rather than a simple concern for formalist issues, much of the work used a formalist framework to express female subject matter. A great deal of the work we saw articulated emotional reality, de-

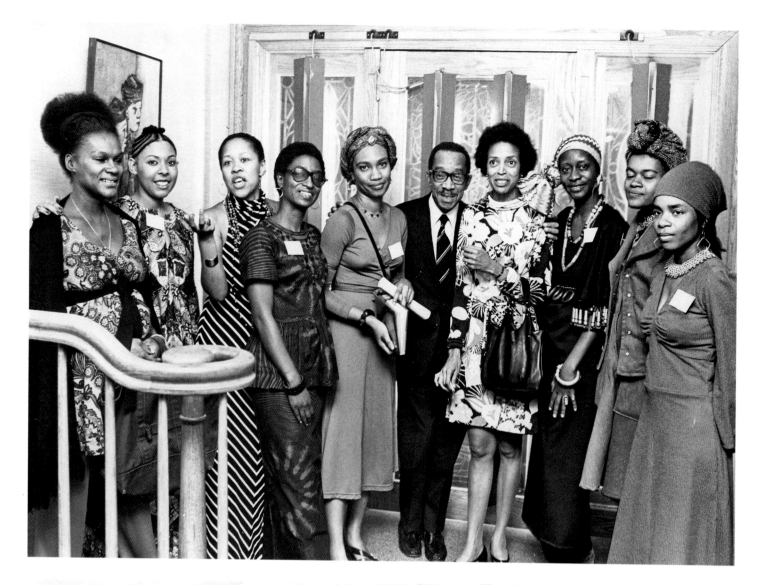

Where We At women artists at M.A.R.C. exhibition, New York, October 1973. From left to right: Carol Blank, Jean Taylor, Kay Brown, Viola Burley, Dr. Kenneth Clark, unidentified, Akweke Singho, Dindga McCannon, Jemillah Jennings.

cookin' & smokin'

"Cookin' and Smokin'." Poster for an exhibition at Nyumba Ya Sanaa Gallery, Harlem, New York, c. 1971–72. Top row, left to right: Dindga McCannon and her daughter, Ann Tanksley, Carole Byard, Joan Taylor, Charlotte Richardson; middle row: Faith Ringgold, Gylbert, Kay Brown; bottom row: Doris Kane, Iris Crump, Carol Blank, Jerri Crooks.

scribed states of feeling, or life as it is lived in kitchens, living rooms, and bedrooms—the woman's environment.[5]

The concept of establishing exhibition spaces to provide visibility for women artists was not limited to New York and Los Angeles. In 1970, Joan Snyder, a painter living in New York, was aware of the feminist rumblings in the artist community. She was also a student at Rutgers University's Douglass College, where she realized that the faculty in the art department were all men although the students were all women. She and Lynn Miller, a reference librarian at the Mabel Smith Douglass Library, approached Daisy Shenholm, librarian, about establishing an exhibition program dedicated to showing the work of women artists. The result was The Women Artists Series at Douglass College, initiated in 1971. The selection was national from the start, and an exhibition in the series was the first major show for many women who later became very well known. Catalogues were published that provided documentation for the series, which has recently celebrated its twentieth anniversary. Even though the coordinators of the Women Artist Series managed to produce annual catalogues, each year they had to mount a new struggle to persuade some department or division within the university to provide funds, or they had to raise funds from sources outside the university.

Women in the Arts (WIA), organized in April 1971, sent an open letter to six New York museums demanding an exhibition of five hundred women artists to be selected by members of Women in the Arts and to be called "Women Choose Women." The group then met with various museum directors; out of the major museums in New York only the New York Cultural Center and the Brooklyn Museum were willing to discuss space for the exhibition. After further discussion, the Brooklyn Museum decided not to participate, and Women in the Arts negotiated for as much space as possible at the Cultural Center. Women in the Arts wanted an open show with all members participating and choosing additional artists for the show, but the museum objected. Tensions arose within the group. Some members were insistent on maintaining the principle of an open show. Others were willing to compromise for the sake of having the exhibition take place. Ultimately Women in the Arts agreed to a compromise form of selection, using a committee composed of three members of Women in the Arts, painters Pat Passlof, Ce Roser, and Sylvia Sleigh, along with outside curators—Linda Nochlin for painting, Elizabeth C. Baker for sculpture, and Laura Adler, exhibition coordinator representing the New York Cultural Center. Women in the Arts had the responsibility of raising funds for the catalogue.

The exhibition opened in January 1973 with 109 artists and was a cross section of what women artists were doing, ranging from modernist abstraction as represented in the show by Pat Adams to Audrey Flack's photorealist painting. It was also probably the first time that art concerned with feminist representation of sexuality was seen by a broad public in New York, as in Martha Edelheit's languid male nudes with their exposed genitalia, Hannah Wilke's latex sculpture resembling labial folds, or Alice Neel's nude portrait of her daughter-in-law in her ninth month of pregnancy. Critiques of the white male pa-

triarchy were also presented to the general public for the first time as in May Stevens's *Hats Go By,* from the Big Daddy series, or in Faith Ringgold's *U.S. Postage Stamp Commemorating the Advent of Black Power.* "Women Choose Women" was reviewed in every major art publication, thus giving tremendous impetus to the women's movement in art.[6]

A.I.R. (Artists in Residence) Gallery in New York and Womanspace in Los Angeles were both established in 1972. As the first women's alternative galleries, they became models that were copied across the country.

The planning for the establishment of A.I.R. began in 1971 when the sculptor Barbara Zucker and the painter Susan Williams, who had met in a women's consciousness-raising group a couple of years earlier, decided to start a women's gallery. Zucker and Williams invited Dotty Attie, Maude Boltz, Mary Grigoriadis, and Nancy Spero to participate. After consulting Lucy Lippard for information on other women artists, they viewed slides of some six hundred women artists and visited fifty-five studios in their search for six other artists to join them; eventually they chose Blythe Bohnen, Agnes Denes, Harmony Hammond, Anne Healy, Louise Kramer, and Howardena Pindell. By the time the gallery opened in September 1972, eight more artists were added—Judith Bernstein, Rachel bas-Cohain, Daria Dorosh, Loretta Dunkelman, Laurace James, Nancy Kitchel, Rosemary Mayer, and Patsy Norvell.

A space was found, responsibilities were assigned, and dues of $21 a month were established. Each member also contributed $150 and 50 hours of work toward the renovation of the 96 Wooster Street gallery, which formerly had been a machine shop. During its first season in 1972–73, the gallery mounted ten two-person member shows, three group shows, and three large-scale invitation shows of nonmember women artists selected by the members. A.I.R. attracted a great deal of attention from the art world and the press. Male artists and critics turned out for openings. One man told Barbara Zucker, "Okay, you did it; you found 20 good women artists, but that's about it."[7]

All of the exhibitions mounted during the first year were reviewed in the weekly newspapers and the monthly art magazines. A.I.R. was successful in attracting funding from the National Endowment for the Arts and the New York State Council on the Arts for specific projects. A.I.R.'s ambitious program included the organization of exhibitions of work by European women artists and Japanese women artists.

But it was hard to maintain such a high level of activity and visibility. The originating members began to leave, some because they had achieved visibility and were moving on, others because their interests changed. While their places were immediately taken, A.I.R. became more of a training ground and an intermediary stop on the way to the commercial gallery system rather than a venue engaging women artists as thoroughly as it had during its early years from 1972 to 1978.

The establishment of SoHo 20 quickly followed in 1973. Mary Ann Gillies and Joan Glueckman joined forces with Sylvia Sleigh and Marilyn Raymond to plan a second all-women's gallery in New York. Sleigh and Raymond dropped out, but there were many other women who wanted to participate so that SoHo 20 opened with 20 members, thereby acquiring its name

in the process. SoHo 20 members were more outsiders in the New York art world than A.I.R. members. Like A.I.R., the gallery also tried to include women artists of color. SoHo 20 never attracted the attention that A.I.R. did in its early days, perhaps because its members were less well connected to the art-reviewing periodicals. However, like A.I.R. it recently celebrated its twentieth anniversary and continues as a respected gallery.

In 1972, Womanspace Gallery became a reality in Los Angeles. The artists who created Womanspace came together as a result of the "Invisible-Visible" show. They formed the Ad Hoc Women Artists' Group and began to discuss the possibility of organizing a showing space for women. A two-day marathon of reviewing slides was held at the home of Max Cole, one of the members of the Ad Hoc Women Artists' Group, and a core of women emerged who began to put together the funds and locate a space.[8]

The Woman's Building opened in Los Angeles in 1973. Arlene Raven had come to teach art history at the Feminist Art Program at California Institute of the Arts where she met Judy Chicago and Sheila Levrant de Bretteville. The three conceived the Feminist Studio Workshop and also "the public center for women's culture," as Raven put it, which they named the Woman's Building.[9] In the Feminist Studio Workshop, "they sought to establish a school that would focus not only on the teaching of artmaking skills, but also on the development of women's identity and sensibility, and the translation of these elements into their art work. Central to the vision of the founders was the notion that art and feminist education should not be separated from the other activities of the burgeoning women's community."[10] The Feminist Studio Workshop began its programs in 1973 when the Woman's Building opened.

The Woman's Building housed the Feminist Studio Workshop, The Center for Feminist Art Historical Studies (Raven and Ruth Iskin); the Women's Graphic Center (de Bretteville); Womanspace, which moved from its original location in an old laundromat; Gallery 707; Sisterhood Bookstore; Associated Women's Press; the Los Angeles Feminist Theatre: Women's Improvisation; and Grandview I and II, like Womanspace also women artists' galleries. The various organizations overlapped and integrated the development of feminist theory with the making and exhibiting of work, thus helping to establish the defining conceptual structure of alternative galleries throughout the decade. Although Chicago moved on to the Dinner Party project after a year, Raven, de Bretteville, and Iskin continued to provide the organizational and ideological energy that made the Woman's Building succeed.

The alternative galleries that were part of the Woman's Building had short lives. Womanspace lasted only eighteen months. Its formation and quick demise provide a case study of the conflicting views that typify the early years of the women's movement in art. Like other alternative gallery and exhibition committee structures, it was antihierarchic. "In its structure Womanspace . . . reflected the belief that leadership should be shared among the artist membership, that it should be rotating, and that no one should be able to wield authoritarian control over the institution. . . . In the beginning, there were many strong, charismatic personalities in leadership positions, but no

real provisions were made in the structure for them to train other women to take their place when their terms were up. Therefore, as in many other 'alternative' institutions, control was eventually taken into the hands of those who committed the most time and made the loudest demands."[11] Another problem was the ideological division between those women who were interested in a radical feminism and women who were reluctant to espouse political views. Conflicting interests and directions left the gallery leaderless, and eventually it closed.

The literary salon was another activity of the alternative gallery and exhibition movement. The Woman's Building organized events that included writers such as Adrienne Rich and Kate Millett. Deena Metzger founded the Women Writers Program at the Woman's Building in 1974. The literary salon was also a feature of the New York scene, with monthly sessions organized by the critic Gloria Orenstein. A typical evening of the literary salon involved a woman reading from new work followed by discussion.

In 1973 ARC and Artemisia galleries were founded in Chicago. The discussions held by Chicago women artists reflected the same doubts that women artists experienced in New York, Los Angeles, or Philadelphia. "Some wondered whether [exhibiting at a women's gallery] would actually hurt rather than help their careers. The fear of stigmatization was especially unfounded since the local arts community had so successfully ignored its budding woman artists. Few had real 'careers' that could be hurt. Founding member Susan Michod remembers yet another fear that 'we wouldn't be able to find enough good women artists, and then great surprise that we had to turn down people.'"[12]

The Chicago artists worked hard to establish their galleries on feminist nonhierarchic principles. In the case of Artemisia, some forty artists gathered to select five core members who were then to choose fifteen additional members. According to Artemisia, some of the group were dissatisfied with the process and split off to form their own gallery, ARC, an acronym for Artist Residents Chicago. The name was consciously chosen as a reference to A.I.R., the first women's cooperative gallery. "A city that for years offered women virtually nowhere to show suddenly boasted two 'all-girl' galleries, as a *Sun-Times* article put it."[13]

In the East, Philadelphia Focuses on Women in the Visual Arts was a project mounted by women artists, curators, and art historians of Philadelphia and its surrounding suburbs in 1973. FOCUS, as it was called, was the brainchild of Diane Burko, an artist teaching at Philadelphia Community College and a veteran of the women's movement in art. Inspired by Cindy Nemser, Burko identified a group of women art professionals in the Philadelphia area who met with her to plan an exhibition of work by women artists that would take place in Philadelphia. The concept of a citywide celebration developed: a steering committee was organized with Diane Burko as chair, with decision-making a group process.[14]

As the members of FOCUS began putting together exhibitions and programs, they used their influence to persuade the institutions at which they were employed to sponsor shows and events. The plan was enormously successful. The participating institutions eventually included major museums, colleges and

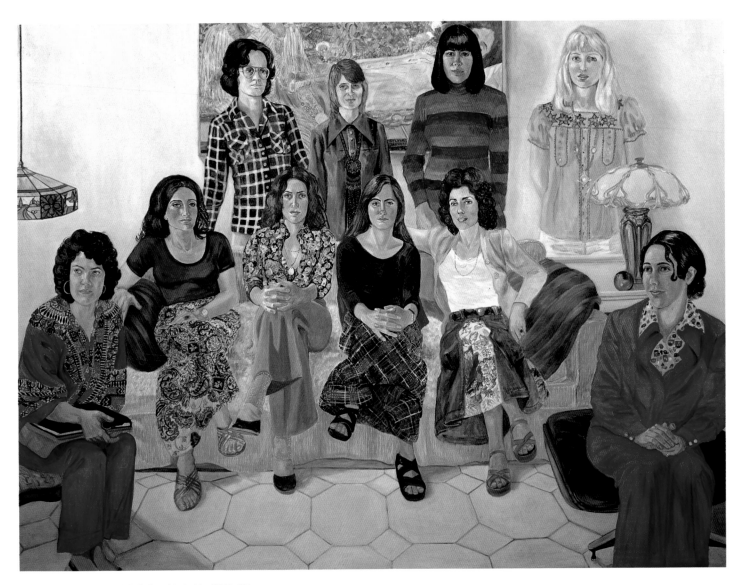

Sylvia Sleigh. *SoHo 20 Gallery* (diptych). 1974. Oil on canvas, each panel, 72 × 96″. Left panel, standing, left to right: Rachel Rolon de Clet, Halina Rusak, Mary Ann Gillies, Suzanne Weisberg; seated, left to right: Marilyn Raymond, Barbara Coleman, Eileen Spikol, Sharon Wybrants, Elena Borstein, Joan Glueckman. Right panel, top row: Sylva Sleigh, Maureen Connor, Marge Helenchild, Lucy Sallick, May Stevens; bottom row, left to right: Eunice Golden, Cynthia Mailman, Rosalind Shaffer, Marion Ranyak. Collection University of Missouri, St. Louis. Gift of Mr. and Mrs. Robert Orchard

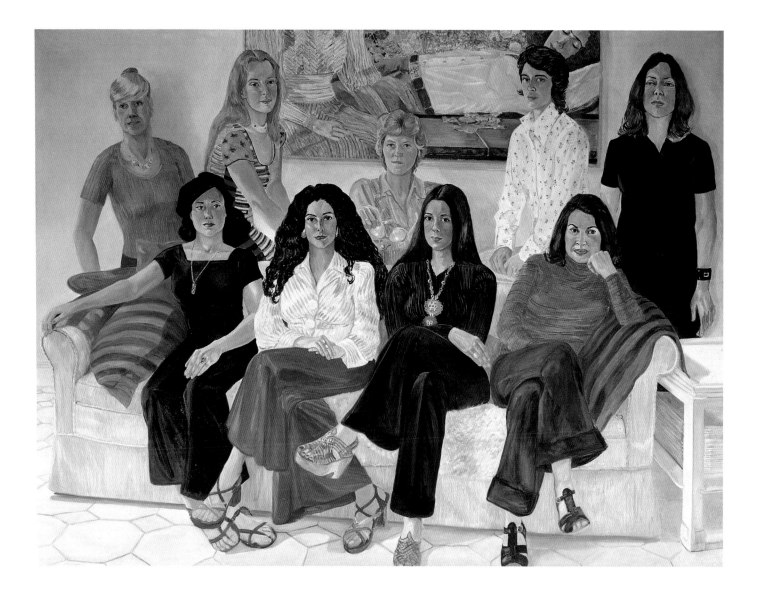

universities, and galleries in the city of Philadelphia and its suburbs, such as the Philadelphia Museum of Art, the Pennsylvania Academy of the Fine Arts, Temple University, the University of Pennsylvania, Moore College of Art and Design, and Beaver College.

But neither the Philadelphia Museum of Art nor the Pennsylvania Academy would host an exhibition of contemporary women artists. The two major contemporary exhibitions, "In Her Own Image," curated by Cindy Nemser, founding editor of the *Feminist Art Journal,* and "Women's Work: American Art 1974," were held at the Samuel Fleischer Art Memorial, a community art center under the administration of the Philadelphia Museum of Art and the Museum of the Civic Center of Philadelphia.

The steering committee of Philadelphia Focuses on Women in the Visual Arts wanted an open, juried regional exhibition at the Museum of the Civic Center, but Marian Aguilera, curator of the museum, wanted an East Coast invitational show. In the hope of opening the exhibition to a more diverse group of artists, the steering committee proposed a selection committee rather than a single curator: Adeline Breeskin, curator at the National Museum of American Art; Cindy Nemser; Anne D'Harnoncourt, then curator at the Philadelphia Museum of Art; Lila Katzen, a sculptor who was active in the women's movement; and Marcia Tucker, then curator at The Whitney Museum of American Art. Each selected twenty artists plus ten alternates, including feminist artists such as Miriam Schapiro, Joyce Kozloff, Audrey Flack, Alice Neel, Sylvia Sleigh, and Nancy Grossman. Other artists were chosen because they were well known rather than for their explicit feminist philosophy: Louise Nevelson, Elaine de Kooning, Louise Bourgeois, Pat Steir. In spite of the stated good intentions of the steering committee to include women of color, they were only represented by two artists well recognized in the mainstream art world, Howardena Pindell and Faith Ringgold. Locally, there was anger because the exhibition included only a handful of Philadelphia artists— Diane Burko, Edna Andrade, Martha Mayer Erlebacher, Eleanor Hubbard, Elizabeth Osborne, and Louise Todd.

The exhibition attracted national press coverage of a sensationalist nature when John Pierron, the director of the Civic Center, removed a drawing by Judith Bernstein from the show because he considered the black hairy "screw" depicted in the drawing obscene.

The various FOCUS events and exhibitions took place in 1974, also the year the alternative gallery movement spread beyond such major urban centers as Los Angeles, New York, and Chicago, in particular with the establishment of Hera in Wakefield, Rhode Island, and Front Range in Denver, Colorado.

"An art gallery in rural Rhode Island seemed to many to be a joke," wrote Valerie Raleigh Yow in *The History of Hera: A Women's Art Cooperative, 1974–1989.*[15] The artists who founded Hera came together through a consciousness-raising group that Elena Jahn, a painter, had helped to establish. Hera, like Womanspace, started out in an abandoned laundromat, which was renovated by the members and their families. Five hundred people from around the state attended the opening. A local newspaper wrote, "A women's art center named after a bitchy Greek goddess and housed in a barn that used to be a laundry is New England's only art gallery completely owned and controlled by women. . . ."[16] Members paid $100 upon joining plus an additional $20 each month; notwithstanding, the gallery often teetered on the brink of financial collapse even though the Rhode Island State Council on the Arts also supplied funds by way of small grants for special projects in the early days, and later on, some operating funds. Like other women's galleries, Hera was nonhierarchical, conceived of as revolutionary by its

Artemisia Gallery, 9 West Hubbard Street, Chicago. Detail of building, 1974

members.[17] Gradually, the sense of revolution waned. The gallery came to be less focused on women and more focused on the community as a whole. Hera began to show the work of men, developed outreach into the community, and made itself a significant cultural center in its area.

Front Range emerged at a retreat organized by three Boulder, Colorado, artists—Fran Metzger, Helen Barchilon Redman, and Michele Amateau—to discuss how women artists could overcome their isolation and solve some of their problems. Unlike other women's galleries that juried prospective members, Front Range was open to any woman artist, the only limitation being a membership no larger than thirty-five people.

The Women's Caucus for Art (WCA) began to mount alternative exhibitions on a national scale when I became the first artist to be president in 1976. The first national exhibition, "Contemporary Issues: Works on Paper by Women," was held in 1977 at the Woman's Building in Los Angeles in conjunction with the first full-blown Women's Caucus for Art conference. Diane Burko and I wanted to mount an exhibition of work by living women artists that would be a contemporary parallel to the Nochlin-Harris historical exhibition, "Women Artists: 1550-1950," which was going to open at the Los Angeles County Museum simultaneously with the College Art Association and Women's Caucus for Art conferences. Arlene Raven, Ruth Iskin, and Sheila de Bretteville agreed to host the exhibition at the Woman's Building, and I approached Ruth Weisberg, who was well established in the Los Angeles art community, to put together an event involving as many galleries in the city as possible.

We invited thirty-seven women from different parts of the United States to propose artists for the show. In addition to East and West Coast representatives like Stephanie Barron, Los Angeles County Museum; Therese Heyman, Oakland Museum;

and critics Lucy Lippard in New York and Jane Holtz Kay from Massachusetts, we invited professors and curators Ellen H. Johnson, Oberlin College, Ohio; Sally Ann Giese, Arizona State University, Tempe; Lee Anne Miller, University of Missouri-Kansas City; and Martha Reesman, University of Michigan, Ann Arbor. We chose feminist artists like Ellen Lanyon, Chicago; Betye Saar, Los Angeles; Miriam Schapiro, New York; Moira Geoffrion, Indiana; Laverne Krauss, Oregon; and June Wayne, Los Angeles, for the selection committee as well. Each curator chose up to six artists.

The resulting exhibition consisted of nearly two hundred artists from more than thirty states. The Museum Programs Division of the National Endowment for the Arts awarded the WCA two thousand dollars toward documentation of the exhibition. Little as it was, we were thrilled that we received any money at all from the NEA. The show traveled to two other venues, the University of Utah in Salt Lake City, which I considered rather astonishing, given the radical nature of the exhibition and the conservative views of Utah, and to the Blaffer Galleries at the University of Houston, where it was the centerpiece exhibition during the Year of the Woman Conference, the United Nations-sponsored event that was also held in Houston.

At subsequent WCA conferences the pattern of mounting national and regional exhibitions in the city of the conference and mobilizing the commercial galleries to show work by women artists became standard. The following year, 1978, when the WCA conference was held in New York, we mounted a national exhibition of work in the materials usually associated with craft, entitled "Clay, Fiber, Metal by Women Artists," held at the Bronx Museum. Elsbeth Woody, a clay artist, and Leora Stewart, a fiber artist, who were both teaching at Baruch College, City University of New York, and Deborah Aguado, a metal artist at

FOCUS panel held at the main branch of the FREE Library, Philadelphia, May 1974. From left to right: Mary Beth Edelson, Ann Sutherland Harris, Diane Burko, Patricia Mainardi. The Marian Angell Boyer and Francis Boyer Library, Philadelphia Museum of Art

Some members of Front Range, Boulder, Colorado. 1984. Back row, left to right: Helen Redman, Linda Herritt, Barbara Baer, Fran Metzger, Cath Murphy, Virginia Maitland, Barbara Takenaga, Marilyn Duke, Margaretta Gilboy; front row, left to right: Meridel Rubenstein, Alice McClelland, Sally Elliott, Sandra Kaplan, Barbara Ball Shark, Virginia Johnson, Geraldine Brussel, Megan Perry. Models: Jerry West, Kevin Baer (baby). Photograph by Meridel Rubenstein

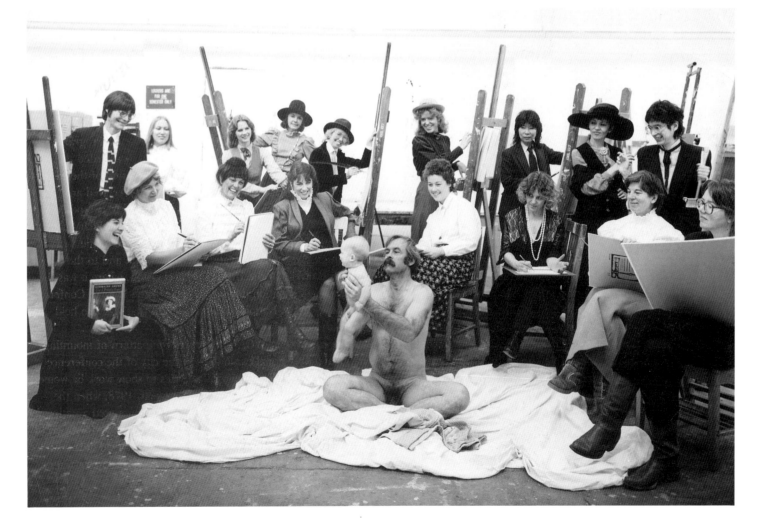

Sheila Levrant de Bretteville. *Eyebolts.*
Diazo printed (edition of 500), 17 × 24".
Announcement poster for the first "Women
in Design" conference at the Woman's
Building, Los Angeles, spring 1974.
Courtesy the artist

Installation view, "Contemporary Issues:
Works on Paper by Women" at the
Woman's Building, Los Angeles, 1977.
Left to right: Audrey Flack. *Weeping
Madonna.* 1977. Lithograph, 34 × 24";
(unidentified); Nancy Grossman. *R to Life.*
1977. Lithograph, 19½ × 26"

The New School, New York, chaired the exhibition. Joan Mondale, wife of the vice president of the United States, officiated at the opening.

The Women's Caucus for Art provided visibility for women artists outside the major art centers through its sponsorship of regional exhibitions. The first regional show was "Women Artists '77, Kansas City Regional Juried Art Exhibition," organized by Lee Anne Miller, then chair of the Art and Art History Department at the University of Missouri-Kansas City, and one of the founding members of the Kansas City chapter of the WCA. Miller invited Miriam Schapiro to jury the exhibition, which attracted eight hundred entries from which one hundred and twenty pieces were chosen for the show. The exhibition was not intended simply to be a collection of work by women artists, but also to show how many women artists were involved in explicit feminist imagery. The second regional exhibition, "Women Artists '78," work by members of Women's Caucus for Art chapters in New York, New Jersey, and Connecticut, took place at the City University of New York Graduate Center in 1978 during the WCA's annual conference. The exhibition was a conscious effort to recognize artists from the suburbs as part of the New York art community. The organizing committee was made up of artists who lived outside Manhattan: Sylvia Pauloo-Taylor, a painter who taught at Suffolk Community College, Huntington, New York; Lucy Sallick, a painter from Westport, Connecticut; and several artists from New Jersey: Joan Webster Price, a sculptor teaching at the City University of New York; Ann Chapman, associate professor, Montclair State College, New Jersey; and two painters, Miriam Beerman and Linda White.

Starting with the Women's Caucus for Art conference in Washington in 1979, the organization mounted a series of exhibitions and ceremonies honoring older women artists, art historians, and curators. The series, "The Women's Caucus for Art Honor Awards for Outstanding Achievement in the Visual Arts," was initiated by Lee Anne Miller, who was the fourth president of the WCA. The first to be honored were Louise Bourgeois, Selma Burke, Alice Neel, Louise Nevelson, and in absentia, Georgia O'Keeffe. Through the efforts of Miller, assisted by Washington artists like Charlotte Robinson and Ellouise Schoettler, the ceremony was presided over by President Jimmy Carter and Mrs. Carter at the White House. The Women of Honor exhibitions and awards became a significant aspect of Women's Caucus for Art activities. While the awards and exhibitions originally honored artists, they were quickly expanded to honor women art historians and curators as well.[18]

The first exhibition with an art-historical theme mounted by the WCA was "Women Artists in Washington Collections," shown during its Washington, D.C., conference in 1979. The exhibition was organized by Josephine Withers, a professor of art history at the University of Maryland, and held at the University of Maryland Gallery. It was originally titled "Up from the Vaults," but that title proved to be too confrontational. Loans were not forthcoming. The title was changed to the more neutral one above, in order to proceed with the show. A catalogue, partially funded by the National Endowment for the Arts, documented the exhibition and also documented a second exhibition, "Her Feminine Colleagues," based on the Frances Benjamin Johnston collection of work by women photographers active around 1900, who were Johnston's contemporaries.

Alternative galleries continued to sprout up in the late 1970s. The Washington Women's Art Center was founded in 1975; Women's Art Registry of Minnesota (WARM) was established in Minneapolis in 1976; both MUSE in Philadelphia and Center Gallery in Carrboro, North Carolina, appeared in 1977.

The Washington Women's Art Center was established by a group of artists, writers, and art historians who had been involved with the Washington Women's Conference at the Corcoran in 1972—Barbara Frank, Ann Slayton, Katherine Butler, Janice Goodman, Sarah Hyde, and Josephine Withers. It opened its space in 1976 and remained in existence until 1989.

The center's involvement with international women's events was one of its achievements. Working with other women's groups, particularly the Coalition of Women's Art Organizations, Nancy Cusick, director of the Washington Women's Art Center in 1979, helped to coordinate American participation in the International Festival of Women Artists, held in Copenhagen in 1980 as part of the United Nations Mid-Decade Women's Conference. The festival, organized by a group of American women and directed by Susan Schwalb, was cosponsored by Danish women artists. The conference featured panels on the women's gallery movement in the U.S. and an exhibition of postcard-size art, sent through the mail, by women artists worldwide.

Cusick repeated her efforts in 1985 when the Washington Women's Art Center cosponsored another women's art event, FOCUS INTERNATIONAL, in Nairobi in conjunction with a United Nations conference marking the end of the Decade of the Woman. For the Nairobi event, Cynthia Navaretta, founding editor of *Women Artists News* and first president of the Coalition of Women's Art Organizations, curated an exhibition of work by American women artists including Georgia O'Keeffe, Lee Krasner, June Wayne, Faith Ringgold, Jennifer Bartlett, and Lois Mailou Jones. Another exhibition mounted for the Nairobi conference, "The American Album," was put together by Ellouise Schoettler, executive director of the Coalition of Women's Art Organizations.

WARM was established as a women's gallery in Minneapolis by Hazel Belvo, Susan McDonald, and others artists living and teaching there. WARM closed its gallery operation after ten years, but established a mentor program in 1986 when the gallery closed. The mentor program pairs experienced artist members of WARM with young or emerging artists. Mentors are paid and are required to spend a certain number of hours with their protégées over a two-year period.

MUSE was the idea of Judith Heep, a printmaker in Philadelphia, who proposed establishing a gallery that would be affiliated with the local Philadelphia chapter of the WCA, to show the work of women artists living in the Philadelphia or nearby New Jersey area. Early gallery members included Diana Luks, Ann Sklar, Carol Seitchik, Deborah Ray, Fedra Kosh, Judith Ingram, and Eleanor Allen. The affiliation with the WCA was a good idea at the beginning because it provided MUSE with credibility, although ultimately it proved to be too complex a relationship and the two organizations separated amicably. By

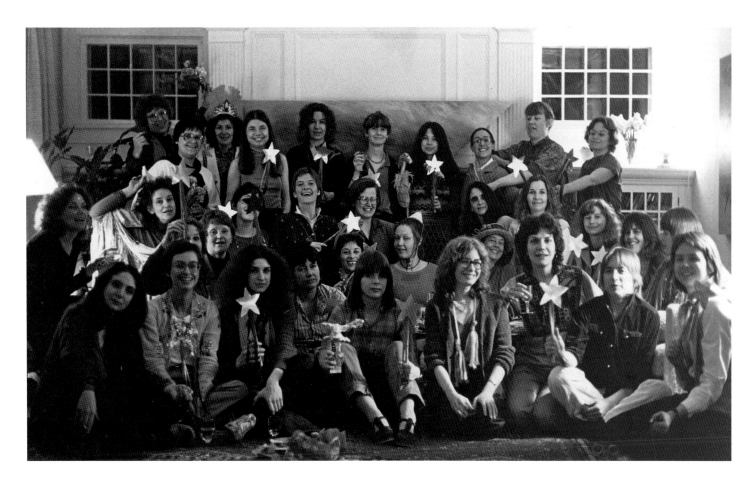

Group photograph of the Women's Art Registry of Minnesota (WARM). 1st row left to right: Terry Becker, Mary Walker, Nancy Robinson, Jantje Vischer, Susan Fiene, Sandra Kraskin, Elizabeth Erickson, Marty Nash, Judy Stone Nunneley; 2nd row left to right: Pat Atmore, Beth Brenner, Carole Fisher, Georgiana Kettler, Marilyn Anderson, Sally Brown, Jane Bassuk, Dorothy Odland, Hazel Belvo; 3rd row left to right: Sam Taylor, Beth Bergman, Cherie Doyle, Susan McDonald, Gemma Cullen, Alice Towle; 4th row left to right: Linda Magozzi, Diane Gorney, Diane McLeod, Judith Roode, Harriet Bart, Patricia Olson, Lynn Ball, Marion Angelica, Joan Tangen, Joyce Lyon

Three of the founders of the Washington Women's Art Center. Left to right: Janice Goodman, Barbara Frank, Ann Slayton

1979 MUSE had grown from the original nine to twenty-one members and a large exhibition of work by the members was held at the Museum of the Philadelphia Civic Center.

Center Gallery in Carrboro, North Carolina, was started by graduate students and faculty at University of North Carolina, Chapel Hill, after hearing Lucy Lippard speak at the university in 1976. Beatrice Schall, one of the students at the lecture, remembers how she and others were inspired to start a women's gallery by Lippard, who talked about the need for women to support each other.[19] The gallery remained a women's space with a feminist mission until 1982 when members decided to admit men. Center Gallery, like Hera in Wakefield, Rhode Island, is now a gallery serving the community as a whole.

The relationship between feminism and diverse cultures became an increasing area of concern among American women artists as the decade of the 1970s drew to a close. In spite of the catalyst role played by black and Hispanic women artists on both coasts in the early part of the 1970s, women artists of color were not an integral part of the planning of alternative exhibitions nor were they deeply involved in the women's galleries discussed here except as occasional members. The galleries or the exhibition committees tried to include women artists of color, but usually at a point when the planning was already complete. A.I.R. mounted "Dialectics of Isolation, An Exhibition of Third World Women Artists of the United States," in 1980. The show included Judith F. Baca, Beverly Buchanan, Janet Olivia Henry, Senga Nengudi, Lydia Okumura, Howardena Pindell, Selena Whitefeather, and Zarina. In 1988 the Women's Caucus for Art sponsored "Coast to Coast: A Women of Color National Artists Collaborative Book Exhibit," coordinated by Margret Gallegos, Faith Ringgold, and Clarissa Sligh. There were other exhibitions and programs as well, but the racial gap was difficult to close, and women artists of color continued to feel that "American Feminism is basically a white middle class movement," as Ana Mendieta wrote in the introduction to the "Dialectics of Isolation" catalogue.

One of the organizations most successful in promoting diversity is The Center for Women and Their Work, an arts center in Austin, Texas, organized by Rita Starpattern, Deanna Stevenson, and Carol Taylor. The city of Austin is culturally diverse with large Latino/Latina and American Indian populations. Like the other galleries and exhibitions discussed in this chapter, its mission is to promote the interests of all women artists, but it also actively sought diversity in its statement of purpose. In 1979, Women and Their Work organized the first statewide exhibition of women artists held in Texas, juried by Marcia Tucker, director of The New Museum of Contemporary Art, New York.

Other racial groups besides African-Americans and Latinas began to organize alternative exhibitions in the late 1970s. Efforts by Asian-Americans have resulted in the establishment of a national group called Godzilla, whose goals are more focused on racial than gender visibility and which sponsors exhibitions and publishes a newsletter.

The New York Feminist Art Institute, a women's art school, was launched in 1979. Its history shows what happened when the early excitement of feminism wore off and the conservative political climate of the 1980s set in.

The first meetings to establish a New York art school with a curriculum based on feminist theory took place in 1976 when women artists came together to form the *Heresies* collective. The group broke up into two subgroups, one of which went on to found the magazine, *Heresies,* and the other which was interested in formng a school. When the original school group fell apart (they had become more interested in the magazine), Nancy Azara, Carol Stronghilos, Irene Peslikis, Lucille Lessane, and Selena Whitefeather became the prime movers. Betsy Damon, who had mounted a feminist art program for one year at Cornell University in 1973, and Miriam Schapiro were key figures in shaping the philosophy of the full-time program. The emphasis was on journals, exploring one's own experience as a woman, and finding direction as a woman artist rather than development of a particular style. In the beginning, Schapiro and Stronghilos ran the full-time, two-year core program while Azara organized the part-time evening program. When the New York Feminist Art Institute opened, women came from all over the country as well as from New York to enroll in the program.

It quickly became apparent that income from tuition was not going to cover the cost of a full-time program. The directors made a decision to concentrate on the part-time program, and Schapiro and Stronghilos left. But the next year, the directors approached the Ford Foundation for funds to reinstitute the full-time program. Funds were ultimately granted and the institute undertook the full-time program again, this time under the direction of painters Catherine Allen and Linda Hill, with contributions from Darla Bjork and Judith Chiti.

The New York Feminist Art Institute flourished during the early 1980s. In 1983, seeking to reach a broader audience in a period of conservatism and backlash, the directors changed the name to New York Feminist Art Institute, Women's Center for Learning. Nevertheless, in the late 1980s, enrollment and interest dropped off.

By the end of the decade, the financial situation had become dire. Even with a donated space, the institute was finally forced to close its doors in 1990. But the New York Feminist Art Institute had impact through both its curriculum and its exhibitions. It functioned as the hub of a network of feminist artists in the 1980s, when feminism in the visual arts began to decline.

The conservative backlash of the 1980s was the background for the establishment in 1987 of the Museum of Women in the Arts in Washington, D.C., by Wilhelmina Holladay. During a trip to Europe, she and her husband had bought a still life by the seventeenth-century Flemish artist Clara Peeters, and became interested in building a collection of women artists. In 1981, Holladay decided to establish a women's museum to house the collection. A landmark building, the Masonic Temple, became the site for the new museum. On permanent display would be the Holladay collection, which included a range of women artists from Peeters and Lavinia Fontana, a sixteenth-century Italian painter, to a number of twentieth-century modern and contemporary works by such important painters as Georgia O'Keeffe, Lee Krasner, Helen Frankenthaler, May Stevens, and Dotty Attie, and sculptors Dorothy Dehner, Eva Hesse, Alice Aycock, and Nancy Graves. Holladay's plans also included a program of changing exhibitions by contemporary women artists.

The Museum of Women in the Arts could have been viewed as the ultimate alternative exhibition space—a permanent monument to the accomplishments of women artists. But the dream burst when a conflict in ideology arose, brought about by a hostile reaction from feminist artists, art historians, and critics. They objected to the conservatism of Holladay's public statements that work addressing social and political issues, such as abortion or homosexuality, had no place on the walls of museums. And they were also angry and suspicious because Holladay had rejected any alliance with them. Instead she identified herself with women in Junior Leagues, women's clubs, and corporate positions. The feminist art community viewed Holladay and her supporters as traditionalists who were cashing in on society's changing views of women, but who themselves refused to speak out for change or recognize the efforts of women who did speak out. To feminist women in the visual arts, the irony of having a radical idea proposed and espoused by a woman with conservative politics completely undermined the concept of the museum.

Another objection to the museum was that it would ghettoize women artists. The old argument was raised that a museum devoted to the work of women artists would provide an excuse for mainstream museums to avoid buying more work by women. Feminists also joined in the criticism that a museum that accepted work on the basis of gender would end up being mediocre because there would be no standards of quality. This objection was ironic since "quality" had, for so long, been seen as a device for exclusion of women artists from the mainstream art world. In spite of its voiced hostility, the feminist community was at heart ambivalent. No one wanted to go on record as categorically opposed to the establishment of the museum. Such opposition was ideologically insupportable.

Ignoring the controversy, Holladay went ahead with her plans and was enormously successful. Even at the height of the women's movement in art during the mid-1970s, women associated with feminism had trouble raising the most meager of funds. In contrast, Holladay, as a prominent Republican married to a high-level corporate executive, was able to attract contributions of $17 million from corporations and wealthy individuals to renovate the Masonic Temple and endow the museum. She also built a nationwide paying membership of 50,000.

The alternative gallery and exhibition movement originated when artists decided to take their own destinies in hand rather than wait to be discovered by the mainstream art world. The efforts of women artists to bring about these exhibitions and galleries knew no limits. Always poorly funded and on the edge of financial collapse, the alternative exhibitions and galleries were supported by women themselves who made up the difference by using their own resources, both financial and personal. But there were limits to their resources. Support did not increase over the years. Instead, with the development of the conservative politics of the 1980s and attacks on feminism, it diminished. Many of the galleries discussed here continued to exist after the 1970s, but their missions changed. They abandoned their radical feminist edge and became support centers for emerging artists and cultural activity centers for their communities. Some viewed the change as an extension of feminist ideas; others saw it as a dilution.

Did the alternative exhibition movement result in fame and fortune for the women artists involved? For a handful, yes. But the significance of the movement as a whole is broader. The various exhibition venues of the alternative art movement made feminist imagery of even the most radical nature visible to the art world, it provided a model for other groups outside the mainstream to emulate in making their presence felt, and it entered women as makers into the history of art.

Convocation for Women's Caucus in Art, coalition of women's art organizations, New York City conference, 1978. Left to right: Carol Bellamy, Judith Brodsky, Joan Mondale. Collection of the Minnesota Historical Society

WRITING (AND RIGHTING) WRONGS: FEMINIST ART PUBLICATIONS

BY CARRIE RICKEY

"There never was a man who said one word for a woman but he said two for man and three for the whole human race."

—*Olive Schreiner,*
"The Story of an African Farm" (1884)

"If we women don't begin to write ourselves into history, who will?"

—*Joan Braderman, "Juggling the Contradictions"*
in Heresies *(1976)*

A sampling of feminist magazines: *Feminist Art Journal*, the Great Goddess special issue, *womanart*, *Heresies*, *Chrysalis*

Imagine, if you will, a far-flung network of moles, each tirelessly burrowing underneath a cultural landscape that spans from the Los Angeles County Museum of Art to the Whitney Museum in New York. The moles may not be entirely aware of it, but after several thousand of them individually put in a decade or so of subterranean overtime, it appears that together they quite literally made an imposing mountain range out of vigorously displaced earth. Never again would anyone dare to regard their peaks as an insignificant patch of molehills. And while excavating the buried history of women's achievements, these moles also tunneled new communications routes that would anticipate the paths of art and intellectual inquiry for years to come. The result was nothing less than a massive reconfiguration of American art.

The moles, of course, are the many feminist artists, historians, critics, chroniclers, and theorists who, during the 1970s, created a thriving cultural network that, despite the demise of many venues and outlets, continues to influence the discourse about—not to mention the practice of—art well into the 1990s. It is not overstatement to say that one of the best predicters of American art during the 1980s was the feminist art press of the 1970s, which fired upon the dominant modernist canon well before the mainstream periodicals dared, and suggested other aesthetic and political alternatives.

In newsletters and reviews as different in frequency and texture as the monthly *Women Artists News*, the quarterly *Feminist Art Journal*, those quasi-quarterlies *Chrysalis* and *Heresies*, and the semiannual *Woman's Art Journal*, interviews, manifestos, and questions appeared, presaging the changes in American art.

There is Pat Mainardi, in a 1973 *Feminist Art Journal*, colorfully reclaiming quilts, a woman's handcraft, as "The Great American Art." There is Lucy Lippard, in a 1977 *Chrysalis*, unearthing the connections between women artists and nature, from Frida Kahlo to Ana Mendieta, from Georgia O'Keeffe to Mary Beth Edelson. And there is Mary D. Garrard demanding in a 1978 *Heresies*, "Why is our art history . . . full of virtuous reversals in which a virile, heroic or austere style suddenly replaces a feminine, lyrical or luxurious one . . . Does it never go the other way?"

From the vantage of the mid-1990s, just the right distance if you're farsighted, it appears during the 1970s and 1980s that yes, many feminine and expressive styles of art dramatically replace the virile and impersonal austerity of Minimalism. And to a significant extent, this feminine and expressive style is art by women, much of it first surfacing—in theory, discussion, and reproduction—in feminist periodicals of the seventies.

SURVEYING THE LANDSCAPE, THEN

If you didn't frequent the vanguard American galleries or museums between, say, 1968 and 1978, then you need some color to evoke the period. How's this? Black. White. Gray. The monochrome of Minimalism predominated, from the works on the walls and floors to the walls and floors themselves. For Minimalism dominated architecture too.

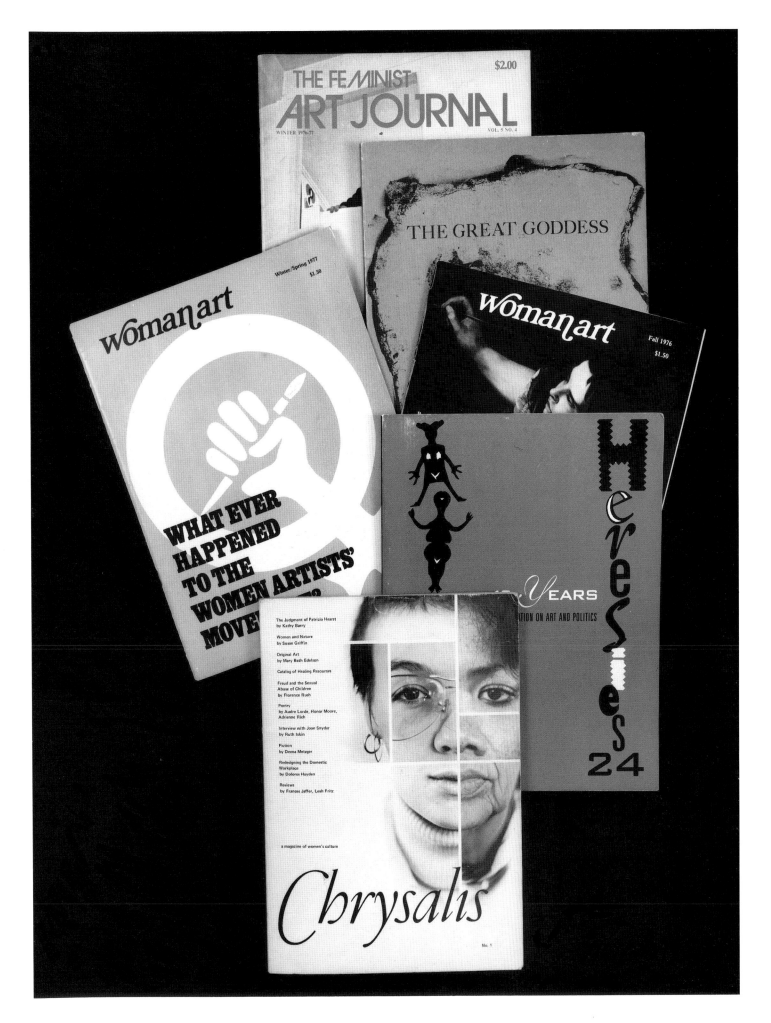

THE FE/MINIST
ART JOURNAL

$2.00

WINTER 1976-77 VOL. 5 NO. 4

THE GREAT GODDESS

Winter/Spring 1977 $1.50

womanart

WHAT EVER HAPPENED TO THE WOMEN ARTISTS' MOVEMENT?

womanart

Fall 1976
$1.50

HeReSieS 24

Years

...TION ON ART AND POLITICS

The Judgment of Patricia Hearst
by Kathy Barry

Women and Nature
by Susan Griffin

Original Art
by Mary Beth Edelson

Catalog of Healing Resources

Freud and the Sexual
Abuse of Children
by Florence Rush

Poetry
by Audre Lorde, Honor Moore,
Adrienne Rich

Interview with Joan Snyder
by Ruth Iskin

Fiction
by Deena Metzger

Redesigning the Domestic
Workplace
by Dolores Hayden

Reviews
by Frances Jaffer, Leah Fritz

a magazine of women's culture

Chrysalis

No. 1

Minimalism was the final stage (or do you call it the last gasp?) of modernism—the belief in the tenet that art had to divest itself of anything not intrinsic to the medium. Thus vanguard art had "evolved" (though to many, "devolved" was more like it) to the point that painting could be merely pigment on unstretched canvas, sculpture could be, like a Carl Andre lead tile, merely the suggestion of a three-dimensional form on a floor. Eliminate anything more, some thought, and you'd have blank walls and spaces to look forward to.

Minimalism, it must be stressed, was not a men's-only club. Along with its most reductivist practitioners Carl Andre and Donald Judd, Sol LeWitt, Robert Morris, and Robert Ryman, the Minimalist ranks also numbered Eva Hesse, Agnes Martin, Michelle Stuart, and Jackie Winsor.

The feminist art press that flourished during the 1970s and beyond was not conceived as an aesthetic antidote to the prevailing theory and practice of Minimalism. Yet it was against the monastic backdrop of Minimalism that antiwar art actions—which would give rise to other art-world political movements, including feminism—were played out. The flatness of modernist canvases and austerity of Minimalism brought art-world politics into the highest possible relief.

In her critical history of the *Feminist Art Journal*, Christine C. Rom perceived that the "increasingly obvious gap between the reform rhetoric of the late 60s and the reality of the traditional view of the sexes spawned the feminist artists' movement much as it had the larger American women's movement."[1]

In New York in 1969, female members of the Art Workers Coalition, appalled to learn that AWC's protests against the art establishment were being waged on behalf of minority men only, splintered off from the group to found Women Artists in Revolution (WAR). (For those who like confirmation that history repeats itself, the AWC/WAR split is an echo of the clamorous nineteenth-century debate between those female abolitionists who believed that feminists should seek the vote for black men first and those who believed that feminists should seek the vote for all women first.)

In a West Coast counterpart to the WAR mobilization, in early 1970, a group of feminist artists calling themselves the Los Angeles Council of Women Artists (LACWA) emerged to protest that no women artists were invited to participate in the "Art and Technology" show at the Los Angeles County Museum of Art. LACWA analyzed the museum's exhibition record, which revealed that of the fifty-three one-artist shows hosted by the museum, only one was dedicated to a woman, photographer Dorothea Lange.[2]

Meanwhile, in 1970, another women's group emerged from AWC, naming itself the Ad Hoc Women Artists' Group. Its agenda: to address the issue of the paltry number of women included in Whitney Annual and in Whitney collections.

On both coasts, the recurring curatorial defense is, "We don't exhibit women artists because there are no significant women artists." Swiftly, an intelligence network/slide registry called the West-East Bag (WEB) was conceived, gestated, and birthed, the result of a lunch among Judy Chicago, Grace Glueck, Lucy Lippard, and Miriam Schapiro, who figure that in order to spread the news of what's happening, the women's art movement needs delegates across the country. The first newsletter, typed on Lippard's manual Remington and photocopied, plants the first seeds of a national movement. Within months, WEB bloomed, with representatives in twelve states and five nations who share information about artists' work, political maneuvers, legal strategies, and discussion ideas. Each month, the WEB newsletter originated from a different city, educating its subscribers about the latest happenings, conducting a census of women faculty at major institutions, maintaining a slide registry so that curators and critics would have a visual data bank of work by women.

Largely as a result of these political actions and intelligence-sharing, the usual 5 percent representation of women artists rises to 22 percent in the 1971 Whitney Annual. But the feminist-art phenomenon in 1971 that exerted the most seismic impact (and still boasts aftershocks some twenty years hence) was the publication of distinguished art historian Linda Nochlin's essay, "Why Have There Been No Great Women Artists?" in the January edition of *ARTnews*.

Nochlin starts out, "If, as John Stuart Mill so rightly suggested, we tend to accept whatever *is* as 'natural,' this is just as true in the realm of academic investigation as it is in our social arrangements: the white Western male viewpoint, unconsciously accepted as the viewpoint of the art historian, is proving to be inadequate."

While there *are* no women equivalents for Michelangelo or Rembrandt, Delacroix or Cézanne, Picasso or Matisse, Nochlin argues, "In actuality, as we know, in the arts as in a 100 other areas, things remain stultifying, oppressive and discouraging to all those—women included—who did not have the good fortune to be born white, preferably middle-class and above all, male. The fault lies not in our stars, our hormones, our menstrual cycles or in our empty internal spaces, but in our institutions and our education. . . ."

Nochlin's argument that historically in most academies women artists could not paint from the nude suggests the institutionalization of inequality. In the way that Kate Millett's voluminous *Sexual Politics* obliges a rereading of all great Western literature as to its implicit assumptions, Nochlin's terse and provocative essay demands a reviewing of the whole of Western art. Though many burrowed before her, Nochlin is the mother mole who displaces the most earth and who challenges other historians, artists, and critics to question their institutions of learning and their received wisdom.

The historical/institutional critique provided by Nochlin's essay swiftly achieved critical mass given the feminist art-world activism already sustaining the Ad Hoc Women Artists' Group, LACWA, WAR, and WEB. . . . Together, these groups conducted the chain reaction from coast to coast. An example: Shortly after the Nochlin article was published, women artists picketed the all-male Corcoran Biennial in Washington, D.C. In atonement, the Corcoran agreed to host a Conference of Women in the Visual Arts the following year. Many participants in this 1972 conclave had previously joined forces to form the Women's Caucus of the College Art Association. And out of all these exchanges of ideas came the publications that took note of, not to mention took off on, the many provocative subjects introduced.

During all this intellectual and social ferment many general feminist periodicals were being founded, from the mainstream *Ms.* to the scholarly *Signs.* Yet though these journals were responsive to literary and social concerns, none was sensitive to the aesthetics and politics of visual representation, which is why the feminist art press truly broke new ground.

It's tempting to think of the Feminist Art movement in terms of a university and the six principal publications that surfaced as different features and courses offered there. The *Feminist Art Journal* was a lively speaker's program spotlighting underknown women painters and sculptors, frequently in an interview format. *Women Artists News* was the all-important bulletin board, listing significant activities, exhibitions, panels, and protests as annotated by their participants and organizers. And *womanart* was the seminar—or do you call it an ovular?—where contemporary art is seen in the context of revisionist art history.

Then there was *Chrysalis*, the interdisciplinary graduate program exploring the confluence of psychology, literature, and art. And *Heresies*, the independent study program devoted to the feminism, art and politics of single themes. Finally, there is the *Woman's Art Journal*, a postgraduate course reexamining art historical subjects from a scholar's perspective. This academy of art publications would define—not to mention alternately embrace and reject—many feminisms.

In fact, the most important of the first wave of publications was born of the schism between the cultural feminists and Marxist feminists working on the short-lived *Women and Art* quarterly, which published two issues, c. 1971–72.

THE FEMINIST ART JOURNAL

"As in the case of many outgrowths of the women's movement, the *Feminist Art Journal* was a product of collective need and individual determination," wrote editor-in-chief Cindy Nemser in a 1974 edition of the Brooklyn, New York-based quarterly that was published from 1972 to 1977.

The collective need was that of art historian Nemser and of painters Pat Mainardi and Irene Moss, all refugees from the cultural wars at *Women and Art.* Its three founders established the *Feminist Art Journal* (*FAJ*) in April 1972, with these stated goals:

1) To be the voice of women artists in the art world;
2) To improve the status of all women artists;
3) To expose sexist exploitation and discrimination.

However well intentioned, the first two ideals would not be realized during *FAJ*'s five years and the third would be only intermittently addressed.

Christine C. Rom, a historian, correctly observes in her essay "The Feminist Art Journal: One View," that "*The Feminist Art Journal* recorded the formative years of the women's art movement, especially as it developed on the East Coast."[3] For this, it remains a necessary resource.

Pat Mainardi's landmark article on quilts, Martha Davidson's essay on Paula Modersohn-Becker, and Cindy Nemser's informative interviews with working artists as generationally and aesthetically far-flung as Diane Burko, Sonia Delaunay, and Louise Nevelson made *FAJ* a publication of unusually broad range. You might say that the *Journal* was a bold crazy quilt of ideas and subjects, which virtually stood alone among art publications during the 1970s in that it deemed representational art and work based on personal experience (Diane Burko, Janet Fish, and Audrey Flack) worthy of serious discussion at a time when such work was not being discussed in the mainstream art press.

FAJ introduced a consideration of Renaissance patroness Marie de' Medici as a tastemaker and history shaper. Ditto a profile of Vinnie Ream, who in 1866 became the first woman commissioned by the U.S. government to do a sculpture (its subject was Abraham Lincoln, who befriended the young artist before his assassination). Likewise, *FAJ* published Toni Flores Fratto's meditation on the aesthetics and literature of samplers.

And it didn't limit itself only to the fine arts: *FAJ* was among the first publications to consider the emergence of women filmmakers, including dancer-turned-director Yvonne Rainer and documentarian Amalie Rothschild. It resurrected the careers of architects Marion Mahony Griffin and Eileen Gray. And it also celebrated women writers, from vanguardist Dorothy Richardson to pop goddess Erica Jong.

Yet in trying to achieve its stated goal of being *the* voice of women artists, *FAJ* was not always prepared to listen to *all* the many feminist voices in the art world. After *FAJ*'s first three quarterly issues, Pat Mainardi and Irene Moss left to pursue their painting careers and the dominating voice became that of editor Cindy Nemser. Nemser and her husband, Chuck Nemser, who eventually became coeditor, kept *FAJ* going from the fall of 1973 to the summer of 1977. While after Mainardi's and Moss's exit many *FAJ* essays demonstrated continued excellence, Nemser's own editorials and interviews grew increasingly personal in their point of view. When Nemser's *Art Talk*, a useful collection of interviews with twelve women artists was published, *FAJ* ran a review (by artist Fay Lansner) describing it as "a bolt of lightning into the male art establishment." In time, as Nemser's own stature and reputation grew, she could be seen as the Barbara Walters among art interviewers, conferring stardom on her subjects—and vice versa.

Interestingly, Nemser is among the first in the women's movement to challenge Judy Chicago's "central cavity" thesis about women's art, more popularly referred to as "cunt art." In the Winter 1973-74 issue of *FAJ*, Nemser argues that Chicago's case for an intrinsic female imagery is simplistic and reductive. In dismissing Chicago as a narrow-minded theorist, Nemser closed the case and preempted real dialogue, proving, perhaps, the narrowness of her own view. And thus letting the discourse take place outside the pages of *FAJ*.

WOMEN ARTISTS NEWSLETTER/ WOMEN ARTISTS NEWS

A prolific chronicler of these feminist debates was photographer and erstwhile *FAJ* contributor Judy Seigel, who with Cynthia

Navaretta cofounded the monthly *Women Artists Newsletter* (*WAN*) in 1975. Over the years, it would subsequently streamline its name to *Women Artists News* and its schedule to bimonthly and then quarterly before ceasing publication in 1991.

In fact it was Seigel, in her capacity as reporter for *WAN*'s godmother the *Women in Art Newsletter*, who characterized the catch-22 of a female aesthetic. In reporting a 1975 lecture by art critic Harold Rosenberg, Seigel noted that he was quick to deny that there existed art typical of women, because if it did exist it could be used both for and against women. Rosenberg, Seigel wrote, made "an analogy with the question of a Jewish art. An anti-Semite says there's a Jewish art. That's anti-Semitic. Another anti-Semite says there's no Jewish art. That's anti-Semitic too!"[4]

Although *WAN* was, as Navaretta jokes, "just a Mom'n'Mom shop," a modest mailer jam-packed with listings and reports from panels, exhibitions, and informational roundups, this bulletin board of the art world performed the important service of recording the evanescent, jotting down the ideas tossed around in public.[5]

WAN was an almanac dotted with unexpected aperçus (a personal favorite: "Art Education—Is it Either?") and shoehorned with news you could use, from *who* was showing where, to *how* to enter juried exhibitions to *where* to show, with or without a fee. While during its heyday even many of its faithful subscribers were overwhelmed by *WAN*'s frantically arranged facts and stats, it was inclusive and therefore has proven to be historically indispensable.

Precociously anticipating the "infotainment" orientation of postmodern journals, *WAN* may very well have invented Headline News. It provided editorialettes and featurettes about what was on the minds of women artists, be it a criticism of H. W. Janson's *History of Art* for including zero female artists (May 1978) or an invitation to Third World women artists to hold a forum on its pages (December 1978) or a stream-of-conscious meditation on how to battle sex discrimination on art faculties (September/October 1979).

As early as 1978, *WAN* perceptively editorialized that if women artists were going to be written up in art histories such as Janson's, then they had to be bought by collectors and museums. *WAN* called for "a new matronage" to hasten the process and lauded many female art collectors, criticizing others whose collections were exclusively male.

Another of *WAN*'s important features was that it paid attention to real politics, chronicling the women artists who went to Washington to lobby for better National Endowment for the Arts funding of women's alternative-exhibition spaces.

Given its typical eight-page format, *WAN* didn't have the space to delve deeply into any subject. Yet it was the women's art journal early proposing the questions—from whether there is a feminist aesthetic to whether the National Museum for Women in the Art was a good or a bad phenomenon—that feminist artists, critics, and historians would subsequently ponder in depth elsewhere. While other feminist journals came and went, *WAN* proved remarkably durable and enduring. Although it ceased publishing as a newsletter in 1990, *WAN* publishes an annual book review which is indispensable.

Less than a decade after the women artists' movement was officially born in 1969, *womanart,* an exemplary Brooklyn-based quarterly founded by Ellen Lubell in 1976, devoted much of a 1977 edition to the question, "What Ever Happened to the Women Artists' Movement?"[6]

In this issue, feminist historian and painter Pat Mainardi noted, "Those of us who were 'women' artists in the late 1960s had no future." Implicit in Mainardi's statement was that in its activism and revisionist look at the past, the women artists' movement had rewritten the history of women artists in order to give contemporary women artists a future.

Womanart, the spiritual daughter of *FAJ*, dedicated itself to women's art past and present. Its first issue (Summer 1976) has essays on "Gertrude Stein and the Making of Modern Art" as well as an update on the current attempts to improve one temple consecrated to modern art: "Erasing Sexism at MoMA."

A careful balance of the historical and the current, a typical *womanart* would publish Barbara Cavaliere's excellent reconsideration of baroque painter Artemisia Gentileschi (Fall 1976, Winter/Spring 1977) as well as a sensitive examination of Dotty Attie's contemporary reinvention of portraiture and self-portraiture (Fall 1976).

Printed on slick paper (as was *FAJ* during its final years) and carrying gallery advertisements, *womanart* was the first feminist art publication to consistently boast the ready-for-newsstand look and professionalism of the mainstream art press. Also like *FAJ*, *womanart* published essays by male historians and critics.

Admittedly, *womanart* rarely published anything that would be potentially divisive in the women artists' movement. In order to provide a forum to bring women together, it tended to steer clear of the "central cavity" aesthetic and the cultural feminist versus socialist feminist disputes that were beginning to separate the women from the gals.

Yet it was *womanart* that polled feminist artists and historians to critically gauge the impact of the women artists' movement. Historian Linda Nochlin would note that women artists were making innovations in resisting a "reductivist formalist direction" and have turned to a kind of "proliferating, rich, decorative and colorful abstract painting," which she thought "definitely connected . . . to the impact of the women's movement."[7] While Nochlin was explicitly referring to Pattern and Decoration artists such as Mary Grigoriadis, Valerie Jaudon, Joyce Kozloff, and Miriam Schapiro, might she also have been thinking of Jennifer Bartlett, Elizabeth Murray, and Susan Rothenberg, whose works similarly juggle the contradictions of abstraction and representation?

And it was *womanart*, in a significant Winter 1977/78 interview with realist painter Joan Semmel, that published the artist's meditations on recurring themes in women's art. Semmel provocatively argued, "The constant recurrence of self-images and autobiographical references in women's art has paralleled feminist preoccupation with the connections between the personal and the public . . . The depersonalization, anomie and alienation, so much a part of men's world, are balanced in women's by intimacy and connectedness."

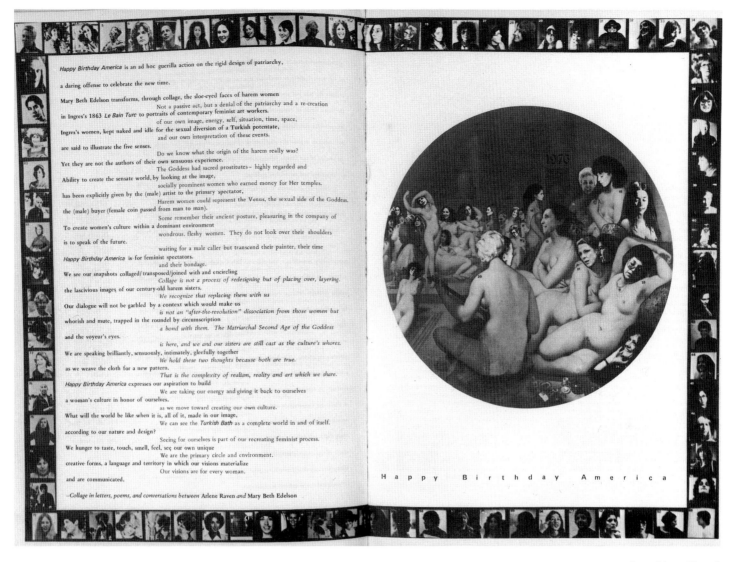

Happy Birthday America is an ad hoc guerilla action on the rigid design of patriarchy,

a daring offense to celebrate the new time.

Mary Beth Edelson transforms, through collage, the sloe-eyed faces of harem women

Not a passive act, but a denial of the patriarchy and a re-creation

in Ingres's 1863 *Le Bain Turc* to portraits of contemporary feminist art workers.

of our own image, energy, self, situation, time, space,

Ingres's women, kept naked and idle for the sexual diversion of a Turkish potentate,

and our own interpretation of these events.

are said to illustrate the five senses.

Do we know what the origin of the harem really was?

Yet they are not the authors of their own sensuous experience.

The Goddess had sacred prostitutes – highly regarded and

Ability to create the sensate world, by looking at the image,

socially prominent women who earned money for Her temples.

has been explicitly given by the (male) artist to the primary spectator,

Harem women could represent the Venus, the sexual side of the Goddess,

the (male) buyer (female coin passed from man to man).

Some remember their ancient posture, pleasuring in the company of

To create women's culture within a dominant environment

wondrous, fleshy women. They do not look over their shoulders

is to speak of the future.

waiting for a male caller but transcend their painter, their time

Happy Birthday America is for feminist spectators.

and their bondage.

We see our snapshots collaged/transposed/joined with and encircling

Collage is not a process of redesigning but of placing over, layering.

the lascivious images of our century-old harem sisters.

We recognize that replacing them with us

Our dialogue will not be garbled by a context which would make us

is not an "after-the-revolution" dissociation from those women but

whorish and mute, trapped in the roundel by circumscription

a bond with them. The Matriarchal Second Age of the Goddess

and the voyeur's eyes.

is here, and we and our sisters are still cast as the culture's whores.

We are speaking brilliantly, sensuously, intimately, gleefully together

We hold these two thoughts because both are true.

as we weave the cloth for a new pattern.

That is the complexity of realism, reality and art which we share.

Happy Birthday America expresses our aspiration to build

We are taking our energy and giving it back to ourselves

a woman's culture in honor of ourselves.

as we move toward creating our own culture.

What will the world be like when it is, all of it, made in our image,

We can see the *Turkish Bath* as a complete world in and of itself.

according to our nature and design?

Seeing for ourselves is part of our recreating feminist process.

We hunger to taste, touch, smell, feel, see our own unique

We are the primary circle and environment.

creative forms, a language and territory in which our visions materialize

Our visions are for every woman.

and are communicated.

—Collage in letters, poems, and conversations between Arlene Raven *and* Mary Beth Edelson

H a p p y B i r t h d a y A m e r i c a

Spread from *Chrysalis*

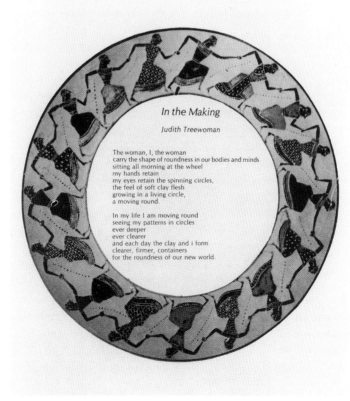

In the Making

Judith Treewoman

The woman, I, the woman
carry the shape of roundness in our bodies and minds
sitting all morning at the wheel
my hands retain
my eyes retain the spinning circles,
the feel of soft clay flesh
growing in a living circle,
a moving round.

In my life I am moving round
seeing my patterns in circles
ever deeper
ever clearer
and each day the clay and i form
clearer, firmer, containers
for the roundness of our new world.

Art and poem from Great Goddess
issue of *Heresies*

CHRYSALIS

Perhaps the reason there was no climactic showdown between the so-called cultural feminists and the so-called socialist feminists is that, on opposite coasts, each group founded her own magazine, the first volumes appearing in early 1977.

The cultural feminist publication was *Chrysalis*, a quasi-quarterly[8] published in Los Angeles. It was so christened, recalled managing editor Kirsten Grimstad, in order to evoke "the metamorphosis of the caterpillar as a metaphor for women's transformation from earthbound creature into a . . . winged symbol of freedom and untamed grace."[9]

Endowed with a small grant from Adrienne Rich—the royalties from her book *Of Woman Born*—the editorial board proceeded. The board included designer Sheila Levrant de Bretteville, whose airy layouts and creative illustration were at least a decade ahead of their time, along with art historians Arlene Raven and Ruth Iskin. These three catalysts behind the Feminist Studio Workshop were joined by East Coast refugees Grimstad and Susan Rennie, publishers of a now-legendary women's alternative catalogue.

Dedicated broadly to "women's culture" rather than narrowly to women's art, *Chrysalis* from its first issue opened up the feminist art discourse. Ruth Iskin's interview with Joan Snyder—dynamically collaging the Q-and-A with Iskin's running critical commentary much the way Snyder collaged found objects with her painted commentary—is a landmark article anticipating by a good three years the "Neo-expressionism" that would later sweep the art world.

Equally ahead of its time is Florence Rush's "The Freudian Cover-Up," which carefully examines Freud's abandonment of his seduction theory. In this ground-breaking piece (which would later be popularized by Freudian revisionists such as Alice Miller and Jeffrey Masson), Rush proves that the father of psychoanalysis couldn't cope with the fact that many of his female patients were actually the victims of sexual abuse during childhood, so he theorized that these women were merely expressing suppressed erotic desires, a theory that for decades permitted analysis to deny the reality of abuse.

The third issue of *Chrysalis* began with poet Audre Lorde's essay on why poems are not luxuries. She encourages us to reject the "European" idea of relying solely on ideas to make us free and exhorts us to "become more in touch with our own ancient, black, non-european view of living . . . to cherish our feelings, to respect those hidden sources of our power where true knowledge and therefore lasting action comes." It was an early admonition against relying on the canons on European art and culture, a preview of the multicultural manifestos that would appear in the mainstream art press during the 1980s.

Also in the same issue there was Janice Raymond's breakthrough article on transsexuals, arguing that "the transsexual merely exchanges one stereotype for the other, thus reinforcing the fabric by which a sexist society is held together." She was one of the first observers to contend that "a society which generates such rigid stereotypes of masculinity and femininity" is the problem. Raymond's essay became one of the landmarks in feminist art debates of the 1980s, about whether gender was

"essential" or "constructed." An impressive profile of performance artist Eleanor Antin in *Chrysalis* issue #8 argued on behalf of art being more inclusive of autobiography and narrative.

Chrysalis maintained consistently high editorial standards, and its book reviews, whether of Ellen Moers's *Literary Women* or Simone Petrement's *Simone Weil: A Life* or Georgia O'Keeffe's *Georgia O'Keeffe,* are extremely learned, eloquent analyses.

The magazine was particularly noteworthy for its historical scholarship: virtually every edition had a piece on feminism's "first wave," gently reminding contemporary feminists that Elizabeth Cady Stanton and Susan B. Anthony had threshed the same grain that their great-granddaughters were now doing. An essay on Ida Harper's and Susan B. Anthony's struggles to finance their feminist newspaper, *The Revolution,* only to be criticized for taking money from politically incorrect sources, obviously reflected the struggles endured at *Chrysalis* to keep the magazine financially afloat during the Carter years of double-digit inflation.

Though *Chrysalis* published its last issue in 1980, its impact on the art landscape is still visible. While magazines such as *Ms.* were publishing articles on how to network, the women involved in *Chrysalis* and *Heresies* were doing it.

HERESIES

"New truths begin as heresies," noted Susan Sontag, whose observation suggested a possible name to a collective of feminist artists, critics, and historians who were meeting in downtown Manhattan, brainstorming plans for a feminist art publication and school.[10]

The first meeting of the group that became *Heresies* was in November 1975 at Joyce Kozloff's loft, its walls lined with her son Niki's giant renderings of cartoon superheroes. Lucy Lippard remembers the occasion as an informal party welcoming Miriam Schapiro back from California. "Mimi came East and said, 'What's going on here?'" Apart from Kozloff, Lippard, and Schapiro, among those present were Mary Beth Edelson, Ellen Lanyon, Joan Semmel, Nancy Spero, May Stevens, Michelle Stuart, and Susana Torre.

At subsequent meetings, they were joined by Joan Braderman, Elizabeth Hess, Arlene Ladden, and Joan Snyder and, following the practice of the feminist movement—by way of the Chinese cultural revolution—they engaged in consciousness-raising and criticism/self-criticism. The first was to define common goals; the second to refine collective practice. A publication could be realized sooner than a school. What would it be like? As Kozloff recalls, "*The Feminist Art Journal* and *Women Artists News* already existed. They had monographic articles about existing artists—we wanted a magazine with ideas."

Thus a journal dedicated to the interconnected issues of feminism, art, and politics was the goal. But despite the socialist-feminist sympathies of many who belonged, the original collective had no women of color. And lesbian feminists, led by Harmony Hammond, had to struggle for inclusion.

The collective was divided as to whether to name the magazine Pink or Heresies; the latter won. The group decided against

accepting a grant from The Playboy Foundation, financing the magazine on subscriptions, grants, and politically correct contributions. It was determined that each issue would be organized around one theme and be produced by an "issue collective" made up of interested members from the "mother collective" plus outsiders. It was conceived as a quarterly, but since between 1977 and 1992 there have been twenty-six rather than sixty issues, let's call it a quasi-quarterly.

With its bold red-and-black cover, the first issue of *Heresies* appeared in January 1977 with each of its contributors—reading like a Who's Who of arts and letters—struggling to broaden the feminist discourse while postulating theories that would, paradoxically, narrow the same. There was Adrienne Rich's provocative "Notes on Lying," Carol Duncan's art-historical analysis of "The Esthetics of Power," and Lucy Lippard's critique of the women artist's movement in America, which she characterized as having "concentrated its efforts on gaining power within its own interest group. . . . The public . . . is hardly considered." Film historian Joan Braderman despaired of articulating a coherent feminist theory of art and politics at a time when "the women's movement seems to have nearly as many political lines as there are women in it."

As artist (and frequent *Heresies* contributor) Martha Rosler described the historical moment, the early 1970s were a time when the unity and energy of the women's movement obviated fine distinctions, but 1977 was a time for "renewed theoretical activity."

Alas, since each *Heresies* issue collective was composed of different women who started from square one, the lack of editorial continuity militated against the journal developing its own theoretical perspective. While this had a downside, the upside was that in teaching themselves to produce a magazine, many artists and critics learned new—and marketable—skills such as design, editing, and proofreading.

Despite its uneven quality (*Heresies* never maintained the consistency of *Chrysalis*), it is the best document of the evolution of feminist art thinking, from 1977 to 1993.

Issue #2 ("patterns of communications among women," May 1977) included an ovular piece by Dolores Hayden, "Skyscraper Seduction, Skyscraper Rape," criticizing the phallocratic profile of the modern metropolis. Filmmaker Lizzie Borden's piece on the contradictions of feminism quoted Federica Montsery to the effect, "To propagate feminism is to foment masculinism, is to create an immoral and absurd struggle between the sexes which no natural law would tolerate. Feminism? Never . . . Humanism? Always." And there was artist Ida Applebroog's prescient piece on humor in women's art, evidence that feminists do laugh.

Issue #3 ("Lesbian Art and Artists," Fall 1977) was a revelation. There was Adrienne Rich talking about "the long process of making visible the experience of women." And Louise Fishman's no-nonsense "Cautionary Advice From a Lesbian Painter," which admonished "against the dangers of purposefully and consciously setting out to make a lesbian or feminist imagery . . . which does not emerge honestly from the rigors of work." To do so would be illustration, not expression, advised this Expressionist artist.

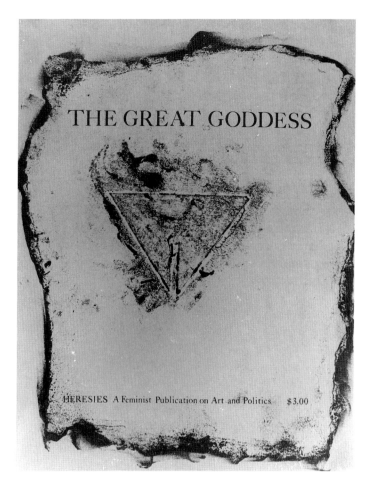

The Great Goddess special issue of *Heresies*, 1978

If Fishman articulated a feminist, Neo-expressionist manifesto, in *Heresies* #4 ("Women's Traditional Arts/The Politics of Aesthetics," Winter 1978) Valerie Jaudon and Joyce Kozloff attacked minimalism and introduced a kind of maximalist thinking in their "Art Hysterical Notes on Progress and Culture." Examining quotations from Adolf Loos and Frank Lloyd Wright, they demonstrated how the language of art history celebrated the pure, the male, the Western and denigrated the eclectic, the female, and the non-Western. Their argument anticipated postmodernist theories at the same time it celebrated embellishment. Also in *Heresies* #4 is Hayden Herrera on Frida Kahlo, a coming attraction of the historian's important biography. Melissa Meyer's and Miriam Schapiro's "Femmage" makes the case that quilts, samplers, and scrapbooks were precursors to art collage and ecological recycling.

Issue #5 ("The Great Goddess," Spring 1978) was a *Heresies* best-seller, a veritable multilcultural textbook in its discussions of the many paths of female spirituality. Mimi Lobell compellingly presented various temples, from Anatolia to Chartres, consecrated to the great goddess. Buffie Johnson and Tracy Boyd knitted together the woven prayers expressed by women from Penelope to the Navajo rugmakers, analyzing the iconography of females as spinners and weavers. Judith Todd's "Opposing the Rape of Mother Earth" literally linked goddess spirituality to ecology in its presentation of the ancient Anasazi structures in Chaco Canyon threatened by strip-mining. Although it is not made explicit in this issue, many of its images of historic sites anticipate the earthwork/sculptures subsequently made by artists such as Nancy Holt, Mary Miss, and Alice Aycock.

While throughout its publishing history *Heresies* included art and essays by woman of all races, for many years the *Heresies* "mother collective" had no women of color. Issue #8 ("Third

Some members of the Heresies collective, at Joan Snyder's farm, 1976. Top row from left: Mary Miss, Joyce Kozloff, Arlene Ladden, Joan Snyder, Patsy Beckert, Elizabeth Hess, May Stevens, Harmony Hammond, Sally Webster, Susana Torre; seated from left: Mary Beth Edelson, Miriam Schapiro, Lucy Lippard, Joan Braderman, Elizabeth Weatherford, Mary Pottenger, Michelle Stuart. Photograph by Mary Beth Edelson

World Women: The Politics of Being Other"), published in 1979, was an important step in making visible women who previously had been invisible in the women's art movement. Although deploring the "racist and maternalistic" attitudes of the all-white mother collective, the Issue #8 collective provided a spectrum of women in the arts. Valerie Harris interviewed filmmaker Chris Choy, theater producer Barbara Ann Teer, artist Camille Billops, and youth service project director and singer Suni Paz. Economist Julianne Malveaux contributed "Three Views of Black Women," an analysis that was cultural, statistical, and personal, which included criticism of *Heresies* for exacerbating women of color's sense of otherness by consigning them to "special issues."

Still publishing in 1993, *Heresies* produced so many issues—devoted to women in architecture, music and the all-important Sex Issue—that it is impossible to detail them all.

The practice of criticism/self-criticism has been productive: Issue #24 ("12th Anniversary," 1989) includes articles by Miriam Schapiro and Faith Wilding discussing the "essentialist" and "deconstructionist" schools of feminism and Lucy Lippard's "Both Sides Now," which attempts to reconcile them. In the same issue is Michele Wallace's excellent "Variations on Negation," in which she challenges Michel Foucault's "What matters who is speaking?" with the answer, "It matters mostly because there is no variety." *Heresies* proved that variety was the essence, not the spice, of art.

WOMAN'S ART JOURNAL

At the same time that *Chrysalis* and *Heresies* were reframing the discourse about contemporary women's art, the semiannual *Woman's Art Journal* (1980–present) was founded, in Knoxville, Tennessee, by art historian Elsa Honig Fine. Disgruntled because *FAJ* and *womanart* had collapsed, Fine saw a continuing need for a journal with the scholarly feminist pieces those journals had pioneered.

"While we are primarily concerned with recording a hidden heritage," Fine wrote in the maiden issue,[11] "we are also interested in a reinterpretation of art history from our new awareness as women. Once consciousnesses have been raised, we cannot use language in the same way."

In the first issue, April Kingsley and Joan Semmel evocatively explored "Sexual Imagery in Women's Art" from Georgia O'Keeffe to Louise Bourgeois, from Judy Chicago and Miriam Schapiro to Mary Frank.

The second issue (Fall 1980/Winter 1981) included a lively essay by Jean McMahon Humez about Anna Mary Robertson Moses, better known as the self-taught painter Grandma Moses. The author brings the commonsensical Moses to life by describing her as "a homespun feminist who advocated women's suffrage on the grounds that women 'have to make a living just the same as men do, so why should they not have a say-so?'" Also in this issue was Janet Kaplan's essay on Mexican painter Remedios Varos, which later became the basis of her scholarly study.

A good example of the kind of offbeat scholarship *WAJ* excels in is Gail Levin's piece on painter Josephine Verstille Nivison Hopper, whose marriage to Edward Hopper effectively ended her career. In contrast to Sophie Taueber-Arp and Sonia Delaunay, artists who continued working after their marriages to artists, Levin characterizes Josephine Hopper as a woman who channeled her energies into advancing her husband's career instead. It is an unusually sensitive piece, aware that spouses such as Josephine Hopper and Alice B. Toklas are, in a sense, collaborators with their more famous partners.

As art historian Richard Martin remarked of *WAJ*, "Its existence reminds us of what we still need to do."

RESURVEYING THE LANDSCAPE

How, you might ask, can we talk about the power of feminist art when the pioneering achievements of so many women artists have been ignored during the backlash of the 1980s?

We can consider it a triumph when we remember that when the *Feminist Art Journal, Women Artists News, womanart, Chrysalis,* and *Heresies* started publication, there was a disjunction between what feminist artists were talking about and what they were seeing in galleries and museums.

But by 1979, what these magazines were addressing *is* what the art-going public was increasingly seeing in work by both women and men. At the 1979 Whitney Biennial, one could see Joyce Kozloff's decorative pilasters and silks hanging near Kim MacConnel's kindred works. At the 1981 Whitney Biennial, there were Joan Snyder's and Julian Schnabel's Neo-expressionist canvases competing side by side. Through the subsequent decade, one could see Susan Rothenberg's figurative paintings as well as David Salle's; ditto Jackie Ferrara's and Martin Puryear's environmental sculptures. In museums and galleries one began seeing Ida Applebroog's compelling social studies—and also Leon Golub's. And by the 1993 Whitney Biennial, there are Alison Saar's meditations on African classicism—and Fred Wilson's.

Although through the twentieth century women artists had been part of vanguard movements, in the 1970s women artists were the vanguard of the vanguard. Thanks in large part to the tireless labors of these indefatigable moles, the modernist mainstream was decisively diverted.

STARTING FROM SCRATCH: THE BEGINNINGS OF FEMINIST ART HISTORY

BY LINDA NOCHLIN

In 1969, three major events occurred in my life: I had a baby, I became a feminist, and I organized the first class in Women and Art at Vassar College. All these events were, in some way, interconnected. Having the baby—my second daughter—at the beginning of the Women's Liberation Movement gave me a very different view of motherhood than I had had back in the middle 1950s when I had my first child; feminism created a momentous change in both my personal life and my intellectual outlook; organizing that first class in feminist art history irrevocably altered my view of the discipline and my place in it, so that all my future production was touched by this originating moment of insight and revision.

It is hard to recapture the sheer exhilaration of that historical moment, harder, perhaps, to remember the concrete details of a conversion experience which, for many women of my age and position, was rather like the conversion of Paul on the road to Damascus: a conviction that before I had been blind; now I had seen the light. In my case, the light had been provided by a friend—just an acquaintance, really—who, shortly after my return from a year in Italy with husband and baby to my familiar job in the Vassar art history department, showed up in my apartment with a briefcase full of polemical literature. "Have you heard about Women's Liberation?" she asked me. I admitted that I hadn't—political activity in Italy, although vigorous, had not been noteworthy for its feminist component—but that in my case it was unnecessary. I already was, I said, a liberated woman and I knew enough about feminism—suffragettes and such—to realize that we, in 1969, were beyond such things. "Read these," she said brusquely, "and you'll change your mind." So saying, she thrust her hand into her bulging briefcase and brought forth a heap of roughly printed, crudely illustrated journals on coarse paper. The pile included, I remember, *Redstockings Newsletter, Off Our Backs, Everywoman,* and many other publications, including special editions of radical news sheets run by men which angry women had taken over for the explicit purpose of examining the conditions of their exploitation. I started reading and I couldn't stop: this had nothing to do with old-fashioned ideas about getting the vote for women and getting men out of the saloons. This was brilliant, furious, polemical stuff, written from the guts and the heart, questioning not just the entire position of women in the contemporary New Left and anti-Vietnam movements (subordinate, exploited, sexually objectified) but the position of women within society in general. And these articles—which touched on every area in which women were involved, from repression at the workplace to oppression at home, from art production to housework—were above all striking in their assertion that the personal was political, and that politics, where sex roles and gender were concerned, began with the personal. That night, reading until two A.M., making discovery after discovery, cartoonish light bulbs going off in my head at a frantic pace, my consciousness was indeed raised, as it was to be over and over again within the course of the next year or so. Or perhaps the right figure of speech is a spatial one: it was as though I kept opening doors onto an endless series of bright rooms, each one opening off from the next, each promising a new revelation, each moving me forward from a known space to a larger, lighter, unknown one.

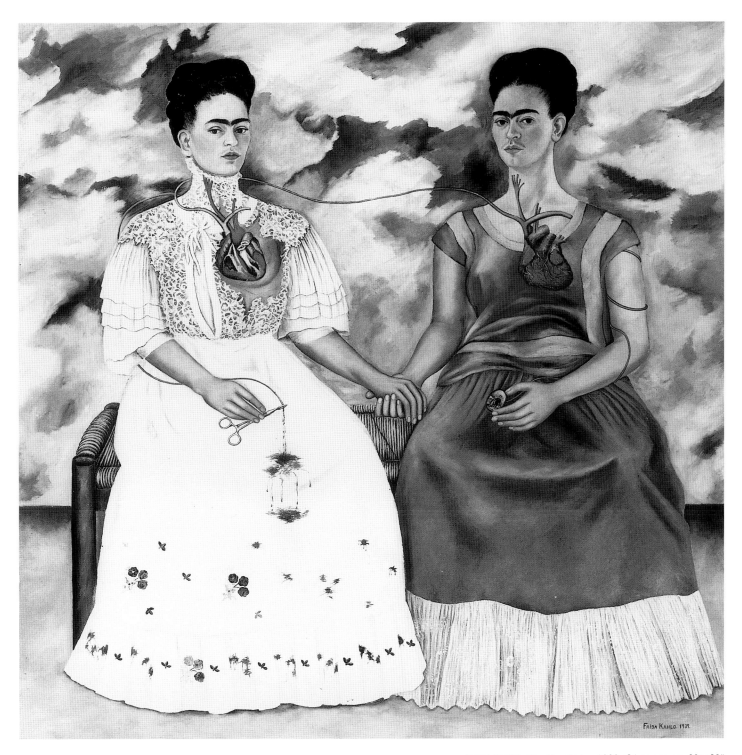

Frida Kahlo. *The Two Fridas.* 1939. Oil on canvas, 69 × 69″.
Museo de Arte Moderno, Mexico City

A few weeks later, or maybe it was a few months, after a certain amount of thought but not much specific research outside of a thorough rereading of Simone de Beauvoir, I posted the following notice on the bulletin board in the art history office at Vassar (I reproduce the announcement and the tentative syllabus exactly as they appeared at the time):

Art 364b
November 25, 1969
I am changing the subject of the Art 364b seminar to:
The Image of Women in the 19th and 20th Centuries. *I have become more and more involved in the problem of the position of women during the course of this year and think it would make a most interesting and innovative seminar topic, involving materials from a variety of fields not generally included in art historical research. This would be a pioneering study in an untouched field. Among fields and areas to be included might be:*

1. Woman as angel and devil in 19th century art
2. The concept of the nude through history with special emphasis on 19th and 20th century (anatomy; must a nude be a female? What is shown and what is not shown)
3. Pornography and sexual imagery
4. The social significance of costume
5. Social realities and artistic myths (i.e. women working in factories and the Birth of Venus *in the Salons)*
6. Advertising imagery of women
7. The theme of the prostitute
8. The Holy Family and the joys of domesticity (imagery of the secular family as nexus of value in bourgeois art in the 19th century)
9. Socially conscious representations of lower class women (almost always in "low" art rather than "high")
10. Freudian mythology in modern art; Picasso and surrealism
11. Matisse and the "harem" concept of women
12. Women as artists
13. The Vampire woman in art and literature (in relation to social, psychological and economic factors)
14. Women in Pre-Raphaelite painting and Victorian literature
Most of this territory—and a great deal more—has never been touched. It would involve work in history, sociology, psychology, literature, etc.

Linda Nochlin Pommer

Looking back from the vantage point of almost a quarter of a century, I am struck by the remarkable combination of ambition and naiveté characterizing the project. Did I really think we could cover all those topics in the course of a single semester? Why did I confine "women as artists" to a single class? (Actually, there were several sessions on women artists in the class as it was taught.) And why was I so fixated on the Vampire woman? Alas, since I have never kept a diary and only minimal evidences of that first seminar remain in my keeping, I cannot answer specific questions about what I had in mind. My fuzziness about these issues is a poignant reminder to historians about the unreliability of witness accounts, especially when the witness is identical with the historian in question. Nevertheless, I am struck by the fact that many of these topics have continued to be of major importance to feminist art historians and critics, and, equally, that they have served as the basis for much of my own work in years to come. Even more amazing, we did, as a class, "cover" all these issues and more, admittedly not with the nuance and wealth of information marking subsequent efforts in these areas, but with a lot of passion, a sense of discovery, and with the knowledge that whatever we did counted; for everything, quite literally, remained to be done. We were doing the spadework of feminist art history, and we knew it.

I say "we" because, in this undergraduate seminar, we were "we": a committed group of feminist or proto-feminist researchers tracking down the basic materials of our embryonic discipline. Although as teacher of the group I had a certain priority in directing the inquiry, I was in many ways as ignorant as my students as far as bibliography or background was concerned: everything had to be constructed from the beginning. We were both inventors and explorers: inventors of hypotheses and concepts, explorers of the vast sea of undiscovered bibliographical material, the underground rivers and streams of women's art and the representation of women. As far as bibliography was concerned, the reading list had to be constructed as we went along. There were no textbooks, no histories of women artists, no brilliantly theorized examinations of the representation of prostitution, no well-illustrated analyses of pornography from a feminist point of view. The concept of the gaze insofar as it related to the visual representation of women had yet to be articulated. Yes, to be sure, there were some outdated and rather patronizing "histories" of women artists like Walter Shaw Sparrow's *Women Painters of the World* (London, 1905), interesting because of its sheer anachronism, serving as raw material for analysis rather than as valid documentation. For raw information, not always accurate, about the nineteenth century and earlier, there was Mrs. Elizabeth Ellet's *Women Artists in All Ages and Countries* (New York, 1858), Clara Erskine Clement's *Women in the Fine Arts* (Boston and New York, 1904), and Ellen C. Clayton's *English Female Artists* (2 vols., London, 1867), none of them illustrated. And luckily for us, since Vassar had been a women's college, there was a rich repository of materials on individual women and their achievements—in the arts as well as in other areas—and a great deal of material about the social position and the problems of women historically. Vassar had had a feminist, as well as a purely feminine, history although this aspect of its past was decidedly low-keyed during the 1950s and '60s, especially since, at the very moment when the Women's Movement was getting off the ground, the college itself was switching from being a single-sex institution to a coeducational one.

Yet in a certain sense, given the specific nature of my own experience of Vassar, where I had been a student (class of 51) and teacher for many years by the time I taught my first class in women and art, I had always been a feminist, albeit a partly unconscious and often confused one. Certainly I believed that I was as intelligent and capable as most of the men I knew, although constantly riven by the self-doubts and pangs of guilt that afflicted smart and ambitious women in those days. I, like

most intellectual women at the time, thought my problems were my own, unique, the products of neurosis or disorganization, not social problems afflicting all women of my sort. Neurosis, not the double message of high achievement coupled with sacrifice of self for husband and family conveyed to intelligent women by the ideological structures controlling gendered behavior, was the reason we were so mixed up, I thought, so often incapable of focusing on intellectual work without pain and conflict. I was exhausted so often, I believed, because I wasn't well-organized enough to juggle housework (admittedly rudimentary, but necessary nevertheless), childcare, husband, teaching, and graduate studies, while also commuting from Poughkeepsie to New York, part time. My graduate "program" consisted of whatever was given at the Institute of Fine Arts on Wednesday afternoon and Saturday morning. If I couldn't manage such a full life (which also included poetry writing, giving and going to fairly lively parties, taking in vanguard theater and dance performances in New York, and playing the recorder with an Ancient Music group), with sufficient calm and expertise, I felt it was because I somehow hadn't figured things out properly. I didn't consider the fact that organized childcare arrangements were nonexistent and that women were supposed to run the household singlehanded even if they were professionals. If I had to correct papers, I felt guilty about not doing research for a seminar report at the Institute; if I worked on the seminar report, I felt haunted by shopping I was neglecting; if I shopped, I felt I wasn't paying enough attention to my child. There was no system of moral or practical support for women like me at that moment in history—just unbounded personal energy and a will to persist under difficult circumstances.

At the same time, however, my Vassar education and my years of teaching gifted women there had given me a profound sense of what women could do, even if they weren't encouraged to do much but Little League and family after graduation. My own work was respected and rewarded, my energy and passionate commitment admired. And in some ways, I had always been interested in the achievements, and problems, of talented women. After all, the first paper I had written in freshman history—awarded the history prize that year—had been about the Fabian Socialist Beatrice Webb. In social psychology, I had produced a "content analysis" of women's magazines, demonstrating their contradictory message about women's roles. I discovered after months of reading *Ladies' Home Journal* and *Good Housekeeping* that despite the fact that achieving women like Mrs. Roosevelt and Dorothy Thompson were featured in their high-minded articles, the fiction section told a different tale: in these emotionally charged stories, professional women were inevitably punished for their ambition and wives and mothers who dedicated themselves to husband and family were always rewarded for their sacrifice as well as winning the readers' sympathy. Then too, the head of the art history department, Agnes Rindge Claflin, had always encouraged women artists. I remember visits and gallery talks from Loren MacIver, Irene Rice Pereira, and Grace Hartigan in the early 1950s, and they were memorable: as a sophomore I had thrust a poem into the hands of MacIver, and as a young teacher I remember being bowled over not just by Hartigan's work, but by her tough, bohe-

mian, unconventional persona. Works by Georgia O'Keeffe, Kay Sage, Florine Stettheimer, Veira da Silva, Agnes Martin, and Joan Mitchell hung in the gallery; a lively woman sculptor, Concetta Scaravaglione, taught sculpture in the studio. Even earlier, in my teens, my mother had shared with me her enthusiasm for women writers like Virginia Woolf, Katherine Mansfield, Rebecca West, and Elinor Wylie.

At Vassar, women were my teachers, respected scholars and intellectuals in their own right. While most of them were a little too tweedy and unglamorous to serve as *exempla* in any sphere but the academic, some, like Agnes Claflin, were elegant, worldly, sophisticated, and a bit wicked as well as brilliant—all characteristics that charmed me, and continue to do so today. All in all, one might have called me a "premature feminist" in many ways before 1969 and my discovery of Women's Liberation. And now my time had come: what I had felt, confusedly, partially, individually, had become a mass movement, passionately articulated in speeches, articles, books, and meetings by ever increasing groups of women, taking inspiration and gaining power from each other, sharing their feelings, their ideas, and their indignation.

By the time Art 364b, "Woman and Art" got underway in January of 1970, there were a few changes and additions to the course: topics became more specific and a rudimentary bibliography had come into being. The reading list was decidedly interdisciplinary and included not only Robin Ironside and John Gere's *Pre-Raphaelite Painters* (1948), Lister's *Victorian Narrative Paintings* (1966), Theodore Reff's "The Meaning of Manet's *Olympia*" (1964), Alfred Barr's *Matisse: His Art and his Public* (1951), and Françoise Gilot's *Life with Picasso* (1964), but Gertrude Himmelfarb's *Victorian Minds* (1968), Havelock Ellis's *Studies in the Psychology of Sex* (1942), Mary Wollstonecraft's *A Vindication of the Rights of Women* (1792), and Mrs. Sarah Ellis's *The Education of Character with Hints on Moral Training* (1856). The seminar included a crash course on nineteenth- and twentieth-century cultural history, sexual ideologies and feminist, as well as feminine, notions of what constituted women's place and identity. Nor was "low" art neglected: the bibliography included Gibbs-Smith's *The Fashionable Lady in the Nineteenth Century* (1960), James Laver's *English Costume of the Nineteenth Century*, Emily Burbank's *Woman as decoration* (1917), as well as several books devoted to advertising and film: E. Jones's *Those were the Good Old Days: A Happy Look at American Advertising* (1959), De Vries's *Victorian Advertisements* (1969), and Alexandra Walker's pioneering *Sex in the Movies* (1966).

Although it is hard to recall the specific features of the class, much less specific students after the passage of time and the repetition of the seminar in various forms in subsequent years, I do remember with great clarity the general air of excitement and enthusiasm that characterized each of its sessions. Students literally fought to give not merely one or two but as many as three class presentations. Discoveries were rife, especially when it came to class presentations on women artists: Frida Kahlo, then relatively unknown to all but a small group of cognoscenti, came to light, as did Meret Oppenheim, known only as the author of the notorious *Fur-Lined Tea Cup* at the Museum of Modern Art, but not known to be a *woman* artist by

Meret Oppenheim. *Object.* 1936.
Fur-covered cup, 4⅜″ diameter;
saucer, 9⅜″ diameter; spoon, 8″.
Collection, The Museum of Modern
Art, New York. Purchase

most of the class. I remember that Donna Hunter, now an art historian at the University of California at Santa Cruz, sent away to Sweden for a recent but obscure exhibition catalogue of Oppenheim's work and revealed to us the richness, variety, and genuine marvelousness—in the Surrealist sense—of her production. "I had thought," Donna wrote to me in her memoir of the class, "with a first name like Meret, that Oppenheim was a man . . . What different interpretations spring to mind when one knows that a woman, in the preponderantly male and male chauvinist world of Surrealism, lined a tea-cup and spoon, symbols of ladylike afternoon rituals, with fur!"

Susan Casteras, another memorable member of the class, now Curator of Paintings at the Yale Center for British Art, remembers that the "tremendous sense of intellectual excitement and expectation that was generated was quite palpable, and those in the class . . . all shared this unspoken and heightened awareness." This was Donna's impression, too: "What I remember most about the seminar was the atmosphere in the room, the high level of energy and enthusiasm—a buzz. Everyone was aware that this was a first: that we as women were working with a woman professor on women artists. . . ." "In retrospect," Susan Casteras explained, "it was a feeling of vicarious empowerment and pride that particularly enthralled us—the idea that women mattered as creators of art and that their efforts, whether frustrated, failed, or successful, were worthy topics to study. . . ." She recalls in the same letter "that several undergraduate presentations were outstanding, and the list of areas covered—demonic and angelic images of women, the concept of the nude, pornography, women workers, prostitution, harems, women artists, the vampire/femme fatale and Pre-Raphaelite feminine prototypes—now reads like a prophetic list of some of the central concerns of scholars of 19th century art in the last 20 years."

In the case of her own work in the class, Casteras, the author of several important books and organizer of at least two major exhibitions about the representation of Victorian womanhood, remembers that one of her reports, "a focus on Victorian courtship imagery, proved to be the germ of my doctoral dissertation and much subsequent iconological research and writing. . . ." Another of her presentations "concentrated on Mary Cassatt and her *Modern Woman* mural (pendant to Mary MacMonnies' *Primitive Woman)* for the Woman's Building at the World's Columbia Exposition of 1893," and resulted in a long senior essay and later, an important article. That senior essay, which I still have on my shelf as a reference work, is an outstanding piece of research about what was then a little-known major achievement of Cassatt's, lost after the exhibition. Donna Hunter has taught courses on art history and feminism and is now working on a project involving a gendered reading of the visual and verbal imagery of the Terror, the martyrs of the Revolution in particular.

But it was not merely the discovery of women artists and their achievements that was exciting. Looking at old themes in new ways was equally revealing: the imagery of the family, especially of mothers and children, was seen in a new light: a comparison of Mary Cassatt's *The Bath* or Berthe Morisot's *The Cradle* with Renoir's *Portrait of Mme. Renoir Nursing Pierre* revealed that it was the male artist's image that was more sentimental, traditional, and clichéd, the women's more emotionally distanced and formally avant-garde. And Dorothea Tanning's hallucinatory image of twentieth-century motherhood, bleak, isolated, preternaturally silent, shredded the myth of essentialist nurturance and benignity entirely, leaving it in Surrealist tatters. Work by such modernist masters as Picasso and Matisse was examined in ways that called into question the whole formalist

apparatus of art criticism and demanded a more critical view of what had formerly been seen as relatively gender-neutral territory. It was not just the iconography of works like the *Demoiselles d'Avignon* or Matisse's harem women that was called into question, but the whole position of the female nude within Western pictorial culture itself. Why were there so few male nudes by women artists and so many female ones by males? What did that say about power relations between the sexes, about who was permitted to look at whom? About who was objectified for whose pleasure?

These issues were pursued at greater length in the introduction I gave to a session on "Eroticism and the Image of Woman in 19th-Century Art" at the College Art Association Meetings in San Francisco in 1972. It was subsequently published as "Eroticism and Female Imagery in Nineteenth-Century Art" in *Woman as Sex Object*, edited by Thomas Hess and myself in the same year, where it was illustrated with the now-notorious photograph of a bearded male nude coyly holding a tray of fruit at penis level, entitled *Buy My Bananas,* created as a pendant to a nineteenth-century female version of the topos called *Buy My Apples.* Today, such critiques may seem obvious, but in 1969 and 1972, when whole lectures or classes could go by without any reference to the specifically sexual qualities of nudes like *Olympia* or Goya's voluptuous naked Maja, discussions of the sexual politics of paintings were anything but self-evident.

I gave the course again in the spring term of 1971, this time in conjunction with one given by Professor Elizabeth Daniels in the English department on women in Victorian literature, a course which again bore fruit (not bananas this time!) in my own work. When I was asked to give the Walter Cook Alumni Lecture at my graduate school alma mater, The Institute of Fine Arts, I decided on a feminist theme, incorporating both the French art, which had always been my field of interest, and the Victorian painting with which I had recently become involved. In this lecture, "Holman Hunt's *Awakening Conscience*: The Theme of the Fallen Woman in Nineteenth-Century Realism," I attempted to reconstruct sexual ideologies through a critical analysis of formal structure as well as iconography in the work of Manet and the Pre-Raphaelites; the talk was unequivocally feminist in its viewpoint. It included not only "fallen women" images from the work of Degas and Hogarth, Augustus Egg and Cézanne, as well as the two featured paintings of the lecture, Hunt's *Awakening Conscience* and Manet's *Nana,* but it juxtaposed misogynistic texts by the Goncourts with feminist ones by John Stuart Mill.

"Woman and Art" surfaced again in a new incarnation at Stanford University during the summer term of 1971. Now the course outline was more complex in its material and more rationalized in its organization; the reading list grouped texts thematically for each class session. There was, in fact, beginning to be a feminist literature in art history and criticism, as well as in many other fields. Looking back, one can see that a discipline, a discourse, and a field of scholarly inquiry was in the making, and one can watch ideas in the process of formulation. Among the texts, some of which were fairly standard art-historical ones, were included such specifically feminist works as: Naomi Weisstein's "Psychology Constructs the Female" from *Women's*

Mary Cassatt. *The Bath.* c. 1891. Oil on canvas, 39⅓ × 26″. The Art Institute of Chicago. Robert A. Waller Fund

Liberation and Literature (1971); my own "Why Have There Been No Great Women Artists?", published that January in *ARTnews* and simultaneously in *Women in Sexist Society* (1971); interviews with Judy Chicago, Miriam Schapiro, and Faith Wilding in *Everywoman; The Victorian Woman: A Special Issue of Victorian Studies*; Lucy Komisar's "The Image of Woman in Advertising," also from *Women in Sexist Society;* and Alex Shulman's "Organs and Orgasms," from the same volume. Students, of course, contributed additional bibliography to the reading list as they prepared their presentations.

The two introductory sessions were devoted to a discussion, based on the reading and slides of the interrelated issues of women in art and women as artists; the third class dealt with the theme of woman in twentieth-century high art: Matisse and the Harem Conception of Women; Picasso, Surrealism, and Freudian mythologies of woman; de Kooning's brutal tactics in his *Women;* Women in Pop Art; pornokitsch. The fourth class was dedicated to nineteenth-century imagery of women. The fifth

Buy My Apples, from a late-19th century popular French magazine. Courtesy Linda Nochlin

Buy My Bananas. 1972. Photograph by Linda Nochlin

class, however, struck out in relatively new territory, or at least considerably expanded on what had previously been a minor issue—women in low or popular art: advertising, TV, movies, costume, women's magazines, and the relation of such imagery to high art. One woman in the class, I remember, brought her grandmother's lacy bloomers and petticoat as objects worthy of art-historical scrutiny and social analysis. For the next session, women as sex, which included pornography and sexual imagery, class members went down to the famous porn shops of San Francisco, where the habitués were evidently shocked speechless by the spectacle of proper young female students avidly paging through the most explosive merchandise. The final reports were on women artists: such nineteenth-century heroines as Bonheur, Cassatt, Morisot, the women sculptors of Rome (the so-called White Marmorean Flock), and twentieth-century ones: O'Keeffe, Romaine Brooks, Frankenthaler, Bontecou, and, as a bow to the

local talent, Julia Morgan, a San Francisco architectural pioneer who had created Hearst's San Simeon, among other achievements.

But perhaps most interesting of all was a final session with Miriam Schapiro and Judy Chicago, up from Womanhouse in Los Angeles, full of ideas and fresh from recent innovations in the actual making of art and the empowering of women artists. While I strongly disagreed with their assertion that there was an innate "feminine" style, signified by centralized imagery or circular forms and existing apart from history and the historically conditioned institutions of art, I agreed just as strongly with their ideas about supporting the work and the working lives of contemporary women artists. The students were enthralled and participated actively in the discussion that followed Schapiro and Chicago's presentation. Among those attending the class was a Stanford graduate student, Paula Harper, who herself was to take a leading role in the early development of feminist art his-

tory. In 1971, Paula taught a course at the California Institute of the Arts pioneering Feminist Art Program—a seminar on the history of women artists— and then went on to participate in the organization of the Women's Caucus at the College Art Association and to chair the first CAA session devoted entirely to women's art history in 1973 in New York. This session included memorable presentations by Eunice Lipton on Manet; Susan Casteras on Susan Eakins; and June Wayne on the "feminized" position of artists in general in American society.

Needless to say, I later made the trip to Womanhouse and found it exciting and provocative, inspiring and controversial. In the works on view in the rackety, "domestic" setting, the aggressive emphasis on the representation of women's bodies as well as the sense of the unrelenting oppressiveness of women's lives was novel and disturbing: the unforgettable *Menstruation Bathroom* with its wall-to-wall Kotex and vivid red-and-white decor was an outstanding case in point. Yet as a Vassar woman and a seasoned professional, I was a bit surprised at the unremitting fascination with domesticity and sexuality that marked the work on view and surprised to find that women art students actually needed so much support and encouragement simply to do their work: we, as students, after all, had taken it for granted that we could produce plays, do the lighting, paint sets, make frescoes and be articulate, independent, and feisty. My one-day experience at Womanhouse made it clear that this was hardly the case universally. Then too, I had always had interesting and brilliant women professors as mentors, in art as well as in more scholarly realms, and took it for granted that other women had had the same opportunity. Womanhouse made it obvious that for many women, authority figures were masculine by definition and having teachers of one's own sex who were openly conscious of their femininity was indeed a radical innovation.

At that point in the women's art movement, contemporary art making and the history of art insofar as it concerned women and their representation were mutually stimulating and interrelated. Once again, excitement was in the air, time seemed to be too short for all we wanted to investigate, critique, discuss, and argue about. The class attitude at Stanford was decidedly *engagé*, and yes, I think that California made a difference.

It was shortly after the California summer that Ann Sutherland Harris and I embarked on a major enterprise in the early history of women's art history: the preparation of the exhibition "Women Artists: 1550–1950" and its accompanying catalogue. The exhibition came into existence at least in part through the persistent activism of women artists and the progressive spirit of the Los Angeles County Museum of Art. During the course of preparing the show, Ann and I traveled extensively in Europe and in this country, encountering every possible attitude on the part of museum curators, ranging from bemused curiosity to patronizing contempt to genuine and enthusiastic support for our project. Open-minded and knowledgeable curators, like the Tate Gallery's Richard Morphet, were rare and greatly appreciated. One museum official actually went so far as to ask me why there had never been any great women artists! Needless to say, some of the very same curators who had sneered or begrudg-

ingly made us a few meager loans were showing women artists themselves a few years later. Working on "Women Artists" was one of the most difficult, and yet ultimately one of the most rewarding, tasks of my life. On the one hand, I knew I was taking a position that directly contradicted my stance in "Why Have There Been No Great Women Artists?" Yet it seemed to me that, after digging around in the basements and reserves of great European museums and provincial art galleries, there had indeed been many wonderfully inventive, extremely competent, and above all, unquestionably interesting women artists; some of these artists had been cherished and admired on their own native turf, even if they could not be considered so-called international superstars. This work and its historical import, without question, deserved to be shown and, even more important, deserved to be thought about and seriously analyzed within the discourse of high art. The show had other effects as well— both simpler and more direct. Even today, women sometimes come up to me, women artists or workers in the art field, and say something like this: "That show changed my life. I never knew before that I, as a woman artist or art-worker, had a history. After that show, I knew I was part of a long tradition and it gave me the courage to go on."

Nothing, I think, is more interesting, more poignant, and more difficult to seize than the intersection of the self and history. Where does biography end and history begin? How do one's own memories and experiences relate to what is written in the history books? Can one complain of "distortion" in historical writing when, inevitably, with the passage of time, our own memories of events and experiences become confused, filmy, uncertain? I have been drawn to the *topos* of self and history since the age of twelve, when I wrote a long blank verse poem called "The Ghosts of the Museum," inspired by my spiritual home-away-from-home, the Brooklyn Museum. Here, in this poem, I attempted to communicate with an Egyptian princess; I brought museum objects, like mummies and cherry-wood cradles, to articulate life in terms of my own, unique, present-day experience of them; and I predicted dolefully that our own cigarette lighters and coffeepots, our radios and necklaces would soon find their place "in the vast, dusty halls of the museum." Later, when I was considerably older and more sophisticated, I wrote a poem entitled "Matisse/Swan/Self" in which I contemplated a photograph of Matisse sketching a swan in the Bois de Boulogne in 1931, the very year I was born, and meditated on the coincidence of totally unrelated events which nevertheless could be interpreted as meaningfully integrated on some transcendent level. Yet in 1969 and the years that followed, the intersection of myself and history was of a different order: it was no mere passive conjunction of events that united me to the history of that year and the ones that followed, but active engagement and participation, a sense that I, along with many other politicized, and yes, liberated, women, were actually intervening in the historical process and changing history itself: the history of art, of culture and of institutions, and of consciousness. And this knowledge even today, almost twenty-five years later, gives us an ongoing sense of achievement and purpose like no other that I know of.

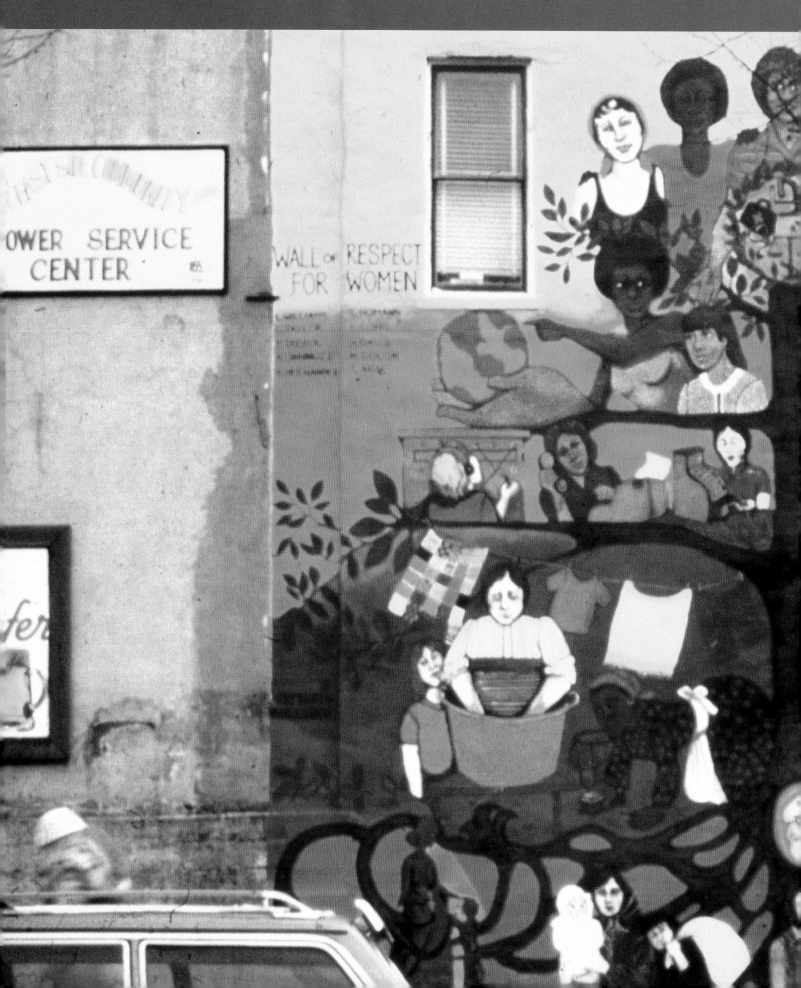

THE FACETS OF FEMINIST ART

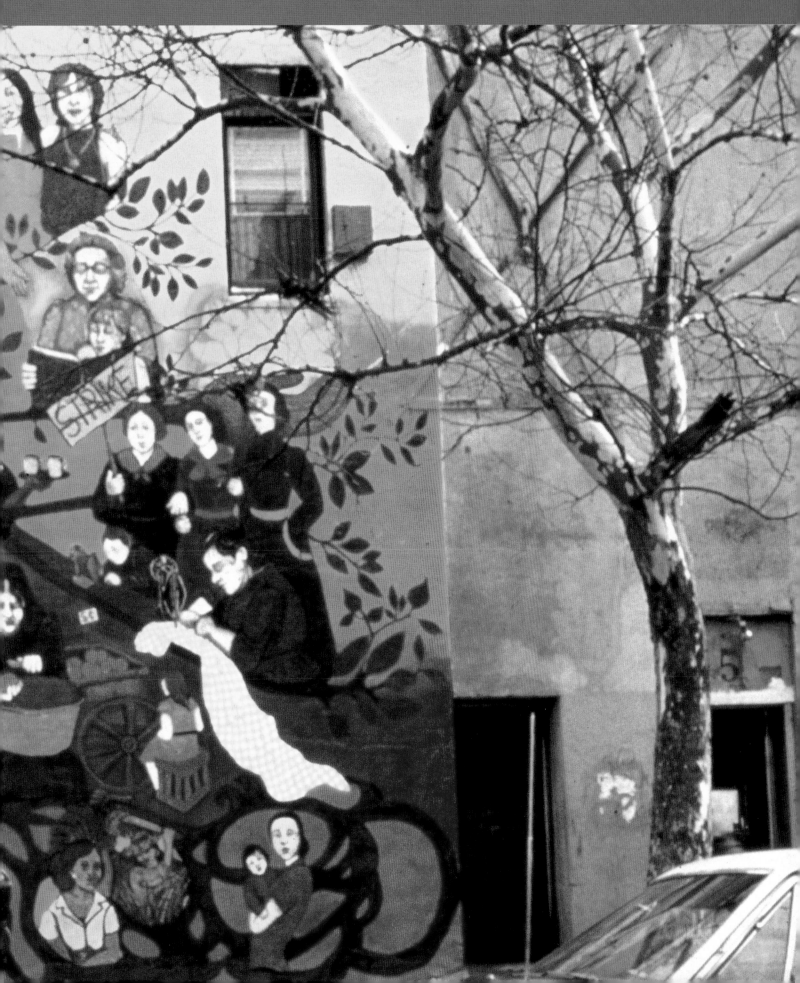

SOCIAL PROTEST: RACISM AND SEXISM

BY YOLANDA M. LÓPEZ AND MOIRA ROTH

In memory of Vivian E. Browne 1929–1993, whose work and life is part of this history.[1]

We write from the viewpoint of our collaboration, one between a San Diego-born Chicana artist and a London-born, Euro-American art historian-critic. We come from distinctly different backgrounds and have lived very different kinds of lives. At the same time, we share similar ethics, visions, and activist concerns. In many ways, our parallel but diverse activities in the late 1960s and early 70s, which brought us to meet in San Diego in 1975, represent certain polarities and similarities in the development of feminism in the visual arts. For this study, we have drawn both upon our lives and memories of the period, and upon our preliminary research into areas of yet little-explored material. There is a dramatic inequality of information on women of color as opposed to Euro-American women. The Feminist Art movement, the subject of this book, suggests an identity prioritized by gender not race. For women artists of color—despite their concern with women's issues— ethnicity more than gender has shaped their primary identities, loyalties, and often the content of their art. Also from the start the women's art movement has been dominated by Euro-American leadership. This reality persists among women artists as it does generally in American society. Thus, despite the many efforts and good intentions of white women in the arena of political art, racial separation and racism existed de facto *within the Feminist Art movement from the beginning. A body of literature on the intersections of culture, gender, and race exists, but it has yet to be seriously incorporated into general historical accounts of women artists. As a small contribution to this end, we have provided broad racial designations for all the artists and historian-critics referred to in the main body of our text at the beginning of the notes section. Just as issues of culture and race are undeveloped territories within the history of women's art, there also needs to be further investigation into the role of lesbian artists and lesbian art within feminist political art.*

After a brief section on the 1968–72 period, we begin this chapter with women's art and activities in New York City and the work of four early artists. From here we turn to the national movements of social/political graphics and murals and follow this section by art and activities in Southern California. Finally, we address the specific situation of many women of color, and, in this context, introduce our expanded definition of women's protest art. We have selected a small group of women, art works, actions, and geographical areas to highlight the various strands of women's protest art at this time. Obviously, we discuss art and acts which express overt outrage and anger against sexism and racism. Equally, however, we have included works of cultural affirmation and celebration which were created within a politically aware conceptual framework. Just as there is a need to redefine the Feminist Art movement, the time has come to do the same for women's protest art.

The late 1960s was a period of paradigm shifts for many artists—women included. There were shifts in notions of the parameters of artistic content, audience, community, and the role of the artist, as well as shifts in the relationship of the artist to the art establishment. The volatile, sensual environment of the civil rights, antiwar, hippie, and student movements, sexual revolution, and left-wing politics provided the context in which the linkage of racism, sexism, and institutional power became blatantly obvious. Artists joined political groups, working as artist-

Preceding pages:
Tomie Arai (collaboration with Mercedes Colon, Harriet Davis, Eleanor Gong, Cami Homann, Nadine Jannuzzi, Phyllis Seebol, Carol Taylor, and Harriet Williams). *Wall of Respect for Women.* 1974. Mural, East Broadway and Rutgers streets, New York. Sponsored by Cityarts Workshop, Inc., New York. Courtesy Tomie Arai

activist-organizers, and out of this world many of the figures in our chapter emerged.

Expressions of early feminism—between 1968 and 1973—took place alongside events like the assassinations of Martin Luther King, Jr., and Robert Kennedy, the My Lai Massacre in Vietnam, and the U.S. invasion of Cambodia. The same period witnessed the incarceration and trials of the Chicago Seven, Huey Newton, and Angela Davis, as well as the Attica prison rebellion; student campus protests around the country and the killings at Kent State; the Native-American occupation of Alcatraz Island and the confrontation at Wounded Knee. The issues of this period were vivified by the political theater of demonstrations, protests, and meetings, which were announced by posters and fliers. The streets were alive with freshly painted murals, and all available spaces seemed energetically appropriated by graffiti and slogans. Women contributed passionately and energetically to these public visual dialogues.

For many women, protesting was inseparably fused with their identities as artists, critics, and historians. The demonstrations and strategies of the civil rights and antiwar movements (which became increasingly intertwined as the 1960s drew to an end) were important models for feminists. Like their models, feminists, too, crossed conventional social as well as political boundaries in their behavior. While they challenged institutions, they also confronted stereotypical expectations of proper women's behavior, including that of women artists. New York and Los Angeles became major centers, each with its own character and approach to art and politics.

NEW YORK CITY

The history of women's protests in the late 1960s must be placed in the context of general art activism in the city. This included the antiwar "End Your Silence" artists' full-page ad in the *New York Times* (1965), the "Week of Angry Arts Against the War in Vietnam" (1967), the activities of the Art Workers' Coalition and the Black Emergency Cultural Coalition (both founded in 1969), and the Art Strike Against Racism, War and Repression (1970).[2] During this period women created their own groups and actions such as Women Artists in Revolution (WAR) and the Ad Hoc Women Artists' Group.

An example of early New York women's activism is the wily, witty, ill-mannered disruptions in 1970 of the prominent, style-setting annual exhibition of the Whitney Museum of American Art. Lucy R. Lippard recalls their strategies to achieve better representation of women at the Whitney. "We forged a press release and an opening invitation. We staged a sit-in at the opening and led fake docent tours. Faith Ringgold brought some whistles and we blew them in the museum's stairwells, driving the guards crazy."[3] Protesters strewed the museum spaces with raw eggs and unused tampaxes, scribbling demands for a representation of 50 percent women and 50 percent "nonwhite" artists on bathroom mirrors in lipstick.

The painters Vivian E. Browne, Audrey Flack, Faith Ringgold, Nancy Spero, and May Stevens were among the women artists who turned to subjects of social justice and Vietnam, and

Lucy Lippard protesting in front of the Whitney Museum of American Art, September 1970, demanding a 50% representation of women and nonwhite artists in the Whitney Annual. Photograph by Ann Arlen

to questions of racial and gender power. For example, in 1967, early performance artist Carolee Schneemann created *Snows,* a mixture of live performance and film images in which war atrocities were juxtaposed with winter environments. Her intent was to "concretize and elucidate the genocidal compulsions of a vicious disjunctive technocracy gone berserk against an integral, essentially rural culture."[4]

As the war escalated, Yoko Ono created *Bed In* (also known as *Bed Peace,* 1969) with John Lennon. Utilizing their celebrity status and the media furor around their marriage, the couple staged an international peace campaign, modeled on the 1960s be-ins. They stayed in bed for a week in the Amsterdam Hilton, repeating this action later in the year in Canada. For Ono, "the message of peace was the strongest idea but there was also the message of love—men and women being able to make a statement together—and the West and East coming together."[5]

In Mexico, North American artist Elizabeth Catlett responded to events in this country, especially to the Black Power Movement.[6] In a color linoleum print of 1969, *Malcolm X Speaks for Us,* she forcefully brought together racial and gender politics in this depiction of rows of black women with Malcolm X, the black leader who was assassinated in 1965. The print's title emphasizes Catlett's specific female viewpoint: Malcolm X speaks for black women as well as for black men. "Art is important," Catlett stated in 1971, "only to the extent that it helps in the liberation of our people . . . it must answer a question, or wake someone up, or give a shove in the right direction."[7]

FOUR WOMEN ARTISTS

Around the country at this time, many women artists were committed to the political function of art. We have chosen to highlight the work of Faith Ringgold, Betye Saar, Nancy Spero, and May Stevens. Born within six years of one another—Stevens in 1924, Saar and Spero in 1926, and Ringgold in 1930—all created early major iconic images of protest.

Between 1963 and 1967, at the height of the civil rights movement and the beginning of Black Power, Ringgold painted her series American People, focusing on images of hostile whites and uneasy attempts at integration. In *The Flag is Bleeding,* three immobile figures stare at us from behind the flag's bars— the white and black man held apart by a small, frail blond woman. As Mary Schmidt Campbell comments, "The group is entrapped—stained and tainted—behind the bleeding stripes of the flag."[8] As the 1960s progressed, Ringgold assumed a prominent role in both black and white artists' protest groups. In 1968, she participated in picketing the Whitney Museum of American Art for its total exclusion of black artists in a major exhibition. In 1969, she led demands that the Museum of Modern Art, New York, create a Martin Luther King, Jr., Wing for Black and Puerto Rican Art. In 1970, Ringgold and her daughter Michele Wallace formed Women Students and Artists for Black Art Liberation (WSABAL), and, in the same year, Ringgold contributed to "The People's Flag Show" at the Judson Memorial Church, and as one of "The Judson Three" was arrested and later found guilty of desecrating the American flag.

A year later, in 1972, Ringgold created *For the Women's House,* a mural for a woman's prison, marking "the beginning of my feminist painting." Shortly afterward she began to make textile-framed paintings and soft sculpture. During the next few years, Ringgold produced works at a feverish pace which focused exclusively on black women, including the Slave Rapes, Political Landscapes, Feminist Landscapes, Family of Women, and Witch Masks series. In 1973, she created a five-foot-tall, raffia-haired, beaded-faced, gourd-breasted figure, called *Women's Liberation Talking Mask.* Men as well as women were to become the subjects of her work, but Ringgold has always foregrounded the voice of women. They speak boldly for themselves, evoking (and creating anew) female histories, yearnings, and multilayered identities.

For years, May Stevens, always an activist, avidly followed the civil rights movement. In 1964, she showed her Freedom Rider paintings—with a text by Martin Luther King, Jr.—in a traveling one-person exhibition sponsored by a church organization. In 1967-68, she developed imagery for the Big Daddy series, "the monstrous symbol," as Lippard has described him, "of distorted patriotism, patriarchy, prejudice and imperialism."[9] Stevens loosely based this character on her father. "I painted out of love for those lower-middle-class Americans I came from and out of a great anger for what had happened to them and what they were letting happen, making happen, in the South and in Vietnam."[10] In *Big Daddy Paper Doll,* one of the largest works in the series, Stevens contorted the conventional associations of childhood games by accompanying Big Daddy's grotesque nude body with his ominous choices of clothing and headgear: those of a hooded hangman, a military figure, a riot policeman, and a butcher.

In 1978, Stevens painted *Mysteries and Politics.* The portraits in this work include contemporary artists and critics on the "spiritual" or "political" sides in the women's movement, group allegiances that often sharply divided feminists. At the time, Stevens was working closely with other women in the *Heresies* collective, and had also been profoundly affected by Adrienne Rich's *Of Woman Born: Motherhood as Experience and Institution,* with its critique of dualism. (In *Mysteries and Politics,* Stevens depicted three pregnant women.) In *Big Daddy* she analyzed male power. In *Mysteries and Politics* she attempted "to let less definable aspects of experience into my art . . . [in order to reproduce] consciousness, as we experience it, on many levels."[11] Since the mid-1970s, Stevens has continued to explore women's histories. Working in various media, including poetry, she created another extended series, Ordinary/Extraordinary, based on images of her mother and Rosa Luxemburg, the German Communist theorist-activist.

In 1966 Nancy Spero, recently returned to the U.S. from a five-year stay in Europe, became immersed in the antiwar movement. "The Vietnam war was the primary impetus in rethinking my position as an artist. I worked rapidly on paper, first using the symbol of total destruction (the bomb), then the symbol of the Vietnam war (helicopters), together with images of crematoriums and rape."[12] Using ink and gouache on rice paper, she created her War Series (1966–70) with such titles as *Search and Destroy* and *Helicopter Eating Victims and Shitting Remains.*

Faith Ringgold. *The Flag Is Bleeding.* 1967. Oil on canvas, 72 × 96″. Collection the artist

Faith Ringgold. *Mrs. Jones and Family.* 1973. Sewn fabric and embroidery, 60 × 12 × 16″. Collection the artist

Nancy Spero. *Male Bomb* (War Series). 1966. Gouache and ink on paper, 34 × 27″. Collection the artist

Nancy Spero. *Torture of Women, No. 10* (detail). 1968. Hand-printing, collage, and painting paper (series of fourteen panels); overall length 20×125″. Collection the artist

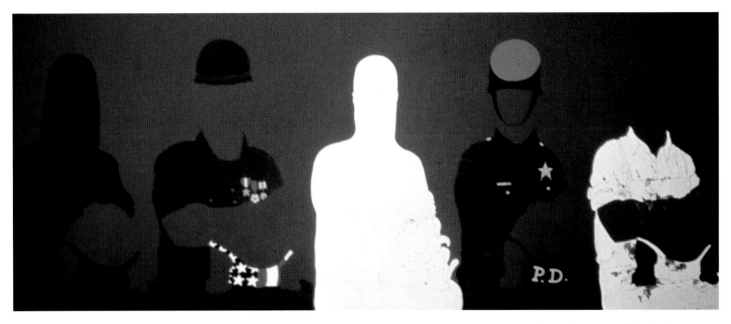

May Stevens. *Big Daddy Paper Doll.* 1970. Acrylic on canvas, 78 × 168". Brooklyn Museum, New York

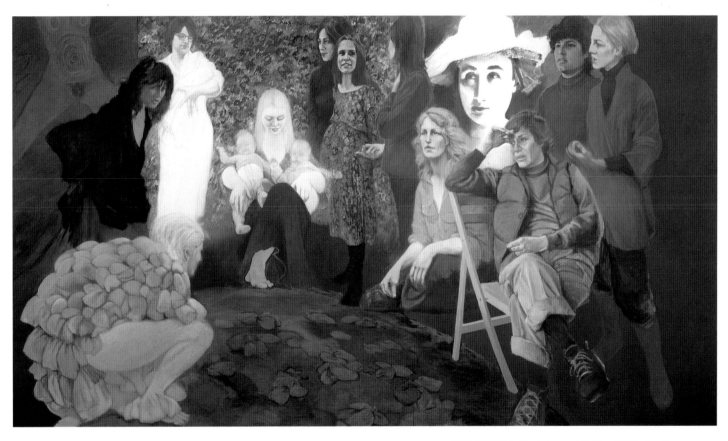

May Stevens. *Mysteries and Politics.* 1978. Acrylic on canvas, 72 × 144". San Francisco Museum of Modern Art

In the series, *Male Bomb*, a two-headed vomiting creature with five phallic-shaped serpents stands erect. For Spero, such imagery suggested the "collusion of sex and power. In a way, little boys' wargames became a reality in real life wargames."[13] At this time Spero was participating vigorously in activist circles. She joined Women Artists in Revolution (WAR), took part in demonstrations against the Whitney Museum, and helped found the Ad Hoc Women Artists' Group. During this period, Spero recalls "a lot of strong women artists were working without [gallery] affiliation."[14] In response to this situation, she and other women established a women artists' collective, A.I.R. Gallery, in 1972.

In 1974, after reading the horrific accounts of torture in Amnesty International's newsletters, Spero created *Hours of the Night* and *Torture in Chile*. In the same year she began the fourteen panels of *Torture of Women*, its contents and texts merging contemporary torture case histories with Sumerian mythology. "I zeroed in on the torture of women because . . . women have supposedly been protected, yet they have been universally victimized. It's an institutional thing. Torture is an institution of the state largely controlled by men."[15] Spero has worked exclusively with the female figure since the mid-1970s, exploring women's oppression and also, as she stated recently, "birth, aging, work, dance, and women from many different cultures and time periods."[16]

For these three New York women artists, their antiwar and civil rights themes addressing issues of power, led naturally to their later involvement in feminist protest themes. Ringgold, Spero, and Stevens, now in their sixties, have been committed to the making of feminist art for more than two decades, providing a generational link between the 1960s and younger artists in the 1990s.[17]

In Los Angeles, during the late 1960s and early 1970s, Betye Saar produced assemblages on subjects ranging from racism to poetry and magic. Her investigations of Aunt Jemima include *The Liberation of Aunt Jemima: Measure for Measure*, in which she holds two measuring cups: one contains explosives, the other a pile of pancake mix. In *Liberation of Aunt Jemima*, Saar plays multiple images of this iconic figure off one another. A cookie-jar Aunt Jemima, armed with a rifle and pistol as well as her traditional broom, is contrasted with the benign and smiling advertising images. In front of this 1972 assemblage, Saar has placed a fist in a Black Power salute. Psychologically as well as politically explosive, Saar's powerful Aunt Jemima series reconfigures the image of a black woman from that of a willing servant to a woman participating in her own liberation.

During this early period from 1969 to 1972, Saar worked on dismantling the crude, popular racist representations of African Americans found in advertising and kitchen utensils. Art historian Samella Lewis cites Saar's incorporation into her work of the "emblems of such products as Darkie toothpaste, Black Crow licorice and Old Black Joe butter beans."[18] At the same time that Saar was working to destroy such vicious stereotypes, she also explored her deeply-felt interest in the occult, astrology, and African connections. In 1969, for example, she created *Black Girl's Window*, which explored a very different sort of liberation from Aunt Jemima's, one that was overtly psychic and

spiritual. Saar has written that even at the time she sensed the autobiographical significance of *Black Girl's Window*. "There's a black figure, pressing its face against the glass, like a shadow. And two hands that represent my own fate. . . . On the top are nine little boxes in rows of three marked by the crescent, the star and the sun [and] in the center, a skeleton. Death is in the center. Everything revolves around death."[19] Saar has described her use of the window as "a symbolic structure which allows the viewer to look into it to gain insight and to traverse the threshold of the mystic world."[20] Over the last twenty years, Saar and her viewers have traversed her mystic worlds in which she weaves together interests in the occult, family, and black culture and history.

MOVEMENT GRAPHICS AND MURALS

While such artists as Saar, Stevens, Spero, and Ringgold produced paintings, sculptures, and mixed media work, other women artists created some of the most memorable and widely distributed graphics of the period. For Yolanda M. López, as for many other radical artists, "thought and image came together in this era. I found my voice as an artist."[21] In 1969 in San Francisco, López designed many graphic images, including an American flag poster, its stripes confining Los Siete, seven young Latinos accused of killing a plainclothes policeman.

I remember the thrill of seeing my art everywhere on walls, telegraph poles, and in demonstrations. I discovered my gallery—it was the streets. One of the most electrifying experiences was when the women in the Los Siete organization took a Greyhound bus to Canada for a conference to hear Indo-Chinese women. When we got back, an incidence of domestic violence in our organization led to the creation of male and female discussion groups. That was the first time that I had really experienced the issue of women's oppression within the larger struggle of racism and imperialism. By 1972, I was doing paintings and drawings of my mother and grandmother, now understanding them within a bigger historical context.

In a period of revolutionary excitement, López and other women worked with men in community-based organizations. Posters, along with T-shirts, buttons, postcards, newspaper graphics, altered billboards, and murals, offered a visual environment of radical ideas. The impassioned style and mood of the images and slogans of the posters were crude, vital, and confrontational. Frequently different causes were connected and intermingled. Heroic images of women began to appear, from Vietnamese women soldiers to Angela Davis. Many women produced graphic designs, often in women-only collectives, the best known of which are the Chicago Women's Graphic Collective and The Women's Graphic Center in Los Angeles.[22] For a variety of reasons, many artists did not sign their names. For example, artist Betty Kano has stated that she saw herself merely as a "facilitator" when she contributed posters to the Third World Liberation Front in Berkeley in 1968.[23] Jean LaMarr, whose 1973 Wounded Knee poster was widely dis-

tributed, recalls that to sign such a poster "wasn't the thing to do those days."[24] The choice of anonymity was also dictated by the need for protection against the very real threat of governmental reprisal.

This fusion of culture and politics came together again in the mural movement. As we searched through Alan W. Barnett's *Community Murals: The People's Art*, and other studies, we were each reminded of our excitement when we first saw murals appearing prolifically on neighborhood walls in the later 1960s. Through their mural activities, women artists of different ethnic backgrounds developed physical, organizing, and leadership skills, and many became politicized. Women muralists insisted on a more central placement for women in their narratives, and represented women as heroic, intelligent, and creative. Positive images of women became a form of revolutionary protest.[25]

In 1970, Vanalyne Green, age seventeen at the time, "liberated" a garage wall in Chicago on which she painted a series of African-American heroines, among them Angela Davis, Coretta King, Nina Simone, and Mary Bethune. (Chicago was a major site for early murals, including the 1968 *Harriet Tubman Memorial Wall*.) The mural, named *Black Women*, was immediately anonymously defaced with white paint. Green decided not to repaint the mural, but instead retitled it *Racism*.[26] Such conditions of impromptu space and the constant threat of erasure were normal in the early "hit-and-run" art of murals and posters.

Another early example is *Wall of Respect for Women*, 1974, a city-funded mural painted on a two-story wall in New York's Lower East Side, under the directorship of Tomie Arai (pages 138–39). In the early 1970s, Arai was working in the community, designing leaflets and posters, and linking up with the Asian Tactical Theater and the Basement Workshop.[27] Throughout the decade she supervised other mural projects: *Women Hold Up Half the Sky*, 1975, *Create a New Society*, 1976, and *Wall of Respect for the Working People of Chinatown*, 1977.

The range of women's roles in the *Wall of Respect for Women* has been deftly described by Alan W. Barnett as extending "[from] homemaking, sewing in sweatshops . . . picketing . . . to the professional careers, at the crown of the tree, that young women are now seeking."[28] Arai and her multicultural team, primarily young women, involved the local community as they ran daily discussions and circulated sketches about the mural's possible imagery, and responded to the community's "monitoring" of the evolving mural. Arai represents many such early community projects when she states: "I make it a point to say that these murals were not my projects. That I was a director only meant that I had certain responsibilities other than artistic ones. These murals were a collective experience."[29]

In the early 1970s a group of San Francisco artists formed a collective, which they called Las Mujeres Muralistas (The Women Muralists), to assert themselves as artists in a traditionally male-dominated field. In the city's Latino Mission District, the collective created a striking series of murals. "For the first time," Patricia Rodríguez wrote, "I feel our work is being shared by the people who see it every day on the streets. Those who work in a hot kitchen, who go home to fix dinner for their kids and husbands, whose only outlet is the TV set or the drive-in movies."[30] Characteristic of the collective's lush imagery and lyri-

cal mythology is *Para el Mercado* (*To the Market*), created in 1974 by Graciela Carrillo and Consuelo Mendez with other members of the collective. The fifty-foot mural was commissioned by a taco stand owner whose livelihood was threatened by the neighborhood's first McDonald franchise a block away. He offered the artists a wall in his parking lot for the mural. In *Para el Mercado*'s narrative of a day's work of gathering, distributing, and cooking food, the Mujeres Muralistas portrayed the historical role of indigenous women as providers and contributors to community and economic life. At the same time the artists linked these women with contemporary Chicana/Latinas in an immigrant, working-class neighborhood.

In the Bicentennial year of 1976, Ester Hernández, a member of the Mujeres collective, created *Libertad*, a visual protest against the conventional representation of American identity. The print shows a woman artist "liberating" the Statue of Liberty and carving out a monumental ancient Mayan sculpture. On the pedestal is inscribed the word *Aztlan*, the Aztecs' land of origin (located in the area of Arizona, Colorado, New Mexico, and California), which had become a symbol for the Chicano movement in its definition of Chicanos as Native Americans. In this and other work—for example, the karate-attired Madonna in *La Virgen de Guadalupe Defendiendo los Derechos de los Xicanos*—Hernández wittily and magically disrupts icons, and simultaneously gives them new life. In her work, we find an ongoing complicated, intelligent, offbeat blend of wit and political commentary. A provocateur, she addresses her primary audience of Chicanos while also engaging other American audiences.

SOUTHERN CALIFORNIA

The early 1970s saw the beginnings of Southern Californian feminist art activities. Moira Roth recalls:

> When I arrived in Los Angeles from U.C. Berkeley in the fall of 1970, I found the women's art movement was exploding there at an incredible rate. It was an ardent, optimistic time. I remember Joyce Kozloff calling up some eighty women artists out of the blue, inviting them to her house, and half of them turned up. I would hear exciting reports about early feminist teaching experiments, filled with fervor and originality, at Fresno State, the California Institute of the Arts, and the Woman's Building. . . . It was a time when many of us formed lifelong friendships and alliances as we exchanged information, planned art actions and events, and took part in consciousness-raising groups. We engaged in many discussions about women's art—contemporary and historical—and how to make it available. Through these encounters and experiences, I became increasingly aware of the historical neglect of women artists while simultaneously reexamining my own art historical training. I began to curate shows of contemporary women artists, and write, especially on women's performance art.[31]

The history, character, circumstances, and strategies of the Los Angeles early feminist protest were distinctly different from those in New York. There was less emphasis, for example, in

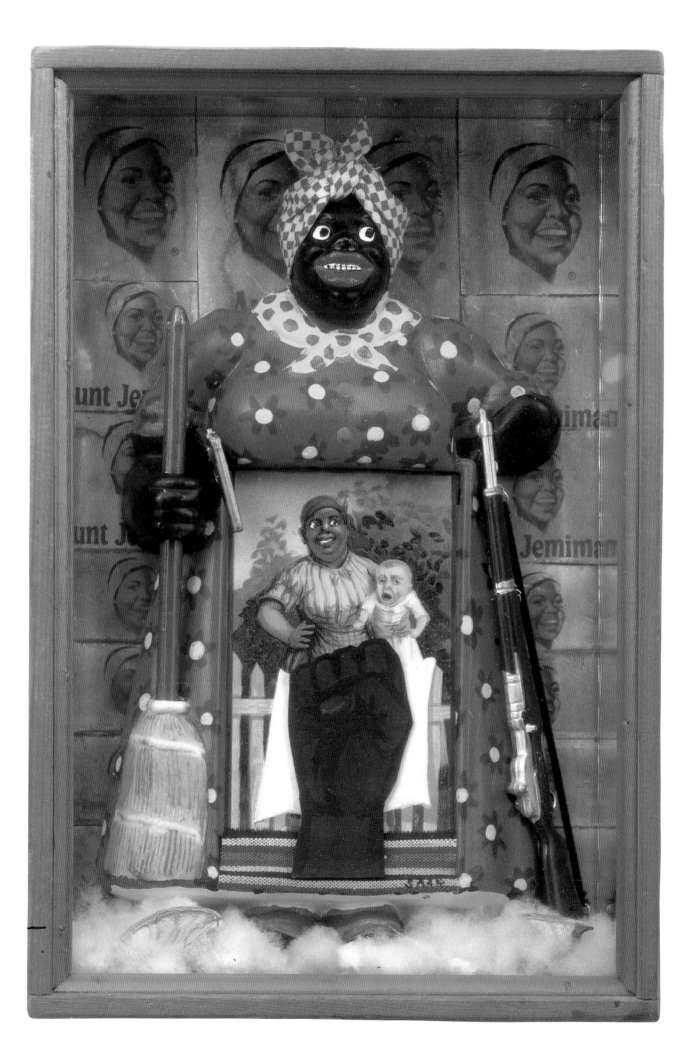

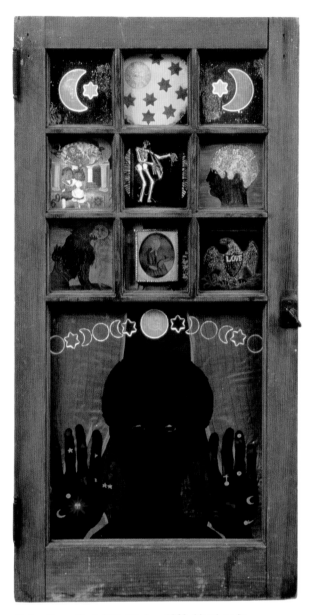

Betye Saar. *Black Girl's Window.* 1969. Mixed media assemblage, 36 × 18 × 1½". Collection the artist

Betye Saar. *The Liberation of Aunt Jemima.* 1972. Mixed media, 11¾ × 8 × 2¾". University Art Museum, University of California, Berkeley. Purchased with the aid of funds from the National Endowment for the Arts, and selected by the Committee for the Acquisition of African American Art

Los Angeles on attacks on museums, and instead more energy devoted to the creation of separatist institutions. An exception was the feminist artists and critic-historians' angry response to the all-white all-male "Art and Technology" show at the Los Angeles County Museum of Art.[32] "We knew what was going on in New York," recalls Joyce Kozloff, "and so did other women. We felt it was time to do a demonstration in the Los Angeles art world."[33] In keeping with the Los Angeles feminist emphasis on separatism, the result was that the museum committed itself to a major historical survey of women artists: the famous traveling exhibition "Women Artists: 1550-1950," which opened in 1976 in Los Angeles.

A year later, two women artists addressed a very immediate situation confronting women in Los Angeles. In 1977, Leslie Labowitz and Suzanne Lacy created *In Mourning and In Rage,* a large-scale public performance, which was extensively covered by newspapers and television reporters.[34] Designed specifically to address the media, it had been triggered by the media's sensational coverage of the Hillside Strangler, a serial killer of women in the area who had carried out his tenth murder a few months before. For the most part, media reportage had been uncritical, indeed often salacious, in its focus on the individual women victims. "We wanted," Lacy states, "to use media conventions to subvert media messages, and to introduce a more complicated feminist analysis into the coverage of the case."[35] *In Mourning and In Rage* contained a dramatic, visual spectacle of blacks and reds, beginning with a motorcade carrying fifty black-clad women from the Woman's Building to City Hall. There, towering shrouded women in black, and one figure garbed totally in red, addressed the media representatives, local politicians, and community activists gathered at the steps of City Hall. The women's terse texts placed the Hillside Strangler case within the much wider continuum of male violence against women, including wife abuse and incest. A banner reading "In Memory of Our Sisters We Fight Back" was designed to fit the proportions of a TV screen. The performance's title stressed the fact that women had turned from powerless mourning to rage and a determination to "fight back." The piece had practical repercussions, and also quickly assumed a position as a classic feminist performance although, as Lacy reminds us, she and Labowitz "had moved into the media as a result of our political intents, not for our artistic ambitions."[36]

Characteristic modes of early Los Angeles feminist art making and strategy included collaborative processes, a savvy use of public space and media, and innovative ways of transmitting didactic messages and presenting women speaking boldly for themselves—frequently in the medium of performance.[37] Important, too, was the emphasis on the political education of both participants and audience. Many artists, among them Labowitz and Lacy, practiced the early feminist concept, "the personal is the political," when, for example, for the first time they interpreted violence from a woman's point of view. They began to see connections between their personal experiences and societal norms concerning rape, incest, and abusive media images. As women artists explored their own hidden histories, they widened their search to include all women's neglected or ignored achievements and contributions to American and world history. A very

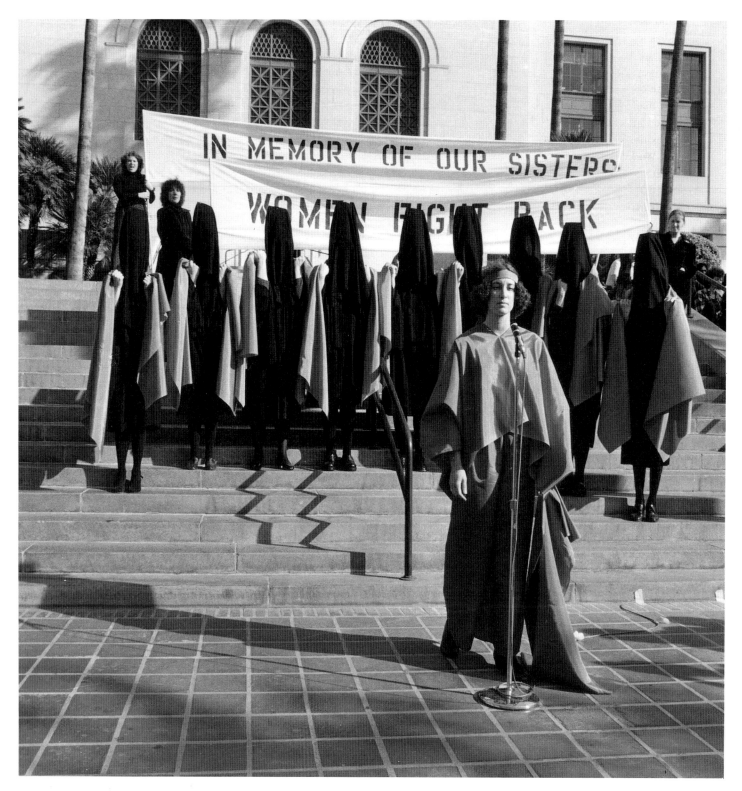

Suzanne Lacy and Leslie Labowitz in collaboration with local women's groups. *In Mourning and In Rage.* Memorial performance at Los Angeles City Hall, 1977, in protest against a series of violent rape/murders in Los Angeles.

key part of this was the exploration of lesbian identity.

Lesbian programs had been offered in the Woman's Building since its foundation in 1973. (There had been earlier lesbian rallies, dances, and lectures at both CalArts and Womanspace.) It served young lesbians as a meeting ground, both confrontational and supportive, for themselves as lesbians, as lesbian feminists, and as lesbian feminist artists. The artist Harmony Hammond has written that, "Many women, especially on the West Coast, came out simultaneously as lesbians and artists. . . . There have always been a lot of lesbian artists. Since the seventies many have come out of the closet, although only a few in the art world made art with lesbian content."[38] (Hammond, at that time based in New York, curated in 1978 the first significant lesbian exhibition in the city, "A Lesbian Show," at the Green Street Workshop.) Thus, proclaiming oneself in public as a lesbian artist was the act of protest. Coded imagery prevailed at first on the East Coast, whereas on the West Coast from the start there was more explicit lesbian content.

The Lesbian Art Project (1977–79), established by Arlene Raven at the Woman's Building, conducted explorations of lesbian iconography. This project, which consisted of writing and art groups and salons, created *The Oral Herstory of Lesbianism*, 1979. Directed by Terry Wolverton, its stories were generated through a workshop for the thirteen performers.[39] Wolverton described the performance's intent: "Most of the history and traditions of lesbians have been lost, erased, or misinterpreted. Lesbians today need to record and make public our experience."[40] Advertised as "Storytelling, Theater and Magic for Women Only," *The Oral Herstory of Lesbianism* was presented at the Woman's Building. During its run, audiences sat in a specially constructed, pink gauze wall space to watch lively scripted vignettes with titles like "Bar Scene," "Butch/Femme Conga Lines," "Jump Rope/Incest," "Yellow Queer," and "Stalking the Great Orgasm." A year later, the Woman's Building put on "The Great American Lesbian Art Show" (GALAS). These lesbian activities and other art-making at the Woman's Building must be read as a major contribution to the city's feminist protest art and art strategies. Across the board at this time, lesbian thought both complicated and deepened the ideological development of women working on gender issues in the political art arena.

Two other large-scale projects in the late 1970s in Los Angeles were produced by Judy Chicago and Judy Baca. In 1979, Chicago's *The Dinner Party* went on view for the first time at the San Francisco Museum of Art: a historical global homage to women that had been created by Chicago over a span of six years, with hundreds of women, working in her Los Angeles studio.[41]

In another Los Angeles space, during five summers between 1976 and 1983, Judy Baca and crews of adolescents and community artists labored on her huge work-in-progress, a multiethnic mural history of California from prehistoric times to the present.[42] Over the years Baca has trained many artists through this *Great Wall of Los Angeles*.[43] "Activism in the 1970s," recalls Baca, "had to do with me turning upside down the notion that the creation of monumental art was a male act. I started painting these ferocious Indian women who looked like they could devour you—in the *Uprising of the Mujeres*, for example—I can't

tell you what backlash there was about those images."[44]

In Los Angeles, protest art was often developed within feminist pedagogical programs which employed consciousness-raising as the teaching tool, and performance as the medium for the explosive new content being generated. Major early work was produced within classes and workshops, and in the mentoring situations of large-scale feminist projects.[45] The Woman's Building, in particular, provided an ongoing physical, emotional, and political center for feminist art,[46] supporting a plethora of feminist programs, conferences, networks, activities, and performance collaborations.[47]

In Los Angeles, protest art was often addressed to two very different audiences. When presented in the Woman's Building, it reconfirmed beliefs and energized an audience that already shared the artist's feminist viewpoint. At the same time, women left such sheltered spaces and sallied forth into the streets, galleries, public spaces, and the media to confront and/or convert unknown, often unpredictable audiences. For several years, for example, Wonder Woman and the many-breasted Waitress Goddess Diana (two members of the Waitresses collective) would appear unannounced in restaurants. Equally startling was the day in 1977 when Leslie Labowitz (in association with Women Against Violence Against Women) staged her *Record Companies Drag Their Feet* under a giant record company billboard in Hollywood. A few years later in a gallery space, Nancy Buchanan presented *If Only I Could Tell You How Much I Really Love You*, which raised a question that haunts many politically committed artists. At the end of the performance, a meditation on the CIA disguised as a musical comedy, Buchanan asked her audience if it were possible for an artist to act as a "conscience to a callous society."[48]

Graphic art held a prominent place in the protest activities of Los Angeles. "Women could publish themselves without asking permission from anybody," says graphics artist Sheila de Bretteville. "No one mediated what women had to say."[49] In 1973, de Bretteville founded The Women's Graphic Center, housed in the Woman's Building, where she, Susan E. King, and others trained young feminists in the use of professional graphics equipment. In this supportive environment, women published sophisticated, elegant, and persuasive posters, postcards, and artists' books. One of the most innovative artists was Bia Lowe; among her designs was the widely distributed image of a small child staggering under the weight of a globe. Its caption read: "Once upon a time she thought incest was something she had to carry around all by herself." De Bretteville herself created many memorable designs. One of her best-known early ones was the now-legendary *Pink* poster, 1973, a response to the color pink, traditionally associated with femininity. De Bretteville handed out small squares of paper to people to transform with images and/or texts which she then assembled in a quiltlike form. "It stood for a notion of participatory democracy of women's voices being heard. I was always so grateful that Lippard included the *Pink Poster* in an article on political posters— I felt she understood my intents."[50]

Video was another favored medium for feminists in Southern California. In 1975, Martha Rosler, a powerful theorist-writer and artist then based in the San Diego region, created

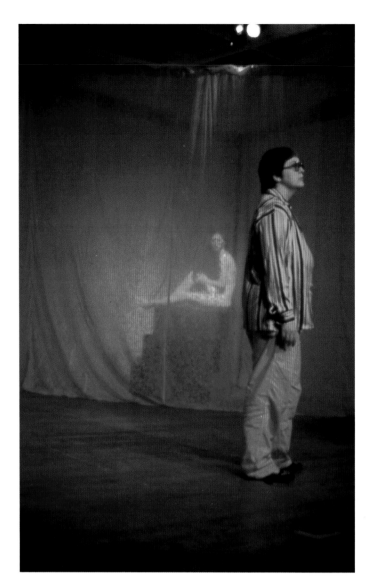

Terry Wolverton in collaboration with the Lesbian Art Project. *The Oral Herstory of Lesbianism*. In this scene, performer Brook Hallock recalls that during her marriage, she often fantasized about her next-door neighbor, played by Cheri Gaulke. The piece was first presented at the Woman's Building, Los Angeles, 1979. Photograph by Jo Goodwin

Semiotics of the Kitchen. In this videotape, playing with her knowledge of theory and gently mocking its often abstract tone, she reveals with disarming humor the culinary arsenal available to women. An underlying motif is women's undeveloped power and suppressed rage. Standing in a kitchen at a chopping block, Rosler produces a series of implements naming them in alphabetical order, "Apron, bowl, chopper, . . ." Deadpan, she noisily plunges an eggbeater into a metal bowl, makes stabbing gestures with a fork and knife, and slams an ice pick into the table. As the alphabetical litany nears a close, she addresses the viewer ("U") directly with semaphore-like gestures. Rosler once explained to an interviewer: "What makes a work have any resonance at all—anyone's work, not just mine—is the relationship between what appears to be direct, unmediated experience and those things which go to make up its mediation and its causation."[51] Rosler's titles—for example, *Domination and the Everyday, Service: A Trilogy on Colonialization*, and *Born to be Sold: The Strange Case of Baby M*—indicate her longtime immersion in the study of power, class, and media representations, always colored by working-class loyalties. Rosler has consistently analyzed feminism within a leftist framework, and critiqued feminist art's frequent tendency to remain within an art sphere. In a 1977 article entitled "The Private and the Public: Feminist Art in California," she argued that a feminist commitment on the part of women artists necessitated "a principled criticism of economics and social power relations and some commitment to collective action."[52]

THE STRUGGLE CONTINUES: RACISM AND SEXISM

Since women, primarily white, first came together to form the women's art movement and to investigate women's art history, racism and racial separatism have been major issues internally as well as externally. As women critiqued art institutions for their sexist and racist practices, racist attitudes also surfaced within feminist art circles. Betye Saar, for example, experienced this in 1973 when she curated "Black Mirror," an exhibition and series of events around black women artists in the newly founded Womanspace in Los Angeles. Although she had formed friendships in the Womanspace circle, and had enjoyed the professional exposure, Saar pointed out in an interview that it was mainly black women and men who turned out for the activities: "It was as if we were invisible again. The white women did not support it. I felt the separatism, even within the context of being in Womanspace."[53] This was to be an ongoing experience for many other women of color in Los Angeles despite considerable attempts by Euro-American women.[54] As Baca stated recently: "The problem was always the same problem—the white feminists thought that they would determine how to approach and confront race. They never came in the capacity to listen."[55]

In New York, too, racism within the women's art movement was a major problem from the start. As one of the few African-American feminist artists working with white women during this early period, Ringgold remembers experiencing white racism and, simultaneously, black accusations of disloyalty because of her feminist commitments. In New York in 1980, Howardena

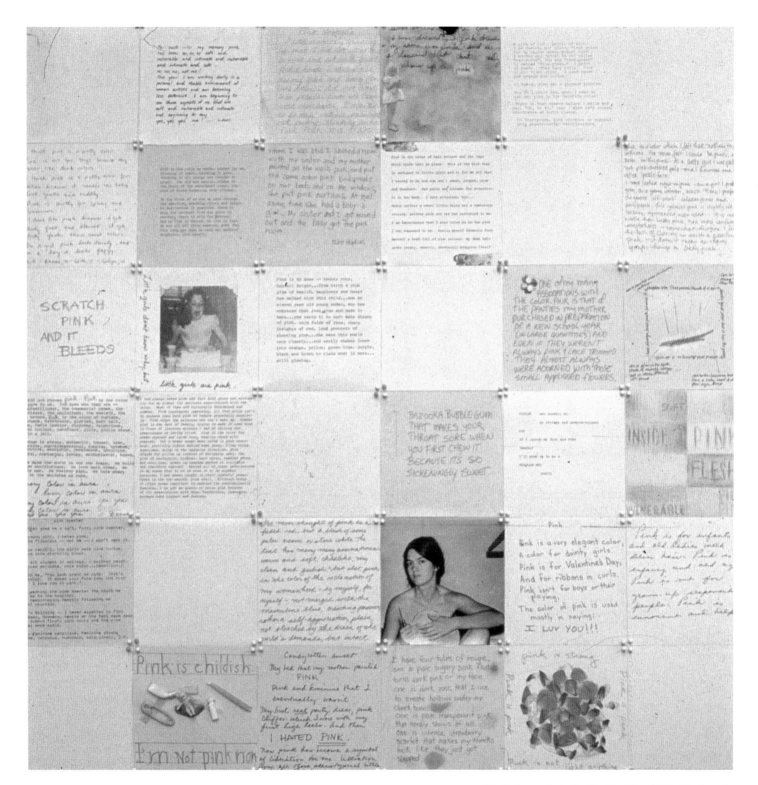

Sheila Levrant de Bretteville. *Pink*. 1973. Mixed media, 30 × 30″. Collection American Institute of Graphic Art

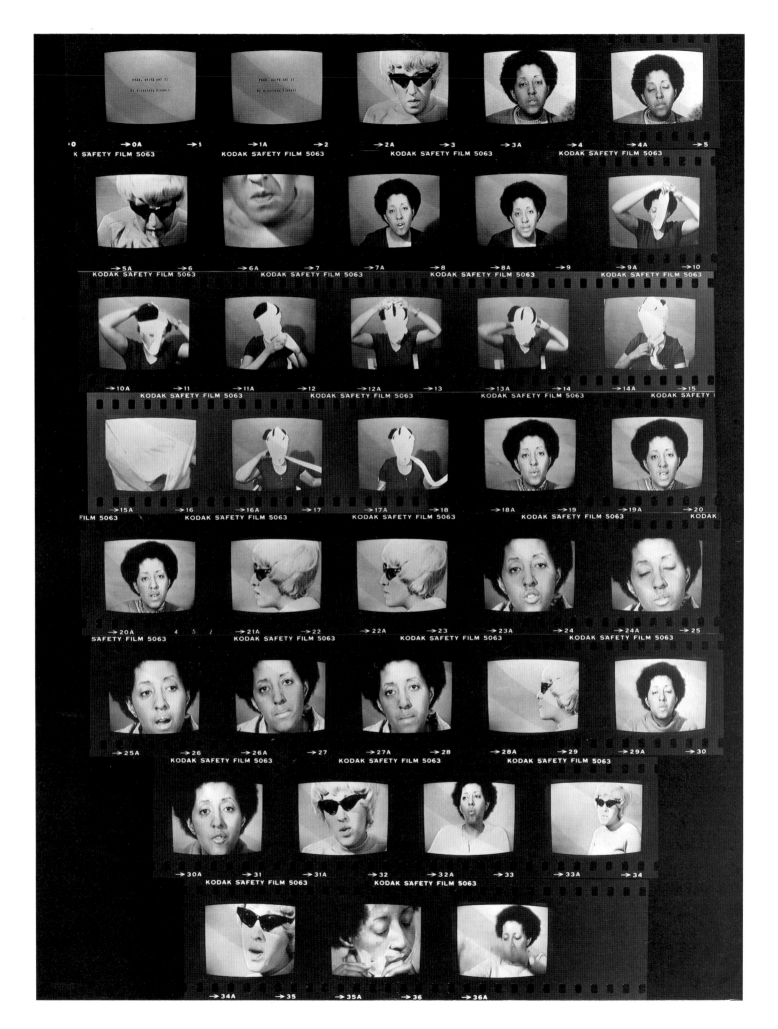

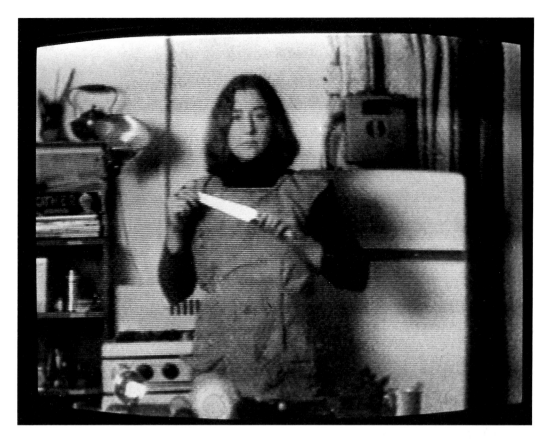

Opposite:
Howardena Pindell. *Free, White and Twenty One.* 1980. Contact sheet of videotape. Collection the artist

Martha Rosler. *Semiotics of the Kitchen.* 1975. Videotape, black and white, 7 minutes. Photograph by artist

Pindell, an active artist and curator throughout the 1970s, was provoked into making *Free, White and 21* by "yet another run-in with racism in the art world and the white feminists.[56] I was feeling very isolated as a token."[57] Pindell appears twice in the *Free, White and 21* video, as the black narrator who relates one racist experience after another, and as a white woman "character" who sarcastically and airily dismisses all such accounts as paranoid, with the refrain "but, of course, I'm free, white and 21." Pindell showed this twelve-minute videotape for the first time in "Dialectics of Isolation: An Exhibition of Third World Artists of the United States," held at the A.I.R. Gallery.[58] In the catalogue, artist-curator Ana Mendieta commented: "As women . . . came together in the Feminist Movement with the purpose to end the domination and exploitation of the white male culture, they failed to remember us."[59]

In the 1980s, Pindell widened her investigations into racism and appropriate strategies, including coalition-building, for combating it. In 1988, she curated "Autobiography: In Her Own Image," an important traveling exhibition that brought together (indeed, frequently introduced) for the first time many major women artists of color from different ethnic backgrounds.[60] At the same time, Pindell assailed institutional racism in oral reports and written accounts that presented the staggering statistics of inequality between white artists and artists of color in the exhibition records of prominent New York museums and galleries.[61] Clear-eyed and courageous, Pindell uses the methodology of an informed professional. "I have experienced the art world from the 'outside' as an artist of color and from the

'inside' working at a major New York museum [Museum of Modern Art] where I was an associate curator. I worked there for twelve years."[62] In her art and research, Pindell combines fierce intelligence, impeccable art-world credentials, and an impolitic rage to articulate the difficult issues and parameters of feminism and racism.

Sexism and racism have been taken on recently by two feminist groups. In 1985, the Guerrilla Girls (whose masks concealed both their identity and their ethnicity) first announced their intent to act as the "conscience of the art world" against sexism and racism. In 1992, a group of women with varying backgrounds in art and other areas created the Women's Action Coalition (WAC); their targets range from rape cases to incidents of art-world discrimination. These two New York-based organizations quickly multiplied around the country. While their boldness builds on earlier feminist art and actions, they often operate with far more inside information (indeed, inside connections) and professional sophistication. Different as the Guerrilla Girls and WAC are, they share certain strategies including the use of costumes, media bites, and posters. Both have also had to contend with accusations of internal racism.

Our vision of the parameters of "protest art" was expanded during the course of writing this essay. We have come to recognize that the work of women of color has broadened the scope of "protest art." In a vast arena of media, styles, and approaches, many women of color are investigating the inextricable fusion of past and present history and of gender with race and ethnicity, while simultaneously de-constructing

Ester Hernández. *La Ofrenda II* (*The Offering II*). 1988.
Screen print, 22¼ × 30⅛". Collection the artist

mainstream representations. Margo Machida, a critic-historian as well as artist, brought many of these threads together in a 1991 three-part public symposium in New York, entitled "(re)ORIENTING: Self Representations of Asian American Women Through the Visual Arts."[63] In this symposium, three artists, Tomie Arai, Hung Liu, and Yong Soon Min, were each matched with two critics of different ethnic backgrounds. In an article on this project, Machida stated that her intention was to juxtapose the clichéd images of Asian women in American popular culture to the lived reality of Asian women artists, and to investigate the relative positions that gender, race and ethnicity occupy in Asian American women's definition of self.[64] In her article, Machida included the 1988 serigraph *Laundryman's Daughter* by Tomie Arai, an image of a seated mother and her standing daughter drawn from photographic archival sources. Machida writes that in many ways, Arai's print stands for "the immigrant legacy of all Asian women" because it "emphasizes the close intergenerational ties between them." Machida con-

trasts this to "the white feminist's critiques of patriarchy and emphasis on individual independence," which for many Asians is read "as a threat to family unity."[65]

FOUR WOMEN ARTISTS

As we worked on our text, we kept returning to the ideas of Margo Machida and Amalia Mesa-Bains, and to three recent works by Ester Hernández, Jean LaMarr, and Hulleah J. Tsinhnahjinnie. Here we present them as guiding lodestars in our argument for the widening of the definition of "protest art" among women artists of color.

Amalia Mesa-Bains—whose studies include a Ph.D. in psychology and whose activities embrace cultural criticism and curating, as well as art-making since the 1970s—has turned to the form of the Mexican and Chicano traditional home altar to create a reclaimed heritage. "Altars become the most political of statements," she observes. "They were the outgrowth of the individualized oppression in the most private places of the domestic chamber, the bedroom and the kitchen."[66] An early example is her 1978 participatory altar for Frida Kahlo, created collaboratively with Carmen Lomas Garza and René Yañez, in which community artists were invited to make artistic offerings (*ofrendas*) for this altar which evoked a rich artistic and cultural genealogy.[67] Exhibited in San Francisco's Galería de la Raza, this multilayered work was an art installation, a homage to a Mexican woman artist, and an emotional and spiritual experience for the community. For Mesa-Bains, "Spirituality is a site of resistance, a socially critical spirituality—especially women's—must be seen as part of the tradition of social protest, of socially engaged work."[68] She argues persuasively that "As long as you frame yourself in the opposition, you are forever controlled by that very destructive force. At some point it is as important, if not more so, to frame what you do stand for, what you do want and desire in your community."[69]

In 1988, Ester Hernández created a serigraph titled *The Offering II* (*La Ofrenda II*). In it, the Virgin of Guadalupe (a major iconic Mexican image since the sixteenth century) appears almost like an apparition on the nude back of a late-twentieth-century woman with a dramatic punk hairstyle, pink lipstick, and crystal earring. A hand, pierced by a thorn, offers a rose and a drop of blood. In this audacious piece, Hernández presents the Chicana as the high-tech, confident, modern woman who still identifies with her culture. "It is my way of honoring 'la chicana-la india,' and also talking about the fact that we carry our culture with us, literally, on our backs—the good and the bad."[70]

Cultural survival, modernity, and the role of the woman's body as a literal bearer of "culture" appeared again in Jean LaMarr's *Cover Girl*, a print series also of 1988. LaMarr created this series as a rebuttal to the nineteenth-century genre of staged photographs of disrobed Native American women taken by white (often government-sponsored) photographers. In one image, LaMarr frames her reclining woman with lace patterns and textiles, and embeds a sacred eagle feather at the bottom. "I gave her back her dignity," says the artist.[71] LaMarr lives in an

area in Northern California where bomb testing is still almost a daily occurrence, which is alluded to by the bomb shape behind the woman. "She is a contemporary woman living in a manmade society with this MX missile, but still holding on to the spiritual, respecting the earth—the contrast of elements that Indian people have to live with. It is a stereotype for Indian people to do stuff about the environment. It shouldn't just be our burden, however—everyone has to do it. We all have to think about the generations to come."[72]

Another example of positioning women in the center of complex contemporary debates occurs in the 1991 *Would I have been a member of the Nighthawk Society, or would I have been a half breed leading the whites to the full bloods?* by Hulleah J. Tsinhnahjinnie. In 1990, a controversial law was passed requiring that, in certain situations, Native-American artists prove their ethnicity.[73] Through a series of twenty-five photo-collages of herself and other Native-American artists with their census numbers, Tsinhnahjinnie informs her audiences (which she conceives as both Indian and non-Indian) about the law itself and its implications.[74] The triptych self-portrait, *Would I have been a member of the Nighthawk . . .* , refers to events that occurred around 1900 regarding Native American participation in government census registration. Members of the Nighthawk and Snake Societies resisted the census, while other Indians, notably half-breeds, were paid to turn in the names of full-blood Indians to white administrators. (Tsinhnahjinnie refers to this episode in the third photo-collage: the dollar sign and the divid-

ing line on the face.) "In a way the work is very personal as I ask myself, would I have been a collaborator or a rebel back then? Equally, I ask my Native audience, are they in a collaborative or resistant position right now regarding the law?"[75] Most importantly, the artist says, the piece "responds to people who think they know what is best for me."[76] Tsinhnahjinnie is part of the continuum of contemporary women artists of differing ethnic backgrounds who have sustained an analytic and impassioned monitoring of society and who fight for justice in their art, protesting whenever and wherever it is needed.

Neither one of us alone could have have written this essay. Separately, our backgrounds, training, networks, and knowledge would have led us on different paths. As we pooled information, skills, and contacts, something more happened. During the process of our intense three-month collaboration as we researched and talked endlessly, we developed a third voice and we feel that we have written in this voice. Partly as a result of our own fruitful experiences, we would advocate collaboration between women of different ethnic backgrounds as one suitable mode for addressing the urgent task of studying this history of women artists afresh without prioritizing Euro-American artists and theoretical frameworks. Issues of sexual orientation and class must equally be prioritized in this much-needed revisionist history. Then, and only then, will we be able to make more productive coalitions, alliances, and collaborations among women of different backgrounds so that we can protest even more effectively on all necessary fronts.

Amalia Mesa-Bains (collaboration with Carmen Lomas Garza). *Frida Kahlo Altar.* 1979. Altar and mixed media installation at Galeria de la Raza, San Francisco, 1979. Courtesy the artist

FEMINIST PERFORMANCE ART: PERFORMING, DISCOVERING, TRANSFORMING OURSELVES[1]

BY JOSEPHINE WITHERS

In New York City on December 11, 1970, a coalition of women artists' groups picketed the Whitney Museum's biannual sculpture exhibition; they planted raw eggs painted black or white, tampax, and littered strips of paper stamped with "50%" in strategic locations throughout the museum.[2] Earlier that same year, Adrian Piper performed by herself in public by riding a New York City bus with a towel stuffed in her mouth. In California at Fresno State in 1971, Judy Chicago's students donned masks and costumes as a dramatic way of creating alter egos and confronting their pent-up feelings during their consciousness-raising sessions. In April of 1972 the Earth Onion performance group electrified the National Conference of Women in the Visual Arts taking place in Washington, D.C., which had become bogged down in argument and name calling. In 1973 in San Diego, Eleanor Antin created *Carving: A Traditional Sculpture*—a month-long weight-reduction diet, in which she photographed herself every day (see page 199). And for seven years, beginning in 1974, Bonnie Sherk directed a multimedia urban education and ecology project under a San Francisco expressway called *The Farm.*

All of these actions have been called feminist performance art by someone at sometime. They are disparate but interconnected. At one time or another performance artists borrow not only from the genres conventionally associated with the performing arts, including acting, singing, music, and dance; they also invoke guerrilla theater, Happenings, and traditional religious rituals. Most, however, shun any association with conventional theater. Performance tends to be open-ended and less directive than conventional theater, but it usually delivers a clearer political message than do Happenings. One observer has acknowledged: "I had no idea at all what was going on. . . . but it was happening in the sense that it appeared to have meaning. . . . There were no parameters, no conventions. I mean, you assumed that no one was going to get hit on the head or buried too deeply, but we had no idea what was going to happen next."[3]

The performance artist, who is normally the writer, producer, director, and actor, is first of all a visual artist, who may have little or no training in theater arts. A performance event is usually presented only once, before a live audience, and seldom has the polish one associates with theatrical performance; if the performance is repeated, it is seldom the same. It can happen just about anywhere: in a loft, on a beach, a bridge, a stage, the street, a cave, or it can even involve an entire city.

The very vitality and strength of performance art is its unruliness—whether completely improvisational or tightly choreographed—and its resistance to tidy definitions. Blurring and otherwise problematizing the boundaries between art and life is one of the generating motifs in all performance art. Although this impetus can be tidily folded into the modernist narrative, since so much art activity in this century has been about questioning art's historical definitions and boundaries, this does not adequately explain the urgency and enthusiasm that so many feminist performance artists brought to this issue. Performance is a paradigm of feminism itself, which despite the claims of its detractors has never been a monolithic movement nor a single philosophical system.

Laurie Anderson. *Duets on Ice.* Street performance in Genoa, Italy, June 1975. Courtesy the artist. The duet emerged between Anderson's live performance on violin and that of a violin "played" on a tape deck. Although Anderson performed deadpan, she was wearing ice skates whose blades were embedded in ice. It was a summer day, so when the ice melted the performance was over.

Adrian Piper. *Catalysis No. 4* (two views). 1970. Performance, New York City. Courtesy John Weber Gallery, New York

The many sources from which feminist performance art drew its inspiration also speak to the diverse purposes it served in the seventies. It grew out of Happenings and Fluxus performance; the Minimalist dance of Yvonne Rainer and others performing at the Judson Church in New York City; the meditative sound experiments of Pauline Oliveros in the Bay Area; the growing interest in women's spirituality and worship of the goddess. Performance became the theatricalized extension of feminist consciousness-raising, particularly in Southern California; it took cues from women protesting the Miss America pageant in 1968 (Robin Morgan et al); from Abbie Hoffman and the Yippies; the sixties love-ins such as Woodstock (1969); Yoko Ono and John Lennon's "bed-ins" protesting the Vietnam war; and the increasingly media-conscious anti-Vietnam War movement.

With gusto, feminist performance also played on the conventional association of women with artifice and masquerading. Los Angeles performance artist Cheri Gaulke observed:

> *Performance is not a difficult concept to us [women]. We're on stage every moment of our lives. Acting like women. Performance is a declaration of self—who one is—a shamanistic dance by which we spin into other states of awareness, remembering new visions of ourselves. And in performance we found an art form that was young, without the tradition of painting or sculpture. Without the traditions governed by men. The shoe fit, and so, like Cinderella, we ran with it.*[4]

In the seventies, performance art was ephemeral, as were Happenings and Fluxus events. But what seems to distinguish feminist performance was its creators' desire to communicate an alternative vision of themselves and the world they lived in— sometimes dystopic, more often utopian and transformative. Today what remains are memories of shared experiences, primary knowledge about ourselves and our lives gained directly through this participatory genre, a few poor-quality grainy photographs, videos, and super-eight films, and some scripts. Yet the legacy of feminist performance was and is inestimable. Although performance art principally flourished in New York City and California, its emotional energy spread to other feminist communities around the country that may never have experienced it firsthand. Its deliberate transgressions of the art/life boundaries, "amateurish" messiness, improvisational character, communal nature, and its openness to the banal and everyday as well as to the realms of myth and ritual, meant that performance art was ideally suited to the feminist agenda of that decade.

The very qualities that gave feminist performance its vitality are the same ones that make it hard to document, to re-create— in a word, to historicize. Some writers have tried to resolve this dilemma by explaining performance art in terms of something else: as a preparation, a complement, an offshoot, or a coda to other genres and activities. While this is not always an inaccurate assessment, explaining away performance art by pointing to its ineffability diminishes the visceral impact it had for all of us who were participants or witnesses, and detracts from the primary position it had in developing feminist consciousness and theory. As Moira Roth, the principal chronicler of California

performance, has put it, "It is extremely hard now to conjure up the feeling of these early performances. Not only was there little interest in documentation, . . . but even more importantly the performances were so integrally locked into their times that when separated from them they appear fragmentary."[5] But at the time performance was understood to play a central role; as such, it became the catalyst for organizing the ongoing activities and institutions: the art centers and galleries, the magazines, the archives.[6]

But before there was anything we could call a women's community, there was Carolee Schneemann's self-described "kinetic theater." Years before feminism had entered the art world Schneemann, a painter, performer, filmmaker, and writer, set out to challenge "the psychic territorial power lines by which women were admitted to the Art Stud Club."[7] In the early sixties many male artists were using the nude in Happenings and body art as an object. Schneemann took a different tack: "I was using the nude as myself—the artist—and as a primal, archaic force. . . ."[8] In the privately performed *Eye Body*, December 1963, and the very public *Meat Joy*, 1964, Schneemann's exuberantly sensual use of the body challenged even her fellow artists. No one seemed to object when French artist Yves Klein used female nude bodies dragged across a canvas to paint a "live" picture (*Anthropometrics of the Blue Period*, 1960), but the notion of female creative agency and directorial élan drove some to condemn *Meat Joy* and Schneemann's erotic film *Fuses*, 1967, as narcissistic and self-indulgent.[9] "I was permitted to be an image [posing as Manet's *Olympia* in Robert Morris's *Site* performance of 1965] but not an image-maker creating her own self-image."[10] Schneemann posed the ultimate rhetorical question, "You may well ask: why didn't you women artists become close in the sixties? Because we were one anomaly staring at another. Only men could authenticate us."[11] Discouraged by her isolation and a lack of support from the art community, Schneemann left for Europe in 1969 and spent the next four years there, where she continued her performance and film work. When she returned to the United States in 1973 the world she had left behind had been radically transformed, thanks partly to Schneemann herself.

Yvonne Rainer was part of that sea change. As founder of the Judson Dance Group (1962) and a pioneer Minimalist, Rainer by 1970 had legendary stature as the doyenne of avant-garde dance and was a prominent role model for many younger women in the performing and visual arts, just as her teacher, Martha Graham, had been for her. Although Rainer had encountered many of the same professional problems as Schneemann, she suppressed any personal references or projection of a performance persona; Minimalist dance required thinking of oneself "as simply a neutral purveyor of information. . . . The early solos are just fraught with all kinds of female projections. Very neurotic, weird."[12] By the early seventies she was once again concerned with the personal and the autobiographical, but she seemed bemused to be taken up by the women's movement and startled when her use of a vacuum cleaner in *Inner Appearances* was seen as "a huge symbol for women's oppression."[13] Rainer was quick, however, to incorporate both the personal and autobiographical content, and the loosely

structured, multilayered improvisational modalities so strongly identified with feminist performance. At first she made these changes within the framework of her dance, but ultimately she turned to film. *This is the Story of a Woman Who . . .* , 1974, was first performed live as a multimedia event with dance, and later created as a film. It is worth noting that film was and continues to be an important medium of performance work.

Although Minimalist and Conceptual art was decidedly unreceptive for many early feminists, among them Schneemann and Miriam Schapiro, Yvonne Rainer was by no means the only woman to make her home in that domain. Conceptual artist Adrian Piper and multimedia performer Laurie Anderson both took a Minimalist route into performance work, initially using their presence to project "a neutral doer," to use Yvonne Rainer's words, rather than a particular character. There are other similarities: neither saw their early work as especially political, and yet it was seen by many as both political and feminist; both used distancing techniques in their performances, yet forcefully engaged the observer; both artists used autobiographical elements, but claimed not to be autobiographical. "I always felt it was a mistake being labeled as an autobiographical artist," Anderson wrote. "Most of the work that I do is two-part or stereo, not monolithic at all—so there's always the yes/no, he/she, or whatever pairs I'm working with."[14] One of Anderson's earliest pair performances was *Duets on Ice*, performed on the streets of New York City in 1974 and Genoa, Italy, in 1975. Art critic Craig Owens described this early persona as a "radiant mid-western Madonna" who shortly was to be transformed "into an expressionless, neuter 'punk'. . . ."[15]

In 1970, Adrian Piper, already known as a Conceptual artist, executed Catalysis—a series of unannounced performance events in the streets, subways, elevators and other public places of New York City. The events were intended as catalysts for non-specific changes in the social environment Piper moved through. In *Catalysis No. 6*, "I attached helium-filled Mickey Mouse Balloons from each of my ears, under my nose, to my two front teeth, and from thin strands of my hair, then walked through Central Park, the lobby of the Plaza Hotel, and rode the subway during morning rush hours."[16] Although gender and race were not conscious considerations for Piper at the time she performed these pieces, she did acknowledge that in "'violating my body' I was making it public. I was turning myself into an object."[17]

During the years Schneemann had been abroad, a loose-knit feminist community had formed in New York City. Her earlier lament, that "we were one anomaly staring at another. Only men could authenticate us," had begun to change, and it was before a woman-only audience that she performed her *Interior Scroll* in 1975. (It was performed once again in 1977 for a mixed audience.) Her persona was neither deadpan nor the "neutral doer." In fact the narration came quite literally from inside her body. To complete the transition into a trance state, she sacralized her body by slowly stroking it with paint. Only then did she slowly begin pulling from her vagina a scroll from which she proceeded to read aloud:

> *I met a happy man*
> *a structuralist filmmaker . . .*

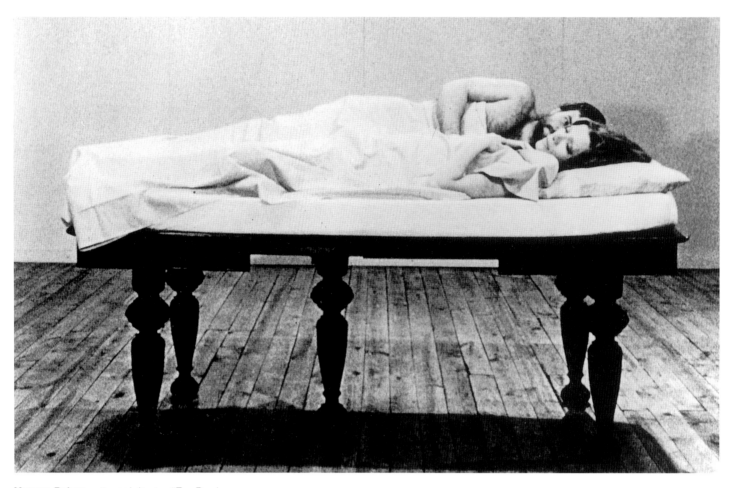

Yvonne Rainer, writer and director. "Two People on
Bed/Table." Still from *This is the Story of a Woman Who. . . .*
1974. 16mm, black and white and color, 105 minutes, sound.
Courtesy the artist. Through mime, slides, narration, and sound
effects we are told of the violent breakup of a love relationship.
The distinction between fantasy and reality is deliberately blurred.
This was originally performed live and subsequently filmed.

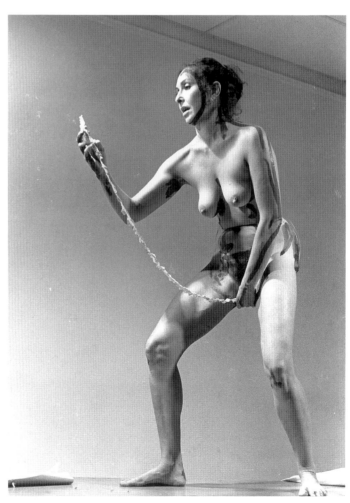

Carolee Schneemann reading from *Interior Scroll*. First
performed in New York City, 1975. Photograph by Anthony
McCall. While performing, Schneemann read from her text
Cézanne: She was a Great Painter, recounting the ways in which
women were erased from history.

he said we are fond of you
you are charming
but don't ask us
to look at your films
we cannot
there are certain films
we cannot look at
the personal clutter
the persistence of feelings . . . []
he said we can be friends
equally tho we are not artists
equally I said we cannot
be friends equally and we
cannot be artists equally

he told me he had lived with
a "sculptress" I asked does
that make me a "film-makeress"?

Oh No he said we think of you
as a dancer[18]

There are multiple ironies in Schneemann's ritualized condemnation of a macho filmmaker obsessed with Minimalist systems, grids, and rational procedures who is too obtuse to appreciate her "personal clutter/the persistence of feelings" Ironic because this was the same moment that Yvonne Rainer was permanently moving into film precisely because she felt it was better suited to her renewed interest in personal narrative and indeterminate structure; ironic because the parting line implicitly acknowledges that women—because of Rainer—are more accepted in the dance world; and ironic because Schneemann is addressing not only the men who couldn't hear her voice, but also a well-known film critic—a woman—who was heard to say: "don't ask us/ to look at your films/ we cannot/ there are certain films/ we cannot look at. . . ."[19]

Schneemann's live performances and films both anticipate and embody some of the central themes of feminist performance art in the seventies. Before most of us were ready for her, she persisted in reclaiming woman's voice and woman's wisdom. She used her body in the Aphroditean tradition—freely, sensually, directly—to create sacred ritual space, and through her writings and performance/lectures (such as *Homerunmuse*, first performed at the Brooklyn Museum in 1976 while "Women Artists: 1550-1950" was being shown), she demonstrated how much we needed to dig up, create, resuscitate, and invent our own history and prehistory: as creative people, as priestesses, as newly enfranchised agents of our own destiny. The experiential immediacy of performance was a powerful tool for creating and exploring ways of knowing within ourselves and our bodies, and by connecting that with our own history—be it real, invented, or mythic. It was also a means for both mourning our erasure and celebrating our reconnection with these pasts.

Donna Henes, Mary Beth Edelson, Betsy Damon, and Linda Montano performed rituals and created sacred space in both private and public settings. Donna Henes describes herself as an urban shaman, and for many years has used the persona of Spider Woman to present her healing rituals. Even before she connected with this persona, she was making knots and webs as a sort of meditation and energy connection. Frustrated by the art world's tendency to regard her creations as sculpture or commodities, Henes turned to interactive events to satisfy her desire to create participatory and accessible public events and celebrations—conceptual networks analogous to her webs.

It all began to come together—"the intellectual and the meditation, the public and the private, the political and the psychic"[20]—in December 1974, when Henes presented her first winter solstice celebration, *Reverence to Her: A Chant to Invoke the Female Forces of the Universe Present in All People.* As the shortest day of the year in the northern hemisphere, the winter solstice has been celebrated as the return of the light in many cultures and for many millennia. In the early morning hours of December 22 on a Long Island beach, a group of women drummed and chanted a Tibetan Buddhist text, "Reverence to Her" to mark the arrival of the solstice at 12:57 A.M.

For several months before and after the chant, Spider Woman's Native-American identity came to Henes in dreams, gifts, stories, and scholarly sources. Two months after the Winter Solstice, in February 1975, she did her first performance with a web, *The Coming Out of Spider Woman.* Since 1974, Henes has publicly celebrated every solstice and equinox, marking the four quadrants of the year. Her joyously inclusive celebrations have expanded as colorful media events performed both for herself and others. "Other people, not just myself, become enchanted. At first I thought it was just that we needed to note these days, but I think it's more than us honoring the day. I think the day notes us. There are celestially auspicious times."[21]

Like Henes, Mary Beth Edelson has also chosen to dedicate her art to the Great Goddess. For more than twenty years, she has created private rituals on remote beaches and in caves, and installations and performances on several continents and in many cities, in public settings and intimate venues.[22]

What, we might wonder, is the difference between ritual and performance? Within feminist practice the boundaries between performance as spectacle and ritual as repeatable communal action have been deliberately blurred. This conflation has led many to experience mythic thinking as a way of living one's life, and the use of ritual is a way of acknowledging that integrated living. Looking back on her seventies rituals, Edelson remarked that while they addressed political issues of the day, they "still occupied mythic space in order to pull up their power. . . ."[23]

But traditionally, ritual knits a community together in a common spiritual or social bond because of its repetitive nature; the continuity thus established is the solace and healing power of ritual. Today, however, these feminist rituals from the seventies live on in memory and on film, where they are witness to a dematerialized experience and a fugitive moment in time.

Edelson continued to design installations and rituals that brought the distant past into the present, as with the *Memorials to 9,000,000 Women Burned as Witches in the Christian Era,* performed Halloween 1977. In hindsight, these rituals, which served to bind the women's community, can be seen as prologue

for more recent action-oriented performance groups such as the Guerrilla Girls and the Women's Action Coalition.

On the spring equinox of 1977, Betsy Damon introduced to the world the *Seven Thousand Year Old Woman,* a prepatriarchal persona which had been forming in her mind through dreams and meditations for almost two years. "She is my woman line of 7,000 years and she is me, the me that I know very little about. She found me in Los Angeles in spring, 1975. . . .[only later] did I identify her as a 7,000-year-old woman. While I was more and more in awe of her and did not know very much about her, naming her was the first step towards performing her." [24] For her performance, Damon was festooned with 420 small bags containing all different colors of flour. Slowly she cut the bags off her body while walking around in a spiral. "After I cut them off, I had this incredible sensation of the dimension of women's oppression. . . . So I decided I would go in the streets and put female energy into the streets. "[25]

Linda Montano's ongoing *Art in Everyday Life* began, if such things have identifiable beginnings, in 1969 while she was doing graduate work at the University of Wisconsin at Madison. Chicken Woman was born out of the ashes of her frustration with being a proper Minimalist. "I attempted to be like everyone else, working in plastics, concepts and real art materials."[26] In turn, Chicken Woman birthed many other personas that Montano performed, including Dr. Jane Gooding, neurosurgeon and shaman; Sister Rose Augustine; Kay Rogers, blues singer; and Hilda Mahler, Olympic swimmer and black belt karate.[27] By 1975, Montano came to think of her art and her life as one. "Art has been generous and has allowed me to explore fears, exuberances, unconscious subject matter, fantasies and ideas. It is the place where I practice for life."[28] For ten days in December 1975 she lived with musician and performance artist Pauline Oliveros in the desert, where everything she did was considered art. *Mitchell's Death,* 1977, commemorating Montano's anguished reactions to the news of her former husband's death, is still vividly remembered by many as one of her most powerful art/life performances. Montano has continued to live her life as art, making no fundamental distinctions between her social, domestic, and artistic activities. She offers a particularly crystalline paradigm of an integrated and seamless life in art.

Black feminist artist Faith Ringgold necessarily had a different experience in the art world of the seventies than her white sisters, prompting a different rationale for moving into performance work. At a time when whites had even more difficulty dealing with racial differences than in the nineties, Ringgold's insistent privileging of her African-American heritage and her identity as a woman was an embarrassment both to the black community, where speaking out against sexism was seen as a betrayal of black solidarity, as well as to the white art community, where she was frustrated in her efforts to exhibit and sell her work. In the art world during the seventies, she was known to come to all-white panel discussions and take up a prominent front-row seat in "white face"!

From these beginnings, Ringgold proceeded to create a new audience for her work on college campuses around the country. The *Wake and Resurrection of the Bicentennial Negro,* commissioned and first performed at Wilson College in Chambersburg,

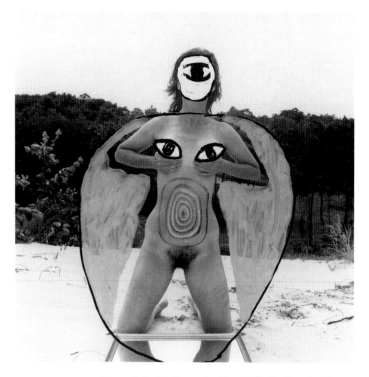

Mary Beth Edelson. *On Site.* 1973. Black-and-white photograph, oil paint, white-out, and ink. Collection the artist

Pennsylvania, in 1976, was generated out of her desire to communicate more directly and expressively than she had felt was possible in her painting. As she remarked at the time, "There's no reason why art has to be so complicated and difficult to deal with. That's one of the things I've gotten from the feminist movement."[29]

In *Wake,* Ringgold used traditional African storytelling techniques as well as her skills as a visual artist to create a performance in which the audience was fully participating. The basic scenario—a funeral in an Abyssinian Baptist Church—was the frame within which the student participant-performers were invited to don masks and costumes and improvise their assigned roles. Black students played the principal characters and the white students played the mourners, witnesses, parishioners, and stage and production crew. Ringgold acted as director. For both women and men, black and white, the performance movingly enacted a ritual that is central to African-American life. Ringgold was often astonished at the depth of feeling and accurate portrayals her student-participants were able to bring to their improvised roles. In her early performance works, Ringgold's principal academic sponsors were feminist groups, but toward the end of the decade she was frequently invited by Black Studies programs.

It seems only fitting that some of the most powerful and riveting performances of the decade should come from the land of dreams itself, California. Many artists turned the fantasy technologies of Hollywood against itself to challenge and demystify the "feminine mystique," which by 1970 had hardly begun to be dismantled (Friedan's germinal book with that title was pub-

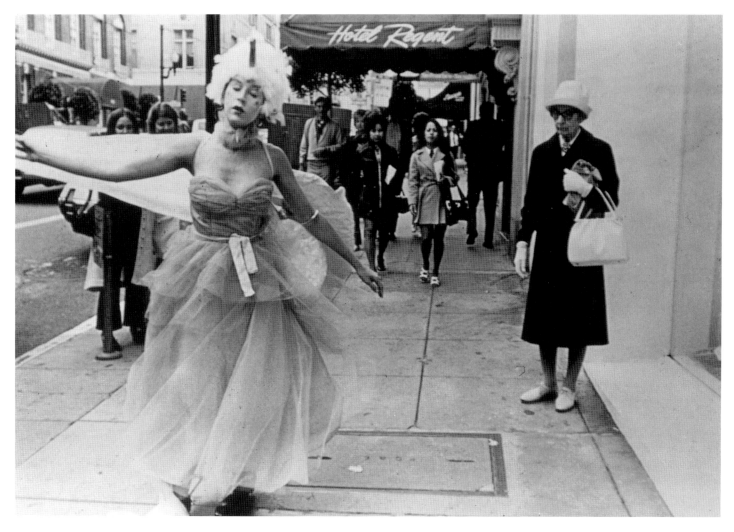

Linda Montano. *Chicken Dance* (Chicken Woman Series).
Performance, San Francisco, 1972. According to Montano,
Chicken Woman was a "nun, saint, martyr, plaster statue, angel,
absurd snow white dreamlike character . . . the chicken became
my totem and my twin." Over a seven-year period, Chicken
Woman sat silently on a Rochester, N.Y., sidewalk, danced on the
Golden Gate Bridge, flapped her wings in and around "framed"
art spaces in the Bay Area, and lay in state in Rochester's
Nazareth College and the Berkeley Museum.

lished in 1963). As performance artist Suzanne Lacy put it,
much of California performance was "consciously designed to
look enough like television's normal bill of fare to slip, as it
were, into mainstream media."[30] In this guise, Californians dra-
matically engaged the urgent questions raised by the feminist
movement: how women were to define themselves in a pa-
triarchal society; how they were to defend themselves in the
context of a rape culture; and how they were to begin to trans-
form that culture. In the East, artists such as Schneemann and
Edelson were claiming their own bodies as a locus of wisdom
and power, and others such as Henes and Montano were sacra-
lizing the continuum of their lives as a way of shaping their
identities. Meanwhile, West Coast artists engaged these issues
with a head-on critique of the status quo, in three principal
locations: San Francisco and the Bay Area, Los Angeles, and
San Diego.

Martha Rosler, now well known for her video work and
ongoing critique of media culture, demonstrated in her *Vital
Statistics of a Citizen, Simply Obtained*, 1977, how desiccated and
powerless women can feel when they are completely dependent
on others to tell them who they are. Presented both live and
later on video, the performance in a matter-of-fact way portrays
men noting and making judgments ("Standard?" "Substan-
dard?") on all the "vital statistics" of the female subject, the
"citizen" (the artist herself). In the process of reducing the
woman's subjectivity to quantifiable data, her inner being im-
plicitly ceased to exist (see also pages 195 and 277).

When Rosler first presented *Vital Statistics* she was living in
San Diego, a locus of innovative work in Happenings and per-
formance. There she participated in the "Nine Women"
collaborative group begun by Eleanor Antin and Aviva
Rahmani.[31] In this supportive environment in the early seven-

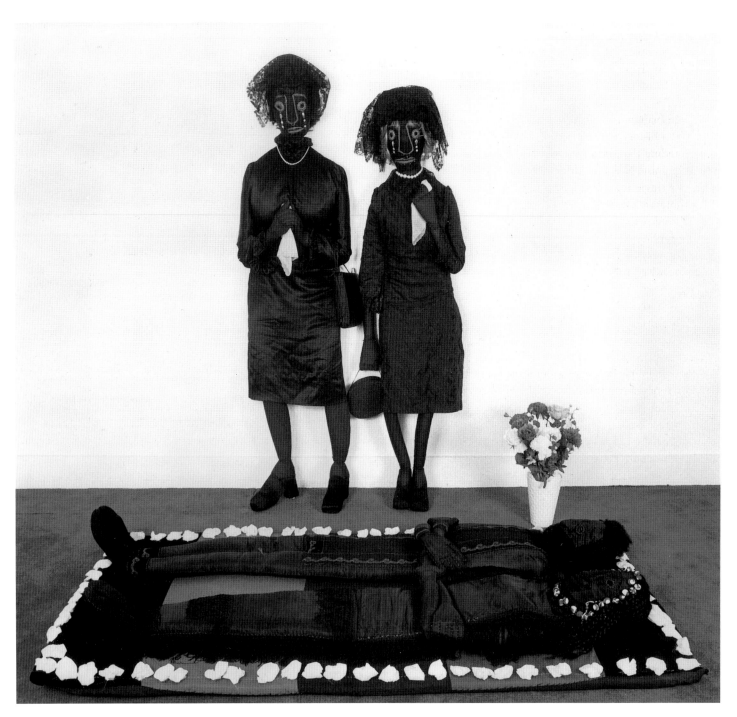

Faith Ringgold. "Bena, Buba, Nana, Moma," from *The Wake and Resurrection of the Bicentennial Negro*. Mixed media, Bena, 65 × 14 × 7″; Buba, 71 × 16 × 7″; Nana, 67 × 16 × 11″; Moma, 62 × 16 × 11″. Commissioned by Wilson College, Chambersburg, Pennsylvania, 1976. Courtesy of artist. Buba, a young man who has died of a drug overdose, is ensconced on the red, black, and green Marcus Garvey flag; in the course of the performance he is brought back to life by the loving witnesses and mourners attending his funeral, whereupon he raps about the evils of drugs.

ties, Antin began to experiment with costume and role play. Working from the outside in, Antin used costume props to create a group of archetypal characters she has continued to deploy over the years: a king, a ballerina, a nurse, and a black movie star who "infiltrates" the other three, sometimes to create more individuated characters. The black movie star playing the ballerina, for example, becomes the Russian prima, Eleanora Antinova. By living through these "four great personas, I have learned a lot about my life and character and my situation in the world."[32]

Antin maintains that this experiential re-creation of a character and a history is a more effective way of knowing and understanding the world than so-called objective research.[33] Other feminists have also observed how many women have rejected the single focus imposed by the dominant culture and have embraced a collective ego in which women explore who "we are" and not simply "who I am."[34] Through her invented autobiographies, Antin "can become part of life. . . . it's a way of living at a very heightened point, but framed by parameters, because when I go home, I take off the King clothes, and I'm Eleanor."[35]

Women were also "dressing up" in the Bay Area. Lynn Hershman invented an alter ego by the name of Roberta Breitmore, who for three years (many of Hershman's projects have had three-year life-spans), from 1975 to 1978, lived in San Francisco and other locations around the country, including a standing-room-only appearance in the Fifth Avenue windows of Bonwit Teller (April 1976).[36] Roberta Breitmore was so fully realized that we could inspect her résumé, bank statements, and other personal data, as well as the room she lived in. Breitmore was Everywoman, an antiheroine who lived in present time and had quite ordinary encounters, unlike the more picaresque adventures of Montano's Chicken Woman or Antin's mythic characters. But in speaking the language of conventionality, Hershman's Breitmore character held up a mirror which reflected the desperation we all encountered in negotiating our lives.

Masquerade and "transformation" were also being used on the East Coast to create liberating alter egos. At about the same time Chicken Woman was moving out to California, and Roberta Breitmore, the King and the Ballerina were born, Claudia was being created in New York City by Martha Wilson and Jacki Apple.

While teaching in Nova Scotia, Wilson had already begun exploring the relationships between outer persona and inner knowing in a series of private performances done for the video camera: as her "perfected" self, as a "deformed" person, as a male impersonator, and as a man impersonating a woman à la Duchamp's alter ego, Rrose Sélavy. Apple had also been doing performance in New York. Both artists were included in the "c. 7,500" show, they liked each others' work, began corresponding, and out of that agreed to collaborate. Instead of Antin's multiple characters, Claudia was one character, but inhabited and presented by two people. Claudia was many of the things these young women were not: rich, glamorous, privileged, and powerful. She had various adventures in and around New York, she was picaresque but also self-reflective. Apple wrote: "July 26,

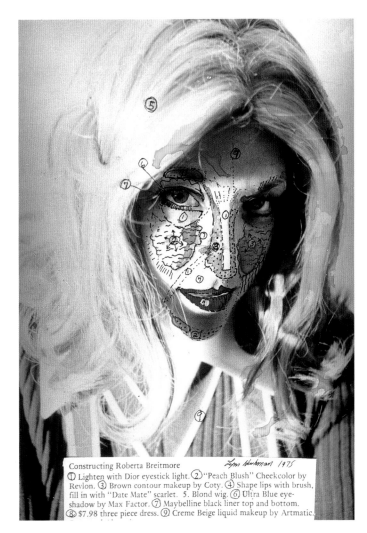

Constructing Roberta Breitmore *Lynn Hershman 1975*
① Lighten with Dior eyestick light. ② "Peach Blush" Cheekcolor by Revlon. ③ Brown contour makeup by Coty. ④ Shape lips with brush, fill in with "Date Mate" scarlet. 5. Blond wig. ⑥ Ultra Blue eyeshadow by Max Factor. ⑦ Maybelline black liner top and bottom. ⑧ $7.98 three piece dress. ⑨ Creme Beige liquid makeup by Artmatic.

Lynn Hershman. *Roberta Breitmore's Construction Chart.* 1973. Third generation "C" print, 18 × 24". Collection the artist. Roberta Breitmore was cobbled together out of the "vital statistics" of numerous ordinary women.

Eleanor Antin as *The King of Solana Beach with Surfers.* Performed in San Diego, California, 1979. Courtesy of artist. In the literary tradition of Virginia Woolf's *Orlando,* Antin transformed herself into the King. She appeared to her subjects as a benevolent monarch in the framed space of the art gallery and as an "artwork that slips into the world as an experience."

Opposite:
Judy Chicago, Suzanne Lacy, Sandra Orgel, Aviva Rahmani. *Ablutions.* 1972. Courtesy Suzanne Lacy. "A woman was tied into a chair and then tied to everything else in the vast room . . . after being 'bathed' in raw eggs, earth, blood. The sound was a tape recording of women telling about their rapes. At the end of the piece the last voice repeated over and over, 'I felt so helpless all I could do was lie there and cry.'" (Arlene Raven)

1974. 'Claudia' was a magnification of role models and stereotypes of power, media images programmed into all of us. The 'power' of the beautiful, rich woman. The illusion of power. We exaggerated it, 'lived' it in order to also shatter it, expose the illusion, blow it up, not reinforce it, or validate it."[37]

Meanwhile, the Los Angeles feminists were institutionalizing the collaborative process. Although Rosler's, Antin's, and Hershman's solo performances were indebted to the collaborative groups they worked with, most of the pioneering feminist work in Los Angeles was created and performed in collaborative groups. If we take Montano's or Antin's observations about how much they learned about themselves by living through their characters and their desire to discover the "I" in relationship to the collective ego, and magnify all this into the synergy of the group, we can begin to understand the profound impact performance had in the Feminist Art Program and at the Woman's Building in Los Angeles.

The collaborative groups had their beginnings in Judy Chicago's feminist art classes at Fresno State in the late sixties as cathartic enactments of the young students' pain, tedium, and fears, which were brought out in their group consciousness-raising sessions. These exercises were continued in the Feminist Art Program and were eventually performed in public at Womanhouse in February 1972.[38] As simple as it is riveting, Faith Wilding's *Waiting* is one of the few performances whose eloquence can be conveyed through reading the script.[39]

Ablutions was a culmination of the performance work in the Feminist Art Program. It came at a transition point, after

Womanhouse was completed and dismantled and before the opening of the Woman's Building in 1973. This "blood ritual" was staged in the spring of 1972 in a large studio in Venice, California, by Judy Chicago, Suzanne Lacy, Sandra Orgel, and Aviva Rahmani. The subject was rape. Thematically, *Ablutions* was a landmark for its stunning revelations of everyday violence against women. Logistically, it was more complex than anything produced so far by that group. In the nineties, we have become accustomed to public revelations of violence against women and children, but in the early seventies it was variously a painful, cathartic, and shocking experience for women to name their fears and feelings of helplessness and rage, whether it was in the privacy of consciousness-raising groups, or in the riskier arena of public performance.

Through the rest of the seventies, the Woman's Building provided a place, and the Feminist Studio Workshop the programmatic context, for some of the liveliest performance work in the country. Many groups and individuals in Los Angeles—including Cheri Gaulke, Jerri Allyn and the Waitresses, Nancy Angelo, Barbara Smith, Rachel Rosenthal, Terry Wolverton and the Oral Herstory of Lesbianism, Leslie Labowitz, the Feminist Art Workers, and Suzanne Lacy—connected, were nurtured, and came of age together through their activities at the Woman's Building. As a performance venue, the Woman's Building also invited leading performance artists from around the country: Eleanor Antin, who had her first public performance there; Linda Montano, who did a live-in performance and first met Pauline Oliveros there; Bonnie Sherk, Helen Harrison, and Mar-

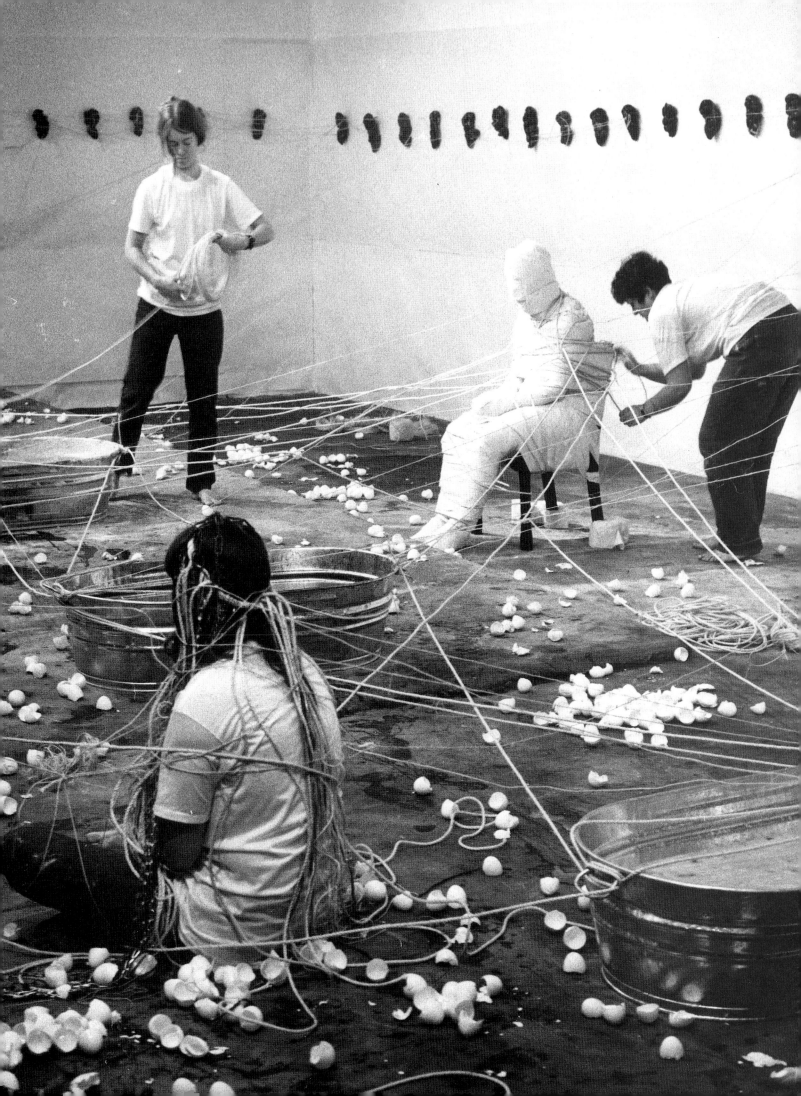

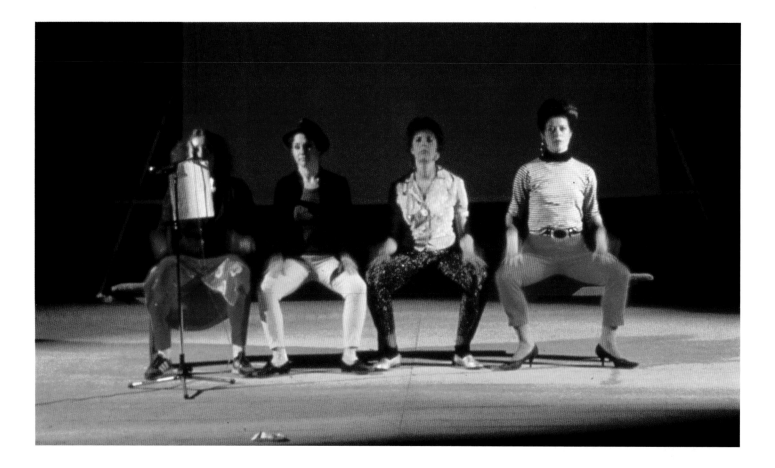

tha Rosler from California; Yvonne Rainer, Joan Jonas, and Martha Wilson, as Claudia and with Disband, from the East Coast.

Rachel Rosenthal's development as a performance artist during this period sheds light on the transformative atmosphere of the Woman's Building. Rosenthal was already a well-established artist when she moved to Los Angeles in 1955. She grew up in an avant-garde milieu in Paris, lived in both Paris and New York City in the years after the war, and from 1956 to 1966 was the founder/director of the improvisational Instant Theater. Unlike other feminist performance artists, Rosenthal had a great deal of experience in dance and theater as well as in the visual arts. Even today, her work is distinguished by its crafted theatricality.

Rosenthal's feminist epiphany came at a conference sponsored by the Feminist Art Program at CalArts in 1971 and was nurtured through contacts with the Woman's Building and June Wayne's Joan of Art seminars held at her Tamarind Lithography Workshop. Rosenthal's performance work of the late seventies has been described as "healing autoethnographies," rather like Montano.[40] Rosenthal herself has observed, "If you put all my performances together, then you will have my life done in the form of an art work."[41] *The Arousing (Shock, Thunder): A Hexagram in Five Parts*, 1979, referring to one of the hexagrams in the I Ching, used live performance, video, slides, music, and dance to focus on the difficult existential questions a woman in her early fifties might ask of life. In 1981, Rosenthal perma-

nently removed yet another "layer" when she had her head shaved as part of *Leave her in Naxos*. Rosenthal has continued to dedicate her performance work to an uncompromising exploration of consciousness: "In performance you squeeze out yourself, you dredge it up from your unconscious. It is a process of giving it a form from the inner to the outer. The process cannot be frivolous, but must be deep, a deep commitment to yourself. It can be really transformational."[42]

Suzanne Lacy, a full generation younger than Rosenthal, also came to artistic maturity in the milieu of the Feminist Art Program and the Woman's Building, where she staged several of her early germinal events. She was a mainstay of the performance program there, and, as mentioned above, participated in the creation of *Ablutions*. By 1974 she was teaching in the Feminist Studio Workshop, and in 1977 collaborated in two city-wide events, both of which represent major steps in the development of performance and feminist practice. Feminist performance in California began as privately performed catharsis, and with *Three Weeks in May* and *In Mourning and In Rage* came out into the open as public media events.

Instead of the anguished passivity expressed in *Ablutions*, *Three Weeks* was angry, assertive, and out to change the consciousness of a large and wholly new public. Working with Barbara Cohen, Melissa Hoffman, Leslie Labowitz, and Jill Soderholm, Lacy designed a whole series of events and activities throughout Los Angeles to dramatize the frequency of sexual vi-

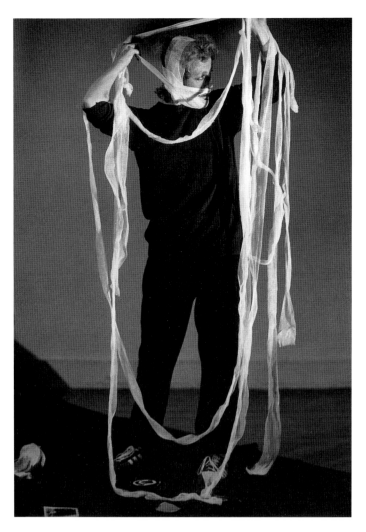

Rachel Rosenthal. *The Arousing. (Shock, Thunder): A Hexagram in Five Parts.* Multimedia performance presented at I.D.E.A., Santa Monica, California, February 11, 1979. Courtesy of artist. Photograph by Lyn Smith. The title refers to one of the hexagrams of the I Ching. The unwrapping of the bandages alludes to the construction, deconstruction, and transformation of an identity through layering, disguise, masquerade.

Opposite:
Martha Wilson, Ilona Granet, Donna Henes, Diane Torr. '"Flamingo" from *Disband.* Performance at Teatro Affratellamento, Florence, Italy, March 5, 1980. Courtesy the artist. Each woman created a character who performed songs about political and environmental issues, using such unlikely instruments as toys, bedsheets, and radios.

olence against women. On display at City Hall was a large map dotted with push pins showing where rapes had occurred during a three-week period in May; women picketed with signs displaying rape statistics; leaflets were distributed giving daily rape reports as well as resource information; and Lacy presented a more esoteric piece, *She Who Would Fly*, which had some of the gutsiness of the earlier *Ablutions*. A proactive use of the media was integral to the success of *Three Weeks*. "It was used as both organizing device," Lacy reports, "to bring people from different anti-violence organizations and different political perspectives together on the same programs—and as a way to create public dialogue on rape and women's solutions for it."[43]

Two other performances-as-media-events followed quickly from this. In August 1977, Leslie Labowitz created *Record Companies Drag Their Feet*, with the collaboration of Women Against Violence Against Women and the California chapter of NOW, as a protest against the glamorizing of violence against women in pop music's lyrics and record covers. Then, on December 13, 1977, Lacy and Labowitz staged *In Mourning and In Rage*, a pure media event created in response to the sensationalized media coverage of the so-called Hillside Strangler, who by then had killed ten women and was still at large.[44] They used "the media's own language of high drama and intriguing visuals to create a newsworthy event. . . . [designed] to fit a news broadcast."[45] Arresting images and a clear story line replaced the randomlike quality ascribed to some early performance pieces; the "I am here for the rage of all women. I am here for women fighting back!" declarations superseded the anguished passivity of the voices in *Ablutions*.

The Feminist Art Workers got their start at the Woman's Building, and from 1976 to the end of the decade staged many events throughout the West and Midwest dedicated to challenging conventional female roles and images. The original group of four adopted stereotyped personas who often acted in surprising ways: Nancy Angelo as Sister Angelica Furiosa, Cheri Gaulke as Cinderella, Vanalyne Green as the Cleavage Woman, and Laurel Klick as the Pussy Cat. Their *Traffic in Women*, 1978, like *Three Weeks in May*, used performance as a vehicle for establishing an empowering network, this time among sexual workers in Las Vegas and Los Angeles.

The Waitresses also percolated out of the Woman's Building and took on the "motherlode" stereotype of them all: the waitress. Formed in 1977, while Judy Chicago and her group were bringing the *Dinner Party* to fruition, The Waitresses used campy satire to both analyze and ridicule women's "natural" role as maker and bringer of food through events such as "Ready to Order?", the "All-City Waitress Marching Band," and a radio show, "The All American Waitress Radio Show."[46] Bonnie Sherk, working in San Francisco, also performed as a "Waitress" and "Short Order Cook" in the early seventies, but the work for which she is best known used performance art as a vehicle for manipulating large social systems.

Indeed, Sherk has a very broad and visionary definition of art: "that which is an integrated manifestation of feeling, idea and form."[47] In 1974 she founded Crossroads Community (The Farm), which eventually inhabited six and a half acres of inner city land nestled under and around the confluence of three ma-

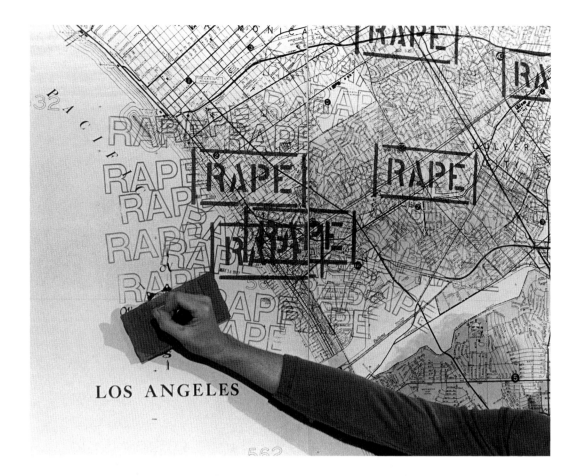

Suzanne Lacy and Leslie Labowitz. *Three Weeks in May* (two views). Performance at Los Angeles City Hall, 1977. A media event created to raise public consciousness about sexual violence against women.

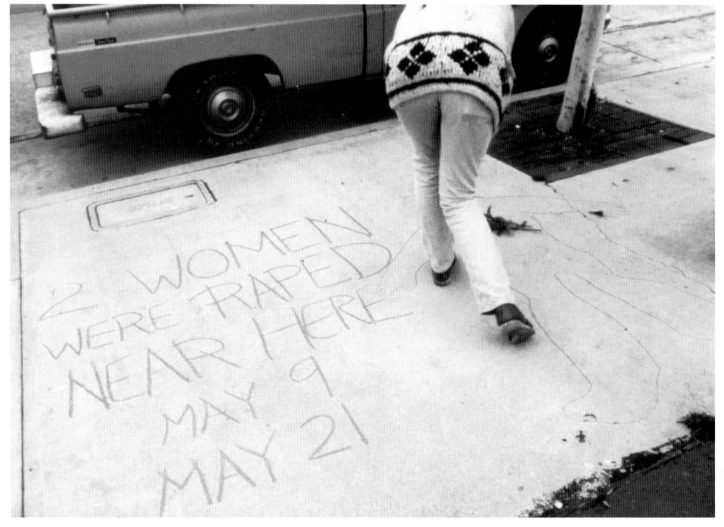

jor expressways. Crossroads Community began as a reclamation of "invisible" space on which the neighboring residents and the passing motorists literally had turned their backs. "The land fragments were owned by the city, state and private sources," Sherk notes. "The city-owned land was under the jurisdiction of several agencies. It was a true collage of spaces. It was also at the convergence of three hidden creeks, a magnet site of invisible energy."[48] The poetic image which generated The Farm came from a recurring childhood dream: "the image of large, monolithic, technological, clanging forms. Inside of them would be growing a fragile flower, just a single flower."[49]

The Farm was serendipitous, practical, visionary, and politically astute all at the same time. It still is a model for what is possible in the increasingly splintered enclaves within our cities. What impact did it have, and what difference did it make? These are difficult questions to answer precisely because the results are mostly indirect and certainly unquantifiable. But they are the kinds of questions that must be raised about any socially activist art. Lacy, who shares so many of the same concerns in her own work, asked: "How many people were motivated to act? (Or should they act?) Did their thinking expand or change? Did their responses find their way into other actions. . .? Is response even discernible?"[50] Bonnie Sherk was not alone in practicing ecofeminism years before it became such a familiar concept. Rosenthal, Rosler, Helen and Newton Harrison of San Diego, Mierle Ukeles of New York City, and Jo Hanson of San Francisco have all used their art/life performance work to stretch our collective consciousness out from the personal and the individual to the group, the community, and the planet.

The seventies ended with a stronger sense of feminist collectivity, with the liberating recognition that there were many kinds or aspects of feminism and feminist activity. There was a sense of optimism, despite the election of President Reagan, for what women could accomplish, yet there was a realization that our work had only just begun. By 1980, Faith Ringgold, Howardina Pindell, and other artists of color were beginning to be heard, yet galleries were still slow to welcome African-American artists. In 1980, Lorraine O'Grady, performance artist and photographer, performed as Mlle. Bourgeoise Noire by attending "the opening of the Nine-White-Personae show" in her coronation gown and cape made of 180 pairs of white gloves.[51] In her always elegant and highly ritualized performance, O'Grady enlarged on Ringgold's "white face" masquerade to remind us once again of feminism's egalitarian vision and of the work still to be done.

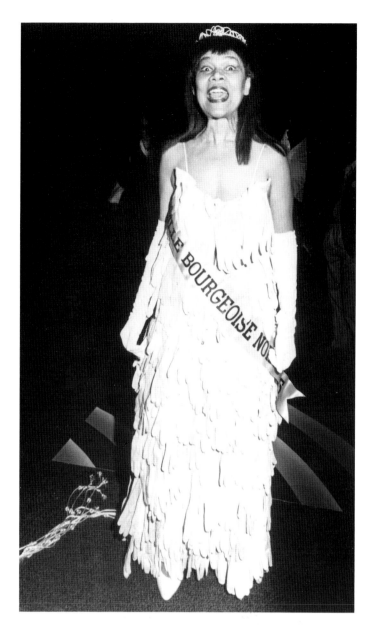

Lorraine O'Grady. *Mlle Bourgeoise Noire Goes to the New Museum.* Guerrilla performance at The New Museum of Contemporary Art during the opening of "Personae," September 1981. Wearing a gown and cape made of 180 pairs of white gloves, the artist invaded the opening, shouting angry poems against the racial politics of the art world. Photograph by Coreen Simpson

RECOVERING HER STORY: FEMINIST ARTISTS RECLAIM THE GREAT GODDESS

BY GLORIA FEMAN ORENSTEIN

In her most recent book, *The Creation of Feminist Consciousness: From The Middle Ages to 1870*,[1] feminist historian Gerda Lerner argues that throughout Western history female mystics such as Hildegard of Bingen (twelfth century), women in the Cathar (eleventh-twelfth centuries), Beguine (twelfth-thirteenth centuries), and Shaker (Ann Lee, founder 1736–84) movements, as well as many secular female visionaries like Margery Kempe (c. 1373–1438), constitute a long matrilineage of women who, through powerful mystical visions and divine revelations, acquired the authority to challenge the sexism and misogyny of their own patriarchal societies and religions. Lerner traces women's biblical commentary and criticism from Hildegard of Bingen and Christine de Pisan through Elizabeth Cady Stanton and Matilda Joslyn Gage's *The Woman's Bible*.[2] Her conclusion is that

> women were denied knowledge of their history, and thus each woman had to argue as though no woman before her had ever thought or written. Women had to use their energy to reinvent the wheel, over and over again, generation after generation. Men argued with the giants that preceded them; women argued against the oppressive weight of millennia of patriarchal thought, which denied them authority, even humanity, and when they had to argue they argued with the "great men" of the past, deprived of the empowerment, strength, and knowledge women of the past could have offered them.[3]

The revelations of these female mystics often contained visions of a feminine aspect of the divinity or of a divine female, such as Sophia (the female aspect of God representing wisdom, or the Goddess of Wisdom). They also included images of the Church as Mother, and they frequently conceived of a holistic spirituality in which heaven and earth were linked, and spirit and nature were no longer antithetical. In retrospect it now seems evident, as Gerda Lerner noted, that "the concept of the divine female, Great Goddess, procreatrix, goddess of life and death, continued to inspire women 2,000 years after her passing. Despite all the gender indoctrination and the intense pressure towards submissiveness, women, obsessed or rational, wrote themselves into the story of redemption."[4]

The female Goddess artists of the 1970s both participate in and expand upon this tradition. However, it is interesting to consider the fact that the movement to reclaim the Goddess in our own time began specifically with artistic and archaeological rather than mystical expression. The two most important scholarly voices of the seventies, women whose works have grounded and launched our contemporary feminist approach to the study of the pre-patriarchal Goddess civilization in archaeology and history, were Marija Gimbutas and Merlin Stone. Merlin Stone had been a sculptor, and she has often told the story of how she uncovered the material that later became her groundbreaking book *When God Was A Woman*.[5] She had been looking for art-historical images of powerful female forms, which led her to the discovery of the Paleolithic Goddesses such as the Venus of Willendorf, and then took her on a quest for other Goddess images in pre-patriarchal cultures. Marija Gimbutas's archaeological studies have given the highest scientific authority to our

Cynthia Mailman. *Self-Portrait as God* from Sister Chapel. 1977. Acrylic on canvas, 60 × 108″. Collection the artist

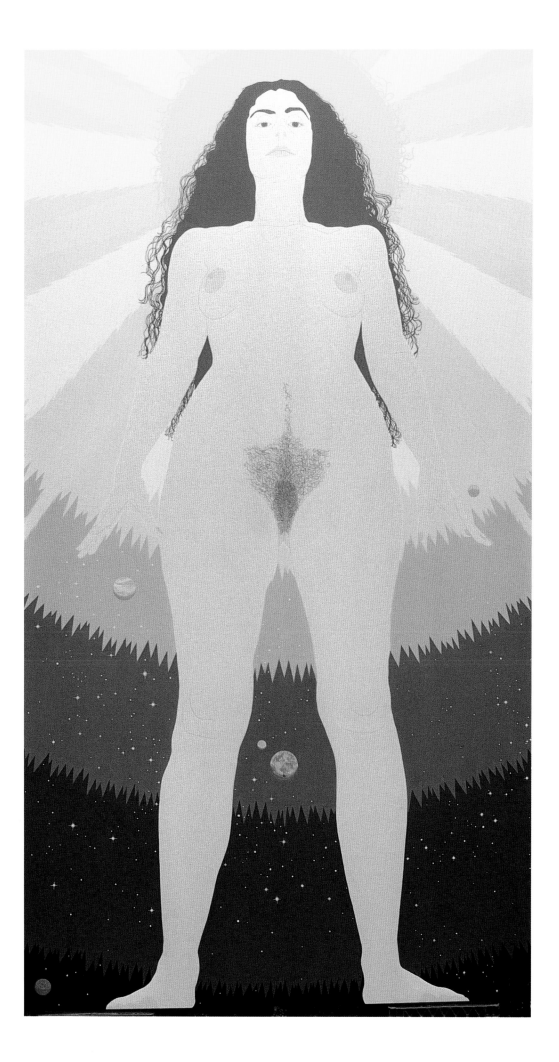

knowledge of ancient Goddess civilization. Her book, originally published in 1974 with the title *The Gods and Goddesses of Old Europe: 7000 to 3500 B.C., Myths, Legends, and Cult Images*,[6] provided a full iconographic lexicon of pre-patriarchal images and symbols.[7]

The examples of these two pioneer women scholars, whose works served to reclaim the Goddess within a feminist "herstorical"[8] context, indicate that art is a potent transmitter of knowledge. We are further reminded that in oral and primal cultures lacking a written language, knowledge was always conveyed through the arts.

The contemporary feminist movement to reclaim the Goddess through the arts is thus to be understood as embedded both within a larger "herstory" of women's historical critique of patriarchal religions and within a pre-patriarchal herstorical context of women's artistic creativity through representations of powerful female figures in nature, on stone, in caves, and in clay. These images contain a vital "herstory" of women's relation to the sacred and to the secular dimensions of their worlds. It was, however, the artistic visions of Merlin Stone and Marija Gimbutas that eventually reinterpreted the meaning of these ancient, artistic images for us historically and archaeologically, making them accessible and meaningful to contemporary feminist artists of the 1970s. Thus, the reclamation of the Goddess in art is situated in the heart of the second wave of the feminist movement (1970s to the present) as well as within the newly developing field of women's studies scholarship.

Although our Western herstorical foremothers from Hildegard of Bingen to Elizabeth Cady Stanton created feminist commentaries, critiques, and images in response to the divine or the sacred as it was inscribed and defined within patriarchal history, the 1970s were the first time that women's artistic creations self-consciously extended beyond the patriarchal art-historical parameters and references, and reclaimed matristic visual models and materials from as far back as the Upper Paleolithic and the Neolithic eras.[9] Thus, the meaning of these early Goddess works by women artists of the 1970s must be read against the Western herstorical background of a powerful tradition of women mystics, heretics, and visionaries, as well as contextualized within a movement that for the first time directed its energy and power toward self-consciously creating an art that would reimagine what it might have been like to be female, and to experience one's body, mind, spirit, and soul free of all the fetters imposed upon women by Western patriarchal religions.[10]

In California, the Goddess art movement explored ancient Goddess civilizations via history and archaeology, uncovering knowledge of such early Goddess figurines as the Venus of Willendorf (25,000 B.C.), the Venus of Lespugne (25,000–18,000 B.C.), the Bird-Headed Snake Goddess (Africa, 4,000 B.C. and Crete, 1600 B.C.), and the Venus of Laussel (20,000 B.C.). It was also a quest for the presence of Goddess energy. This might be manifested in nonhuman nature, in the cosmos, and in our female bodies, both at ancient sacred sites where the Goddess was once worshipped, as well as in our minds when they entered an altered state of consciousness in which past-life memories could be accessed.

In New York, the context of the reclamation of the Goddess in art was, to a large extent, colored by the rediscovery of Jung's concept of the archetype of the Great Goddess. The word *archetype* was freely used in those days, and it had been taken from Erich Neumann's discussion of Jungian ideas about the archetype of the Great Goddess in his book *The Great Mother: An Analysis of The Archetype*.[11] Jungian psychology had posited that the Great Mother represents the feminine in the human psyche, and that archetypes are internal images that exist in the collective unconscious and are at work in the psyche everywhere. I then used archetype in the title of my first article for the Great Goddess issue of *Heresies* (Spring 1978), "The Re-emergence of The Archetype of the Great Goddess in Art by Contemporary Women," because I had also come to believe that the archetype of the Great Goddess was emerging in the universal psyche at that moment in history.

As a critic, I, too, espoused the Jungian hypothesis because, at the time, I had no other theoretical framework within which to interpret the Goddess images I was encountering in feminist art of the seventies, and also because many of the artists I interviewed placed their works within this context. The Jungian interpretation, which predated Goddess scholarship, lent an intellectual legitimacy to the powerful female images that women were painting, sculpting, and drawing. In other words, while art and historical research could perhaps explain why certain artists were inspired by these newly rediscovered Goddess images, only the Jungian hypothesis seemed to explain why women artists who had never read about the Goddess before were suddenly dreaming about and creating images that tallied with the ancient forms and symbols of the Goddess that appeared in pre-patriarchal cultures.

Surrealist artist Leonora Carrington, who became a friend in the early 1970s and whose art I had studied, had a great affinity for the works of Jung, as opposed to those of Freud. Indeed, when I began to analyze her paintings within a Jungian perspective that included an understanding both of alchemical symbology as well as of the archetype of the Goddess, I was at last able to interpret her otherwise cryptic and mysterious paintings in ways that revealed important and inspiring feminist meanings. But Leonora Carrington was not the only artist during that time who spoke to me about Jung.

Buffie Johnson also told me that since the late 1940s her work had been influenced by the Jungian concept of the collective unconscious.[12] Her paintings evoke mythic memories and archetypal images from ancient civilizations such as the Minoan civilization of Crete, where the Great Goddess was once revered. The titles and subjects of Johnson's paintings, such as *Labrys*, 1972, are often symbolic of the fruits of nature that were sacred in the worship of the Great Goddess of Crete. Several of Johnson's works contain specific references to the aspect of the Great Goddess known as Mistress of the Beasts and Lady of the Plants. In *Ariadne (Barley Mother)*, 1971, the Goddess of Vegetation is depicted in the image of a gentle rain-flow of a skirt of long-grain barley. *Pasiphae*, 1976, combines the image of the iris (the sacred Lily of Crete), with a bovine head and leaves that become the horns of the bull (as in The Horns of Consecration at Knossos). All these Cretan mythic resonances show the ways in which contemporary artists may use ancient Goddess memories

to transform our perception of the natural world from patriarchal to matristic. The paintings complete the regeneration process by stimulating memory in the psyches of those viewers who now learn to perceive the bull-in-the-lily (in the composite image painted by Johnson) in a matristic way. The viewer will then, presumably, begin to summon up other mythic memories of the Cretan Goddess civilization once the unconscious has been thus awakened.

Architect Mimi Lobell, working with two other women, one a Jungian, designed a Goddess Temple that expressed the themes of intiation and rebirth into a Goddess religion. The temple was considered to be the externalization of an archetypal structure that exists within the psyche. Its eventual site was to be a mountainous region near Aspen, Colorado, and it was conceived of as analogous to the body of the Great Goddess through which the initiate would pass in a ceremony of transformation. According to Lobell "To go through the temple will be to experience an initiation into the mysteries of the feminine and activate a prelogical consciousness."[13]

In the 1970s Donna Henes was making process environmental sculptures based upon Spider Woman from the Navajo Emergence Myth. Jungian writer Sheila Moon, in her study of the Navajo Emergence Myth, has said that Spider Woman is "the protective feminine objectivity. Spider Woman is the unobtrusive but powerful archetype of fate—not in the sense of determinism, but in the sense of the magical law of one's own gravity, which leads always beyond itself towards wholeness."[14] Donna Henes also performed a yearly winter solstice ritual celebration entitled *Reverence to Her: A Chant to Invoke the Female Forces of the Universe Present in All People*. Since, according to Erich Neumann, it is at the winter solstice that "the Great Mother gives birth to the Sun, who is Her Son, and stands at the center of the matriarchal mysteries,"[15] Henes's participatory chant invoked the Great Goddess as the archetypal principle of female power. (See also Withers, page 163.)

Feminists of the nineties, reflecting upon the ways in which some American, white, middle-class female artists used images from ancient and indigenous cultures in their own works, might be led to conclude that these artists were appropriating images from tribal peoples and foreign cultures, and making them their own in ways that today might be considered a form of cultural imperialism. However, I would argue that within the context of the notion of Jungian archetypes in the collective unconscious as it was understood in the early seventies (a period of pioneering and exploratory research in women's studies done in the absence of a feminist multicultural theory), many artists and scholars tended to believe that this collective unconscious was equally accessible to anyone, anywhere, and that the images thus inspired or created transcended all patriarchal cultural barriers. Indeed, it was believed that via these images all oppressed women (whether oppressed by class, race, or ethnic origin, for example) could reconnect with an ancient primal female force emanating from these symbols, which would charge them with a specifically female energy (known as "gynergy"). This gynergic force would then bring together in a new harmony women who had previously been separated from each other by patriarchally constructed divisions such as class and race.

It seems to me that these artists of the seventies were actually searching for specific matristic symbols (such as the web) that could become universalized in order to replace the icons of a hegemonic, patriarchal religion (such as the cross) with those of a universal matristic and holistic spirituality.[16] In the 1970s, Goddess artists such as Ana Mendieta, Mary Beth Edelson, Ursula Kavanagh, Betsy Damon, Monica Sjöö, and Donna Henes reclaimed such forms as the spiral, the labyrinth, the egg, the circle, crescents, horns, quatrefoils, disks, coils, meanders, lozenges, concentric circles, the labyris, the earth mound, and the serpent from pre-patriarchal Goddess art. They then elevated these symbols to a quasi-universal matristic status, interpreting them as symbols and aspects of a unified Goddess culture, rather than seeing them as cross-culturally diverse.

In the seventies, women artists reclaiming the Goddess were looking for a unity beyond the pluralism of culturally specific symbols. It was important to them to learn that Goddesses once existed everywhere, and that their presence tended, on the whole, to give women higher status in their societies. At the time, feminists did not realize that this retrieval of a worldwide Goddess civilization was largely being done by white, middle-class, Western women and for the sake of what some have called an "essentialist" theory[17] until it was pointed out to them. As with other feminist art of the seventies, women were looking for forms and themes that showed female bodies as strong, and that depicted women in positions of power, both socially and spiritually. While this pursuit may be viewed as simplistic today, in the nineties, it was revolutionary in the seventies. The aesthetic questions asked at the time sought a universal female response to the inquiry about whether there is a specifically female art or a specifically female iconography. The questions that were then posed in feminist art-historical research sought to use data from diverse cultures to prove that the Great Goddess, whether archetype or historical reality, was the original female image of the Creator of all life, and that the multiplicity of different Goddess images found in different cultures simply illustrated her many varied aspects. There was, in my opinion, an important feminist political motive in the way that the Goddess art of the 1970s ignored cultural specificity and transgressed many historic and geographic boundaries by importing, transporting, and transplanting images freely, and by using them as universal symbols for a notion of "Womankind", understood archetypally, as if such a general concept could unite women from around the world in a global revolution against patriarchal oppression.

An example of contemporary Goddess images that transcend specificity is the work of Anne Healy. Her *White Goddess*, 1972, and *Hecate*, 1972, depict flowing sculptural forms made of nylon fabric and aluminum bars (to delineate the form over which the fabric flows); both are suggestive and evocative, rather than culture-specific. They refer to the light and dark aspects of a universal Goddess. While their titles give mythological substance to the forms, the sculptures themselves are like spirits, and can fly in the wind or bend and turn according to the surrounding air currents. These works indicate the spiritual nature of an all-embracing Goddess.

While feminist Goddess art of the eighties and the nineties has come to be closely linked to ecological themes and to Earth

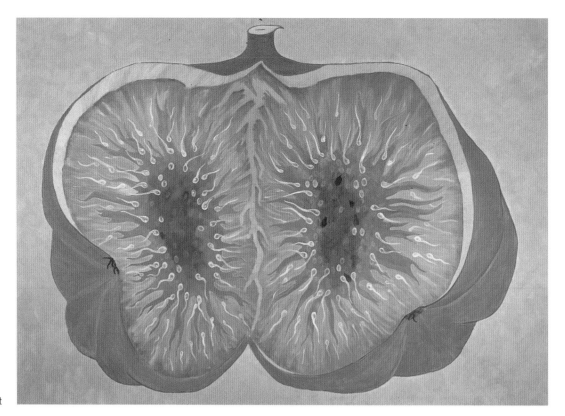

Buffie Johnson. *Labrys.* 1972. Oil on linen, 68×96". Collection the artist

Art, because of the growing awareness of the ecological devastation of our planet, Goddess art of the seventies was primarily focused on the Goddess as a symbol of women's lost herstory and as a path for women to recover their lost spiritual power. For if the theory of the collective unconscious is true, this information and these experiences are not only located in the deep strata of rock and earth, in the deepest strata of pre-patriarchal herstory, but also in the deepest strata of the minds, spirits, souls, and bodies of all women, everywhere, who ultimately descend in time from this ancient matristic matrilineage.

Marija Gimbutas's book, *The Gods and Goddesses of Old Europe,* presented the first archaeological evidence that Neolithic Europe (6500–3500 B.C.) the Great Goddess Creatress was worshipped for thousands of years primarily in two aspects: as Cosmogonic Creator and source of all life (Fertility Goddess, Mother Goddess, Goddess of Vegetation and Creation), and as Goddess of Life, Death, and Regeneration (Moon Goddess), incorporating the cycles of light as well as the cycles of darkness— the symbol of all renewing and becoming.[18] In my earliest studies of contemporary feminist Goddess art I began to observe that the new Goddess artworks fell into the same two categories as the ancient ones. In the aspect of Cosmogonic Creator, Source of all Life and Fertility, were the painted and sculpted artworks by artists such as Ursula Kavanagh, Judy Chicago, Betty La Duke, Judy Baca, Nancy Azara, Yolanda M. López, Ghila Hirsch, Anne Healy, Jovette Marchessault, Betye Saar, and Leonora Carrington. In the aspect of Life, Death and Regeneration that dealt with the cycles, both cosmic and historical, were works based upon ritual, ceremony, performance, and journey by artists such as Mary Beth Edelson, Betsy Damon, Donna Henes, Jane Ellen Gilmore, Beth Ames Swartz, Kyra, Susan Schwalb, and The Waitresses performance art group.

While it seems more than coincidental that the contemporary artworks should fall into the same categories as the ancient ones, the reasons for this can be attributed to the influence of the books by Merlin Stone, Marija Gimbutas, and other pioneering feminist scholars upon these contemporary women artists, as well as a Jungian explanation that would posit the reemergence of the archetype of the Goddess in the human psyche. As a professsor of women's studies I would prefer to think that the flourishing of Goddess imagery in these contemporary works was the direct result of historical, social, and political changes brought about by the Women's Liberation Movement in conjunction with women's studies scholarship. Many of the artists that I interviewed who did not place their works in a Jungian perspective cited studies, travels to Goddess sites, readings, and scholarship as the immediate sources of inspiration and influence upon their Goddess works. The research engaged in by the group of women who worked on Judy Chicago's Dinner Party Project illustrates the importance of scholarship. These feminist researchers came up with the subjects for the plates used in *The Dinner Party,* among which were The Primordial Goddess, The Fertile Goddess, and The Eye Goddess. Yet, while a simple academic approach might decide in favor of a material explanation of the influence of the new feminist data in the social, historical, political, and archaeological sciences, it is also possible that because the Goddess symbolizes a spiritual mythos and ethos, the latent force unleashed by the discovery of the repres-

Josette Marchessault. *Plant Mother*. 1975. Wood, plaster, acrylic and raffia, 5′ 5″. Collection the artist

Donna Henes. *Pocono Web* (Spider Woman Series). 1976. Cotton, 8 × 8 × 8′. Site installation at Mountain Home, California. Photograph by artist

Mary Beth Edelson. *Goddess Head* (Calling Series). 1975. Photograph, collage, and china markers, 40 × 40″. Documentation of a private ritual performed at Montauk, Long Island. Collection the artist

Mary Beth Edelson. "See for Yourself," from *Grapčeva Cave*. 1977. Photograph. Collection the artist

sion of this image in patriarchal civilization might also have generated a powerful psychic effect resulting in the return of the repressed in our time via dreams. Most probably it was the confluence of these two phenomena that contributed to the development of this movement in the arts in the seventies. Thus, we are led to a synergistic explanation of the origins of this seventies art movement.

However, once women artists became conscious of this ancient material as it appeared both in their research and in their dreams, they self-consciously set about creating a symbolic vocabulary based upon the pre-patriarchal signs and symbols revealed in the Gimbutas material, where the constellations of motifs and forms linked to the pre-Indo-European mythology included the Serpent Goddess, the Bird Goddess, the Eye Goddess, the Primordial Egg, the butterfly, caves, labyrinths, grains, rivers, pottery, horns, bull, labyris, the uplifted arms of the Cretan Goddess, and assorted spirals, zigzags, moons, lozenges, disks, animals, and female forms. These symbols can also be divided into two categories: natural symbols referring to fertility, sexuality, plant and animal life, and the cosmos; and symbols associated with specifically female contributions to the creation of culture such as weaving, cooking, pottery, agriculture, healing, and the arts.

Because of their pre-technological nature, ancient Goddess or "matristic" symbols—displaying the talents, powers, creativity, and important cultural contributions made by women of the past—have been omitted from the patriarchal record of history. These symbols also re-create an animistic vision that reveals the existence of a vital spiritual energy or life-force inherent in all matter. The works that fall into the second category of the Cycles of Life, Death, and Regeneration manifest vital animistic energies in dynamic aesthetic forms that often invite audience participation.

COSMOGONIC CREATOR, EARTH MOTHER, FERTILITY

One of the most prolific Goddess artists from the 1970s is Ursula Kavanagh, who came to the United States from Ireland and who participated in the early Goddess movement in the arts in Chicago. Kavanagh now lives and works in New York, and spends each summer in Ireland making Goddess earthworks and stone circles for rituals near the sea.

Kavanagh's art establishes a symbolic language and a matristic iconography relating to a wide variety of Goddess cultures and to numerous sacred sites that she visited. An example from her archaeology series is *Crete*, 1979, in which she depicts stone and ceramic fragments bearing images of the Goddess and the Priestess of the Minoan culture. The colors she employs restore the vibrancy and rhythm of a matristic life wherein gestures of dance, offering, and joy were experienced by the women of Minoan Crete. Kavanagh's work teaches us how a woman archaeologist might draw certain gynocentric[19] conclusions about women's roles in ancient cultures, with only shards and chips of stone or ceramic from which to extrapolate.

In the early seventies, New York artist Mary Beth Edelson

pioneered Goddess works by using her own body in photographs taken of poses with her arms uplifted as a stand-in for Everywoman receiving Goddess energy from the cosmos. The gesture of uplifted arms soon became a popular feminist symbol of matristic spiritual empowerment. It is inspired by the figurines of the Cretan Goddess of the Minoan culture and from the Bird-headed Snake Goddess from Egypt. In *Nobody Messes With Her*, 1973, Edelson draws in the Goddess wings of energy that spiritually empowered women will acquire as they reclaim their ancient sacred relationships to nature and culture. Edelson's work in the seventies also addressed the second aspect of the Great Goddess—the Cycles of Life, Death, and Regeneration. Her installation and ritual entitled *Your 5,000 Years Are Up*, 1977, held at the Mandeville Gallery of the University of California in La Jolla, and her piece *Memorial to the 9,000,000 Women Burned as Witches in the Christian Era*, 1977 (A.I.R. Gallery, New York) commemorate the cycles of history in which women who worshipped the Goddess were crucified for their heretical beliefs. Her fire circles and fire ladders made these events into ceremonies about the exorcism of the pain of patriarchal history, and they also illuminated the hidden cycles of female empowerment in Goddess civilizations, which the women in the audience could then reclaim. In *See For Yourself* (Grapčeva Cave: Memorial Pilgrimage), 1977, Edelson documented her journey to the Grapčeva cave on Hvar Island in Yugoslavia. She sat in a fire ring in the Neolithic cave on Hvar Island, where the Goddess was once revered, and photographed herself in meditation. An unexpected energy flare can be seen in the photo on the right, suggesting that the photo might have captured a trace of the Goddess's spiritual presence in the cave during Edelson's ceremony. In this work Mary Beth Edelson attempted to experience what it must have felt like to be a worshipper of the Goddess during the Neolithic era, when people crawled into caves to perform their sacred ceremonies.

Los Angeles Chicana artist Judy Baca painted *Califia* in 1976, which is based upon the legend of the Amazon Califia for whom California was named. This work is Baca's vision of the beginning of the world. Califia's body is webbed with venal and arterial networks that become her roots in the earth and that grow into her flowering branched arms, reaching up to the sky. In this image the Amazon woman is a Goddess Creatress of all life. She is powerful, she radiates the life-force, and she mediates between heaven and earth, between human and nonhuman nature. All that lives emanates from her fertile, creative energy.

Québecoise artist and writer Jovette Marchessault sculpted *Telluric Women: Women of Hope and Resurrection* in the seventies, and she participated in a group show in New York as well as in the New York Woman's Salon for Literature,[20] where her visual art as well as her literary texts created an important link between the Goddess artists of Quebec and the U.S. Her sculpture *Plant Mother* portrays The Great Mother of Vegetation. Made of materials found in piles of rubbish, *Plant Mother* exemplifies the recycling of materials as an alchemical process transforming primal matter into a matristic image of feminine spiritual enlightenment. *Plant Mother* wears branches on her head, which receive and transmit Goddess energies to and from the universe. They serve as her "arms uplifted," her radar an-

Yolanda M. López. "Portrait of the Artist as Virgin of Guadalupe" from *Guadalupe Triptych.* 1978. Oil pastel on paper, 22 × 30". Collection the artist

Betye Saar. *Voo Doo Lady with Three Dice.* 1977. Mixed media collage on fabric, 10¾ × 10½". Collection the artist

Nancy Azara. *About the Goddess, Kali, for Pamela Oline.* 1979. Oiled and bleached willow, cherry, black locust, maple and fir; height, 7'.

Anne Gauldin (left) and Denise Yarfitz (center) in *The Waitress Goddess Diana.* First performed in Venice Beach, California, 1978. Photograph by Maria Karras

tennae, showing us there is no distinction between spirit and matter, for the branches of a tree can become the receptors of spiritual messages.

An artist known for the multiplicity of her poetic renderings of Goddess images from a wide variety of cultures is Betty La Duke, a professor of art at Southern Oregon State University in Ashland, Oregon. Her many travels to Goddess-revering cultures have fueled her shamanic vision. In her depictions of the Ur Mothers of all cultures, La Duke shows how the Great Chain of Being—animal, vegetable and human—and the cycles of life, death, and rebirth are incarnated in the bodies of humble women, seen as epiphanies of the Great Goddess around the globe. Her X-ray, clairvoyant renderings show us how animal, plant, and human life flow through each other, and are composed of spiritual energies and material substances from many parts of the world and from many cultures.

Chicana artist Yolanda M. López projected the images ofthree generations of women (her grandmother, Victoria F. Franco, her mother, Margaret F. Stewart, and herself) onto the image of Our Lady of Guadalupe, who is at once a woman of color and the Virgin Mary. The Virgin of Guadalupe is the Patroness of Mexico, and she is understood as the idealized Mother, The Great Mother. In her self-portrait as The Virgin of Guadalupe, López depicts herself as an athlete—a runner wearing sneakers and the cloak of the Virgin—and she carries a serpent in her hand, thus brandishing the serpent power of the Goddess. Her mother, a seamstress, sits at her sewing machine stitching her cloak of the heavens. Her divine aura radiates powerful spiritual forces. Contrary to the tendency of most other Goddess artists of the seventies, López has always worked within the Chicano cultural context, and has located her Goddess images within a specific ethnic, national, and religious heritage. Her work at once questions the racism of the Roman Catholic Church, whose image of the Virgin Mary is white, while it also celebrates the spiritual powers, the athletic prowess, and the skills of ordinary contemporary women, who are created in the image of the Goddess, the female aspect of the divine Creator.

African-American artist Betye Saar created images of black female power by delving deeply into the religious practices of Africa and Haiti. Saar resurrects images of the Black Goddess, the voodoo Priestess, and the Queen of Witches. For Saar, contemporary black women are all incarnations of the Black Goddess.

One of the first sculptors whose work dealt with the Goddess, and continues to do so today, is New York artist Nancy Azara, who is also a visionary and a psychic healer. Nancy Azara actually sees the spiritual energy fields surrounding all living things. Her works carved in wood and painted in red and gold leaf make visible the physical (red) and the spiritual (gold) energies that traverse all that lives. Using wood as her primary medium, Azara's Goddess Trees of Life, such as *About the Goddess, Kali, For Pamela Oline*, 1977, reveal the female forms of the many-breasted goddess in abstract symbolic sculptures. These works also relate to the ancient image of Diana of Ephesus, and inspire us to see her as a Goddess Tree of Life as well as a source of healing.

Exploring Goddess imagery within the Jewish tradition are Gilah Yelin Hirsch and Beth Ames Swartz, who have both been inspired by the Shekinah of the Cabala. According to scholar Gershom Scholem, the foremost authority on the Kabbalah, the Shekinah was the feminine element of God. Hirsch's work involves the Ain Soph (divine essence or divine thought in the Kabbalah), and she uses the Ain Soph as the DNA spiral weaving it within the woman's body, so that the sacred Word is born in the womb of woman. In her work the female body becomes the temple of the soul. In 1977 Beth Ames Swartz did both a Cabala Series and a Torah Scroll Series based upon the Shekinah. In 1978 she worked on her large project, *Israel Revisited*, in which she honored ten women from Jewish history at ten sacred sites in Israel.

Feminist artists of the seventies who wanted to reclaim the images and roles of powerful women from herstory and mythology created a traveling exhibit entitled "The Sister Chapel" (in contrast to The Sistine Chapel). Each artist painted a nine-foot-high portrait of a woman of strength and courage; two of these were self-portraits as Goddesses. Diana Kurz painted herself as The Durga killing the Buffalo Demon and liberating the world from evil. Cynthia Mailman painted *Self-Portrait as God* (page 175), in a pose suggesting cosmic force similar to that of Judy Baca's Amazon Califia.

The works by these and many other artists of the seventies created a consciousness-raising that immediately deconstructed the patriarchal dualism of nature versus culture. In these paintings and sculptures women artists asserted their positive relationships to nature and culture as creators of both life and art. The Goddesses in these works embodied images of women of power in domains other than those traditionally associated with stereotypic femininity in the West. Here, instead of images of women as mothers or in other domestic roles, we see women of power in religious roles (as Priestesses in works by Kavanagh), as Warriors (in Kurz's Durga), as Athletes (in López's *Self-Portrait as Athlete*) and as cosmic creators (in Baca's Califia). In Judy Chicago's *Dinner Party* we discover women astronomers, doctors, artists, and musicians, to name but a few. Not only do these representations of women show them creating life, such as the famous *God Giving Birth*, 1968, of Monica Sjöö, (a Scandinavian artist now living in England[21]), but also creating culture.

THE CYCLES OF LIFE, DEATH, AND REGENERATION

Ana Mendieta, whose life came to a tragic end when she fell to her death at the age of thirty-six in 1985, had come to the United States as a child, when she was exiled from her native homeland in Cuba. During most of the seventies Mendieta lived and worked in Iowa. Through her art, she transformed the pain of her separation from her homeland into a metaphor about the pain of all women's exile from the Great Earth Mother. Mendieta's earthworks were often private rituals and ceremonies in which she sketched the outline of her body, arms uplifted, onto the earth. In *Silueta en Fuego*, 1975, she exploded gunpowder in the earthen sketch of the outline of her body, creating a

flaming image of a sacred site in which one woman reclaimed her passionate link to the Great Earth Mother. Her Silueta Series of flaming works and their ashen after-images blaze a trail back to our earthly origins as children of the Earth Goddess. *Silueta de Cohetes*, 1976, shows us the crucifixion of the Goddess with her arms uplifted on a burning pyre, reminding us of the cross. Here it is the Goddess (tradition and history) that has been crucified and sacrificed, not the son of God.

Kyra has been creating both paintings and drawings as well as rituals of the Goddess since the early seventies. While she has drawn Athena, Isis, Artemis, Astarte, and Medusa, her rituals have frequently focused on pre-Columbian goddesses. Kyra's constant work since the seventies, both as an artist and as a teacher, has carried the images and rituals of the Goddess from many cultures across the United States.

New York performance artist Betsy Damon became well known for her incarnation of *The 7,000 Year Old Woman*, a piece she performed publicly on May 21, 1977, in the streets of New York (page 188). Covering her body with many small colored flour bags, Damon appeared on Wall Street as the living embodiment of the many-breasted Artemis of Ephesus (page 184). In the manner of a ritual, Damon punctured each bag and emptied its contents of sand, like a miniature sand timer, arranging the bags in a labyrinthine pattern on the ground. In so doing, she reclaimed the seven thousand years of women's erased herstory from the Neolithic period to the inception of the patriarchal era. Damon, who lived in Turkey as a child (1944–48) near the ancient Neolithic Goddess sites of ancient Anatolia, was directly influenced by the presence of the Goddess there.

Midwestern artist Jane Ellen Gilmore uses humor and irony in her performance pieces at the ancient ruins of Goddess sites, which were overtaken by patriarchal religions. In her Eclecticism and Stress series, 1978, she staged a comical tableau of cat-headed women draped as Goddesses, posing in melodramatic gestures at the Temple of Olympian Zeus II. The performances

Jane Ellen Gilmore. *Eclecticism and Stress Series: The Great Goddess at the Temple of Olympian Zeus.* 1978. Staged photograph

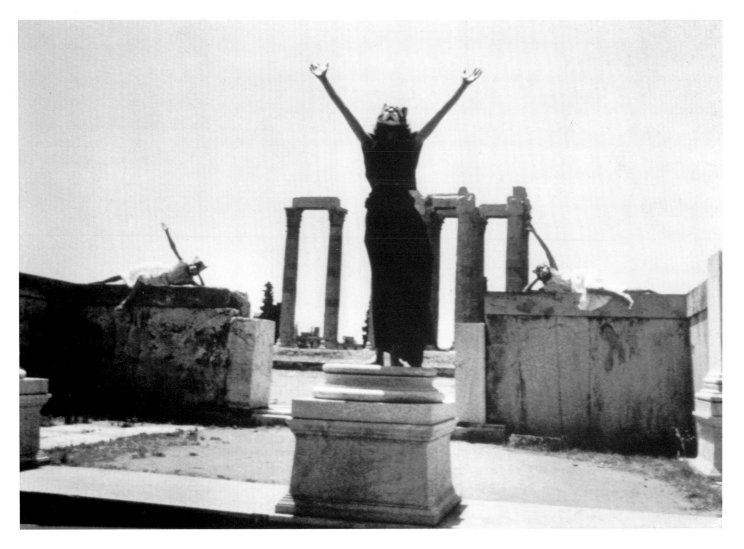

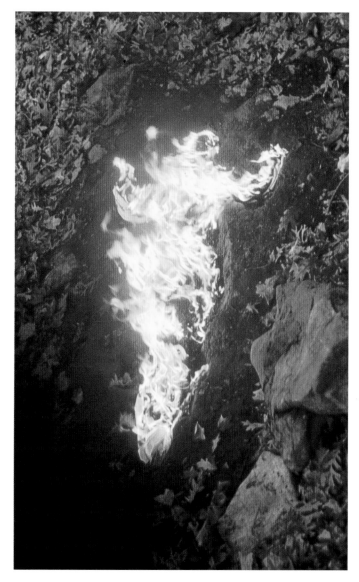

Ana Mendieta. *Earth Bodywork* (Silueta Series). 1976. Color photograph, 13¼ × 20″. Courtesy Gallery Lelong, New York, © Estate of Ana Mendieta

Ana Mendieta. *Silueta en Fuego.* 1975. Color photograph, 13¼ × 20″. Documentation of earth-work performance with fire, cloth, and earth, in Miami. Courtesy Gallery Lelong, New York, © Estate of Ana Mendieta

enacted at these ancient sacred sites reveal the discrepancy between images of empowered women who once revered the Goddess and the way these images have been debased today, when women are depicted as coy sex objects, as pussy cats.

New York and Boston silverpoint artist Susan Schwalb made symbolic works relating to the Goddess in the form of monumental orchids throughout the seventies. Then, toward the end of the seventies (and in 1980 when she went to Norway), she performed a private fire rite intending to return to the land the paper on which she had drawn the Goddess, the Great Earth Mother. After burning the silverpoint drawing and liberating the spirit of the Goddess, Schwalb used the ashes to make small Goddess altars. Her flower drawings, when combined with the flames from the burnings, linked female sexuality to female spirituality in intimate and powerful ways.

The Waitresses was a feminist performance group that created the guerrilla restaurant theater piece *The Great Goddess Diana,* which played to unsuspecting customers in restaurants around Los Angeles from 1978 to 1981. During dinner, the Waitresses would appear wearing their many-breasted waitress uniforms and explain to the diners that today's waitresses, who are underpaid and overworked, are the debased modern version of the ancient Great Mother Goddess as nurturer. The Waitresses' works focused on social criticism in the areas of sexual harassment, work, and money.

These ritual and performance works by Ana Mendieta, Mary Beth Edelson, Kyra, Betsy Damon, Jane Ellen Gilmore, Susan Schwalb, and The Waitresses often invited the participation of the spectators charging the exorcism of patriarchal oppression and the reclamation of matristic values with the collective energies of the crowd. Involving the audience and passersby lifted a barrier between art and life so that the new cycle of the Goddess would be ushered into the world, and not remain cloistered and cut off from the populace, as so often occurs in the art world and in academia.

In conclusion, it must be stressed that the feminist movement to reclaim the Goddess in art in the seventies was international in scope. Indeed, French artist Hélène de Beauvoir, Québecoise artist Jovette Marchessault, Canadian weaver Sasha McInnes, Scandinavian artist Monica Sjöö, Israeli artist Miriam Sharon, and Surrealist artist Leonora Carrington (living in Mexico), all interacted with the Goddess artists in the United States. Many of these women took part in shows at feminist cooperative galleries, and also attended The Woman's Salon that I co-created in New York from 1975 to 1985.

In honor of these international links, especially among those artists of the Americas, I would like to close by speaking about Leonora Carrington's Women's Liberation poster, *Mujeres Consciencia* of 1972, that we carried from Mexico City to New York City in the summer of 1972, and which was distributed to friends in the Goddess and feminist art movements.

In this poster the New Eve returns the apple to the Old Eve from the biblical story of the Fall. The New Eve, thus rejecting the patriarchal myth of the sinful nature of woman and her expulsion from the garden (which is the Earth Mother), experiences an immediate liberation when her Goddess energy is released in the form of the serpent power of the Kundilini, which rises through the *chakras* of her body reaching the Third Eye of Illumination. The poster is green for Green Politics and for our green planet, for as we have seen, Eve is born of the garden, and recognizes her dependence upon it for her life. Carrington's poster transforms the patriarchal myth of the Garden of Eden in several fundamental ways: It establishes forbidden knowledge (in patriarchal civilization this is Goddess knowledge) as liberatory for women—both socially and spiritually, for it leads to political empowerment and spiritual enlightenment; it exemplifies the values associated with the religion of an Earth Mother Goddess, who teaches us that we must renew the fertility of the natural world by changing our cosmic vision to one that reveres both women and nature. (The parallel counterpoint is the patriarchal Sky Father God, who had us believe that humans are superior to and above nonhuman nature, and that nature and women should serve the purposes of men.) It asks women to be conscious *and* to have a conscience—to take the lead in restoring the Goddess vision that is so necessary to the survival of all planetary life today.

As She was reclaimed by women artists of the 1970s, the Goddess signaled a multilevel revolution vis à vis women's art. This revolution included a change in the gender of the Creator, accompanied by a shift toward earth-revering, gender-egalitarian and pacific values, reclaimed from the most ancient and original religion of the earth, the Mother Goddess religion; a recovery of women's erased "herstory" from as far back as the Upper Paleolithic (25,000 B.C.); a holistic vision of the interconnectedness of spirit and matter, heaven and earth, male and female, human and nonhuman life forms; an empowering of women by reconnecting with the ancient energies, roles, and talents both of mythological goddesses and of real women who lived in matristic cultures, and who are credited with the invention of agriculture, weaving, ceramics, healing, and many other important contributions to civilization; a contemporary movement that does not separate politics from spirituality, but that sees art as the crossroads where feminist activism and feminist imagination converge, making for a revolutionary change in both consciousness and culture; and a political and spiritual symbol (perhaps naively universalizing) that would create a sisterhood among women everywhere in a struggle to overcome their oppression as women, despite the many obstacles that ordinarily divide them from each other.

Finally, it can be said that in the 1970s the Goddess was perceived to be the one symbol that could transcend difference, diversity, and division, and that could harmonize women from a wide variety of backgrounds on a level that penetrated so deeply into human history and the collective psyche that the contemporary patriarchal political and social constructions separating women from each other could be overcome. Although regarded as theoretically naive by postmodern revisionists in the nineties, this spirit of solidarity continues to unite women around the world at international conferences and gatherings, and serves as a rallying cry and an emblem of transformation, empowerment, freedom, and rebirth. The Goddess may be interpreted as a luminous symbol of hope for women living through the dark night of patriarchal holocausts, genocide, and ecological disaster.

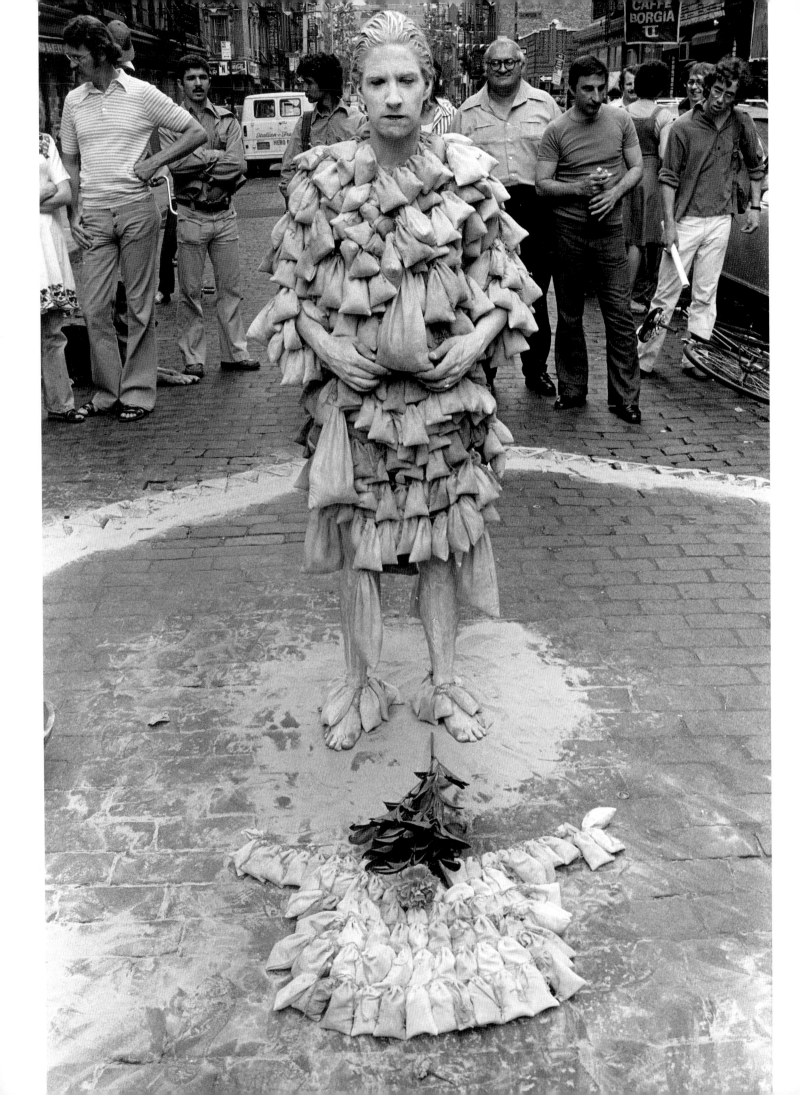

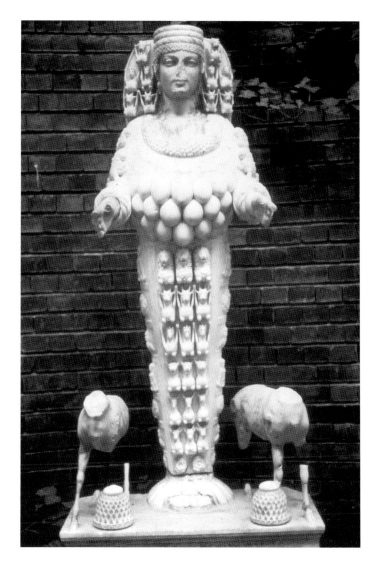

Diana of Ephesus (*Artemis*). Second century B.C. Archeological Museum, Ephesus, Turkey.

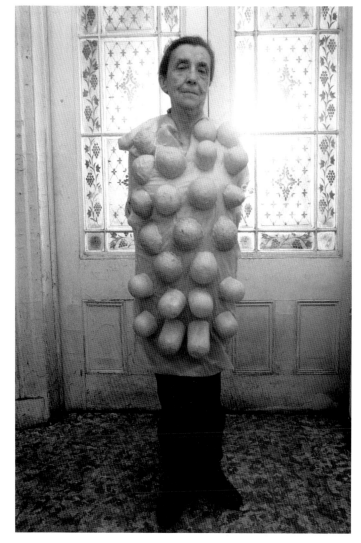

Louise Bourgeois wearing a latex costume that she designed and made, 1970. Photograph by Duane Michals (originally published in *Vogue* magazine, October 1980)

Betsy Damon as *The Seven Thousand Year Old Woman*. Street performance, New York, March 1977. Courtesy the artist

THE BODY THROUGH WOMEN'S EYES

BY JOANNA FRUEH

I write my words in loving memory of Hannah Wilke, who died of cancer January 28, 1993.

Ana Mendieta. *Anima (Alma/Soul)* (Fireworks Silhouette Series). 1976. Color photograph, 13¼ × 20″. Documentation of earth/body-work performance in Oaxaca, Mexico. Courtesy Galerie Lelong, New York, © Estate of Ana Mendieta

Feminists who portrayed the human body or used their own bodies in their art created some of the most radical and provocative works of the 1970s. Since then, the body has been an image, an idea, and an issue of continuing significance in women's art. In the seventies, women artists became acutely aware of the social and cultural idealizations of the female form—in advertising and media, and in Western art. Idealizations of the female body reflect and enforce cultural desires about a woman's beauty and sexuality, her social place and power.

In *The Second Sex*, published in the United States in 1953, and subsequently reprinted in paperback ten times between 1961 and 1968, the author Simone de Beauvoir, one of the mothers of twentieth-century feminist theory, states ideas that surfaced and expanded in 1970s feminist thinking and art-making: "Woman sees herself and makes her choices not in accordance with her true nature . . . , but as man defines her Man dooms woman to artifice One is not born, but rather becomes, a woman."[1] In 1978, British art historian Lisa Tickner wrote, in an article focusing on English and American women's art in the 1970s that deals with the body, "Breasts, the womb, ovarian secretions, menstruation, pregnancy and labour, as de Beauvoir has reminded us, are for the benefit of others and not ourselves."[2]

In the 1970s, feminist artists, wanting to reclaim the female body for women, asserted women's ability to create their own aesthetic pleasures by representing women's bodies and women's bodily experiences. The resulting positive images of the female body are a critical part of feminist aesthetics of the 1970s. They also show that women could become makers of meaning, as opposed to being bearers of man's meaning. Yet younger feminists have since called these 70s images naive, utopian, essentialist, and romantic. Intergenerational conflict and matrophobia, fear of becoming one's (not sufficiently successful) mother, have interfered with art-historical understanding and placement of women's treatment of the body in the 1970s.[3] However, Hannah Wilke's poses/performances for camera and/or live audiences are one road to Cindy Sherman's 1980s deconstructions of universal womanhood. Carolee Schneemann's performances of female pleasure in her nude, "ecstatic body" make possible Karen Finley's 1980s-90s performances about violence to women, which Finley has reified in her own ecstatic body of pain.[4] Ana Mendieta's famous *Rape-Murder*, 1973, is an emotional source for anti-abuse works such as Sue Williams's painted rages against sexual violence; and Lynda Benglis's and Louise Bourgeois's sculptural body abstractions are precursors of Kiki Smith's and others' fascination with bodily matter and fluids.

Feminist artists affirmed not only the authenticity of their own experiences that informed their art, but also the beauty and sexual and spiritual power of the female body as correctives to idealizations, which British and American writers like Germaine Greer, Shulamith Firestone, Una Stannard, and Angela Carter said epitomized misogyny and female self-loathing. As Carter writes in *The Sadeian Woman and the Ideology of Pornography*, 1978, "It is in this holy terror of love that we find, in both men and women themselves, the source of all opposition to the emancipation of women."[5] Adrienne Rich spoke

for many feminists in *Of Woman Born: Motherhood as Experience and Institution*, 1976: "The repossession of our bodies will bring . . . essential change to human society. . . . We need to imagine a world in which every woman is the presiding genius of her own body."[6]

The critical significance of the body in 1970s feminist art owes much to the 1960s sexual revolution and widespread use of The Pill. In 1960 the Food and Drug Administration approved Enovid, which was the United States' first commercially available oral contraceptive. The Pill and the sexual revolution permitted, even demanded, women's exploration of sexual pleasure. This was especially true for younger women, in their twenties, whose sexual experimentation in an increasingly "permissive" decade was encouraged. Artists Hannah Wilke and Carolee Schneemann, key figures in the development of seventies' body works and feminist erotics, were in their twenties in the 1960s and were probably influenced by the decade's new sexual tenor.

By 1973, when Erica Jong fantasized about "the zipless fuck," a woman's sexual fling without taking responsibility, in her novel *Fear of Flying*, women had initiated what critic Maryse Holder called a "sexualist" strain of art. That same year she rhapsodized, "Whereas male sexuality is a cliché . . . female sexuality is uncharted and a matter of the freshest curiosity. A recent round of visits to shows and studios convinced me that female sexuality is especially visible in the fine arts."[7]

Seeing the body through women's eyes was a crucial aspect of women's self-determination and self-actualization. Artists worked to wrest the representation of the female body, to some degree, from patriarchal authority. They examined ideas about femininity, they attempted to cure self-repulsion through self-love, they reclaimed female genitalia from degradation in word and image, and they were active critics of male fantasies and sexuality.

Feminist artists transformed the female nude, and in so doing became "cunt-positive." Greer lengthily describes women's and men's fear and loathing of female sex organs in her feminist classic, *The Female Eunuch*, 1970. She writes, "The universal lack of esteem for the female organ becomes a deficiency in women's self-esteem," and, "The worst name anyone can be called is *cunt*."[8] In order to end women's low regard for their genitals, Schneemann, Wilke, Judy Chicago, and others asserted the necessity of a "cunt-positive" attitude, and so did artist and sexual therapist Betty Dodson. Dodson believed that masturbation was a necessary form of self-love. In her body and sexual self-esteem workshops, women drew their own genitalia, and the variety and beauty of the forms established an aesthetic for female genitals. At the 1973 "National Organization for Women's Sexuality Conference," Dodson gave a slide presentation that contrasted a series of anatomical diagrams of female genitalia, gathered from educational and medical sources, drawn incorrectly and made to look ugly, with the genital pictures drawn by women in her own workshops. She received a standing ovation from the thousand women who were in attendance for her "cunt-positive" attitude.

Women artists represented and literally embodied ideas developed by de Beauvoir in *The Second Sex* and by feminist thinkers in the early 1970s. De Beauvoir posited that man's creation of woman in an ideal image petrifies her body into a thing and makes it a passive object of his possession.[9] Stannard as well as Greer and Firestone discuss the media's impact on women's desire to be beautiful. In "The Mask of Beauty," Stannard says that women's social conditioning impels them to don a disguise. Makeup, the maintenance of a youthful appearance, painful procedures such as cosmetic surgery and silicone breast implants, and the sway of movies, beauty contests, and advertising are the indoctrination and enticements that make sure, as Stannard says, "Women are the beautiful sex."[10] Artists considered traditionally beautiful, like Hannah Wilke, Carolee Schneemann, Lynda Benglis, and Adrian Piper, ran the risk of being called self-indulgent, vain, narcissistic, and self-exploitative by their peers, but they also had the capacity to give the female body a mind, to humanize beauty, and to reformulate visual pleasure by destroying it as we know it.[11]

Wilke's reputation as a beauty, and, consequently, a female star, spread through the art world with performance and photographic works in which she appeared nude or semiclothed. *S.O.S. Starification Object Series*, 1974–82, is one such work (page 198). Striking high fashion poses, modeling her beauty, Wilke also "scarred" herself with chewing-gum sculptures that have a simple shape and multiple meanings. Chewed gum, twisted into a shape that variously reads as vulva, womb, and tiny wounds, marks her face, back, chest, breasts, and fingernails, and marks her, too, with pleasure and pain that are not limited to female experience. Sexual pleasure is universal, and anyone can be raped. Wilke's "scarification," symbolically related to the desired and admired keloided designs on the bodies of African women, who without anesthesia suffer hundreds of cuts, alludes to the suffering that Western women undergo in their own beautification rituals. To be a star as a woman is to bear "starification." To be "starified" is, to some degree, to be ill-starred, and the "ornaments" decorating Wilke are not only "stars" but also stigmata that mark the model woman as a martyr. *S.O.S* is a cry for help.[12]

Schneemann's *Interior Scroll*, first performed in 1975, overhauls the myth of the stupid, weak, or powerless beauty. Schneemann undraped herself, as if revealing a finished sculpture, and stood naked on a platform defining the contours of her body with paint. Gently and gradually she unraveled from her vagina a ten-foot-long scroll made of intricately folded papers, recently described by her as a "strange origami."[13] She had typed a text of her own words on the scroll, and assuming a series of poses, from awkward to acrobatic, as if the body were a machine coming to human life, she read the text aloud. *Interior Scroll* is dance, ritual, oratory, proclamation, exorcism, and vision—of a time beyond patriarchal and misogynist control of women's bodies. Scrolls can contain proclamations, and scrolls, like the Torah, can contain sacred texts. Schneemann placed her scroll in "vaginal space" and removed it from there, thus giving female genitals a public and spiritual voice.

Women's love of their sex organs may mythologize sexuality, but "cunt-positiveness" is cultural heresy and therefore challenges Angela Carter's argument against romanticizing and exalting the "dumb . . . nether mouth."[14] With elegant sarcasm,

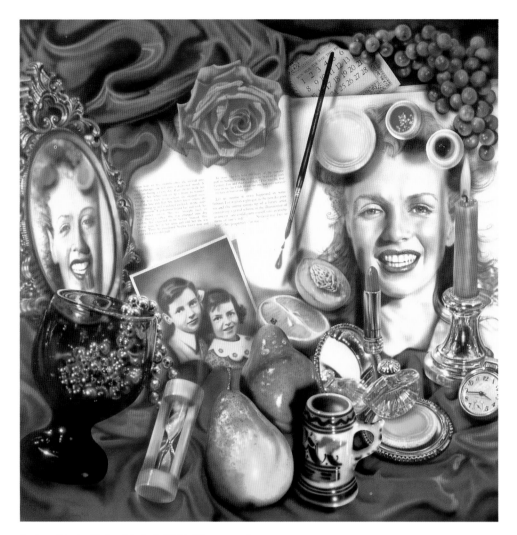

Audrey Flack. *Marilyn (Vanitas)*. 1977. Oil over acrylic on canvas, 96 × 96″. Courtesy Louis K. Meisel Gallery, New York

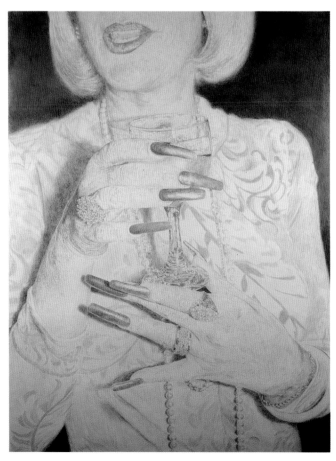

Claire Prussian. *Prismacolor IV*. 1976. Color pencil and graphite, 52 × 40″. Collection Kaaren Johnson Boyd. Courtesy Sazama Gallery, Chicago

Carter says society permits that mouth to be the essence of woman and her wisdom, but then society dismisses the speech of a woman's body. Carter's anger is legitimate, because genitals as symbols of sexual essence delimit imagination and behavior. But in Schneemann's art the vagina is a passage for information, and she, like Wilke, sees the vagina and vulva as sculptural forms. Vagina and vulva are aesthetic, not aestheticized, and woman's body is a site of knowledge on woman's terms, not as something "known"—sexually, medically, or aesthetically—by men or by man. Schneemann's rage at man's having stolen woman's body and symbols impelled her to love the female body in her art. She was the "ecstatic body," "Aphroditean," not Dionysian, whose beauty challenges society's phobia of the female body and of female pleasure.[15]

Adrian Piper's *Food for the Spirit,* 1971, was a private loft performance in which Piper, a philosopher by profession, countered fear of self-loss by seeing and photographing her image in a mirror. To see oneself embodied is one way to know that one exists. During a two-month juice and water fast, Piper studied Kant's *Critique of Pure Reason* and practiced yoga. Piper says the intensity of intellectual, spiritual, and bodily experience threatened her sense of self and reality: perhaps she would transcend embodiment. Instead Piper seized embodiment, chose "the 'reality check' of the mirror," and recorded physical reality for posterity.[16] Moreover, Piper distinctly gives the female body a mind. Stannard writes that "women are supposed to be bodies, not differentiated complex minds," and that "society has so overvalued beauty that most women, given the choice between unusual intelligence and great beauty, would choose beauty."[17]

Black artist Lorraine O'Grady writes in 1992 that she and black art historian Judith Wilson agree that *Food for the Spirit* may be "the catalytic moment for the subjective black nude." In Western art the black female nude is a rarity. According to O' Grady, the black body's absence secures the white body's status as a voyeuristc object, for the black body is a "chaos" that must be "safely removed from sight." As O'Grady says, "White is what woman is; not-white . . . is what she had better not be."[18] Piper makes a point of the black female body speaking for itself. Unclothed in one of the ritually repeated shots, Piper observes herself: she takes her own picture and controls the looking.

Benglis's infamous November 1974 *Artforum* ad, in which a nude Benglis holds, in a jack-off gesture, a huge latex dildo that seems to grow from her crotch, is an aggressive "fuck you."[19] Benglis destroys the visual pleasure associated with female beauty because she does not play feminine. Conventional femininity is a complex of culturally designated passive qualities that do not disturb man's concept and enforcement of what woman is—modest, gentle, delicate, docile. An essential component of female beauty is femininity, which also describes the traditional female nude. In many ways, Wilke, Schneemann, and Piper, as well as many other women whose art in the 1970s deals with the body, rip off the "mask of beauty," which is also the mask of femininity, thereby affirming that woman is not biologically determined. Feminists in the 1970s set a precedent for ideas significant in feminist theory today that gender is an unstable identity.[20] In the 1970s, feminists did not believe that because a woman has a uterus, because she menstruates and can give

birth and produce milk, that she must bear children and she will develop traditionally feminine qualities. Feminists believed that feminine qualities are not given female attributes.[21]

Audrey Flack's *Marilyn (Vanitas),* 1977, treats femininity as a willed choice. Powder puff, rouge, and eyeshadow crown and halo Marilyn Monroe as a queen and saint of "makeup," the make-believe of feminine beauty. A levitating crimson lipstick and paintbrush dripping red pigment resonate as magical tools used by masters of illusion—visual artists who are painters and women who "paint" themselves into the Eternal Feminine.

Benglis's ad "sells" masturbatory impulse and vanity, which have been part of the myth of the male artist as miracle worker and warrior, or what artist June Wayne calls the "demonic myth" in her 1973 *Art Journal* article, "The Male Artist as a Stereotypical Female." The demonic myth is macho posing, and it is camouflage for the male just as femininity is for the female.[22] Benglis demonized her image and shocked the art world. Where "offensiveness" played a potent part in destroying femininity and female beauty for Benglis, it also did so for Judy Chicago in her notorious *Red Flag,* 1971, a photolithograph of herself from the waist down pulling out a bloody tampon. Greer suggested that to overcome disgust for one's menstrual blood, a woman should taste it.[23] In order to overturn femininity, feminist artists necessarily flouted good taste and feminine respectability by pointedly showing women's desire for sexual and cultural power, manifested by Benglis's dildo/phallus, and by breaking the taboo of ladylike purity. *Red Flag* takes a female bodily process out of obscurity; it is interesting to note that some viewers saw the tampon as an image of castration, which shows how much the eye has been socially and culturally educated to *not* see the reality of women's bodies. Although Benglis assumes a stereotypic "feminine" pin-up pose, a conventional invitation to aesthetic and sexual pleasure, some men and women were repulsed by her twisting of gender. Benglis's image merges masculinity and femininity in a way that society deems incompatible. Patriarchy's demand for a difference between the sexes assures the inferiority of femininity and of women.[24]

Later in the 1970s, French feminist theorist Hélène Cixous took an unapologetic approach, like Benglis, to women's possession of their own bodies. In what has become a classic text in feminist theories of the body, Cixous asserted in "The Laugh of the Medusa," published in 1976 in the important feminist academic journal *Signs,* "A woman without a body, dumb, blind, can't possibly be a good fighter."[25] Artists who saw through femininity were warriors in the name of women at peace with themselves, not only about their beauty, intelligence, and aggressiveness, but also about motherhood and aging, respectively seen by patriarchal eyes as the glory of femininity and the death of femininity. Feminists knew the aging woman was socially illegitimate. In a 1972 issue of *Saturday Review,* writer Susan Sontag described how aging for women is "a process of becoming obscene. . . . That old women are repulsive is one of the most profound esthetic and erotic feelings in our culture."[26]

Claire Prussian's *Prismacolor IV,* 1976, depicts an aging former starlet. The subject is an ironic icon of youth, whose red fingernails exaggerate feminine necessity. The fingernails dance across the drawing's overall blondeness in an artificial liveliness

that unmasks femininity as reproductive ideal, but does not condemn the illusion. Prussian understands that woman is a picture at once sexy, compelling, and absurd, and that aging need not signal the flight of eros. Rather, old(er) women can use and unravel the "feminine" erotic art of impersonation.

In contrast to Prussian, Alice Neel gives no quarter to femininity in her nude self-portrait done in 1980 at the age of eighty. In that painting we see sad and intensely alert eyes, a grim mouth, and grotesquely blushing cheeks. Boniness and flab are pronounced. This is not a representation of grandmotherly wholesomeness, for we see the Grand Mother, a dangerously naked power divested of the little old lady's appealing sweetness.

Neel also undoes motherhood as a form of ideal femininity in paintings of pregnant women. The pregnant body has been shunned in Western art, even though Paleolithic sculptures of big-bellied women may indicate worship of female fertility, and the Virgin Mary, Western art's primary mom, embodies a reverential focus. But the unclothed pregnant body is grotesque in relation to the feminized female nude, the abstraction of form discussed by Kenneth Clark in his classic, *The Nude: A Study in Ideal Form,* 1956. Neel never avoided the taboo—consider *Isabetta,* 1934, a nude girl, and *Joe Gould,* 1933, a man endowed with multiple genitals—and was unafraid to show pregnancy to be an uncomfortable condition, as in *Margaret Evans Pregnant,* 1978.[27] The subject's body stares at the viewer, and, as is typical with Neel, appears at once agitated and forced into stillness. Neel compresses her subject through elongation, ages and saddens her face, and makes the "miracle" of pregnancy feel like a trap.

Women artists avoided the subjects of pregnancy and motherhood. Due to the "demonic myth," being a mother and being an artist were incompatible in the art world, and to a great extent, still are. The demand that a woman embody femininity, desirable for social success, and machismo, desirable for art-world success, was absurd and anxiety-provoking. Feminist artists' avoidance of pregnancy and motherhood as subjects should not be seen as anti-preganancy or anti-motherhood, but rather as a sad professional necessity rooted in fear.[28]

Feminist artists knew that "real" female bodies were taboo within patriarchy, so it was left to them to create works critiquing and challenging society's homogenized dictates. Greer says, "Every human body has its optimum weight and contour, which only health and efficiency can establish. Whenever we treat women's bodies as aesthetic objects without function we deform them and their owners."[29] One of the ultimate aesthetic objects in Western art is the female nude, and if we think about Greer's words in relation to the female nude, we could conclude that it deforms the actual female body. Kenneth Clark sees the actual female body as shapeless, a kind of deformity: "On the whole there are more women whose bodies look like a potato than like the Knidian Aphrodite."[30] Clark asserts a distinction between naked and nude: nakedness is natural and "bad," and nudity is ideal and "good." This celebrated difference is continued by John Berger in his *Ways of Seeing*.[31]

Lisa Tickner quotes Berger in "The Body Politic: Female Sexuality and Women Artists since 1970" and comments on his importance for feminist artists. In particular, Tickner quoted

Berger as having written: "A woman must continually watch herself. . . . From earliest childhood she has been taught and persuaded to survey herself continually. And so she comes to consider the surveyed and the surveyor within her as the two constituent yet always distinct elements of her identity as a woman." For Tickner, these points are "central to a consideration of the subject/object contradictions which face women working with the female body."[32] British art historian Marcia Pointon looks critically at Berger's ideas in 1990, but in the 1970s some American feminist artists' works dealt intensely, and sometimes humorously, with being "surveyed."[33]

Martha Rosler's 1977 videotape *Vital Statistics of a Citizen, Simply Obtained* addresses female body standards. As she obeys orders from two clinicians, she strips naked in the process. She is the docile female body. Only in voice-over do we hear her. She speaks about the making of self into product, of the body groomed and manufactured into objecthood, of scientific study and measurement of the body as social control, of gender roles, and of the "scientifically" determined inferiority of women and people of color. Rosler's fierce erotics of analysis replaces scopophilia, for neither the process of stripping nor Rosler's unclothed body are sexy. She is truly an object, of no desire—a specimen.

Eleanor Antin displays herself as a dieting specimen in *Carving: A Traditional Sculpture.* During a strict diet, from July 15 through August 21, 1973, she photographed herself—front, back, right and left sides—each morning. Far from being glamorous, the four repeated poses turn the poetry of the nude into mug-shot prose (page 199). Overweight women commit a crime against patriarchal femininity, but women who diet are artists who try to shape perfection. Antin's intention was, in her own words, to "make an academic sculpture," an ideal form. Just as the Classical Greek nude occludes women's bodies in this kind of aesthetically rigid form, so the socially correct beautiful body disciplines—and punishes—women, through frustration, guilt, anxiety, and competitiveness with other women.

The title of Susie Orbach's 1978 book about compulsive eating tells women, *Fat Is a Feminist Issue.* Orbach writes, "Fat is an adaptation to the oppression of women," and though she supports women's weight loss for psychological health and not for the fulfillment of a feminine ideal, she understands the power of fat as protection against sexual advances and other gender-based invasions of privacy, and as an expression of necessary separateness and a woman's need to take up space, to be significantly present.[34] *Carving* foregrounds contradictions between societal demands and self-definition, both of which operate in the creation of art, which deals with the abstract and history, and in the creation of self, which is bound to the concrete and the immediate.

Like Antin and Rosler, Martha Wilson nullifies the nude through banality. Her *Breast Forms Permutated,* 1972, like *Carving,* plays with late sixties through mid-seventies art-world interests in systems, permutations, and grids, which belong to Minimalist, Conceptual, and Pattern and Decoration trends. Wilson presents a grid of photographed breasts—naturally permutated, an organic pattern, a ridiculously and realistically decorative display. Her spectacle of differences, like the pictures

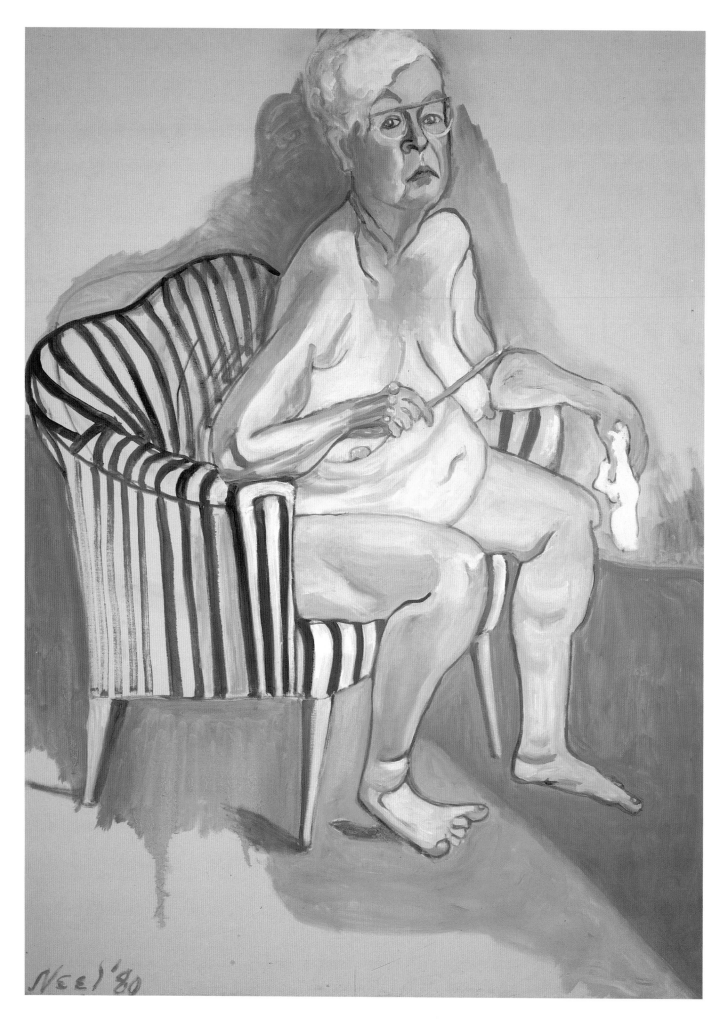

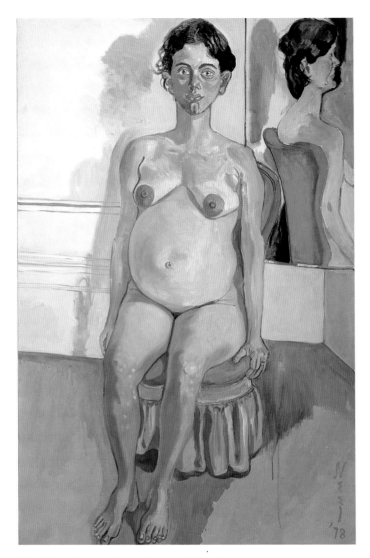

Alice Neel. *Margaret Evans Pregnant.* 1978. Oil on canvas, 57¾ × 38". Private collection

Alice Neel. *Nude Self-Portrait.* 1980. Oil on canvas, 50 × 40". National Portrait Gallery, Washington D.C.

of female genitalia done by Betty Dodson's workshop participants, implies infinite possibilities that cancel the cosmetic limitations of tits in art and advertising.

Some of the most profound and visually astounding examples of studies of the female body are Joan Semmel's paintings of larger than life-size female nudes. In a series dating from the mid- to late seventies, the figure more than fills the canvas, and the looking is replete with pleasure. Each nude is monumental; the canvas cannot contain her. Semmel's nude is Adrienne Rich's "presiding genius of her own body." In many of the paintings the viewer and the nude share the same or a similar vision, which is the subject's body. Nowhere is the subject's head depicted, and in *Me without Mirrors,* 1974, the viewer sees exactly what the subject herself sees, so that identification and communal pleasure displace possible voyeurism, and body-as-object is not a given, but rather a question (page 200).

In the 1970s, feminists began critiquing pornographic portrayals of the female body, particularly violence done to its integrity by means of fragmentation and focus on particular parts.[35] *Me without Mirrors* and other paintings in the series frequently foreground breasts, and, specifically in *Me without Mirrors,* the crotch is central, due to Semmel's use of negative space, a fairly symmetrical composition, and a pink cloth that peeks up from behind the pubic hair. We see folds, creases, and mounds that are voluptuous, but not ideal; a close-up focus, often on "fragments" of the body, sometimes makes for an initially ambiguous reading of an image. But Semmel indulges in the view without misappropriating body parts. Her use of colors that are neither pretty nor naturalistic precludes easy consumption of the nude. Yellows, stone blues, eerie greens, and purples give the flesh an acidic glow, even a corpselike remove. The conventional nude has been conceived anew—this is an attentiveness to the body that eschews conventional pornographic or art imaging, not only in palette, but also in body type, pose, and scale.

Semmel, Schneemann, and Wilke are key figures in the scrutiny and exploration of beauty and female pleasure in the 1970s. Schneemann and Semmel continue that adventure today, as did Wilke until her death in January 1993. Since innovation remains an art-historical criterion of genius, for both traditional and feminist scholars, Schneemann, Semmel, and Wilke, a matrilineage, deserve recognition for their origination of a feminist erotics, and for their charting, over the decades, of female pleasure.[36]

Although many feminist artists in the seventies dealt with the idea that femininity is not natural—women are not innately feminine, female beauty, culturally defined, is a cultivated attribute, and the nude is a purely aesthetic formulation—many feminists advocated a powerful connection between women and nature. While feminists like Susan Griffin in *Woman and Nature: The Roaring Inside Her* examined Western civilization's dangerous way of speaking in one breath of mastering nature and women, because man "set himself apart from woman and nature," they also acknowledged, as Griffin did with poetic beauty, that "we know ourselves to be made from this earth. We know this earth is made from our bodies. For we see ourselves. And we see nature. We are nature seeing nature. We are nature with a concept of nature."[37] Anthropologist Sherry Ortner con-

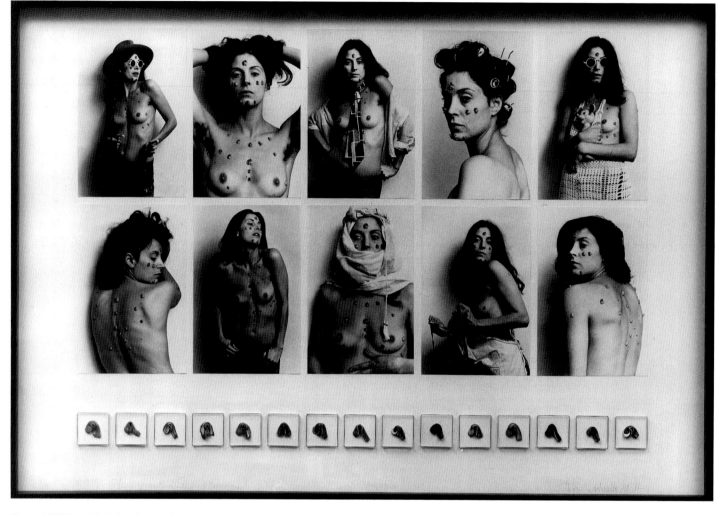

Hannah Wilke. *S.O.S. Starification Object Series.* 1974–1982.
10 black-and-white photographs with 15 chewing-gum sculptures
in Plexiglas cases mounted on ragboard; overall 40½ × 58″. From
original series *S.O.S Mastication Box*, an exhibition-performance
at the Clocktower, New York, January 1, 1975. Courtesy Ronald
Feldman Fine Arts, New York

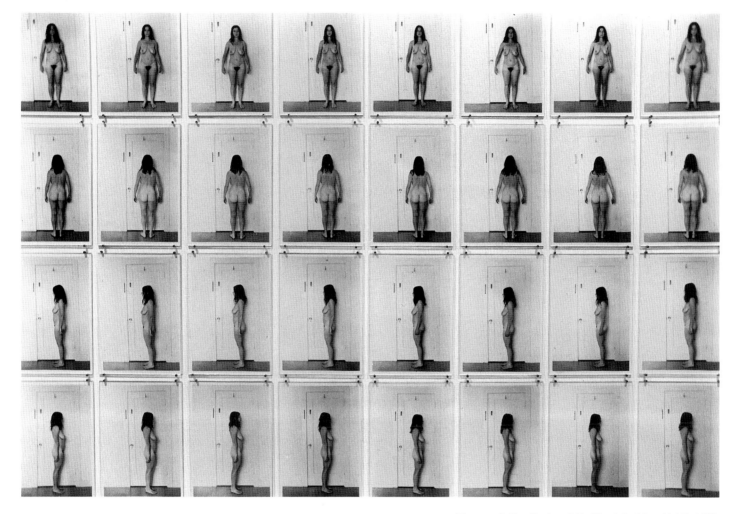

Eleanor Antin. *Carving: A Traditional Sculpture* (detail). 1973.
148 photographs; overall length 20'. Courtesy of artist.
Installation of photographs depicting a 5-week diet, resulting in
a weight loss of 11½ pounds.

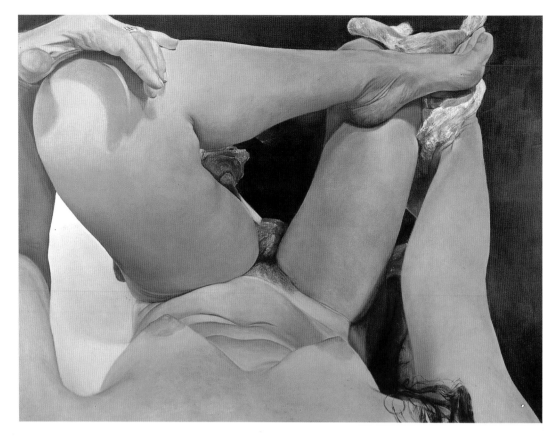

Joan Semmel. *Me Without Mirrors.* 1974. Oil on canvas,
50 × 68". Collection the artist

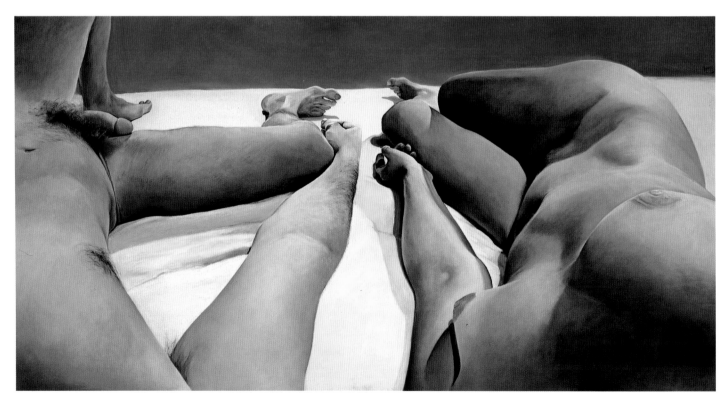

Joan Semmel. *Intimacy/Autonomy.* 1974. Oil on canvas,
50 × 98". Private collection

cluded her now classic "Is Female to Male as Nature Is to Culture?" published in 1974, with, "Woman is not 'in reality' any closer to (or further from) nature than man," but "woman is being identified with—or, if you will, seems to be a symbol of—something that every culture devalues, something every culture defines as being of a lower order of existence than itself, . . . and that is 'nature' in the most generalized sense."[38]

The woman and nature connection is further embraced by those feminists who honor the Goddess. *Heresies: A Feminist Publication on Art and Politics* published "The Great Goddess" issue in 1978. There Carol P. Christ gave three reasons why women needed the Goddess. One was that "the Goddess symbol for women is the affirmation of the female body."[39] Mary Beth Edelson's Woman Rising, a 1973–74 photographic series, was such an affirmation. Her words,"*I am, and I am large, and I am my body, and I am not going away,*" describe the work, and they create for the female body a heroic status that resonates with political, sexual, and soul-inseparable-from-the-body presence.[40] In the same *Heresies*, art historian Gloria Feman Orenstein discussed women artists' use of the Great Goddess archetype to "restore the spirit already present in the natural world" and to energize "the self through the internalization of [the Earth's] sacred spirits."[41]

Ana Mendieta was one of the artists Orenstein chose to exemplify women artists' use of matter and spirit for cultural and personal healing. Mendieta's prime media were her own body and Mother Earth. *Anima (Alma/Soul),* 1976, belongs to the Silueta series begun in the late 1970s. In many of those pieces Mendieta traced her five-foot-tall body on fields, sand, earth, mud, and tree stumps. Sometimes she used gunpowder and fireworks (the point always being a use of the elements—air, water, earth, and fire) in an alchemy of erosion, explosion, or dissolution that would reveal elemental connections between the earth, body, and soul. *Anima* was a monumental and blazing silhouette, a bamboo armature lit with fireworks. Soul on fire and impassioned, martyred body, *Anima* faded into the night to become part of the atmosphere (page 191).

Just as feminist artists affirmed the spiritual presence of the female body, so they also affirmed its erotic powers and sexual appetite. On August 25, 1978, black lesbian feminist Audre Lorde delivered the paper "Uses of the Erotic: The Erotic as Power" at the Fourth Berkshire Conference on the History of Women at Mount Holyoke College.[42] Lorde said society fears and suppresses the erotic in women, which she defines as rich living and internal satisfaction that leads to social action. For Lorde, the erotic is transformative. For Erica Jong in *Fear of Flying*, the epitome of the erotic is pure sexual pleasure. Both perspectives exemplify aspects of women's love of their own sexual pleasure and of their own sex.[43] Lorde, Jong, and Monique Wittig, in her intensely erotic novel, *Les Guérillères*, published in English in 1971, were describing and inventing women's eroticism. Wittig's lyrical, dazzling prose creates women warriors who love each other and who overthrow the patriarchal order. Women artists in the seventies described and invented women's eroticism in abstract and figurative representations of lesbian and heterosexual political and sexual power, celebration, desire, rage, and satisfaction. Some artists joined male and female

features in images and abstractions of androgyny.

Hannah Wilke's *Pink Champagne*, 1975, is a heroic figure of "cunt-positiveness," masturbation, and multiple orgasms. The sculpture is a rippling pink, petal-like, horizontal expansion of pleasure. Like all of Wilke's latex wall sculptures (1971–77), *Pink Champagne* uses the liquid poured onto a wide plaster bed, which is then pulled into thin layers and massed into overlapping clusters, which suggest waves of sensation experienced in excited vaginal and clitoral flesh. The casting side is chalky, the other has a shiny, sexy, wet appearance that emphasizes the labial structure. Pink champagne is a pleasure to look at and to taste and drink, and Wilke's *Pink Champagne* is a visual treat and a multiplicity of lips, which are beautiful forms that speak of morphological sameness and difference, of plural pleasures, not only in orgasmic capacity but also in regard to the many areas of sensitivity in women's external and internal anatomy.[44]

Lesbian artists, especially in the late 1970s, were speaking and writing about their lives and art from the perspective of their sexual orientation. *Heresies* devoted its Fall 1977 issue to lesbian artists and art. At the same time, scholars were writing lesbian and gay history.[45] Lesbians were essential in focusing the questions: What is female? What is feminine? What is a woman? But heterosexual feminists treated lesbians as the "Lavendar Menace," and Betty Friedan and members of her circle within the National Organization for Women discriminated against lesbians because they felt lesbians to be a liability to the women's movement. One way that lesbians in the 1970s debunked myths about themselves was to discover and celebrate lesbian foremothers in art and literature. Djuna Barnes is such a figure—an American expatriate who lived in Paris, the setting for her 1936 novel *Nightwood*. The book, now a lesbian literary classic, delves into obsessive love, the eroticism of night, and the burden of social regimentation. Lili Lakich, who had been inspired by a 1921 photo of Barnes and by a Gitanes cigarette package, portrayed the writer in neon, which is Lakich's characteristic medium. One of her three versions of *Oasis: Portrait of Djuna Barnes*, 1977, glows turquoise-aqua, cerulean-violet, and searing white.

Whether a fashion or a permanent reality, the art world's current interest in identity makes the lesbian artist and lesbian content more acceptable today than in the 1970s. Then, to identify oneself as lesbian, let alone to work from that perspective, was radical. To be an "out" lesbian in the art world was dangerous to an artist's career. Nonetheless, women were coming out in California as artists, feminists, and lesbians through performance art. Elsewhere, several "out" lesbians were dealing with the body in differing ways. In Chicago, Janet Cooling and Hollis Sigler used a figurative style to represent relationships between women, and in New York, Harmony Hammond and Louise Fishman created abstract works whose physicality was informed by bodily forces and sensations.

Cooling's and Sigler's drawings and paintings from the 1970s reflect the prominence of Chicago Imagist figuration, which partakes of Expressionism, Surrealism, Pop Art, and California Funk. A late 1970s through early 1980s series by Cooling focuses on women lovers desiring each other or having sex. In *Bed of Dreams*, 1979, intense colors express intensity of desire,

as two figures, one dressed, one unclothed, stand on either side of a chaise lounge. Cooling's treatment of sex is daring and unusual for the seventies, a time when lesbians, whom society had identified in terms of their bodies and their sexual behavior, began to identify themselves in political and cultural terms, thus desexualizing lesbian identity. Unlike Cooling, Sigler almost always absents or obscures a represented subject, whom Sigler nevertheless often identifies as "She" and "The Lady" in titles written on her paintings and drawings. Sigler focuses on the intimacies of love, whether it be comforting or anguished, and *Let Me Love You In Fleshy Colors,* 1978, is characteristically poignant. Two silhouetted figures, whose sex is ambiguous, embrace in the shower of a pink bathroom, whose tender warmth is the color of their love.[46]

Hammond began a series of sculptures in the late 1970s, which continued into the 1980s, whose materials—cloth, wood, rubber, gesso, acrylic, rhoplex, and wax—are raw, sensuous, and not pretty. The large ovoid or grasping forms are bodies at once hard and soft, claiming physical and psychic space. Hammond equates them with the "raw, passionate, sensual" quality of Wittig's novels, *Les Guérillères* and *The Lesbian Body.*[47] *Kudzu,* 1981, all arms and legs and desire, seems to want to embrace a viewer. Like Eva Hesse's sculptures from the late 1960s, which incorporate rope, latex, metal, and clay, Hammond's wrapped sculptures are tactile and at once darkly and humorously sexual. Louise Fishman's Angry Paintings, 1973, are also viscerally potent. Portraits of women Fishman knew or admired emerged from feminist rage, visible in slashes, drips, and overlays of pigment that register bodily as well as emotional vehemence.

"The lesbian relationship as metaphor stands at the heart of feminist art and has on some level affected every feminist's work," posits art historian Ruth Iskin in a theoretical conversation with art historian Arlene Raven, printed in *Chrysalis.* The lesbian relationship is not simply sexual, for, as Raven says, "We can describe a relationship of love among women which is lesbian regardless of whether or not their sexual practice is with women." Iskin agrees, "We cannot rule out the possibility that an artist who is heterosexual, bisexual, or celibate may act and live as a strong, independent woman, and those 'lesbian' feminist ideals may be apparent or dominant in her work."[48]

Joan Semmel's 1971–73 "fuck paintings," to use her term, focus on heterosexual partners, yet they exemplify Iskin's and Raven's ideas. Semmel's couples fill the canvas (with pleasure), have no heads, and are painted colors that alert the viewer to their abstractness and their actions. Semmel's combining of power and pleasure predates Betty Dodson's book *Liberating Masturbation,* in which she stresses pleasure-based power for women, "so we could avoid some of the mistakes of misusing power. If we achieved economic power without sexual power we would simply become a ruling matriarchal system, no different than the present patriarchal system, because they are authoritarian and sex negative."[49]

Semmel's series developed from her and other artists' interest in working with sexual subject matter and finding people who would "model." Through her research, Semmel located a man who liked to perform with his sex partners. As the contact, he would bring female sex partners with him to Semmel's studio, which became a studio/theater used by a group of people who filmed, drew, or photographed the sexual activity. Semmel would move around the couple with her camera, looking where *she* wanted, seeing with *her* desire, creating an imagery as different from standard porn shots as her single female figures are different from conventional nudes.

One of Semmel's most haunting works of a heterosexual couple is *Intimacy/Autonomy,* 1974. A woman and a man lie next to each other, post- or pre-sex. The aesthetically and emo-

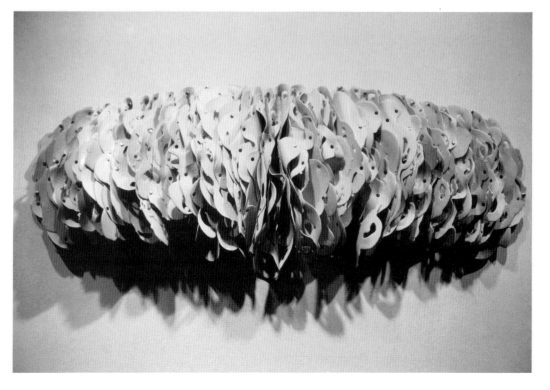

Hannah Wilke. *Pink Champagne.* 1975. Latex rubber and snaps, 57 × 18″. Courtesy Ronald Feldman Fine Arts, New York

Opposite:
Harmony Hammond. *Kudzu.* 1981. Cloth, wood, metal, gesso, acrylic, celastic, glitter, rhoplex, wax, and charcoal powder, 84½ × 84½ × 36½″. Wadsworth Atheneum, Hartford, Connecticut

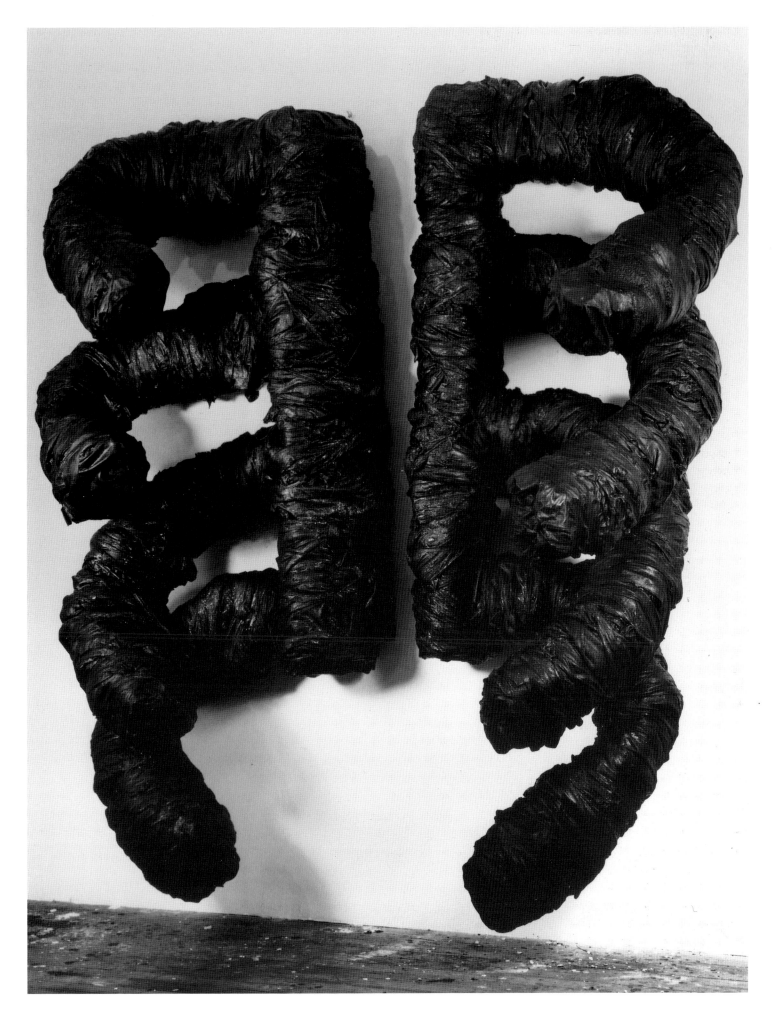

Hollis Sigler. *Let Me Love You in Fleshy Colors*. 1978. Oil pastel on paper, 13 × 24″. Collection the artist

Janet Cooling. *Bed of Dreams*. 1979. Colored pencil and acrylic on paper, 22 × 30″. Courtesy David Zapf Gallery, San Diego, California

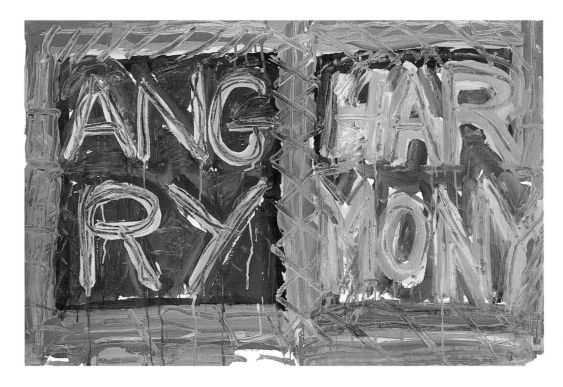

Louise Fishman. *Angry Harmony.* 1973. Acrylic, pastel, pencil, charcoal on paper, 26 × 40″. Courtesy Robert Miller Gallery, New York

Sylvia Sleigh. *The Turkish Bath.* 1973. Oil on canvas, 76 × 102″. Left to right: art critics Paul Rosano, Scott Burton, John Perreault, Carter Ratcliff, Paul Rosano, and, foreground, Lawrence Alloway. Courtesy Zaks Gallery, Chicago, and Stiebel Modern Gallery, New York

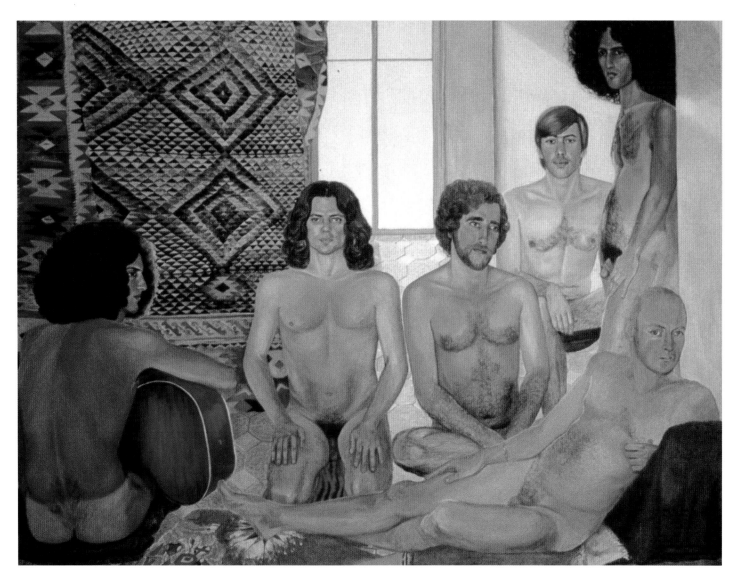

Louise Bourgeois. *Femme Couteau.* 1982. Polished black
marble, 5½ × 30½ × 8″. Courtesy Robert Miller Gallery, New York

tionally perfect distance between their hands, which are their body parts closest to each other, is a space of contradictions—tension, longing, and utmost comfort. It is the space of eternity and spontaneity, a great divide that may never be crossed or that can be breached in an instant.

The androgyne does breach the sex and gender divide, and traditionally it has been a symbol of love and the unification of opposites. The manifestation in the 1970s of the androgyne grew in part from 1960s flower-child unisex style, which was not simply a fashion statement, but rather an embodied embrace of both gender and sexual differences. Feminists adopted androgyny as a symbol and enactment of male/female and feminine/masculine equality. Mary Daly expressed the 1970s feminist position toward androgyny in *Beyond God the Father: Toward a Philosophy of Women's Liberation* (1973). She viewed masculinity for men only and femininity for women only as "caricatures of human beings" and advocated an "androgynous mode of living" enacted by "psychologically androgynous beings" who would transcend gender.[50] Androgyny interested the art world, too, as shown by the publication of three articles in the November 1975 *Artforum* that dealt with the androgyne.[51] For Nancy Grossman, androgyny unifies the human and divine, animal and devil, racial, sexual, and magical. Her *Cob I*, 1977–80, a leather mask over a wood head, further distinguished by horns, both exaggerates Grossman's own features yet looks not at all "feminine."[52]

The cover of psychoanalyst June Singer's *Androgyny: Toward a New Theory of Sexuality*, 1977, which is a serious Jungian study, shows a woman dressed in a double-breasted man's suit. The brim of a fedora hides the upper half of her face. Dressing in drag here represents the psycho-physical cross-dressing despised by Daly in 1978 in her book *Gyn/Ecology: The Metaethics of Radical Feminism:* "The semantic abomination, androgyny, is a confusing term which I sometimes used in attempting to describe integrity of be-ing. The word is misbegotten—conveying something like John Travolta and Farrah Fawcett-Majors scotch-taped together."[53] Daly's recanting exemplifies some feminists' fear that androgyny was a simplistic term, but women artists in the seventies used androgyny in bold, subtle, dark, and humorous ways, notably Lynda Benglis in her *Artforum* ad.

Since the 1940s, Louise Bourgeois has produced abstract sculptures whose organic, tumescent shapes often read as female and male, from which an aura of psychological trauma has consistently radiated. The knifelike female figure shape in *Femme couteau*, 1982, is tense, fragile, static, restless, vulnerable, and dangerous. *Femme couteau* is a blade with exposed female genitalia. Bourgeois says the work "embodies the polarity of woman, the destructive and the seductive . . . A girl can be terrified by the world. She feels vulnerable because she can be wounded by the penis. So she tries to take on the weapon of the aggressor."[54]

Benglis's abstract encaustic sculpture *Valencia*, 1972, like *Femme Couteau*, shares male and female sex organs, which "love" each other under the artist's touch. Labial folds grace phallic form, and the sensation, as with Bourgeois's work, is organic, but unlike Bourgeois's, it is playful and orgasmic. As we know from some feminists' insistence on "cunt-positiveness," female genitals were long regarded as taboo (*vulvic* has yet to be *normal* vocabulary) and male genitals have been totemized, held in high regard by patriarchy. Benglis joins the two in aesthetic and public display.

Judith Bernstein's huge charcoal drawings of cocks-as-screws are, like Benglis's *Artforum* ad, seizures of phallic power. Although the penises are puns about getting screwed—frank and nasty statements about phallic force, painful, mechanistic power and rape—the hairy strokes with which Bernstein covers the forms are sensuous and make them feel touchable (see Brodsky, page 105). In a 1975 article critic Cindy Nemser quotes Bernstein, who says that works such as *Big Horizontal*, 1973, are metaphors for women "ready to admit things hidden for a long time—that they have the same drive, the same aggressions, the same feelings as men."[55] In the early 1970s, that admission was a revelation.

Just as Alice Neel defrocks motherhood, so Sylvia Sleigh removes the reclining and resting nude's feminine habit. Appropriating celebrated paintings and themes from the history of Western art, she replaces female with male figures. Men stand, sit, and lounge around in *The Turkish Bath*, 1973, which is neither a facile reversal nor parody of Ingres's *The Turkish Bath*, 1863. Satire is not the only point, for Sleigh wants to humanize the nude, not simply feminize men in order to ridicule the human body's gendered costume.[56] Ingres's feminine actresses, all young, curvaceous, and lacking body hair or facial character, become men of differing ages, whose body shapes, hair patterns, and faces are individualized in a de-aestheticization of the nude. Unlike Ingres's pleasure, which is invested in homogeneity, Sleigh's wit and pleasure create disparate portraits of the body.

As women artists in the 1970s invented ways for women to escape self-loathing through self-love and become presiding geniuses of their own bodies, their work, like that of feminists in other fields, challenged a woman to live "up to and including her limits," a phrase I borrow from Schneemann's mixed media performance of the same title. Presented several times between 1974 and 1976, *Up to and Including Her Limits* featured Schneemann nude and suspended in a harness, marking up a wall behind her. The piece demonstrates endurance and fragility and makes use of unpredictability and randomness. One's limits are not known in advance, but the feminist artist must be willing to love what she does not yet know.

THE PATTERN AND DECORATION MOVEMENT

BY NORMA BROUDE

Among the six miniaturized rooms of *The Dollhouse* created by Miriam Schapiro and Sherry Brody for Womanhouse in January 1972, there is a room called The Seraglio, in which a lavish collection of richly colored fabrics and patterns are juxtaposed imaginatively to suggest an exotic Persian interior. For Schapiro, trained in the modernist tradition that scorned the decorative, the creation of The Seraglio was a breakthrough experience, a rebellious and transgressive act of liberation that quickly gave rise in 1972 to works made of fabric on canvas that were very different from anything she had done before. Works such as *Lady Gengi's Maze* and *Explode* (see page 77) feature swatches of patterned fabric, which at first intrude upon and then exuberantly burst the bonds of the modernist linear grids and geometries that can no longer either physically or symbolically confine and contain them. For Schapiro, who had been immersed in the collaborative teaching and learning environment of the Feminist Art Program at CalArts, these bits of brightly colored and patterned fabric with which she now made her new independent works presented a clear feminist statement and were loaded with personal and political meaning. Writing in 1977 about the significance these works had had for her, she explained: "I wanted to validate the traditional activities of women, to connect myself to the unknown women artists who made quilts, who had done the invisible 'women's work' of civilization. I wanted to acknowledge them, to honor them."[1]

Indeed, throughout the history of modernism, the decorative and domestic handicrafts have been regarded, literally, as "women's work," a form of "low art" from which Western "high art," with its claims to significant moral and spiritual content, has striven to separate itself. But as art in the twentieth century became increasingly abstract, this dichotomized hierarchy between high and low, the fine arts and the crafts, the "meaningful" and the "merely decorative" became increasingly difficult to maintain. And the struggle to do so became dependent on a rhetoric that was both sexist and racist in its insistence upon the "virility" and transcendence of the Western high art tradition and the superiority of that tradition over all non-Western forms of visual expression.[2]

In 1978, Joyce Kozloff and Valerie Jaudon, artists who like Schapiro had embraced the decorative and the ornamental in a positive and transgressive spirit, published an eye-opening article in the feminist journal *Heresies*. In page after page of canonical quotations from the modernist mainstream (for example, the proclamation by Adolf Loos in 1908 that "ornament is a crime"; or Le Corbusier and Amédée Ozenfant's assertion in 1918, "There is a hierarchy in the arts: decorative art at the bottom, and the human form at the top. Because we are men."), the article made explicit and unforgettable the extent to which decoration and ornament are consistently gendered as female in the Western tradition, and it also exposed the power relationships embedded in this discourse, designed to cast decoration as abstraction's despised and inferior "other."[3]

In the years between Schapiro's breakthrough, feminist work at CalArts and the appearance of Kozloff and Jaudon's article in a non-mainstream feminist journal, Pattern and Decoration, or Pattern Painting as it was first called, had emerged to become a flourishing mainstream art movement. Fed by several

Miriam Schapiro. *Garden of Paradise.* 1980. Acrylic and fabric on canvas, 63 × 66". Collection the artist

Miriam Schapiro in collaboration with Sherry Brody. "The Seraglio" room detail from *The Dollhouse*. 1972. Three-dimensional construction and mixed media. Collection Miriam Schapiro

tendencies, not all of them feminist or even necessarily political in intention, the movement gained impressive media visibility in the New York art world in the late 1970s, and it also enjoyed remarkable success in Europe, where art marketeers packaged and promoted it under the rubric of "P&D."

Although the major practitioners of the Pattern and Decoration movement included men as well as women, it might fairly be claimed that this was the first time in Western history that women had taken the leading role in an art movement. However, it might also fairly be asked (as this essay will do): Should the Pattern and Decoration movement be viewed as the expressions of a deep and lasting revision of values in the art world wrought in large measure by feminist consciousness? Or should the movement and its public successes be understood rather as the art world's way of diffusing newly emergent feminist and multicultural values by coopting them into the mainstream, where those values might give brief life to a fashionable but inevitably time-dated "movement," soon to be superseded by a new season's novelties?

In the mid-1970s, a number of artists who had been working independently in diverse ways to counter the reductive and increasingly sterile dictates of mainstream Minimalism and Conceptualism discovered that they were not alone. The impulse to organize initially came from Miriam Schapiro and the painter Robert Zakanitch, who called a meeting at the latter's studio in New York in January 1975 to discuss matters of mutual concern with artists Joyce Kozloff, Robert Kushner, Tony Robbin, and critic Amy Goldin. In February, a second meeting, convened at Zakanitch's studio by Joyce Kozloff to consider the issue of "decoration," and a public panel, organized in Soho by the painter Mario Yrisarry and entitled "The Pattern in Painting," attracted

a widening group of artists. In the next year, out of the organizational efforts of several of these artists, came the show "Ten Approaches to the Decorative," which opened at the Alessandra Gallery in Soho on September 25, 1976. Curated by artist Jane Kaufman, the show presented works by Kaufman, Valerie Jaudon, Joyce Kozloff, Tony Robbin, Miriam Schapiro, Arlene Slavin, George Sugarman, John Torreano, Robert Zakanitch, and Barbara Zucker. In the meantime, Robert Kushner and Kim MacConnel, already established as pioneers of the decorative, had begun to show their fully developed work in 1975 at the Holly Solomon Gallery in Soho. Examples of their richly patterned cloth pieces were also included in the 1975 Whitney Biennial, where they were singled out for praise by Amy Goldin. Noting the diversity of styles in the Whitney's newly egalitarian, and hence controversial, nationwide survey of recent art, Goldin pointed astutely to "an oddly persistent interest in pattern" as a possible harbinger of things to come. "From a strictly formal point of view," she wrote, "the number of pieces whose impact depended on the structures and strategies of decoration—frames and grids—was startling. . . . Once you start looking for it, pattern seems to be everywhere. The reason its presence is not [more] heavily felt is that few artists dare rely on it—or show much grasp of its formal and emotional possibilities."[4]

These rudimentary efforts at organization and self-definition among a handful of artists and their friends soon bore surprising fruit in the organized commercial art world. The new rumblings of an alternative, "decorative" sensibility were picked up quickly by an art world that had been virtually starved in the preceding years by the increasing reductionism of mainstream Minimalism, an art world that was now, as a result, remarkably motivated to embrace the novelty of that which had

previously been anathema. Suddenly, as the critic David Bourdon succinctly put it in the title of a 1976 review in the *Village Voice*, "Decorative is not a Dirty Word."[5]

In the years between 1976 and 1979, Pattern and Decoration became the subject of much attention and debate. Among the articulate and dedicated critics and writers who helped to define and defend it were Amy Goldin, John Perreault, Jeff Perrone, and Carrie Rickey. Group shows began to proliferate. In October of 1977, a show called "Patterning and Decoration," selected by Holly Solomon and with a catalogue essay by Amy Goldin, presented the work of twenty-three artists at The Museum of the American Foundation for the Arts in Miami, Florida, and then traveled to the Galerie Alexandra Monett in Brussels. In the next month, New York was treated to its own first mammoth exhibition of the phenomenon when "Pattern Painting," organized by John Perreault, opened at P. S. 1 in Long Island City with the work of twenty-five artists. And in 1979, Perreault organized a smaller show entitled "Patterning Painting" for the Palais des Beaux-Arts in Brussels that focused on the work of Tina Girouard, Valerie Jaudon, Joyce Kozloff, Robert Kushner, Kim MacConnel, Tony Robbin, Miriam Schapiro, and Robert Zakanitch. Although the Holly Solomon Gallery represented only a handful of the artists who exhibited at these and other group shows during these years, the gallery became known as a center for the Pattern and Decoration phenomenon in New York, and Solomon was instrumental in helping to spread enthusiasm for it among dealers and collectors in Europe, where much of the work was initially sold.

But even though the Pattern and Decoration movement forged its collective identity and found its initial gallery and media support in the mid-1970s in New York, several of the currents that formed it had originated in California. In 1969–70, Amy Goldin was a visiting professor at the University of California at San Diego. Her courses in criticism and aesthetic theory had a profound impact on Kim MacConnel, then a graduate student, and on Robert Kushner, an undergraduate at UCSD. Both credit her with leading them to question the Eurocentric focus of American culture with its hierarchical privileging of "art-making" over decorative work. She supported them in their tastes for Oriental rugs and Third-World fabrics, and encouraged them, in the words of MacConnel, "to reject Western art in favor of the broader voice that we now call Multi-Culturalism." Also at UCSD in those days, MacConnel recalls, as he describes the environment that nurtured them, was the poet Jerry Rothenberg, "whose translations of ethnopoetic tribal poetries and songs were very influential on all of us; and Jehanne Teilhet, who devised a kind of hands-on, non-Western art history course that was equally influential in offering an alternative view of art and art-making. Even the composer Pauline Oliveros in the music department exerted an influence on us in this direction."[6]

In the spring of 1971, while still students, MacConnel and Kushner joined forces for a two-person show at UCSD, which they provocatively entitled "Decorations," at a time when such concerns would have been considered outside the bounds of serious art. In the next years, although MacConnel and Kushner went their separate ways, they continued to support each other's predilection for the decorative, which they viewed as the primary impulse behind all forms of art making in all periods and in all cultures—and for deploying in their work new forms, new materials, and new strategies that might successfully debunk the hierarchies with which Western culture had confined and marginalized that ubiquitous impulse. "What is impressive [about decoration]," MacConnel later wrote, "is that it goes on, in abundance, regardless of class, race, sex, country or cultural center. Decoration is nearly everything. What it isn't is Fine Art. What the Hell is Fine Art?"[7]

Between 1972 and 1974, MacConnel developed one of his characteristic formats: large-scale fabric wall hangings made of commercially printed textiles (combined later in the decade with those of his own design), which he would selectively overpaint, cut into discontinuous vertical strips, and then sew to recombine. The soft informality of these tapestry-like pieces which flutter against the wall surfaces to which they are pinned, unstretched and unframed, is heightened by the uneven lengths of the strips from which each is fashioned. With these strategies, MacConnel announced the decorative sources and intentions of these pieces, which managed to be banal and sophisticated, discordant and harmonious at the same time. Although they sprang from a desire to challenge fetishized notions of tastefulness in Western culture, they are, ironically, works that are tastefully nuanced and balanced across their insistently flattened surfaces, despite their often brilliant, clashing colors and the brash scale of their patterning (so much, one might say, for the enduring power of "Art" to consume "non-art").

MacConnel appropriated his imagery from a variety of sources: motifs from Chinese, Indian, Islamic, and Mexican folk cultures were eclectically juxtaposed with those of his own invention, such as flower and fish forms and Matissian arabesques. His discovery in 1974 of a series of Chinese advertising books printed in Hong Kong provided him with an important source of pictorial motifs and border imagery, a clichéd chinoiserie that—because it was already clichéd—could avoid the taint of the colonizing and be deployed for our own period as part of a new global language of decoration.

In 1976, at two shows entitled "Collection Applied Design," MacConnel presented some unusual hanging pieces made from Christmas flocked aprons and installations of painted furniture—chairs, sofas, tables, lamps, and screens. These installations threatened to violate the established boundaries between the private interior space of the home and the public space of the art gallery, and they laughed in the face of the high-art tradition's ultimate taboo, the distinction between the aesthetic and the utilitarian. "Tasteless" 1950s furniture salvaged from secondhand junk stores in Southern California had been serving MacConnel as foundations for his painted patterns since 1972. These pieces seem to be the literal embodiments of Matisse's famous metaphor for art as the comfortable armchair in which the tired businessman might be soothed by the sensual and released from the mundane and the cerebral after his day's occupations. As ecological salvage and recycling, they were also read in the 1970s as a challenge to the waste that accompanies affluence in our disposable society.[8]

For Robert Kushner, too, fabric has been crucial both as medium and inspiration.[9] The earliest and most characteristic

of his so-called antiart statements in this medium were the performance costumes that he began to create shortly after graduating from UCSD in 1971. A trip with Amy Goldin to Iran, Turkey, and Afghanistan in 1974 inspired him to model his performance costumes after Iranian chadors, the traditional floor-length capes and face coverings worn by Islamic women. These garments were reconceived by Kushner as unisex costumes that could also function as unstretched wall hangings, and they were presented by him in mock fashion show/performances throughout the seventies. Pieced together from fragments of found and painted fabrics, these sumptuously colored and patterned two-dimensional fields were activated into three-dimensional, kinetic forms by the expansive movements of the male and female models (including Kushner himself) who draped their otherwise naked bodies with these pieces before hanging them casually with pushpins on the gallery walls. Examples include *Moonlight* of 1974, whose large-scale lily motif Kushner derived from a book of Chinese illustrations and *Bias Cut Rainbow W* of 1975, featured in the 1975 performance "Persian Line" at the Holly Solomon Gallery in New York.

Kushner's soft fabric pieces have been displayed and used as costumes, pinned loosely to walls, draped over pieces of furniture, and hung as fabric "gates" to mark an entrance or to subdivide an interior space (for example, *Rose Gate*, 1980). In all of these forms, they self-consciously undermined the rigid rectangular format of the Western easel painting tradition, just as Kushner's exhibition installations, jumbled and bazaarlike in their evocations, purposefully violated the modernist notion of the gallery as a pristine unit of space, hermetically sealed off from its real-world environment.

In the early and mid-1970s, the art of MacConnel and Kushner challenged the hierarchies of ethnicity and gender that governed the definition and production of "Art" in Western culture, and both artists deployed materials and techniques—fabric and sewing—that Western culture has traditionally classified as domestic and female. Feminism, however, was not their cause. Nor did they regard gender as the central determinant of the aesthetic restrictions against which they chafed. Nevertheless, both took great professional risks by identifying themselves and their art with the stereotypically feminine.[10] Later in the seventies, for the brief period when Pattern and Decoration was riding high on the international art market, MacConnel and Kushner (and Robert Zakanitch, another major male figure in the group) may have benefitted to some extent from their gender, receiving more attention from the better-known galleries and the press, at least in Europe, than did some of their female cohorts in the movement. But along with the women, they too suffered the gendered backlash of the eighties, even though—and this is worth reiterating—feminism per se had never been their issue and female culture had never been, in any political sense, the content of their art or their cause.

The leading conceptual and political role played by feminist women in the Pattern and Decoration movement was acknowledged and emphasized by John Perreault, who was one of the group's chief critical supporters and an active polemical spokesperson. Much of the movement's "strength and resilience," he wrote in 1979, "can be attributed to such artists as

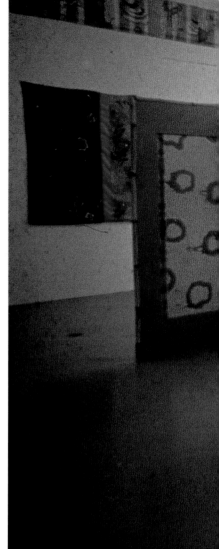

Kim MacConnel. Installation View, "Collection Applied Design," La Jolla Museum of Contemporary Art, May 1976

Joyce Kozloff, Miriam Schapiro and Valerie Jaudon, who have used the organizational skills they picked up in feminist politics to encourage a dialogue among artists with shared concerns."[11] "It still amazes me," he wrote again in 1979, "that at last we have an art movement in which women artists are right at the forefront—innovators, leaders, and, in a certain sense, pioneers."[12] Perreault's own courage and vision in this regard had been applauded in 1977 by April Kingsley, who wrote in her review of Perreault's large-scale "Pattern Painting" show at P. S. 1:

It should be noted that it took a sensitive non-museum person like Perreault, working in a non-museum situation like P.S.1, to bring this show about. Any of the gallery-controlled museums might have shoe-horned in works by Jasper Johns, Al Jensen, Frank Stella, Robert Ryman, Sol Lewitt, Alan Shields, Ellsworth Kelly, or Gene Davis, whether they were truly pattern generated or not. Then, too, about a third of the artists

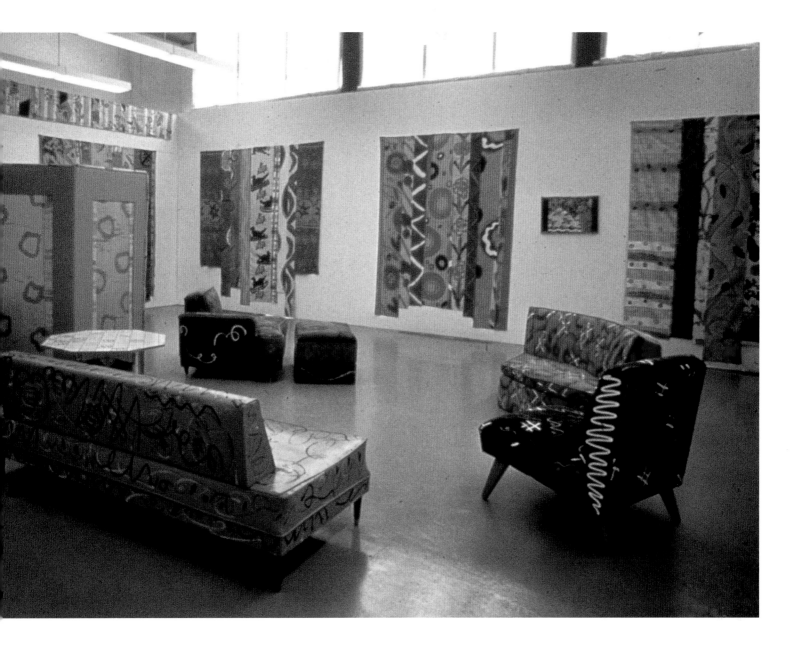

Perreault has included are practically unknown, which is a feat no museum or museum-type institution I know of seems able to accomplish, and I also doubt they would have put 18 women out of 26 artists in the show. Even an art form so dominated by women as this one wouldn't have caused them to adjust their quotas that radically.[13]

In the next years, however, as Pattern and Decoration became fashionable on the exhibition circuit, gender ratios, in the hands of other exhibition organizers, abruptly changed. For example, "Arabesque," a show organized by the Contemporary Arts Center in Cincinnati, Ohio, in 1978, showcased the work of six artists, only two of whom were women. (The artists were Joyce Kozloff, Robert Kushner, Kim MacConnel, Rodney Ripps, Barbara Schwartz, and Ned Smyth.) And gradually, works by such artists as Frank Stella and Lucas Samaras were, in Kingsley's term, "shoe-horned" into P&D exhibitions, as "the

decorative impulse" was temporarily embraced in the post-minimal atmosphere of the mid- and late seventies by a variety of artists who were simply looking for the next place to go. "The Decorative Impulse," for example, a traveling show organized by Janet Kardon for the Institute of Contemporary Art of the University of Pennsylvania in 1979, presented the work of eleven artists, seven of whom now (including Stella and Samaras) were men. In the catalogue, Kardon established several categories of shared interest within this diverse group of artists: Decoration/Pattern, Orientalism, Matisse, The Easel Painting/The Environment, Fabric, and The Vernacular. "Kardon's premises," wrote the critic Jeff Perrone who reviewed the show, "allow a collage-like understanding of a wide-ranging phenomenon, one she sees as being 'open' rather than 'closed.'" Yet Perrone was discomforted enough by the resultant blurring and depoliticizing of the notion of the "decorative" to offer his own definition and to make the following important distinctions:

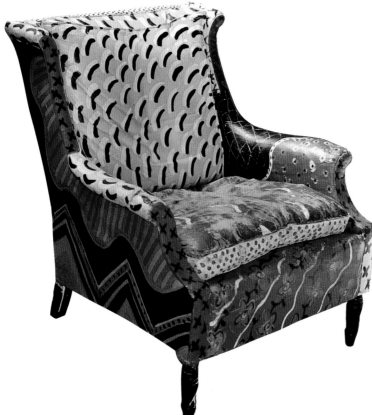

Kim MacConnel. *Wing Back Chair.* 1972. Acrylic on found upholstered chair. 32 × 32 × 32″. Courtesy of artist

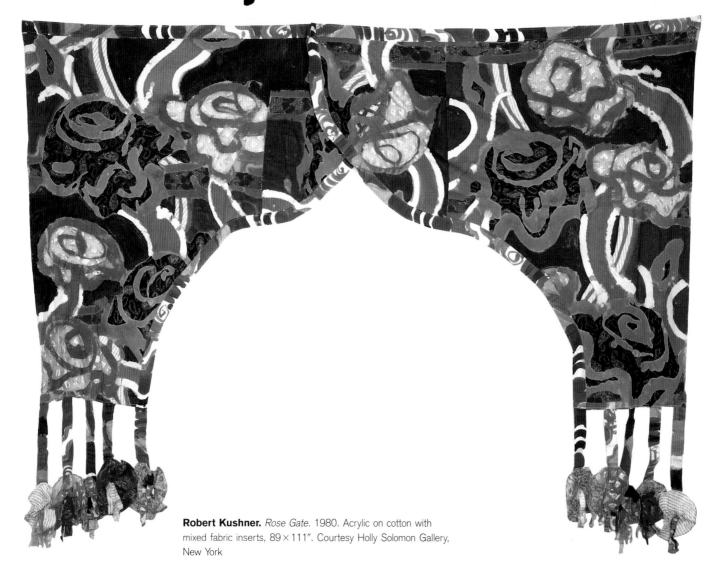

Robert Kushner. *Rose Gate.* 1980. Acrylic on cotton with mixed fabric inserts, 89 × 111″. Courtesy Holly Solomon Gallery, New York

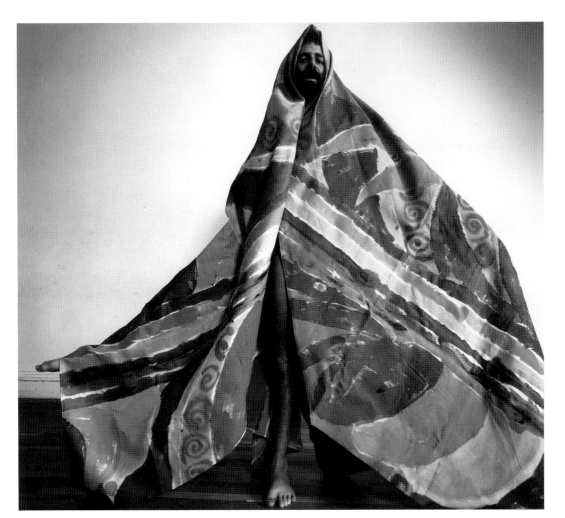

Robert Kushner wearing *Bias Cut Rainbow W* from the "Persian Line." Performance at Holly Solomon Gallery, New York, 1975. Acrylic on synthetic fabric, 83½ × 161½". Photograph by Harry Shunk

Decorative refers to pictorial creation which does not express the ego desires of a single artist It is, for example, impossible to reconcile the decorative with any form of violence or aggression, these being extreme manifestations of egocentric desire. Samaras' spiky chairs, his sado-masochistic fantasies, even his "quilts," exhibit a personal horror, a frightening destructiveness which is anti-decorative. Stella's latest works, sharp, cut-out metal reliefs, jut out into space with an aggressive force; the razor-blade edges speak of a sensibility exploitative, sarcastic, unsympathetic, cold, manipulative, utterly lacking the self-effacing qualities of decoration. [14]

In 1984, in the context of a discussion of collaboration, Robert C. Hobbs picked up and expanded upon Perrone's definition of the decorative as "a concept of creating that does not separate but integrates, that does not make the ego the subject but instead is attuned to some function outside the individual." And he used this definition to distinguish, astutely, between the work of Miriam Schapiro and Frank Stella:

One needs only to consider the differences between Frank Stella's Protractor series and Miriam Schapiro's fan-shaped canvases to realize that the immediacy of the former works, which were instantly recognizable, almost preformulated ge-

stalts, were replaced by works similar in shape but vastly different in appeal, works that invite viewers to come close and study the surface of cloth, sequins, paint, and remnants of patchwork and embroidery created by anonymous women in the past. Although Schapiro seems to appeal to Stella's immediacy and design, his large distancing permutations on basic shapes, his art that functions best in the lobbies of anonymous late-modern steel and glass buildings, she humanizes her art by incorporating in it the work of other women . . . the accretion of women's traditonal handicrafts, their very personal creations for their families and friends. [15]

In both her art and her life, Schapiro has long seen herself as a mediator, as one who facilitates communication between (and thereby contributes to dismantling) the artificially separated and gendered worlds upon which patriarchal power structures depend: the private versus the public, the domestic "crafts" versus "high art," the oppositional feminist movement versus the mainstream art world. In the same way, her art might be regarded as an androgynous blending of female cultural experiences and values with a high-art language of public power and presence—the very language that has traditionally denied the female a voice in the public realm. The large and striking forms of her fans and hearts and houses of the late 1970s re-

tain the power of the Minimalist gestalt now transformed into iconic and politically loaded symbols, self-consciously selected in order to reclaim for "Art" and for humanity that which had formerly been trivialized as sentimental, as merely feminine and merely decorative. As Schapiro told art historian Ruth Appelhof in 1979:

> *Part of my ethos is to test sentimentality. I want to know how far I can go with it because it's so taboo in terms of high art. I've chosen to use fabric and the decorative arts as tangible symbols of my connection to domesticity and to express my belief that art resides in domesticity. For me the fabric of my art and the fabric of my life neatly equate each other.*[16]

From 1958, the year of her first solo show at the Andre Emmerich Gallery, Schapiro was an established presence in the New York art world where she regularly exhibited her work. That work gradually evolved throughout the sixties from a form of painterly Abstract Expressionism to Abstract Illusionism and then to the making of hard-edged, computer-generated images by the end of the decade. But while her paintings were stylistically in step with New York's high art scene, their contents—their recurring emphasis on centralized imagery and on the forms of the egg, the window, the shrine—harbored a latent and barely submerged feminist consciousness, as Schapiro came to recognize when she joined forces with Judy Chicago at CalArts in the early seventies, thereby turning her back on and risking all that she had formerly worked to build for herself as a woman in the pre-feminist art world.

In the early seventies, Schapiro derived the impetus and inspiration for her politically transgressive art of decoration from the creative artifacts of women's lives and experience—the embroidered handkerchiefs and samplers, aprons and quilts that she increasingly sought out and collected over the course of that decade—and also from a growing awareness of and openness to those non-Western traditions in which the decorative had been neither gendered nor taboo. Again, in a 1979 interview, Schapiro said:

> *I got the idea for the* Explosion *series from being so overwhelmed by seeing* The King's Book of Kings *[exhibition] in the Metropolitan [Museum of Art]. I saw that the year before we made* Womanhouse . . . *I was struck by the miniature aspect which later led me into the* Dollhouse. *I was also struck by . . . the geometrizing of the page; the flora and fauna inside, moving out into the borders. I could not get over that. I loved doing that [Explosion] series and I felt that for me it was a really new form. It was the first time that I had used political content in my work and it was not easy.*[17]

But despite her attraction to the formal and expressive lessons to be learned from non-Western art forms, Schapiro's aims, unlike those of Kushner and MacConnel, were never antiart in general or anti-Western art in particular. She sought, rather, to push Western art beyond its exclusionary boundaries of gender, to retrieve and to honor the unsung work of the women who had come before her and to clear a space—an unprecedentedly large space—for the changing values and visions of those women who would come after her.

Nowhere in her oeuvre are these aims better exemplified than in the monumental piece, *Anatomy of a Kimono*, a ten-panel, fifty-two-foot-long painting/femmage (Schapiro's term for the female tradition of sewing, piecing, hooking, quilting, and appliquéing that parallels and precedes the high-art activity of "collage").[18] Schapiro created *Anatomy of a Kimono* in less than three months as an installation at the Andre Emmerich Gallery in 1976. It was inspired by plates in a book on traditional Japanese costumes and fabrics that the artist Sherry Brody (Schapiro's friend and former assistant at CalArts) had sent to her and on which she had already based a work that she now incorporated as one panel in the new ten-panel structure. Here, the forms of the obi and the kick variously flank the stylized form of a kimono in four repetitions, which Schapiro conceived, she said, as "a symphony" of color, moving from "pale" to "neutral" to "dark and sonorous, and finally the red crescendo" of the last triumphant kick, chosen to end the painting so that it "would walk or strut its way into the 1980s." Writing in 1978 about how she made *Anatomy of a Kimono*, Schapiro admitted that, as a woman, she had been politically self-conscious about claiming space and taking "territory" in this work: "I hoped that other women would be secure after me in this way. Indeed they have been." And she stressed the androgynous nature of her formal choices (her need, for example, to contrast and harmonize, in traditionally gendered terms, the "curvilinear" form of the obi and the "geometric" form of the kick). While she had originally intended to address the audacious statement of this piece only to women, she said its message had changed and deepened for her as she had worked on it:

> *I wanted to speak directly to women—I chose the kimono as a ceremonial robe for the new woman. I wanted her to be dressed with the power of her own office, her inner strength . . . I wanted the robes to be clear, also I wanted them to be a surrogate for me, for others. Later I remembered that men also wore kimonos, and so the piece eventually had an androgynous quality. Nice. The painting gave me a gift.*[19]

In the late 1970s, the Pattern and Decoration movement was usually described as a colorful and exuberant rebellion against Minimalism, a rejection of the latter's confining sterility both in form and content. It may be more accurate and more useful, however, to describe the formal relationship between the two movements in terms of continuity rather than complete rupture, for "Pattern Painting" (as the movement was first called) was in many ways a logical extension of the premises of the compositionally nonrelational and nonhierarchic Minimalist grid. As Amy Goldin astutely pointed out in 1975, at a time when the organized movement was still in its infancy, what defines pattern is not, as is generally thought, the repetition of a motif, but rather "the constancy of the interval between motifs." "The fundamental structure of pattern," she wrote, "is the grid."[20] Indeed, for many of the Pattern and Decoration artists of the 1970s, pattern first emerged from the painterly mark and

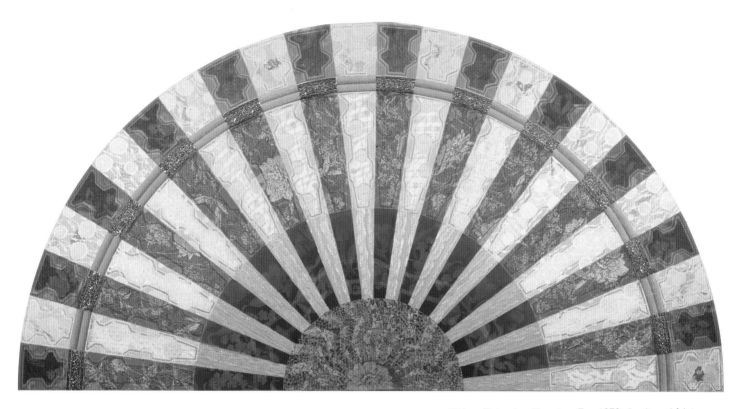

Miriam Schapiro. *Barcelona Fan.* 1979. Acrylic and fabric on canvas, 72 × 144″. Collection Steven M. Jacobson and Howard A. Kalka, on permanent loan to The Metropolitan Museum of Art, New York

from the texture of raw materials as a self-conscious extension and variation upon the Minimalist grid. And for some of these artists, the ideological agenda and promise of "pattern and decoration" was often more formalist than it was political.

The painter Robert S. Zakanitch, for example, who worked in a Minimalist and Color Field mode in the late sixties, has said that the primary content of his art has always been painting itself, "the pure act of painting."[21] He began his move toward Pattern and Decoration in the early 1970s out of dissatisfaction with the ever more reductive and cerebral direction of mainstream modernism. Urged by his own sensibility toward painterliness and a more additive art, he began in the early seventies to create grids out of increasingly painterly abstract marks. Nervous at first about these moves, then regarded as heretical, he was encouraged to follow his bent by conversations held in 1974 with Miriam Schapiro in California.

Over the next two years, Zakanitch's abstract marks rapidly metamorphosed into floral forms derived from such blatant and banal decorative sources as linoleum and wallpaper pattern books. Often working with large canvases in a triptych format, as in *Robespierre's Pomegranates* of 1976 or *Amazon* of 1978, Zakanitch would place a gorgeous profusion of enormous blossoms in his central panel and would then play off against them in the flanking panels floral patterns of a very different scale and density (page 224). In combination with white borders

and/or fade-outs toward the edges of his canvases and the insistent painterliness of the irregular floral forms that comprise his "patterns," Zakanitch's compositional strategies thus maintained the relational and hieratic design principles of modernist high art and avoided the overall and mechanical repetitions that characterized his decorative sources.

Although he maintained a distinction between art and craft and never embraced Schapiro's self-consciously feminist political agenda, Zakanitch has nevertheless ascribed his own taste for wallpaper and linoleum patterns to the personal experience of his Eastern European background—memories of his mother's embroidery and the painted and stenciled walls of his childhood home. And while he recognizes the gendered basis of the art establishment's resistance to decoration ("Even when Pattern and Decoration was hot," he has said, "the galleries were trying to destroy it because it was so threatening"),[22] for him, the importance of the Pattern and Decoration movement lay principally in its ability to open up another avenue to painting. He has written: "Pattern, decoration, craft, has in itself innocence They are just acts of pleasure and creation which may be sexual, but not in terms of masculine and feminine. It is our conditioning that brings the inference . . . it may just be the first truly androgynous art form."[23]

In 1971, the artist Cynthia Carlson painted her first "pattern painting," an image that depicted an enlarged section of

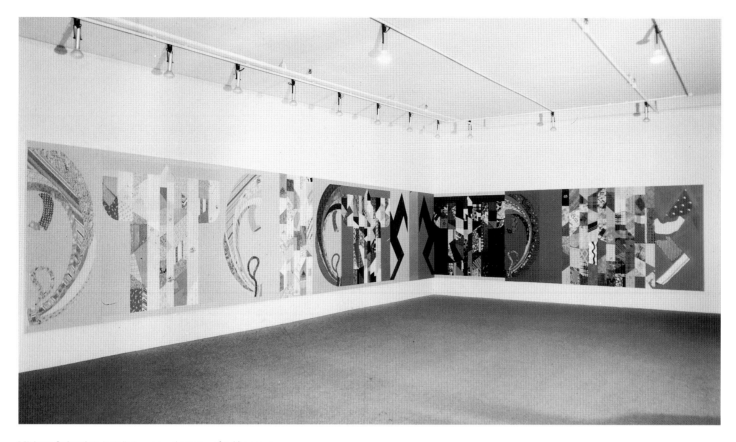

Miriam Schapiro. Installation view, *Anatomy of a Kimono* at Andre Emmerich Gallery, New York, September 18–October 12, 1976. Fabric and acrylic on canvas, 6'8" × 52'½" (10 panels). Courtesy Galerie Bruno Bischofberger, Zurich

cross-woven fabric.[24] Over the next few years, magnified patterns derived from her earlier landscape paintings gradually became the real subject of her new all-over paintings, in which thickened pigment, applied rapidly and experimentally by such methods as squeezing through a pastry tube, created increasingly sculptural effects. In the mid-1970s, inspired in part by the example of Ree Morton, her friend and longtime colleague at the Philadelphia College of Art, Carlson made her important breakthrough from painting to large-scale installations, using a decorative vocabulary to challenge and to blur, in increasingly witty ways, traditional distinctions between painting, sculpture, and architecture. In 1976, for an installation at the Hundred Acres Gallery in New York entitled *Wallpaper*, Carlson hardened large chunks of acrylic pigment into brushstroke-like squiggle shapes, and glued hundreds of them at regular intervals from floor to ceiling across approximately seventy feet of the gallery's walls. Here and in other "wallpaper" installations featured in 1977 in the "Pattern Painting" show at P. S.1 and in 1979 in "The Decorative Impulse" show at the University of Pennsylvania, Carlson turned walls into paintings and the decoration of those walls into sculpture, humorously blurring traditional distinctions between the so-called fine and decorative arts and

endowing the decorative with a new monumentality and grandeur.

The aesthetic iconoclasm that marks Carlson's association with the Pattern and Decoration movement grew initially from her fascination with problems of formal structure; but it was entirely consonant with her acknowledged commitment to feminism's values and concerns. Soon discomforted by the narrowness of the pattern and decoration label, in fact, Carlson moved quickly to expand the focus of her installations beyond formal play to encompass and draw contextual meaning from her installation sites, as many feminist artists of this period were doing. For example, in *R is for Red is for . . .*, an installation created for a show at the Contemporary Arts Center in Cincinnati, Ohio, in 1980, the painted and sculpted leaf patterns on blue diamonds of Masonite applied across the painted red field were derived by Carlson from local Rookwood and Roseville pottery decoration (both of these companies, part of the Art Pottery movement in the United States, had been run by women). And the mock paintings, which punctuate the all-over grid, take as their motif varieties of trees indigenous to this region. These "paintings," placed one on each wall, allude to high art's traditional window opened onto the reality of nature; but they here seem to become, in ironic reversal, decorative embel-

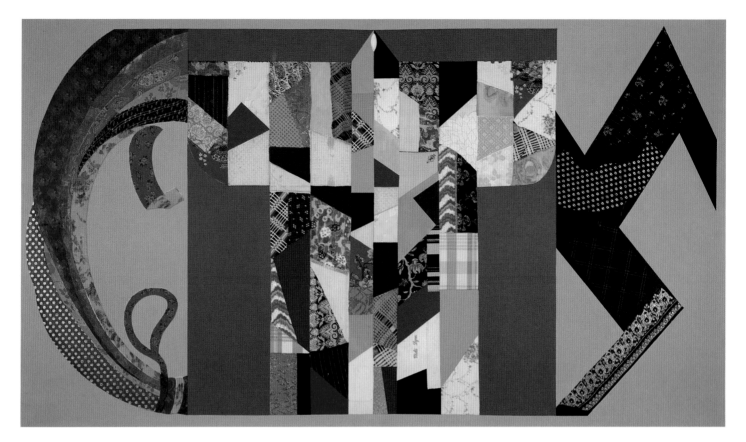

Miriam Schapiro. *Anatomy of a Kimono* (detail). 1975–76. Fabric and acrylic on canvas (5 of 10 panels); whole 6'8" × 52'½". Courtesy Galerie Bruno Bischofberger, Zurich

lishments that are subordinated to the reality of Carlson's intensely colored and patterned walls.

Increasingly in the late 1970s and early 1980s, many artists associated with the Pattern and Decoration movement turned their attention to creating and decorating usable objects, as MacConnel and Kushner had done earlier in the decade. By thus breaking the ultimate taboo of the high-art tradition, many of them hoped to challenge once and for all the artificial boundaries between art and craft, between the fine and the applied arts. During these years, for example, Joyce Kozloff, who had been known up to this point principally as a painter, collaborated with the well-known ceramicist Betty Woodman to create a series of usable cups, pitchers, and vases, which stand as an impressive demonstration of the fluidity between the traditional categories, as do Patsy Norvell's etched glass screens and garden environments and Jane Kaufman's sumptuous "curtains."

The work of Jane Kaufman can be seen both as a variation on Minimalist rectangles and grids and as a feminist rejection of the Minimalist ethos. Kaufman, who had both organized and participated in the historic "Ten Approaches to the Decorative" show at the Alessandra Gallery in 1976, moved definitively out of the orbit of conventional painting in the late 1970s. Her new

hanging curtains, however, whether transparent or opaque, still functioned in part to transform light, as her earlier paintings made of metalflake on canvas had done. But the light in question now was real light, and the increasingly unconventional materials employed—ranging from rhinestones and bugle beads sewn onto such fabrics as velvet, satin, or chiffon to curtains fashioned from crocheted gold filament, strings of pearls, or pheasant feathers—were blatantly and provocatively an affirmation of the so-called feminine values of opulence and decoration, values that had previously been denigrated.

In order for art like Jane Kaufman's to succeed in making its affirmative and hence powerfully feminist political statement, her audience had to accept as natural—as many did in the 1970s—the association of women and the decorative. In reality, of course, these qualities are not innately female, but are rather part of the cultural construction of the female that Western society has imposed upon women. This essentialist interpretation of the decorative, moreover, is entirely relative to our own culture, a culture that has gendered ornament as female, and hence inferior, because it is produced not only by women but also by those in non-Western cultures whom we classify as other. Thus, when Pattern and Decoration artists of both sexes looked

to sources in Eastern or Islamic cultures, where decorative art is neither gendered nor lacking in significant content and its production is not considered to be the biologically preordained province of women, they did so, clearly, not as an embrace of biological essentialism but as a challenge to it—as an effort to liberate an area of visual expression that has long been feminized—and hence policed and artifically controlled—by our male-dominated and Eurocentric art establishment.

Among the Pattern and Decoration artists, Valerie Jaudon and Joyce Kozloff have drawn inspiration most directly and consistently from the traditions of non-Western decorative arts, and as a result their works have departed perhaps most radically from the hierarchic and relational aspects of traditional Western-style pictorial composition. They have embraced instead the very different mode of looking and visual attentiveness that pattern demands in both physiological and psychological terms, a leisurely and less focused scanning for detail that our own cul-

ture denigrates and genders, by implication, as female.[25] Turning to a variety of traditional decorative sources (among them Celtic, Islamic, Hispano-Arabic, and Mexican), many of which had in turn been the product historically of rich multicultural mixes, the work of these artists inventively combines East and West and demonstrates what can be accomplished today by artists who work openly and creatively in borderline situations, at the interface between cultures. Valerie Jaudon, who had her first solo exhibition in New York at the Holly Solomon Gallery in 1977, is known for canvases covered with sumptuous and complex all-over interlacings of curved and straight bands (see below). Her work evolved in the late 1970s from symmetrical and concentric traceries of delicate lines on monochromatic surfaces to heavily impastoed and high-contrast bichrome pieces in which ribbonlike linear elements interact dynamically with their backgrounds and suggest the architectural. Although Jaudon transformed and invented her

Valerie Jaudon. *Aberdeen.* 1981. Oil on canvas, 102 × 136″. Collection Pehr Gyllenhammar, Sweden

Cynthia Carlson. *R is for Red is for. . . .* 1980. Latex, acrylic, Masonite, and charcoal (3 panels), approx. 13 × 53′. Installation at the Contemporary Arts Center, Cincinnati, Ohio

own variations on Islamic and Celtic interlace patterns, working in the Western manner with a variegated pigment surface that creates illusionistic tensions between figure and ground, her paintings (many of them named for towns in her native Mississippi) nevertheless retain unmistakeably the flavor of their non-Western sources of inspiration. They seem at first to be far closer to those sources than do the works of Joyce Kozloff, even though Kozloff more directly accepted the individual patterns and motifs that she found in the arts of other cultures, transforming them only by incorporating them into new and larger decorative entities.

The career of Joyce Kozloff is a revealing case study of the trajectory and implications of Pattern and Decoration in a feminist context. In 1970, when Kozloff had her first solo show at the Tibor de Nagy Gallery in New York, she was doing what she has since described as "large, formal, geometrical, abstract, New York (male) painting."[26] In 1971, when she moved to California, she became politically active in organizing women artists in the

Bay Area and involved in women's consciousness-raising groups. In 1972, during two months at the Tamarind Lithography Workshop in Albuquerque, she visited the Pueblos, and patterns began to emerge in her lithographs. But her breakthrough experience came in the summer of 1973 in Mexico, where she became obsessed with patterns and their cultural significance. There she made drawings of patterns derived from Pre-Columbian folk art, rugs, textiles, baskets, ceramic tiles, and architectural ornament. These became the bases for a series of large acrylic paintings executed back in New York in 1973, including *Three Facades,* an almost literal rendering of patterns derived from the tiled façades of the churches Kozloff had visited. Attracted by the complexity and beauty of Islamic ornament, she visited Morocco in 1975 and Turkey in 1978. During this period, she painted increasingly large canvases that incorporated decorative patterns from these cultures into a still gallery-oriented and acceptable Western high-art language of color field and grid abstraction. Her involvement with the women's move-

Opposite:
Joyce Kozloff. Installation view, *An Interior Decorated* at Mint Museum, Charlotte, North Carolina, September 1980. This piece is one of several installations, started in 1978, and completed in 1979. It is composed of hand-painted, glazed ceramic tile floor, pilasters with grout and plywood, silkscreened hanging silks, lithographs on silk laminated on rice paper. Courtesy of artist

Top:
Joyce Kozloff. *Three Facades.* 1973. Acrylic on canvas, 80 × 59″. Collection Massachusetts Institute of Technology. Courtesy of artist

Bottom:
Joyce Kozloff. Vestibule view of Amtrak Station, Wilmington, Delaware, 1984. Hand-painted glazed ceramic tiles, 30 × 20 × 15′. Courtesy of artist

Robert S. Zakanitch. *Amazon* (triptych). 1978. Acrylic on
canvas; overall dimensions, 96 × 167″. Courtesy Jason McCoy
Inc., New York

ment, however, made her increasingly uncomfortable with this
position and increasingly aware of its contradictions. She
remembers:

> *Some of us worked on the "Women's Traditional Arts" issue of*
> *Heresies in 1977–78, researching and hashing out the aes-*
> *thetics of high/low in other cultures, finding one could not sim-*
> *plistically celebrate what was sometimes a form of oppression*
> *(little girls going blind making lace in Europe or weaving in*
> *the Near East) or devalued in its own context (where carved*
> *sculpture by men for ritual purposes was Art and clay pots by*
> *women for cooking were not)!*
>
> *I think about how I began to feel dishonest claiming to*
> *break down the hierarchies between high art and craft while*
> *continuing to take from decorative art sources to make paint-*
> *ings! How I forced myself to experiment with clay when I was*
> *teaching at the University of New Mexico in 1978 (I'd flunked*
> *ceramics in art school), and how I was a visiting professor in*
> *painting there and the chairman was horrified when he found*
> *out I was spending all my time in the ceramics room and asked*
> *me to please not tell the students (they already knew).*[27]

Kozloff now began to combine ceramic pilasters with large pat-
terned collages to decorate single walls (one such installation

appeared in the 1979 Whitney Biennial), and moved from there
to room-sized installations using ceramic tiles, printed silks, and
lithographs in an effort to create functional envirnoments. *An
Interior Decorated*, the generic name for the four separate in-
stallations she showed in gallery and museum spaces between
1979 and 1981, was "a personal anthology of the decorative
arts," a potpourri drawn from an amazing number of periods,
regions, and ethnic sources as a celebration of their variety and
their individual and collective vitality.[28] When the parts of these
installations were sold separately, Kozloff decided to break out
of the gallery world and to enter the realm of public art, where
she hoped that she might have more control over the totality of
her work and more of a direct impact on the way in which art
can function and be made accessible to a wide variety of people
in everyday life. There followed a series of major commissions
to decorate such public spaces as the Harvard Square Subway
Station (1979–85), the Wilmington Delaware Amtrak Station
(1980–84), the San Francisco Airport (1982–83), the Humboldt-
Hospital Subway Station in Buffalo (1983–84), and the Subur-
ban Train Station in Philadelphia (1985). In each, with local
audiences always firmly in mind, Kozloff used vibrantly pat-
terned tiles and mosaics to create a symbolic portrait of the
region in terms of its indigenous ornament: in Buffalo, for ex-
ample, motifs derived from native Seneca Indian jewelry are

combined with those based on the architectural ornament of Louis Sullivan and Frank Lloyd Wright; the Harvard Square Subway Station features the traditional decorative arts of New England; and the decor for the Amtrak Station vestibule in Wilmington pays homage to its designer Frank Furness by quoting details and ornamental motifs from his other buildings.[29]

Kozloff has not been alone among the Pattern and Decoration artists in moving from gallery to public art in the 1980s. Cynthia Carlson and Miriam Schapiro are among the women who have taken this route (for example, Schapiro's vibrantly colorful, 35-foot-high painted aluminum sculpture, *Anna and David*, installed in 1987 in front of a modernist office building in Rosslyn, Virginia).[30] And they in turn reflect a growing trend nationwide in our post–*Tilted Arc* era, as women artists, working cooperatively with local governments, corporations, and community groups, have managed to produce a new generation of "user-friendly" public art, art that combines the personal with the political and that reconciles the concerns of the artist with those of the community.

In 1983, John Perreault, who, over the years, had consistently presented the phenomena of patterning and decoration as a broadly based alternative to the Western tradition, now began to speak about Pattern Painting as a subcategory of "Decorative Art," capitalized, he said, to designate a "fine art" movement, as we capitalize Pop Art or Abstract Expressionism.[31] Perreault's insistence at this juncture upon defining a "movement," his evident desire to grasp and hold onto an art-world rubric that might insert this moment and these artists into history, was understandable in light of the masculinist backlash already underway in the 1980s, a period when Neo-expressionist figuration would supplant Decoration, and appropriation, as a tool of deconstruction, would make business-as-usual images of white male hegemony and misogyny—masquerading now as social commentary—newly acceptable in the art world.

But even though Pattern and Decoration did make its way as a "movement" into a few (but by no means all) of the histories of contemporary art that have been written over the last decade, this strategy may ultimately be a self-defeating one. For by defining the decorative as a modernist movement of the 1970s, we risk reducing this phenonomen, which set out to present a mortal challenge to the authoritative mainstream, to being merely a part of that mainstream's own history.[32] Moreover, to claim a single modernist movement as the parameters of the decorative seems woefully inadequate in light of the issues that were exposed and foregrounded by the aesthetic debates of the 1970s: namely, the broad and persistent patterns of sexist and racist exclusion in modern Western culture that have marginalized and subordinated as other what has in fact constituted a major aspect of human visual production not only around the world but in Western culture as well (from the Book of Kells to Renaissance groteschi, the Rococo, Art Nouveau, and Louis Sullivan, to name but a few!).

Pattern and Decoration is thus perhaps best understood not simply as a transient modernist movement but as a phenomenon that helped to articulate in the 1970s the postmodern recognition of the power relations that lie embedded within "pure" stylistic choices, a phenomenon that contributed in important ways to the rethinking and reframing of the role of the artist and the function of art in modern society. "P&D" questioned the hierarchies and the ideology upon which the art world and gallery systems have been predicated; it survived those systems' efforts to coopt it and in the end contributed to a development that may one day render that system obsolete, as art moves out of the economic and cultural control of an elitist commercial system into a more democratized public sphere. As Joyce Kozloff has put it:

> *At its best, decoration is the coming together of painting, sculpture, architecture, and the applied arts. Decoration humanizes our living and working spaces. It connects with ancient, worldwide traditions and crafts. It opens up the possibility for artists of varying skills to work collaboratively on public projects. Decoration abolishes hierarchical distinctions between "high" and "low" art. It is not elitist and does not condescend; it will expand our notions of "the artist" and the "art audience."*[33]

Jane Kaufman. *Crocheted Gold Hanging.* 1980. Gold filament and rhinestones, 82 × 60″. Collection the artist

COLLABORATION

BY JUDITH E. STEIN

"What would happen if one woman told the truth
about her life? The world would split open"

—*Muriel Rukeyser*, Kathe Kollwitz, *1968*[1]

The romantic image of the artist as striving and starving alone is one of the received myths of Western culture. This quaint paradigm of artistic creativity was never universally appropriate, certainly not for dancers, musicians, and architects, who by virtue of their craft, worked in concert with others. Nor did it fit the printmaker, who traditionally worked hand in hand with master printers. The stereotype of the lone genius was altered in the New York art world of the fifties and the sixties when such visual artists as Robert Rauschenberg, Grace Hartigan, Alfred Leslie, and Alex Katz worked with writers and choreographers on collaborative projects. But it was not until the seventies, with the renewal of feminism in America, that artistic collaboration became for many women a political act and a creative first choice. As a member of the San Francisco mural collective Las Mujeres Muralistas noted in 1974, "We feel this work is really important because it takes us beyond the level of individualism."[2]

As women awakened to feminism, they began to redefine their relationship to each other, to society, and even to the earth itself. While women might experience the "click" of recognition when they were confronted by societal sexism, it was the communal process of consciousness-raising that became the feminist archetype. Here, the shared insights of individual contributors built one upon the other to effect social change. The personal became the political. For artists who now defined themselves as feminists, the power of art as a transformative agent had never been more apparent.

Feminist collaborations in the visual arts took many forms. For some, it was an aesthetic partnership, in which the participating women shared responsibility for a given work's form and content. Others updated the model of the quilting bee, where one artistic vision initiated and directed a given project, which was then realized and completed by the labor of many. Yet others took inspiration from the format of the potluck supper, where each guest contributes a culinary creation for the common good, the meal as a whole being greater than the sum of its parts. For those feminists who were social activists, the forum of the political demonstration offered a vehicle for communal performance events. Propelled by their redefinitions of "public" and "private," some feminist artists gravitated toward public art, by its nature a collaborative endeavor pairing artists, for example, with engineers and landscape architects. And finally, ecofeminists joined hands with Mother Earth to collaborate with nature itself.

Like the black and gay liberation movements of the late sixties and seventies, the women's movement sought out its own history. Women artists "collaborated" with their heritage, which was newly understood to include the decorative as well as the fine arts. Painter Miriam Schapiro was brought up believing in the romantic myth of secluded genius. But when she and Judy Chicago taught in the Feminist Art Program, they based their pedagogy on the communal process of consciousness-raising. As Schapiro began working on the collaborative Womanhouse project with her students, she became aware that "Collaboration was taking place right then and there in my brain and liberating me from the idea of being solitary."[3]

As Schapiro began to educate herself about historical

Judy Chicago. *The Dinner Party*. 1974–79. White tile floor inscribed in gold with 999 women's names; triangular table with painted porcelain, sculpted porcelain plates, and needlework; each side 48′ set with thirty-nine place settings, each representing a historic or legendary woman. Collaborative work involving over four hundred people. Collection the artist

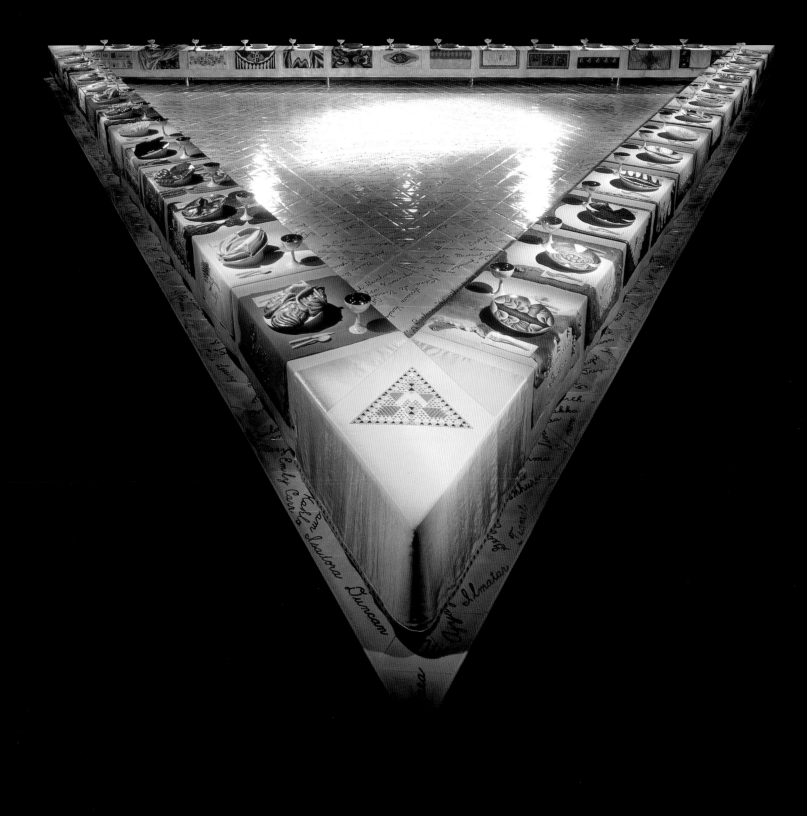

women artists and about women's traditions of needlework, she embarked on a process of collaboration with the past. She amassed vintage embroidered handkerchiefs, doilies, pot holders, quilt pieces, and table runners, which she incorporated into her artwork. Although Robert Rauschenberg had previously included actual patchwork quilts in his paintings, and Arthur Dove had used scraps of lace and cloth in his collages, no other artist had permitted the found fabrics to speak for themselves with such eloquence or as a means of affirming the creativity of their source. By listening and responding, Schapiro collaborated with the unknown women needleworkers to create a visual dialogue about form and content and about the histories and lived experiences of women.

For Schapiro, the "other side of the [collaborative] coin" was her work with historical women artists. Her interest in this hidden history was piqued when in 1972 Schapiro saw "Old Mistresses: Women Artists of the Past," the pioneering show organized by Ann Gabhart and Elizabeth Broun for the Walters Art Gallery in Baltimore. Four years later, when she saw Linda Nochlin and Ann Sutherland Harris's "Women Artists: 1550-1950," she was inspired to "engage myself, in an imaginative sense, with women of the past." She decided to effect this by using reproductions of historical artworks, which, in the wake of the media coverage of "Women Artists: 1550–1950," were newly available. Schapiro followed her collage *Me and Mary Cassatt* with others about Elisabeth Vigée-Lebrun and Berthe Morisot. Subsequently she enlisted the "collaboration" of Frida Kahlo and several twentieth-century Russian and Soviet women artists in femmages made throughout the 1980s and early 90s.

In a parallel but distinct fashion, Judy Chicago also chose to focus on the hitherto marginalized art activities of women and to forge connections between her own art and that of her female forebears:

> *I recognized that my work could only be accurately understood against the background of a female history, and I wanted to find a way to incorporate that history into my work so that the viewer would be forced to confront my work in the context of other women's work.*[4]

Initially, Chicago created a series of abstract portraits of women of the past in her Great Ladies series of 1973. Her search for female artistic predecessors took her into the realm of decorative arts, where she discovered the art of china painting. Not only was she intrigued by the subtleties of the technique, long relegated to women practitioners, but also she began to consider the potentials of china plates as painting surfaces: "Since plates are associated with eating, I thought images on plates would convey the fact that the women I planned to represent had been swallowed up and obscured by history. . . ."[5]

Trained in the "fine" arts, Chicago augmented her education by studying the decorative art of china painting for a year and a half. To her, the china-painting world "was a perfect metaphor for women's domesticated and trivialized circumstances."[6] Her initial plan was to create one hundred plates honoring historic female figures, "which would hang on the wall as paintings normally do."

The concept of *The Dinner Party* evolved over time. She discarded the idea of doing the hundred abstract portrait plates, and thought next about a series called Twenty-five Women Who Were Eaten Alive, symbolizing the achievements of women "who had been left out of history." Gradually she began to think about the piece "as a reinterpretation of the Last Supper from the point of view of women, who, throughout history, had prepared the meals and set the table." But in Chicago's version, "women would be the honored guests." Eventually she settled on the format of a triangular table with thirty-nine place settings, situated on a floor inscribed with the names of 999 additional women. The components of this ceremonial meal would include embroidered runners, sculpted and painted ceramic plates, flatware and chalices, napkins and cloths.

Thus the women who were in Chicago's view "swallowed up by history" were now presented as substantial nourishment for an audience hungry to learn about the past. From an anthropological point of view, collaborating with the past was, on an elemental level, akin to imbibing and consuming it. Practicing both ancestor worship and symbolic cannibalism, "collaborators" were empowered and enriched by the spirit and achievements of Chicago's dinner guests. These worthies were embodied by an abstract butterfly/vagina design on each plate. The audience response to this metaphoric imagery ranged from those who regarded it as "a grotesque embarrassment,"[7] to those who, like Dorothy Weiss Bernstein, this writer's sixty-five-year-old mother, exclaimed to the male art critic from the New York *Daily News* during the *The Dinner Party* opening at the Brooklyn Museum: "Men have been calling us cunts for centuries; don't you think it's time we glorified it?"

As an art teacher in the feminist programs at Fresno and Los Angeles in the early seventies, Chicago had encouraged her students to work together. But her own art-making life remained solitary. As the *Dinner Party* snowballed in scale and concept, she took her own advice and began to work with a variety of individuals who took charge of technical and historical research and helped execute her designs. Major assistance was provided by Susan Hill, Leonard Skuro, and Diane Gelon in the areas of embroidery, ceramics, and art history, respectively. By the time of its completion in 1979, some four hundred people had "had a hand in it," in Lucy Lippard's well-phrased description.[8]

The Dinner Party, which had taken five years to realize, is the most ambitious and widely known example of a feminist collaborative work. It was Chicago's hope that the process of its fabrication would serve as a model for "another mode of art-making for a woman artist."[9] But with the exception of performance artist Suzanne Lacy, who understood the political power of grandly scaled gestures, Chicago's example did not provide a usable template. Although photographs and text describing its manufacture and crediting the work of all hands was included whenever it was on display, some critics discounted *The Dinner*

Miriam Schapiro. *Me and Mary Cassatt.* 1976. Acrylic collage (collaboration series), 30 × 24". Private collection

The Needlework Loft, for work on *The Dinner Party* project,
the mid-1970s

Party as a collaborative effort. Writing in 1984, critic Robert C. Hobbs called Chicago "less a collaborator than an enterprising businessperson," who farms out work to technicians but "is not really allowing [the fabricators] to collaborate fully in the work."[10] Indeed, her method of working in which she maintained control of the overall design and direction of the project has more in common with artists outside the feminist community such as Christo, whose projects require legions of helpers, or Red Grooms and Mimi Gross, who assembled a band of assistants to realize *Ruckus Manhattan*. Nonetheless, Chicago's project is uniquely flavored by the emotional zeal and selfless labor of the feminist contributors, who were motivated by the heady prospect that art might effect social change.

In 1980 Judy Chicago embarked on her second major work, *The Birth Project*, which likewise was five years in the making. Working with a worldwide team of volunteer needleworkers with whom she communicated in person or by mail and phone, Chicago first "auditioned" the stitchers with trial samplers and then assigned the design, color, and thread range. The application and screening process developed by Chicago and her core team of associates tried to identify those needleworkers who could fully commit themselves to the laborious tasks. Even so, of the approximately 150 pieces of embroidery, petit point, quilting, macrame, crochet, and weaving that were begun, only 85 were completed.

Chicago provided the image, the framework, and the guid-

ance for collaborators who, in the words of embroiderer Frannie Yablonsky, regarded themselves as "creating within Judy's creation."[11] Although Chicago was sometimes frustrated by the volunteers' difficulties in translating her drawings into stitches, she was fortified by the "truly creative dialogue" that occurred "when a needleworker with highly developed skills was able to imagine how those skills could enliven my image."[12] In place of the abstract labial blossom of *The Dinner Party*, she now favored representational forms, often presenting birthing women from a midwife's vantage point. In *Creation of the World*, 1980-81, embroidered by Pamela Nesbit, Mother Earth lays back against the firmament, giving birth to herself. From her primordial birth canal flow the seas, the land, and the creatures who inhabit them. Like the ancient earth/female body analogy found in the Song of Songs, the Creator's breasts can be read as distant mountains.

Nonpatriarchal versions of creation flourished in the seventies. Thinking about the imagery contained in Michelangelo's Sistine Chapel, painter Ilise Greenstein asked: "Where was Eve in man's relationship to God? In retelling the myth from a woman's point of view I conceived the idea of the Sister Chapel."[13] Envisioned as a monument for Washington, D.C., to commemorate "women's contribution to civilization," it was to house a hall of fame, a museum, a library, and an archive for women in the arts, sciences, sports, and humanities. Greenstein first presented the project in 1974 as an idea typed on 3-by-5-inch cards in a show titled "Works in Progress" at New York's

Judy Chicago. "Creation of the World." 1980–81. 8 × 16". From the *Birth Project*, 1981–84. Embroidered by Pamela Nesbit. The Pennsylvania Academy of Fine Arts. Gift of Through the Flower Corporation

Women's Interart Center.[14] According to June Blum, Greenstein enlisted the participation of several friends, who, like herself, were members of the womens' cooperative Central Hall Gallery in Port Washington.[15] Others were political activists, either veterans of the Women in the Arts 1973 picket confrontations at various New York museums, or participants in the "Women Choose Women" show that same year at the New York Cultural Center.[16] The circle of those involved widened during the course of many meetings. Eventually, a group of eleven women, working at their own expense, each committed to create a free-standing 9-by-5-foot portrait of a real or mythic heroine of her choice. Regarding the collaborative process, Elsa Goldsmith, who chose Joan of Arc, noted in 1978 that, "As individual artists, everybody started out thinking, 'I'm going to do a painting.' Suddenly we were very much caught up in respecting each other."[17]

The actual chapel was never constructed. After an early maquette proved unworkable, in 1976 sculptor Maureen Connor constructed a tentlike scale model for a traveling version of a twelve-sided chapel.[18] Greenstein painted an eighteen foot abstract canvas in a tondo format, which she envisioned as a ceiling that would one day float above the finished chapel. With a mirror in its center, it enabled the viewer to see herself in the context of the historical and spiritual luminaries depicted on the walls. The panels and ceiling were exhibited in January 1978 at P. S. 1 in New York, at the Art

Gallery, Fine Arts Center, State University at Stony Brook, in November and December 1978, and at a Festival of Women in Syracuse in 1979.[19]

Five of the panels showed legendary figures, including Martha Edelheit's art-historical composite *Womanhero;* Cynthia Mailman's nude self-portrait as *God;* and Sylvia Sleigh's androgenous *Lilith,* her vision of the woman who preceded Eve.[20] Six artists chose earthly role models. June Blum depicted Betty Friedan as a prophet and Betty Holliday showed Marianne Moore "in the upper middle class, American spinster role within which she chose to house the radically innovative poet."[21] While working on her painting of the Mexican artist Frida Kahlo, who had withstood multiple physical challenges in her career, Shirley Gorelick herself suffered a back injury and had to paint while lying down. Alice Neel's panel of Bella Abzug is smaller than the others because the elderly artist found it difficult to work on such a large scale. Regarding her unflattering portrayal of the ardent politician, an impish and irreverent septuagenarian Neel told a reporter at the P. S. 1 opening that "the breasts I took a little liberty with, . . . it shows she would nurture the electorate. I'll bet she'll hate that face, much as I love it because it shows her energy, and I think the hat is great—it's like a cowboy—oh, I should have said cowgirl. And I like the little ankles."[22]

Collaboration proved a highly adaptable methodology. In 1977, Los Angeles-based performance artist Suzanne Lacy worked with Chinese-American actor Kathleen Chang to de-

Ilise Greenstein. "Ceiling Painting" from Sister Chapel (an environmental work by thirteen women artists). Collage tondo with mirror: diameter 18'. Installation view P. S. 1, Queens, New York, January 1, 1978.

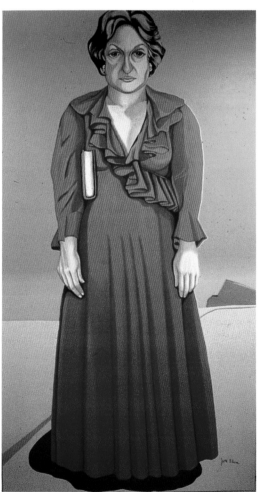

June Blum. Betty Friedan as the Prophet. 1976. Oil on canvas, 9 × 5'

velop *The Life and Times of Donaldina Cameron,* which dealt with the experience of Asian women immigrants to California. Cameron, herself an immigrant, was a nineteenth-century missionary who rescued young Chinese girls who had been enslaved and clandestinely transported to America. For more than seventy years, she agitated for political reform and fought for the legal custody and the education of those in her care.

Chang invented the fictional character Leung Ken-Sun, who was modeled after her husband's grandmother and whose voice embodied countless women at that time. Before an audience of invited guests and passersby on the ferry to and grounds of San Francisco's abandoned Angel Island Immigration Station, the performance consisted of dramatic readings and acted monologue. In the final section, the two women resumed their contemporary roles and recounted the political and emotional issues that were raised during the creation of the piece.

The collaborative projects of Lacy, a former VISTA community organizer, proved a potent and adaptive strategy for political actions that linked a small community of artists with society at large. Galvanized into action by the statistics on the prevalence of violence against women, she and artist Leslie Labowitz created Ariadne, A Social Art Network, an affiliation of women in the arts, media, government, and feminist community dedicated to creating major collaborative works on specific social issues.[23] Principal among these were Lacy's *Three Weeks in May,* 1977, which dramatized the high incidence of rape in Los Angeles (page 172); Labowitz's *Record Companies Drag Their Feet,* 1977, which brilliantly manipulated the participation of the media itself in a protest against the violent images of women on record covers and billboards (page 266); and *In Mourning and In Rage,* 1977, which they co-created as a televised ritual to express their dismay at the press coverage of the Hillside Strangler's rape-murders (page 150).

On November 18, 1978, Lacy, Labowitz, and Ariadne joined the organizers of one of the first *Take Back the Night* rallies to stage a mass ritual performance. The evening march was the culmination of a conference on feminist perspectives on pornography. Lacy briefed the marchers before their hour-long trek into the heart of the San Francisco tenderloin district, notorious for its vice and corruption. When the three thousand chanting women reached the last hill before the strip, a float appeared. Engulfed by passersby and marchers, the gaudy float inched forward, displaying a festooned madonna. As it passed, spectators peered behind the statue to discover the grotesque image of a three-headed lamb carcass, stuffed to overflowing with pornographic texts and pictures. The performance culminated when twenty black-clad women systematically destroyed the printed materials and the march moved on to its final destination accompanied by songwriter Holly Near singing "Fight Back."[24]

Lacy's decorated float and orchestrated performance harnessed the unique communal energy of the political demonstration. In her view, the public rituals she creates form a continuum with the pageants staged by turn-of-the-century women's labor and suffrage movements. Mindful that "organizers used dinners, birthday parties, and gift-giving as rituals to . . . build a sense of solidarity,"[25] she has often shaped preexisting

Installation view, Sister Chapel opening at P. S. 1, Queens, New York, January 15, 1978. From left to right: *Bella Abzug* by Alice Neel, *Superwoman* by Sharon Wybrants, *Durga (Hindu Goddess)* by Diana Kurz. Acrylic on canvas, each panel 9 × 15′. Photograph by Maurice Blum

Suzanne Lacy and Kathleen Chang. *The Life and Times of Donaldina Cameron.* Performance, San Francisco, 1977. Photograph by Rob Blalack

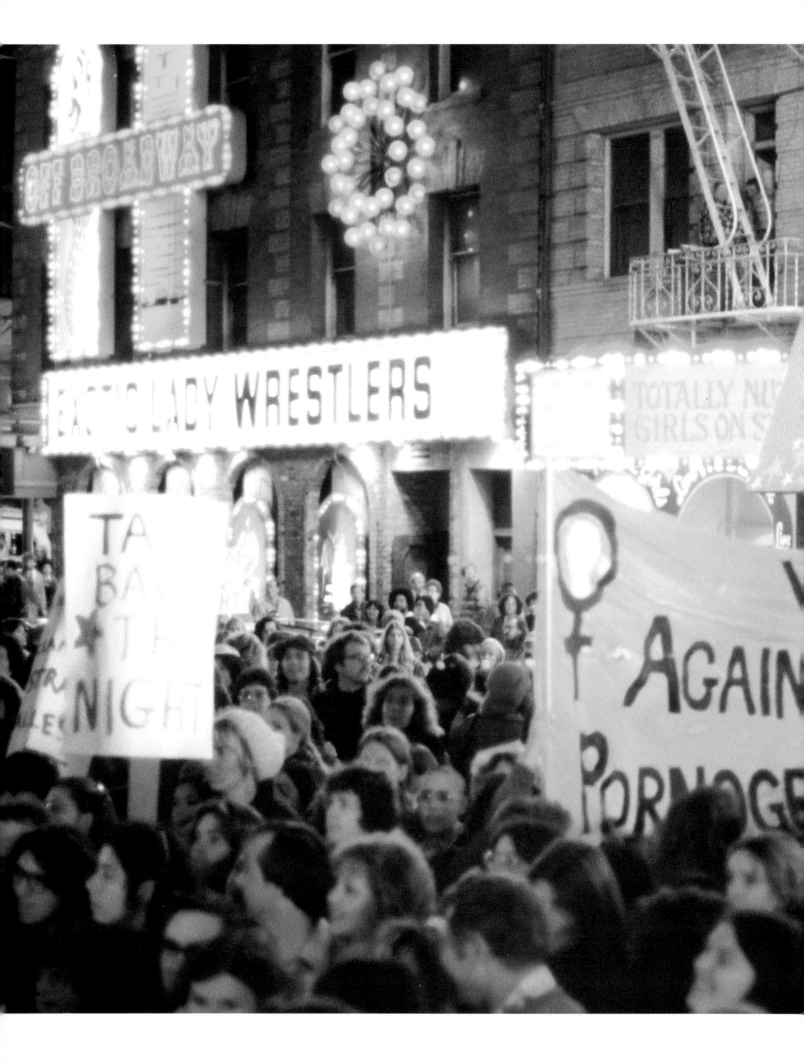

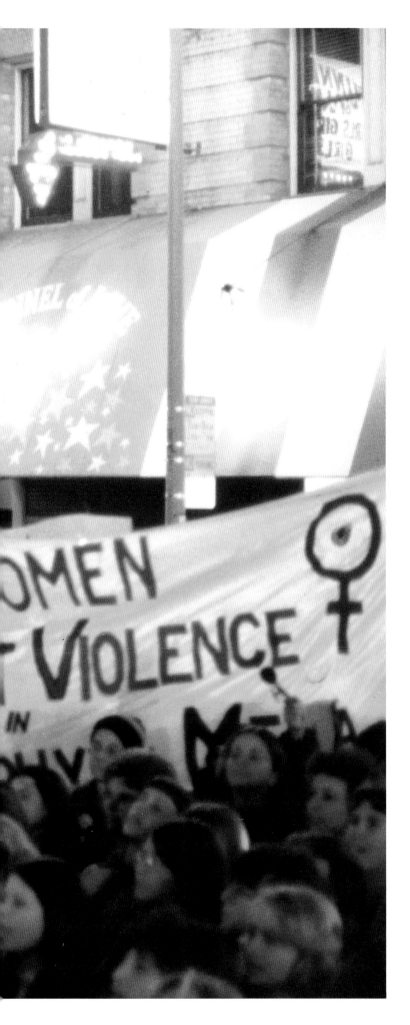

women's networks into feminist art forms. For example, on March 14, 1979, she set in motion "The International Dinner Party" event to mark the opening of Judy Chicago's *Dinner Party*.[26] Over two thousand women worldwide dined together in various-sized groups to honor women of their choice.

Lacy went on to mine the informal collaborative tradition of the potluck dinner, which Lucy Lippard has insightfully described as "a classically feminist collage [bringing] together a highly disparate group of women and their culinary 'offerings.'"[27] In 1980, the Women's Caucus for Art was obliged to hold its annual convention in New Orleans, in a state that had not ratified the Equal Rights Amendment. Lacy was invited by conference organizers to participate in the planning process, and collectively they staged the entire five-day event as an "expanded performance." As a symbolic protest, they stayed in private homes and boycotted restaurants. The conference opened with a potluck meal that brought together five hundred ethnically diverse women to celebrate their southern heroines. Lacy choreographed this and other communal dinners as performances that succeeded in raising the political consciousness of the local women's community.[28] She also involved local artists in a variety of events and strategized an ERA media campaign.

Into the eighties, Lacy addressed issues of aging in two performances in which she adapted the meal format and the social exchange it generated. *Whisper, The Waves, the Wind*, performed on May 19, 1984, took place on two adjacent beach coves in the retirement and resort community of La Jolla, California.[29] Accompanied by Susan Stone's taped sound score, approximately 160 white-clad women between the ages of 65 and 100 arrived in a slow processional and seated themselves at 40 card tables covered with white cloths. Their prerecorded conversations, played to an audience on the cliffs above, dealt with such topics as appearance, sexuality, physical problems, freedom, nursing homes, and death. The performance concluded as the audience, on cue, came down to the beach to converse with the seated women.

Three years later Lacy revisited this form and content in *The Crystal Quilt*, performed by more than four hundred older women in the Crystal Court of the IDS Building, a Philip Johnson-designed commercial edifice in downtown Minneapolis.[30] As four black-costumed women in each group were seated at a table, they folded back its black cover, revealing red or yellow cloths. Viewed from the balconies, the pattern of the colored squares—designed by Miriam Schapiro—took the form of an enormous quilt (pages 238–39). Accompanied by an audiotape that joined Minnesota nature sounds with excerpts of conversation, they silently enacted choreographed hand motions that added a shifting plane of pattern to the quilt as seen from above. Susan Stone's soundtrack concluded with Minnesota's octogenarian social activist Meridel LeSueur proclaiming "I'm not aging, I'm ripening." In all, a pool of fifteen hundred volunteers worked together over a period of two and one half years to realize the performance on Mother's Day, May 10, 1987. For

Leslie Labowitz and Suzanne Lacy. *Take Back the Night.*
Street performance/demonstration, San Francisco, November 1978

Harmony Hammond and Bob Douglas. *Fan Lady Meets Ruffled Waters.* 1983. Cotton quilt, 75 × 90″. Collection Philip Morris Companies, Inc.

Faith Ringgold and Willi Posey. *Echoes of Harlem.* 1980. Dyed, painted, and pieced fabric, 96 × 84″. Collection Philip Morris Companies, Inc.

Lacy's lay performers, *The Crystal Quilt* was a transformative and empowering experience.

The craft of quilt making was subject to a revival in the early seventies as a concomitant of the general renewal of interest in Americana and as an early feminist model of communal women's work.[31] The Artist and the Quilt, a collaborative enterprise that matched women in the visual arts and needlework, was spearheaded by Washington D.C.-based artist Charlotte Robinson. Following her attendance at the first national "Conference of Women in the Visual Arts" held at the Corcoran Museum of Art in 1972, Robinson determined to integrate feminism into her art—"A door I had never thought of opened. I got up and walked through."[32] Subsequently, she and artists Dorothy Gillespie and Alice Baber decided to ask women artists to design quilts as a way of celebrating the year 1975, designated as the International Year of the Woman by the United Nations. In so doing, they intended to assail the barriers between the fine and decorative arts, as well as "acknowledg[e] the chain connecting contemporary women with generations of their mothers. . . ."[33]

The process of piecing together their lofty project took seven years. Using a miniature prototype quilted by Bonnie Persinger as bait, they gradually enlisted the support of fabricators and funders, spurred by a small grant from the National Endowment for the Arts in 1978. In all, eighteen designs were executed in large scale by sixteen needleworkers. While Isabel Bishop, Miriam Schapiro, Joyce Kozloff, and Faith Ringgold created colorful compositions in homage to the quilt's traditional grid, Marilyn Lanfear collaborated with her needleworker daughter Teresa Helms to create an elegant monochrome design that permitted the overstitching to convey the principal pattern. A central row of tiny wedding dress buttons unevenly fastens together the two sides of Lanfear's quilt, a fact which the artist views as symbolic of the imperfect union of matrimony and her own typically fragmented female life. Ellen Lanyon's quilt wittily referred to the construction process of patching and layering by appliquing unpieced swatches held by a hand. For her quilt design, Harmony Hammond transposed two whimsical feminist personages from her painted canvases, describing a flirtatious encounter between the voluble Ruffled Waters and Fan Lady, whose oval body resembles a rag rug.

For artists and the general public alike, feminism stimulated a fresh regard for women's traditional crafts; thousands of individuals outside the art world used these populist traditions to dramatize the need for social change. If the antiwar movement of the sixties had spawned agitprop tactics and street theater, so too did feminism inspire political activists to craft artful public demonstrations. The Women's Pentagon Action, staged on November 17, 1980, was initiated by an informal group of New England women who had attended a conference at the University of Massachusetts called "Women and Life on Earth: Ecofeminism in the Eighties." Fired by the need to protest ecological destruction and the subjugation of women, they staged a theatrical event at the Pentagon following the November election of Ronald Reagan as president. Some had participated in Peter Shumann's Bread and Puppet Circus in Vermont, which used giant puppets to great dramatic effect.

On the appointed day, approximately two thousand women participated. Of the many temporary gravestones they created for women victims of militarism, one read "For the three Vietnamese Women My Son Killed." The appearance of a white puppet called Defiance triggered the formation of a circle around the Pentagon, joining demonstrators and links of fabric called "women extenders" to protest the American war machinery. Although writer Grace Paley was singled out to read a unity statement of their concerns, it was a communal event with no designated leader.[34] Five years later, the unrelated "Ribbon Project," initiated by peace activist Justine Merritt, encircled the Pentagon with nearly 20,000 hand-sewn panels.[35]

Justine Merritt enjoyed the pun in describing her antiwar sewing project as "peacework." So too did artist and social activist Helene Aylon, who in 1981 orchestrated a collaborative performance in the Middle East using Arab and Israeli women, who manipulated stone-filled sacs in symbolic efforts for unity. For *Terrestri: Rescued Earth*, 1982, Aylon gathered earth from the twelve Strategic Air Command weapons sites in the U.S. Volunteers donated eight hundred pillowcases on which they wrote their concerns for the planet's future, which were then filled with S.A.C. soil and brought to the United Nations in an "Earth Ambulance." Emptied, they were hung on a "clothesline" that spanned 47th Street, and the diverse earth samples were exhibited in transparent boxes.

There are many examples of communal undertakings rooted in the traditions of women's work. *The NAMES Project AIDS Memorial Quilt* is an ongoing project using the metaphor of the nineteenth-century mourning quilt, which was pieced from the clothing of a friend or relative by bereaved stitchers. It was conceived in November 1985 by San Francisco gay rights activist Cleve Jones while he was watching marchers arrange placards with the names of over one thousand San Franciscans who had died of AIDS. Inspired to create a more permanent memorial, a year later Jones created the quilt's first fabric panel, which like the larger project, was dedicated to his friend Marvin Feldman. The NAMES Project galvanized support and contributors—people all across America sent panels to the California workshop in memory of their friends and loved ones. Composed of 1,920 three-by-six-foot panels, the quilt was displayed for the first time on October 11, 1987, as part of a national gay and lesbian rights march. Six years later it encompassed 25,246 memorial sections, contributed by people in twenty-nine countries. By personalizing the devastation of the AIDS pandemic, the ongoing NAMES Project has proved a potent force for education, fund raising, and communal healing.[36]

Feminist artists found many collaborative models in the domestic arena—sometimes even in their own families. Thus it was with a special sense of coming home that in the early seventies artist Faith Ringgold switched her painting surfaces from taut canvases to soft fabrics, and began collaborating with her mother, Willi Posey, a fashion designer and dressmaker. Before Posey's death in 1981, the two worked together on collage paintings framed by cloth tangas, which Ringgold adapted from the tradition of Oriental prayer hangings. Other collaborative endeavors were quilts and dolls. For example, Ringgold made a series of African-inspired masks—beaded, fringed, and embroi-

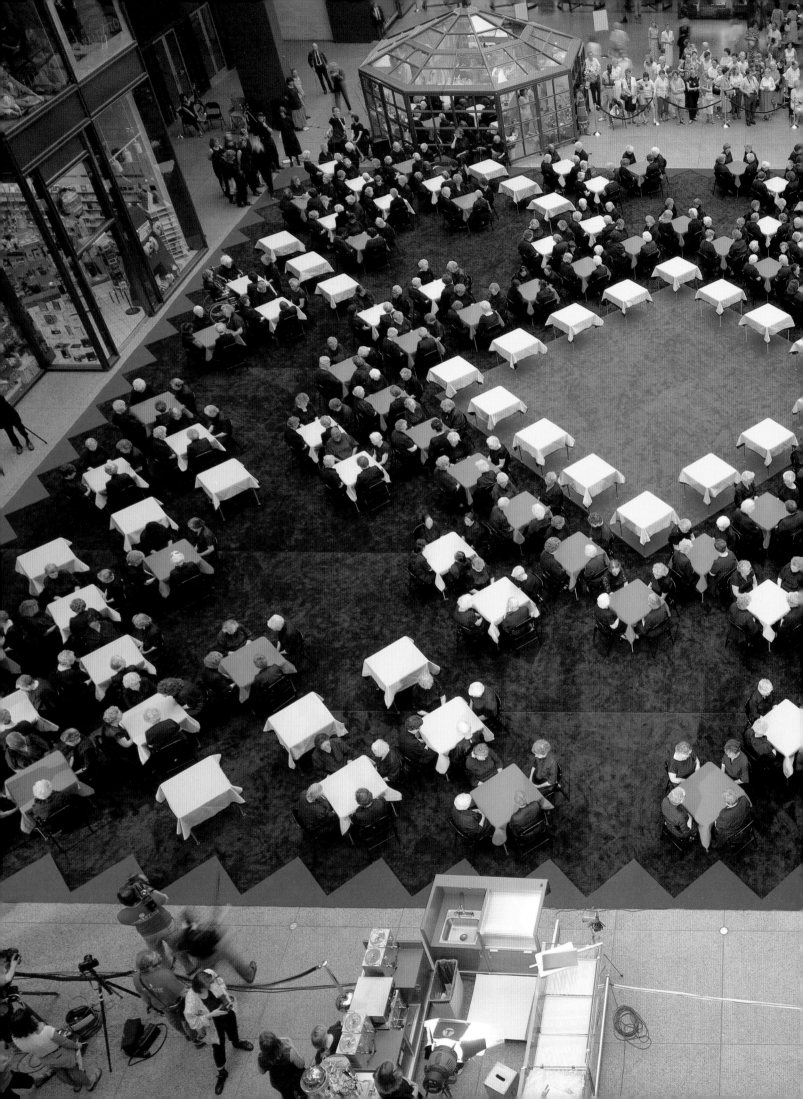

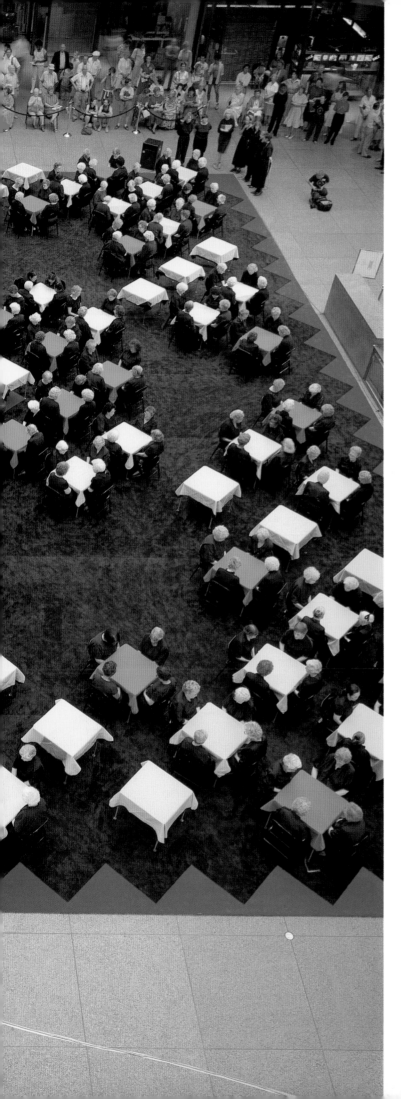

Cleve Jones (originator). *The NAMES Project AIDS Memorial Quilt* (two views). 1985–present. Fabric, each panel, 3×6'. Photograph by Marcel Miranda III. Courtesy The NAMES Project Foundation, San Francisco

The Crystal Quilt. Performance by Suzanne Lacy in collaboration with 430 women, in Philip Johnson-designed IDS Building, Minneapolis, 1987. Photograph by Ann Marsden

Judith Baca (collaborative work).
Uprising of the Mujeres (detail). 1979.
Portable mural, acrylic on wood
panels, 96 × 24″. Courtesy SPARC,
Venice, California

Las Mujeres Muralistas (Patricia Rodríguez, Graciela Carrillo,
Consuelo Mendez, and Irene Perez). *LatinoAmérica*, also known
as *Pan America*. 1974. Mural, approx. 25 × 70′. Mission Street
between 25th and 26th Streets, Mission District, San Francisco

dered portraits of women and children acquaintances—for which Posey fashioned bodies and clothes. Their final joint undertaking was a quilt entitled *Echoes of Harlem*, for The Artist and the Quilt series:

The quilt was our great work together. We had great gossip! We didn't do any kitchen-talking, we did working-talking. . . . I couldn't have done it alone. I needed my mother. And she would never have collaborated with anyone else.[37]

Baltimore-based Joyce Scott, whose mother, Elizabeth Scott, is an acclaimed quilter, grew up doing what she good-humoredly refers to as "house stuff," or joint projects with her mother. To Joyce Scott, collaboration was a way "to get a project done without having to know how to do everything."[38] An artist whose interdisciplinary training ranged from Japanese traditional and contemporary theater, Navajo rug weaving, and an undergraduate degree at the Maryland Institute College of Art, Scott came to aesthetic consciousness in the late sixties, nurtured by the freewheeling energies of street theater and the burgeoning crafts revival. An African-American, Scott also credits improvisational jazz—in which individual performers share "a layer of trust" with each other—as an influence on her interest in collaboration. For example, in *Bad Mamma Jamma*, 1982, a multi-media fashion performance, and the *Thunder Thigh Revue*, 1986, in which she teamed up with actress Kay Lawal, Scott used a seriocomic approach to address issues of race and body image. In the description of Lowery Stokes Sims, the Revue is about "the pain and passion of being the 'other,' an overweight black woman in this society."[39]

For "hyphenated" feminists—African-American, Asian-American, and Mexican-American, for example—issues of gender go hand in hand with questions of race and cultural identity. The Chicano movement, founded in the mid-sixties, offered a fresh opportunity for self-affirmation to male and female artists of Mexican-American descent. As Amalia Mesa-Bains has described it, the movement "was a collective action toward cultural, political, social, economic, or educational change."[40] In their search for models of style and content, Chicano artists turned to the earlier twentieth-century Mexican mural movement, which passionately espoused the cause of social justice. The Mexican murals were normally worked on by teams under the direction of one individual. Embodying a collectivist philosophy, the Chicano mural movement provided new collaborative models by utilizing "many cooks" on a given project, and by including untrained community participants.[41]

Los Angeles, the city with the largest Mexican population in the United States, was the site of greatest Chicano mural activity. Women were an active presence in the mural movement, bringing a "gender perspective to the issues of identity and community."[42] One such pivotal artist-organizer is the painter Judith F. Baca, a native Angelena. As a new college graduate and artist-in-residence in the East L.A. barrio in 1970, Baca persuaded teenaged girls and boys from different gangs to work together on a Hollenbeck Park mural. She found that her gender was an asset: "I was no threat to their machismo. Had I been a man, they would have been suspicious of my presence in their territory."[43] Working with young women proved more difficult: "Girls were not allowed the same mobility. . . . Latin women are not supposed to be doing things like climbing on a scaffold, being in the public eye."[44]

Baca is best known for designing the monumental Great Wall of Los Angeles, a half-mile-long mural on the history of California, accomplished by the efforts of 40 ethnic scholars, 450 multicultural neighborhood youth, 40 assisting artists, and over 100 support staff. The longest mural in the world, it was painted on the concrete walls of Studio City's Tujunga Wash flood control channels during five summers between 1976 and 1983. Subjects include women's suffrage, the development of Hollywood, the Depression, the Zoot Suit riots, and the Japanese internment camps.

Social and feminist concerns have informed Baca's process: "Rage at injustice or at the spiritual disharmony with the earth, with what is female is a starting point. . . ."[45] Baca explored the theme of women's protests against the defense industry in a portable mural, *Uprising of the Mujeres*, 1979, which was first displayed as part of a public demonstration against the development of nuclear plants. The image derived from her experience as the sole woman in a class on mural painting in Mexico's Taller Siqueiros in 1977:

[The male students] had decided that they wanted to do something about women's issues and then . . . proceeded to do an image of a woman spread-eagled with a funnel in her mouth . . . [to represent] how women were fed all this consumerism and were buyers of everything. Yet this was a giant rape image that they used. I started the Uprising *as a counter to that— [the image was] a fierce Indian . . . they could never get a funnel into this girl's mouth.*[46]

The artists known as Mujeres Muralistas, Spanish for women muralists—a San Francisco collective founded by the Guatemalan Irene Perez, the Venezuelan Consuelo Mendez, and the Chicanas Graciela Carrillo and Patricia Rodríguez—became friends in the early seventies when they were students at the San Francisco Art Institute. Carrillo and Rodríguez had been involved in the Mission Community in mural projects but felt that as women they had not been given credit for their work. As Rodríguez has reflected,

It was sort of like "the good woman behind the good man." We were already in competition with the men. We were looking for avenues and we saw an opportunity. One night Graciela and I started thinking about a mural. The next day we went out and recruited materials. We got scaffolding, primer, paint. . . . It was very experimental because two people were using one canvas. We managed to pull it off very well. . . .[47]

In 1974, the four women tackled an enormous wall at the Mission Model Neighborhood Corporation parking lot. The image was called *Pan America*. To Rodríguez,

It was a wonderful process. We had to brainstorm for three months to figure out how to break up the space with four peo-

Mierle Laderman Ukeles. *Touch Sanitation.* 1979–81. New York City–wide performance in all 59 community districts, with 8,500 NYC sanitation workers. Photograph by Marcia Bricker. Courtesy Ronald Feldman Fine Arts, New York

ple working together on one wall. We had some ideals that went along with it: there was no real leader; we were working collectively. I think the reason why we were such a dynamic group is because we had no leader.

Ester Hernández, who joined Mujeres Muralistas to work on *Pan America*, had commented on the mural as a process of empowerment: "Doing a wall that was so visible—that was public—was probably one of the best ways to make a statement in terms of women gathering together and saying 'Yeah, we can do it!'"[48] Although the group was short-lived, working together from 1973 to 1979, in art historian Shifra Goldman's view it proved a "seminal" example for women artists throughout the state.[49]

Juana Alicia had come to California from Detroit in 1970. During the five years between 1982 and 1987 she worked alone and in teams to create twelve murals on the themes of labor, cultural history, and women and children.[50] Texas-born Susan Kelk Cervantes, who has painted one hundred murals in her twenty-two-year career, is the founder and director of Precita Eyes Mural Art Center. Between 1988 and 1990, Alicia and Cervantes collaborated on a mural project about international literacy and intercultural understanding for the Cesar Chavez School, a public facility formerly called the Hawthorne School, located in San Francisco's multiculturally diverse Mission District.

Mural painting was just one of the forms of public art that flourished in the seventies and the eighties. Following the city of Philadelphia's first Percent for Art resolution in 1959, in the ensuing decades many American municipalities adapted similar measures to ensure that art was a component of new urban con-

struction. The jurying process for these commissions was often more equitable than the workings of the larger art world, and as a result women artists became an active presence in the sphere of public art. Such diverse talents as Mary Miss, Jody Pinto, Joyce Kozloff, Nancy Holt, Patricia Johanson, Betye Saar, Andrea Blum, Elyn Zimmerman, Jackie Ferrara, Patsy Norvell, Alexis Smith, Michelle Stuart, Agnes Denes, Valerie Jaudon, Lauren Ewing, Athena Tacha, Beverly Pepper, Howardena Pindell, Ann Sperry, Alice Adams, Nancy Graves, Judy Pfaff, and Kit-Yin Snyder have made major contributions in the arena of public art. Layers of collaboration are inherent in the process of creating art for public sites. For example, artists may be asked to form a design team, working with engineers, architects, and landscape architects. In the later stages of a given project, most artists work integrally with contractors, riggers, and foundry personnel.

In the seventies, artists such as Mary Miss and Jody Pinto sited their work in the public domain without waiting for an invitation, utilizing a found setting that was outside the gallery system. Unbidden, in 1973 Miss created an untitled wood sculpture in a wintry urban landfill along the Hudson River in Manhattan. In 1975, Pinto excavated a series of abandoned wells in a barren "waste space" bordering Philadelphia's I-95 highway, then under construction. These were public works in that they were located out-of-doors, available to anyone who chanced upon them.

But the more usual understanding of public art implies a commissioned work. Perhaps the best-known example is the 1982 Vietnam Veterans Memorial in Washington, D.C., by Maya Ying Lin. Her winning proposal was chosen on its merits by a blind jury from a group of 1,421 final entries. The twenty-one-

year-old Lin, then an undergraduate architecture major at Yale University, fulfilled the design requirements to provide a place for reflection, free of political sentiments, located within a significant setting. Lin's solution, sited on the Mall between the Washington Monument and the Lincoln Memorial, used two triangular wedges of seventy polished granite panels each, which angle downward. Viewers walk through it by gradually stepping below the surface grade and then regaining ground level. A chronologically ordered list of the names of 58,007 men and women who died in the Vietnam War between 1959 and 1975 is inscribed on the wall.

The highly reflective surface acts as a mirror, literally permitting each viewer to see her or himself in relation to the roster of loss. Furthermore, as Shirley Neilsen Blum has suggested, "for those friends and relatives of the dead, the Wall performs a liturgical purpose: the slab with the beloved name becomes the altar before which an offering is made."[51] Such is the connecting bond engendered by Lin's Memorial that visitors annually leave thousands of offerings of photographs, letters, and memorabilia that are reverently collected and stored in off-site warehouses. A selection of these is documented in Laura Palmer's book, *Shrapnel in the Heart*.

Do women and/or feminist artists conceive of public art differently than their male counterparts? Writing in 1978 about such artists as Alice Aycock, Mary Miss, Michelle Stuart, and Nancy Holt who work with the landscape, art critic April Kingsley argued that as women, their art reflected a unique "intent and content."[52] Tellingly, Kingsley's characterization of their environmental projects as "private places made for interiorizing values and universal experiences," and exemplifying a "rapport with their site and their materials, rather than a victory over them," provides an excellent description, *avant le lettre*, of Lin's Memorial. When Lin herself was asked in 1983 if her work had a female sensibility, she responded:

> In a world of phallic memorials that rise upwards, it certainly does. I didn't set out to conquer the earth, or overpower it, the way Western man usually does. I don't think I've made a passive piece, but neither is it a memorial to the idea of war.[53]

To identify a distinct intent and content in the art of women who work in the overlapping genres of earth art, environmental art, and public art is not to suggest such art results from "essential" differences between the sexes. One variable of artistic style is lived experience, and the socialization process for men and women differs widely. When, in 1983, artist Barbara Kruger alluded to society's correlation between women and nature by proclaiming, "We won't play nature to your culture," she was rejecting woman's patriarchically assigned, subsidiary role. From an ecofeminist perspective, the oppression of women and the abuse of the environment are issues inextricably linked. As ecofeminist theorist Ynestra King has suggested, "The domination of nature originates in society and therefore must be resolved in society. . . . And there is no point in liberating people if the planet cannot sustain their liberated lives. . . ."[54]

In 1969 the artist Mierle Laderman Ukeles had an epiphany. She realized that as an artist, a woman, a wife, and a

Betsy Damon. *A Memory of Clean Water.* 1985–86. Casting of a dry riverbed along Castle Creek, Castle Valley, Utah. Photograph by Pat Switzer. Courtesy of artist

Maya Lin. *Vietnam Veterans Memorial.* 1982. Black granite. The
Mall, Washington, D.C. Photograph by Judy Scott Feldman

mother, she did "a hell of a lot of washing, cleaning, cooking, renewing, supporting, preserving. . . ."[55] These "maintenance everyday things," as she called them, were taking her away from making art. She saw that "culture confers lousy status on maintenance." But, she reasoned, if "everything I say is Art is Art," then she could confer art status on maintenance. Voilà: "My working will be the work." Like the performance artist Pat "I am therefore I art" Oleszko, who embodied a playful version of the body art genre of the seventies, Ukeles was a feminist pioneer who used witty and audacious proposals to jolt and raise our collective consciousness. In a subsequent "maintenance art" event entitled "The Trees Are Having Their Period: Time Slice," staged at Vassar College in the fall of 1974, she poked fun at the woman/nature correlation by draping a fifty-foot sanitary napkin under a one hundred-year-old tree, and then encircling the geriatric wonder with incantations to its "weeping womb."

As the unsalaried artist-in-residence for New York City's Department of Sanitation (DOS), Ukeles is perhaps best known for the project she initiated in 1978 called *Touch Sanitation,* in which she shook hands with and personally thanked all 8,500 workers: "I hope that my handshakes will eventually burn an image into the public's mind that every time they throw something out, human hands have to take it away."[56] Ukeles's subsequent tribute to the human dimension of urban life was the freestanding sculpture, *Ceremonial Arch Honoring Service Workers in the New Service Economy,* 1988, composed of thousands of used work gloves, subway straps, walkie-talkies, and fire hoses. In 1983 she designed the multimedia installation *Flow City,* for the DOS Marine Transfer Station on the Hudson River. Working in collaboration with DOS architects and engineers to upgrade a decrepit facility, she envisioned a "museum of the environment," in her description, which *Garbage* magazine authoritatively calls "the first disposal system in the U.S. designed for public viewing."[57] Ukeles planned a passage ramp composed of recycled waste materials and a glass observation bridge which would permit visitors to view the dumping operations that daily handle 24,000 tons of garbage. "After seeing this, you'll never be able to say your garbage doesn't matter,"[58] the artist has said.

In the late seventies and eighties, artist Betsy Damon did street performances about community, women, and rituals, using such personas as the "Seven-thousand-year-old woman" or "the blind beggarwoman." In the nineties, she still creates occasional performances, but they are now fueled by a passionate concern about water quality:

My work always is about archetypal images and communicating with a community. In my street performances about water, I seek to bring together people who might never come together. Artists must work with different sectors of society, we must collaborate with scientists, politicians, businesspeople — everyone. . . .[59]

As the initiator of Humphrey Institute's Keepers of the Waters: Citizens' Rights and Responsibilities project, Damon is currently working on new models of collaboration with community partners who share her interest in clean water. For example, a scientist in Duluth, Minnesota, has researched the damaging effects of water-borne pollutants on fish. Damon works with a pollution control agency and assists artists and scientists to create innovative educational and artistic projects based on these cases.

Damon is best-known for the ambitious project *A Memory of Clean Water,* 1988, a two-hundred-and-fifty-foot paper casting of a dry riverbed along Castle Creek, Castle Valley, Utah. Creating the mold on site using paper pulp made from both commercial flax and the fibrous plants at hand, Damon and a crew of twelve associates pigmented it with red- , blue- , and green-colored clays found in the area. When the resulting cast was gently pried from the creek bed, its swirls and configurations uncannily embodied the water that once flowed in the valley. Its richly textured surface was embedded with such natural flotsam as animal bones, feathers, mica slivers, and pebbles. Damon is an artist who strongly believes that "the future of art lies in acknowledging the connection between public issues, public spaces and aesthetic forms."[60]

At a distance of two decades, many of the feminist collaborations of the seventies radiate with an intensely idealistic glow. It was a time of wildly improbable projects, undertaken with the irrepressible and contagious spirit that Judy Garland and Mickey Rooney exhibited in forties movies when they goaded their chums on to mount full-scale theatrical extravaganzas by remarking "Hey, kids, we've got a barn. Let's put on a show." Fueled by their indignation at being excluded from the mainstream art world, enterprising women used the materials at hand to develop new forms and political content. In the process, they subverted the myth of isolated genius. Some commandeered the means of women's traditional group activities, adapting them for feminist ends. Others pooled their talents to divine new visual schemes to celebrate the history of female achievements. For artists who were part of a minority culture, collaborative projects helped reinforce community bonds.

The feminists of the seventies were sparked by the women's movement's intuition that "the personal is the political." Later, some artists would take to heart the admonition of ecologists to "think globally, act locally." But regardless of their generation, all feminists shared an often unspoken belief in what Muriel Rukeyser had articulated as the revolutionary power of women's truth telling.

Surveillance
is their busywork

THE IMPACT OF FEMINIST ART

BACKLASH AND APPROPRIATION

BY MIRA SCHOR

One of the major lessons of the feminist revision of the discipline of art history is the degree to which what had been put forth as an objective canon is in reality subjective and personal, riven with the prejudices and idiosyncracies of individual art historians. For any art writer, developments in art history are crystallized in particular art works and events. This essay on the backlash in the 1980s against 1970s feminist art is organized around a painting, a panel discussion, and two sculptures, each of which made me aware of significant ideological shifts in the status of feminism in art: David Salle's painting *Autopsy*, 1981, exhibited at the Leo Castelli Gallery, New York, in 1982; "The Great Goddess Debate" held at the New Museum of Contemporary Art, New York, in 1987; and the exhibition in May 1992 of Sue Williams's sculpture *Irresistible*, 1992, and Kiki Smith's *Tale*, 1992.

At the right side of David Salle's *Autopsy* is a black-and-white photo of a naked woman sitting cross-legged, sad and stiff, on a rumpled bed, a dunce cap on her head and smaller ones on her breasts. This pathetic image of a woman being punished is juxtaposed with a larger generic modernist abstraction of blue, black, and white blocks. The difference in the scale of the segments reveals the underlying hierarchy of the work: not only does the history of modernism dominate, it is a tool in the oppression of degraded femininity.

The visual organization of this piece is standard in the works of David Salle: a woman in a sexually humiliated or violated state, usually naked, bending over, baring her ass or vulva, on the floor, spread-eagled, headless, is rendered in a dry brush grisaille and overlain by colorful, painterly, and sculptural quotations from the history of art or popular culture.

Challenged to explain the meaning of his depiction of women, Salle stated tersely that it was about "irony." Indeed his work has been hailed as acutely representative of a postmodern relativism. Seen as the most important exponent of appropriation art, his work spoke to the "uncertain status of imagery, the problems of representation that infect every art."[1] That Salle only abused the female nude, never the male nude, thereby confirming the status of at least one image, has been irrelevant to the discourse that has supported his work. In a signal essay of the early 80s, "Last Exit: Painting," Thomas Lawson offered an analysis of the decadence of modernism as an adversarial force within bourgeois culture. He concluded that although photo-media works constitute a useful site for the subversion of received ideas about art and culture because "the photograph *is* the modern world," painting, perhaps paradoxically, is "that last refuge of the mythology of individuality, which can be seized to deconstruct the illusions of the present. For since painting is intimately concerned with illusion, what better vehicle for subversion?" Lawson fixed on Salle as one of the hopes for the survival of painting, painting being the last "exit" before the despair of "an age of skepticism" in which "the practice of art is inevitably crippled by suspension of belief."[2] At this last exit, painting is only a strategic device. Lawson does not admit that by relying on misogyny for his basic vocabulary, Salle returns to an unsubversive position.

Autopsy indicated a major shift in art values, away from the utopianism of modernism and feminism as well as from the

David Salle. *Autopsy.* 1981. Oil, acrylic on canvas, photo-sensitive linen, 48 × 112″. Courtesy Leo Castelli Gallery, New York

"what you see is what you see"[3] rough morality and honesty of minimalism, post-minimalism, and process art of the 70s. The relativistic nihilism of appropriation and simulation art was influenced and buttressed by the writings of such French philosophers and critics as Roland Barthes, Jean Baudrillard, and Jacques Derrida. Since identity was a destabilized concept, political action from an identity position such as "woman" was impossible. Belief in any meaning for an image in this age of mechanical reproduction was dismissed as naive so that Salle's painting attacked not only woman but also idealism of any kind.

Whatever its personal psychological origins, Salle's misogyny may be considered in the context of the radical avant-garde feminism to which he was exposed while a student at the California Institute of the Arts in the early 70s. The Feminist Art Program at CalArts was a unique and ground-breaking educational experiment, which aimed at channeling reconsidered personal experience into subject matter for art. Sexuality as content often found its way into figuration and forced its way back onto the picture plane which had been vacated of any such extra-aesthetic elements by the Greenbergian formalism that had for years been the dominant art ideology. Analysis and quotes (i.e., "appropriation") of mass-media representations of women influenced work by students in the program. "Layering"—a technique favored by Salle—was a buzzword of radical feminist art as a basic metaphor for female sexuality. The Feminist Art Program received national attention and was the subject of excitement, envy, and curiosity at CalArts. Even students, male and female, who were hostile to the Program, could not ignore its existence or remain unchallenged by its aims. So perhaps

Salle's work was an act of gender revenge, conscious or unconscious, perhaps against the loss of total centrality which by all rights a talented young male artist might feel entitled to and would have enjoyed in any other art school. It was also a political strategy that fed on the culture-wide backlash against feminism, documented in Susan Faludi's 1991 bestseller *Backlash*, which marked the Reagan/Bush era and which continues to this day.

Salle was arguably the most written-about artist of the early 1980s, and critics consistently fell all over themselves to defend his work against charges of pornography, while never addressing the issue of misogyny. Of *Autopsy*, Donald Kuspit wrote that "to put dunce caps of the breasts as well as the head of a woman, and to paint her with a mechanically rendered pattern . . . is to stimulate, not critically provoke—to muse, not reveal."[4] Carter Ratcliff concluded that Salle's images "are not exactly pornographic. He brings some of his nudes to the verge of gynecological objectivity," and that he is "like a self-conscious pornographer, one capable of embarrassment." More significantly, Ratcliff noted that "to see his paintings is to *empathize with his intentions*, which is to deploy images in configurations that *permit them to be possessed*"[5] [my emphasis]. It is crucial to emphasize that this form of possession implies a male spectator and is condoned by the male critic. But even women commentators, such as Sherrie Levine, offered elaborate excuses for Salle's "*almost*" pornography or misogyny.[6]

In an effort to give art-historical validation to works by Salle and others, forgotten artists were resurrected, and discredited bodies of work by artists better known for less gender-

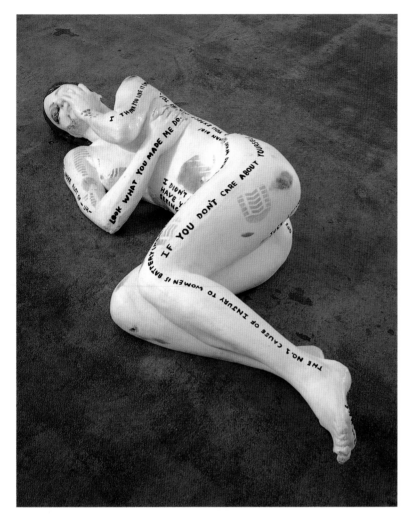

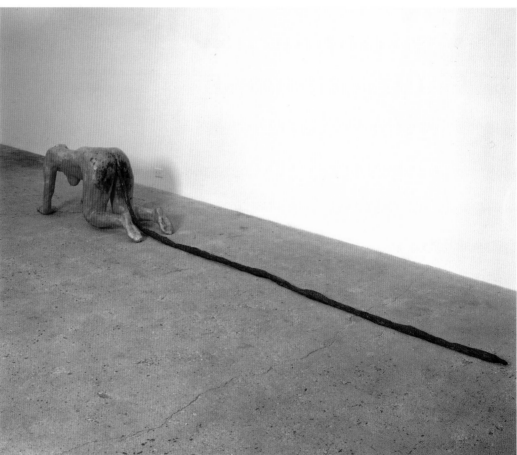

Sue Williams. *Irresistible.* 1992. Rubber, 12 × 57 × 24″.
Courtesy 303 Gallery, New York

Kiki Smith. *Tale.* 1992. Wax, pigment,
papier-mâché, 160 × 23 × 23″. Courtesy
Fawbush Gallery, New York

inflected contributions to modernism were reevaluated. Thus kitschy late works by Francis Picabia that employed similar techniques to Salle's of visual overlays and that depicted pornographic or erotic scenes were now exhibited, whereas previously they had been excluded from the modernist canon.[7] Late-nineteenth-century French artists, such as William Bouguereau, given to academically rendered effulgences of idealized female flesh, who had been blown off the face of the history of high art, enjoyed a flutter of renewed interest and increased auction value.

Salle's gender politics and his critical and financial success epitomized a system of art practices and theories that dominated the 80s. But he was certainly not alone. Eric Fischl, whose reputation was based on the sexual narratives of his paintings, was also a huge critical and financial success. Like Salle, he had been a student at CalArts the first year of the Feminist Art Program and his work can be seen as chronologically, and to some extent conceptually, indebted to issues raised by the feminist movement and to the permissions it gave for representations of sexuality and vulnerability. His representations of women were far more nuanced than Salle's and, notably, he confronted male sexuality through frank depictions of the male body. However, many works veered toward the exploitative, while insuring his fame. *Bad Boy*, 1981, was such a career-making painting: in it a naked woman displays her sex to her young son who is reaching into her purse, a traditional symbol of female genitalia. He steals money and a peek, while equally symbolic bananas and apples battle it out in a foregrounded still-life detail. Descriptions and reactions to this painting by such critics as Peter Schjeldahl and John Yau were, in a familiar pattern of critical reception, complicitous with the sexual politics and viewer position of the painting. Yau writes: "These tiger stripes of light and dark convey the woman's animalistic powers, her caged sexual ferociousness. An incredible delineation of her being is conveyed by painterly means. . . . *Bad Boy*, like many of Fischl's other paintings, is not the projection of a desire so much as the acute registration of a potential embarrassment."[8]

In other paintings of nude people, Fischl's disposition of available female flesh seemed to pander to traditional male eroticism and voyeurism. *Untitled*, 1982, shows Fischl in an overtly, gratuitously prurient mode. Two naked women in a room produce the intimation of lesbianism, a favorite theme of heterosexual male fantasy. The woman on the bed is posed awkwardly, as if for the sole purpose of grotesquely enlarging her buttocks and exposing her vulva to the artist and the viewer. Note how Fischl imagines himself in his 1984 *Portrait of the Artist as an Old Man*: before his (blank) canvas, near a field shaded by a late afternoon sun, he faces the viewer but his eyes are hidden by dark glasses and his hand reaches beneath a folded copy of the *New York Times* to hold his hidden penis. These two paintings serve as textbook illustrations of the psychoanalytic categories of *Phallus* and *lack* in which the penis is always hidden to protect the primacy of the phallus, while the woman must expose her lack of both attributes.

The backlash against feminism in the 1980s involved not only outright misogyny or old-fashioned sexual exploitation, but also the reestablishment of art values and traditions that feminism had called into question. In the 1970s, feminism had opened up the language of sculpture and performance art; a decade later big painting on canvas returned with a vengeance as the principal commodity of an inflated art market. Feminism had pointed to the exclusionary aspects of the myth of the genius; now the mythology of the—always-male—genius was explosively reasserted. Common to the period were multigallery exhibitions of artists such as Julian Schnabel and Salle, and mid-career retrospectives for artists in their early thirties such as Salle, Fischl, and Schnabel. The mythologizing of these new male geniuses was also accomplished through relentless media hype. A social system was in place that aggressively promoted male art stars and star dealers of which the most archetypal was Mary Boone, pictured in *New York* magazine in 1982 with her exclusively male stable of artists. "What has she learned?" the article asked, to which Boone replied, "'That sculpture is hard to sell. And women. I'll always take a great woman artist, but the museum hierarchies won't accept them."[9] This from a woman whom the article describes as so ferocious that she was known to threaten to come over and rip unpaid work off of collector's walls. But, "Boone denies she's anti-feminist: 'It's the men now who are emotional and intuitive. The females are more structured.'"[10] This comment was notable for its twisting of language: women had always been put down for being "emotional and intuitive" by nature, but now that men were supposedly exhibiting these traits, these were admirable qualities which women didn't have!

Casual sexism and ripping off feminist art and artists often seemed to go hand and hand, as in the work of Mike Kelley. On the one hand he produced drawings such as *Bookworm*, 1984, of a smart, bright-eyed, mortar-board hatted penile worm emerging from the cunt of a grossly distended, big-boobed, dot-eyed woman, flat on her back, with teeny arms and legs as helpless as Kafka's bug. On the other hand, his wall hanging of colorful afghans and toys, *More Love Hours Than Can Ever Be Repaid*, 1987, seems derivative of Miriam Schapiro's earlier celebratory collage of lace, samplers, and gaudy textiles, *Wonderland*, 1983. Yet Kelley's ironic and strategic use of childhood kitsch gained him a favored place in the avant-garde while Schapiro's genuine, *un-ironic* embrace of kitsch as an aesthetic is consigned to the attic of modern art. But rather than acknowledge a possible debt to feminist art for his freedom to use toys and domestic textiles such as afghans as art materials and subjects, Kelley, also a CalArts graduate, is said to have "jokingly termed his frieze of stuffed animals 'my homage to Jackson Pollock,'"[11] thereby insuring his place in the patrilineage.

Feminist artists had developed less commodifiable art forms such as performance and installation for their often radically unwelcome content, but the male artists discussed here heartily embraced the commodity culture while shrewdly situating themselves as both critical or subversive of it. Pornographic and misogynist depictions of women proved a quick and remunerative path to critical attention, even when critics said they hated the work. Thus Jeff Koons, who pushed the art world's focus on commodification and pop culture to its most uncomfortably crass extreme and was widely excoriated for it, moved in his work from enshrined actual vacuum cleaners (*New Shelton*

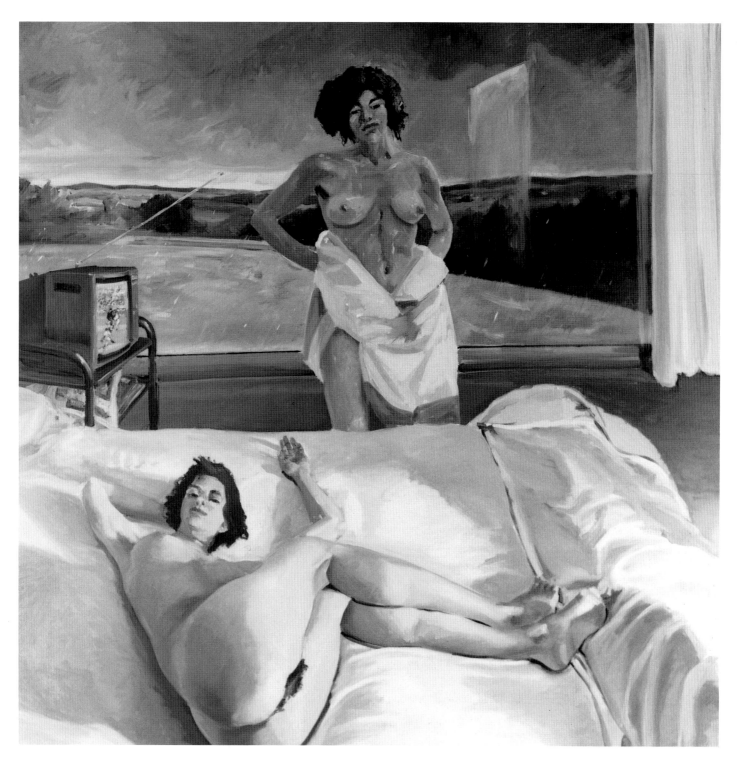

Eric Fischl. *Untitled* (Two Women in Bedroom). 1982. Oil on
canvas, 84 × 84″. Courtesy Mary Boone Gallery, New York

Wet/Dry Double Decker, 1981) to garish porcelain sculptures of truncated and prone women juxtaposed with pigs in such works as *Fait D'Hiver*, 1988, and later to pornographic multimedia tableaux using himself and his Italian former porn-star wife, La Cicciolina, as models, successfully gathering reams of art press coverage.

The success of the male artists discussed here took place within an international art world that continued the pattern of sexism. Major national and international exhibitions routinely excluded almost all women while Salle, Fischl, Schnabel, and later Koons and Kelley, among many male art stars, were ubiquitous. The *Zeitgeist* exhibition in Berlin in 1982 included only one woman, Susan Rothenberg. "Documenta 7" in 1982 included 28 women to 144 men, "Documenta 8" in 1987, 47 women out of 409 artists! The 1985 "Carnegie International" included 4 women to 42 men, the 1988 exhibition included 10 women to 41 men. In June 1984, the Museum of Modern Art reopened its enlarged facilities with the exhibition "An International Survey of Painting and Sculpture." Of the 164 artists chosen, only 13 were women. This gender percentage symbolized how few inroads had been made by women into the mainstream of the art world, as well as the degree of backlash and slippage that had taken place as a decade of noisy activism gave way to complacency. Although MoMA was picketed by demonstrators protesting the lamentable underrepresentation of women artists in the exhibition, in the main organized feminist pressure on mainstream institutions had let up.

In May 1985, posters appeared in Soho pointing an accusatory finger at specific galleries' gender representation ("THESE GALLERIES SHOW NO MORE THAN 10% WOMEN ARTISTS OR NONE AT ALL") and named names ("WHAT DO THESE ARTISTS HAVE IN COMMON?"). Twenty major galleries from Blum Helman, Mary Boone, and Leo Castelli to Tony Shafrazi, Ed Thorp, and Washburn, and 42 male artists from Francesco Clemente and Eric Fischl to Bill Jensen and Richard Serra were depicted as either actively responsible for or, in the case of the artists, complicit in the egregious sexism of the art world. The black-and-white print posters proclaiming this information were signed "Guerrilla Girls—Conscience of the Art World." The Guerrilla Girls' posters offer important documentary proof of systematic sexist practices within the art world; for example, in 1986, two posters declared "ONLY 4 OF THE 42 ARTISTS IN THE CARNEGIE INTERNATIONAL ARE WOMEN," and "THE GUGGENHEIM TRANSFORMED 4 DECADES OF SCULPTURE BY EXCLUDING WOMEN ARTISTS. Only 5 of the 58 artists chosen by Diane Waldman for 'Transformations in Sculpture: 4 Decades of European and American Art' are women."

In response to the GG's interventions, Leo Castelli said that they suffered from a "chip that some women have on their shoulders. There is absolutely no discrimination against good women artists. There are just fewer women artists."[12] In 1989 the GG broke their self-imposed rule of not mentioning specific *women* artists' names and published two posters that authoritatively refuted such flagrant misconceptions. "WHEN RACISM & SEXISM ARE NO LONGER FASHIONABLE, WHAT WILL YOUR ART COLLECTION BE WORTH?" listed 67 distinguished women artists, including Elisabeth Vigée-Lebrun, Frida Kahlo, and

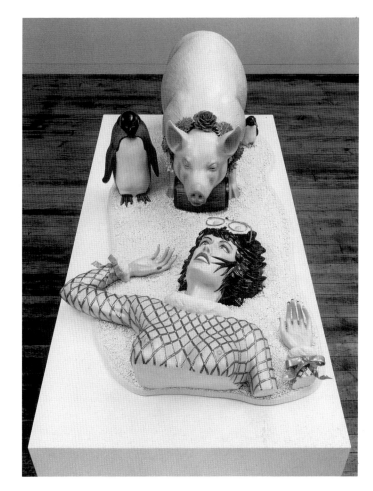

Jeff Koons. *Fait D'Hiver.* 1989. Porcelain (edition of three), 19½ × 63 × 31½". Courtesy of artist

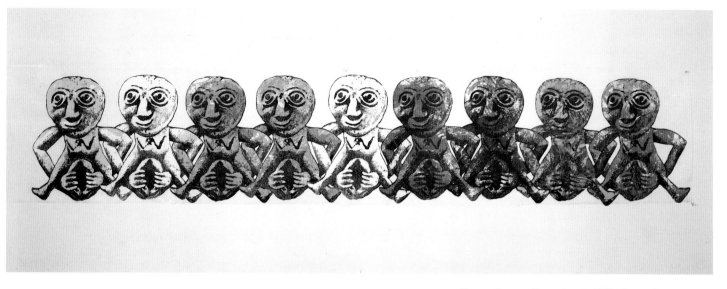

Nancy Spero. *Chorus Line I.* 1985. Print collage on paper, 20 × 110″. Courtesy Josh Baer Gallery, New York

Georgia O'Keeffe, a collection of whose works would in total be worth less on the inflated and gender-biased 1980s art-auction market than *one* painting by Jasper Johns at that time. The second poster tweaked the art world's intense desire to unmask the GG: "guerrilla girls' identities exposed!" listed 500 women artists.

In many ways—except for their anonymity and their activist program—the format of the Guerrilla Girls' work, particularly the use of language as a primary visual element, typified the work by women artists that was sanctioned by the critical avant-garde during the 1980s, echoing the style of established artists such as Jenny Holzer and Barbara Kruger. These artists were situated at the complex intersection of the postmodern avant-garde of appropriation and simulation art with feminist critical theory coming from England and France. This nexus of discourses framed a second phase of the backlash against 70s feminism that took place within feminism itself, although it operated in a broader field of avant-garde art.

"The Great Goddess Debate—Spirituality vs. Social Practice in Recent Feminist Art" was a panel held at the New Museum of Contemporary Art in December 1987. On the panel were artist Nancy Spero, video artist Lyn Blumenthal, critic Arlene Raven, critical theorists and art historians Kate Linker and Helen Deutsch; the moderator was art historian Judith Williamson. The debate exposed a major rift within feminism itself. Linker and Deutsch bemoaned the notion of a mythical vision of essential femininity and argued for the social and historical basis which structured the production of images and their readings. Although they were personally deferential to Spero and despite the fact that she graciously expressed great interest in their ideas, Deutsch and Linker could scarcely conceal their contempt for her depictions of women, including ancient goddesses, for the relatively handmade look of her work, and for her identification with 70s activist feminist art. Spero's strategic appropriation of male texts, from Antonin Artaud to Amnesty International,

was not credited. Their words, by logical extension, could be seen as possible attacks on the work of Ana Mendieta, given that the debate took place during the New Museum's Mendieta retrospective exhibition. Linker and Deutsch were opposed to the *essentialist* idea of a Great Goddess, whereas the audience seemed filled with goddess worshippers attracted to the debate by its title and by its coincidence with the Mendieta retrospective. Judging from their questions and comments, these women did not seem to understand the language of critical theory being used against their beliefs or its consequences to their own practice.

"The Great Goddess Debate" epitomized the intellectually exciting but often hierarchic and repressive polarization which transformed the terms of feminist art in the 1980s. The polarization was usually described as existing between those who believed that sexuality and gender are produced by culture at the service of ideology, and those who believed—or, more accurately, those who were *said* to believe—in an innate, immutable essence of femininity, which would preclude altering women's status. "By promoting an essential difference of woman grounded in the body, the argument runs, essentialism plays straight into the hands of the patriarchal order, which has traditionally invoked anatomical and physiological differences to legitimate the socio-political disempowerment of women."[13] The "philosophical critique" of essentialism, "elaborated by Derrida," suggested that, "Essentialism . . . is complicitous with Western metaphysics. To subscribe to the binary opposition man/woman is to remain a prisoner of the metaphysical with its illusion of presence, Being, stable meanings and identities." And also essentialism "is a form of 'false universalism.'"[14] However, essentialism in this context was a category created by its opposition. Except perhaps for those unwitting goddess worshippers at the New Museum,[15] most women artists who were condemned for being essentialists did not consider themselves as such, once they learned the meaning of the terminology.

It was felt that women artists who tried to *create* "original" images of woman, particularly positive ones, were deluding themselves: such efforts were doomed to relapse into unconscious stereotypes created by patriarchy. The best strategy was consciously to cull images from patriarchy's repertory and deconstruct them through ingenious juxtapositions and changed contexts. Representations by women were permissible only if they were of and about representation, mediated by culture; so too paint and traditional sculpture media were only acceptable if they were mediated through a critical screen.[16]

This discourse, now sometimes referred to as academic feminism, was text-based and text-driven, and the art works that were admired and supported were either based on text or could be easily assimilated by it. The importance of theoretical texts cannot be overstressed in any history of feminist art in the 1980s or of what might be considered a backlash against 70s-style feminist art. The anthology *Art After Modernism: Rethinking Representation*,[17] published in 1984, contained most of the relevant essays: "From Work to Text," by Roland Barthes, on the plurality of meanings and authors in a text; "Precession of Simulacra," by Jean Baudrillard, on the dissolution of the real; "Visual Pleasure and Narrative Cinema," by Laura Mulvey, as well as texts by Kate Linker and Mary Kelly on Sigmund Freud and Jacques Lacan's theories of sexuality and femininity. Michel Foucault's analyses of the cultural production and controlled circulation of ideology were highly influential on feminist thinking. Boundaries among the disciplines of literary criticism, art history, philosophy, linguistics, and social history were blurred. Theory seemed far more important than visual imagery, and many of the texts, which concerned visual artists of all sorts, including feminists, were critiques of the uses of visuality. This put feminist women artists involved with visuality in a bind even when they were fully aware of the discourse. The polarization also came down to which texts one favored: for example, fans of the renegade Lacanian, Luce Irigaray, were often flagged as essentialists.

Craig Owens's essay, "The Discourse of Others: Feminists and Postmodernism," published in another important anthology of the 80s, *The Anti-Aesthetic*, edited by Hal Foster, was just such a crucial text in the new postmodern feminism. Owens significantly notes that, "Because of the tremendous effort of reconceptualization necessary to prevent a phallologic relapse in their own discourse, many feminist artists have, in fact, forged a new (or renewed) alliance with theory."[18] Owens focused on Sherrie Levine's "refusal of authorship [as a] refusal of the role of creator as 'father' of his work, of the paternal rights assigned to the author by law."[19] The utter deadpan irony of Levine's appropriations of the work of famous male artists, such as Walker Evans, Alexander Rodchenko, or Marcel Duchamp, linked her by more than just her appropriative methodology to male contemporaries such as David Salle. Her work's lack of affect made it hard to distinguish in spirit or intent from the photo appropriations representing naked babes on motor bikes or *Playboy* cartoons by Richard Prince for example. The same question is raised by Levine's work as by Salle or Prince's: Is the re-presentation of imagery with an ironic intent enough to subvert the original meaning of the material that has been appro-

priated? But the dominant theoretical discourse excluded such considerations.

Owens also praised the works of Barbara Kruger and Cindy Sherman. These two artists produced the work that most closely exemplified the critique of social construction of gender proposed by theory. In every text on postmodernism and feminism, in every exhibition that was seen to matter to the critical avant-garde, at the many panel discussions on feminism and postmodernism, all roads ended at their door, often at only their door, when it came to inclusion of any women artists at all.

Barbara Kruger's juxtaposition of representations of women from the history of twentieth-century production of femininity and masculinity with sharply pointed texts was appreciated for its adherence to what seemed called for by Walter Benjamin's highly influential writings: the revelation of "unintentional truth"[20] about the culture through a re-presentation of photographic material. Cindy Sherman's work was considered an exemplar of the instability of identity and functioned as an illustration of critical analyses of the "specularization" of woman. Formally mimicking cultural productions dominated by the male gaze, namely Hollywood movies and film posters, Sherman posed and *made herself up*. There was no one "I" in her work. But a substantial number of the women enacted by Sherman are either squatting, crouching or prone, crazed or dead. She is a sweating, open-mouthed, vacant-eyed, prone woman in a wet T-shirt, a witch, a pig, a pimply ass, or a corpse half-visible under dirt, debris, or vomit. The ironic intentions that critics assigned to Sherman ensured that these textbook representations of the "other"—cunt, witch, bimbo, victim—were seen as *critiques* of this vision of woman, in much the same way that critics explained away similar images in the work of David Salle. But one has only to see certain Sherman photographs on a collector's wall to understand the rather traditional nature of their appeal: a wet T-shirt clinging to breasts is the same old thing, whether you call it *draperie mouillée* (Kenneth Clark, *The Nude*) or tits and ass. These negative representations were disturbingly close to the way men have experienced or fantasized women. Her camera seemed male and her images so successful not because they threatened phallocracy but because they reiterated and confirmed it.

Most of this discourse was functionally racist in its focus on the theories and art works of white men and women. However, works by women artists of color similar in media and format to those by Kruger or Sherman were critically recognized in ways that women of color working in traditional media were not. The antiessentialist critique favored Lorna Simpson's cool, ironically guarded photographic essays, on stereotypes of black representation with printed language as part of the work, over Faith Ringgold's colorful, quilted narratives of life in Harlem (even though those also included language!). Simpson offered the white critical hierarchy an African-American Cindy Sherman, although far less text was devoted to her rather more enigmatic *and* political work.

Feminist art historians, critics, and artists convincingly noted the uses of visual pleasure in cinema and in painting to express and produce male eroticism while enforcing the repression of female subjectivity. Laura Mulvey's "Visual Pleasure in

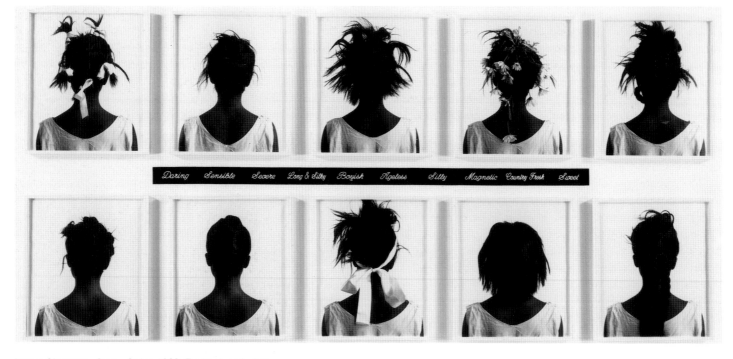

Lorna Simpson. *Stereo Styles*. 1988. Ten black-and-white
Polaroids; 10 plastic plaques, each 24 × 20″; whole, 64 × 116″.
Courtesy Josh Baer Gallery, New York

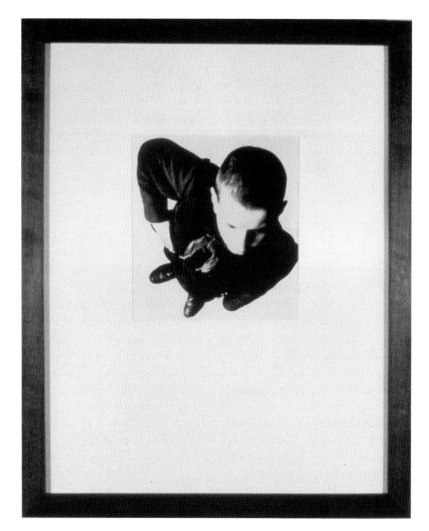

Sherrie Levine. *After Rodchenko*.
1987. Black-and-white photograph,
20 × 16″. Courtesy Marian Goodman,
New York

Narrative Cinema," and Griselda Pollock's essay, "Screening the seventies: sexuality and representation in feminist practice—a Brechtian perspective,"[21] impelled women artists to resist producing visual pleasure. The artist at the center of their discourse was Mary Kelly, whose *Post-Partum Document*, 1974, was exhibited at the New Museum in 1984.[22] *Post-Partum* reported the mother and child relationship through diagrammatic documentary evidence within a psychoanalytic framework ending with the child's mark of full socialization through his acquisition of written language, the "Law of the Father." Mother and child are never pictured: "The physical presence of woman fetishized in modern Western art is thereby replaced by another order of presences accompanied by the discourse of and from the place of the traditionally silenced feminine. In place of the exclusively masculine theorization of fetishism, Kelly explored aspects of feminine fetishization of the child and its substitutes."[23] *Post-Partum Document* and the later *interim*,[24] 1984–90, were praised for refusing the viewer the illusionary sense of identification with the work offered by visual pleasure, although neither Pollock nor Kelly would deal with the inherent contradictions of embedding a critique of visual seduction *in* a visual project. The exclusionary aspects of the work and its critical system were redoubtable: to understand the work one often felt an advanced degree in philosophy and psychoanalytic theory was required.

There was an almost sinister convergence between postmodernist and Marxist critiques of painting,[25] the feminist rejection of visual pleasure as male eroticism, and continued assertions *by* men of painting as the sole domain *of* men *because* of its connection to male eroticism or because of the *nature* of male eroticism. Peter Schjeldahl, as late as 1990, suggested as much:

> *What there are now, after feminism's long march through the art culture, are more and more top women sculptors, photographic artists, and artists of installation and performance. . . . But no truly great painters. Is it biology? The very suggestion seems sexist, but what if it happens to be true? A theory lately in the air holds that male eroticism is concentrated in the sense of sight, whereas for women the erotic is distributed more evenly among the five senses. That would make painting, the medium of maximum physical control over the visual, naturally more intense in its pleasures for men than for women.*[26]

Mary Boone had said in 1982 that "The females are more structured," and the first women she chose to represent, in the late 1980s, were Barbara Kruger and Sherrie Levine, who had chosen the ironic, photo-media, appropriative route. It should be noted that those "emotional and intuitive" men were allowed to get away with imagery whose blatant essentialism would have been condemned if done by a woman. For instance, Francesco Clemente's primitivistic pastels of naked men and women shitting, coming, and giving birth to each other were never put under the same theoretical microscope as were the works of so many, much less essentialist women artists. Of course his financial success was much greater than any of the women discussed here. In fact, pushing women into the ghetto of photo-media also pushed them away from the potentially greater financial rewards of painting in the 1980s.

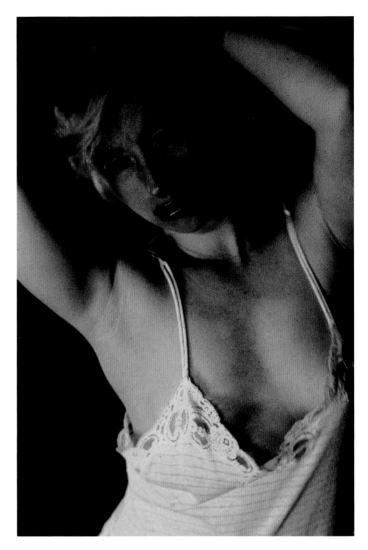

Cindy Sherman. *Untitled No. 103.* 1982. Color photograph. Courtesy Metro Pictures, New York

Mary Kelly. *Post-Partum Document.* Analyzed fecal stains and feeding chart, (Documentation I of 28), 14 × 11″. 1974. Collection the artist

The combination of all of these discourses constituted a rejection of 70s feminism's search for what female eroticism might *look like in visual art.* It condemned the sexual politics and ideals of the 70s feminists and the materiality of their efforts while at the same time writing out of the history of late twentieth-century art much of the work of the 70s, which was in fact photo-based or text-oriented.

Similarities of subject and basic political content between the two groups of work often went unnoticed. In Kruger's *We have received orders not to move,* 1982, as in Ana Mendieta's photo from the Tree of Life series, 1977, woman's contingent body has been immobilized. Kruger's woman is "pinned-up" into a subservient pose, a Barbie doll impaled on a scrim of media design by order of the unnamed power of patrimon(e)y (page 262). Mendieta's woman is matter encased within itself and returned sacrificially to nature. Although Mendieta often bonds woman to earth through her choice of materials and sites, it is important to note that both Kruger *and* Mendieta rely on photography to document woman's transition from subjectivity to subjugation.

According to the Oedipal narrative central to psychoanalytic theory, the phallic gaze constantly reassures itself that it has a something to see (although it usually won't let us see it). In this narrative woman is both *"a nothing to see"*[27] and the object of the phallic gaze. Kruger undermines the importance of Big Daddy's speculation of woman by her description of it as *Surveillance is their Busywork,* 1984 (pages 246–47). But in Bourgeois's *Nature Study, Velvet Eyes,* also from 1984, the object of the gaze, a tub of stone, has eyes which stare back up at the viewer. The specularized "nothing to see" ogles back unblinking, recuperating the agency of vision.

Works that realized the discourse's precepts were ignored. Susan Silas's archly titled *post-mortem,* 1990, may be an orthodox postmodern response to Salle's *Autopsy,* because of its use of photography, appropriation, language, and cool materials of steel and glass. But, because the man's genitals are obscured, because of the different valence of the male nude in patriarchal culture, and because Laurel and Hardy are beloved fools rather than reviled females, the work lacks sting (page 262). By contrast, Ida Applebroog's large multicanvas works constitute a more powerful response in painting to the representations of women by David Salle and Eric Fischl. She disposes of a broader spectrum of femininity *and masculinity* through compositional techniques related to their visual strategies while also deploying strategies proposed by Griselda Pollock, "dis-identificatory practices"[28] and "distanciation" that "liberate the viewer from the state of being captured by illusions of art which encourages passive identification with fictional worlds."[29] This "critique of realism" depends on the "use of montage, disruption of narrative, refusal of identifications with heroes and heroines, the intermingling of modes from high and popular culture, the use of different registers such as the comic, tragic as well as a confection of songs, images, sounds, film, and so forth. Complex seeing and complex multilayered texts [are] the project."[30] Clearly Applebroog deploys these prescribed strategies: a large bodybuilder, a woman flexing her biceps in *Rainbow Caverns,* 1987, is juxtaposed with a small image of a girl, a single strand

of spaghetti suspended between her fork and mouth, bonding a Michelangeloesque tradition of heroic sculptural rendering to cartoonlike figuration and action. But her use of visceral, gleaming paint is the key to Applebroog's apparent exclusion from the canon-forming texts of the feminist avant-garde, for whom paint was not the material of choice for postmodern women artists. The discourse left out Elizabeth Murray's response to modernism, even though she deconstructed the very ground of painting in her fragmented, sculptural works, and expressed the interiority of the female body through the complexity of her paintings as objects. Murray's work continued the vigorous exploration of abstraction as an arena for representation of female sexuality, which also marked the work of Eva Hesse and others.

In reality, most women artists dealing with gender representation have operated in a complex zone between the polarities of "essence" and "culture." The comparisons made here indicate that the polarity was a false one, based on balkanized art world/art style battles. One must ask whose interests it served to foster a schism among women. Would a complex and varied, if not unified at least not antagonistic, body of work by women threaten the art establishment in a way that the hierarchic dichotomy of the postmodern feminist discourse does not?

It must be noted that some aspects of the backlash against both pluralism and 70s feminism were made possible and even justified by these movements' weaknesses in the late 70s. The sharp political focus of the early years of the feminist movement was diffused by careerism, perhaps even by the relative success of some of its members. A kind of intellectual laziness seeped in which allowed that if a work was by a woman it was feminist. Also, simplistic representations of women as cunts in works by artists heavily identified as 70s feminists could be downright offensive: Judy Chicago's reduction of *Emily Dickinson* and *Virginia Woolf* to cunt plates in *The Dinner Party* may seem to some as good a reason for an antiessentialist critique as any and at least as problematic as Salle's representations, notwithstanding putatively opposite intentions. Despite Miriam Schapiro's tireless efforts on behalf of feminism in art, her painting of a chorus girl in a tea cup, in *Ragtime*, 1988, perhaps intended as celebratory, seemed to many of the new generation to have strayed far from anything recognizable as an intellectually convincing critique of patriarchy.

The critical discourse of the 1980s, while regrettably exclusionary, was intellectually rigorous and challenging. Women artists who answered the challenge reeducated themselves and moved much further along an examination of gender and visuality than the men whose critical and financial success marked the 80s art market.

Unfortunately the exclusionary aspect, the dearth of visual pleasure, and the distance that was sought from the materiality of the body may have set the stage for the most disturbing backlash against 70s feminist art, namely its amnesiac return in the 1990s. Many women were struck by the simultaneity, in May 1992, of Kiki Smith's prone featureless female creature dragging feces across one gallery floor (*Tale*, 1992) with Sue Williams's abused, beaten, and branded female laid out on another (*Irresistible*, 1992).[31] The antiessentialist discourse as a critical

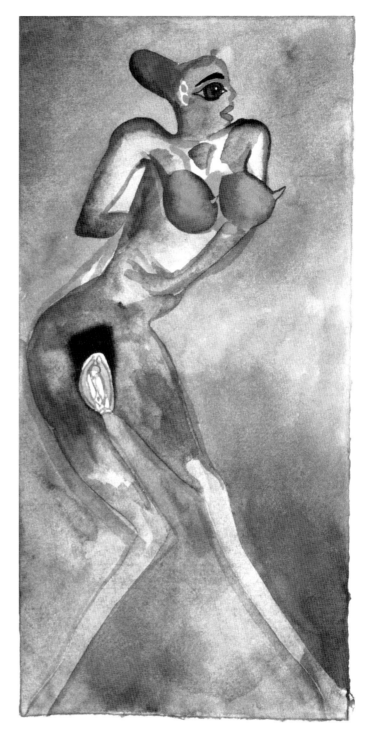

Francesco Clemente. *Untitled IX.* 1988. Watercolor on handmade paper, 12¼ × 6". Courtesy Sperone Westwater, New York

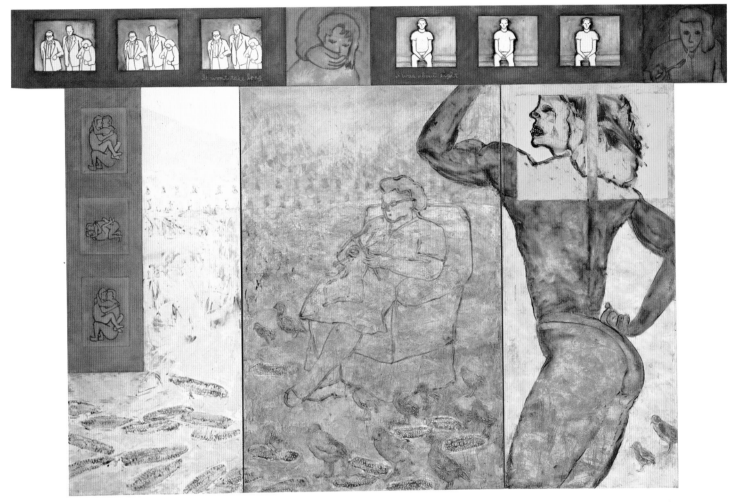

Ida Applebroog. *Rainbow Caverns.* 1987. Oil on canvas,
86 × 132″. Courtesy Ronald Feldman Fine Arts, New York

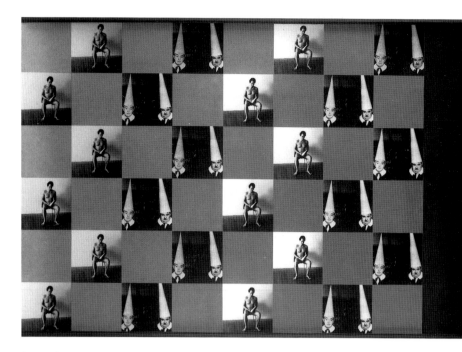

Mam my
Mam my
I'd walk a mil lion miles
for one of your smiles.
my Mam my.

Susan Silas. *post-mortem*. 1990. Chalk on slate, black-and-white photographs on aluminum, steel, and plate glass, 48 × 112″. Collection Alvin and Phyllis Trenk. Courtesy Jose Freire Fine Art, New York

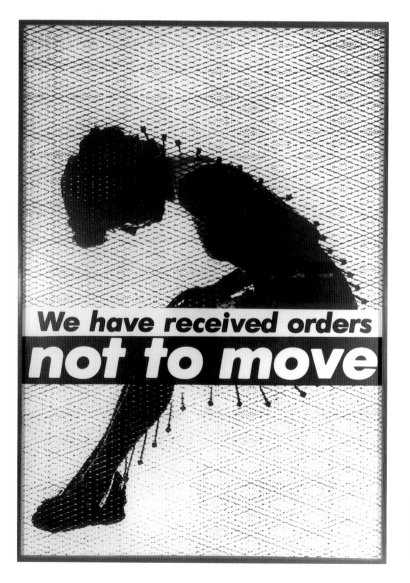

We have received orders
not to move

Barbara Kruger. *Untitled* ("We have received orders not to move"). 1982. Black-and-white photograph, 72 × 48″. Private collection. Courtesy Mary Boone Gallery, New York

system seemed to have suddenly collapsed, as women working in sculpture and painting, depicting women in a very essentialized victim position, received a great deal of attention. These works were not analyzed for what they naturalize about women, and one suspects their popularity is partly based on the attractiveness to many of the female victim position.

The promotion[32] of emerging women artists as feminists seems predicated on a continued devaluation and simplification of the 70s, influenced also by the misogyny of the 80s. The image on the postcard for Exit Art's 1993 historical survey exhibition of women artists, "1920 The Subtlety of Subversion, The Continuity of Intervention," is telling. A naked woman squats precariously on a hollowed log, holding her buttocks as if about to pee, shit, or give birth. The date, 1920, overlays the unkempt hair that obscures her face. Thus the year when women received the vote in the United States is celebrated through the kind of animalized image of woman that the suffragists fought so hard to transcend. That this representation fronted a survey of women artists was all the more objectionable when the card was turned around, revealing the title, *Mujer Incognita,* and the artist, Papo Colo, the male curator of the exhibition (the date of this work, 1982, placed it squarely in the backlash time zone). Reaction to this card was mixed; some people were outraged, including artists in the show,[33] but critic Kay Larson "loved the postcard for Exit Art's show of New Feminism: a naked woman, crouched on a post, hair over head—an Abominable Snowwoman for this equal opportunity era."[34] Just imagine for a moment an all African-American artists' exhibition celebrating the date of the Emancipation Proclamation fronted by the image of a black sambo or a slave which turns out to be a work by the white curator!

The difficulty of establishing institutional memory and permanent status for feminism is evident in our contradictory present. It seems certain that Sherman and Kruger's work will be necessary to a visual representation of the decade of the 1980s. Kruger's influence now permeates all the forms of media culture that she appropriated, and Sherman's work has grown from narrow appropriation toward ever deeper, more idiosyncratic expressions of current theories of gender, while Fischl and Salle seem redundant, thwarted by the commodity culture they exemplified and by the adolescent sexuality they could not outgrow. However, institutional sexism continues: a 1993 survey of American art curated in Berlin by the curators of the *Zeitgeist* show only included 5 women out of 66 artists.[35] The Guerrilla Girls' 1993 premiere issue of the quarterly *Hot Flashes* damningly "probe[s]" the *New York Times* art coverage, which overall bestows 67.5% of its attention on white men, to 23.8% on white women, 6.6% on men of color, and a scandalous 1.9% on women of color.[36]

One would hope for a synthesis of sensuous, body-based material explorations of femininity, theoretical critiques of the production of gender, and the activism by feminist artists necessary to keep feminism on track and in the public domain. This synthesis exists in individual artists. The work of the next decades will be to establish it within a culture that prefers simplification, polarization, amnesia, and the subjection of women.

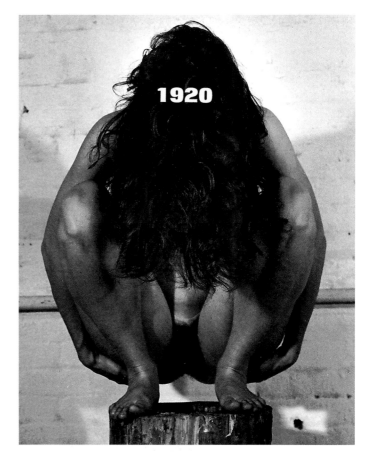

Papo Colo and Jeanette Ingberman. *Mujer Incognita.* 1982. Exhibition card for "1920: The Subtlety of Subversion, The Continuity of Intervention," Exit Art, New York, March 6–April 17, 1992. Courtesy Exit Art, New York

AFFINITIES: THOUGHTS ON AN INCOMPLETE HISTORY

BY SUZANNE LACY, INCLUDING A CONVERSATION WITH JUDITH BACA[1]

It's not just nostalgia that keeps calling me back to the pioneering feminist art of the '70s, but the ever-more obvious affinities with what's going on in the '90s. It seems politically and esthetically crucial that the work done then not be forgotten now, and that its connections to the succeeding decades be clarified.[2]

—*Lucy Lippard*

Lynn Hershman. *Roberta in therapy session.* Performance, January 24, 1978

Perhaps it is true that the longing to connect and to be one with, and the desire for separation or distinction, run like a split river under the veneer of both personality and culture. The self/other analysis at the base of 1960s feminist theory was a translation of this psychological observation into the social realm. In the Feminist Art movement of the seventies, influenced as it was by Simone de Beauvoir, psychology, and radical feminist activism and theory, two themes stand out: investigations of gender identity and the relationship of art practice to public life. Over the last twenty years the latter aspect with regard to feminist art has been less examined than the former. I propose to discuss the feminist art project of the seventies, first by reuniting these dual themes, then by raising challenges from the 1980s, and finally by linking this heritage to current practice. It is my contention that how we have come to view 1970s feminist art is limited, more concerned with differentiation than with synthesis. As Lippard suggests, perhaps it is time to build on our "ever-more obvious affinities," and to develop an analysis based on connections.

CONSCIOUSNESS AND ACTIVISM: THE DUAL PROJECT OF FEMINIST ART

In order to understand the Feminist Art movement of the seventies we must look outside the art-world discourse, because the initial impetus came from the larger world of political action. The goal was to align cultural production with a clearly defined set of political values. In the beginning of the decade, at least in my experience as a student in Judy Chicago's Fresno Feminist Art Program and later in the women's design and writing programs at the California Institute of the Arts, there were no divisions between art based on identity investigations and art that explored new relationships with its audience. Both sprang from the same political agenda—the transformation of the power differential between men and women. This agenda included an activist approach to racial equality, although artwork by mostly white women dealing with racism was naive by today's standards, and with class inequality, although Marxism was, with few exceptions, not prominent then in feminist art analysis.[3]

The nature of female identity was seen as not yet known but knowable. Private and public (including mass-mediated) experiences were investigated for their roles in shaping gender identity. Even then, analysis of individual identity was firmly ensconced in a critique of dominant culture. At issue were the ways in which identity constructions affected women's lives. Forms of art ranging from limited-audience rituals to mass-audience murals and televised performances spoke simultaneously of current representations of race and gender and of the need to reconstruct them, a process critical to a political agenda. Consciousness-raising and community organizing were techniques for understanding and enacting both individual identity and the differentiated and multiple nature of communities.

Deconstruction was tied to an activist project of shifting power relationships in *daily* life, rather than a theoretical exercise in a rarefied language addressed to an art-world viewership. In the performance *In Mourning and In Rage*, for example, an

"Americans show
greater differences
gesturally"

"Do crossed arms
mean that 'I am
frustrated?'"

"A hand to the
face may serve
as a barrier"

"Crossed legs point
to each other. "

"Crossed arms do
the same thing"

"Crossing arms
defines posture"

"Does she try to
avert attention
avoiding your eyes?"

"Is she sitting
stiffly and not
relaxed?"

"Covering legs
reveals frigidity,
fear of sex."

ROBERTA'S BODY LANGUAGE CHART

(photographed during a psychiatric session)

January 24, 1978

Leslie Labowitz. *Record Companies Drag Their Feet.* 1977. Media performance in collaboration with Women Against Violence Against Women, Los Angeles. Photograph by artist

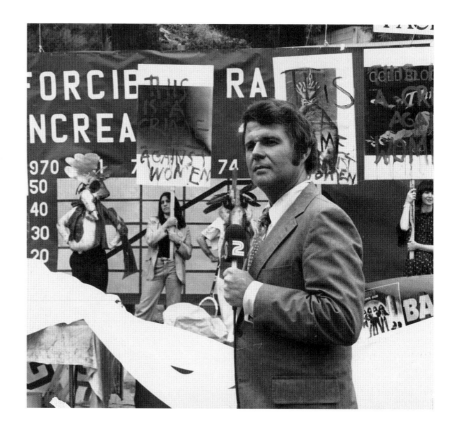

Judith Baca. *Mi Abuelita.* 1970. Mural. Hollenbeck Park, Los Angeles, California. Courtesy SPARC, Venice, California

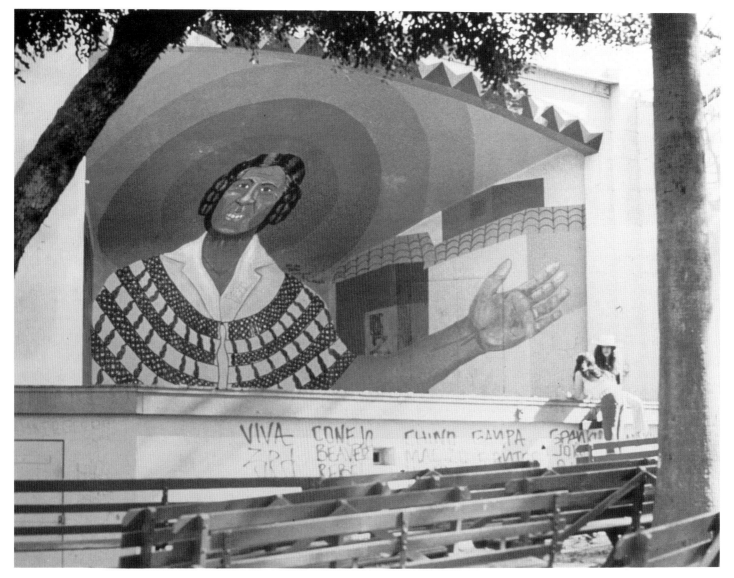

intervention into prime-time news, Leslie Labowitz and I analyzed conventions of television news, deconstructed the gender representation in sex-violent news reporting, and created a performance that critiqued this construction even as it called for concrete action. The performance, staged at City Hall as a media event for an audience of politicians and news reporters, was designed as a series of thirty-second shots that, when strung together in a two- to four-minute news clip, would tell the story we wanted told. We considered, for example, camera angles, reporters' use of voice-over, and the role of politicians in traditional reporting strategies. We attempted to subvert various conventions of sex-violent reporting—like focusing on the identity of the victim as an explanation of why the crime occurred—with both imagery and statements made during the performance. In subsequent appearances on television we further developed this analysis. Several responsive actions by public agencies resulted from this performance.[4]

Also confronting issues of everyday life and culture was Los Angeles muralist Judith Baca's first major mural, *Mi Abuelita*, 1976, which represented the figure of a traditional Latina "grandmother." This work operated as an intrusion of a female image into the territorialized male culture of the public parks in East Los Angeles; as a statement of Latino experience with its reverence for the elderly in the context of the larger white culture of Los Angeles; and as part of an activist project to unite rival gang members.

Although they were neither mutually generated nor dependent theoretically or practically on each other, the artworks of ethnic and community-based artists and those of feminist artists must be evaluated with respect to mutual influences, because both inform political art in the 1990s. This was particularly evident in Los Angeles during the seventies, where major institutions focused on gender and ethnicity interchanged ideas. "The Social and Public Art Resource Center," said Judith Baca, "was in one part of town doing its work in ethnicity, and the Woman's Building was in the other. We were all richer for that mix, and we crossed back and forth to work in both places. There was a mutual respect."[5]

There were many differences, but there was an uncontested parallel between feminist and ethnic artists: obtaining equality—of resources, representation, and power—was the political motivation that fueled both art practices. This aspiration led artists in both groups to examine the interactive potential of art making, both within the work itself through collaboration and between the work and its audience. This activist orientation toward the audience challenged artists to seek and identify specifically who their work was for. More broadly, it signaled the beginnings of today's theories that articulate a diverse and differentiated public for art.

In the 1970s, West Coast feminist art students embraced collaboration, in particular its activist component. In the mid- to late seventies, several women's groups based on activism were created: in California, Mother Art (1974), The Feminist Art Workers (1976), the Waitresses (1977), Ariadne, A Social Art Network (1978-80), and Sisters of Survival (1981); and in New York, Group Material (1978), No More Nice Girls (c. 1980), and Carnival Knowledge (1982), all of which used public interven-

Mother Art. Helen Million hangs photographs of laundry on clotheslines, from *Laundryworks*. 1976. *Laundryworks* was a series of five performances throughout Los Angeles, which was intended to transform the environment and to be a ritual celebration of cleansing and women's work. Photograph by Hal Cohen

tion as art.[6] Many of these groups lasted for years, challenging the notion of a singular art authorship as well as the art world's constraints on activism. This activist legacy was the precursor of today's Women's Action Coalition (WAC) and the Guerrilla Girls.

Feminists were also drawn to collaboration because it provided a forum for challenging modernist notions of individualism and isolated art production. In the feminist view, art could express the self in a metaphoric encounter with the other. The construction of inside/outside was used in 1970s collaborations to describe several aspects of psychological and political reality: the self/other paradigm, class and racial relationships, and feminist artists' positioning within the art world. In one exercise at the Feminist Studio Workshop at the Los Angeles Woman's Building, for example, I asked my students to select a category of experience culturally defined as "other," such as women on welfare, and to represent that experience as it intersected with their own. As a second step, they were to initiate a collaboration with a person or group representing that experience, meeting, for example, with a welfare rights group to

Sisters of Survival (Jerri Allyn, Nancy Angelo, Anne Gauldin,
Cheri Gaulke, and Sue Maberry). *End of the Rainbow: S.O.S.
for Avebury.* 1983. Photograph by Sisters of Survival

develop a performance. Although the 1990s has seen a re-
surgence of art works in which artists make contact with
"others"—prisoners, women who've experienced domestic vio-
lence, or homeless people—and from these connections develop
more or less collaborative representations, art criticism has not
recognized the precedents of this practice in 1970s feminism
and performance art.

Emphasis on the nature and politics of relationship was
fundamental to most 1970s feminist art, extending quite natu-
rally into the construction of public audiences. Adrian Piper's
Mythical Being, a street performance in Cambridge, Massachu-
setts; Bonnie Sherk's appearance as a waitress selling donuts
during an art conference; Linda Montano, who could not sing
but who took a lead position in a country and western band;
Barbara Smith, allowing her nude and vulnerable self to be
"fed" by a largely male audience in an installation at the San
Francisco Museum of Conceptual Art; and Lynn Hershman's
"Roberta Breitmore," a fictional character complete with a so-

cial security number, driver's license, apartment, and therapist—
all were part of this same impulse to explore a contextualized,
constructed, and experienced "self."

In fact, the dislocation of art into the public, and the public
into art, was critical to its meaning. For example, when one
looks at Hershman's work from a contemporary vantage point,
aspects of its dispassionate presentation tempt us to see it styl-
istically as a unique predecessor of 80s-style deconstructive
works. Yet the interrogation of women's identity was as much a
part of 70s feminism as of the 80s, but with one significant dif-
ference: in the earlier decade, individual identity was seen in
relationship to a possibility of public, "lifelike" art action.

It was at CalArts that the writings and practice of Allan Ka-
prow were first seen to offer a link between avant-garde art and
the feminist goal to diversify audiences. According to Kaprow,
"The key experiment [of the 60s] was . . . the secularization of
the entire art situation: genre, frame, public and purpose. The
critical move . . . was the shift of art away from its familiar con-

texts, the studios, museums, concert halls, theaters, etc., to anywhere else in the real world . . ."[7]

Kaprow's project, to investigate the border between art and life, was a theoretical substratum for feminist artists wishing to unite art, the conditions of women's lives, and social change. If art could be an articulation of real time and images collapsed into a frame of daily life, as Kaprow argued, then political art need not only be an art of *symbolic* action, but might include *actual* action. Although 70s feminist artists, including Judy Chicago, drew on a long tradition of art in the service of social change, the challenge was to develop this not only in terms of morality (i.e., art in the service of social "good") but in terms of current aesthetics. Kaprow, not recognized as political at that time, offered the link with the traditionally defined avant-garde. In the end, both Kaprow and Chicago were concerned with the relationship between aesthetics and values. It was feminism, however, that most clearly posited political and cultural activism as part of 70s conceptual and performance art. At the intersection of the questions Kaprow asked of the artist's role and the challenges Judy Chicago raised to the relevance of female experience, there grew the possibility of feminist activist art.

Throughout the decade, the strategic manipulation by feminist and ethnic artists of cultural materials, forms, institutions, and sites not only established the notion of a "public" beyond the art-world audience, it differentiated that heretofore heterogeneous body. The communicative and change-oriented tenets of feminist art demanded the development of multiple audiences along lines of class, gender, and race. Why talk about rape exclusively in an art gallery when you could still be attacked on the way home? Artists were not simply trying to draw attention to social issues; they hoped, in a manner now dismissed as utopian, to have a *measurable* effect on the situation. According to Faith Ringgold, "It was a time when people really thought they could change the world, as different from now as night is from day. Today people just feel like they can't do anything. *Then* we believed that an individual in consort with other persons could change the world."[8]

Because the nature of art was under scrutiny, the strategies developed for reaching diverse communities came to be seen as part of a developing aesthetic language. Throughout the seventies, politically oriented artists mined their backgrounds for art forms that would stretch the boundaries of current practice and support the imperative of reaching a broad public. The Mexican mural movement was reclaimed by Latino artists, as were Midwestern quilting bees by feminist performance artists and painters. Media sites like television news were populist venues for several West Coast artists,[9] just as in the early twentieth century the activist theatrical component of Russian Constructivism had used sophisticated framing of populist art forms as a means to reach and "reeducate" the Russian peasantry.

Accessibility, a key principle in the 70s agenda to democratize art, suggested that high art be recontextualized to include populist or folk practices of different audiences. Thus, Mother Art, a collaborative group of housewife artists, many of whom trained at the Feminist Studio Workshop, performed and exhibited in the mid-seventies in laundromats. Mierle Laderman Ukeles, extending traditionally feminine notions of social main-

Bills of Rights, performance handouts by Feminist Art Workers, New Orleans, 1980. Graphic design by Sue Maberry. Through various interactive performances, the FAW helped to lobby for the ERA in key problem states targeted by activists. In a New Orleans hotel where the College Art Association and Women's Caucus for Art national conferences were being held, the FAW "posed" as hotel service employees and handed out these "dollar bills." Information about women's achievements in society was printed on the bills.

tenance into the public sphere, shook hands with eighty-five hundred New York City sanitation workers. The Waitresses, a group formed by Jerri Allyn and Anne Gaulden at the Feminist Studio Workshop, performed witty critiques in restaurants and collaborated with unions on activist projects. In these works nonartists were considered equal collaborators in the construction of artworks that drew on practices not conventionally described as art. Artists were in effect redefining the tools, skills, audience, makers, and imagery of art. By stretching the boundaries of art, these performers were among the many artists who fulfilled Kaprow's 1958 prophecy that artists "will disclose entirely unheard-of happenings and events, found in garbage cans, police files, hotel lobbies; seen in store windows and on the streets . . ."[10] Reciprocally, it was 70s feminist art that gave a public life and political meaning to these theories, which had remained, in spite of Kaprow's best intentions, largely within the art-world community.

Bonnie Sherk. *The Waitress at Andy's Donuts.* 1973. Costumed in a bouffant hairdo and black nylon uniform, Bonnie Sherk performed as "The Waitress" at a coffee shop in San Francisco. Photograph by Tony Smull

Given the substantive relationship of 70s feminist art to theories such as Kaprow's, to activist traditions within ethnic communities, to media deconstruction, and to a long history of political art, we must question why these complex interrelationships have been ignored in today's historicizing. In part this can be explained by the cultural volley between synthesis and differentiation. During the 1970s the desire to connect, to name similarities, and to unite in the service of social transformation were compelling in both radical culture and feminist art and so gender and ethnic identity was constructed within an activist paradigm. In the subsequent shift from an inclusive, socially contextualized and activist notion of identity to a "theoretically" differentiated one in the 80s, something was lost—and feminist art criticism became an internalized and somewhat esoteric dialogue.

WERE WE LOSING GROUND? POLITICS AND FEMINIST ART IN THE 1980S

In 1980, exactly ten years after the "Art and Technology" exhibition at the Los Angeles County Museum in which Maurice Tuchman had featured over seventy white male artists and no women,[11] Tuchman once again mounted a major exhibition without any works by women or minorities. History was repeating itself. Women protested in 1970, and now they protested again, mounting a humorous performance with "Maurice Tuchman" cowboy masks and cowgirl commandos in hot pink (reflecting the spirit of the times). Unlike in 1970, this time there were no changes in museum practice or policy. Museum spokespeople's rebuttals were more assured, based on experience gleaned from women's own arguments for parity, and we found ourselves wondering, were we losing ground?

Feminists and radicals everywhere were asking themselves the same questions. The notion of backlash and its cyclically recurring nature has become part of recent feminist theory through Susan Faludi's book *Backlash: The Undeclared War Against American Women*, although the phenomenon had been noted by writers as long ago as the 1920s in the period following the passage of the 19th Amendment. "By the mid-80's," Faludi writes, "as resistance to women's rights acquired political and social acceptability, it [the most recent round of backlash] passed into the popular culture. And in every case, the timing coincided with signs that women were believed to be on the verge of a breakthrough."[12]

This perceived trend is relevant to ideological disputes among feminist artists. During the 1980s it became fashionable to dismiss much of the preceding decade's feminist art as essentialist. In the early 1990s, an exhibition of Judy Chicago's *The Dinner Party* planned for the Wight Gallery at the University of California at Los Angeles was contested by campus academic feminists on the grounds of its so-called essentialism. The politics of the essentialist/deconstructionist construction (wherein one group has labeled the other *other*; I've never heard *essentialism* used to describe one's own theoretical position) operate not only within the highly competitive world of art, but within the much larger cultural backlash. The trivialization

of 70s feminist art history coincides with a rise in art and art theory positioned within a stance of individual—rather than collective—identity, in a field where action seems naive and futile.

The activist and relational aspects of the art/audience paradigm remained largely uninvestigated during the 80s. Many artists held up as feminists during that era, such as Barbara Kruger and Cindy Sherman, initially aimed their work (which did draw upon themes and forms of popular culture) at art-world audiences, though their use of mass media and advertising language eventually led to the development of larger and larger audiences. Jenny Holzer's provocative work originated in community activism, and its nonagenda-driven interaction with broad audiences throughout the 80s is intriguing to consider in the context of 70s agenda-specific feminist art. In part, it was the critical context of the 80s that repositioned her work outside the activist paradigm. However, neither she nor other "new" feminist artists of the 1980s explored the aesthetics of interaction laid out by community-based feminist and political artists in the 1970s.

It was not until the end of the decade that younger artists seemed to rediscover this territory explored by 70s artists. This has resulted in the present confusion about what is political about art—subject, intent, or form—and how it can be evaluated as art.

The subversiveness of the attack by "theory" on 70s feminist art was that while it indeed developed important aspects of feminism, it seemed to disconnect us from activist issues, rarifying the debate by the obscurity of its language. Political change, based on what was taken to be a "utopian" social construction, was impossible. Deconstruction was the only possible action, and thus feminist art theory played to the cynicism of postmodernism. In the sparse rethinking of 70s feminist art that has appeared up to now, the nonrelational "identity" aspects of that work have been the focus, rather than the attempt by artists to reframe a relationship to society and to reconstruct artists' roles.

By reducing the diverse language and contexts of 1970s feminist artists to specific topics and static symbols (such as quilts and seedlings), theorists in the 80s played into the backlash. Seventies art about gender-based violence, for example, was not merely topical but an extension of identity—the physical body, its representation and action. The quilt was not simply a fixed visual symbol of women's indigenous labor, but a structure in which individual identity, contextualized by a collective, politicized whole, could be a multivocal expression. Judy Chicago's *The Dinner Party* was seen as a limited representation of the feminine rather than as a conceptual foray into reconstructing history, reframing popular culture, and addressing a mass audience.

The art/life task and its implications for an effective political art have been theorized largely *outside* the purview of the feminist discussion. But it is precisely the desire to address and include a broad populist audience and to explore the self in the context of other that connects 70s feminist art to the present time, laying the foundation for current theories in performance and public art. The practice of an interactive public art, for example, has led us to the threshold of a critical language that

analyzes the temporal, interactive, and change-oriented aspects of work as diverse as Mierle Laderman Ukeles's *Flow City*, a transfer station for New York garbage, and Rachel Rosenthal's many performances that draw upon contemporary ecological theory—both of whose theoretical origins are firmly embedded in 70s feminism. In both cases these works—one seen as public art installation and the other as theatrical performance—are linked not only by their subject matter but by their commitment to a legible and accessible language, to reaching a broad audience, and to proposing, even shaping, an activist and engaged audience response to the issue at hand.

THE HOUSE WAS ON FIRE: 1980

Although the 80s backlash against 70s feminist art served to disconnect its theoretical heritage, the activist agenda was nevertheless advanced through the work of artists of color, many of whom worked in performance, installation, and public art. The fascination with popular culture, high and low art, and the increasing numbers and strength of the minority voice fueled the growing public nature of art in the 80s.

Women artists of color challenged the authority of authorship posed by the white art world, a challenge that included a critique of the Feminist Art movement. I talked with Latina artist Judy Baca as I wrote this essay, in order to include this critique from a perspective other than mine, that of a white woman. Baca discussed her experiences during the 70s, caught between Latino and feminist camps.

> The problem was always the same—white feminists thought that they would determine how to approach and confront racism. They never came with the capacity to listen. They came because they were concerned with self-empowerment. Feminists of the 70s framed the dialogue and made the assumptions—first, that they should do it, and second, that they were uniquely poised to represent the world—the female world, when the majority of people in the world, even then, were not white. That gender is a unifying concept is an assumption. It assumes you are central. That is what we call "thinking white."
>
> One of the not-so-subtle attitudes in early feminism was that eventually we women of color would understand that our real political oppression was gender-based. The whole notion that somehow as a group of people we were impeding the women's movement through our refusal to leave our cultures of origin. It was the same thing our men said to us.

It is in the work of artists of color, many of them women, that individual identity in the 1980s remained connected to a sense of community, an activist agenda, and the necessity of relating to a broad and diverse audience. (Among younger white feminists, community per se was no longer in vogue.) According to Elaine Kim, literary critic from the University of California, Berkeley, questions of the essentialist versus the constructed aspects of identity were more complicated, and the theoretical divide not as pronounced for women of color as for white women. The experiences of women artists of color within their

Yolanda M. Lopéz. *Things I Never Told My Son about Being a Mexican*. 1984–93. Mixed media installation, 96 × 114″. Courtesy the artist

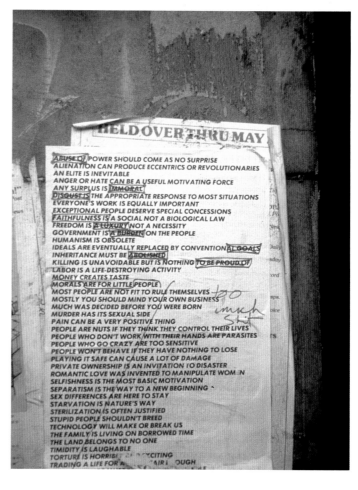

Jenny Holzer. *Selections from Truisms*. 1982. Offset ink on paper, 8 sheets, each 36 × 24″. Street installation, New York City. © Barbara Gladstone Gallery, New York

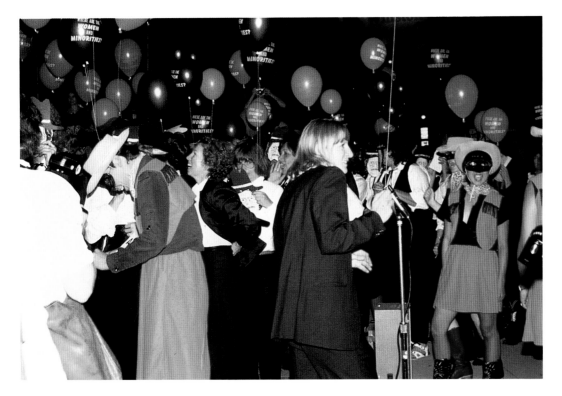

Women and minority artists wearing "Maurice Tuchman" cowboy masks and cowgirl commando outfits at a protest demonstration at the Los Angeles County Museum of Art, 1981. The demonstration was organized by Arts Coalition for Equality. Ruth Weisberg is in the foreground. Photograph by Linda Eber

own communities placed the larger cultural politics of oppression high on their agendas and underscored the link between identity and action, themes we see returning in the 90s. Judy Baca expresses the urgency of this connection.

> I feel, more than ever, race is the issue that will deconstruct democracy. In the United States we have abandoned inner-city schools, our prison population has increased six-fold over the last ten years, we spend four million dollars annually on graffiti abatement, but we have no educational programs, jobs, or recreation for our kids. We seem to be hell-bent on putting every child of color into prison rather than spend the money to send them to college. This is the dismantling of democracy. . . . We've basically developed an entire economy on the exploitation of one ethnic group after the other. In America we don't deal with the fundamental issues of race, economy, immigration. These were the concerns of our art. In our communities, the house was on fire.

BUILDING BRIDGES: 1990

Spurred by 80s feminist theory, ethnic, and gay activism,[13] certain issues have been repositioned, shifted from the outside to the inside. Subjects of AIDS, U.S. intervention in Central America, and violence against women are commonly included in exhibitions. More artists of color are visible, influencing entrenched aesthetic values. Yet while it is no longer out of vogue to be a political artist as it was in the 1970s, activism is still problematic. The problem of cooption remains prevalent, supporting the divorce of style from meaning and eliminating the

history, theory, and values upon which the work is founded.

For example, work produced by the early pioneers of the Latino art *movimiento*—Judith Baca, Jose Montoya, and Rupert Garcia, among others—was tied in the late 1960s and early 70s to indigenous communities and rooted in Mexican aesthetics. The relationship between self-expression, identity, and power was well understood. But with the "Latino Boom" in the 1980s, the fundamental political analysis and grass-roots connections upon which such work was built were obscured by an emphasis on its visual appearance. Likewise, the pioneering work of 1970s artists on gender crimes and violence against women is virtually ignored by critics. Artists appear to be reacting only to today's popular cultural influences when they make art on domestic violence, rape, incest, incarceration, and prostitution. The result is art that has a stylized "look," or that remains topical, but is naive in its intervention strategies. Activism is pitted against analysis, with a clear-cut art-world bias toward the latter, one that recalls its condescension toward political and community-based art of the 70s. The dialectic between analysis and action is valuable, but only if it is contextualized by the embrace of a larger collective project of social change.

Granted, the definition of feminism and what constitutes social change is different for different people, but it often appears that the commitment to the whole—the whole body of women, of racial equality, of political struggle, of history—is missing from contemporary debate. That's where the question, "in whose interest," comes in. Who gains if history is forgotten? Who gains if feminism in a new, theoretical, abstract stance is allowed into the academy and those scruffy activists are left, once again, outside? If low-riders and zoot-suiters are in and muralists out? If it's enough to simply evoke the name of Hiroshima in a high-

rent gallery to be called political art? While the language to interrogate history was popularized during the 80s, feminist and ethnic artists from the prior decade understood that both the presentation *and* the forgetting of history always contains a political agenda.

The art world's premium on originality and authorship make remembering a dangerous business indeed. At the Society for Photographic Education conference in Houston in 1988, I sat in the audience watching a slide show about high heels as a critic deconstructed pornography. I remembered (although no one else, including the speaker, seemed to) the pioneering work of the group Women Against Violence Against Women, artists whose slide shows in 1976, twelve years earlier, featured a similarly pointed and specific analysis (down to the details of how spike heels are arranged pointing phallically toward the vagina). And I wondered if the reason their deconstruction was forgotten was because it ended in a protest march? At an exhibition I mused over Cindy Sherman's self-portraits and I couldn't rid myself of the disturbing feeling that I was witnessing an originating impulse of feminism, an irony I have seen repeatedly when women artists first encounter the discrepancy between interior and exterior definitions of woman. In particular, I remembered how in 1969, in the Fresno Feminist Art Program, we intuitively photographed ourselves as stereotypical images of women. I studied the slides left from these experiments—a woman in a bridal gown staring pensively, a seductress beckoning, a kewpie doll with head tilted stupidly and arms akimbo. Less elaborated as images, but isn't there a connection?

Debates about women's *essential* versus her *constructed* nature seem, like earlier arguments about whether gender or race was more important in the construction of identity, to divide rather than to stimulate. Perhaps deconstruction and essentialism would better be seen as temporary strategies, rather than fixed positions, to be adopted at various times depending upon the situation.[14] A black woman artist may use essentialism to claim a territory unique to her racial experience and later deconstruct the representation of her identity within a white dominant culture. If this is the case, the question to be considered is no longer where, on the theoretical continuum, an artist's

work can be "fixed." Rather, it shifts the debate to one of intention and strategy. Toward what end are we analyzing? For what reason are we acting?

When theory is disconnected from activism the notion of identity is bereft of a discussion of values. When activism is disconnected from its history, the real political agenda must be continuously reinvented. The questions feminist and ethnic artists raised in the 70s, ones that signaled a profound departure from existing notions of art, are present today in the work of artists of color, performance artists, and public artists. This larger vision of feminist art—embracing art as an agent in social transformation—is a radical legacy that must be reclaimed, since the questions asked today by younger artists are so similar to those upon which our work was built.

In a decade in which multiple voices and histories are surfacing, we are in an astoundingly vital moment, one with a difficult charge of connecting radically diverse themes and interests from the last twenty-five years of feminist, political, and ethnic art practice and theory. Our task is to investigate and construct links among practices based in identity, ethnicity, social analysis, ecology, politics, and community, to name a few, and to look for common values and points of collective action.

This integrative task, urgent for our times, comes with a caveat, one we perhaps did not realize in our enthusiasm in the early 70s. Judy Baca concluded our interview with it:

Ethnicity won't join a white feminist agenda. It will transform it. It will become the central agenda of feminism, as rightly it should, because we are the majority. I think what's going to happen is that the groundwork laid by white feminists of the 70s, that body of knowledge, will be a resource, but we will have to redefine it according to the experience of women of color. The longing to connect is not a breakfast food. You cannot have it instantly. I can't relate to the universality of all women. We make these bridges tentatively, we don't make assumptions, we build a relationship slowly, like you and I have, over seventeen years. It's a long struggle, a long time building bridges.

Cindy Sherman. *Untitled Film Still.* 1979. Black-and-white photograph, 100×8″. Courtesy Metro Pictures, New York

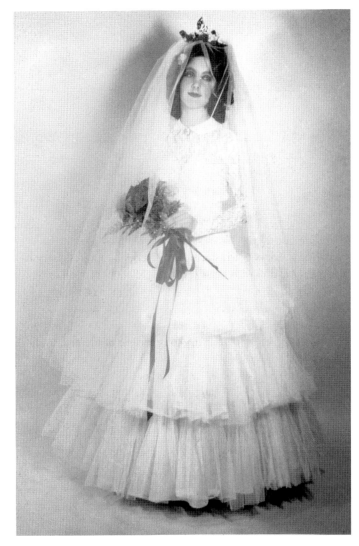

Shawnee Wollenman. *The Bride.* 1969. Color photograph. Private collection

THE FEMINIST CONTINUUM: ART AFTER 1970

BY LAURA COTTINGHAM

Martha Rosler. *Vital Statistics of a Citizen, Simply Obtained.*
1977. Videotape, color, 40 minutes. Courtesy of artist.
Photograph, Visual Studies Workshop

Writing in 1980, American feminist art's primary critical ally, Lucy Lippard, reflected that "perhaps the movement's greatest contribution has been its lack of contribution to Modernism."[1] In the same year, America's foremost conservative art critic, Hilton Kramer, rhetorically asked whether the "influence of the women's movement [hadn't] contributed to an erosion of critical standards in art?"[2] By 1980, the Women's Liberation Movement and its sister art movement had ceased to exist as mass popular movements. But feminist art's chief defender and one of its staunchest antagonists agreed upon the nature of its influence: the Feminist Art movement was antithetical to the aims of Euro-American modernism.

An assault on modernism surfaced defiantly within the Feminist Art movement of the 1970s; its explorations were led without serious regard for the most fundamental prerequisites of what comprised art and artistic value according to the dominant assumptions of post-World War II Euro-American aesthetics. Feminism asserted that art, like "the personal," is political. The movement refused a formalist imperative, insisted on the importance of content, contested the absoluteness of history, favored collective production, asserted a place for the autobiographical, reclaimed craft, emphasized process and performance, and, perhaps most radically, refuted the idea that art is neutral, universal, or the property of men only. At the same time, the movement was in no sense antiart; rather, its adherents wanted a "new" art, one inspired by the transformative possibilities invested in radical feminism.

The movement was decisively "anti" rather than "post" modernist. It was neither ironic, relativistic, cynical, nor anything less than utopian. Like their activist sisters from whom they borrowed both theory (Simone de Beauvoir's *The Second Sex*, Shulamith Firestone's *The Dialectic of Sex*, Kate Millet's *Sexual Politics*) and practice (consciousness-raising), feminist artists sought to forge a new (art) world from a new consciousness. Feminism originated, after all, from women's feelings and observable experience that something was "wrong"—with the way their lives as women were subordinated to the lives of men and children, and with the way fine art, a supposedly "enlightened" cultural arena, assisted in the ideological devaluation and material exclusion of women from political and cultural power. Through their new "consciousness," feminists felt they could change not just their own lives, but society itself. Lucy Lippard has described the process this way: "A developed feminist consciousness brings with it an altered concept of reality and morality that is crucial to the art being made and to how life is lived with that art. We take for granted that making art is not simply 'expressing oneself' but is a far broader and more important task—expressing oneself as a member of a larger unity, or comm/unity, so that in speaking for oneself one is also speaking for those who cannot speak."[3]

Although utilized in various ways by different individuals and groups, consciousness-raising was the primary method used as a catalyst for the making of feminist art during the 1970s.[4] The particular collusion between artists and activists of the Women's Liberation Movement during the 70s was a kind of historical anomaly: although a shared aim between artists and activists is common, if not necessary, to a political liberation

B

D

277

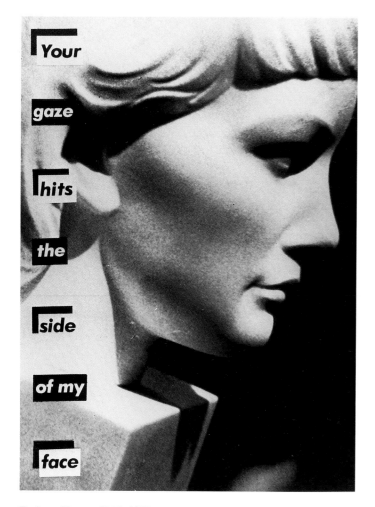

Barbara Kruger. *Untitled* ("Your gaze hits the side of my face").
1981. Photograph, 60 × 40″. Collection Vijak Mahdavi and
Bernardo Nadal-Ginard. Courtesy Mary Boone Gallery, New York

movement, there is no other historical example of artists literally borrowing and utilizing, as an aesthetic method, the same practice used by activists to further political change. Perhaps the most direct art-historical parallel to America's Feminist Art movement is the Russian and Soviet avant-garde that occurred from 1915 to 1932; both movements were led by a utopian vision based on a euphoric ideological awakening that critiqued bourgeois modernist art as a site of political oppression.[5]

Since the early 1980s, "postmodernity" has become the nomenclature most commonly used to group new American art. In many ways this is a completely inadequate, if not decisively erroneous, term for describing the kind of consciously antimodernist practices that have dominated developments in American visual culture since the 70s. Although postmodern is sufficient as a nomenclature for locating a historical period, it is unacceptable as a generalized category overlaid upon the diverse varieties of visual art practices which do not adhere to modernist, especially Greenbergian, assumptions. For instance, the most critically and commercially successful American women artists who found international recognition during the 80s—Jenny Holzer, Barbara Kruger, Sherrie Levine, and Cindy Sherman—are routinely categorized as postmodern. But their art developed and has been received according to and as a result of 70s feminism. If their works do not formally resemble the raw, visceral, emotive practices most often associated with 70s feminist art, their strategies are nonetheless derived from the intellectual and aesthetic concerns that preoccupied first-generation feminist artists. If the visual appearance of post-70s feminist-influenced works often resembles that of their non- or antifeminist contemporaries, the tone and content of their work is still more similar to 70s feminism than to that of Richard Prince, Jeff Koons, or David Salle—artists whose works repeatedly uphold sexist assumptions but with whom Holzer, Kruger, Levine, and Sherman are nonetheless regularly grouped.[6] Kruger even provides a direct formal and ideological link to the 70s; her submission to the 1973 Whitney Museum of American Art Biennial, *2 A.M. Cookie-Big*, 1973, was a fabric floor piece made from ribbons and patchwork quilting. To situate Kruger, Levine, Holzer, Sherman, and other feminist-influenced artists under the totalizing umbrella of postmodernism erases their 70s antecedents and denies the political imperative of their art.

But most discussions of artistic influence are unfortunately still framed within a formalist paradigm that situates artistic developments in relationship to physical similarities while denying the existence of emotive or intellectual continuums. The legacy of feminism is particularly misunderstood if forced into a formalist lineage of style because 70s feminism was a consciously anti-formalist, cross-media movement. Its refusal to accept modernism's hegemonic preference for painting and sculpture, its embrace of new forms such as video and performance, and its generalized suspicion of any hegemony of form are among the movement's most definitive features. The stylistic breadth of the first generation of feminist art was wide enough to have incorporated Suzanne Lacy's demonstrations against rape, Faith Ringgold's quilts, Miriam Schapiro's femmages, Lynda Benglis's *Artforum* advertisement of herself naked with a dildo, Martha Wilson's performative interrogation of cosmetics, Dara

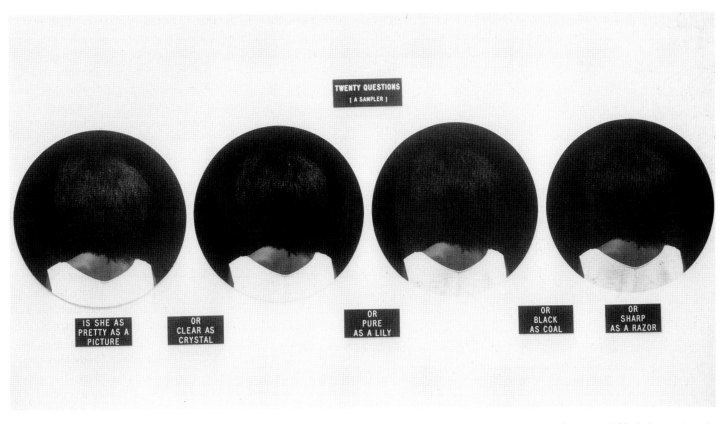

TWENTY QUESTIONS
[A SAMPLER]

IS SHE AS
PRETTY AS A
PICTURE

OR
CLEAR AS
CRYSTAL

OR
PURE
AS A LILY

OR
BLACK
AS COAL

OR
SHARP
AS A RAZOR

Lorna Simpson. *Twenty Questions.* 1986. 4 silver prints and 6 plastic plaques, each photograph 24" diameter. Courtesy Josh Baer Gallery, New York

Birnbaum's Wonder Woman, Eleanor Antin's photographic and sculptural "portraits," Betye Saar's personalized assemblages, Mierle Laderman Ukeles's maintenance works, Harmony Hammond's shamanistic fabric pieces, Sylvia Sleigh's realist paintings, Martha Rosler's videotapes, Hannah Wilke's utilization of her own nude body as medium, Barbara T. Smith's investigations of personal life, Mary Kelly's use of Lacan, Joan Jonas's videos and performances, Nancy Spero's female goddesses, Ana Mendieta's earth-body works, Audrey Flack's Photorealism, Nancy Graves's cascading ceiling pieces, Nancy Grossman's lithographs of gun-wielding men, Judy Chicago's porcelain plates, Mary Beth Edelson's feminized re-creation of *The Last Supper*, Adrian Piper's racially-conscious conceptual works, Joan Snyder's expressionist canvases, Faith Wilding's enactments of female experience, Elaine Reicheck's compositions in organdy, Ree Morton's scattered domestically-coded installations, Joan Semmel's re-renderings of the female nude, and Joyce Kozloff's public art works enacted in tile—these are only a few of the feminist-influenced gestures from the 70s; and most of these artists are still alive and producing work.

For most American women artists since 1970, including those who have come of age during the 80s and 90s, some understanding of feminist theory and history is as central to understanding their work as any art history is. A conscious incorporation of feminist insights is explicit in late 80s and early 90s works, such as Lorna Simpson's racially-conscious photo and text installations, Lynne Yamamoto's autobiographical sculptures, Polly Apfelbaum's fabric constructions, Nicole Eisenman's wall drawings, Liz Larner's soft knots and wax forms, Deborah Kass's appropriations of Andy Warhol, Erika Rothenberg's politicized greeting cards, Lorraine O'Grady's race-conscious performances and portraits, Sue Williams's visceral renderings of female victimization, Janine Antoni's body works, Karen Finley's subjectively-female performances, Beverly Semme's clothing sculptures, Catherine Opie's cross-dressing portraits, Andrea Fraser's museum interventions, Susan Silas's conceptual works, Zoe Leonard's photographic explorations in museography, Marlene McCarty's text-based canvases, Holly Hughes's lesbian-explicit performances, Rona Pondick's psychologically-suggestive body sculptures, Ilona Granet's billboards for abortion rights, Cheryl Donegan's video send-ups of Abstract Expressionism, Patty Matori's domestics of violence, Lauren Szold's floor spills, Ann Hamilton's feminization of the Protestant work ethic, Ashley King's female confessions, Marilyn Minter's portraits of sex and food, Mary Weatherford's floral paintings, Carrie Mae Weems's photographic documents of identity, Ava Gerber's feminized sculptural assemblages, Catherine Howe's interrogations of painterly styles and imagery, Rachel Lachowitz's works in lipstick, Julia Scher's surveillance monitors, Jessica Diamond's wall paintings, Annette Kapon's bathroom-scale comment on

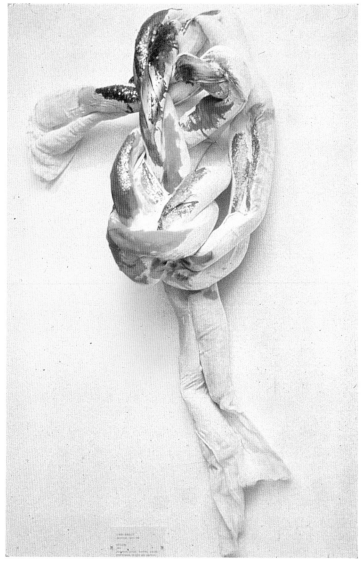

Lynda Benglis. *Epsilon*. 1972. Wire mesh, bunting, gold, plaster paint, and enamel, 37 × 30 × 12″. Courtesy Paula Cooper Gallery, New York

Cheryl Donegan. *MakeDream*. 1993. Videotape, color, sound, 3 minutes 21 seconds. Courtesy of artist

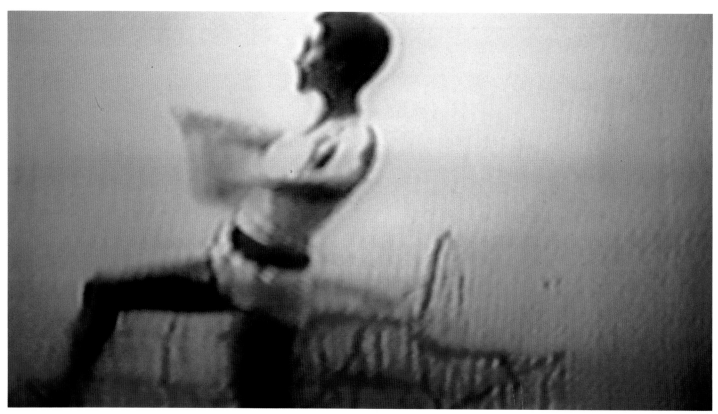

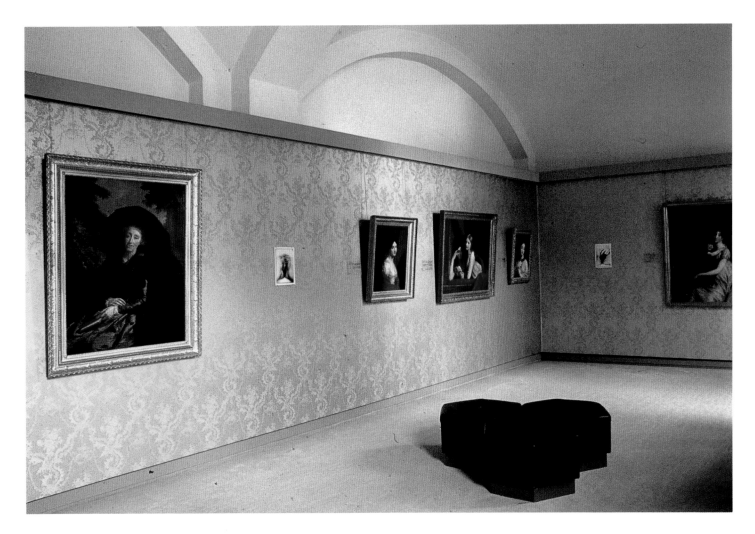

Zoe Leonard. Untitled installation (two views). Documenta IX, Kassel, Germany, June 13–September 20, 1992. Courtesy Paula Cooper Gallery, New York

male Minimalism, Karen Kilimnik's girlish scatters, Jane Hammond's randomly generated images, Paula Hayes's domestic floor assemblages, Kay Rosen's word plays, Millie Wilson's *Museum of Lesbian Dreams*, Chysanne Stathacos's hair paintings, Kiki Smith's bodily forms, Sadie Benning's youthful videos of lesbian love, Cady Noland's Patty Hearst, Robin Kahn's embroidered fabric pieces, and Kathe Burkhardt's "bad" paintings. All of these artists incorporate an understanding of women's experience—and of women's historical devaluation and cultural exclusion—in their works.

Since the early 80s, when Sherrie Levine first exhibited a series of rephotographed images of well-known male photographers, such as Edward Weston and Walker Evans, feminist-conscious "appropriation" works that directly confront, and attempt to subvert, the masculinized canon of twentieth-century American art history have begun to appear. While first-generation feminist artists attempted to rewrite art-historical consciousness by rediscovering and celebrating women artists from previous centuries, subsequent feminist artists have shown a preference for critiquing male artistic practices rather than retrieving female ones. In Cheryl Donegan's 1993 video, *MakeDream*, the artist uses her gyrating hips to produce a blue painting from pigment that spews from a plastic container suspended from her waist, thus mimicking the penile projections of American Abstract Expressionism. As a comment on the authoritative stance of Richard Serra's monumental sculptures, Rachel Lachowitz's *Sarah*, 1992, uses red lipstick to re-create and mock one of the male Minimalist's metal constructions. Susan Silas's *We're Not Out of the Woods Yet*, 1990, includes an Anselm Kiefer photograph from the late 1960s that acts as a challenge to Kiefer's relationship to Nazism. Mary Weatherford has incorporated Jasper Johns's signature targets into images of flowers, thus reclaiming Pop through a play of feminization; Deborah Kass has re-created male nudes in the style of David Salle to call attention to that artist's objectifications of the female nude; and Sue Williams has presented her own repaintings of Richard Prince that take issue with Prince's "jokes" at women's expense.

Another difference between 70s feminist art and its contemporary progeny includes a movement away from the generalized idea of "woman" that guided so much of the early work. The feminist-inspired art being produced in the early 90s is more likely to directly address differences among women, such as race and ethnicity, as in Lorraine O'Grady's, Carrie Mae Weems's, Lorna Simpson's and Renee Green's double-valenced explorations of being black and female, and the Japanese-American experiential basis of Lynne Yamamoto's art; and sexual identity, including the very recent emergence of lesbian content in works by Sadie Benning, Nicole Eisenman, Daphne Fitzpatrick, Holly Hughes, Nan Goldin, Deborah Kass, Leone & MacDonald, Catherine Opie, Collier Schorr, Millie Wilson, and Zoe Leonard.

Feminist-inspired artists working in the 80s and the 90s have less of a sense of themselves as a "movement," in part due to the collapse of alternative structures. While the 70s movement was far from a unified front, it was united by an alternative structure of newsletters, slide registries, journals, and cooperative galleries that, except for a very few—such as the A.I.R. and Soho 20 galleries in New York, or the occasionally-

Sue Williams. *A Funny Thing Happened.* 1992. Acrylic on canvas, 48 × 42". Courtesy 303 Gallery, New York

Susan Silas. *We're Not Out Of The Woods Yet.* 1990.
Photograph, glass and steel, 13½ × 18¼″. Collection Barbara
and Howard Morse. Courtesy Jose Freire Fine Art, New York

I remember very well being in the 6th Grade. But I remember going into the kitchen, and nothing was cooking, and then I heard the water running. So I went to the *furoba* (bath house), and then I can't remember . . .

from interview with Carol, December 21, 1992

Lynne Yamamoto. *Wash Closet* (detail). 1993. Mixed media installation. Courtesy Information Gallery, New York

published *Heresies* journal—no longer exist. Still, there have been a few successful institutional transformations generated by and since the 70s, including the New York performance center, Franklin Furnace, whose founder and director, Martha Wilson, was one of the most active performance artists in the 70s milieu; or The New Museum, New York, which was founded by a former Whitney Museum curator and feminist, Marcia Tucker. In 1991, Trial Balloon, directed by the British artist Nicola Tyson, opened in New York as an all-woman, semi-commercial gallery—perhaps the first all-woman exhibition space to open in New York in twenty years. Trial Balloon has been especially influential in showcasing work by lesbian artists and art that deliberately addresses lesbian experience.

Most contemporary feminist-influenced art is not as dependent on an alternative, separatist exhibition structure because of its partial integration into the dominant commercial gallery and museum matrix: almost every major downtown New York gallery represents at least one artist who could accurately be described as feminist. In the first few years of the 90s, there was partial movement away from the austerity of the photo-and-text works that dominated 80s New York art, and a return to the possibilities found in the funkier and more emotive strategies associated with 70s feminism. Artists such as Polly Apfelbaum, Janine Antoni, Nicole Eisenman, Ava Gerber, Robin Kahn, Rona Pondick, Kiki Smith, Chrysanne Stathacos, and Sue Williams are among those involved with visual strategies that suggest a kind of return to the personalized, consciously un-slick aesthetics of the 70s. Antoni, who, like Smith and Williams, was featured in both the 1993 Whitney Museum and Venice Biennials, acknowledges a debt to first-generation feminist art in her works (like Hannah Wilke before her, Antoni has cast her body in chocolate) and in her understanding of her art. As Antoni notes: "My strategy has more to do with the feminist artists of the 70s—the humor, the process, the emphasis on performance, the intensely visceral quality of their work. The 80s feminists used a language that was already respected and they put their content in it, whereas the 70s feminists were much more extreme, and they have paid for it by being dismissed."[7]

"Post-68" could, in fact, have been the subtitle of the 1993 Whitney Biennial Exhibition, the so-called politically correct or multicultural Biennial. The exhibition included 70s feminist artists Maureen Connor, Ida Applebroog, and Nancy Spero, along with other feminist-influenced works by Janine Antoni, Shu Lea Cheang, Leone & MacDonald, Alison Saar, Kiki Smith, Sue Williams, and others. But rather than acknowledge the historical continuity of the politicized gestures of artists engaged with feminism, racism, gay rights, and other social issues, the majority of American critics preferred to damn the 1993 Biennial, like the reviewer for *New York Magazine* who bemoaned the exhibition as "one extended exhibitionist frenzy of victimization and self-pity."[8] While 70s feminism produced the largest and most influential activist-inspired art movement, the insights and demands of all 60s American activism, especially those of the Black Power and Gay Rights mobilizations, continue to form and inform the direction of American social, political, and cultural life. But the criticism around consciously political artistic gestures is consistently more conservative in its aesthetics and its politics than is a great deal of art currently being produced in the United States. It is within this generalized antipolitical and ahistorical critical climate that the influence of feminism, like the influence of Black Power and Gay Rights, has been eliminated, minimized, and denied.

The inchoate influence of 70s feminist art, especially its ambitious hope for a "conscious art," persists in recent American art that constructs personal narrative within an understanding of political exigency. Other contemporary artists, not specifically feminist, produce work that conforms to the feminist model of rendering the personal within the realm of the political. If feminism is not singularly responsible for creating this new movement of content-based work, it nonetheless provided the initial ideological support that both validates and encourages the politicization of aesthetics. Most of the politically conscious new American art that is not explicitly feminist has direct roots in

Ava Gerber. *Sisterhood.* 1992. Mixed media, wire and aprons, 5 × 5 × 3′. Courtesy Jose Freire Fine Art, New York

the other mass activist movements of the late 60s. Artists such as Felix Gonzalez-Torres, John Lindell, and Donald Moffet utilize both personal and historical information to forefront their concerns as gay men living during the AIDS epidemic in a homophobic society. Similarly, the development of a visual language for the investigation of racism in the United States has been deployed in the work of numerous contemporary artists working after the ground-breaking work of Adrian Piper, Faith Ringgold, and Betye Saar, including Renée Green, Glenn Ligon, Lorna Simpson, Gary Simmons, and Fred Wilson.

Without the feminist agitation and aesthetic innovations of the 70s, many subsequent American artists—most especially those who are female—would not have had the subject matter,

critical support, or the opportunity for high-level commercial recognition that is now somewhat possible, even though the contemporary American visual art structure continues to critically and economically overvalue the contributions of men and to undervalue those of women.

As an activist movement, feminism forced the American fine-art system to end its exclusionary, men-only practices; even women who do not incorporate a feminist understanding into their art are indebted to 70s feminism for this. Similarly, the influence of feminism on the development of art and art theory expands outward from consciously feminist practices—even when that influence is expressed in backlash, usurption, or denial—and affects every current of American art since 1970.

Sadie Benning. *It Wasn't Love.* 1992. Videotape, black and white, 20 minutes. Courtesy Video Data Bank, Chicago

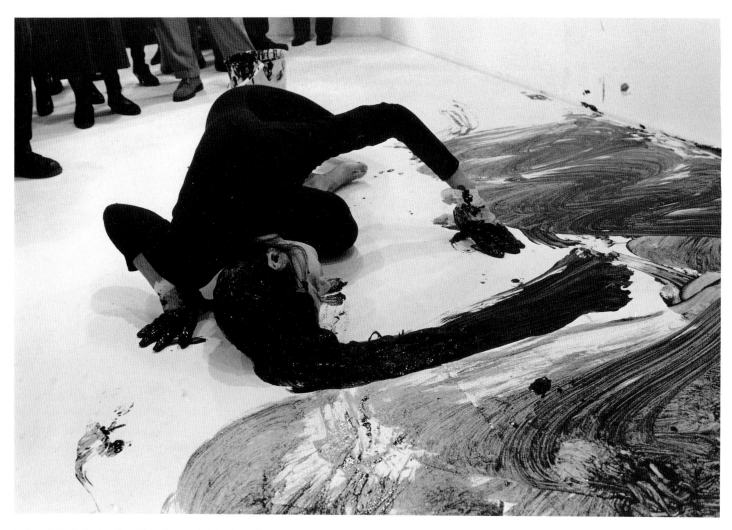

Janine Antoni. *Loving Care* ("I soaked my hair in dye and mopped the floor with it"). Performance at Anthony D'Offay Gallery, London, 1975. Courtesy Sandra Gering Gallery, New York. Photograph by Prudence Cuming Associates Ltd, London

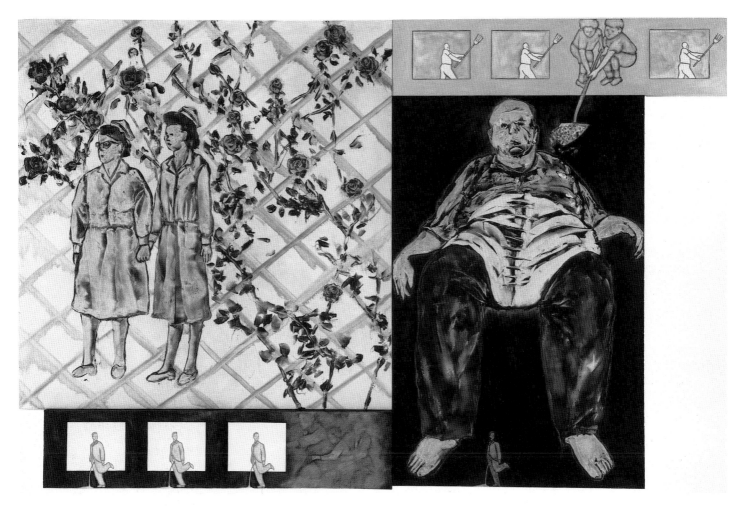

Ida Applebroog. *ooze/whose*. 1991. Oil on canvas (4 panels),
86 × 136″. Courtesy Ronald Feldman Fine Arts, New York

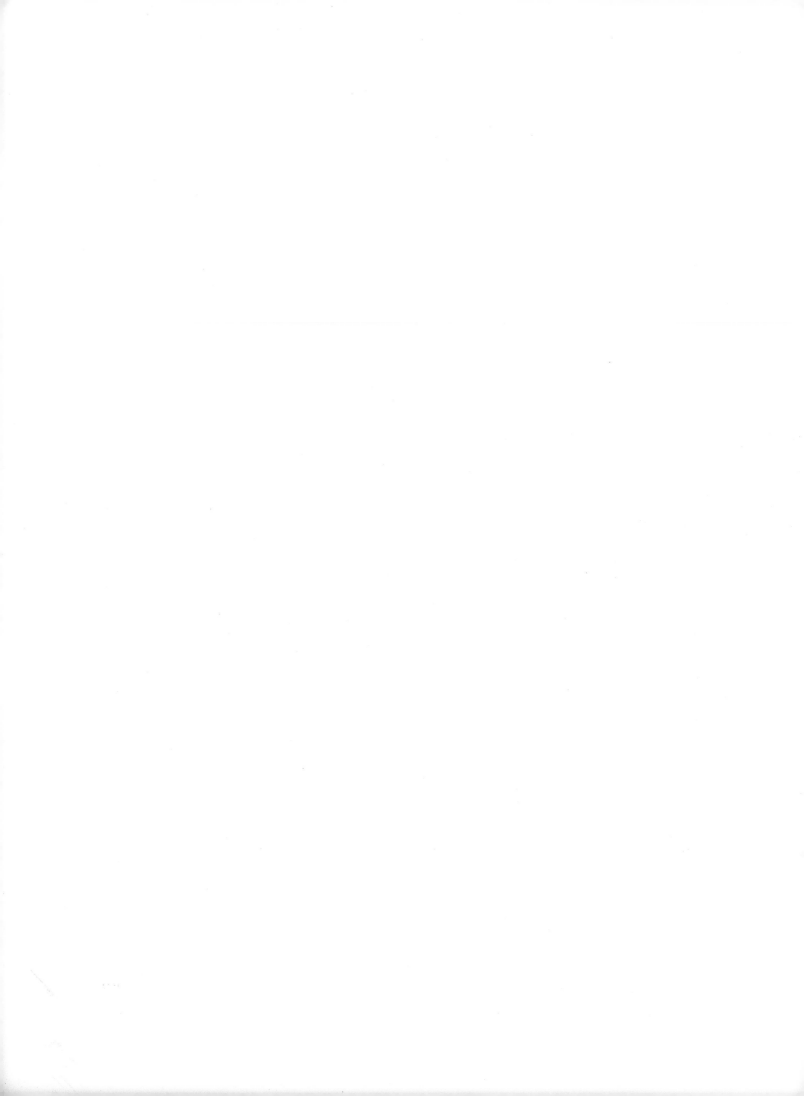

NOTES

Broude and Garrard / Introduction

1. Ruth Iskin, quoted in Lucy R. Lippard, "Sweeping Exchanges: The Contribution of Feminism to the Art of the 1970s," *Art Journal* 39 (Fall/Winter 1980): 362–65.

2. Morris Dickstein, *Gates of Eden: American Culture in the Sixties* (New York: Basic, 1977), x.

3. Lippard, "Sweeping Exchanges," 362 and n.3.

4. Today, postmodernism is more frequently linked with poststructuralist concepts such as the "death of the author" thesis, advanced independently by Roland Barthes and Michel Foucault in the late 1970s. But it is important to emphasize that the intellectual ground had already been broken by feminist artists and art historians. For discussion of the relationship of feminist art history to postmodernism, see Norma Broude and Mary D. Garrard, eds., *The Expanding Discourse: Feminism and Art History* (New York: HarperCollins, 1992), 1–7.

5. On the theoretical framework for women's "different voices," see Carol Gilligan, *In a Different Voice: Psychological Theory and Women's Development* (Cambridge: Harvard University Press, 1982).

6. On postmodernism's perpetuation of modernism's strategies, see Norma Broude, *Impressionism, A Feminist Reading: The Gendering of Art, Science, and Nature in the Nineteenth Century* (New York: Rizzoli, 1991), 179.

7. See Tamar Garb, "*L'art feminin*: The Formation of a Critical Category in Late Nineteenth-Century France," in Broude and Garrard, *Expanding Discourse*, 206–29.

8. Anthea Callen, *Women Artists of the Arts and Crafts Movement, 1870–1914* (New York: Pantheon, 1979), esp. 214–22.

9. Wanda M. Corn, "Women Building History," in Eleanor Tufts, *American Women Artists, 1830–1930*, exh. cat. (Washington, D.C.: National Museum of Women in the Arts, 1987), 26–34. See also Judith Paine, "The Women's Pavilion of 1876," *Feminist Art Journal* 4 (Winter 1975/76): 5–12.

10. See Jeanne Madeline Weimann, *The Fair Women* (Chicago, 1981), cited by Corn, "Women Building History."

11. Lisa Tickner, *The Spectacle of Women: Imagery of the Suffrage Campaign, 1907–1914* (Chicago: University of Chicago Press, 1988).

12. See Gloria Orenstein, "Women of Surrealism," in *Feminist Collage: Educating Women in the Visual Arts*, ed. Judy Loeb (New York: Columbia University Teachers College Press, 1979), 35–58, first published in *Feminist Art Journal* 2 (Spring 1973): 1 and 15–21; and Whitney Chadwick, *Women Artists and the Surrealist Movement* (Boston: Little, Brown, 1985).

13. See Barbara Lynes, "Georgia O'Keeffe and Feminism: A Problem of Position," in Broude and Garrard, *Expanding Discourse*, 437–49.

14. See Helen Langa, "Egalitarian Vision, Gendered Experience: Women Printmakers and the WPA/FAP Graphic Arts Project," in Broude and Garrard, *Expanding Discourse*, 409–24.

15. Cindy Nemser, *Art Talk: Conversations with Twelve Women Artists* (New York: Charles Scribner's Sons, 1975), 85.

16. On the dynamics of the artist-couple during the first half of the twentieth century, see the essays in *Significant Others: Creativity and Intimate Partnership*, ed. Whitney Chadwick and Isabelle de Courtivron (New York: Thames and Hudson, 1993). On Krasner's struggle to establish and maintain her separate identity as an artist during her years with Pollock, see Anne Wagner, "Lee Krasner as L.K.," in Broude and Garrard, *Expanding Discourse*, 425–36, and also the comments of Grace Hartigan in an interview with Cindy Nemser in Nemser, *Art Talk*, 151–52.

17. Clement Greenberg, *The Collected Essays and Criticism*, ed. John O'Brian, 2 vols. (Chicago: University of Chicago Press, 1986), 1: 209–10; as cited by Wagner, "Lee Krasner as L. K.," 428 and 435 n.8.

18. Stephen Westfall, "Then and Now: Six of the New York School Look Back," *Art in America*, June 1985, 114.

19. Moira Roth, "Interview with Miriam Schapiro," in *Miriam Schapiro: The Shrine, the Computer and the Dollhouse*, exh. cat. (La Jolla: University of California, San Diego, Mandeville Art Gallery, 1975), 11.

20. H. W. Janson, interview, *Women Artists' News*, September/October 1979, 12.

21. Eugene C. Goossen, *Helen Frankenthaler* (New York: Whitney Museum of American Art, 1969), 9.

22. Lee Krasner, quoted in Grace Glueck, "Scenes from a Marriage: Krasner and Pollock," *ARTnews*, December 1981, 61.

23. On Frankenthaler, see the remarks of Cindy Nemser and Louise Nevelson, in Nemser, *Art Talk*, 4 and 68.

24. Krasner, Statement in *Art: A Woman's Sensibility*, (Valencia: California Institute of the Arts, Feminist Art Program, 1975), 39.

25. Grace Hartigan, quoted in Nemser, *Art Talk*, 151.

26. Hartigan, quoted in *Twelve Americans*, ed. Dorothy C. Miller, exh. cat. (New York: Museum of Modern Art, 1956), 53.

27. Hartigan, quoted in Nemser, *Art Talk*, 158.

28. Ibid, 157–58.

29. E.g., Lucy R. Lippard, "Eva Hesse: The Circle," *Art in America*, May/June 1971, 68–73; see also Lippard, *Eva Hesse* (New York: New York University Press, 1976), esp. 205–10.

30. Hesse, quoted in Nemser, *Art Talk*, 214.

31. Ibid, 209–10.

32. Michael Kimmelman, "Louise Bourgeois Comes into Her Own at 80," *New York Times*, Sunday, August 30, 1992, sec. 2, pp. 1 and 27.

33. Whitney Chadwick, *Women, Art, and Society* (New York: Thames and Hudson, 1990), 303.

34. See Hartigan's comments in an interview with Stephen Westfall, "Then and Now," 119.

35. See the review by Vicki Goldberg, "Grace Hartigan Still Hates Pop," *New York Times*, Sunday, August 15, 1993, sec. 2, pp. 30–31.

36. Roberta Smith, "Haunting Works from the 60s," *New York Times*, Sunday, October 3, 1993, sec. 2, p. 42.

37. Miriam Schapiro and Judy Chicago, "Female Imagery," *Womanspace Journal* 1 (Summer 1973): 13.

38. Miriam Schapiro, interview by Norma Broude, summer 1993. See also Bontecou's own statement in Eleanor Munro, *Originals: American Women Artists* (New York: Simon and Schuster, 1979), 384.

39. Judith Papachristou, ed., *Women Together: A History in Documents of the Women's Movement in the United States* (New York: Knopf, 1976), 23.

40. See Claes Oldenburg, *Store Days, Documents from The Store, 1961, and Ray Gun Theater*, selected by Oldenburg and Emmett Williams (New York: Something Else Press, 1967). Ray Gun, said Oldenburg, saw man as "only alive when he is constantly arranging to upset his existence, when he is solving situations." Quoted in Barbara Rose, *Claes Oldenburg*, exh. cat. (New York: Museum of Modern Art, 1970), 46.

41. Judy Chicago, statement in *Artforum*, September 1974, quoted in Lippard, "Sweeping Exchanges," 362.

42. Lisa Tickner, "The Body Politic: Female Sexuality and Women Artists since 1970," *Art History* 1 (July 1978): 239.

43. Joan Semmel, quoted in Dorothy Seiberling, "The Female View of Erotica," *New York Magazine*, February, 1974, 55.

44. Gloria Orenstein, "The Reemergence of the Archetype of the Great Goddess in Art by Contemporary Women," *Heresies: A Feminist Publication on Art and Politics*, Issue 5 (Spring 1978), 74–78. For feminist theology of the period, see Mary Daly, *Beyond God the Father: Toward a Philosophy of Women's Liberation* (Boston: Beacon Press, 1973) and Merlin Stone, *When God Was a Woman* (New York: Dial Press, 1976). A valuable recent overview is Elinor W. Gadon, *The Once and Future Goddess: A Symbol for Our Time* (San Francisco: Harper & Row, 1989). Mary Beth Edelson, "An Open Letter to Thomas McEvilley," *New Art Examiner*, April, 1989, 34–38, usefully clarifies the intentions of Goddess-focused artists.

45. Lippard, "Sweeping Exchanges," 363–64.

46. Joyce Kozloff, letter to the authors, July 16, 1990.

47. Cixous, from "Sorties" in *New French Feminism: An Anthology*, ed. Elaine Marks and Isabelle de Courtivron (New York: Schocken, 1980), 96; originally published in *La jeune née*, Union Générale d'Editions, 10/18, 1975.

48. Constance Penley, ed., *Feminism and Film Theory* (New York: Routledge, 1988), 5.

49. Judith Barry and Sandy Flitterman-Lewis, "The Politics of Art-Making," in *Feminist Art Criticism: An Anthology*, ed. Arlene Raven, Cassandra Langer, and Joanna Frueh (1988; New York: HarperCollins, 1991), 89. A useful discussion of the poststructuralist critique of essentialism (or "cultural feminism") is Linda Alcoff, "Cultural Feminism versus Poststructuralism: The Identity Crisis in Feminist Theory," *Signs: Journal of Women in Culture and Society* 7 (Spring 1988): 405–37. For a rigorous philosophical analysis of the "bad rap" that essentialism has received, see Diana Fuss, *Essentially Speaking: Feminism, Nature, and Difference* (New York: Routledge, 1989).

50. Patricia Mainardi, "Feminine Sensibility?—Two Views," *Feminist Art Journal* 1 (April 1972): 4, a statement originally delivered at the forum, "Does Art Have a Gender?" at the 14th Street YWCA, New York City, February 16, 1972.

51. Cindy Nemser, "The Women Artists' Movement," *Feminist Art Journal* 2 (Winter 1973/74): 8.

52. E.g., Cindy Nemser, "Toward a Feminist Sensibility: Contemporary Trends in Women's Art," *Feminist Art Journal* 5 (Summer 1976): 19–23. See also the analysis by Christine C. Rom, "*The Feminist Art Journal: One View*," *Woman's Art Journal* 2

(Fall 1981/Winter 1982): 19–24, who notes that the catholicity of Nemser's call for women's freedom of expression "did not extend to Chicago or Schapiro."

53. Schapiro and Chicago, "Female Imagery," 11–14.

54. In an early description of Judy Chicago's lectures on this subject, Maryse Holder reported that at Cornell University, Ithaca, N.Y., in April 1972, Chicago named four patterns that she had observed in women's art: repeating forms such as cylinders, circular forms such as breasts, organic or biomorphic forms, and the central aperture or opening at the center of a painting. Holder, "Another Cuntree: At Last, a Mainstream Female Art Movement," originally published in *off our backs*, September 1973; reprinted in Raven, Langer, and Frueh, *Feminist Art Criticism*, 2.

55. Chicago and Schapiro, "Female Imagery," 14.

56. Mary Daly, *Gyn/Ecology: The Metaethics of Radical Feminism* (Boston: Beacon Press, 1978), 355, and Adrienne Rich, *On Lies, Secrets, and Silence* (New York: Norton, 1979), 18. Both books are discussed as essentialist by Alcoff, "Cultural Feminism," 405–37.

57. Adrienne Rich, *Of Woman Born: Metaethics as Experience and Institution* (New York: Bantam, 1977), 21.

58. For an overview of the issues, see Lucy R. Lippard, *From the Center: Feminist Essays on Women's Art* (New York: Dutton, 1976), especially the chapters "What is Female Imagery?" and "Six." An early example of the use of the term "essentialist" (i.e., "based on the belief in a female essence residing somewhere in the body of a woman") to criticize vaginal forms in art, mysticism, and ritual is Judith Barry and Sandy Flitterman-Lewis, "The Politics of Art-Making," in Raven, Langer, and Frueh, *Feminist Art Criticism*, 87–97, esp. 89.

59. Lucy R. Lippard, "A Note on the Politics and Aesthetics of a Women's Show," pp. 6–7 in *Women Choose Women*, catalogue of an exhibition organized by Women in the Arts at The New York Cultural Center (New York: Women in the Arts, 1973).

60. "Judy Chicago Talking to Lucy R. Lippard," in Lippard, *From the Center*, 227.

61. Chicago, quoted in *Womanhouse*, exh. cat. (Valencia: California Institute of the Arts, Feminist Art Program, 1972), n.p.

62. Luce Irigaray, "Pouvoir du discours, subordination du féminin," in her *Ce sexe qui n'en pas un* (Paris: Éditions de Minuit, 1977), 74. Published in English as *This Sex Which Is Not One*, trans. Catherine Porter with Carolyn Burke (Ithaca, N.Y.: Cornell University Press, 1985).

63. Miriam Schapiro, "Notes from a Conversation on Art, Feminism, and Work," in *Working It Out: 23 Women Writers, Artists, Scientists, and Scholars Talk About Their Lives and Work*, ed. Sara Ruddick and Pamela Daniels. (New York: Pantheon, 1977), 300.

64. See, e.g., Barry and Flitterman-Lewis, "Politics of Art-Making," 91–92. The anti-essentialists' argument is analogous to Edward Said's critique of "nativism" as an obstacle to the progress of Africans and postcolonials to true liberation. Said, *Culture and Imperialism* (New York: Knopf, 1993).

65. Walter Pater as quoted in Diane Russell, "Walter Pater and John Addington Symonds: A Raking View," paper presented at the session "Art and Homosexuality: Classical to Modern Times," at the annual meeting of the College Art Association, February 1977.

66. Representative reinterpretations of the fabled Renaissance as the cultural enterprise of a small, empowered segment of the population are Joan Kelly, "Did Women Have a Renaissance?" in her *Women, History, and Theory* (1977, Chicago: University of Chicago Press, 1984), and Jonathan Goldberg, ed., *Queering the Renaissance* (Durham, N.C.: Duke University Press, 1994). For a discussion of the revival of classical forms and values in the eighteenth century to support "gender ideology," see Natalie Kampen, "The Muted Other: Gender and Morality in Augustan Rome and Eighteenth-Century Europe," in Broude and Garrard, *Expanding Discourse*, 161–69.

67. For discussions of the generational differences and conflicts, see *Art Journal* 50 (Summer 1991), Feminist Art Criticism issue, especially Linda S. Klinger, "Where's the Artist? Feminist Practice and Poststructural Theories of Authorship," Flavia Rando, "The Essential Representation of Woman," and Christine Tamblyn, "No More Nice Girls: Recent Transgressive Feminist Art."

68. Jeff Perrone, "Unfinished Business: 1982 New York Overview," *Images and Issues*, January/February 1983, 39.

69. *New York Times Magazine*, December 5, 1993, 77.

Wilding/Feminist Art Programs

Acknowledgments

I thank the women of the Feminist Art Program who shared their memories, comments, photos, and journals with me—especially Chris Rush, Nancy Youdelman, Dori Atlantis, Robin Mitchell, Mira Schor, Shawnee Wollenman, Suzanne Lacy, and Karen LeCoq. Special thanks to my mentors, Judy Chicago and Miriam Schapiro. I am grateful to Mira Schor, Elizabeth Hess, Everett Frost, Laura Cottingham, Susan Bee, and Steven Kurtz for their critical readings and discussions of drafts of this chapter.

1. The Los Angeles Council of Women Artists was founded in 1970 to protest the exclusion of women from the "Art and Technology" show at the Los Angeles County Museum of Art. New York groups included WAR (Women Artists in Revolution), founded 1969, and AWC (Ad Hoc Women Artists' Committee), founded 1970, to mount protests at the Whitney Museum. The Women's Slide Registry was started in 1971.

2. The Feminist Art movement consisted of many different strands. The California branch focused on collaborative art making, and education and was less career-based than the New York group. Women artists in New York City were more politically active and career-oriented than the California women and more intent on disrupting the art world than in forming alternative institutions.

3. For Chicago's account, see Judy Chicago, *Through the Flower: My Struggle as a Woman Artist* (Garden City, N.Y.: Doubleday, 1975; New York: Penguin, 1993), 70–92.

4. The original students were Dori Atlantis, Susan Boud, Gail Escola, Vanalyne Green, Suzanne Lacy, Cay Lang, Karen LeCoq, Janice Lester, Chris Rush, Judy Schaefer, Henrietta Starkman, Faith Wilding, Shawnee Wollenman, Nancy Youdelman, and Cheryl Zurilgen.

5. "Environments" were a concept of the late 60s and early 70s that derived from Happenings. In California, artists such as Connie Zehr and Lloyd Hamrol were early practitioners.

6. See "Women's Liberation: Notes From the Second Year," *Journal of the Radical Feminists*, New York, 1970, for historical articles on consciousness-raising and the concept of "the personal is the political."

7. Cheryl Zurilgen, "Becoming Conscious." *Everywoman*, 2, no. 7, issue 18, May 7, 1971, 8.

8. The *Everywoman* special issue, Miss Chicago and the California Girls (see ibid.) was designed by Sheila de Bretteville. *Time* magazine's March 2, 1972, special issue, The American Woman, also discussed Womanhouse and brought it to a national audience.

9. The twenty-two were Beth Bachenheimer, Sherry Brody, Camille Grey, Susan Frazier, Vicky Hodgetts, Kathy Huberland, Judy Huddleston, Karen LeCoq,* Janice Lester,* Paula Longendyke, Ann Mills, Robin Mitchell, Sandra Orgell, Jan Oxenberg, Chris Rush,* Marcia Salisbury, Robbin Schiff, Mira Schor, Robin Weltsch, Faith Wilding,* Shawnee Wollenman,* and Nancy Youdelman* (*denotes original Fresno members). Suzanne Lacy also transferred to the Design School at CalArts.

10. These included Nam June Paik, bi-coastal video exchanges; John Baldessari, post-studio art; Allan Kaprow, Happenings and the performance of everyday life; Alison Knowles, Simone Forti, and Graham Weinbren, Fluxus, body movement, spiritual practices, and interactive media; Dick Higgins and Emmett Williams, concrete poetry, text-sound, and artist-bookmaking; Herb Blau, neo-Brechtian theater/performances; and Sheila de Bretteville and Peter de Bretteville, "real life" design and architecture studies.

11. Faculty couples included Sheila de Bretteville and Peter de Bretteville; Vaughan Kaprow and Allan Kaprow; Judy Chicago and Lloyd Hamrol; Miriam Schapiro and Paul Brach; Herb Blau and Eleanor Blau; Dick Higgins and Alison Knowles; and Emmett Williams and Ann Noel.

12. On the subject of female art education, see for example Linda Nochlin, "Why There Have Been No Great Women Artists?" in *Art and Sexual Politics*, ed. Thomas B. Hess and Elizabeth C. Baker (New York: Collier, 1971), 1–44, originally published in *ARTnews*, January 1971, 22–39 and 67–71.

13. Mira Schor, "Authority and Learning," *M/E/A/N/I/N/G*, no. 8, (1990): 32.

14. Women and nature was a quintessentially 70s topic. The reading list that fueled our investigations at the time included Simone de Beauvoir, *The Second Sex*; Helen Diner, *Mothers and Amazons*; Erich Neumann, *The Great Goddess*; Kate Millett, *Sexual Politics*; "Women's Liberation: Notes from the Second Year," 1970 [*Journal of the Radical Feminists*]; Shulamith Firestone, *The Dialectic of Sex*; Friedrich Engels, *The Origins of the Family, Private Property, and the State*; Germaine Greer, *The Female Eunuch*; Doris Lessing, *The Golden Notebook*; Juliet Mitchell, *Woman's Estate*; Robin Morgan, *Sisterhood Is Powerful*; Mary Wollstonecraft, *A Vindication of the Rights of Woman*; and Virginia Woolf, *A Room of One's Own*. We also read novels by Anne, Charlotte, and Emily Brontë, Jane Austen, George Eliot, Willa Cather, Colette, Edith Wharton, and Virginia Woolf.

15. For a discussion of performance art, see Josephine Withers's book. Here I have only described some early performances and the emergence of the form in daily Feminist Art Program work.

16. Moira Roth, ed., *The Amazing Decade: Women and Performance Art in America, 1970–1980* (Los Angeles: Astro Artz, 1983).

17. Virginia Woolf, "Professions for Women," in *The Death of the Moth and Other Essays* (New York: Harcourt Brace Jovanovich, 1942), 238.

18. In 1992–93, I saw scores of panties—stained, bloodied, mutilated, pinned, ripped, stitched, decorated, and stuffed—in New York galleries and art schools. Evidently this subject has not yet been exhausted.

19. Lucy R. Lippard, *From the Center: Feminist Essays on Women's Art* (New York: Dutton, 1976), 81.

20. Ibid., 85.

21. *The Bus* was certainly influenced by the work of Ed Kienholz, but it also derived much of its imagery from literature, such as Dickens's description in *Great Expectations* of Miss Haversham frozen in time in her cobwebby wedding regalia, waiting eternally for her ghostly bridegroom.

22. *Anonymous Was a Woman: A Documentation of the Women's Art Festival; A Collection of Letters to Young Women Artists* (Valencia: California Institute of the Arts, Feminist Art Program, 1974). In 1975 Schapiro published *Art: A Woman's Sensibility*, also through the Feminist Art Program.

23. WEB was an international network of women in the arts started by Chicago, Schapiro, Lippard, Ellen Lanyon, Marcia Tucker, and others in 1971.
24. Faith Wilding, *By Our Own Hands: The Women Artists' Movement, Southern California, 1970–1976* (Santa Monica, Calif.: Double X, 1977), 41. Nevertheless, de Bretteville has since held positions at Otis Parsons and is currently Head of the Design School at Yale University. Her ideas about the humane, content-driven, democratic basis for design in the real world have profoundly influenced many of her students, who have developed workshops, products, publications, and artwork based on these ideas.
25. Schor, "Authority and Learning," 33.
26. Suzanne Lacy published a letter protesting this show in the *CalArts Newsletter* in 1981. CalArts students to whom she lectured in 1979 had no knowledge of the Feminist Art Program.
27. Laura Cottingham, "Claiming the Forefront: The 70s Feminist Art Movement and the Idea of Postmodernity," lecture at the symposium "Contact Zones between the Aesthetic Media in the United States in the 20th Century," held at Amerikahaus, Berlin, on June 26, 1993.

Raven/Womanhouse

1. Judy Chicago, *Through the Flower: My Struggle as A Woman Artist* (Garden City, N.Y.: Doubleday, 1975; New York: Penguin, 1993), 65.
2. Ibid., p. 114.
3. Betty Friedan, *The Feminine Mystique* (New York: Dell, 1963).
4. Ibid., p. 38.
5. Ibid., p. 64.
6. Jane O'Reilly, "The Housewife's Moment of Truth," *Ms.*, introduced in *New York Magazine*, December 20, 1971, 54.
7. Judy Syfers, "I Want a Wife," *Ms.*, introduced in *New York Magazine*, December 20, 1971, 56.
8. Pat Mainardi, "The Politics of Housework," in *Sisterhood Is Powerful: An Anthology of Writings from the Women's Liberation Movement*, ed. Robin Morgan (New York: Random House/Vintage, 1970), 448.
9. Chicago, *Through the Flower*, from caption for *Menstruation Bathroom*, n.p.
10. Chicago, *Cock and Cunt* play script, in *Through the Flower*, 208–12.
11. Ti-Grace Atkinson, *Amazon Odyssey* (New York: Links Books, 1974), 41–42.
12. Kate Millett, *Sexual Politics* (Garden City, N.Y.: Doubleday, 1970), 46.
13. Shulamith Firestone, *The Dialectic of Sex: The Case for Feminist Revolution* (New York: William Morrow/Bantam, 1970), 91.
14. Performance texts of *Cock and Cunt* and *Waiting* are reproduced in Chicago's *Through the Flower*.
15. Chicago, *Through the Flower*, 121.
16. Ibid., 119–20.
17. Ibid., 123.
18. Documentation of the Womanhouse project includes *Womanhouse*, a catalogue with pictures and descriptions of the environment, designed by Sheila Levrant de Bretteville; a forty-minute documentary color film by Johanna Demetrakas; reviews in *Time* and *New Woman* among others, contemporary with the installation; a description of the process, the project, and the performances in Chicago's *Through the Flower*, chap. 6; a one-hour television special on KNET-TV, Los Angeles (Channel 28), produced by Lynn Litman, in 1972; a short interpretative film by Mako Idemitsu; a description in Faith Wilding's *By Our Own Hands*; and a collection of color slides first housed at the California Institute of the Arts, then by Miriam Schapiro.
19. Miriam Schapiro, letter to the author, June 21, 1983.
20. Adrienne Rich in *Sinister Wisdom*, no. 6.

Garrard / Feminist Politics

1. For example, statistics publicized by the Guerrilla Girls in the mid-1980s show that major exhibitions of "contemporary" or "recent" art at the Guggenheim, MoMA, Brooklyn, and Whitney museums between 1984 and 1987 were 80 to 95 percent male (see Josephine Withers, as cited in note 42, below). In the 1991–92 New York season, there were thirty-six one-person museum exhibitions; seven of these were by women. Women's Action Coalition, *WAC Stats: The Facts about Women* (New York: New Press, 1993), 15.
2. Jo Freeman, *The Politics of Women's Liberation: A Case Study of an Emerging Social Movement and Its Relation to the Policy Process* (New York: David McKay, 1975), 57.
3. For WITCH and radical feminist actions in general, see Freeman, *Politics*, 111 ff.; and Robin Morgan, ed., *Sisterhood Is Powerful: An Anthology of Writings from the Women's Liberation Movement* (New York: Random House/Vintage, 1970), photo insert between pp. 282–83.
4. "Redstockings Manifesto," July 7, 1969, reproduced in *Women Together: A History in Documents of the Women's Movement in the United States*, ed. Judith Papachristou (New York: Knopf, 1976), 237.
5. New York Radical Women, "Principles," reproduced in Morgan, *Sisterhood*, 520.
6. Pat Mainardi, author of the widely reproduced "Politics of Housework" (Morgan, *Sisterhood*, 447–54), was, according to Cindy Nemser, "the first to write about the plight of women artists in feminist terms." Nemser, "The Women Artists' Movement," *Feminist Art Journal* 2 (Winter 1973/74): 8.
7. On the New York Art Strike, see Elizabeth C. Baker, "Pickets on Parnassus," *ARTnews*, September 1970, 30–33 and 64–65. See also Faith Ringgold, "An Open Show in Every Museum," *Feminist Art Journal* 1 (April 1972): 10.
8. For information on the New York women's groups, I thank Jackie Skiles, Lucy Lippard, and Nancy Spero. Invaluable for the history of WAR/AWC, though now out of print, is *A Documentary Herstory of Women Artists in Revolution* (Pittsburgh, Pa.: KNOW Press, 1971; 2d ed. 1973). An essential overview of art and political action in the early seventies is Lucy R. Lippard, *Get the Message? A Decade of Art for Social Change* (New York: Dutton, 1984).
9. See Women in the Arts, "Women Choose Women," *Feminist Art Journal* 1 (April 1972): 16; also, Corinne Robins, *The Pluralist Era: American Art, 1968–1981* (New York: Harper & Row, 1984): 57–59.
10. Papachristou, *Women Together*, 239.
11. Morgan, *Sisterhood*, xxviii–xxix.
12. Ibid., xxxiv.
13. Faith Wilding, *By Our Own Hands: The Women Artists' Movement, Southern California, 1970–1976* (Santa Monica, Calif.: Double X, 1977), 17–21.
14. Ibid., 22–23.
15. Tamarind Lithography Workshop, "Tamarind Issues Bias Report," *Feminist Art Journal* 1 (April 1972): 20.
16. Wilding, *By Our Own Hands*, 31–32; Alexis Krasilovsky, "CalArts Conference," *Feminist Art Journal* 1 (April 1972): 8.
17. Statement of principle by Woman's Building founders Judy Chicago, Sheila de Bretteville, and Arlene Raven, quoted in Wilding, *By Our Own Hands*, 83. Double X, founded in 1976, was similarly both a gallery and a political structure (Wilding, 95–97). See also Nancy Marmer, "Womanspace, a Creative Battle for Equality in the Art World," *ARTnews*, Summer 1973, 38–39.
18. Cindy Nemser, "Directory of Women Artists' Activities," *Feminist Art Journal* 2 (Spring 1973): 23.
19. On the "mushroom effect" of the growth of the women's liberation movement, see Freeman, *Politics*, 147 ff.
20. Kay Brown predicted "a coming together of all women in the arts," as a step beyond their previous division of allegiance in the fights against racism and sexism. Nemser, "Women Artists' Movement," 10. By contrast to the other groups, Women in the Arts still existed in 1993, issuing a newsletter and sponsoring women's exhibitions in nonprofit spaces.
21. Cindy Nemser, Editorial, *Feminist Art Journal* 1 (April 1972): 2.
22. Cindy Nemser, "The Women's Conference at the Corcoran," *Art in America*, January/February 1973, 86–90.
23. This impact is attested by the Twentieth Anniversary Celebration of the 1972 Corcoran Conference of Women in the Visual Arts, held on April 12, 1992, at the Corcoran Gallery of Art. Included among reunion conferees were the seven original organizers and many of the original participants.
24. For example, the A.I.R. Gallery in New York and the Woman's Building in Los Angeles. For coverage of many panels and conferences of the period, see Judy Seigel, ed., *Mutiny and the Mainstream: Talk That Changed Art, 1975–1990* (New York: Midmarch Arts Press, 1992).
25. Ann Sutherland Harris, "College Art Association Women's Caucus," *Feminist Art Journal* 1 (April 1972): 12–13 and 17, and Harris, "The Second Sex in Academe," *AAUP Bulletin*, Fall 1970.
26. The Rip-Off File was actually produced for the Ad Hoc Women Artists' Group and circulated by the Caucus; the committee also included Maude Boltz, Loretta Dunkelman, Joan Snyder, and May Stevens.
27. WCA's second Affirmative Action Officer was Mary Fifield, who, with Lynn Chapman Grant for the WCA Affirmative Action Committee, produced *Anger to Action: A Sex Discrimination Guidebook*, published by WCA in 1978. Results of the museum survey were presented at a panel chaired by Diane Russell and Bernice Davidson at the annual meeting of the CAA in Los Angeles, 1977. Janice Ross's *Survey of MFA Programs, Students, and Faculty* (1978) is circulated by the CAA. Mary D. Garrard, *Slides of Works by Women Artists: A Sourcebook* (WCA, 1974); Athena Tacha Spear and Lola B. Gellman, eds., *Women's Studies in Art and Art History* (WCA, 1974; 2d ed., 1975); Elsa Honig Fine, Lola B. Gellman, and Judy Loeb, eds., *Women's Studies and the Arts* (WCA, 1978). An important publication produced by WCA members is Claire R. Sherman with Adele M. Holcomb, *Women as Interpreters of the Visual Arts, 1820–1979* (Westport, Conn.: Greenwood Press, 1981).
28. Front Range was founded in 1974, WWAP in 1973. Other Washington groups were the Washington Women Printmakers, the D.C. Registry of Women Artists, the Adhibit Committee, and the Foundry Artists. Members of the executive committee for WWAP/WCA were Donna Ari, Eleanor Fink, Marsha Mateyka, Ellen Miles, Diane Russell, Susanna Saunders, Claire Sherman, Sue Stromberg, and Roslye Ultan.
29. A broader spectrum of women's representation on the CAA Board: 1963–1; 1968–2; 1968–2; 1970–1; 1971–4; 1972–5; 1973–7; 1974–9; 1975–11.
30. According to Judith Brodsky, presentation at WCA Presidents' Panel, at the annual meeting of the CAA in Chicago, 1992.

31. Marilyn Stokstad (1978–80), Ruth Weisberg (1990–92); Judith K. Brodsky became president of CAA in 1994.

32. A sampling of women's arts organizations in CWAO: WCA, Washington Women's Arts Center, Los Angeles Woman's Building, Chicago Artists Coalition; New York Art Workers' Union.

33. Susan Faludi, *Backlash: The Undeclared War against American Women* (New York: Crown, 1991), 41.

34. Ibid., 60 and 236.

35. When the ratification period set by Congress ended in 1979, a three-year extension was granted. The extension expired on June 30, 1982, defeated in the legislatures of Florida, North Carolina, and Illinois, the three states on which ERA drive leaders had focused their energies and resources.

36. Elsa Fine, letter to Lee Anne Miller, April 18, 1979.

37. Tina Slaney, letter to Lee Anne Miller, July 25, 1979.

38. Cynthia Ware, letter to the Ad Hoc Committee for an Alternative Conference, June 13, 1979.

39. Sandy (Cassandra) Langer, letter to Lee Anne Miller, n.d.

40. An overview of WCA history through the administrations of its successive presidents was given in the panel "The Women's Caucus for Art: 1972–1992," at the annual meeting of the CAA in Chicago; (available on audio tape from the CAA).

41. H. J. Gerth and C. W. Mills, eds., *From Max Weber: Essays in Sociology* (New York: Oxford University Press, 1946), and Robert Michels, *Political Parties* (Glencoe, Ill.: Free Press, 1949), cited by Freeman, *Politics*, 100 and 145.

42. On the Guerrilla Girls, see Josephine Withers, "The Guerrilla Girls," *Feminist Studies* 14 (Summer 1988): 284–300, and Mira Schor, "Girls Will Be Girls," *Artforum*, September 1990, 124–27.

43. SisterSerpents now has members in San Francisco, Atlanta, Cleveland, and Seattle. See Victor Margolin, "SisterSerpents: A Radical Feminist Art Collective," *AIGA: Journal of Graphic Design* 10 (1992): 2.

44. Important for the intersection of feminist and ethnic expression in art is Lucy R. Lippard, *Mixed Blessings: New Art in a Multicultural America* (New York: Pantheon, 1990).

45. On WAC, see Margot Mifflin, "Feminism's New Face," *ARTnews*, November 1992, 120–25.

46. Barbara Ehrenreich, quoted in Lynn Darling, "Angry? Yes. Grim? No Way," *New York Newsday*, July 23, 1992, 53.

47. Ursula K. LeGuin, *Dancing at the Edge of the World: Thoughts on Words, Women, Places* (New York: Harper & Row, 1989), 177–78.

48. Gerda Lerner, *The Creation of Feminist Consciousness: From the Middle Ages to 1870* (New York: Oxford University Press, 1993). Lerner's point is sharply focused by Mary McLaughlin in her review of the book in *Women's Review of Books*, October 1993, 19–20.

Brodsky/Exhibitions, Galleries, and Alternative Spaces

1. The material in this paragraph is based on information in Faith Wilding, *By Our Own Hands: The Women Artists' Movement, Southern California, 1970–1976* (Santa Monica, Calif.: Double X, 1977).

2. Jackie Skiles, "Life at the Alternate Structure, Women's Interart Center," *Women and Art* 1 (Winter 1971). This newsletter was a publication of Redstockings and Redstocking Artists.

3. Kay Brown, "Where We At Black Women Artists," *Feminist Art Journal* 1 (April 1972): 25.

4. According to Brown's article (ibid.), the other members of Where We At were Carol Blank, Vivian Browne, Carole Byard, Gylbert Coker, Iris Crump, Doris Kane, Onnie Millar, Charlotte Richardson, Akweke Shingho, Ann Tanksley, and Jean Taylor.

5. Wilding, *By Our Own Hands*, 44.

6. "Women Choose Women" was the most ambitious of the early alternative exhibitions held at museums, but there were others as well, such as June Blum's "Unmanly Art" in 1972 at the Suffolk Museum and Joan Semmel's "Contemporary Women: Consciousness and Content" at the Brooklyn Museum's Art School Gallery. Women members of art department faculties used their leverage to mount shows at college galleries, such as Shirley Kassman's "From Women's Work to Art Objects" at State University College, Buffalo, New York, in April 1972 and Moira Geoffrion's "Women Artists, Here and Now" at the University of Notre Dame Art Gallery in the summer of 1976.

7. Corinne Robins, "The A.I.R. Gallery: 1972–1978," *A.I.R. Gallery Overview, 1972–1977, An Exhibition in Two Parts*, exh. cat. (New York: A.I.R. Gallery, 1978).

8. In the "Chronology of the Woman's Building, 1973–1983," in *At Home*, the catalogue for the exhibition celebrating the tenth anniversary of the Woman's Building (Long Beach, Calif.: Long Beach Museum of Art, 1983), Arlene Raven lists the following as the members of the founding board of Womanspace: Wanda Westcoast, chairwoman; Max Cole, vice chair; Fran Raboff, secretary; Eugenie Osmun, treasurer; Gretchen Glicksman, director; with board members Lucy Adelman, Mickie Benoff, Sherry Brody, Bruria, Carole Caroompas, Judy Chicago, Judith Fried, Elyse Grinstein, Linda Levi, Joan Logue, Mildred Monteverdi,

Rachel Rosenthal, Betye Saar, Miriam Schapiro, Deborah Sussman, Faith Wilding, and Connie Zehr. Many were also members of the Ad Hoc Women Artists' Group.

9. Ibid., x.

10. *Fifteen Years and Growing: Celebrating the Fifteenth Anniversary of the Woman's Building, the History and Programs of the Woman's Building, a Public Center for Women's Culture Founded in 1973* (Los Angeles: Woman's Building, 1988), 6.

11. Wilding, *By Our Own Hands*, 54.

12. *Artemisia Tenth Anniversary Catalogue*, exh. cat. (Chicago: Artemisia Gallery, 1983), 1.

13. The statement from the *Sun-Times* is quoted in ibid. Lynne Warren, in *Alternative Spaces, A History in Chicago* (Chicago: Museum of Contemporary Art, 1984), lists the founding members of both Artemisia and ARC. The Artemisia group included Phyllis Bramson, Shirley Fedorow, Sandra Gierke, Barbara Grad, Carole Harmel, Vera Klement, Linda Kramer, Phyllis MacDonald, Susan Michod, Sandra Perlow, Emily Pinkowski, Joy Poe, Claire Prussian, Nancy Redmond, Christine Rojek, Heidi Seidelhuber, Alice Shaddle, Hollis Sigler, Mary Stoppert, Carol Turchan, and Margaret Harper Wharton. The founding members of ARC were Dalia Alekna, Jan Arnow, Gerda Meyer Bernstein, Judy Lerner Brice, Ellen Ferar, Irmfriede Hogan, Johnnie Johnson, Maxine Low, Mary Min, Civia Rosenberg, Gina Rosenblum, Laurel M. Ross, Frances Schoenwetter, Sara Skolnik, Myra Toth, and Monika Wehrenberg.

14. The members of the FOCUS steering committee were Penny Bach, Judith K. Brodsky, Diane Burko, Frieda Fehrenbacher, Alexandra Grilikhes, Kyle Hammond, Thora Jacobson, Ruth Fine, Deborah Marrow, Cindy Nemser, Arleen Olshan, Ellen Ravin, Tara G. Robinson, Ruth Selzer, Paula Suransky, Carol B. Stapp, Judith E. Stein, Ann Williams, and Patterson Williams.

15. Valerie Raleigh Yow, "Chapter One, The Founding of the Hera Gallery," *The History of Hera: A Women's Art Cooperative, 1974–1989* (Wakefield, R.I.: Hera Educational Foundation, 1989), 4.

16. Ibid., 5.

17. According to ibid., the founding members of Hera were Constance Greene Alexander, Merle Barnett, Mary Jane Christofferson, Bernadette Hackett, Elena Jahn, Marlene Malik, Frances Powers, Roberta Richman, Althea Smith, and Barbara Johns Waterston.

18. Women honored from 1980 to 1993 were: New Orleans 1980—Anni Albers, Louise Bourgeois, Caroline Durieux, Ida Kohlmeyer, and Lee Krasner; Washington, D.C. 1980 alternate awards—Bella Abzug, Sonia Johnson, Sister Theresa Kane, Grace Paley, Rosa Parks, and Gloria Steinem; San Francisco 1981—Ruth Bernhard, Adelyn Breeskin, Elizabeth Catlett, Sari Dienes, Claire Falkenstein, and Helen Lundeberg; New York 1982—Berenice Abbott, Elsie Driggs, Elizabeth Gilmore Holt, Katharine Kuh, Charmion von Wiegand, and Claire Zeisler; Philadelphia 1983—Edna Andrade, Dorothy Dehner, Lotte Jacobi, Ellen Johnson, Stella Kramrisch, Lenore Tawney, and Pecolia Warner; Toronto 1984/Los Angeles 1985—Minna Citron, Clyde Connell, Eleanor Raymond, Joyce Treiman, June Wayne, and Rachel Wischnitzer; New York 1986—Nell Blaine, Leonora Carrington, Sue Fuller, Lois Mailou Jones, Dorothy Miller, and Barbara Morgan; Boston 1987—Grace Hartigan, Agnes Mongan, Maud Morgan, Elizabeth Talford Scott, Honore Sharrer, and Beatrice Wood; Houston 1988—Margaret Taylor Burroughs, Dorothy Hood, Miriam Schapiro, Edith Standen, and Jane Teller; San Francisco 1989—Margret Craver, Clare Leighton, Samella Sanders Lewis, Betye Saar, and Bernarda Bryson Shahn; New York 1990—Ilse Bing, Elizabeth Layton, Helen Serger, May Stevens, and Pablita Velarda; Washington, D.C. 1991—Theresa Bernstein, Mildred Constantine, Otellie Loloma, Mine Okubo, and Delilah Pierce; Chicago 1992—Vera Berdich, Paula Gerard, Lucy Lewis, Louise Noun, Anna Tate, and Margaret Tafoya; Seattle 1993—Ruth Asawa, Shifra M. Goldman, Nancy Graves, Gwen Knight, Agueda Salazar Martinez, and Emily Waheneka.

19. Center Gallery founding members were Carol Adamec, Kaola Allen, Stephanie Cote, Carla House, Pat Jenks, Marion Krueger, Isabel Chiquor Levitt, Michele Paterson, Kathleen Rieder, Nina Sagatov, Beatrice Schall, Hollie Taylor, and Jo Wright Whitten.

Rickey / Writing and (Righting) Wrongs: Feminist Art Publications

1. Christine C. Rom, "*The Feminist Art Journal*: One View," *Woman's Art Journal* 2 (Fall 1981/Winter 1982): 19–24.

2. The LACWA critique of the museum's policies resulted in the institution's important support of the 1976 landmark exhibition "Women Artists: 1550–1950."

3. As cited above, note 1.

4. Judy Seigel, report on Rosenberg lecture, *Women in Art Newsletter*, February 1975.

5. Judy Seigel, ed., *Mutiny and the Mainstream: Talk That Changed Art, 1975–1990* (New York: Midmarch Arts Press, 1992), is a rich collection of columns from *WAN*'s glory years.

6. *womanart*, Winter/Spring 1977.

7. Linda Nochlin in ibid.

8. Ten issues of *Chrysalis* were published between 1977 and 1980.
9. See Kirsten Grimstad's essay on *Chrysalis* in *Yesterday and Tomorrow: California Women Artists*, ed. Sylvia Moore (New York: Midmarch Arts Press, 1989).
10. In the interest of full disclosure, I was an active member of the *Heresies* collective between 1978 and 1980.
11. Elsa Honig Fine, statement in *Woman's Art Journal*, Spring/Summer 1980.

López and Roth / Social Protest: Racism and Sexism

Acknowledgments

We are deeply grateful to the women contacted during the course of this project whose generous contributions of ideas, material, time, and energy were invaluable. We also acknowledge the insightful critical readings of our text by JoAnne Bernstein, Norma Broude, Whitney Chadwick, Mary D. Garrard, Lucy R. Lippard, and Leslie Simon. More generally, we are indebted to the ideas of many women, among them Coco Fusco, bell hooks, Elaine H. Kim, Lucy R. Lippard, Margo Machida, Amalia Mesa-Bains, Trinh T. Minh-ha, Howardena Pindell, Elizabeth Rodríguez, Martha Rosler, Jaune Quick-to-See Smith, and Michele Wallace.

Racial designations of artists and critics referred to in the essay:

Arai, Tomie Asian American
Baca, Judy Mexican American
Barnett, Alan W. Euro-American
Browne, Vivian E. African-American
Buchanan, Nancy Euro-American
Campbell, Mary Schmidt African-American
Carrillo, Graciela Mexican American
Catlett, Elizabeth African-American
Chicago, Judy Euro-American
de Bretteville, Sheila Euro-American
Flack, Audrey Euro-American
Garza, Carmen Lomas Mexican American
Green, Vanita African-American
Hammond, Harmony Euro-American
Harper, Paula Euro-American
Hernández, Ester Mexican American/Native American
Kano, Betty Asian-American
King, Susan E. Euro-American
Kozloff, Joyce Euro-American
Labowitz, Leslie Euro-American
Lacy, Suzanne Euro-American
LaMarr, Jean Native American
Lennon, John Euro-American
Lewis, Samella African-American
Lippard, Lucy R. Euro-American
Liu, Hung Asian American
Lowe, Bia Euro-American
Machida, Margo Asian American
Mendez, Consuelo Latin American
Mendieta, Ana Latin American
Mesa-Bains, Amalia Mexican American
Min, Yong Soon Asian American
Ono, Yoko Asian American
Pindell, Howardena African-American
Raven, Arlene Euro-American
Ringgold, Faith African-American
Rodríguez, Patricia Mexican American
Rosler, Martha Euro-American
Saar, Betye African-American
Schapiro, Miriam Euro-American
Schneemann, Carolee Euro-American
Spero, Nancy Euro-American
Stevens, May Euro-American
Tsinhnahjinnie, Hulleah J. Native American
Wallace, Michele African-American
Wolverton, Terry Euro-American
Yañez, René Mexican American

1. At the memorial service for Vivian E. Browne in New York in 1993, mourners received a small pamphlet that included a description by Lowery S. Sims of her first encounters with Browne in the early 1970s at the annual meetings of the National Conference of Artists: "Her work was figurative then, and often featured bloated figures of men—inevitably, white men—. . . allegorical references to the excesses and unjustices in society. These works were contextualized within the contemporary civil rights and feminist movements."
2. Useful chronologies of New York art protests can be found in Deborah Wye, *Committed to Print: Social and Political Themes in Recent American Printed Art* (New York: Museum of Modern Art, 1988), 94–99, and Mary Schmidt Campbell, ed., *Tradition and Conflict: Images of a Turbulent Decade, 1963–1973* (New York: Studio Museum in Harlem, 1985), 83–89. Other useful sources for such accounts are the relevant essays in Lucy R. Lippard, *Get the Message? A Decade of Art for Social Change* (New York: Dutton, 1984), and Theresa M. Schwarz's series of articles "Politicization of the Avant-garde," *Art in America*, November 1971, March 1972, March 1973, and January 1974.
3. Lucy R. Lippard, interview by Moira Roth, Boulder, Colo., February 21, 1993.
4. Carolee Schneeman, *More than Meat Joy: Complete Performance Works and Selected Writings*, ed., Bruce McPherson (New Palz, N.Y.: Documentext, 1979), 129.
5. Yoko Ono, quoted in Barbara Haskell and John G. Hanhardt, *Yoko Ono: Arias and Objects* (Salt Lake City: Peregrine Smith, 1991), 110.
6. Catlett had lived in Mexico since the late 1940s.
7. Elizabeth Catlett, quoted in Samella S. Lewis and Ruth G. Waddy, *Black Artists on Art*, rev. ed. (Los Angeles: Contemporary Crafts, 1976), 2:107.
8. Campbell, *Tradition and Conflict*, 55.
9. Lucy R. Lippard, "Masses and Meetings," in *May Stevens: Ordinary/Extraordinary, A Summation, 1977–1984*, ed. Patricia Hill (Boston: Boston University Art Gallery, 1984), n.p.
10. May Stevens, statement quoted in ibid.
11. Stevens, statement made at the panel discussion "Theoretical Concepts of Feminist Art," held at A.I.R. Gallery, New York, March 24, 1980.
12. Nancy Spero, response to questionnaire by Nina Yankowitz, 1976.
13. Spero, statement made in "Woman as Protagonist: The Art of Nancy Spero," documentary videotape by Irene Sosa, 1993.
14. Spero, statement made in *womanart*, Winter/Spring 1977, 31.
15. Spero, quoted in Carol De Pasquale, "Dialogues with Nancy Spero," *womanart* (Winter/Spring 1977): 8.
16. Spero, statement delivered at panel discussion held at Cooper Union, New York, October 1989.
17. See, for example, Nancy Spero, "Sue Williams," *Bomb*, Winter 1993, 22–27.
18. Samella Lewis, *Art: African American* (New York: Harcourt Brace Jovanovich, 1978), 173.
19. Betye Saar, quoted by Lucy R. Lippard in *The Art of Betye and Alison Saar: Secrets, Dialogues, Revelations*, ed. Elizabeth Shepherd (Los Angeles: University of California, Wight Art Gallery, 1990), 16.
20. Lewis and Waddy, *Black Artists on Art*, 1: 35.
21. Yolanda M. López, interview by Moira Roth, Berkeley, Calif., July 10, 1993. Other quotations in this paragraph are drawn from this interview.
22. The study of contemporary political posters and graphic design is in its infancy, particularly with respect to women's roles. Many of these posters are neither signed nor dated, and this lacuna poses a problem in ascertaining the identity and gender of the artists. Women-only graphic centers as well as male-and-female organizations need to be researched. Among the significant women's collectives were the Chicago Women's Graphics Collective (1970–c. 1982) and the Women's Graphic Center in the Woman's Building in Los Angeles (1973–1988). Among the histories to be told is that of the women who worked in mixed groups in the Bay Area. These women include Linda Lucero at La Raza Silkscreen (later renamed La Raza Graphics [1971–]; Gail Aratani, Nancy Hom, Stephanie Lowe, and Wendy Yoshimura in the Kearny Street Workshop (1972–) and Japantown: Art and Media (1977–). Another prominent figure in this history is Rachel Romero, who with Leon Klayman cofounded the San Francisco Poster Brigade, previously known as the Wilfred Owen Brigade. Among the main collections of political graphics are All of Us or None (AOUON), gathered over the years by Michael Rossman and housed in Berkeley, Calif. (see his account of this collection, Up Against the Wall, in *Mother Jones*, July/August 1993, 38–40); PAD/D (Political Art Documentation/Distribution) Archives now housed in the Museum of Modern Art, New York; and the Center for the Study of Political Graphics in Los Angeles, directed by Carol Wells, which contains an extensive archive and also circulates exhibitions.
23. Betty Kano, telephone interview by Yolanda López, July 12, 1993.
24. Jean LaMarr, telephone interview by Yolanda López, July 12, 1993.
25. After the publication of *Community Murals: The People's Art* (Philadelphia: Art Alliance Press/Cornwall Books, 1984), Alan W. Barnett discovered the work of Lilli Ann Killen Rosenberg, who was trained in the California Labor School, San Francisco, by Pablo O'Higgins and Antonio Refregier, and then for seventeen years (1952–1969) ran the arts program at the Henry Street Settlement in New York City. See the section on Rosenberg in Barnett, "Northern Journey, Part 2. New York to Michigan," *Community Murals Magazine* (Spring 1983), 53–54, in which he writes, "If the community mural movement can be said to have a mother, this must be Lilli Ann." A study of murals by women would include the activities of such figures as Eva Cockcroft in New York, Los Angeles, and Central America; Caryl Yasko in Chicago; and the large group of women muralists in California. See Timothy W. Drescher, "Strength, Vision, and Diversity: Women's Community Murals," in *Yesterday and Tomorrow: California Women Artists*, ed. Sylvia Moore (New York: Midmarch Arts Press, 1989), 37–60. Among the artists he discusses are Ruth Asawa, Sally Woodbridge, the Mujeres Muralistas, Miranda Bergman and Jane Norling of the Haight-Ashbury Muralists, Fran Valesco, Johanna Poethig, Juana Alicia, Judy Baca, Judith Hernandez, Barbara Carrasco, and Yreina Cervántez. See also Drescher, *San Francisco Murals: Community Creates Its Muse,*

1914–1990 (St. Paul, Minn.: Pogo Press, 1991). Another useful general source for material on women muralists is Eva Sperling Cockcroft and Holly Barnet-Sanchez, eds., *Signs from the Heart: California Chicano Murals* (Venice, Calif.: Social and Public Art Resource Center, 1990), especially the articles by Shifra M. Goldman and Amalia Mesa-Bains.

26. For a photograph of this work, see Barnett, *Community Murals*, 84.

27. The Basement Workshop, a major center in New York City for Asian-American writers, artists, and musicians, was founded in 1970–1971. Its history, together with its visual arts component, is briefly outlined in Fay Chiang and Margo Machida, "Two Voices from Chinatown's Basement Workshop," *Upfront: A Journal of Activist Art*, Winter/Spring 1987/88, 52–57, but the role of women artists in this organization remains to be researched specifically.

28. Barnett, *Community Murals*, 12.

29. Tomie Arai, quoted in Philip Pocock, "Interviews, August 1980," in *The Obvious Illusions: Murals from the Lower East Side* (New York: Braziller, 1980), 17.

30. Patricia Rodríguez, "Mujeres Muralistas," *Street Art News* 1, no. 2 (1975): 5.

31. Moira Roth, interview by Yolanda M. López, July 10, 1993.

32. In 1981, another protest, "Artists Missing In Action," was staged against the Los Angeles County Museum on the occasion of its all-white male exhibition "Seventeen Artists of the 60s." See Lippard, *Get the Message?*, 257–58.

33. Joyce Kozloff, telephone interview by Moira Roth, May 26, 1993.

34. Originally Labowitz and Lacy had conceived of a piece that called attention to the violence through the metaphor of mourning; but in discussion with other feminist artists, primarily in the Woman's Building, they developed the metaphor of rage to signify an aggressive self-protective stance.

35. Suzanne Lacy, telephone interview by Moira Roth, July 20, 1993.

36. Ibid.

37. The feminist performance scene in California is discussed more fully by Josephine Withers in her chapter in this book. Women performance artists living in Los Angeles at the time included Jerri Allyn, Nancy Angelo, Nancy Buchanan, Cheri Gaulke, Vanalyne Green, Laurel Klick, Suzanne Lacy, Leslie Labowitz, Aviva Rahmani, Rachel Rosenthal, Barbara T. Smith, and Terry Wolverton. The roster for the San Diego region during these early years included Eleanor Antin, Norma Jean Deak, Linda Montano, Pauline Oliveros, and Martha Rosler.

38. Harmony Hammond, "A Space of Infinite and Pleasurable Possibilities: Lesbian Self-Representation in Visual Art," in Joanna Frueh, Cassandra L. Langer, and Arlene Raven, eds., *New Feminist Criticism: Art, Identity, Action* (New York: HarperCollins, 1994).

39. According to Christine Wong, who created "Yellow Queer" for the event.

40. Wolverton, quoted in Bia Lowe, "Theater as Community Ritual: An Interview with Terry Wolverton," *Heresies: A Feminist Publication on Art and Politics* 5, no. 1, Issue 17 (1984): 48.

41. See Judith Stein's chapter in this book for more extensive discussion of Judy Chicago.

42. For more extensive discussion of Judy Baca, see the chapters by Judith Stein and Suzanne Lacy in this book.

43. Among the Chicana artists who worked on the *Great Wall of Los Angeles* are Judith Hernandez, Olga Muniz, Isabel Castro, Yreina Cervántez, and Patssi Valdez. See list in Cockcroft and Barnet-Sanchez in *Signs from the Heart*, 47.

44. Judy Baca, interview (with Suzanne Lacy) by Moira Roth, Berkeley, Calif., April l, 1993.

45. For discussions of the history of various feminist art programs, see the chapters by Faith Wilding and Arlene Raven, as well as the interview with Judy Chicago and Miriam Schapiro by Norman Broude and Mary D. Garrard, in this book.

46. Both New York and San Francisco had a Woman's Building, but in neither of these cities did the center take on such a dominant and sustained role in feminist art activities as it did in Los Angeles. For other accounts of the Woman's Building in this book, please refer to the index.

47. Witness the development of the performance collectives Feminist Art Workers, Sisters of Survival, Mother Art, The Waitresses, and Ariadne, run by Suzanne Lacy and Leslie Labowitz.

48. Nancy Buchanan, "If Only I Could Tell You How Much I Really Love You," *High Performance* 3 (Fall/Winter 1980): 22.

49. Sheila de Bretteville, telephone interview by Moira Roth, July 12, 1993.

50. Ibid.

51. Craig Owens, "Martha Rosler" (interview), *Profile* (published by Video Data Bank) 5 (Spring 1986): 2–3.

52. Martha Rosler, "The Private and the Public: Feminist Art in California," *Artforum*, September 1977, 64.

53. Betye Saar, quoted in Ruth Askey, "A Baker's Dozen: Oral Histories of Women Artists," Master's thesis, Goddard College, 1981.

54. For example, there were sporadic contacts between Euro-American women and Chicanas in the context of the Woman's Building, which Shifra M. Goldman discusses in her essay, "Mujeres de California: Latin American Women Artists," in Moore, *Yesterday and Tomorrow*, 207–9. Among the major events were the exhibition "Venas de la Mujer" (A Woman's Veins), 1976, and the Women's Graphic Center's "Madre Tierra" (Mother Earth), a limited-edition portfolio of thirteen artists and poets, organized by Linda Vallejo, assisted by Susan E. King, 1982.

55. Judy Baca, interview (with Suzanne Lacy).

56. Pindell had been involved in protests around the controversial "Nigger Drawings" exhibition of 1979.

57. Howardena Pindell, *Free, White and 21*, reproduced in *Third Text*, Summer 1992, 31.

58. Pindell was a founding member of A.I.R. Gallery in 1970 but left in 1975.

59. Ana Mendicta, quoted by Lowery Stokes Sims, "Synthesis and Integration in the Work of Howardena Pindell, 1972–1992," in *Howardena Pindell: Painting and Drawings, A Retrospective Exhibition, 1972–1992* (New York: Exhibits USA, Roland Gibson Gallery at Potsdam College, State University of New York, 1992), 18.

60. The exhibition was organized by New York's INTAR Latin American Gallery and traveled to Atlanta, Ga.; Oakland, Calif.; Boca Raton, Fla.; and Austin, Tex.

61. Pindell's research was first presented at Hunter College, New York in 1987 and then published in both England and the United States in expanded form as "Art (World) & Racism," in *Third Text* 3/4, double issue, Spring/Summer 1988, 157–62, and in a shorter version, "Art World and Racism, A Documentation," in *New Art Examiner*, March 1989, 32–33.

62. Pindell, "Art (World) & Racism," 160.

63. Margo Machida is one of a group of scholars at work researching Asian American art history. Elaine H. Kim and Betty Kano are in the process of editing *Fierce Dreams*, the first book-length study of this material, to be published by Temple University Press in 1994. Research is also being generated by Asian American artist-critic activist groups, notably the Bay Area-based Asian American Women Artists Association (founded 1989) and the New York-based Godzilla (founded 1990), a mixed group of men and women.

64. Margo Machida, "(re)ORIENTING," *Harbour: A Magazine on Art and Everyday Life* 1, no. 3 (1991): 38.

65. Ibid. 39 and 41.

66. Amalia Mesa-Bains, *Offerings: The Altar Show* (Venice: Social and Public Resource Center, 1984/85), 5–6.

67. Amalia Mesa-Bains, telephone interview by Moira Roth and Yolanda López, September 5, 1993. It should be noted that Mesa-Bains had already created an altar for Frida Kahlo in 1976 as one of a Day of the Dead series of altars dedicated to women.

68. Ibid.

69. Ibid.

70. Ester Hernández, telephone interview by Yolanda López and Moira Roth, September 10, 1993.

71. Jean LaMarr, telephone interview by Yolanda López and Moira Roth, July 12, 1993.

72. Ibid.

73. The Indian Arts and Crafts Act of 1990 requires Native artists to prove their heritage by producing tribal registration numbers. These numbers were issued beginning in the late nineteenth century, in the context of government reallocation of Indian land. At the time, many Indians resisted registration, seeing it as a strategy for breaking up communal land. Many whole tribes are not registered, and many individual Natives cannot produce registration papers. Also, many contemporary artists, such as Jimmie Durham, continue to resist and have refused to produce such papers.

74. The earlier works are grouped under the title "Census Makes a Native Artist"; the more recent works were exhibited in 1993 "Nobody's Pet Indian" at the San Francisco Art Institute.

75. Hulleah J. Tsinhnajinnie, interview by Moira Roth, Berkeley, Calif., September 1993.

76. Ibid.

Withers / Feminist Performance Art

1. This chapter on performance art of the seventies is dedicated to the Women's Coalition for Change and other performance groups of the upcoming generation who are continuing to bring a feminist perspective to social issues of the day.

2. Led by artists Poppy Johnson, Faith Ringgold, and Brenda Miller and critic Lucy Lippard, the groups represented were the Ad Hoc Women's Committee of the Art Workers Coalition, Women Artists in Revolution, and Women Students and Artists for Black Art Liberation, plus unaffiliated sympathizers, both women and men. See Grace Glueck, "Women Artists Demonstrate at Whitney," *New York Times*, December 12, 1970, 19, and Elizabeth Baker, "Sexual Art-Politics," *ARTnews*, January 1971, 62.

3. Observer quoted in Paula Jardine, "Public Dreams and a Parade for Spring," *Heresies: A Feminist Publication on Art and Politics* 5, no. 1, Issue 17 (1984): 12. This issue of *Heresies* is titled "Acting Up! Women in Theater and Performance."

4. Cheri Gaulke, "Performance Art of the Woman's Building," *High Performance* 3, (Fall/Winter 1980): 156.

5. Moira Roth, "A Star Is Born: Performance Art in California," *Performing Arts Journal* 4, no. 3 (1980): 86.

6. Arlene Raven, also an early participant, has described the exhilaration of participating in performance work and how other feminist projects were indeed contingent on performance: "I see [the ritual/performance piece *Ablutions*] in retrospect, and symbolically, as initiation into the circle of women with whom I could bond over and over to create the feminist institutions, educational methods,

criticism, publications, relationships, and the art. . . . Womanspace, *Womanspace Journal*, the Woman's Building, The Feminist Studio Workshop, Mother Art, Feminist Art Workers, Ariadne, Waitresses, An Oral Herstory of Lesbianism, Lesbian Art Project, *Chrysalis*—to name some of our work." Raven, "The Circle: Ritual and the Occult in Women's Performance Art," *New Art Examiner*, November 1980, 9; reprinted in Raven, *Crossing Over: Feminism and Art of Social Concern* (Ann Arbor, Mich.: UMI Research Press, 1988), 23–32.

7. Carolee Schneemann, *More than Meat Joy: Complete Performance Works and Selected Writings*, ed. Bruce McPherson (New Paltz, N.Y.: Documentext, 1979), 52.

8. Ibid., 52.

9. Carolee Schneemann, telephone interview by Josephine Withers, June 22, 1993.

10. Schneemann, *More than Meat Joy*, 194. In the Morris performance, Schneemann was posed impassively in a *tableau vivant* based on Manet's famous painting *Olympia*—the paradigmatic object of the male gaze.

11. Carolee Schneemann, *Cézanne, She Was a Great Painter* (New Paltz, N.Y: Tresspuss Press, 1975), 36.

12. Willoughby Sharp and Liza Bear, "The Performer as a Persona: An Interview with Yvonne Rainer," *Avalanche*, no. 5 (Summer 1972): 50.

13. Ibid., 59.

14. Laurie Anderson, quoted in Mel Gordon, "Laurie Anderson: Performance Artist," *Drama Review* 24, (June 1980): 51.

15. Craig Owens, "Amplifications: Laurie Anderson," *Art in America*, March 1981, 122.

16. Lucy R. Lippard, "Catalysis: An Interview with Adrian Piper," in *From the Center: Feminist Essays on Women's Art* (New York: Dutton, 1976), 167; originally published in *Drama Review* 16, (March 1972).

17. Ibid., 170.

18. The text is taken from Schneemann's film "Kitch's Last Meal," (1973–77) and is reproduced in its entirety in *More than Meat Joy*, 239–40.

19. Ibid. Schneemann says that the text used in *Interior Scroll* is "actually a secret letter to Annette Michaelson. There are some women whose insight is so important to me, but who couldn't understand my work and couldn't deal with it or regard it. She was one of those." Schneemann, telephone interview by Josephine Withers, June 22, 1993.

20. Donna Henes quoted in "Spider Woman: Donna Henes Interviewed by Linda Burnham," *High Performance* 2 (June 1979): 27.

21. Ibid., 28.

22. See Mary Beth Edelson, *Seven Cycles: Public Rituals*, intro. Lucy R. Lippard (New York: self-published, 1980).

23. Edelson quoted in *Mary Beth Edelson Firsthand: Photographs 1973–1993 and Shooter Series* (New York: self-published, 1993), 23.

24. Betsy Damon, "The 7000 Year Old Woman," *Heresies* 1, no. 3 (Fall 1977): 11.

25. Betsy Damon telephone interview by Josephine Withers, June 4, 1993.

26. Linda Montano, *Art in Everyday Life* (Los Angeles: Astro Artz, 1981), n.p. (sec. 2).

27. Montano's characters appeared on video in a talk show format titled *Learning to Talk*, 1977.

28. Montano, *Art in Everyday Life*, n.p. (sec. 3).

29. Faith Ringgold, quoted in Lucy R. Lippard, "Faith Ringgold's Black, Political, Feminist Art," in *From the Center*, 262.

30. Suzanne Lacy, "Made for TV: California Performance in Mass Media," *Performing Arts Journal*, no. 17 (1982): 54.

31. Aviva Rahmani, personal communication, July 22, 1993. The others of the group were Ida Applebroog, Faiya Fredman, Pat Patterson, Judy Nikolaides, Joyce Cutler Shaw, and Barbara Stresan.

32. Eleanor Antin, in acknowledgments to *Angel of Mercy*, exh. cat. (La Jolla, Calif.: La Jolla Museum of Contemporary Art, 1977), n.p. The Angel of Mercy is the moniker for her incarnation as Eleanor Nightingale.

33. See Josephine Withers, "Eleanor Antin: Allegory of the Soul," *Feminist Studies* 12, no. 1 (Spring 1986): 117–27.

34. See, for example, Lucy Lippard, introduction to Mary Beth Edelson, *Seven Cycles: Public Rituals*; Elizabeth Abel, "(E)merging Identities: The Dynamics of Female Friendship in Contemporary Fiction by Women," and Judith Kegan Gardiner, "The (Us)es of (I)dentity: A Response to Abel on '(E)Merging Identities,'" *Signs: Journal of Women in Culture and Society* 6, no. 3 (1981): 134–35 and 438; and Christa Wolf, "Interview with Myself," in her *The Reader and the Writer: Essays, Sketches, Memories* (New York: International, 1977), 76. Note that Carol Gilligan's influential *In a Different Voice* was not published until 1982.

35. Josephine Withers, interview with Eleanor Antin, San Diego, April 29, 1980.

36. See Moira Roth, "An Interview with Lynn Hershman," *Journal of the Los Angeles Institute of Contemporary Art* 5 (January/February 1978): 18–24.

37. "Correspondence between Jacki Apple and Martha Wilson, 1973–1974," *Heresies: A Feminist Publication on Art and Politics* 1, no. 2 (May 1977): 47.

38. See Faith Wilding's essay in this book.

39. See Judy Chicago, *Through the Flower: My Struggle as a Woman Artist* (Garden City, N.Y.: Doubleday, 1975; New York: Penguin, 1993), 213–17.

40. Françoise Lionnet, *Autobiographical Voices* (Ithaca, N.Y.: Cornell University Press, 1989), as quoted in Judith Hamera, "Loner on Wheels as Gaia: Identity, Rhetoric, and History in the Angry Art of Rachel Rosenthal," *Text and Performance Quarterly* 11 (January 1991): 36.

41. Rachel Rosenthal, quoted in Moira Roth, ed., *The Amazing Decade: Women and Performance Art in America, 1970–1980* (Los Angeles: Astro Artz, 1983), 126.

42. Rosenthal, statement at a workshop at New York University, May 21–June 7, 1985, as quoted in Eelka Lampe, "Rachel Rosenthal: Creating Her Selves," *Drama Review* 32, (Spring 1988): 170.

43. Lacy, "Made for TV," 55.

44. This performance is more fully discussed in the essay by Moira Roth and Yolanda M. López in this book.

45. Suzanne Lacy, "In Mourning and In Rage (With Analysis Aforethought)," *IKON*, 2d series, no. 1 (Fall/Winter 1982).

46. At one time or another, The Waitresses included Jerri Allyn, Leslie Belt, Anne Gauldin, Anita Green, Chutney Gunderson, Patti Nicklaus, Jamie Wildman-Webber (a.k.a. Jamie Wild, and Wildone), and Denise Yarfitz.

47. Bonnie Sherk, interview by Linda Frye Burnham, "Between the Diaspora and the Crinoline," *High Performance* 4 (Fall 1981): 70.

48. Ibid., 58.

49. Ibid.

50. Suzanne Lacy, "The Greening of California Performance: Art for Social Change—A Case Study," *Images and Issues* 2, (Spring 1982): 67.

51. Lorraine O'Grady, correspondence with Josephine Withers, July 2, 1993. The first performance took place at the Just Above Midtown/Downtown Gallery on June 5, 1980. O'Grady performed this character again, with modifications, in 1981 at the New Museum of Contemporary Art in New York City.

Orenstein / Recovering Her Story

1. Gerda Lerner, *The Creation of Feminist Consciousness: From the Middle Ages to 1870* (New York: Oxford University Press, 1993).

2. Elizabeth Cody Stanton and Matilda Joslyn Gage, *The Woman's Bible*, 1895. A radical feminist critique of the Bible, summarizing Bible criticism and providing, in a critical perspective, information pertinent to women.

3. Lerner, *Creation*, 115.

4. Ibid.

5. Merlin Stone, *When God Was A Woman* (New York: Dial Press, 1976).

6. When her book was republished, Marija Gimbutas changed its title to *Goddesses and Gods of Old Europe*, thereby giving priority to the Goddesses.

7. Marija Gimbutas, *The Gods and Goddesses of Old Europe: 7000 to 3500 B.C., Myths, Legends, and Cult Images* (Berkeley: University of California Press, 1974).

8. The term "herstory" (her story) is used to contrast history (his story), to connote a feminist rather than a patriarchal narrative.

9. The word "matristic" is used in general to mean Mother Goddess–centered, to characterize cultures for which the terms "matrilineal," "matrifocal," and "matriarchal" would be too precise given the lack of texts and other specific data available about them.

10. According to Z Budapest: (Zsuzsanna Budapest), a Priestess of the Goddess Religion and author of *The Holy Book of Women's Mysteries: Feminist Witchcraft, Goddess Rituals, Spellcasting, and Other Womanly Arts* (Oakland, Calif.: Wingbow Press, 1989); *The Grandmother of Time: A Woman's Book of Celebrations, Spells, and Sacred Objects for Every Day of the Year* (San Francisco: Harper San Francisco, 1989); *Grandmother Moon: Lunar Magic in Our Lives: Spells, Rituals, Goddesses, Legends, and Emotions under the Moon* (San Francisco: Harper, San Francisco, 1991); *The Goddess in the Office: Personal Energy Guide for the Spiritual Warrior of Work* (San Francisco: Harper San Francisco, 1993).

11. Erich Neumann, *The Great Mother: An Analysis of the Archetype* (Princeton: Princeton University Press, 1955).

12. Buffie Johnson, *Lady of the Beasts: Ancient Images of the Goddess and Her Sacred Animals* (San Francisco: Harper & Row, 1988).

13. Mimi Lobell, "The Goddess Temple," *Humanist Ideas in Architecture* 29, no. 1, 20.

14. Sheila Moon, *A Magic Dwells* (Middletown, Conn.: Wesleyan University Press, 1970), p. 152.

15. Neumann, *Great Mother*, 313.

16. I use the word "matristic" instead of matriarchal, because I am referring to a mythos and ethos that neither is hierarchical nor operates via domination. The word *matriarchal* means rule by the mother. The word *matristic* is used by Marija Gimbutas to mean a civilization, culture, or religion that was focused upon the Goddess. In general, these cultures were earth-revering, gender-egalitarian, and pacific. Theirs was an Earth Mother Goddess.

17. With regard to the use of the term *essentialist*, critics of Goddess scholarship maintain—wrongly, I believe—that a monolithic Goddess symbol creates an image of the "essential" feminine. Of course, we know that what is referred to as "feminine" is culturally constructed. I maintain, however, that the creation of a monolithic Goddess symbol was an attempt to establish not a universal image of the "feminine" but rather a universal symbol of a worldwide civilization that was the antithesis of patriarchy.

18. Gimbutas, *The Gods and Goddesses of Old Europe*.

19. "Gynocentric" is used to mean woman-centered, as contrasted with "matristic," Goddess-centered.

20. The New York Woman's Salon for Literature was cofounded by Erika Duncan, Karen Malpede, Gloria Orenstein, and other writers in 1975 and lasted until 1985.

21. Monica Sjöo and Barbara Mor, *The Great Cosmic Mother: Rediscovering the Religion of the Earth* (San Francisco: Harper & Row, 1987).

Frueh / The Body Through Women's Eyes

1. Simone de Beauvoir, *The Second Sex*, trans. H. M. Parshley (New York: Bantam, 1961), 127–28, 148, 249.

2. Lisa Tickner, "The Body Politic: Female Sexuality and Women Artists since 1970," in *Looking On: Images of Femininity in the Visual Arts and Media*, ed. Rosemary Betterton, (New York: Pandora, 1987), 237–38; originally published in *Art History* 1 (June 1978): 236–49.

3. Feminist critics and theorists asserted differing ideas about women's ability to represent themselves as subjects and be understood on their own terms. Lucy R. Lippard states that "a significant psychological factor converts [women's] bodies or faces from object to subject." Lippard, "The Pains and Pleasures of Rebirth: European and American Women's Body Art," in *From the Center: Feminist Essays on Women's Art* (New York: Dutton, 1976), 124. Whereas Laura Mulvey claims that because the female body is a visual spectacle, the passive object of an active male "gaze," the pleasures of looking, as we know them, must be destroyed. Mulvey, "Visual Pleasure and Narrative Cinema," in *Art after Modernism: Rethinking Representation*, ed. Brian Wallis, 361–73 (Boston: David R. Godine/New Museum of Contemporary Art, New York, 1984).

4. Schneemann has often spoken of the "ecstatic body."

5. Angela Carter, *The Sadeian Woman and the Ideology of Pornography* (New York: Pantheon, 1978), 150.

6. Adrienne Rich, *Of Woman Born: Motherhood as Experience and Institution* (1976; New York: Bantam, 1977), 292.

7. Maryse Holder, "Another Cuntree: At Last, a Mainstream Female Art Movement," in *Feminist Art Criticism: An Anthology*, ed. Arlene Raven, Cassandra Langer, and Joanna Frueh (1988; New York: HarperCollins, 1991), 1; originally published in *off our backs*, September 1973.

8. Germaine Greer, *The Female Eunuch* (New York: McGraw Hill, 1971; Bantam, 1978), 39, 260, and, for more discussion of "cunt-negativity," 257–59.

9. de Beauvoir, *Second Sex*, 146–48.

10. Una Stannard, "The Mask of Beauty," in *Woman in Sexist Society: Studies in Power and Powerlessness*, ed. Vivian Gornick and Barbara K. Moran, (New York: Mentor, 1971), 187.

11. Critic Lucy Lippard calls Wilke a "glamor girl" and reminds readers that Schneemann was "known in the early 1960s as a 'body beautiful.'" Piper was a model in her youth. Lippard's comments show concern about beautiful artists' self-exploitation, and she criticizes Wilke because an audience could perceive her as "flirt" or "feminist." Lippard, "The Pains and Pleasures of Rebirth," in *From the Center*, 124–26. Lisa Tickner, "Body Politic," 248–49, shares Lippard's concerns.

12. Much of my discussion of *S.O.S.* here is drawn from my essay, "Hannah Wilke," in *Hannah Wilke: A Retrospective*, ed. Thomas H. Kochheiser (Columbia: University of Missouri Press, 1989), 51–52.

13. Carolee Schneemann, interview by Joanna Frueh, June 26, 1993.

14. Carter, *Sadeian Woman*, 4–5. For more argument against privileging female genitalia, see Monique Wittig, *Les Guérillères*, trans. David Le Vay (1971; Boston: Beacon Press, 1985), 57, 61, 66, 72.

15. "Aphroditean" is Schneemann's term. Interview by Frueh.

16. Adrian Piper, one-page unpublished description of *Food for the Spirit*, undated.

17. Stannard, "Mask of Beauty," 197, 199.

18. Lorraine O'Grady, "*Olympia's Maid*: Reclaiming Black Female Subjectivity," *Afterimage* 14 (June 1992): 14.

19. A group of *Artforum* associate editors wrote that the Benglis ad was "an object of extreme vulgarity," a "shabby mockery of the aims of [the women's liberation] movement," which the editors said *Artforum* had supported, and a brutalization of the readers and the editors themselves. Lawrence Alloway, Max Kozloff, Rosalind Krauss, Joseph Masheck, and Annette Michelson, Letter to the Editor, *Artforum* December 1974, 9.

20. One of the key texts is Judith Butler, *Gender Trouble: Feminism and the Subversion of Identity* (New York: Routledge, 1990).

21. As de Beauvoir writes in *Second Sex*, "In speaking of certain women, connoisseurs declare that they are not women, although they are equipped with a uterus like the rest. . . . It would appear, then, that every female human being is not necessarily a woman; to be so considered she must share in that mysterious and threatened reality known as femininity" (xii).

22. June Wayne, "The Male Artist as a Stereotypical Female," in *Feminist Collage: Educating Women in the Visual Arts*, ed. Judy Loeb (New York: Columbia University Teachers College Press, 1979), 132; originally published in *Art Journal* 32 (Summer 1973). I dealt with what I call the language of war and the language of miracles in "The Dangerous Sex: Art Language and Male Power," *Women Artists News* 10 (September 1985): 6–7, 11, and also more extensively in my performative lecture, "The Language of War and the Language of Miracles," first delivered in 1991.

23. Greer, *Female Eunuch*, 259. Women said men saw *Red Flag* as a bloody—"castrated"—penis.

24. Referring to the title of Greer's book, Betty Dodson proclaims positively: "We are now in the process of changing our image from that of the 'FEMALE EUNUCH' to the 'PHALLIC WOMAN.' Look up phallus in your dictionary . . . It refers to both the penis and the clitoris." Dodson, *Liberating Masturbation: A Meditation on Self-Love* (New York: Bodysex Designs, 1974), 54 (published the same year Benglis's ad appeared).

25. Hélène Cixous, "The Laugh of the Medusa," trans. Keith Cohen and Paula Cohen, in *New French Feminisms: An Anthology*, ed. Elaine Marks and Isabelle de Courtivron (New York: Schocken, 1981), 250. The article first appeared as "Le rire de la meduse" in *L'arc* 61 (1975): 39–54, and a revised version appeared as "The Laugh of the Medusa" in *Signs: Journal of Women in Culture and Society* 1 (Summer 1976).

26. Susan Sontag, "The Double Standard of Aging," *Saturday Review*, September 23, 1972, 37. De Beauvoir also writes about aging in the bleak *Coming of Age*, trans. Patrick O'Brien (New York: Putnam's Sons, 1972).

27. Alice Neel, quoted in Patricia Hills, *Alice Neel* (New York: Harry N. Abrams, Inc., 1983), 162, says her pregnant nudes show "just a fact of life . . . very important . . . and neglected."

28. Lippard, "Pains and Pleasures of Rebirth," 138, notes that although "women photographers have dealt fairly often with pregnant nudes," women body artists have not used childbirth and pregnancy as prime images. She offers several reasons for that absence and concludes, "Perhaps procreativity is the next tabu to be tackled."

29. Greer, *Female Eunuch*, 35–36.

30. Kenneth Clark, *The Nude: A Study in Ideal Form* (New York: Pantheon, 1956), 93.

31. John Berger in *Ways of Seeing* (Harmondsworth: BBC/Penguin, 1972) first posited that men subject women to an oppressive "gaze" three years before Laura Mulvey did so in 1975. Berger's *Ways of Seeing* was reprinted eleven times between 1972 and 1981, became undergraduate art history reading in the United States by the end of the 1970s, and, according to British art historian Marcia Pointon, "more than any other [text], has informed a whole generation (at least in Britain) not only on the nude but on art in general." Pointon, *Naked Authority: The Body in Western Painting, 1830–1908* (Cambridge: Cambridge University Press, 1990), 15.

32. Tickner, "Body Politic," 247.

33. Pointon, *Naked Authority*, 4, 11, 12, 15–17, 18–19, 28–29.

34. Susie Orbach, *Fat Is a Feminist Issue: The Anti-Diet Guide to Permanent Weight Loss* (New York: Berkley Books, 1979), 22; originally published by Paddington Press in 1978.

35. Almost all the essays in *Take Back the Night: Women on Pornography*, ed. Laura Lederer (New York: William Morrow, 1980), were originally published in the 1970s. They exemplify anti-porn positions. For a collection of pro-porn essays on the feminist debate about pornography from the 1960s into the 1980s, see Kate Ellis, Beth Jaker, Nan D. Hunter, Barbara O'Dair, and Aby Tallmer, eds., *Caught Looking: Feminism, Pornography, and Censorship* (East Haven, Conn.: LongRiver Books, 1986).

36. For feminist discussions of female genius and innovation see Christine Battersby, *Gender and Genius: Towards a Feminist Aesthetics* (Bloomington: Indiana University Press, 1990), and Wendy Slatkin, *Women Artists in History: From Antiquity to the 20th Century*, 2d ed. (Englewood Cliffs, N.J.: Prentice-Hall, 1990), 5.

37. Susan Griffin, *Woman and Nature: The Roaring Inside Her* (New York: Harper Colophon, 1978), 1, 226.

38. Sherry Ortner, "Is Female to Male as Nature Is to Culture?" in *Woman, Culture, and Society* ed., Michelle Zimbalist Rosaldo and Louise Lamphere (Stanford, Calif.: Stanford University Press, 1974), 72, 87.

39. Carol P. Christ, "Why Women Need the Goddess," *Heresies: A Feminist Publication on Art and Politics*, Issue 5 (Spring 1978): 10.

40. Mary Beth Edelson, quoted in Joyce Tenneson Cohen, *In/Sights* (Boston: David R. Godine, 1978), 119. Edelson's statement also appears in her description of *Woman Rising* in Edelson, *Seven Cycles: Public Rituals* (New York: self-published, 1980), 17.

41. Gloria Feman Orenstein, "The Reemergence of the Archetype of the Great Goddess in Art by Contemporary Women," *Heresies: A Feminist Publication on Art and Politics*, Issue 5 (Spring 1978), 74.

42. Lorde's lecture appears in her *Sister Outsider* (Trumansburg, N.Y.: Crossing Press, 1984), 53–59.

43. Linda Nochlin, "Eroticism and Female Imagery," in *Woman as Sex Object: Studies in Erotic Art, 1730–1970*, ed. Thomas B. Hess and Linda Nochlin (New York: Newsweek, 1972), 9–15, discusses the erotic in Western art as erotic for men.

44. Much of my discussion of *Pink Champagne* is drawn from my "Hannah Wilke," 18. See Luce Irigaray, "This Sex Which Is Not One," trans. Claudia Reeder, in Marks and de Courtivron, *New French Feminisms*, 99–106, and esp. 102–3, for an elaboration of female pleasures. Irigaray's "Ce sexe qui n'en pas un" was originally published in 1977 by Minuit; new translation by Catherine Porter with Carolyn Burke published by Cornell University Press, 1985.

45. The first issue of *Gay Academic Union Journal: Gai Saber* (Spring 1977) printed a review of the anthology *Lesbianism and the Women's Movement*, and *Frontiers: A Journal of Women's Studies* published Lillian Faderman's "Who Hid Lesbian History?" (Fall 1979).

46. In the 1970s, Nancy Fried produced a group of flour, salt, and acrylic paintings, which are the size of large cookies. Many of the paintings show women couples in domestic interiors whose rich colors and patterns describe a wealth of coziness and warmth.

47. Harmony Harmond, letter to Joanna Frueh, September 22, 1993.

48. Arlene Raven and Ruth Iskin, "Through the Peephole: Toward a Lesbian Sensibility in Art," *Chrysalis* 4 (1977): 23–24 and 26.

49. Dodson, *Liberating Masturbation*, 21.

50. Mary Daly, *Beyond God the Father: Toward a Philosophy of Women's Liberation* (Boston: Beacon Press, 1973), 15, 21, and 26.

51. See *Artforum*, November 1975, Robert Knott, "The Myth of the Androgyne," 38–45, and two articles in which the androgyne appears but not as the principle subject: Max Kozloff, "Pygmalion Reversed," 30–37, and Whitney Chadwick, "Eros or Thanatos: The Surrealist Cult of Love Reexamined," 46–56.

52. Barbara G. Walker, *The Woman's Encyclopedia of Myths and Secrets* (San Francisco: Harper & Row, 1983), 409–10, writes, "Perhaps the most distinguishing feature of a divine being used to be a horned head. . . . The Horned God was as old as the Stone Age." See Arlene Raven, *Nancy Grossman* (Brookville, N.Y.: Hillwood Art Museum, 1991), for a complete discussion of Grossman's career.

53. Mary Daly, *Gyn/Ecology: The Metaethics of Radical Feminism* (Boston: Beacon, 1978), xi.

54. Louise Bourgeois, quoted in Lippard, "Pains and Pleasures of Rebirth," 246.

55. Cindy Nemser, "Four Artists of Sensuality," *Arts Magazine*, March 1975, 73.

56. In the 1970s, feminists used reversal as an education method. A later example of this technique is Trudy Wheeler, *The Revisionist Art Calendar 1983: Art History Revisited* (Atlanta, 1983).

Broude / The Pattern and Decoration Movement

1. Miriam Schapiro, "Notes from a Conversation on Art, Feminism, and Work," in *Working It Out: 23 Women Writers, Artists, Scientists, and Scholars Talk about Their Lives and Work*, ed. Sara Ruddick and Pamela Daniels (New York: Pantheon, 1977), 296.

2. On these issues, see Norma Broude, "Miriam Schapiro and 'Femmage': Reflections on the Conflict between Decoration and Abstraction in Twentieth-Century Art," *Arts Magazine* 54 (February 1980): 83–87; reprinted in *Feminism and Art History: Questioning the Litany*, ed. Norma Broude and Mary D. Garrard (New York: Harper & Row, 1982), 315–29.

3. See Valerie Jaudon and Joyce Kozloff, "Art Hysterical Notions of Progress and Culture," *Heresies: A Feminist Publication on Art and Politics* 4 (Winter 1978): 38–42.

4. Amy Goldin, "The 'New' Whitney Biennial: Pattern Emerging?" *Art in America*, May/June 1975, 72.

5. David Bourdon, "Decorative is not a Dirty Word," *Village Voice*, October 11, 1976.

6. Kim MacConnel, letter to Norma Broude, June 11, 1993.

7. Kim MacConnel, artist's statement, *Painting '75/'76, '77*, exh. cat. (Bronxville, N.Y.: Sarah Lawrence College Gallery, 1977), n.p.

8. Holly Solomon, interview by Marc Miller, *Aspects of Pattern and Decoration* (New York: Art/New York and Inner-Tube Video, 1982); videotaped interviews produced and directed by Paul Tschinkel.

9. See Janet Kardon, *Robert Kushner*, exh. cat. (Philadelphia: University of Pennsylvania, Institute of Contemporary Art, 1987).

10. In 1976, for example, a critic reviewing an exhibition in San Diego of painted fabric wall hangings and furniture by the ambiguously named Kim MacConnel referred to the artist condescendingly as "Miss MacConnel." Bill Northwood, "Kim MacConnel, No Allegiances, No Guideposts," *The Museum of California* (Oakland Museum of Art) 7 September/October 1983: 15.

11. John Perreault, "The New Decorativeness," *Portfolio* 1 (June/July 1979): 46.

12. John Perreault, review of Joyce Kozloff's show "An Interior Decorated," *Soho Weekly News*, September 13, 1979, 47.

13. April Kingsley, "Opulent Optimism," *Village Voice*, November 28, 1977.

14. Jeff Perrone, "The Decorative Impulse," *Artforum* November 1979, 80–81.

15. Robert C. Hobbs, "Rewriting History: Artistic Collaboration since 1960," in *Artistic Collaboration in the Twentieth Century*, ed. Cynthia Jaffe McCabe (Washington, D.C.: Smithsonian Institution Press, 1984), 79–80.

16. Miriam Schapiro, interview by Ruth A. Appelhof, February 1979, in *Miriam Schapiro, A Retrospective: 1953–1980*, exh. cat., ed. Thalia Gouma-Peterson (Wooster, Ohio: College of Wooster, 1980), 48.

17. Ibid.

18. See Melissa Meyer and Miriam Schapiro, "Waste Not/Want Not: Femmage," *Heresies: A Feminist Publication on Art and Politics*, Issue 4 (Winter 1978): 66–69.

19. This and all other quotes in this section are from Miriam Schapiro, "How Did I Happen to Make the Painting *Anatomy of a Kimono*?" (1978), in *Miriam Schapiro, A Retrospective*, 26–30. (The book that inspired Schapiro was *Japanese Costume and Textile Arts* by Seiroki Noma [New York: Westerhill, 1974].)

20. Amy Goldin, "Patterns, Grids, and Painting," *Artforum*, September 1975, 50–54; quotations from 50 and 51. Goldin illustrated her remarks with a selection of works by Minimalist, or at least formally reductivist, artists of the 1960s,

such as Ad Reinhardt, Ellsworth Kelly, Alfred Jensen, Alan Shields, and Agnes Martin.

21. Robert S. Zakanitch, interview with Norma Broude, May 23, 1993.

22. Ibid.

23. "Notations by Robert S. Zakanitch, 1975–1979," in *Robert S. Zakanitch*, exh. cat. with essay by Janet Kardon (Philadelphia: University of Pennsylvania, Institute of Contemporary Art, 1981), 39.

24. For this discussion of Carlson's early career and involvement with the Pattern and Decoration movement, I have drawn on an essay by David S. Rubin, "Cynthia Carlson: From the Decorative to the Commemorative," in *Cynthia Carlson: Installations, 1979–1989 (A Decade, More or Less)*, exh. cat. (Reading, Pa.: Albright College, Freedman Gallery), 4–17.

25. In 1975, Amy Goldin was the first to analyze and describe the different perceptual processes evoked by "compositions" and "grids" in relation to modern painting. Her somewhat negative description of the experience of "scanning," however, is neither applicable nor congenial to feminist practice. "Scanning," she wrote, "is a much more specialized, anxious kind of looking. It contains an element of search and unsatisfied search at that, since it implies a restless refusal to focus and an attempt to grasp the nature of the whole. The characteristic response to patterns and grids is rapid scanning." Goldin, "Patterns, Grids, and Painting," 51.

26. Joyce Kozloff letter to Norma Broude, May 31, 1993.

27. Ibid.

28. Kozloff enumerated her sources for the motifs she painted on the nearly one thousand star- and hexigon-shaped tiles that comprise the floor: "American Indian pottery, Moroccan ceramics, Viennese Art Nouveau book ornament, American quilts, Berber carpets, Caucasian kilims, Egyptian wall paintings, Iznik and Catalan tiles, Islamic calligraphy, Art Deco design, Sumerian and Romanesque carvings, Pennsylvania Dutch signs, Chinese painted porcelains, French lace patterns, Celtic illuminations, Turkish woven and brocaded silks, Seljuk brickwork, Persian miniatures and Coptic textiles." Artist's statement, *An Interior Decorated*, exh. cat. (New York: Tibor de Nagy Gallery, 1979), 8.

29. On Kozloff's transition to public art and her first public art projects of the early 1980s, see the essays by Patricia Johnston, "Joyce Kozloff: Visionary Ornament: An Overview," and Thalia Gouma-Peterson, "Decorated Walls for Public Spaces: Joyce Kozloff's Architectural Installations," in Patricia A. Johnson, *Joyce Kozloff: Visionary Ornament*, exh. cat. (Boston: Boston University Art Gallery, 1986), 9–15 and 45–57.

30. On Schapiro's "Anna and David" and on public sculpture by women (Nancy Holt, Elyn Zimmerman, and Anne Poirier) in the Washington, D.C., area, see Norma Broude, "Alternative Monuments," *Art in America*, February 1991, 73–81.

31. John Perreault, "On Decorative Art," in *New Decorative Works from the Collection of Norma and William Roth*, exh. cat. (Orlando, Fla.: Loch Haven Art Center, 1983), 6–7.

32. Traditionally, Western culture's method of dealing with the threat of oppositional groups has been to coopt and absorb them into the mainstream's own metanarrative. In fact, the very dynamic of the creation, growth, naming, and then commercial consumption of modernist "movements" has worked efficiently to make oppositional groups complicit in a long-recognized and -recognizable modernist process—a process that adapts the forms of low or popular culture and then quickly subordinates them to a rejuvenated high art, sending the original forms back into popular culture, stripped of their authenticity, as commercialized kitsch. On this phenomenon, see Clement Greenberg, "Avant-Garde and Kitsch," *Partisan Review* 6 (Fall 1939): 34–49, and Thomas Crow, "Modernism and Mass Culture," in *Modernism and Modernity: The Vancouver Conference Papers*, ed. Benjamin H. D. Buchloh, Serge Guilbaut, and David Solkin (Halifax: Press of the Nova Scotia College of Art and Design, 1983) 215–64.

33. Joyce Kozloff, artist's statement, in Carrie Rickey, "Decoration, Ornament, Pattern, and Utility: Four Tendencies in Search of a Movement," *Flash Art*, June/July 1979, 23.

Stein / Collaboration

1. Muriel Rukeyser, "Kathe Kollwitz," in *The Collected Poems of Muriel Rukeyser* (New York: McGraw-Hill, 1982), 482.

2. Unnamed member of Las Mujeres Muralistas, quoted in Charlotte Streifer Rubinstein, *American Women Artists* (New York: Avon, 1982), 431.

3. Miriam Schapiro, interview with Judith E. Stein, April 10, 1993.

4. Judy Chicago, *Through the Flower: My Struggle as a Woman Artist*, (Garden City, N.Y.: Doubleday, 1975; New York: Penguin, 1993), 178.

5. Judy Chicago, *The Dinner Party* (Garden City, N.Y.: Anchor, 1979), 8.

6. This and the following quotes are from ibid., 11.

7. Los Angeles *Times* art critic Suzanne Muchnic, quoted in Lucy Lippard, "Judy Chicago's 'Dinner Party,'" *Art in America*, April 1980, 116. For other contemporary critiques, see Carrie Rickey, "Judy Chicago, *The Dinner Party*" (1981), and Karin Woodley, "The Inner Sanctum: *The Dinner Party*" (1985), reprinted in *Visibly Female: Feminism and Art, An Anthology*, ed. Hilary Robinson (New York: Universe, 1988), 94–99.

8. Lippard, "Judy Chicago's 'Dinner Party,'" 116.

9. Judy Chicago, quoted in ibid.

10. Robert C. Hobbs, "Rewriting History: Artistic Collaboration since 1960," in *Artistic Collaboration in the Twentieth Century*, ed. Cynthia Jaffee McCabe (Washington, D.C.: Smithsonian Institution Press, 1984), p. 80.

11. Frannie Yablonsky, quoted in Judith Stein, "Midwife to the Revolution," *New York Times Book Review*, September 15, 1985, 31.

12. Judy Chicago, *The Birth Project* (Garden City, N.Y.: Doubleday, 1985), 227.

13. Ilise Greenstein, "Sister Chapel," artist's statement on obverse of poster announcing the Sister Chapel exhibition at P.S. 1, New York, 1978, collection National Museum of Women in the Arts.

14. See Dorothy Gillespie's description in Greenstein's retrospective catalogue *Full Circle* (Hollywood, Fla.: Art and Cultural Center, 1981), 10.

15. June Blum, interview by Judith E. Stein, October 20, 1993.

16. Laurie Johnston, "The 'Sister Chapel': A Feminist View of Creation," *New York Times*, January 30, 1978, sec. B, 1.

17. Elsa Goldsmith, quoted in ibid.

18. The model, no longer extant, is reproduced in Gloria Feman Orenstein, "The Sister Chapel—A Traveling Homage to Heroines," *womanart*, Winter/Spring 1977, 12.

19. In addition, Greenstein's ceiling painting was shown at the National Armory, Washington, D.C., as part of "Wash Art '79," May 2–7, 1979.

20. For a full discussion of the iconography, see Orenstein, "Sister Chapel."

21. Betty Holliday, quoted in Amei Wallach, "Women, God, and the World—The Sister Chapel's Trinity," *Newsday*, January 29, 1978, pt. 2, 15.

22. Alice Neel, quoted in Johnston, "Sister Chapel."

23. See Leslie Labowitz and Suzanne Lacy, "Feminist Artists: Developing a Media Strategy for the Movement," in *Fight Back!*, ed. Frederique de la Coste and Felice Newman (Minneapolis, Minn.: Cleis Press, 1981), 266–72, and Suzanne Lacy, Leslie Labowitz, Julia London, and Joan Howarth, "Evolution of a Feminist Art, Public Forms and Social Issues," *Heresies: A Feminist Publication on Art and Politics*, Issue 6 (Summer 1978); 76, 78–88.

24. Suzanne Lacy, "Take Back the Night," *High Performance*, Winter 1979/80, 32–34.

25. Suzanne Lacy, quoted in "Political Performance Art: A discussion by Suzanne Lacy and Lucy Lippard," *Heresies* 7 (1985): 25. Regarding contemporary feminist gift-giving within the Los Angeles women's community, see Joanne Kerr's 1980 doctoral dissertation for the University of California, Irvine, *Art and Community: A Sociological Study of Contemporary Feminist Art* (Ann Arbor, Mich.: University Microfilms International, 1980), "Art in Everyday Life: The Lesbian Gift of Art," 160–98.

26. Moira Roth, "Suzanne Lacy's Dinner Parties," *Art in America*, April 1980, 126.

27. Lucy Lippard, "Some of Her Own Medicine," *Drama Review*, Spring 1988, 73.

28. Suzanne Lacy, "Battle of New Orleans," *High Performance* 3, Fall 1980, 2–9.

29. Stephanie Arnold, "Suzanne Lacy's 'Whisper, The Waves, the Wind,'" *Drama Review*, Spring 1985, 126–30.

30. See Diane Rothenberg, "Social Art/Social Action," *Drama Review*, Spring 1988, 61–70, and Moira Roth, "Suzanne Lacy at the IDS Building," *Art in America*, March 1988, 162.

31. The 1971 exhibition "American Pieced Quilts" at the Whitney Museum in New York had sparked the general revival of interest in the genre. In 1973, art historian and artist Pat Mainardi wrote the pioneering essay "Quilts: The Great American Art," reprinted in *Feminism and Art History: Questioning the Litany*, ed. Norma Broude and Mary D. Garrard (New York: Harper & Row, 1982), 330–46; in 1980, Pat Ferrero made the film "Quilts in Women's Lives"; and in 1981, Ferrero, Linda Reuther, and Julie Silber collaborated to curate the exhibition "American Quilts, A Handmade Legacy," at the Oakland Museum, California, accompanied by a catalogue of the same title.

32. Charlotte Robinson, quoted in Mary Swift, "Charlotte Robinson," in *Hands of Artists*, exh. cat. (Arlington, Va.: Arlington Arts Center, 1981), n.p.

33. Charlotte Robinson, "The Quilt Project, A Personal Memoir," in her *The Artist and the Quilt* (New York: Knopf, 1983), 10.

34. I gleaned information about the Women's Pentagon Action from conversations with Grace Paley, Donna Gould, Dorothy Marter, and Ynestra King in November 1993. For a discussion of the Women's Pentagon Action, see the essay by Ynestra King in *Keeping the Peace*, ed. Lynne Jones (London: Women's Press, 1983); for photo documentation of the event, see *Heresies* 4, no. 1, Issue 13 "Feminism and Ecology" (1981): 1.

35. Justine Merritt, introduction to *The Ribbon: A Celebration of Life*, ed. Larks Books staff and Marianne Philbin (Asheville, N.C.: Lark Books, 1985), 11. This publication served as the catalogue for an exhibition mounted in 1985 at the Peace Museum, Chicago, of approximately 350 panels from the Ribbon Project.

36. For discussions about the quilt as public art, see E. G. Crichton, "Is the NAMES Quilt Art?" in *Critical Issues in Public Art*, ed. Harriet F. Senie and Sally Webster (New York: Icon, 1993), 287–94, and Jonathan Weinberg, "The Quilt: Activism and Remembrance," *Art in America*, December 1992, 37–39.

37. Faith Ringgold, quoted in Robinson, *Artist and the Quilt*, 105.

38. Joyce Scott, interview with Judith E. Stein, October 2, 1993.

39. Lowery Stokes Sims, "Aspects of Performance in the Work of Black American Women Artists," in *Feminist Art Criticism: An Anthology*, ed. Arlene Raven, Cassandra Langer, and Joanna Frueh (New York: HarperCollins, 1991), 219.

40. Amalia Mesa-Bains, "Quest for Identity: Profile of Two Chicana Muralists," in *Signs from the Heart: California Chicano Murals*, ed. Eva Sperling Cockcroft and Holly Barnet-Sánchez (Venice, Calif.: Social and Public Art Resource Center, 1990), 69.

41. Shifra Goldman, "How, Why, Where, and When It All Happened: Chicano Murals of California," in *Signs from the Heart*, 34.

42. Mesa-Bains, "Quest for Identity," 70.

43. Judy Baca, quoted in Martin Zucker, "Walls of Barrio Are Brought to Life by Street Gang Art," *Smithsonian*, October 1978, 109.

44. Baca, quoted in Shifra M. Goldman, "Mujeres de California: Latin American Women Artists," in *Yesterday and Tomorrow: California Women Artists*, ed. Sylvia Moore (New York: Midmarch Arts Press, 1989), 205.

45. Baca, quoted in Mesa-Bains, "Quest for Identity," 81.

46. Baca, quoted in Frances Pohl, brochure to exhibition "Judith F. Baca: Sites and Insights, 1974–1992," Montgomery Gallery, Pomoma College, Claremont, Calif., March 7–April 4, 1993, n.p.

47. Patricia Rodríguez in *Connecting Conversations: Interviews with 28 Bay Area Women Artists*, ed. Moira Roth (Oakland, Calif.: Eucalyptus Press, 1988), 132–33.

48. Ester Hernández, quoted in ibid., 136.

49. Shifra Goldman, "'Portraying Ourselves': Contemporary Chicana Artists," in Raven, Langer, and Frueh, *Feminist Art Criticism*, 193.

50. Goldman, "Mujeres de California," 203–4.

51. Shirley Neilsen Blum, "The National Vietnam War Memorial," *Arts Magazine*, December 1984, 128.

52. April Kingsley, "Six Women at Work in the Landscape," *Arts Magazine*, April 1978, 108.

53. Maya Ying Lin, quoted in "An Interview with Maya Lin," *Art in America*, April 1983, 123.

54. Ynestra King, *What Is Ecofeminism?* (New York: Ecofeminist Resources, 1990), 47 and 52. The term "ecofeminism" was first introduced by the French feminist Françoise d'Eaubonne, who in 1972 had argued that "the destruction of the planet is due to the profit motive inherent in male power." See *Ecofeminism and the Sacred*, ed. Carol J. Adams (New York: Continuum, 1993), xi.

55. Mierle Laderman Ukeles, Maintenance Art Manifesto, 1969, collection Ronald Feldman Gallery, New York.

56. Mierle Laderman Ukeles, quoted in Suzi Gablik, *The Reenchantment of Art* (New York: Thames and Hudson, 1991), 70.

57. Bill Breen, "The Greatest Flow on Earth," *Garbage*, January/February 1992, 12.

58. Ukeles, quoted in ibid., 13.

59. Betsy Damon, quoted in Macia Goren Weser, "Community-Oriented Artist Strives to Be Involved," *San Antonio Light*, May 1, 1991, sec. G, 3.

60. Betsy Damon, "Keepers of the Waters: Citizens' Rights and Responsibilities," proposal for a Minnesota Water Policy and Art Project, April 20, 1992, collection of the artist.

Schor / Backlash and Appropriation

1. Donald Kuspit, "Reviews: David Salle," *Art in America*, Summer 1982, 142.

2. Thomas Lawson, "Last Exit: Painting," *Artforum*, October 1981, 45.

3. Frank Stella, quoted in Bruce Glaser, "Questions to Stella and Judd," *Minimal Art—A Critical Anthology*, ed. Gregory Battcock (New York: Dutton, 1968), 158.

4. Kuspit, "David Salle," 142.

5. Carter Ratcliff, "David Salle and the New York School," in *David Salle* (Rotterdam: Museum Boymans-van Boeuningen, 1983), 36.

6. Sherrie Levine, "David Salle," *Flash Art*, no. 103 (Summer 1981): 34. Levine writes: "His obsessive use of the female form makes Salle's work very vulnerable to accusations of misogyny. But this label can be an obstacle to a much wider possibility of discussion. . . . the true subject of Salle's work [is] . . . the impossibility of any individual's real congress with the world at large." Levine's unwillingness to call Salle's work misogynist enmeshed her in a web of sophistry and damaged her image as a feminist.

7. Richard Blistene, "Francis Picabia: In Praise of the Contemptible," *Flash Art*, no. 113 (Summer 1983): 24–31; "Flash Art News: Francis Picabia and David Salle," *Flash Art*, no. 115 (January 1984): 31; Janet Kardon, *David Salle* (Philadelphia: University of Pennsylvania, Institute of Contemporary Art, 1986), 26–30.

8. John Yau, "How We Live: The Paintings of Robert Birmelin, Eric Fischl, and Ed Paschke," *Artforum*, April 1983, 65.

9. Anthony Haden-Guest, "The New Queen of the Art Scene," *New York Magazine*, April 19, 1982, 25.

10. Ibid., 28.

11. Peter Schjeldahl, "Mike Kelley," in *The Hydrogen Jukebox: Selected Writings of Peter Schjeldahl, 1978–1990*, ed. Malin Wilson (Berkeley: University of California Press, 1991), 302.

12. Leo Castelli, quoted by Patricia Lynden, "The Art of Protest," *New York Woman*, September 1987, 11. A look at Castelli's roster proves that he puts his money where his mouth is. In the *Art in America Annual Guide to Museums, Galleries, and Artists, 1990–91*, Castelli listed sixteen male artists and no women.

13. Naomi Schor, "This Essentialism Which Is Not One: Coming to Grips with Irigaray," *differences* 1 (Summer 1989), "This Essential Difference, Another Look at Essentialism": 41.

14. Ibid., 42.

15. Judy Chicago, however, speaks of "the development of goddess worship, which represents a time when women had social and political control (clearly reflected in the goddess imagery common to the early stages of almost every society in the world)." *The Dinner Party* (Garden City, N.Y.: Anchor, 1979), 53. This historical misconception is convincingly refuted by Gerda Lerner in *The Creation of Patriarchy* (New York: Oxford University Press, 1986).

16. Thus, during the late 1980s, as a visual aid in teaching, I constructed a general but useful diagram of the hierarchic binarisms that marked the decade within feminist art itself: nature/culture, essentialism/social construction of gender, traditional painting and sculpture/photo media and appropriation.

17. Brian Wallis, ed., *Art After Modernism: Rethinking Representation* (Boston: David R. Godine/New Museum of Contemporary Art, New York, 1984).

18. Craig Owens, "The Discourse of Others: Feminists and Postmodernism," in *The Anti-Aesthetic: Essays on Postmodern Culture*, ed. Hal Foster (Port Townsend, Wash.: Bay Press, 1983), 63.

19. Ibid., 73.

20. Susan Buck-Morss, "A Logic of Disintegration: The Object," in her *The Origin of Negative Dialectics: Theodor W. Adorno, Walter Benjamin, and the Frankfurt School* (New York: Free Press, 1977), 63–81.

21. Griselda Pollock, *Vision and Difference: Feminity, Feminism, and Histories of Art* (New York: Routledge, 1988), 155–99.

22. *Difference—On Representation and Sexuality*, exh. cat. Kate Linker, guest curator (New York: New Museum of Contemporary Art, 1984).

23. Pollock, *Vision and Difference*, 169.

24. Mary Kelly, *Mary Kelly, INTERIM: Corpus, Pecunia, Historia, Potestas* (New York: New Museum of Contemporary Art, 1990).

25. Cf. Benjamin Buchloh, "Figures of Authority, Ciphers of Regression," and Douglas Crimp, "The End of Painting," *October*, 16 (Spring 1981): 39–68, 69–86.

26. Peter Schjeldahl on Cindy Sherman, *7 Days*, March 26, 1990, reprinted in the *Village Voice*, April 10, 1990.

27. Luce Irigaray, *Speculum of the Other Woman*, trans. Gillian C. Gill (Ithaca, N.Y.: Cornell University Press, 1985), 47.

28. Pollock, *Vision and Difference*, 158.

29. Ibid., 163.

30. Ibid., 164–165.

31. Kiki Smith at Fawbush Gallery and Sue Williams at 303 Gallery, May 1992.

32. This promotion is nevertheless founded on the continued erasure of the two preceding decades of feminist art. Roberta Smith's feature on Sue Williams, "An Angry Young Woman Draws a Bead on Men," *New York Times*, May 24, 1992, sec. 2, p. 25, provides an example of such an erasure. Smith places Williams at CalArts at the same time as male art stars David Salle and Eric Fischl. Neither Smith nor Williams mentions that there was a ground-breaking Feminist Art Program at CalArts at that time. Williams remembers the school as "a man's world there." This rewriting of the school's history is of more than local import because of the school's significance to the history of the appropriation movement.

33. Maureen Connor, one of the artists included in the exhibition, gave a critique of the card image during a related panel, "Libido," held at Exit Art, May 13, 1993.

34. Kay Larson, "Men of Iron," *New York Magazine*, April 5, 1993, 65.

35. "American Art in the 20th Century: Painting and Sculpture," Berlin, organized by Christos M. Joachimedes and Norman Rosenthal; see Kim Levin, "The Masterpiece Mentality," *Village Voice*, June 1, 1993, 84.

36. Guerrilla Girls, *Hot Flashes* 1, no. 1 (1993): n.p.

Lacy / Affinities: Thoughts on an Incomplete History

1. Over the course of many years, Los Angeles muralist Judith Baca and I have exchanged ideas on art, politics, and identity. This article includes portions of several discussions with her, and, in its entirety, reflects ideas we have mutually considered.

2. Lucy Lippard, "In the Flesh: Looking Back and Talking Back," catalogue essay for "Back Talk," an exhibition of California women artists at the Santa Barbara Contemporary Art Forum, 1993, curated by Marilee Knode and Erica Daborn, with a video exhibition curated by JoAnn Hanley.

3. Martha Rosler, in San Diego during the early seventies, was part of the extended Southern California women's art community and did combine both feminist and Marxist analysis in her art and writing.

4. As a result of its broad media exposure through television news, *In Mourning and In Rage* prompted several direct actions. One news reporter went immediately from the site of the performance at City Hall to the telephone company. There she interviewed on camera an executive who, when confronted with the company's repeated refusal to list rape hotline numbers along with their other emergency listings, publicly affirmed an immediate change. One city councilwoman pledged during the performance to create free self-defense classes for city employees. Another pledged to support activists' efforts to convert the $100,000 reward money offered for information on the strangler to funding for free citywide self-defense training for women. As a result of the performance this proposal was finally acted upon.

 For a complete discussion of media coverage of sex-violent crimes, see Suzanne Lacy, "In Mourning and In Rage (with Analysis Aforethought)," in *Femicide: The Politics of Woman Killing*, ed. Jill Radford and H. Diane Russell (New York: Twayne/Maxwell Macmillan International, 1992).

5. Judith Baca, interview by Lynn Hershman, 1992, for a forthcoming video on feminist art in the 1970s.

6. Mother Art was founded by Helen Million Ruby, Suzanne Siegal, and Laura Solagi; Feminist Art Workers, by Nancy Angelo, Candace Compton, Cheri Gaulke, and Laurel Klick, who was later replaced by Vanalyne Green; the Waitresses, by Jerri Allyn and Anne Gaulden; and Sisters of Survival, by Jerri Allyn, Nancy Angelo, Anne Gaulden, Cheri Gaulke, and Sue Mayberry.

7. Allan Kaprow, "The Real Experiment," in *Essays on the Blurring of Art and Life*, ed. by Jeff Kelley (Berkeley: University of California Press, 1993), 205.

8. Faith Ringgold, interview by Lynn Hershman, 1992, as cited above, note 5.

9. Antfarm's "Media Burn" press conference and performance (1976), which featured a fictional John F. Kennedy delivering a speech on mass media conventions while a Cadillac crashed through a wall of flaming television sets, and Lowell Darling's extended year-long campaign for governor of California, which played out with such success that he gathered 60,000 votes in the primaries, each functioned as a witty critique of media within its own venue. During the 1970s, Leslie Labowitz's and my work included media events, informational feature news campaigns, and media critiques, which were based on similar media analyses but were differentiated by their consistent commitment to direct action on specific social issues. These 1970s media art works were further differentiated from those of many 1980s artists by their location within mass media rather than in museums or as reproductions in art magazines.

10. Kaprow, "The Legacy of Jackson Pollack," in *Essays*, 9.

11. This exhibition and the resulting protest are credited with the subsequent exhibition "Women Artists: 1550–1950" at the Los Angeles County Museum of Modern Art, curated by Ann Sutherland Harris and Linda Nochlin. (Unfortunately, Tuchman later behaved as if this exhibition's stopping point of 1950 gave him a carte blanche to ignore women working after that date.) Adding to the outrage of the 1980 exhibition's exclusion of women was a simultaneous retrospective of work from the 50s, curated by Tuchman's colleague Stephanie Barron, which was also woefully unrepresentative of women.

12. Susan Faludi, *Backlash: The Undeclared War against American Women* (New York: Crown, 1991.)

13. For more detailed information on gay activism, see the essays by Mary D. Garrard, Carrie Rickey, and Yolanda M. López and Moira Roth, in this book.

14. A discussion with Chris Johnson, Lisa Findley, and Rick Bolton helped me to clarify this point.

Cottingham / The Feminist Continuum

1. Lucy R. Lippard, "Sweeping Exchanges: The Contribution of Feminism to the Art of the 70s," *Art Journal* (Fall/Winter 1980): 339–65.

2. Hilton Kramer, "Does Feminism Conflict with Artistic Standards?" *New York Times*, January 27, 1980, sec. 2, pp. 1, 27.

3. Lippard, "Sweeping Exchanges," 363.

4. Inspired by Mao Tse-Tung's *Little Red Book*, feminist consciousness-raising was developed by Kathie Sarachild of the New York City–based Redstockings, one of the first radical feminist activist groups to emerge from the antiwar and countercultural movements in 1968. Redstocking's rules for consciousness-raising were first distributed in the group's 1969 *Notes from the Second Year*, a photoduplicated packet of radical feminist writings that was one of the most widely read documents of the Women's Liberation Movement. Although not employed by every artist who worked in the name of feminism, consciousness-raising was central to most of the newly formed "woman artist groups" that sprang up throughout the United States and in other countries during the 70s. For instance, a 1972 newsletter of the feminist art network West-East Bag (WEB) provided its readers with eight "consciousness-raising rules" followed by over fifty suggested "topics;" by 1974, seven of eight city chapters of WEB who responded to a query concerning their "philosophy" listed consciousness-raising as a basis.

5. Surrealism and Dada, especially the more politicized gestures of artists such as Georg Grosz and John Heartfield, also closely anticipated feminism's extensive ambitions for a political and revolutionary art. But it could be argued too that the 70s Feminist Art movement was, within the modernist sense as defined by Peter Bürger, a true "avant-garde": it rejected artistic tradition, emphasized the collective and the popular, was committed to political engagement, and sought a mass, not an elite, audience.

6. For a discussion of how a backlash against feminism inspired misogynistic content in American (white male) art of the 80s and 90s, see Laura Cottingham, "Feminism versus Masculinism: Recent New York Art," *Tema Celeste*, no. 39 (Winter 1993): 64–67.

7. Laura Cottingham, "Janine Antoni: Biting Sums up My Relationship to Art History," *Flash Art*, no. 171 (Summer 1993): 104–5.

8. John Taylor, "Mope Art," *New York Magazine*, March 22, 1993, 16–17. For other citations and a discussion of the general critical response to the 1993 Whitney Biennial, see Laura Cottingham, "Pleasure Principled," *Frieze*, Issue 10 (May 1993): 11–15.

SELECTED BIBLIOGRAPHY

Wilding / The Feminist Art Programs

Art: A Woman's Sensibility. Valencia: California Institute of the Arts, Feminist Art Program, 1975.

Chicago, Judy. *Through the Flower: My Struggle as a Woman Artist*. Garden City, N.Y.: Doubleday, 1975; New York: Penguin, 1993.

Diner, Helen. *Mothers and Amazons: The First Feminine History of Culture*. Edited and translated by John Philip Ludia. Garden City, N.Y.: Anchor, 1973.

Firestone, Shulamith. *The Dialectic of Sex: The Case for Feminist Revolution*. New York: Bantam, 1970.

Hess, Thomas B., and Elizabeth C. Baker, eds. *Art and Sexual Politics*. New York: Collier, 1971.

Lippard, Lucy R. *From the Center: Feminist Essays on Women's Art*. New York: Dutton, 1976.

Loeb, Judy, ed. *Feminist Collage: Educating Women in the Visual Arts*. New York: Columbia University Teachers College Press, 1979.

Moore, Sylvia, ed. *Yesterday and Tomorrow: California Women Artists*. New York: Midmarch Arts Press, 1989.

Nemser, Cindy. "The Women's Art Movement." *Feminist Art Journal* 2, (Winter 1973/74).

Raven, Arlene. *At Home*. Exh. cat. Long Beach, Calif.: Long Beach Museum of Art, 1983. Reprinted in Raven, *Crossing Over: Feminism and Art of Social Concern*, 83–153. Ann Arbor, Mich.: UMI Research Press, 1988.

Wilding, Faith. *By Our Own Hands: The Women Artists' Movement, Southern California, 1970–1976*. Santa Monica, Calif.: Double X, 1977.

"Women's Liberation: Notes From the Second Year." *Journal of the Radical Feminists*. New York, 1970.

Woolf, Virginia. *A Room of One's Own*. 1929. New York: Harcourt, Brace Jovanovich, 1991.

Raven / Womanhouse

Burton, Sandra. "Bad Dream House." *Time* 99:12 (March 20).

Chicago, Judy. *Through the Flower: My Struggle as a Woman Artist*. Garden City, N.Y.: Doubleday, 1975; New York: Penguin, 1993.

Demetrakas, Johanna. *Womanhouse*. Forty-minute independent documentary color film.

Friedan, Betty. *The Feminine Mystique*. New York: Dell, 1963.

Litman, Lynn. *Womanhouse*. One-hour film made for Los Angeles Educational Television (KCET-TV), February 1972.

Raven, Arlene. *At Home*. Exh. cat. Long Beach, Calif.: Long Beach Museum of Art, 1983. Reprinted in Raven, *Crossing Over: Feminism and Art of Social Concern*, 83–153. Ann Arbor, Mich.: UMI Research Press, 1988.

————. "A Remarkable Conjunction: Feminism and Performance Art." In *Yesterday and Tomorrow: California Women Artists*, edited by Sylvia Moore, 242–51. New York: Midmarch Arts Press, 1989.

————. "The Circle: Ritual and the Occult in Women's Performance Art." *New Art Examiner*, November 1980. Reprinted in Raven, *Crossing Over, 23–32*.

Schapiro, Miriam. "The Education of Women as Artists: Project Womanhouse." *Art Journal* 31 (Spring 1972): 268–70.

Wilding, Faith. *By Our Own Hands: The Women Artists' Movement, Southern California, 1970–1976*. Santa Monica, Calif.: Double X, 1977.

Womanhouse. Exh. cat. Valencia: California Institute of the Arts, Feminist Art Program, 1972.

Broude and Garrard / Conversations with Judy Chicago and Miriam Schapiro

Judy Chicago: Selected Writings and Interviews
The Birth Project. Garden City, N.Y.: Doubleday, 1985.

The Dinner Party, A Symbol of Our Heritage. Garden City, N.Y.: Doubleday/Anchor, 1979.

Embroidering Our Heritage. Garden City, N.Y.: Doubleday/Anchor, 1980.

"Female Imagery," coauthor with Miriam Schapiro. *Womanspace Journal* 1 (Summer 1973): 11–14.

Holocaust Project: From Darkness into Light. New York: Penguin, 1993.

"Judy Chicago Talking to Lucy R. Lippard." *Artforum*, September 1974, 60–65.

"Letter to a Young Woman Artist," coauthor with Arlene Raven. In *Anonymous Was a Woman: A Documentation of the Women's Art Festival; A Collection of Letters to Young Women Artists*. Valencia: California Institute of the Arts, Feminist Art Program, 1974.

Raven, Arlene, and Susan Rennie. "Interview with Judy Chicago." *Chrysalis*, no. 4 (1978): 89–101.

Roth, Moira, ed. *Conversations: Interviews with 28 Bay Area Women Artists*. Oakland, Calif.: Mills College, 1988.

Through the Flower: My Struggle as a Woman Artist. Garden City, N.Y.: Doubleday, 1975; New York: Penguin, 1993. Excerpts reprinted in *Voicing Our Visions: Writings by Women Artists*, edited by Mara Witzling. New York: Universe, 1991.

Miriam Schapiro: Selected Writings and Interviews
Anonymous Was a Woman: A Documentation of the Women's Art Festival; A Collection of Letters to Young Women Artists. Valencia: California Institute of the Arts, Feminist Art Program, 1974.

Art: A Woman's Sensibility. Valencia: California Institute of the Arts, Feminist Art Program, 1975.

Avgikos, Jan. "The Decorative Politic: An Interview with Miriam Schapiro." *Art Papers* 6 (November/December 1982): 6–8.

"Cunts/Quilts/Consciousness," coauthor with Faith Wilding. *Heresies: A Feminist Publication on Art and Politics*, Issue 24 (1989): 6–13.

"The Education of Women as Artists: Project Womanhouse," *Art Journal* 31 (Spring 1972): 268–70.

"Female Imagery," coauthor with Judy Chicago. *Womanspace Journal* 1, (Summer 1973): 11–14.

"Geometry and Flowers." In *The Artist and the Quilt*, edited by Charlotte Robinson, 26–31. New York: Knopf, 1983.

"How Did I Happen to Make the Painting *Anatomy of a Kimono*?" In *Anatomy of a Kimono*. Exh. brochure. Reed College, April 1978.

"Notes from a Conversation on Art, Feminism, and Work." In *Working It Out: 23 Women Writers, Artists, Scientists, and Scholars Talk about Their Lives and Work*, edited by Sara Ruddick and Pamela Daniels, 283–305. New York: Pantheon, 1977.

"Recalling Womanhouse." *Women's Studies Quarterly* 15 (Spring/Summer 1987): 25–30.

Roth, Moira. "Interview with Miriam Schapiro." In *Miriam Schapiro: The Shrine, the Computer, and the Dollhouse*. Exh. cat. La Jolla: University of California, San Diego, Mandeville Art Gallery, 1975.

"Waste Not/Want Not: Femmage," coauthor with Melissa Meyer. *Heresies: A Feminist Publication on Art and Politics*, Issue 4 (Winter 1978): 66–69. Reprinted in *Collage: Critical Views*, ed. Katherine Hoffman. Ann Arbor and London: UMI Research Press, 1989, 295–315.

Garrard / Feminist Politics

A Documentary Herstory of Women Artists in Revolution. Pittsburgh, Pa.: KNOW Press, 1971; 2d ed. 1973.

Faludi, Susan. *Backlash: The Undeclared War against American Women*. New York: Crown, 1991.

Freeman, Jo. *The Politics of Women's Liberation: A Case Study of an Emerging Social Movement and Its Relation to the Policy Process*. New York: David McKay, 1975.

Lerner, Gerda. *The Creation of Feminist Consciousness: From the Middle Ages to 1870*. New York: Oxford University Press, 1993.

Lippard, Lucy R. *Get the Message? A Decade of Art for Social Change*. New York: Dutton, 1984.

————. *Mixed Blessings: New Art in a Multicultural America*. New York: Pantheon, 1990.

Morgan, Robin. *Sisterhood Is Powerful: An Anthology of Writings from the Women's Liberation Movement*. New York: Random House/Vintage, 1970.

Papachristou, Judith, ed. *Women Together: A History in Documents of the Women's Movement in the United States*. New York: Knopf, 1976.

Robins, Corinne. *The Pluralist Era: American Art, 1968–1981*. New York: Harper & Row, 1984.

Seigel, Judy, ed. *Mutiny and the Mainstream: Talk That Changed Art, 1975–1990*. New York: Midmarch Arts Press, 1992.

Wilding, Faith. *By Our Own Hands: The Women Artists' Movement, Southern California, 1970–1976*. Santa Monica, Calif.: Double X, 1977.

Women's Action Coalition. *WAC Stats: The Facts about Women*. New York: New Press, 1993.

Brodsky / Alternative Galleries and Exhibitions

A.I.R. Gallery Overview, 1972–1977, An Exhibition in Two Parts. Exh. cat. New York: A.I.R. Gallery, 1977.

Alloway, Lawrence. "Women's Art in the 70s." *Art in America*, May/June 1976: 64–72.

Artemisia Tenth Anniversary Catalogue. Exh. cat. Chicago: Artemisia Gallery, 1983.

Beattie, Ann. "A Room of One's Own." *New York Times*, April 5, 1987, sec. 2.

Brown, Kay. "Where We At Black Women Artists." *Feminist Art Journal* 1 (April 1972).

Contemporary Issues: Works on Paper by Women. Poster/brochure. Los Angeles: Women's Caucus for Art/Woman's Building, 1977.

Davis, Gayle Renee. "The Cooperative Galleries of the Women's Art Movement, 1969–1980." Ph.D. diss., Michigan State University, 1981.

Day, Sara. "A Museum for Women." *ARTnews*, Summer 1986; 111–18.

Dialectics of Isolation: An Exhibition of Third World Women Artists of the United States, September 2–20, 1980. Exh. cat. New York: A.I.R. Gallery, 1980.

Fifteen Years and Growing: Celebrating the Fifteenth Anniversary of the Woman's Building, the History and Programs of the Woman's Building, a Public Center for Women's Culture Founded in 1973. Los Angeles: Woman's Building, 1988.

The First Decade, Celebrating the Tenth Anniversary of the Woman's Building, a Pictorial History and Current Programs. Los Angeles: Woman's Building, 1983.

FOCUS: A Document of Philadelphia Focuses on Women in the Visual Arts. Mimeographed report. FOCUS archives, Philadelphia Museum of Art Library.

The Founders, October 7–25, 1980. Exh. cat. Washington, D.C.: Washington Women's Arts Center.

Gear, Josephine. "Some Alternative Spaces in New York and Los Angeles." *Studio International* 195 (1980): 63–68.

Glueck, Grace. "A New Showcase for Art by Women." *New York Times*, April 1, 1987, sec. C, p. 23.

Grillo, Jean Bergantini. "Soho 20: A Diverse Women's Gallery." *Woman's Art Journal*, Summer 1976, 36–37.

The History of Hera: A Women's Art Cooperative, 1974–1989. Wakefield, R.I.: Hera Educational Foundation, 1989.

Journal of the Rutgers University Libraries 54 (June 1992). The entire issue is devoted to the celebration of the twenty years of the Mary H. Dana Women Artist Series at the Mabel Smith Douglass Library.

Karras, Maria. *The Woman's Building, Chicago 1893/The Woman's Building, Los Angeles 1973–*. Los Angeles: Women's Community Press, 1975.

Lubell, Ellen. "Soho 20." *womanart*, n.d.

McGuignan, Cathleen. "A Museum of One's Own." *Newsweek*, April 13, 1987, 76.

MUSE, An Exhibition of Works by 21 Women Artists. Exh. cat. Museum of the Philadelphia Civic Center. Philadelphia: MUSE Gallery, 1979.

Nemser, Cindy. "Focusing on FOCUS." *Feminist Art Journal* 3 (Spring 1974): 22.

———. "In Her Own Image: Exhibition Catalog." *Feminist Art Journal* 3 (Spring 1974): 11–18.

———. "The Women Artists' Movement." *Feminist Art Journal* 2 (Winter 1973/74): 8–10.

New York Feminist Art Institute, Catalogue, 1981–1982.

NYFAI Women's Center for Learning, 10th Year Anniversary, Spring 1989 Schedule of Classes, Workshops and Events. New York: New York Feminist Art Institute, 1989.

Raven, Arlene. *At Home*. Exh. cat. Long Beach, Calif.: Long Beach Museum of Art, 1983. Reprinted in Raven, *Crossing Over: Feminism and Art of Social Concern*, 83–153. Ann Arbor, Mich.: UMI Research Press, 1988.

Richard, Paul, and Benjamin Forgey. "Birth of the Women's Museum." *Washington Post*, April 5, 1987, sec. G, pp. 1, 5–7.

Skiles, Jackie. "Life at the Alternate Structure, Women's Interart Center." *Women and Art* 1 (Winter 1971). A newsletter published by Redstockings and Redstocking Artists.

Transformations: Women in Art, 70s–80s. Exh. cat. New York: New York Feminist Art Institute, 1981.

Tucker, Marcia. "Bypassing the Gallery System." *Ms.*, 1973.

WARM: A Landmark Exhibition. Exh. cat. Minneapolis: Women's Art Registry of Minnesota, 1984.

Warren, Lynne. *Alternative Spaces: A History in Chicago*. Exh. cat. Chicago: Museum of Contemporary Art, 1984.

Washington Women's Art Center Archives. Martin Luther King Library, Washington, D.C.

Wilding, Faith. *By Our Own Hands: The Women Artists' Movement, Southern California, 1970–1976*. Santa Monica, Calif.: Double X, 1977.

Withers, Josephine, and Toby Quitslund. *Women Artists in Washington Collections. Her Feminine Colleagues' Photographs and Letters Collected by Frances Benjamin Johnston in 1900*. Exh. cat. College Park, Md.: University of Maryland Art Gallery and Women's Caucus for Art, 1979.

Woman's Building Records, 1973–1991. Archives of American Art, Smithsonian Institution, Washington, D.C.

Woman's Work: American Art 1974. Slide set no. 756. Stamford, Conn.: Sandak.

Women and Their Work: Tenth Anniversary. Exh. cat. Austin, Tex.: Women and Their Work, 1988.

Women Artists '77: Kansas City Regional Juried Art Exhibition. Kansas City, Mo.: Women's Caucus for Art, 1977.

Women Choose Women, January 12–February 18, 1973: An Exhibition Organized by Women in the Arts. Exh. cat. New York: New York Cultural Center, 1973.

Women's Art Registry of Minnesota Archives. Minnesota Historical Society, St. Paul, Minn.

Women's Caucus for Art. Records. Special Collections, Alexander Library, Rutgers University, New Brunswick, N.J.

Rickey / Writing (and Righting) Wrongs: Feminist Art Publications

I am grateful to the library at the Moore College of Art, Philadelphia, an invaluable resource and oasis. I also thank Elizabeth Baker, Sheila Levrant de Bretteville, the Guerrilla Girls, Elsa Honig Fine, Elizabeth Hess, Joyce Kozloff, Lucy Lippard, Cynthia Navaretta, Miriam Schapiro, and Judy Seigel for their lively recollections and indispensable archives.

Brunsman, Laura, and Ruth Askey. *Modernism and Beyond: Women Artists of the Pacific Northwest*. New York: Midmarch Arts Press, 1993.

Chrysalis, a quarterly, 1977–1980 (10 issues total).

Feminist Art Journal, a quarterly, 1972–1977.

Guerrilla Girls. *The Banana Report: The Guerrilla Girls Review the Whitney*. Catalogue for exhibition at the Clocktower, New York, April 16–May 17, 1987.

Heresies: A Feminist Publication on Art and Politics, a quarterly, 1977–present.

Hess, Thomas B., and Elizabeth C. Baker, eds. *Art and Sexual Politics*. New York: Collier, 1971.

Lippard, Lucy R. *From the Center: Feminist Essays on Women's Art*. New York: Dutton, 1976.

———. "Sexual Politics, Art Style," *Art in America*, September 1971.

Millett, Kate. *Sexual Politics*. Garden City, N.Y.: Doubleday, 1970.

Moore, Sylvia, ed. *Yesterday and Tomorrow: California Women Artists*. New York: Midmarch Arts Press, 1989.

Nochlin, Linda. "Why Have There Been No Great Women Artists?" in Hess and Baker, *Art and Sexual Politics*, 1–44. Originally published in *ARTnews*, January 1971, 22–39 and 67–71.

Seigel, Judy, ed. *Mutiny and the Mainstream: Talk That Changed Art, 1975–1990*. New York: Midmarch Arts Press, 1992.

Woman's Art Journal, a semiannual, 1980–present.

Women Artists Newsletter/Women Artists News, a monthly, 1975–1990.

Nochlin / Starting from Scratch: The Beginnings of Feminist Art History

Broude, Norma, and Mary D. Garrard. "An Exchange on the Feminist Critique of Art History." *Art Bulletin* 71 (March 1989): 124–26.

———, eds. *The Expanding Discourse: Feminism and Art History*. New York: Harper-Collins, 1992.

———. *Feminism and Art History: Questioning the Litany*. New York: Harper & Row, 1982.

Chadwick, Whitney, *Women, Art, and Society*. New York: Thames and Hudson, 1990.

Fine, Elsa Honig. *Women and Art: A History of Women Painters and Sculptors from the Renaissance to the 20th Century*. Montclair, N.J.: Allanheld and Schram, 1978.

Gabhart, Ann, and Elizabeth Broun. "Old Mistresses, Women Artists of the Past." *Walters Art Gallery Bulletin* 24 (April 1972), n.p. [1–8], on the concurrently running exhibition of the same title.

Gouma-Peterson, Thalia, and Patricia Mathews. "The Feminist Critique of Art History." *Art Bulletin* 69 (September 1987): 326–57.

Greer, Germaine. *The Obstacle Race: The Fortunes of Women Painters and Their Work*. New York: Farrar, Straus and Giroux, 1979.

Harris, Ann Sutherland, and Linda Nochlin. *Women Artists: 1550 to 1950*. New York: Knopf, 1976.

Hess, Thomas B., and Linda Nochlin, eds. *Woman as Sex Object: Studies in Erotic Art, 1730 to 1970*. New York: Newsweek, 1972.

Munro, Eleanor. *Originals: American Women Artists*. New York: Simon and Schuster, 1979.

Nochlin, Linda. "Why Have There Been No Great Women Artists?" in *Art and Sexual Politics*, ed. Thomas B. Hess and Elizabeth C. Baker, 1–44 (New York: Collier, 1971). Originally published in *ARTnews*, January 1971, 22–39 and 67–71.

———. *Women, Art, and Power and Other Essays*. New York: Harper & Row, 1988.

Petersen, Karen, and J. J. Wilson. *Women Artists: Recognition and Reappraisal, from the Early Middle Ages to the Twentieth Century*. New York: Harper & Row, 1976.

Pollock, Griselda. *Vision and Difference: Femininity, Feminism, and Histories of Art*. New York: Routledge, 1988.

Pollock, Griselda, and Rozsika Parker. *Old Mistresses: Women, Art, and Ideology*. New York: Routledge and Kegan Paul, 1981.

Rubinstein, Charlotte Streifer. *American Women Artists from Early Indian Times to the Present*. Boston: G.K. Hall; New York: Avon, 1982.

Tickner, Lisa. "Feminism and Art History." *Genders* 3 (Fall 1988): 92–128.

Tufts, Eleanor. *Our Hidden Heritage: Five Centuries of Women Artists*. New York: Paddington Press, 1974.

Vogel, Lise. "Fine Arts and Feminism: The Awakening Consciousness." In *Feminist Art Criticism: An Anthology*, ed. Arlene Raven, Cassandra Langer, and Joanna Frueh (1988; New York: HarperCollins, 1991). Originally published in *Feminist Studies* 2, no. 1 (1974): 3–37.

López and Roth / Social Protest: Racism and Sexism

Abelove, Henry, Michele Aina Barale, and David M. Halperin, eds. *The Lesbian and Gay Studies Reader*. New York: Routledge, 1993.

Asian Women United of California. *Making Waves: An Anthology of Writings by and about Asian American Women*. Boston: Beacon Press, 1989.

Barnett, Alan W. *Community Murals: The People's Art*. Philadelphia: Art Alliance Press/Cornwall Books, 1984.

Campbell, Mary Schmidt, ed. *Tradition and Conflict: Images of a Turbulent Decade, 1963–1973*. New York: Studio Museum in Harlem, 1985.

Chicago, Judy. *Through the Flower: My Struggle as a Woman Artist*. Garden City, N.Y.: Doubleday, 1975; New York: Penguin, 1993.

The Decade Show: Frameworks of Identity in the 1980s. New York: Museum of Contemporary Hispanic Art/New Museum of Contemporary Art/Studio Museum in Harlem, 1990.

Ferguson, Russell, Martha Gever, Trinh T. Minh-ha, and Cornel West, eds. *Out There: Marginalization and Contemporary Cultures*. Cambridge: MIT Press/New Museum of Contemporary Art, New York, 1990.

Griswold del Castillo, Richard, Teresa McKenna, and Yvonne Yarbro-Bejarano, eds. *Chicano Art: Resistance and Affirmation, 1965–1985* (CARA). Los Angeles: University of California, Wight Art Gallery, 1991.

Hammond, Harmony, and Jaune Quick-to-See Smith. *Women of Sweetgrass, Cedar, and Sage*. New York: Gallery of the American Indian Community House, 1985. Includes essays by Erin Younger and Lucy R. Lippard.

Lippard, Lucy R. *From the Center: Feminist Essays on Women's Art*. New York: Dutton, 1976.

———. *Get the Message? A Decade of Art for Social Change*. New York: Dutton, 1984.

———. *Mixed Blessings: New Art in a Multicultural America*. New York: Pantheon, 1990.

Withers / Feminist Performance Art

Benamou, Michel, and Charles Caramello, eds. *Performance in Postmodern Culture*. Madison, Wis.: Coda Press, 1977.

Goldberg, Rosalee. *Performance Art: From Futurism to the Present*. Rev. ed. New York: Abrams, 1988.

Heresies 5, no. 1, Issue 17 (1984). Special issue "Women in Theatre and Performance."

——— 5, no. 4, Issue 20 (1984). Special issue "Women and Activism."

Lippard, Lucy R. *Get the Message? A Decade of Art for Social Change*. New York: Dutton, 1984.

———. "Quite Contrary: Body, Nature, and Ritual in Women's Art," *Chrysalis*, no. 2 (1977): 30–47.

Loeffler, Carl E., and Darlene Tong, eds. *Performance Anthology: Source Book of California Performance Art*. Rev. ed. San Francisco: Last Gasp Press, 1989.

Roth, Moira, ed. *The Amazing Decade: Women and Performance Art in America, 1970–1980*. Los Angeles: Astro Artz, 1983.

Sayre, Henry. *The Object of Performance: The American Avant-Garde since 1970*. Chicago: University of Chicago Press, 1989.

Wilding, Faith. *By Our Own Hands: The Women Artists' Movement, Southern California, 1970–1976*. Santa Monica, Calif.: Double X, 1977.

Orenstein / Recovering Her Story

Budapest, Zsuzsanna. *The Holy Book of Women's Mysteries: Feminist Witchcraft, Goddess Rituals, Spellcasting, and Other Womanly Arts*. Berkeley, Calif.: Wingbow Press, 1989.

Carrington, Leonora. *The Hearing Trumpet*. New York: Pocket Books, 1977.

Chadwick, Whitney. *Women Artists and the Surrealist Movement*. Boston: Little, Brown/New York Graphic Society, 1985.

Christ, Carol P., and Judith Plaskow, eds. *Womanspirit Rising: A Feminist Reader in Religion*. San Francisco: Harper & Row, 1979.

Cles-Reden, Sibylle. *The Realm of the Great Goddess: The Story of Megalithic Builders*. Englewood Cliffs, N.J.: Prentice-Hall, 1962.

Daly, Mary. *Gyn/Ecology: The Metaethics of Radical Feminism*. Boston: Beacon Press, 1978.

Downing, Christine. *The Goddess: Mythological Images of the Feminine*. New York: Crossroad, 1981.

Gadon, Elinor W. *The Once and Future Goddess: A Symbol of Our Time*. San Francisco: Harper & Row, 1989.

Gimbutas, Marija. *The Civilization of the Goddess: The World of Old Europe*. San Francisco: HarperSanFrancisco, 1991.

———. *The Goddesses and Gods of Old Europe: Myths and Cult Images, 6500–3500 B.C.* Berkeley: University of California Press, 1982.

———. *The Language of the Goddess: Unearthing the Hidden Symbols of Western Civilization*. San Francisco: Harper & Row, 1989.

Heresies: A Feminist Publication on Art and Politics, Issue 5, "The Great Goddess" (Spring 1978).

James, E. O. *The Cult of the Mother Goddess*. New York: Praeger, 1959.

Levy, Gertrude Rachael. *The Gate of Horn: A Study of the Religious Conceptions of the Stone Age and Their Influence upon European Thought*. London: Faber & Faber, 1946.

Marchessault, Jovette. "Night Cows." In *Lesbian Triptych*, translated by Yvonne M. Klein. Toronto: Women's Press.

Neumann, Erich. *The Great Mother: An Analysis of the Archetype*. Princeton: Princeton University Press, 1955.

Orenstein, Gloria. *The Reflowering of the Goddess*. Athene Series. New York: Columbia University Teachers College Press, 1990.

Plaskow, Judith P., and Carol P. Christ, eds. *Weaving the Visions: New Patterns in Feminist Spirituality*. San Francisco: Harper & Row, 1989.

Sjöö, Monica, and Barbara Mor. *The Great Cosmic Mother: Rediscovering the Religion of the Earth*. San Francisco: Harper & Row: 1987.

Spretnak, Charlene. *The Politics of Women's Spirituality: Essays on the Rise of Spiritual Power within the Feminist Movement*. Garden City, N.Y.: Anchor, 1982.

Starhawk. *The Spiral Dance: A Rebirth of the Ancient Religion of the Great Goddess*. New York: Harper & Row, 1979.

Stone, Merlin. *When God Was A Woman*. New York: Dial Press, 1976. First published in Britain as *The Paradise Papers*.

Walker, Barbara G. *The Woman's Encyclopedia of Myths and Secrets*. New York: Harper & Row, 1983.

Frueh / The Body Through Women's Eyes

Ana Mendieta: A Retrospective. Petra Barreras del Rio and John Perreault, guest curators. Exh. cat. New York: New Museum of Contemporary Art, 1987.

Berger, John. *Ways of Seeing*. London: Penguin, 1972.

Carter, Angela. *The Sadeian Woman and the Ideology of Pornography*. New York: Pantheon, 1978.

Cixous, Hélène. "The Laugh of the Medusa." Translated by Keith Cohen and Paula Cohen. In *New French Feminisms: An Anthology*, edited by Elaine Marks and Isabelle de Courtivron, 245–64. New York: Schocken, 1981.

Dodson, Betty. *Liberating Masturbation: A Meditation on Self-Love*. New York: Bodysex Designs, 1974.

Frueh, Joanna. "Hannah Wilke." In *Hannah Wilke: A Retrospective*, edited by Thomas H. Kochheiser, 11–103. Columbia: University of Missouri Press, 1989.

Greer, Germaine. *The Female Eunuch*. New York: McGraw-Hill, 1971; Bantam, 1978.

Hammond, Harmony. "A Sense of Touch." *Heresies: A Feminist Publication on Art and Politics* 3, no. 4 (1981): 43–47. An earlier version appeared in *New Art Examiner* 6 (Summer 1979).

Holder, Maryse. "Another Cuntree: At Last, a Mainstream Female Art Movement." In *Feminist Art Criticism: An Anthology*, edited by Arlene Raven, Cassandra L. Langer, and Joanna Frueh, 1–20. New York: HarperCollins, 1991. Originally published in *off our backs*, September 1973.

Irigaray, Lucy. "This Sex Which Is Not One." Translated by Claudia Reeder. In *New French Feminisms: An Anthology*, edited by Elaine Marks and Isabelle de Courtivron, 99–106. New York: Schocken, 1981. New translation by Catherine Porter with Carolyn Burke. Ithaca, N.Y.: Cornell University Press, 1985.

Jong, Erica. *Fear of Flying*. New York: Signet, 1974.

Lippard, Lucy R. "The Pains and Pleasures of Rebirth: European and American Women's Body Art." In *From the Center: Feminist Essays on Women's Art*, 121–38. New York: Dutton, 1976. Originally published in *Art in America*, May/June 1976: 73–81.

Lorde, Audre. "Uses of the Erotic: The Erotic as Power." In *Sister Outsider*, 53–59. Trumansburg, N.Y.: Crossing Press, 1984.

Mulvey, Laura. "Visual Pleasure and Narrative Cinema." In *Art after Modernism: Rethinking Representation*, edited by Brian Wallis, 361–73. Boston: David R. Godine/New Museum of Contemporary Art, New York, 1984. Originally published in *Screen* 16 (Autumn 1975): 6–18.

Nemser, Cindy. "Four Artists of Sensuality." *Arts Magazine* March 1975, 73–75.

Orbach, Susie. *Fat Is a Feminist Issue: The Anti-Diet Guide to Permanent Weight Loss*. 1978. New York: Berkley Books, 1979.

Raven, Arlene, and Ruth Iskin. "Through the Peephole: Toward a Lesbian Sensibility in Art." *Chrysalis* 4 (1977): 19–31.

Reitz, Rosetta. *Menopause: A Positive Approach*. London: Penguin, 1979.

Rich, Adrienne. *Of Woman Born: Motherhood as Experience and Institution*. 1976. New York: Bantam Books, 1977.

Schneemann, Carolee. *More than Meat Joy: Complete Performance Works and Selected Writings*. Edited by Bruce McPherson. New Paltz, N.Y.: Documentext, 1979.

Semmel, Joan, and April Kingsley. "Sexual Imagery in Women's Art." *Woman's Art Journal* 1, (Spring/Summer 1980): 1–6.

Tickner, Lisa. "The Body Politic: Female Sexuality and Women Artists since 1970." In *Looking On: Images of Femininity in the Visual Arts and Media*, edited by Rosemary Betterton, 235–53. New York: Pandora, 1987. Originally published in *Art History* 1, (June 1978): 236–49.

Wittig, Monique. *The Lesbian Body*. Translated by David Le Vay. New York: Bard, 1976.

———. *Les Guérillères*. Translated by David Le Vay. 1971. Boston: Beacon Press, 1985.

Broude / The Pattern and Decoration Movement

Art/New York and Inner-Tube Video. *Aspects of Pattern and Decoration*. Text and interviews by Marc Miller; produced and directed by Paul Tschinkel. 1982.

Broude, Norma. "Miriam Schapiro and 'Femmage': Reflections on the Conflict between Decoration and Abstraction in Twentieth-Century Art," *Arts Magazine*, February 1980, 83–87.

Goldin, Amy. "The 'New' Whitney Biennial: Pattern Emerging?" *Art in America*, (May/June 1975): 72–73.

———. "Patterns, Grids, and Painting," *Artforum*, September 1975, 50–54.

———. "Pattern and Print." *Print Collectors' Newsletter* 9 (March/April 1978): 10–13.

Jensen, Robert, and Patricia Conway. *Ornamentalism: The New Decorativeness in Architecture and Design*. New York: Clarkson N. Potter, 1982.

Kardon, Janet. *The Decorative Impulse*. Exh. cat. Philadelphia: University of Pennsylvania, Institute of Contemporary Art, 1979.

Perreault, John. "Issues in Pattern Painting." *Artforum*, November 1977, 32–36.

———. *Pattern Painting*. Exh. cat. Brussels, Belgium: Palais de Beaux-Arts de Bruxelles, 1979.

———. "The New Decorativeness." *Portfolio* 1 June/July 1979: 46–50.

Perrone, Jeff. "Approaching the Decorative." *Artforum*, December 1976, 26–30.

———. "The Decorative Impulse." *Artforum*, November 1979, 80–81.

———. "Seriously, Folks." *Arts Magazine*, December 1980, 104–6.

Rickey, Carrie. "Pattern Painting." *Arts Magazine*, January 1978, 17.

———. "Decoration, Ornament, Pattern, and Utility: Four Tendencies in Search of a Movement." *Flash Art*, June/July, 1979, 19–29.

———. "Art of Whole Cloth." *Art in America*, November 1979, 72–83.

Robins, Corinne. "Pattern Painting and Decorative Art." In *The Pluralist Era, American Art, 1968–1981*, 131–54. New York: Harper & Row, 1984.

Stein, Judith. "Rediscovering Decorative Traditions," in *Making Their Mark: Women Artists Move into the Mainstream, 1970–1985*. Exh. cat. Randy Rosen and Catherine C. Brawer, curators, 155–67. New York: Abbeville, 1989.

Stroud, Marion Boulton, ed. *An Industrious Art: Innovation in Pattern and Print at The Fabric Workshop*. Philadelphia: Fabric Workshop/New York: Norton, 1991.

Wheeler, Daniel. "Pattern and Decoration." In *Art Since Mid-Century: 1945 to the Present*, 283–89. New York: Vendome Press, distributed by Rizzoli International Publications, 1991.

Stein / Collaboration

Arnold, Stephanie. "Suzanne Lacy's 'Whisper, The Waves, the Wind.'" *Drama Review*, Spring 1985, 126–30.

Chicago, Judy. *The Birth Project*. Garden City, N.Y.: Doubleday, 1985.

———. *The Dinner Party*. Garden City, N.Y.: Anchor, 1979.

Gablik, Suzi. *The Reenchantment of Art*. New York: Thames and Hudson, 1991.

Hammond, Leslie King, and Lowery Stokes Sims. *Art As a Verb*. Baltimore: Maryland Institute College of Art, 1988.

Hess, Elizabeth. "A Tale of Two Memorials." *Art in America*, April 1983, 120–27.

Johnston, Laurie. "The 'Sister Chapel': A Feminist View of Creation." *New York Times*, January 30, 1978, sec. B, p. 1.

Kerr, Joanne. *Art and Community: A Sociological Study of Contemporary Feminist Art*.

Ph.D. diss., University of California, Irvine. Ann Arbor, Mich.: University Microfilms International, 1980.

King, Ynestra. *What Is Ecofeminism?* New York: Ecofeminist Resources, 1990.

Kingsley, April. "Six Women at Work in the Landscape." *Arts Magazine*, April 1978, 108–12.

Lacy, Suzanne. "Take Back the Night." *High Performance*, Winter, 1979/80.

McCabe, Cynthia Jaffee, ed. *Artistic Collaboration in the Twentieth Century*. Washington, D.C.: Smithsonian Institution Press, 1984.

Mesa-Bains, Amalia. "El Mundo Femenino: Chicana Artists of the Movement—A Commentary on Development and Production." In *Chicano Art: Resistance and Affirmation, 1965–1985*, edited by Richard Griswold del Castillo, Teresa McKenna, and Yvonne Yarbro-Bejarano, 131–40. Los Angeles: University of California, Wight Art Gallery, 1991.

Moore, Sylvia, ed. *Yesterday and Tomorrow: California Women Artists*. New York: Midmarch Arts Press, 1989.

The Ribbon: A Celebration of Life. Edited by the Lark Books staff and Marianne Philbin. Asheville, N.C.: Lark Books, 1985.

Robinson, Charlotte. *The Artist and the Quilt*. New York: Knopf, 1983.

Robinson, Hilary, ed. *Visibly Female: Feminism and Art Today*. New York: Universe, 1988.

Roth, Moira, ed. *Connecting Conversations: Interviews with 28 Bay Area Women Artists*. Oakland, Calif.: Eucalyptus Press, 1988.

———. "Suzanne Lacy at the IDS Building." *Art in America*, March 1988, 162.

———. "Suzanne Lacy's Dinner Parties." *Art in America*, April 1980, 126.

Rubinstein, Charlotte Streifer. *American Women Artists*. New York: Avon, 1982.

Signs from the Heart: California Chicano Murals. Edited by Eva Sperling Cockcroft and Holly Barnet-Sánchez. Venice, Calif.: Social and Public Art Resource Center, 1990.

Sims, Lowery Stokes. "Aspects of Performance in the Work of Black American Women Artists." In *Feminist Art Criticism: An Anthology*, edited by Arlene Raven, Cassandra Langer, and Joanna Frueh, 207–25. New York: HarperCollins, 1991.

Wallach, Amei. "Women, God, and the World—the Sister Chapel's Trinity." *Newsday*, January 29, 1978, Part II, p. 15.

Schor / Backlash and Appropriation

Ida Applebroog. Exh. cat. New York: Ronald Feldman Fine Arts, 1987.

Benjamin, Walter. "The Work of Art in the Age of Mechanical Reproduction." In *Illuminations*, edited and introduced by Hannah Arendt, translated by Harry Zohn, 217–52. New York: Shocken, 1969.

Berger, John. *Ways of Seeing*. 1972. New York: Viking, 1973.

Blistene, Richard. "Francis Picabia: In Praise of the Contemptible." *Flash Art*, no. 113 (Summer 1983): 24–31.

Buchloh, Benjamin. "Figures of Authority, Ciphers of Regression." *October*, no. 16 (Spring 1981): 39–68.

Buck-Morss, Susan. *The Origin of Negative Dialectics: Theodor Adorno, Walter Benjamin, and the Frankfurt School*. New York: Free Press, 1977.

Butler, Judith. *Gender Trouble: Feminism and the Subversion of Identity*. New York: Routledge, Chapman & Hall, 1990.

Chadwick, Whitney. *Women, Art, and Society*. New York: Thames and Hudson, 1990.

Chicago, Judy. *The Dinner Party: A Symbol of Our Heritage*. Garden City, N.Y.: Anchor, 1979.

Cixous, Hélène, and Catherine Clement. *The Newly Born Woman*. Theory and History of Literature, vol. 24. Minneapolis: University of Minnesota Press, 1986.

Crimp, Douglas. "The End of Painting." *October* 1 (Spring, 1981): 69–86.

de Lauretis, Teresa. "The Essence of the Triangle or, Taking the Risk of Essentialism Seriously: Feminist Theory in Italy, the U.S., and Britain." *differences* 1, (Summer 1989): 3–37.

———. *Technologies of Gender: Essays on Theory, Film, and Fiction*. Bloomington: Indiana University Press, 1987.

Difference: On Representation and Sexuality. Exh. cat. Kate Linker, guest curator. New York: New Museum of Contemporary Art, 1984.

Endgame: Reference and Simulation in Recent Painting and Sculpture. Exh. cat. Cambridge: MIT Press/Institute of Contemporary Art, Boston, 1986.

Faludi, Susan. *Backlash: The Undeclared War against American Women*. New York: Crown, 1991.

"Flash Art News: Francis Picabia and David Salle." *Flash Art*, no. 115 (January 1984): 31.

Foster, Hal. *Recodings: Art, Spectacle, Cultural Politics*. Port Townsend, Wash.: Bay Press, 1985.

Foster, Hal, ed. *The Anti-Aesthetic: Essays on Postmodern Culture*. Port Townsend, Wash.: Bay Press, 1983.

Gallop, Jane. *The Daughter's Seduction: Feminism and Psychoanalysis*. Ithaca, N.Y.: Cornell University Press, 1982.

Gilbert, Sandra M., and Susan Gubar. *The Madwoman in the Attic: The Woman Writer and the Nineteenth-Century Literary Imagination*. New Haven: Yale University Press, 1979.

Glaser, Bruce. "Questions to Stella and Judd." In *Minimal Art: A Critical Anthology*, edited by Gregory Battcock, 148–164. New York: Dutton, 1968.

Guerrilla Girls. *The Banana Report: The Guerrilla Girls Review the Whitney*. Exh. cat. information booklet. New York, 1987.

Hawthorn, Jeremy. *A Glossary of Contemporary Literary Theory*. New York: Routledge, Chapman & Hall, 1992.

Irigaray, Luce. *Speculum of the Other Woman*. Translated by Gillian C. Gill. Ithaca, N.Y.: Cornell University Press, 1985.

Kardon, Janet. *David Salle*. Exh. cat. Philadelphia: University of Pennsylvania, Institute of Contemporary Art, 1986.

Kelly, Mary. *Mary Kelly interim: Corpus, Pecunia, Historia, Potestas*. Exh. cat. New York: New Museum of Contemporary Art, 1990.

Kristeva, Julia. *Powers of Horror: An Essay on Abjection*. New York: Columbia University Press, 1982.

Kuspit, Donald. "Reviews: David Salle." *Art in America*, Summer 1982, 142.

Lawson, Thomas. "Last Exit: Painting." *Artforum*, October 1981.

Lerner, Gerda. *The Creation of Patriarchy*. New York: Oxford University Press, 1986.

Levin, Kim. "The Masterpiece Mentality." *Village Voice*. June 1, 1993, 84.

Levine, Sherrie. "David Salle." *Flash Art*, no.103 (Summer 1981): 34.

MacShine, Kynaston. *An International Survey of Recent Painting and Sculpture*. Exh. cat. Edited by Harriet Schoenholz Bee and Jane Fluegel. New York: Museum of Modern Art, 1984.

Ana Mendieta, A Retrospective. Exh. cat. New York: New Museum of Contemporary Art, 1987.

Moi, Toril. *Sexual/Textual Politics: Feminist Literary Theory*. New York: Methuen, 1985.

Mulvey, Laura. *Visual and Other Pleasures*. Bloomington: Indiana University Press, 1989.

Parker, Rozsika and Griselda Pollock. *Old Mistresses: Women, Art, and Ideology*. New York: Pantheon, 1981.

Parker, Rozsika, and Griselda Pollock, eds. *Framing Feminism: Art and The Women's Movement 1970–1985*. London: Routledge & Kegan Paul/Pandora Press, 1987.

Pollock, Griselda. *Vision and Difference: Femininity, Feminism, and Histories of Art*. New York: Routledge, 1988.

Ratcliff, Carter. "David Salle and the New York School." In *David Salle*. Exh. cat. Rotterdam: Museum Boymans-van Boeningen, 1983.

Robinson, Hilary, ed. *Visibly Female: Feminism and Art Today, An Anthology*. New York: Universe, 1988.

Schjeldahl, Peter. "Absent-Minded Female Nude on Bed, for David Salle." *Artforum*, December 1981, 49.

Schor, Naomi. "This Essentialism Which Is Not One: Coming to Grips with Irigaray." *differences* 1, (Summer 1989): 38–58.

Tema Celeste, no. 37/38 (Autumn 1992) and no. 39 (Winter 1993). Suzanne Joelson, and Andrea Scott, guest eds. "The Question of Gender in Art."

Women's Action Coalition. *WAC Stats: The Facts about Women*. New York: New Press, 1993.

Wallis, Brian, ed. *Art After Modernism: Rethinking Representation*. New Museum of Contemporary Art, New York, Boston: David R. Godine/1984.

Wallis, Brian, ed. *Blasted Allegories: An Anthology of Writings by Contemporary Artists*. Cambridge: MIT Press/New Museum of Contemporary Art, New York, 1987.

Wilson, Malin, ed. *The Hydrogen Jukebox: Selected Writings of Peter Schjeldahl, 1978–1990*. Berkeley: University of California Press, 1991.

Cottingham / The Feminist Continuum

Carmichael, Stokely, and Charles Harrison. *Black Power: The Politics of Liberation in America*. New York: Vintage, 1967.

de Beauvoir, Simone. *The Second Sex*. 1949. New York: Vintage, 1974.

Dent, Gina, ed. *Black Popular Culture*. New York: Dia Center, 1992.

Firestone, Shulamith. *The Dialectic of Sex: The Case for Feminist Revolution*. New York: William Morrow/Bantam, 1970.

Greenberg, Clement. *The Collected Essays and Criticism*, edited by John O'Brian. 2 volumes. Chicago: University of Chicago Press, 1986.

Guilbaut, Serge. *How New York Stole the Idea of Modern Art: Abstract Expressionism, Freedom, and the Cold War*. Chicago: University of Chicago Press, 1983.

Lippard, Lucy R. *From the Center: Feminist Essays on Women's Art*. New York: Dutton, 1976.

Malcolm X. *The Autobiography*. New York: Grove Press, 1966.

Millett, Kate. *Sexual Politics*. Garden City, N.Y.: Doubleday, 1970.

Pollock, Griselda. *Vision and Difference: Feminity, Feminism, and Histories of Art*. New York: Routledge, 1988.

Redstockings of the Women's Liberation Movement. *Feminist Revolution*. New York: Random House, 1978.

Picketing the Whitney Museum of American Art, April 1972 (Photo Maurice C. Blum)

- The West-East Bag, otherwise known as WEB, is created as a liaison to inform women artists' groups internationally of each other's actions, legal maneuvers, methodology, discussion topics, and techniques; within months, it has representatives in 12 states and 5 countries. Each WEB rep organizes a slide library of work by women; each takes a turn in publishing the WEB newsletter.

- Supreme Court rules that employers may not refuse to hire women merely because they have small children.

- *Art and Sexual Politics*, edited by Thomas B. Hess and Elizabeth C. Baker, is published; it includes Nochlin's essay and responses to it by Elaine de Kooning, Louise Nevelson, Eleanor Antin, Marjorie Strider, and Lynda Benglis.

- In Washington, the National Press Club votes to end a ban on women members.

- Judy Chicago and Miriam Schapiro initiate the Feminist Art Program at California Institute for the Arts.

- In Washington, the Corcoran Biennial is devoted exclusively to male artists. Female artists picket. In expiation, the Corcoran agrees to host a Conference on Women in the Arts the following year.

- *Women and Art Quarterly* founded; after issue published, staff splits along ideological lines, the cultural feminists versus the Marxist feminists. Second issue published (with Marxist supplement). Some members will go on to found *The Feminist Art Journal.*

From left to right: Faith Ringgold, Harmony Hammond, Suzanne Lacy, Lucy Lippard at a Women's Caucus for Art panel (Photo Special Collections and Archives, Rutgers University Libraries)

1972

- (January) The Women's Caucus for Art (WCA) of the College Art Association (CAA) is founded; Ann Sutherland Harris is the first WCA president.

- (April) In Washington, the Corcoran hosts the Conference on Women in the Arts.

- (July) *Ms.* magazine begins official publication.

- In New York, A.I.R. Gallery, the first women's cooperative gallery since the short-lived Gallery 15 in 1958, is founded.

- *The Feminist Art Journal* (1972–77), a quarterly, is founded by Woman in Art survivors Cindy Nemser, Pat Mainardi, and Irene Moss, with Nemser as editor-in-chief.

- Richard Nixon re-elected President.

1973

- (January) In Los Angeles, Womanspace—exhibition space and community center—opens; publishes *Womanspace Journal.*

- (November) In Los Angeles, Woman's Building opens at Chouinard School, Grandview Street; Womanspace becomes a primary tenant.

- Joyce Kozloff and Nancy Spero publish *The Rip-Off File,* a newsletter containing some unforgettable depositions by women in the arts who experienced significant institutional or personal sexism.

- Number of women artists in Whitney Biennial (no longer an annual) is 52 out of a total of 214 artists.

- Vice-president Spiro Agnew resigns, pleading guilty to tax evasion.

- In Chicago, Artemisia Gallery, a women's cooperative named for Artemisia Gentileschi, is founded. Shortly thereafter, a second Windy City co-op, ARC, opens its doors.

- In New York, the women's co-op gallery Soho 20 is founded.

- Native-American activists and federal officers face off at Wounded Knee, South Dakota.

- Sarah Lawrence College offers first graduate program in Women's Studies.

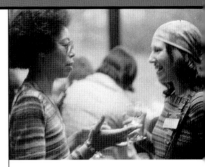

WCA reception, Washington, D.C., conference, 1975. Vivian Brown, left, speaking with Suzanne Perkins

1974

- Oil crisis; double-digit inflation.

- In Philadelphia, a 100-woman steering committee, led by Diane Burko, organizes a far-ranging event, Philadelphia Focuses on Women in the Visual Arts. Among its components is "Woman's Work," an invitational exhibition highlighting feminism's foremothers (among them Isabel Bishop, Louise Bourgeois, Lee Krasner, and Louise Nevelson) and "In Her Own Image," a historical survey including Lilly Martin Spencer and Mary Cassatt. Informational panels feature women curators, critics, and dealers.

- In Wakefield, R.I., Hera Gallery, a women's cooperative, holds its first exhibition.

- President Richard Nixon resigns; Gerald Ford pardons him.

- Fredi Wechsler, analyst for the National Women's Political Caucus, estimates that the Equal Rights Amendment (ERA), which will bar discrimination based on sex by action of federal, state, and local governments—and already ratified in 33 of the required 38 states—will be ratified.

A Redstockings meeting, with founder Cathy Sarachild, far right, 1975. (Photo © Bettye-Lane)

1970s

1975

- United States forces evacuate Southeast Asia.

- (December) In Los Angeles, the Woman's Building relocates to 1727 N. Spring Street. Its tenants include Womanspace; the Feminist Studio Workshop run by historian Arlene Raven, designer Sheila Levrant de Bretteville, and artist Judy Chicago; the co-op galleries Grandview 1 and 2; Sisterhood Bookstore; the Los Angeles chapter of the National Organization for Women.

In Mourning and In Rage, Los Angeles City Hall, 1977

- In India, Prime Minister Indira Gandhi declares national emergency and imposes press censorship, moving the 28-year-old democracy toward dictatorship.

- Number of women in Whitney Biennial is 33 out of 128 artists.

- (April) In New York, *Women Artists Newsletter* (1975–91), a monthly, commences publication with Cynthia Navaretta at the helm, with contributions by Judy Seigel. Over its life it will streamline its title to *Women Artists News.* From 1984–86 it publishes bimonthly. From 1986–91, it publishes quarterly.

- Designated as the International Year of the Woman by the United Nations; conference held in Mexico City.

- In the United States Senate, there are no women; in the House of Representatives, 16.

1976

- (April) In Minneapolis, WARM Gallery (Women's Art Registry of Minneapolis) opens.

- Betty Friedan says at a Ford Foundation–sponsored conference on Women and the American Economy, "The women's movement is only a way-station."

- In New York, *womanart* (1976–78) magazine, a quarterly edited by Ellen Lubell, commences publication.

- Jimmy Carter elected president.

- (December) "Women Artists: 1550–1950," organized by Linda Nochlin and Ann Sutherland Harris, opens at the Los Angeles County Museum of Art and travels to other institutions, including the Brooklyn Museum. Many Americans get their first introduction to the works of Rachel Ruysch, Angelica Kauffman, Artemisia Gentileschi, Elisabeth Vigée-Lebrun, and Rosalba Carriera.

1977

- *womanart* (Winter/Spring 1977) publishes issue devoted to the question, "What Ever Happened to the Women Artists' Movement?"

- In Philadelphia, MUSE, a cooperative gallery and women's community center, opens its door.

- In Los Angeles, *Chrysalis* (1977–80), a quasi-quarterly, commences publication. Its editorial board includes Sheila Levrant de Bretteville, Kirsten Grimstad, Ruth Iskin, Arlene Raven, and Susan Rennie.

Take Back the Night protest, San Francisco, November 1978

Bills of Rights, performance handouts by Feminist Art Workers, New Orleans, 1980

- Number of women in Whitney Biennial is 9 out of 40 artists.

- In New York, *Heresies* (1977–present), a sometimes quarterly, commences publication. Its founding collective includes Joan Braderman, Mary Beth Edelson, Harmony Hammond, Elizabeth Hess, Joyce Kozloff, Lucy Lippard, Miriam Schapiro, and May Stevens.

1978

- (November 18) In San Francisco, Suzanne Lacy, Leslie Labowitz, and the group Ariadne join organizers to stage one of the first *Take Back the Night* rallies in response to the prevalence of pornography and violence against women.

1979

- Germaine Greer's *The Obstacle Race* is published.

- Number of women in Whitney Biennial is 18 out of 57 artists.

- Judy Chicago's *Dinner Party* goes on national tour of U.S. museums, prompting both controversy and awareness of feminist art.

- Margaret Thatcher elected British prime minister.

1980s

1980

- Ronald Reagan elected president.

- (November 17) Women's Pentagon Action group stages a theatrical protest at the Pentagon following the election of Ronald Reagan as president.

- In the United States Senate, there are 2 women; in the House of Representatives, 17.

- In Minneapolis, *WARM Journal,* a quarterly, is founded. On the committee are Elizabeth Erickson, Susan McDonald, and Alice Towle.

- In Knoxville, Tennessee, *Woman's Art Journal* (1980–present), a scholarly semiannual edited by Elsa Honig Fine, commences publishing.

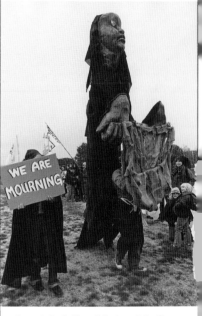

Demonstration by Women's Pentagon Action Group, Washington, D.C., 1980 (Photo Dorothy Marder)

1981

- Number of women in Whitney Biennial is 15 out of 81 artists.

- Sandra Day O'Connor seated as the first woman justice on the U.S. Supreme Court.

1982

- (June) After a 10-year fight for ratification, the Equal Rights Amendment dies in Congress.

1983

- (June) Astronaut Sally Ride becomes the first American woman in space aboard the space shuttle *Challenger*.

- Number of women in Whitney Biennial is 14 out of 46 artists.

1984

- Geraldine Ferraro nominated as vice-presidential candidate by the Democratic Party.

- Ronald Reagan re-elected president.

1985

- EMILY'S List (Early Money Is Like Yeast), a donor network, devoted to electing Democratic women to the Senate, is founded.

- In the United States Senate, there are 2 women; in the House of Representatives, 20.

- Number of women in Whitney Biennial is 13 out of 52 artists.

- Guerrilla Girls, "conscience of the art world," begin their stealth actions in Manhattan, plastering informational posters throughout Soho and appearing at panels wearing gorilla masks to protect their anonymity. A GG census of New York galleries reveals that fewer than 10% of those exhibiting in calendar year 1984 were women. The Museum of Modern Art's 1984 reopening show features 13 women out of 169 artists. (The female to male ratio is quite close to that of the 1969 Whitney Annual—which sparked protest by Women Artists in Revolution —for including only 8 women out of 151 artists.)

Anniversary issue of *Heresies*, 1989 (Photo Zindman/Fremont)

1987

- Number of women in Whitney Biennial is 9 out of 44 artists.

1988

- George Bush elected president.

1989

- *Heresies* publishes its 24th issue, reflections on 12 years of feminism, art, and politics.

- Number of women in the Whitney Biennial is 30 out of 76 artists.

- National Endowment for the Arts (NEA) becomes the subject of attack by conservative Republican Senator Jesse Helms, who wants to "prevent NEA funding of such trash." Specifically this includes artists Robert Mapplethorpe, Andres Serrano, and Karen Finley.

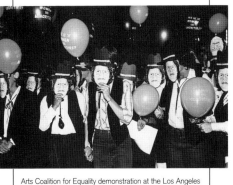

Arts Coalition for Equality demonstration at the Los Angeles County Museum of Art, 1981 (Photo © Linda Eber)

1990s

1991

- Susan Faludi's *Backlash* is published.

- Naomi Wolf's *The Beauty Myth* is published.

- Number of women at Whitney Biennial is 33 out of 94 artists. (In addition, there are seven women's collectives whose work was shown.)

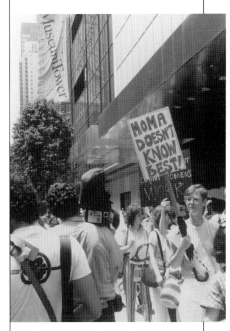

Picketing the Museum of Modern Art, New York, June 1984 (Photo Mira Schor)

1992

- (January): Women's Action Coalitions (WAC) is founded in response to the Clarence Thomas Supreme Court confirmation hearings, during which former Thomas colleague Anita Hill's allegation of sexual harassment became the subject of the committee's scrutiny.

- Bill Clinton elected president. His wife, Hillary Rodham Clinton, is the most activist first lady since Eleanor Roosevelt.

- In the United States Senate, there are 6 women; in the House of Representatives, 47.

1993

- Number of women in Whitney Biennial is 30 out of 42 artists. (In addition, there are 10 collectives whose work is on view.)

- Betty Friedan publishes *The Fountain of Age*.

- In the United States Senate, there are 7 women.

- Ruth Bader Ginsburg is seated as a U.S. Supreme Court Justice.

1994

- (January/April) Two-part "Bad Girls" exhibition, devoted to feminist art, takes place at New Museum of Contemporary Art, New York City.

- Admiral Frank Kelso, chief of naval operations tarred by the Tailhook scandal, retires.

- (April 22) Louise Bourgeois retrospective at the Brooklyn Museum—the first major show of her sculpture and drawings in nearly 15 years.

- (April 22) Richard Nixon dies.

THESE GALLERIES SHOW NO MO THAN 10% WOMEN ARTISTS OR NONE AT ALL.

Blum Helman	Fun
Mary Boone	Marian Goodman
Grace Borgenicht	Pat Hearn
Diane Brown	Marlborough
Leo Castelli	Oil & Steel
Charles Cowles	Pace
Marisa Del Re	Tony Shafrazi
Dia Art Foundation	Sperone Westwater
Executive	Edward Thorp
Allan Frumkin	Washburn

SOURCE ART IN AMERICA ANNUAL 1984-85 A PUBLIC SERVICE MESSAGE FROM GUERR CONSCIENCE OF THE

Guerrilla Girls poster, 1985

1949–69

1940s

- (1949) Simone de Beauvoir's *The Second Sex* is published in France. Knopf publishes U.S. edition in 1953.

1960s

- (1963) Betty Friedan's *The Feminine Mystique* is published.

- (June 29, 1966) National Organization for Women (NOW) is founded in Washington by Betty Friedan and 30 other women in order to fight sexual discrimination.

- (1969) Shirley-Chisholm, the first black female member of the House of Representatives, fights her way off an agricultural subcommittee, insisting on a committee with more relevance to her predominantly black and Hispanic constituents.

- (1969) Shirley Temple Black makes her debut as U.S. delegate to the United Nations.

- (1969) U.S. troops in Vietnam number more than 500,000.

- (1969) Vice-president Spiro Agnew lambastes "unelected television elite."

- (1969) In New York, Women Artists in Revolution (WAR), made up of disgruntled female members of Art Workers Coalition (AWC), forms to talk about discrimination against women in the art world. Many WAR members are appalled to learn that AWC's attack on the art establishment is being waged on behalf of minority males only.

- (1969) As he makes his historic walk on the moon, astronaut Neil Armstrong says, "That's one small step for a man, one giant step for mankind."

1970s

1970

- (July) Kate Millett's *Sexual Politics* is published; 22,000 copies sold in first month.

- (August 26) On the 50th anniversary of Women's Suffrage, author Betty Friedan and many other prominent feminists demonstrate in the Women's Strike for Equality. One of the marchers hoists a banner declaring the 1970s "The Decade of Dames." Eleanor Holmes Norton, chair of the New York City Commission on Civil Rights, declares that women's rights would be the social movement of the 70s as civil rights was to the 60s.

- (October) In New York, Ad Hoc Women Artists' Committee emerges from AWC and WAR to tackle issue of number of women included in Whitney Annual and in Whitney collections. Because of feminist pressure, the usual 5% representation of women artists is 22% in the 1971 Annual.

- In the United States Senate there is 1 woman; in the House of Representatives, 11 women.

- In Los Angeles, Los Angeles Council of Women Artists (LACWA) emerges to protest that no women artists were invited to participate in the "Art & Technology" show at the Los Angeles County Museum of Art (LACMA). An analysis of the museum's exhibition record reveals that of 53 one-artist shows hosted by museum only 1 was dedicated to a woman, photographer Dorothea Lange.

- U.S. military incursions into Cambodia.

- In Ceylon, Mrs. Sirimavo Bandaranaike is elected prime minister, raising the global number of female pms—including Israel's Golda Meir and India's Indira Gandhi—to 3.

- In California, Judy Chicago teaches separate women's studio art classes at Fresno State.

- Women, Students and Artists for Black Art Liberation (WSABAL) is founded by Faith Ringgold and her daughter Michele Wallace, which helps launch the black art movement.

1971

- (January) Linda Nochlin's "Why Have There Been No Great Women Artists?" is published in *ARTnews*.

- (March 21) National Women's Political Caucus is founded in New York City.

- (June) LACWA statistics show that less than 1% of the art on view at the Los Angeles County Museum of Art is by women.

- (September) Lucy Lippard's "Sexual Politics, Art Style" appears in *Art in America*.

- "Where We At Black Women Artists" exhibition is held in New York City.

- Shulamith Firestone's *The Dialectic of Sex* is published.

- Vivian Gornick and Barbara K. Moran's anthology, *Woman in Sexist Society: Studies of Power and Powerlessness*—which also includes the Linda Nochlin essay—is published.

- After attending Ad Hoc Women Artists' Committee meetings, Ce Roser calls an informal meeting of female artists she knows socially, including Buffie Johnson, Alice Neel, and Fay Lansner—who in turn call Elaine de Kooning and Pat Passlof, who in turn The women meet informally and at each meeting the group mushrooms. Out of these informal meetings a core group forms and calls itself Women in the Arts (WIA). The core includes Cynthia Navaretta and Ce Roser and holds occasional meetings (and publishes a newsletter) to, among other activities, plan gallery actions against owners who do not exhibit women artists.

- *Everywoman* publishes observations by Judy Chicago, Miriam Schapiro, and Faith Wilding on "central cavity" imagery, theorizing a feminine aesthetic.

The Womanhouse building, Los Angeles, 1971

INDEX

PHOTOGRAPH CREDITS

The authors and publisher wish to thank the individuals, galleries, and institutions for permitting the reproduction of works in their collections. Those credits not listed in the captions are provided below. All references are to page numbers.

Karen Bell: 143 below, 166; Kay Brown: 107; Judy Chicago: 68, 70, 72; Geoffrey Clements, N.Y.: 11; D. James Dee: 209, 229; Wolfgang Dietz: 157; 272 above; Mary Beth Edelson: 96–97, 128; Judy Scott Feldman: 244; Courtney Frisse, Syracuse, N.Y.: 77 below; Stanley Greenstein: 232; Lloyd Hamrol: 49, 52–57, 60, 62; Lynn Hershman: 265; Eeva Inkeri: 203; Valerie Jaudon: 220; Joyce Kozloff: 223 above; Suzanne Lacy: 150, 165, 172, 233 below, 234–235, 266 above, 275 right; Sheila Levrant de Bretteville: 153; Yolanda M. López: 240 below; Robert Miller Gallery/© Estate of Alice Neel: 199; Peter Moore: 206; Peter Muscato: 283; Judy Stone Nunneley: 117 above; Gloria Orenstein: 179 above, 183 above, 185; Beth Phillips 205: above; David Reynolds: 144 above; Philipp Scholz Rittermann: 2–3, 76; Abby Robinson: 225; Rutgers University Libraries, Special Collections and Archives, New Brunswick, N.J.: 95 above, 98, 100 above, 101, 115 below; Miriam Schapiro: 41; Ellouise Schoettler: 89; Joan Semmel: 200 below; Fern Schaffer: 112–113; Ann Slayton: 117 below; Oren Slor: 80; Lee Stalsworth: 26 above; Steinbaum Krauss Gallery, N.Y./Ken Cohen: 217; Jim Strong, N.Y.: 17; Through the Flower Corporation, Santa Fe, N.M.: 230; Marvin Trachtenberg: 27; Faith Wilding: 30–31, 39, 40 right; Donald Woodman: 227, back cover; Nancy Youdelman: 33, 42; Zindman/Freemont, N.Y.: 19, 20, 34, 44, 45 above, 121, 125, 127. Copyright A.R.S., New York: Lee Krasner, Georgia O'Keeffe; Copyright A.R.S., New York/Pro Litteras: Meret Oppenheim.